Music 101

A Guide to
Active Listening
for a Generation Online

Second Edition

James E. Shearer

with

Fred Bugbee

New Mexico State University

Kendall Hunt
publishing company

Portions of chapters 1 and 10 are adapted from *Jazz Basics: A Brief Overview with Historical Documents and Recordings* by James E. Shearer. Copyright ©2002 by Kendall Hunt Publishing Company.

www.kendallhunt.com
Send all inquiries to:
4050 Westmark Drive
Dubuque, IA 52004-1840

Copyright ©2005, 2010 by Kendall Hunt Publishing Company

PAK ISBN: 978-1-5249-0422-7
Text Alone ISBN: 978-1-5249-0423-4

Printed in the United States of America

Contents

Classical Listening Guides

Foreword

This book, along with its companion volume, *Jazz Basics*, is the product of a lifelong passion for music in all its forms. It is equally the product of a passion for teaching music. I have known few people with a passion for music and for teaching as strong as that of the book's author, Professor Jim Shearer. As Director of the Honors College at New Mexico State University, I have had the opportunity and the pleasure of observing this passion at first hand. Dr. Shearer created for the Honors College and has for several years taught a course called "Music in Time and Space," which explores musical forms from opera to rock and roll. The students who are lucky enough to get into this popular course (which every semester fills early) learn not only about the history of music and about the various musical genres, but how to *listen* to music.

Dr. Shearer brings the same intelligence, clarity, and passion for music to this book as he displays in his classroom. Like its companion volume, *Music 101* presents a balance of commentary, historical documentation, and insightful listening guides. It is a proven methodology based on years of successful teaching, and the student can be confident of an authoritative, yet highly readable textbook. *Music 101* offers the student a lifelong guide to listening, an entrance into the rich and diverse world of classical music, jazz, and world music.

Once or twice a week each semester, as I work in my office, I hear the muted strains of some sonata, or jazz riff, or rock and roll song, or country western melody, come streaming from the classroom below. The songs are briefly interrupted by the sound of a man's voice, explaining and drawing out the nuances of a particular piece, or of students with urgent questions. I immediately recognize the sounds of "Music in Time and Space." They are the pleasant classroom sounds of a teacher passionate about his subject and devoted to sharing his knowledge with young people, and of young people eagerly seeking his knowledge. What does learning sound like? It sounds like the music streaming from that classroom.

William Eamon
New Mexico State University

Preface

As we begin this journey into the sometimes-daunting world of classical music, jazz, and world music, I am reminded of the fictional cover of an electronic book created by the late author Douglas Adams. The book was titled *The Hitchhiker's Guide to the Galaxy*, and in big red letters the cover said "Don't Panic." Yes, 1,500 years of music history is a lot to take in, but no one expects you to learn in one or two semesters everything musicians have taken lifetimes to learn. The truth is, I want to help you eliminate your fear of (and in some cases indifference to) these musical styles. This is great music, and at the risk of sounding like an infomercial, it really can change your life. My biggest goal for this book is to create some new classical music fans, because, quite frankly, a lot of our established fans are dying off. For this music to survive outside of a museum setting we need some new audience members, and we need them now.

Perhaps you have never given much thought to the role music plays in your life. Now's a good time to reflect and decide if you really like what you are listening to, or if you are just taking in what the record companies, MTV, and the radio offer you. Trust me, what makes it into the top ten is usually music programmed for the lowest common denominator. Please understand that there is nothing wrong with pop music. (Well, there are some things wrong with *some* pop music, but that's another story.) No, it's just that what passes these days for "popular" is so *limited*. In his day, Mozart's piano concertos and Verdi's operas were the ultimate in pop music. People sang the tunes in the street, and if they had had radios in their horse-drawn carriages during the eighteenth and nineteenth centuries they would have been tuning in to the *Live from the Met* opera broadcasts every Saturday morning. Bach and Haydn wrote party music, and Handel went so far as to write music for the King of England to sail down the river to *and* a live soundtrack to be played while they were shooting off a bunch of fireworks. This music is not dull. It's full of joy, sex, murder, depression, sex, dancing, sex, and lots of other good stuff. You just have to know where to look for it.

And that is what this book is all about . . . helping you find the good stuff in classical music, jazz, and world music. So sit back, relax, and most of all, "Don't Panic."

The following items are just a few important features of the book and listening materials that you will want to pay particular attention to.

- Streaming access is included with over five hours of some of the finest classical music ever recorded.

- Each recorded selection has a coinciding listening guide found within the appropriate chapter of the text. In addition, each listening guide uses time-codes along with descriptive explanations of what is happening within that given section of the music. With most vocal selections, both the original text and an English translation have been provided.

- Each chapter offers extended reading passages drawn from historical documents, letters, and other famous publications. These diverse items include everything from Bach's contract with the Town of Leipzig to Frank Zappa's 1984 keynote address to the American Society of University Composers.

- All important terms and concepts are presented in **boldface**. Wide outside margins also contain matching boldface terms to help students quickly locate a specific definition or musical concept. These wide margins also allow space for quick notes at any given point of interest.

- Where appropriate, you will find special *Focus On Form* sections that offer more detailed information on specific topics in a very concise manner. These topics are offset to facilitate ease of study and to keep the more complex information out of the conversational body of the general text.

- New to the 2nd edition of the book are *Dig Deeper* sections that offer students and teachers research sources for more detailed information on a given subject. The principal categories include websites, books, movies, and recordings, but other resources are also offered as needed from topic to topic.

- Each chapter contains a study guide that may be extracted from the text without the loss of other important book materials.

It is my sincere hope that you find this a useful, engaging, and informative textbook. Comments and suggestions for improvement are both welcomed and sincerely appreciated. Please feel free to communicate with the author at the following e-mail address: jshearer@nmsu.edu.

Acknowledgments

As with my first book, *Jazz Basics*, I once again extend my sincere thanks to the faculty, staff, and students of New Mexico State University for their kind assistance and patience during the creation of this textbook. Special thanks to NMSU Music Department Chairman Dr. Greg Fant for helping me secure a sabbatical, which allowed me the extended research and writing time necessary to develop this book. Thanks also to Dr. Joseph Sylvan for his knowledgeable input during the final stages of manuscript preparation. The staff at the NMSU Library has been most helpful, with special thanks going to Dr. Gary Mayhood for his tireless efforts on behalf of the NMSU Music Department. Thanks also to Steve Haddad, who covered my studio and my position with the El Paso Brass during my sabbatical and beyond. I also extend thanks to my colleagues in the El Paso Brass for allowing me time away from the group to work on this manuscript.

My father passed away during the creation of this manuscript, and with his death I lost not only my dad but a great manuscript editor as well. Dr. T. J. Ray, retired Professor of English at the University of Mississippi, stepped in to edit the entire text and to offer numerous suggestions for the improvement of the final product. Any errors remaining are solely the responsibility of the author. Dr. Ray, along with several members of the Howell family, also took over many of the day-to-day operations of our family business, a weekly newspaper called *The North Mississippi Herald*. Mere words can never express the depth of my gratitude, as well as the appreciation of my entire family.

My wife Celeste truly has the patience of Job, and my love for her is unending. She is my best friend and an excellent colleague in the world of music as well. Her suggestions and proofreading skills added immensely to the final text. I look forward to spending more time with her in the future.

Thanks also to Mrs. Willie Wood for once again contributing her artwork for use on the cover of this book and the accompanying CD set. The Wood family has become quite dear to me over the past few years, and I thank them all for their many kindnesses.

Finally, I extend once again my sincere thanks to everyone at Kendall Hunt Publishing Company. As with *Jazz Basics*, from talking me into writing this book in the first place, to helping create the document and clearing the permissions to a number of photos, recordings, and articles, these fine people have been extremely helpful and supportive. I never could have (or would have) done it without them.

This book is dedicated with much love and respect to the memory of my father. Daddy loved music. He was an excellent musician and a wonderful teacher as well. Had he not gone into the newspaper business, I believe he would have made a fine band director or even a college professor. He truly was the smartest man I have ever known, and it is my sincere hope that this book will, in some small way, preserve the musical legacy he left behind.

Acknowledgments for the Second Edition

Since the creation of the first edition of this book, originally called *Classical Basics,* many people have offered constructive suggestions that have led to the creation of this updated and expanded text. In particular, the authors thank all of the staff at Kendall Hunt for their help extending this text to include more jazz and world music information, and thanks as well to all of our colleagues who suggested helpful additions and corrections to enhance the current text. In particular, thanks go to Dr. Richard Rundell, Department Head of Languages and Linguistics at New Mexico State University. His formidable language skills, along with his insightful knowledge of European history in general, have greatly enhanced this version of the text. Thanks also to our music department colleagues Eike Gunnarson and Andrew Zimmerman for their help with German translations. Dr. T. J. Ray once again served as a great sounding board for issues of language and punctuation, and we thank him for his time and efforts. The authors also wish to thank Dr. Ken Van Winkle, Chairman of Music at NMSU, for his continued support.

Fred Bugbee would like to thank his parents, Gerry and Becky, for inspiring him to examine the larger world. Thanks also to Ed Pias, my friend and colleague at New Mexico State University, for sharing his insight and expertise in the study of global cultures. Special thanks to Jim Shearer who, in addition to making this project possible, spent countless hours helping me write and rewrite chapter 11. Finally, thanks to my two-year-old son Luke, who enthusiastically provided a soundtrack of Christmas carols in July, and to my best friend and wife Monika, who supported me every step of the way.

A Note about the Listening Guides and the Streaming Listening Materials that Accompany this Textbook

Throughout this book you will find detailed written listening guides that coincide with streaming audio tracks found on the Great River Learning website, which also houses an eBook version of this text and other ancillary materials. To access the steaming listening tracks (for Chapters 1-9 only), simply go to www.grtep.com, log in, and navigate to the class-specific website for the course you are taking. All listening materials will be clearly marked as such on that homepage. Each written listening guide is time-coded for these specific recorded examples. It should be noted, however, that not all playback devices agree to the exact millisecond regarding time-codes. Your player may be off from the printed time-codes by as much as two or three seconds. You should also keep in mind that some clearly identifiable events in music can happen in much less than a single given second. The printed time-code may say "3:45" when the event really happens at "3:45.55". Finally, the general information contained in the listening guides will work with any recorded example of the same piece, but the time-codes will not match up. Students are heartily encouraged to experience as many different performances of the same work as possible.

To help you compare and contrast musical styles and techniques from the various historical periods, several different settings of the mass *Kyrie* and the *Ave Maria* texts are included throughout this collection. Beyond the recordings included here, students are encouraged to seek out other works making use of the same texts for additional study.

These particular recordings that accompany your book were selected for a number of different reasons including overall performance quality, adherence to authentic performance practices, and, in some cases, obvious historical significance. There are almost as many different opinions about how a specific piece of music should be performed as there are recordings of that piece. In the last 30 years, many new groups have emerged who are offering "authentic" performance practices in both their live concerts and recordings. These include the use of period instruments or reproductions, reduced forces, and a return to marked tempos whenever practical and appropriate. Most of these groups specialize in the performance of music written before 1825. As you will hear on a few of your listening examples, the movement toward using the reduced forces appropriate to a given piece of music has also spilled over into some "modern" performing organizations as well.

With the development of convenient digital recording technology over the past 35 years or so, the classical music world has enjoyed a wealth of historical re-releases, a trend that is sure to continue in the future. As the historical recordings in this collection clearly demonstrate, with a little research and prudent shopping there are a lot of tremendous recordings available at very reasonable prices. As you will notice in the older "live from the stage" opera recordings, even if the sound quality is not perfect, the immediacy of the live performance is still worth the price of admission.

The listening guides found in Chapter 10 are suggested listening for jazz, but be aware that the recordings are not included in the streaming material for *MUSIC 101*. As they are all very famous "standard" recordings, all of the suggested recordings are readily available from a number of different sources. For further jazz listening, students and professors alike are encouraged to purchase recordings from the Ken Burn's *Jazz* series and/or the *Smithsonian Collection of Classic Jazz*. Both sets provide an excellent overview of the recorded history of jazz music from ragtime to fusion.

Chapter 1
The Basic Elements of Classical Music

"If I were to begin life again, I would devote it to music.
It is the only cheap and unpunished rapture on earth."

Sydney Smith

Scholars have been arguing for centuries about the true definition of music. It's a very complicated discussion that centers on aesthetics, culture, and personal beliefs. Let's not even try for a working definition. You know what music is. You hear it every day. It is an integral part of your life from the time you wake up until the time you go to bed. Music just is . . . and really, that's all it needs to be.

One thing to keep in mind is that music is simply another language—another way for humans to communicate. The difference is that unlike other languages, you don't need full use of the vocabulary to get a pretty good understanding of what is being said; however, music tends to function on many different levels. Peel away the outer layer, and there is often more being said emotionally than meets the eye (or ear). There is almost always some communication between the musicians and the audience, but dig inside the performance a bit more and you will find there is a lot of musical conversation or "back-and-forth" between the musicians themselves. Music is a very powerful art form, but, in many ways, it is the most intangible. Regarding the power of music, critic Alan Rich once wrote:

> Of all the arts, music inspires the greatest fear of the unknown. If a painting or a sculpture offends, you can walk away. Music attacks, grabs hold and imposes its own time frame; try to escape from a live performance of some act of blatant musical innovation, and you risk stepping on toes, both literally and figuratively. A piece of new music sounds new because it does battle with expectations we've amassed from listening to other music not as new; therein lies its power.[1]

The following material is some very basic music terminology to help you start digging a little deeper into the music. You don't have to know how to read music to apply any of this information to your experiences. In fact, about the only thing you really need to master is a new way of counting to four. With an attentive ear, and some repeated listening to the same material, you should begin to hear *inside* the music. For musicians, this is where the really good stuff is. Yes, it is a little more complex than just humming along with the melody of a tune, but you may also find your listening experiences a lot more enjoyable as you dive inside the music. It has been suggested that some "non-musicians" believe embracing a deeper technical understanding of how music functions will actually detract from their enjoyment of the music in some way, but these same people would never drive without knowing the rules of the road or attend a sporting event without at least some basic knowledge about how the game is played.[2] Music works the same way. The more you know, the better your understanding of what a composer and/or performer is attempting to convey through a musical performance.

A Few of the Basic Building Blocks Used to Create Classical Music

pitch

intervals

octave

Any sound that has an identifiable **pitch**, or sustained harmonic frequency, can be considered a musical sound. In Western music, pitches of different frequencies are called **intervals**, with the smallest interval being one half-step away from its neighbor. Next comes a whole step, a step and a half, and so forth, all the way up to an interval 12 half steps (or 8 whole steps) wide, called an **octave**. Examine the piano keyboard diagram below, and you can view some different intervals in relationship to one another. In music, we use the first seven letters of the alphabet to distinguish the seven basic tones, and we repeat them again and again, octave after octave. Notice that in the first octave the black keys have letter names that are followed by flats, while in the second octave the letter names are followed by sharps. The notes are exactly the same, but the given key center determines whether the note is a sharp or a flat. (The technical term for this dual note spelling is *enharmonic*, but that is starting to get too complicated for this textbook. Don't worry too much about the why; just get a basic sense of the different note intervals.)

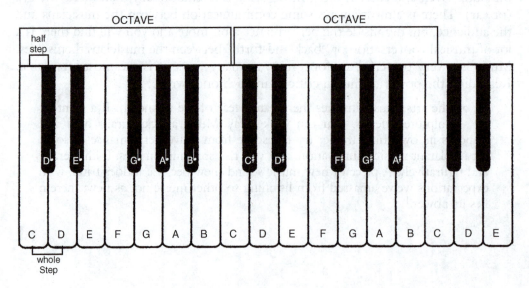

String a series of pitches together, and you will create a **melody**. Melodies can be simple or complex, harsh or beautiful, full of wide intervallic leaps or conjunct passages of one note flowing up or down to the next. A single line of melody with no accompaniment is referred to as **monophonic**, meaning one sound. All of the earliest Gregorian chants you will study in the next chapter are monophonic.

Over the course of music history a number of different patterns, called **scales**, evolved and were used as basic building blocks for music. In the world of classical music, prior to 1600 there were seven different patterns of half steps and whole steps, each consisting of an eight-note pattern within a given octave, called the **church modes**. Each different mode was said to convey a specific set of emotions, though in practice composers did not always adhere to that theory. After 1600, music was codified into two scale patterns drawn from the church modes, the major scale and the minor scale. Without getting too technical, the major scale pattern tends to sound happy; the minor scale often conveys a sense of sadness or anger. These two patterns remain in use to this day, although, as you will learn in Chapter 9, a few twentieth-century composers did begin to make use of an entirely different system of musical organization.

When you group two or more different pitches together, you create **harmony.** The term "harmony" also brings into play the concepts of consonance and dissonance. These two basic elements are the core answer to how most music functions. Here are two simple definitions for you: **consonance** - tones at rest; **dissonance** - tones that need to be resolved. Almost all music is based on the contrast of movement between dissonance and consonance—just like the basic concept of how drama and literature function: you create tension (dissonance) and then resolve it (consonance). Prior to 1600, the various church modes contained clear elements of both consonance and dissonance. After 1600, the music of what became known as the "common practice period" adopted a distinct hierarchy of chord patterns that are still in use today with most classical music and in all popular formats. When music starts making use of more than one note at a time, there are a few more textural terms you will need to become familiar with. The first of these is **homophonic** (combined sounds), which simply means playing groups of different notes with the same basic rhythm. The other important term is *polyphonic*, or many sounds. The term **polyphonic** applies when two or more simultaneous melodies weave together with different rhythms and notes. Harmony is created, but so is a certain amount of rhythmic complexity.

Dealing with consonance and dissonance means dealing with the movement of harmony or chords. **Chords** are groups of notes that sound consonant or dissonant when played together or when sounded close together in two or more polyphonic lines. They can be played by one instrument such as a piano or guitar or by a group of instruments including strings, woodwinds, and/or brass. A consonant chord is pretty stable: it either is or it isn't. Dissonant chords are a bit more complex as there is a whole sound spectrum from mildly dissonant to sounding like you put a set of bagpipes through a limb shredder.

To gain a better understanding of how consonance and dissonance function, let's focus on three big "building block" chords. These three chords are found in almost every piece of popular music ever written. Most obviously, they make up the basic structure of the blues in American popular music. In addition, these three chords can be found in every piece of classical music ever composed by Bach, Mozart, Beethoven, and Wagner, just to name a few. In classical music, we refer to

melody

monophonic

scales

church modes

harmony

consonance

dissonance

homophonic

polyphonic

chords

DIG DEEPER

WEBSITE
www.musictheory.net

tonic/dominant axis harmony

this system as **tonic/dominant axis harmony.** Think of these chords in terms of the various parts of a sentence you might study in English class.

tonic

- **Tonic** (I chord) - Home base. A consonant chord. Works like the subject in a sentence and is the main focus of most pieces of music

dominant

- **Dominant** (V chord) - A dissonant chord. Works like the verb in a sentence and is the action chord

sub-dominant

- **Sub-dominant** (IV chord) - Also a dissonant chord, but less dissonant than the dominant. Works like a helping verb in a sentence and modifies the dominant

basic beat

We'll get back to those chords in just a second, but first you need to learn about finding the **basic beat** in a piece of music. Finding the basic pulse of the music and counting along can be the best way to figure out the structure of many smaller compositions or to help you define individual sections of larger works. In music, we group sets of the basic beat together in something called a **measure** (or **bar**). To keep track of the measure groupings as they pass by, count like this: 1,2,3,4; 2,2,3,4; 3,2,3,4; 4,2,3,4; etc. Now, while groupings of four beats per measure are most common, we can also have groups of three: 1,2,3; 2,2,3; 3,2,3 like a waltz; and groups of two: 1,2; 2,2; 3,2; 4,2 like a march, a polka, or a ragtime piece. There can also be more complex groupings of 6, 9, and 12 basic beats, which can then be divided into larger patterns of two, three, or four.

measure (or bar)

12-bar blues

For a simple listening exercise, group those building block chords together with a certain basic beat pattern, and you've got the formula for thousands of songs. This format is called the **12-bar blues.** Below is a chart with the beat numbers and the different bars marked for you in groups of four beats per measure. Also included are the chord symbols to show you where the consonance and dissonance fall in the structure. The lyrics are from the *St. Louis Blues* by W. C. Handy.

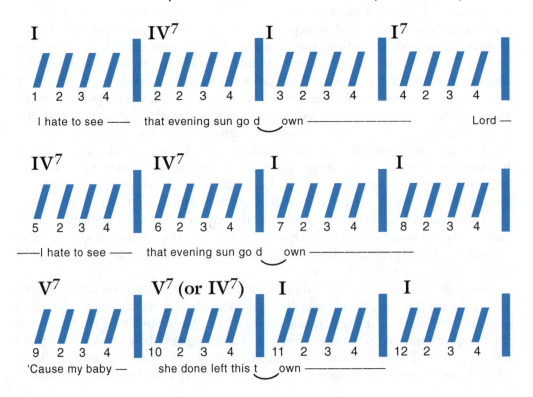

Now within the basic 12-bar blues pattern there are lots of minor variations to the chord structure, but they all really work the same way. Here is a list of tunes that use the blues as their basic structure.

Jazz	Rock
West End Blues–Louis Armstrong	*Rock Around the Clock*–Bill Haley
C Jam Blues–Duke Ellington	*Maybellene*–Chuck Berry
Billie's Bounce–Charlie Parker	*Hound Dog*–Elvis Presley
Blue Monk–Thelonious Monk	*Yer Blues* (White Album)–Beatles
All Blues–Miles Davis	*Little Wing*–Jimmy Hendrix
Blue Train–John Coltrane	*Ball and Chain*–Janis Joplin
West Coast Blues–Wes Montgomery	*Cocaine*–Eric Clapton
Broadway Blues–Ornette Coleman	*Cold Shot*–Stevie Ray Vaughn
Stormy Monday–Eva Cassidy	*Bad to the Bone*–George Thorogood

Compared to popular music formats such as the blues, the formal structures of classical music are usually more complex. In particular, they tend to be much longer. Nonetheless, there are still clear formal structures at play, even in works that can last well over an hour. With just a few exceptions (and all of them during the past 100 years), music is very rarely a random series of events. The following sections, as well as many of the *Focus on Form* selections found throughout the text, will help you gain a better understanding of the many different ways classical music can be organized.

Before we move on, however, here are a few more basic music terms you will run across in the course of learning about music. First up is *rhythm*. **Rhythm** includes the basic beat and everything the musicians play in a given *tempo*. **Tempo** is simply how fast or slow a piece of music is performed. Another important term is **dynamics**, which indicates how loud or soft a certain musical event should be. The following two charts will offer you some basic Italian terms that you will commonly run across in the world of classical music.

rhythm

tempo

dynamics

Tempo Markings	Dynamic Markings
grave – very, very slow	*pianississimo* (***ppp***) – very, very soft
largo – very slow	*pianissimo* (***pp***) – very soft
adagio – slow	*piano* (***p***) – soft
andante – at a walking tempo	*mezzo piano* (***mp***) – moderately soft
moderato – moderate	*mezzo forte* (***mf***) – moderately loud
allegretto – moderately fast	*forte* (***f***) – loud
allegro – fast	*fortissimo* (***ff***) – very loud
vivace – very fast	*fortississimo* (***fff***) – very, very loud
presto – very, very fast	*crescendo* – gradually get louder
	decrescendo – gradually get softer

Instruments Used in Classical Music

There are five families of instruments used to create most classical music. These general groups include strings, woodwinds, brass, percussion, and various keyboard instruments. In addition, one of the most important "instruments" in all of classical music is the human voice. With the exception of the human voice, all of the instrumental families underwent an evolutionary process that has taken hundreds of years to complete. When we deal with keyboard instruments in particular, we should remember that the evolution is not yet complete. New electronic instruments are being developed on a regular basis.

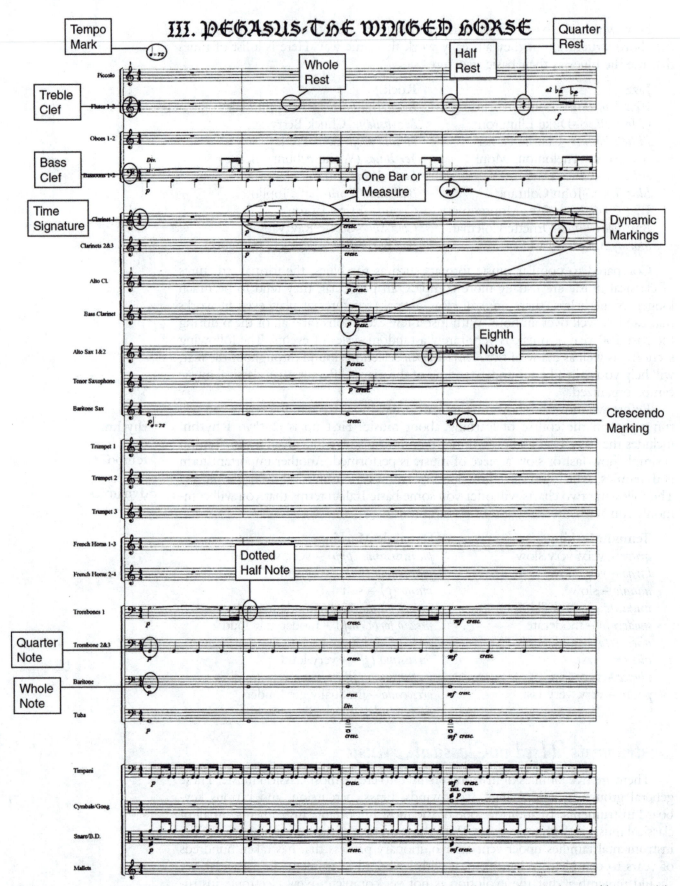

To illustrate some basic elements of music notation, here is a page taken from the full score of a wind ensemble composition by Samuel Hollomon. The complete work is titled Legends, *and this is the first page of the third movement.*
Courtesy: Samuel Hollomon

From smallest to largest, the four members of the string family include the violin, viola, cello, and string bass. These instruments came into common use during the late Renaissance, but variations of these instruments (especially the violin) can be traced back hundreds of years earlier. Today, all of these instruments have four strings of various pitches. To produce a tone, the player draws a bow made of horse hair across the strings with the right hand while the left hand presses down on the fingerboard to change pitches by making the vibrating portion of the string longer or shorter. String players can also pluck the strings with their right hand using a technique called *pizzicato*. By vibrating the left hand on the string the player can produce a tone vibration called *vibrato*, which gives the instrument more of a "singing" quality.

Woodwind instruments are called that because many of them were originally made of wood, and you blow air through them to produce a tone. The most common instruments in this family include flute, clarinet, oboe, and bassoon. Today, all woodwind instruments have mechanized keys to help the player extend the range of the instrument and to play technical passages with relative ease. Along with various percussion instruments, primitive flutes are some of the oldest instruments in existence. The concept of a simple tube with three to six holes to change pitches can be found in almost every culture on the planet. Modern classical flutes are all made of metal, and they have a complex key mechanism. To produce a sound, the player blows air across a hole in the mouthpiece using the same basic technique you use to create a tone on a Coke bottle. Most clarinets are still made of wood, and they make use of a key mechanism similar to the flute. The biggest difference is that to produce a tone, the clarinet has a mouthpiece with a single reed attached. When the player blows into the instrument the reed vibrates against the mouthpiece, and a sound comes out the other end. The oboe is very similar to the clarinet, except instead of a mouthpiece and a single reed, the oboe uses two reeds tied together to produce a tone vibration. The small opening between the two reeds is a big part of what gives the oboe its somewhat stuffy, nasal sound quality. Like the oboe, the bassoon is also a double reed instrument though it is much larger and produces a much deeper tone. Finally, in the 1800s, a man named Adolph Sax invented an instrument made of brass but using a mouthpiece with a single reed. The *saxophone*, as he called it, was intended to be the perfect orchestral instrument because it had qualities of both the woodwind and the brass families. Unfortunately for Adolph Sax, the instrument never caught on with the symphony orchestra and is rarely found in classical orchestral music. The instrument, however, did catch on with wind bands and has subsequently become very popular as a jazz instrument as well. All of these

HEARD in the ORCHESTRA

Violin

Bass Clarinet

Violoncello

Bass Bassoon

Double Bass

Bassoon

Clarinet

Cornet

Oboe

Piccolo

Flute

Trombone

Tuba

French Horn

Cymbals

Snare Drum

Triangle

Xylophone

Kettle Drum

Bass Drum

Orchestra Bells

Late nineteenth-century display of some of the typical instruments found in the symphony orchestra.
Source: Jupiterimages, Corp.

basic instruments feature entire families, from very small versions of the instrument to very large ones.

All brass instruments work basically the same way. You have a length of metal tubing, one end smaller than the other, into which you place a cup-shaped mouthpiece. The player then places both lips into the mouthpiece and produces a buzzing vibration, which, in turn, produces a sound from the other end of the horn. By tightening or relaxing the lips, the instrument will play certain higher or lower notes. With the exception of the trombone, all brass instruments today use a set of valves to open and close extra lengths of tubing. This change in overall length makes the instrument longer or shorter and allows it to play all the notes of a given scale pattern as opposed to a select few as in olden times. The four most common instruments in the brass family are the trumpet, horn, trombone, and tuba. The trumpet is the smallest member of the brass family, and it plays the highest notes. The trumpet bell faces forward, and it can be played quite loudly, giving it a sort of "fanfare" quality for which it is frequently used. The horn (often mistakenly referred to as the "French" horn, which is technically incorrect) began its life as a hunting instrument. It is shaped in a circle with the bell facing backwards so that a player on horseback could play horn calls with the sound going back to alert the hunting party behind where the fox might be running. The instrument was later brought inside for use in the orchestra, and players began placing their hands in the bell to help adjust the pitch. Valves were later added, but the hand in the bell became a traditional sound that composers came to rely on. The trombone uses a long slide to make the instrument longer or shorter in order to change pitch. It is pitched lower than both the trumpet and the horn but higher than the largest brass instrument, the tuba. The tuba is the bass voice of the brass family, with its basic construction being very similar to the horn. As with the saxophone, in the 1800s a new instrument called the euphonium (or baritone) was introduced to serve as a bridge between the low voice of the tuba and the higher-pitched brass instruments. Like the saxophone, it never found favor among most orchestral composers though it did become a regular part of the typical concert band.

The percussion family is by far the most diverse of the five instrumental groups we are considering. The most important thing to keep in mind is that the percussion family is usually divided into two classifications, *pitched* instruments and *non-pitched* instruments. The pitched instruments include mallet percussion instruments such as the xylophone and marimba, the chimes, and the large tunable drums called tympani. Non-pitched instruments include various drums such as the snare drum, which is a two-headed drum with a metal attachment that vibrates against the bottom head, small- to medium-sized drums called tom-toms, and the large bass drum. Other non-pitched percussion instruments include a wide array of metal cymbals, gongs, and tam-tams. Beyond the previously mentioned instruments, it's anybody's guess. There is virtually nothing a percussionist won't hit, crash, or bang on in an attempt to make music.

Keyboard instruments have been popular since the Middle Ages and include the pipe organ, harpsichord, piano, and electronic synthesizer, among many, many others. By using a series of alternating black and white keys, all the possible notes of the chromatic scale are laid out in front of the keyboard player. These notes can be played one at a time to form a single-line melody or grouped together to create harmonies. Most commonly, keyboard players are called upon to do both jobs at once. There are a few other instruments that, while not technically "keyboards," make use of a structured pattern to offer the player access to all of the notes in the chromatic scale. Some of these instruments include the harp, the lute, and the guitar. All of these instruments can play a single melody, a series of chords, or, in many cases, do both at once.

🔍 **DIG DEEPER**

BOOK
Mozart in the Jungle: Sex, Drugs, and Classical Music by Blair Tindall

Finally, we must consider the human voice. Most early classical music was written exclusively for the human voice, and the voice continues to be a very popular mode of musical expression today. There are basically four voice ranges: soprano, alto, tenor, and bass/baritone. Sopranos are the highest female voices, and the alto range is directly below that. Tenor refers to the higher-pitched male voice and baritone or bass are the terms commonly used to indicate men with lower-pitched vocal ranges. You will also notice these same terms being applied to families of musical instruments.

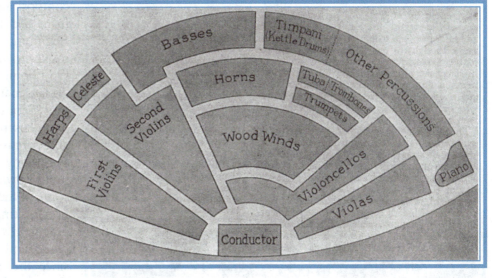

Seating chart for a modern symphony orchestra. In many orchestras, however, the cellos and violas trade places from what you see in this illustration.
Source: Jupiterimages, Corp.

A Few Common Musical Ensembles

Today the most common ensemble used in classical music is the symphony orchestra. The typical symphony orchestra is made up of a large string section, along with various woodwind, brass, and percussion instruments. Most symphonies use 12–14 first violins, 12–14 second violins, 8–12 violas, 8–12 cellos, and 6–8 basses in their string section. The woodwind section will usually be made up of three flutes (one of whom doubles on the smaller piccolo), three clarinets (with a player or two who can double on the small E-flat clarinet and the larger bass clarinet), two oboes (one of whom doubles on the larger English horn), and two bassoons. The brass section will usually have three or four trumpets, four to six horns, three trombones (one of which is usually the larger bass trombone), and one tuba. Most orchestras generally carry three or four percussionists on their core roster, one of whom devotes almost all of his or her time to the tympani while the other percussionists cover all the other parts as needed. In addition, most major orchestras will have both a harpist and pianist on staff as well. Depending on the demands of the composition being performed, players will come or go as required. For example, when performing large works such as Berlioz's *Symphonie fantastique*, extra musicians must be hired for the performance. Conversely, when performing an early orchestral work by J. S. Bach or Vivaldi, the orchestral forces might be reduced considerably to better imitate the size of the smaller chamber orchestras common throughout the Baroque period.

Another common large group is the concert or symphonic band. The band movement in America really took off around 1900, inspired by the military and civilian bands directed by the legendary John Philip Sousa. The band movement in America has become very popular as an educational tool, and even today, many high schools around the country offer the chance to participate in both marching and concert bands. Large symphonic bands can number 80 to 100 members, and they frequently perform original

John Philip Sousa.
Source: © 2009 Jupiterimages, Corp.

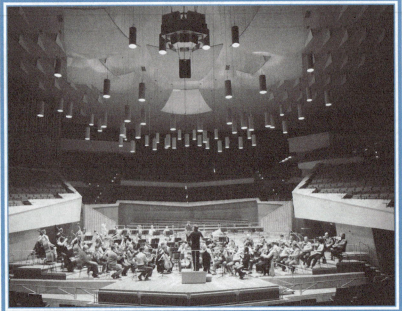

The Berlin Philharmonic Orchestra in rehearsal.
Source: ©2004 Photos.com

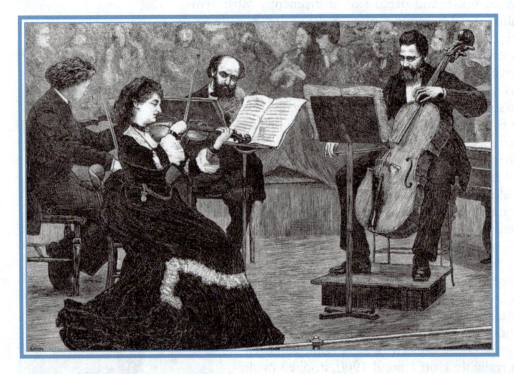

Nineteenth-century woodcut image of a typical chamber music ensemble.
Source: Jupiterimages, Corp.

compositions, as well as transcriptions from the standard orchestral repertory. Beginning in the 1950s, there was a move toward a kind of pared-down symphonic band called a wind ensemble. Today, many of the finest colleges and music conservatories have highly skilled wind ensembles made up of 50–60 wind and percussion players. With traditional symphony orchestras moving more and more toward being "living museums," some of the finest modern composers are now putting their efforts toward creating new works for the wind band.

Chamber music has been popular since the late Renaissance, and it continues to be a popular form of musical expression today. By far, the most common chamber ensemble format is the string quartet, made up of two violins, one viola, and one cello. In addition, you will be introduced to a number of other chamber music ensembles that make use of various string instruments. Growing in popularity today are the woodwind quintet (flute, oboe, clarinet, bassoon, and horn) and the brass quintet (two trumpets, horn, trombone, and tuba). Solo keyboard players have always been popular on the chamber music scene, with the harpsichord being dominant until the end of the Baroque era and the piano rising in popularity ever since. Almost every major classical composer created some works especially for the solo harpsichord or piano. Finally, you will frequently see the piano grouped with various other strings and/or winds to form a wide array of chamber music ensembles featuring between 2 and 15 musicians.

In the world of vocal music, choirs and solo singers have been around since the very beginning of Western art music during the Middle Ages. Voices have lent themselves well to performances of both sacred and secular music during every period of music history. In addition, around 1600 a new format called opera (which is basically a play set to music) was created, and it remains an extremely popular format in the world of classical music today.

General Dates for Classical Music

In music, we tend to apply the term "classical" in two different ways. When you see the term with a lower case first letter, the term is being used as a catchall to imply all Western art music from the Middle Ages to the present. When you see the term with an upper case first letter the term becomes period specific and implies the music of 1750-1825, especially the compositions of Haydn, Mozart, and Beethoven. To help you get a basic grasp on the entire scope of music history, we will break classical music down by individual style periods. With a couple of minor exceptions, we will be using 150 year blocks of time. Music historians are constantly revising the general dates applied to each of the individual style periods of music. In an attempt to mark more accurately the beginning or end of a new phase in music history, these time shifts usually involve a movement of 20-30 years. The only problem for the beginning student of music history is that the new dates are much harder to remember than the old ones used to be. Therefore, for ease of use, this text attempts to go both ways. General periods will be marked by their older 150 year breaking points, but, in deference to emerging historical scholarship, an extra chapter will be added to focus exclusively on the styles of *Impressionism* and *Post-Romanticism*. Memorize the following general dates, and the rest of music history will take care of itself. Throughout this text, composers' dates are clearly listed, and this is also the practice on most concert programs and recording liner notes as well. Be aware that there is a great deal of historical "overlap" between most of these style periods. The Middle Ages can be broken down into several smaller time periods, but that breakdown tends to confuse the issue, so let's avoid it and just dedicate a big block of time to the early development of classical music. You will also notice that the Classical and Romantic periods form a nice 150 year block of time and have been neatly broken down into two 75 year sections. Finally, going by the 150 year plan, we are obviously living in the second half of the modern era. Unfortunately, it will be another 100 years or so before historians can tell if this type of date grouping will still make any sense.

Middle Ages	500-1450
Renaissance	1450-1600
Baroque	1600-1750
Classical	1750-1825
Romantic	1825-1900
Modern	1900-present

A Few Thoughts on the Art of Active Listening

For the most part, people today tend to be passive listeners. Music is often playing in the background, but we don't really notice it. Tunes in the car, movie and TV soundtracks, music in the elevator and at the mall are all examples of how music constantly surrounds us. In order to really get into classical music as an art form, you will need to become an **active listener**. Here are a few suggestions to help you get started.

active listener

- One time through the composition is not enough. The better you know the original melodies and understand the basic structure, the more you will get out of the work as a whole. There is absolutely a time to simply "sit back and listen," but to gain a better understanding of how classical music functions, you will need to explore how all of the different parts fit together to form the whole.

- Listen "down" into the entire composition. Don't just follow what the melody line is doing. Singing along with the melody is a great way to get started, but that's not all there is. Try to hear how the composer supports his melody with certain rhythmic structures or countermelodies. During developmental sections, pay close attention to how the original themes have been altered, both harmonically and melodically.
- With large symphonic or operatic works, pay close attention to the orchestrations. Tone color can play a major role in helping the composer convey his or her artistic message. Notice the interplay between the various instruments and sections of the orchestra.

Odds and Ends

The following topics are a few more basic points of interest that are somewhat unique to the world of classical music (and in a few cases jazz as well). They don't fit neatly together as in the previous sections, but they are things you will want to be aware of as you explore this art form.

Concert Attendance

During the course of your studies, and hopefully for the rest of your life, you are going to want to attend some live concerts. Recordings are great, but nothing can replace the unique immediacy and intense communication of a live concert. Dress for a typical classical concert as you would for any nice event. Evening clothes are never required with the possible exception of a big opening night gala in New York City or Vienna. Gentlemen, please remove your hats, and everyone remember to turn off your cell phones. Talking of any kind during a performance is rude to both your fellow concertgoers and the performers on stage as well. Almost every classical concert you attend will offer a program complete with biographical information on each performing artist and an extended set of program notes discussing the works that will be performed. These notes can be very helpful in enhancing your enjoyment of the concert, but you are encouraged to get to the concert early enough to read them *before* the music begins. In most concerts, modern conventions suggest that the audience hold their applause until an entire work has been performed. At a symphony concert, for example, you should applaud when the concertmaster (1st violin) enters the stage. He or she will help the orchestra tune their instruments and then the conductor will enter, usually from the left side of the stage. At this point, it is again appropriate to applaud. Works with only one movement should receive applause upon their conclusion. For compositions with more than one movement, the audience is expected to hold their applause until the completion of the entire work. The biggest exception to the previous "rule" is at the opera. Applause is still

Audience attending a Gala opening-night performance at the Metropolitan Opera in New York City during the late 1930s. **Source:** Jupiterimages, Corp.

considered perfectly acceptable throughout the performance of an opera. Most operas are grouped into individual acts, which are each usually broken down into several separate scenes. The end of a big aria or the conclusion of a scene is almost always a good time for applause. When in doubt, never be the first person to applaud, and always stop as soon as you hear the applause start to fade. After a few concerts, you will catch on and feel as though you fit right in. Jazz concerts are a bit different. Applause between songs is always appreciated, but the audience is also usually encouraged to applaud at the conclusion of any improvised solo. When in doubt, simply watch the body language of the performers on stage, and you should be able to figure out what's going on.

Opus Numbers, Köchel Numbers, and Others

In addition to a title such as Symphony No. 5 or *Symphonie fantastique,* some composers use *opus* numbers to help catalog and identify their compositions. The term **opus** means "work," and most composers tend to number their first composition Opus 1 (or Op. 1), and subsequent works follow in sequential order. If a composer writes 200 compositions over a 40-year career, it is usually a safe guess that a low opus number means an earlier work, whereas a higher number typically comes from later in his or her lifetime. To complicate matters a bit farther, composers sometimes group a set of compositions under one opus number. For example, Haydn wrote a number of string quartets throughout his career, and they were frequently grouped into sets of six individual, four-movement works. Therefore, String Quartet in C Major *(Emperor),* Op. 76, No. 3 indicates the third string quartet in a group of six, and Haydn viewed the set as number 76 in his compositional output. The previous explanation simplifies things a bit as composers sometime withdraw works after they are written or feel that some minor compositions are not worthy of attaching an opus number. Revisions, alternate arrangements, and conflicting publications can also play havoc with the opus system of organization. When there are major abnormalities in the history of a particular composition, the program notes at a concert or the liner notes of a CD will usually explain the situation.

Prior to the Romantic era, many composers did not bother to number their own works, and the creation of a complete catalog of a given composer's works fell to a friend or music historian. Often, these catalogs were created long after the composer passed away, so it is sometimes impossible to know exactly when a work may have been written. Whenever you see something accompanying a work title besides *Opus* it usually indicates a cataloging system created by someone other than the composer. The two most famous catalogs were created for J. S. Bach and W. A. Mozart. Ludwig von Köchel created a catalog for Mozart's works in the mid-1800s. He used a system that was mostly chronological, but there are some major exceptions. In a program of Mozart's music you will see titles such as Symphony No. 40 in g minor, K. 550 or *Eine kleine Nachtmusik,* K. 525. Bach's catalog is even more confusing and continues to be complicated by the fact that every now and then some historian discovers a new Bach composition or two lying in a drawer of a library basement. Bach's music is organized by a numbered thematic catalog titled *Bach Werke-Verzeichnis* (An Index to the Works of J. S. Bach). For example, in a program you might see a listing such as *Brandenburg Concerto No. 2,* BWV 1047 or *Das Wohltemperierte Klavier* (The Well-Tempered Clavier), BWV 846-893. In the second example there are 48 preludes and fugues and, as you can see, each individual piece has a separate BWV catalog number. A few other important composer catalogs include Otto Deutsch's catalog of the works of Schubert and Peter Ryom's catalog of the works of Vivaldi. Finally, even though Haydn did assign opus numbers for many of his

compositions, Anthony van Hoboken also created a thematic catalog for Haydn's compositions that was first published in 1957. Consequently, you will sometimes see a marking such as "Hob III:77" attached to the end of some work titles for Haydn's compositions.

One Last Thought

Before we dive off into the history of classical music, take a few moments to read a selection written by one of America's finest composers, Aaron Copland. As a twentieth-century composer, Copland faced an audience that was growing more apathetic toward classical music in general and modern music in particular. As one of the few popular living composers of his time, Copland took it upon himself to become a spokesman and a strong advocate for the world of classical music. He wrote magazine articles and books, and he hosted radio and television programs in an attempt to bring the American public back to classical music. Most of the following article was originally published in the July 4, 1959 edition of the *Saturday Evening Post*, and it also includes a brief excerpt from a radio address the composer gave a few years earlier.

Aaron Copland.
Source: Library of Congress.

The Pleasures of Music* by Aaron Copland

Perhaps I had better begin by explaining that I think of myself as a composer of music and not as a writer about music. This distinction may not seem important to you, especially when I admit to having published several books on the subject. But to me the distinction is paramount because I know that if I were a writer I would be bubbling over with word-ideas about the art I practice, instead of which my mind—and not my mind only but my whole physical being—vibrates to the stimulus of sound waves produced by instruments sounding alone or together. Why this is so I cannot tell you, but I can assure you it is so. Remembering then that I am primarily a composer and not a writer, I shall examine my subject mostly from the composer's standpoint in order to share with others, in so far as that is possible, the varied pleasures to be derived from experiencing music as an art.

That music gives pleasure is axiomatic. Because that is so, the pleasures of music as a subject for discussion may seem to some of you a rather elementary dish to place before so knowing an audience. But I think you will agree that the source of that pleasure, our musical instinct, is not at all elementary; it is, in fact, one of the prime puzzles of consciousness. Why is it that sound waves, when they strike the ear, cause "volleys of nerve impulses to flow up into the brain," resulting in a pleasurable sensation? More than that, why is it that we are able to make sense out of these "volleys of nerve signals" so that we emerge from engulfment in the orderly presentation of sound stimuli as if we had lived through a simulacrum of life, the instinctive life of the emotions? And why, when safely seated and merely listening, should our hearts beat faster, our temperature rise, our toes start tapping, our minds start racing after the music, hoping it will go one way and watching it go another, deceived and disgruntled when we are unconvinced, elated and grateful when we acquiesce?

We have a part answer, I suppose, in that the physical nature of sound has been thoroughly explored; but the phenomenon of music as an expressive, communicative agency remains as inexplicable as ever it was. We musicians don't ask for much. All we want is to have one investigator tell us

*Delivered in the Distinguished Lecture Series at the University of New Hampshire in April 1959.

why this young fellow seated in Row A is firmly held by the musical sounds he hears while his girl friend gets little or nothing out of them, or vice versa. Think how many millions of useless practice hours might have been saved if some alert professor of genetics had developed a test for musical sensibility. The fascination of music for some human beings was curiously illustrated for me once during a visit I made to the showrooms of a manufacturer of electronic organs. As part of my tour I was taken to see the practice room. There, to my surprise, I found not one but eight aspiring organists, all busily practicing simultaneously on eight organs. More surprising still was the fact that not a sound was audible, for each of the eight performers was listening through earphones to his individual instrument. It was an uncanny sight, even for a fellow musician, to watch these grown men mesmerized, as it were, by a silent and invisible genie. On that day I fully realized how mesmerized we ear-minded creatures must seem to our less musically inclined friends.

If music has impact for the mere listener, it follows that it will have much greater impact for those who sing it or play it themselves with some degree of proficiency. Any educated person in Elizabethan times was expected to be able to read musical notation and take his or her part in a madrigal-sing. Passive listeners, numbered in the millions, are a comparatively recent innovation. Even in my own youth, loving music meant that you either made it yourself or were forced out of the house to go hear it where it was being made, at considerable cost and some inconvenience. Nowadays all that has changed. Music has become so very accessible it is almost impossible to avoid it. Perhaps you don't mind cashing a check at the local bank to the strains of a Brahms symphony, but I do. Actually, I think I spend as much time avoiding great works as others spend in seeking them out. The reason is simple: meaningful music demands one's undivided attention, and I can give it that only when I am in a receptive mood, and feel the need for it. The use of music as a kind of ambrosia to titillate the aural senses while one's conscious mind is otherwise occupied is the abomination of every composer who takes his work seriously.

Thus, the music I have reference to in this article is designed for your undistracted attention. It is, in fact, usually labeled "serious" music in contradistinction to light or popular music. How this term "serious" came into being no one seems to know, but all of us are agreed as to its inadequacy. It just doesn't cover enough cases. Very often our "serious"music *is* serious, sometimes deadly serious, but it can also be witty, humorous, sarcastic, sardonic, grotesque and a great many other things besides. It is, indeed, the emotional range covered that makes it "serious" and, in part, influences our judgment as to the artistic stature of any extended composition.

Everyone is aware that so-called serious music has made great strides in general public acceptance in recent years, but the term itself still connotes something forbidding and hermetic to the mass audience. They attribute to the professional musician a kind of Masonic initiation into secrets that are forever hidden from the outsider. Nothing could be more misleading. We all listen to music, professionals and non-professionals alike, in the same sort of way—in a dumb sort of way, really, because simple or sophisticated music attracts all of us, in the first instance, on the primordial level of sheer rhythmic and sonic appeal. Musicians are flattered, no doubt, by the deferential attitude of the layman in regard to what he imagines to be our secret understanding of music. But in all honesty we musicians know that in the main we listen basically as others do, because music hits us with an immediacy that we recognize in the reactions of the most simple-minded of music listeners.

It is part of my thesis that music, unlike the other arts, with the possible exception of dancing, gives pleasure simultaneously on the lowest and highest levels of apprehension. All of us, for example, can understand and feel the joy of being carried forward by the flow of music. Our love of music is bound up with its forward motion; nonetheless it is precisely the creation of that sense of flow, its interrelation with and resultant effect upon formal structure, that calls forth high intellectual capacities of a composer, and offers keen pleasures for listening minds. Music's incessant movement forward exerts a double and contradictory fascination: on the one hand it appears to be immobilizing time itself by filling out a specific temporal space, while generating at the same moment the sensation of flowing past us with all the pressure and sparkle of a great river. To stop the flow of music would be like the stopping of time itself, incredible and inconceivable. Only a catastrophe of some sort produces such a break in the musical discourse during a public performance. Musicians are, of course, hardened to such interruptions during rehearsal periods, but they don't relish them. The public, at such times, look on, unbelieving. I have seen this demonstrated each summer at Tanglewood during the open rehearsals of the Boston Symphony Orchestra. Large audiences gather each week, I am convinced, for the sole pleasure of living through that awefull moment when the conductor abruptly stops the music. Something went wrong; no one seems to know what or why, but it stopped the music's flow, and a shock of recognition runs through the entire crowd. That is what they came for, though they may not realize it—that, and the pleasure of hearing the music's flow resumed, which lights up the public countenance with a kind of all's-right-with-the-world assurance. Clearly, audience enjoyment is inherent in the magnetic forward pull of the music; but to the more enlightened listener this time-filling, forward drive has fullest meaning only when accompanied by some conception as to where it is heading, what musical-psychological elements are helping to move it to its destination, and what formal architectural satisfactions will have been achieved on its arriving there.

Musical flow is largely the result of musical rhythm, and the rhythmic factor in music is certainly a key element that has simultaneous attraction on more than one level. To some African tribes rhythm *is* music; they have nothing more. But what rhythm it is! Listening to it casually, one might never get beyond the earsplitting poundings, but actually a trained musician's ear is needed to disengage its polyrhythmic intricacies. Minds that conceive such rhythms have their own sophistication; it seems inexact and even unfair to call them primitive. By comparison our own instinct for rhythmic play seems only mild in interest—needing reinvigoration from time to time.

It was because the ebb of rhythmic invention was comparatively low in late-nineteenth-century European music that Stravinsky was able to apply what I once termed "a rhythmic hypodermic" to Western music. His shocker of 1913, *The Rite of Spring*, a veritable rhythmic monstrosity to its first hearers, has now become a standard item of the concert repertory. This indicates the progress that has been made in the comprehension and enjoyment of rhythmic complexities that nonplused our grandfathers. And the end is by no means in sight. Younger composers have taken us to the very limit of what the human hand can perform and have gone even beyond what the human ear can grasp in rhythmic differentiation. Sad to say, there is a limit, dictated by what nature has supplied us with in the way of listening equipment. But within those limits there are large areas of rhythmic life still to be explored, rhythmic forms never dreamed of by composers of the march or the mazurka.

In so saying I do not mean to minimize the rhythmic ingenuities of past eras. The wonderfully subtle rhythms of the anonymous composers of the late fourteenth century, only recently deciphered; the delicate shadings of oriental rhythms; the carefully contrived speech-based rhythms of the composers of Tudor England; and, bringing things closer to home, the improvised wildness of jazz-inspired rhythms—all these and many more must be rated, certainly, as prime musical pleasures.

Tone color is another basic element in music that may be enjoyed on various levels of perception from the most naïve to the most cultivated. Even children have no difficulty in recognizing the difference between the tonal profile of a flute and a trombone. The color of certain instruments holds an especial attraction for certain people. I myself have always had a weakness for the sound of eight French horns playing in unison. Their rich, golden, legendary sonority transports me. Some present-day European composers seem to be having a belated love affair with the vibraphone. An infinitude of possible color combinations is available when instruments are mixed, especially when combined in that wonderful contraption, the orchestra of symphonic proportions. The art of orchestration, needless to say, holds endless fascination for the practicing composer, being part science and part inspired guesswork.

As a composer I get great pleasure from cooking up tonal combinations. Over the years I have noted that no element of the composer's art mystifies the layman more than this ability to conceive mixed instrumental colors. But remember that before we mix them we hear them in terms of their component parts. If you examine an orchestral score you will note that composers place their instruments on the page in family groups: in reading from top to bottom it is customary to list the woodwinds, the brass, the percussion, and the strings, in that order. Modern orchestral practice often juxtaposes these families one against the other so that their personalities, as families, remain recognizable and distinct. This principle may also be applied to the voice of the single instrument, whose pure color sonority thereby remains clearly identifiable as such. Orchestral know-how consists in keeping the instruments out of each other's way, so spacing them that they avoid repeating what some other instrument is already doing, at least in the same register, thereby exploiting to the fullest extent the specific color value contributed by each separate instrument or grouped instrumental family.

In modern orchestration clarity and definition of sonorous image are usually the goal. There exists, however, another kind of orchestral magic dependent on a certain ambiguity of effect. Not to be able to identify immediately how a particular color combination is arrived at adds to its attractiveness. I like to be intrigued by unusual sounds that force me to exclaim; Now I wonder how the composer does that?

From what I have said about the art of orchestration you may have gained the notion that it is nothing more than a delightful game, played for the amusement of the composer. That is, of course, not true. Color in music, as in painting, is meaningful only when it serves the expressive idea; it is the expressive idea that dictates to the composer the choice of his orchestral scheme.

Part of the pleasure in being sensitive to the use of color in music is to note in what way a composer's personality traits are revealed through his tonal color schemes. During the period of French impressionism, for example, the composers Debussy and Ravel were thought to be very similar in personality. An examination of their orchestral scores would have shown that Debussy, at his most characteristic, sought for a spray-like iridescence,

a delicate and sensuous sonority such as had never before been heard, while Ravel, using a similar palette, sought a refinement and precision, a gemlike brilliance that reflects the more objective nature of his musical personality.

Color ideals change for composers as their personalities change. A striking example is again that of Igor Stravinsky, who, beginning with the stabbing reds and purples of his early ballet scores, has in the past decade arrived at an ascetic grayness of tone that positively chills the listener by its austerity. For contrast we may turn to a Richard Strauss orchestral score, masterfully handled in its own way, but overrich in the piling-on of sonorities, like a German meal that is too filling for comfort. The natural and easy handling of orchestral forces by a whole school of contemporary American composers would indicate some inborn affinity between American personality traits and symphonic language. No layman can hope to penetrate all the subtleties that go into an orchestral page of any complexity, but here again it is not necessary to be able to analyze the color spectrum of a score in order to bask in its effulgence.

❧ ✝ ❧

Music is designed, like the other arts, to absorb entirely our mental attention. Its emotional charge is imbedded in a challenging texture, so that one must be ready at an instant's notice to lend attention wherever it is most required in order not to be lost in a sea of notes. The conscious mind follows joyfully in the wake of the composer's invention, playing with the themes as with a ball, extricating the important from the unimportant detail, changing course with each change of harmonic inflection, sensitively reflecting each new color modulation of the subtlest instrumental palette. Music demands an alert mind of intellectual capacity, but it is far from being an intellectual exercise. Musical cerebration as a game for its own sake may fascinate a small minority of experts or specialists, but it has no true significance unless its rhythmic patterns and melodic designs, its harmonic tensions and expressive timbres penetrate the deepest layer of our subconscious mind. It is, in fact, the immediacy of this marriage of mind and heart, this very fusion of musical cerebration directed toward an emotionally purposeful end, that typifies the art of music and makes it different from all other arts.

Endnotes

1. Alan Rich, "Music at the Turn," *LA Weekly* (January 8-14, 1999), http://www.laweekly.com/ink/printme.php?eid=3294.

2. Joseph Machlis and Kristine Forney, *The Enjoyment of Music*, 7th ed. (New York: W. W. Norton, 1995), 3.

Study Guide

Chapter 1 Review Questions

True or False

F 1. The term polyphonic implies a single line of music.

T 2. Chords are groups of notes that sound consonant or dissonant when played together.

T 3. Vibrato can give string instruments more of a "singing" quality to their tone.

F 4. Today the most common ensemble used in classical music is the percussion ensemble.

T 5. Today the most common ensemble used in classical music is the symphony orchestra.

T 6. The term opus means work.

F 7. At most classical concerts it is considered acceptable to applaud whenever you feel like it.

F 8. General dates for the Baroque era in music are 1450-1600.

Multiple Choice

9. Consonance is best defined as:
 a. tones at rest.
 b. tones that need to be resolved.
 c. tones that sound good together.
 d. tones that sound bad together.
 e. none of the above.

10. Dissonance is best defined as:
 a. tones at rest.
 b. tones that need to be resolved.
 c. tones that sound good together.
 d. tones that sound bad together.
 e. none of the above.

11. Most operas are:
 a. really long.
 b. grouped into individual acts.
 c. performed in English.
 d. full of dancing.

12. Most symphony orchestras are made up of:
 a. a large string section.
 b. woodwinds.
 c. brass.
 d. percussion.
 e. all of the above.

13. Some of the most common keyboard instruments used in classical music include the:
 a. pipe organ.
 b. harpsichord.
 c. piano.
 d. all of the above.
 e. none of the above.

Fill in the Blank

14. To produce a tone on any _Brass_ instrument the player places both lips into the mouthpiece and produces a buzzing vibration.

15. The tempo marking _Allegretto_ indicates moderately fast.

16. _Rhythm_ includes the basic beat and everything the musicians play in a given tempo.

17. The term _Polyphonic_ applies when two or more simultaneous melodies weave together with different rhythms and notes.

18. Any sound that has an identifiable _Pitch_, or sustained harmonic frequency, can be considered a musical sound.

19. In music, we group sets of the basic beat together in something called a _Measure_ or a _Bar_.

20. The most common instruments in the _Woodwind_ family of instruments include the flute, clarinet, oboe, and bassoon.

Short Answer

21. List the names of the four different instruments found in the string section. *Viola Bass Cello Violin*

22. List the three "building block" chords. *Tonic (chord I) Dominant (chord V) subDominant (chord IV)*

23. List three different tempo markings and what those terms indicate.

24. List three different dynamic markings and what those terms indicate.

25. List the titles and general dates for each of the six major style periods in classical music.

Essay Questions

1. Discuss how music functions in your day-to-day life. Do you consider yourself an "active listener?"

2. Read the article *The Pleasures of Music* by Aaron Copland found at the end of this chapter. Do Mr. Copland's comments about music still apply to modern society? Discuss why or why not.

Chapter 2
The Middle Ages

"Music, the greatest good that mortals know,
And all of heaven we have below."

Joseph Addison

*A*s you begin to search for the "source" of classical music, you will quickly realize there are many theories and a good bit of writing *about* music, but very little actual notated music has been preserved. Most scholars generally agree that music was in common use during biblical times, as is evidenced by numerous passages in the Bible. Perhaps the best example is the book of *Psalms*, written by David. The common perception of these texts is that they were frequently sung. Certainly, they have provided composers a wealth of textual material during the past 1,200 years or so since actual music began being preserved in notation. The ancient Greeks displayed a particular interest in music. Their examination was two-fold in that they approached music from a mathematical/scientific point of view as well as a philosophical one. Pythagoras, Plato, and Aristotle all discussed music extensively in their writings, but, unfortunately for history, they only talked *about* the music; they didn't write it down. Around 500 A.D., a Roman mathematician, philosopher, and statesman named Boethius wrote a history of how music functioned in ancient Greek culture, titled *De institutione musica*. It is quite amazing how the ancient Greeks related to music over 2,500 years ago in many of the same ways we do today (and Boethius seemed to support these theories about 1,000 years later). For example, they listened to soft, pretty music to help them go to sleep and faster, louder music to help them wake up again. The biggest difference today is that we have clock radios and iPhones, whereas the Greeks had live musicians (or simply played music for their own enjoyment). The following article is an excerpt from a translated version of *De institutione musica* by Boethius.

Monument to Boethius.
Source: Jupiterimages, Corp.

From De institutione musica by Boethius
Book One

I. Introduction

Music is related to us by nature and can ennoble or corrupt the character

The perceptive power of all the senses is so spontaneously and naturally present in certain living creatures that to conceive of an animal without senses is impossible. But a scrutiny of the mind will not yield to the same degree a knowledge and clear understanding of the senses themselves. It is easily understood that we use our senses in understanding sensible things, but what in truth is the nature of the actual senses in conformity with which we act, and what is the peculiar property of sensible things, is not so apparent or intelligible save by proper investigation and reflection upon the facts.

For sight is common to all mortals, but whether it results from images coming to the eye or from rays sent out to the object of sight is doubtful to the learned, though the vulgar are unaware that such doubt exists. Again, any one seeing a triangle or square easily recognizes what he sees, but to know the nature of a square or triangle he must inquire of a mathematician.

The same may be said of other matters of sense, especially of the judgment of the ear, whose power so apprehends sounds that it not only judges them and knows their differences, but is often delighted when the modes are sweet and well-ordered, and pained when disordered and incoherent ones offend the sense.

From this it follows that, of the four mathematical disciplines, the others are concerned with the pursuit of truth, but music is related not only to speculation but to morality as well. Nothing is more characteristic of human nature than to be soothed by sweet modes and stirred up by their opposites. Nor is this limited to particular professions or ages, but is common to all professions; and infants, youths, and the old as well are so naturally attuned to musical modes by a kind of spontaneous feeling that no age is without delight in sweet song. From this may be discerned the truth of what Plato not idly said, that the soul of the universe is united by musical concord.[1] For when, by means of what in ourselves is well and fitly ordered, we apprehend what in sounds is well and fitly combined, and take pleasure in it, we recognize that we ourselves are united by this likeness. For likeness is agreeable, unlikeness hateful and contrary.

From this source, also, the greatest alterations of character arise. A lascivious mind takes pleasure in the more lascivious modes, or often hearing them is softened and corrupted. Contrariwise, a sterner mind either finds joy in the more stirring modes or is aroused by them. This is why the musical modes are called by the names of peoples, as the Lydian and Phrygian modes, for whatever mode each people, as it were, delights in is named after it. For a people takes pleasure in modes resembling its own character, nor could it be that the soft should be akin to or delight the hard, or the hard delight the softer, but, as I have said, it is likeness which causes love and delight. For this reason Plato holds that any change in music of right moral tendency should be especially avoided, declaring that there could be no greater detriment to the morals of a community than a gradual perversion of chaste and modest music.[2] For the minds of those hearing it are immediately affected and

[1] Timaeus, 37A.
[2] Republic, 424B–424C.

gradually go astray, retaining no trace of honesty and right, if either the lascivious modes implant something shameful in their minds, or the harsher modes something savage and monstrous.

For discipline has no more open pathway to the mind than through the ear. When by this path rhythms and modes have reached the mind, it is evident that they also affect it and conform it to their nature. This may be seen in peoples. Ruder peoples delight in the harsher modes of the Thracians; civilized peoples, in more restrained modes; though in these days this almost never occurs. Since humanity is now lascivious and effeminate, it is wholly captivated by scenic and theatrical modes. Music was chaste and modest so long as it was played on simpler instruments, but since it has come to be played in a variety of manners and confusedly, it has lost the mode of gravity and virtue and fallen almost to baseness, preserving only a remnant of its ancient beauty.

This is why Plato prescribes that boys should not be trained in all modes, but only in those which are strong and simple. And we should above all bear in mind that if in such a matter a series of very slight changes is made, a fresh change will not be felt, but later will create a great difference and will pass through the sense of hearing into the mind. Hence Plato considers that music of the highest moral quality and chastely composed, so that it is modest and simple and masculine, and not effeminate or savage or ill-assorted, is a great guardian of the commonwealth.

⌘ — † — ⌘

Indeed, it is well known how often song has overcome anger, how many wonders it has performed in affections of the body or mind. Who is unaware that Pythagoras, by means of a spondaic melody, calmed and restored to self-mastery a youth of Taormina who had become wrought up by the sound of the Phrygian mode? For when, one night, a certain harlot was in his rival's house, with the doors locked, and the youth in his frenzy was about to set fire to the house and Pythagoras was observing the motion of the stars, as his custom was; learning that the youth wrought up by the sound of the Phrygian mode, was deaf to the many pleas of his friends to restrain him from the crime, he directed them to change the mode, and thus reduced the youth's fury to a state of perfect calm.

Cicero, in his *De consiliis,* tells the story differently, in this manner: "But if I may compare a trifling matter to a weighty one, struck by some similarity, it is said that when certain drunken youths, aroused, as is wont to happen, by the music of the tibiae, were about to break into the house of a modest woman, Pythagoras

Collage image of some of the greatest Greek philosophers. Many of these scholars wrote about music, and some of them were composers and music theorists as well.
Source: Jupiterimages, Corp.

The Greek god Apollo playing the lyre (a kind of early harp). In the right hands, music could calm the passions of youth and heal any number of ills.
Source: Jupiterimages, Corp.

Two pages from Boethius's manuscript.
Source: Alexander Turnbull Library, Wellington, N.Z.

Recreation of a rare Greek manuscript fragment (ca. 408 B.C.) with early musical notations from the play Orestes *by Euripides.*
Source: Jupiterimages, Corp.

urged the player to play a spondaic melody. When he had done this, the slowness of the measures and the gravity of the player calmed their wanton fury."

Indeed, the power of the art of music became so evident through the studies of ancient philosophy that the Pythagoreans used to free themselves from the cares of the day by certain melodies, which caused a gentle and quiet slumber to steal upon them. Similarly, upon rising, they dispelled the stupor and confusion of sleep by certain other melodies, knowing that the whole structure of soul and body is united by musical harmony. For the impulses of the soul are stirred by emotions corresponding to the state of the body, as Democritus is said to have informed the physician Hippocrates, who came to treat him when he was in custody as a lunatic, being so regarded by all his fellow townsmen.

But to what purpose all these examples? For there can be no doubt that the state of our soul and body seems somehow to be combined together by the same proportions as our later discussion will show to combine and link together the modulations of harmony. Hence it is that sweet singing delights even children, whereas any harsh sound interrupts their pleasure in listening. Indeed, this is experienced by all ages and both sexes; though they differ in their actions, they are united by their enjoyment of music.

Why do the sorrowing, in their lamentations, express their very grief with musical modulations? This is especially a habit of women, to make the cause of their weeping seem the sweeter with some song. It was also an ancient custom that the music of the tibia preceded funeral lamentations, as witness the lines of Statius:

> The tibia with curving end,
> Wont to lead the funeral rites of tender shades,
> Sounds a deep note.[3]

[3] Thebaid, vi. 120-121.

And he who cannot sing agreeably still hums something to himself, not because what he sings gives him pleasure, but because one takes delight in giving outward expression to an inner pleasure, no matter what the manner.

Is it not evident that the spirit of warriors is roused by the sound of the trumpets? If it is true that a peaceful state of mind can be converted into wrath and fury, then beyond doubt a gentler mode can temper the wrath and passionate desire of a perturbed mind. What does it signify that when anyone's ears and mind are pleased by a melody, he involuntarily keeps time by some bodily motion and his memory garners some strain of it? From all this appears the clear and certain proof that music is so much a part of our nature that we cannot do without it even if we wish to do so.

The power of the mind should therefore be directed to the purpose of comprehending by science what is inherent by nature. Just as in the study of vision, the learned are not content to behold colors and forms without investigating their properties, so they are not content to be delighted by melodies without knowing by what proportion of sounds these are interrelated.

From *Source Readings in Music History: From Classical Antiquity through the Romantic Era,* translated by Oliver Strunk. Copyright © 1950 by Oliver Strunk, W. W. Norton & Company, Inc.

Pope Gregory I.
Source: © 2009 Jupiterimages, Corp.

Music in the Church

For practical purposes, we will start our examination of the development of "modern" classical music with the early Roman Catholic Church. This is not to say that music outside the church did not exist at that time, but rather to point out that, for the most part, only the church went to the trouble of writing things down. As the church service became codified, particularly the order and text of the mass, music played a major role in most services. At first, only the text was preserved, but eventually a system of musical notation began to evolve, which allowed for music to be preserved and performed the same way over and over again. Most scholars agree that the earliest church music was **monophonic,** which means a single melodic line. As long as only one melody is performed, a work is said to be *monophonic* whether it is sung by one person or one hundred. As the body of church liturgy grew, it became difficult for church musicians to remember all of the different melodies. Eventually Pope Gregory I (ca. 540-604), also known as Gregory the Great, set down an edict saying that the monasteries should preserve the chants by writing them all down using a system of musical notation. For that reason, the early monophonic music of the church is most frequently referred to as **Gregorian Chant** though you will also see the term *plainchant* or *plainsong* used in reference to the same music. As the mass continued to evolve, anonymous monks and other church musicians composed numerous chants for use throughout every church service. The following *Focus on Form* explores the different parts found in a typical church mass.

monophonic

Gregorian Chant

Proper

Ordinary

Focus on Form
The Mass

The development of the mass service in the early church was a gradual process. For the purposes of this *Focus on Form,* we are going to compress a few hundred years of music history and take a look at what became the typical format for the high mass. You should be aware, however, that a number of slightly different mass formats exist for special purposes, such as the *requiem* mass for the dead. The mass text is divided into two sections called the **Proper** and the **Ordinary.** The Proper portions of the text change every week, following the liturgical calendar. The five sections of the mass that make up the Ordinary are the same text week after week. Until about 1100 A.D., composers wrote numerous chants for both parts of the service. Toward the end of the Middle Ages (and continuing up through today), composers began to focus most of their attention on creating new music for the five unchanging portions of the mass Ordinary. Here are a few points to be aware of regarding the chart below. The *Sermon* is included in its correct place in the Proper though it was never sung. Also in the Proper, the *Sequence* was quite popular during the Middle Ages, and a great deal of music was composed for this section at that time. Its use, however, fell out of favor after the Middle Ages. The six areas of the Proper that were most commonly set to music were the *Introit, Gradual, Alleluia/Tract, Offertory,* and *Communion.* Finally, you will note a sixth section at the very end of the Ordinary titled *Ite, missa est.* This is simply the dismissal, and when composers began to compose new music for the Ordinary later in the history of music, this section was usually omitted in their compositions. The following chart traces the order of a typical mass from start to finish.

	Proper	Ordinary
Introduction	Introit	
		Kyrie
		Gloria
	Collect	
Liturgy of the Word	Epistle	
	Gradual	
	Alleluia (Tract during Lent)	
	Sequence (Middle Ages only)	
	Gospel	
	*Sermon (not sung)	
		Credo
Liturgy of the Eucharist	Offertory	
	Secret	
	Preface	
		Sanctus
	Canon	
		Agnus Dei
	Communion	
	Post-Communion	
		Ite, missa est

Gregorian Chant: Anonymous (ca. 540~1100 A.D.)

Most Gregorian chants fall into three basic categories: *syllabic, neumatic,* and *melismatic.* The term *syllabic* means one note per syllable of text and is generally the simplest form of chant. *Neumatic* refers to the term "neumes" (which was the notation system in use at the time) and usually indicates two or three notes per syllable. The *melismatic* chants came about later as the Church began to expand eastward and started to incorporate a more fluid singing style common to many non-Western cultures. *Melismatic* chants tend to have the most expansive ranges of all the chants, and they frequently make use of many notes per syllable of text. With very few exceptions, music composed during this period was written by composers in the direct service of the church; therefore, it is quite rare to find chant material with a specific name attached to it. In spite of the fact that one can hear a wide variety of compositional styles among the 600 or so years of Gregorian chant composition, the composer's name most frequently found on modern CD liner notes and concert programs is simply "Anonymous."

Kyrie "Cum Jubilo"

The following listening guide is an example of Gregorian chant taken directly from the first section of the mass Ordinary. You can get a real sense of the flowing, rhythmically loose structure used in early church services. This particular chant will offer you a sample of both neumatic and the more melismatic styles of chant composition. In particular, note how the melody adds more notes per syllable the longer the piece continues. The lyrics are quite simple: *Lord have mercy, Christ have mercy, Lord have mercy.* The three-part structure is said to represent the Trinity of Father, Son, and Holy Ghost. Kyrie compositions are also usually very clear examples of ternary or three-part form, commonly represented by the letters A-B-A. As you go through the rest of the listening guides contained throughout this text, pay close attention to the many different ways various composers made use of the *Kyrie* text and some of the different melodies originally composed for the *Kyrie.*

This is an example of an elaborately illuminated Gregorian chant. As seen in real life, this would be a very large manuscript page with vivid colors. This is not an example of Cum Jubilo, *but it is an excellent reproduction of how the chant was perserved in the Middle Ages.*
Source: Shutterstock, Inc.

Listening Guide

Kyrie "Cum Jubilo"
Anonymous

Format: Gregorian Chant
Performance: Ensemble Officium
Recording: *Sounds of a Cathedral* (Christophorus CHR 77243)

Performance Notes: This performance was recorded in a live concert at St. Peter's Cathedral, Worms (pronounced *Verms*), Germany on July 22, 2001. While this selection is a traditional performance, parts of the CD from which this example is taken mix chant performances with an overlay of jazz saxophone. There are actually several recordings like this available today, including a very popular one on the ECM label by Jan Garbarek and the Hilliard Ensemble. These recordings are quite popular with fans of New Age music and jazz.

:00	Kyrie eleison	Lord have mercy
:33	Christe eleison	Christ have mercy
:58	Kyrie eleison	Lord have mercy

Illumination of the Universal Man *from Hildegard's* Liber divinorum operum *(Book of Devine Works) ca. 1163-1173.*
Source: © 2009 Jupiterimages, Corp.

Hildegard von Bingen (1098-1179)

One of the first composers known to us by name was the abbess Hildegard von Bingen. She was the tenth child of a noble family, and as such, she was promised to the church from childhood (a practice referred to as a *tithe*, literally "giving one-tenth").[1] Hildegard eventually founded her own convent in Rupertsberg, Germany, where she was an active writer, visionary, and composer. It was her visions and the subsequent prophecies based on those revelations that led to her fame during her lifetime. Her music was collected into a volume titled *Symphonia armoniae celestium revelationum* (Symphony of the Harmony of Celestial Revelations). The pieces are notated in typical monophonic chant notation, but there is a great deal of argument among scholars as to whether or not Hildegard made use of instrumental accompaniment along with the human voice. Her melodies run the gamut from simple syllabic settings to extremely complex *melismatic* passages, and they represent some of the most innovative melodic techniques of the Middle Ages.

O lucidissima Apostolorum turba

This work is a *Responsorium*, or Response. The *Response* was not a formal part of the typical mass, but it was frequently interpolated into the church service. Hildegard composed 19 such works, along with a number of other similar compositions. This particular text deals with the apostles and their support for the "bride of the Lamb."

Listening Guide

O lucidissima Apostolorum turba (excerpt)
Hildegard von Bingen (1098-1179)

Format: Response with improvised instrumental accompaniment
Performance: Ensemble für frühe Musik Augsburg
Recording: *Celestial Stairs* (Christophorus CHR 77205)

Performance Notes: This 1997 performance is a "best guess" version as to how a work like this one might have been performed during Hildegard's day. All we have preserved is the melody with text that you hear from the soprano. The rest of this music is improvised as the performers think it might have been done in the Middle Ages.

NOTE: Text included in this listening example in italics.

:00

O lucidissima Apostolorum turba,	O most luminous band of apostles
surgens in vera agnitione,	rising in true knowledge
et aperiens clausuram magisterii Diaboli,	and opening the enclosure of the teaching of the devil,
abluendo captivos in fonte viventis aquæ,	washing the captives in a font of living water:
tu es clarissima lux in nigerissimis tenebris,	you are a most radiant light in the blackest darkness
fortissimumque genus columnarum,	and a most powerful set of pillars
sponsam Agni sustentans in omnibus ornamentis ipsius,	supporting the bride of the Lamb in all her ornaments.
per cuius gaudium ipsa mater et virgo est vexillata.	Through his joy she is mother and standard-bearing virgin.
Agnus enim immaculatus est Sponsus ipsius Sponsæ	For the immaculate Lamb is the bridegroom of his
immaculatæ.	immaculate bride.

The Notre Dame School: Léonin (ca. 1135~1201) and Pérotin (ca. 1160~1240)

With the composers of the *Notre Dame School* we begin to see the first written examples of **polyphonic** music, or music with more than one melodic line. Beginning late in the twelfth century, manuscripts originating from the Notre Dame Cathedral in Paris began to display two independent lines of music, a style called *organum*. Later a third (and eventually a fourth) independent line of music was added, and these works were called *motets*. In both cases, Gregorian chants provided the basis for composition (referred to as a *cantus firmus*), but the extra melodic lines were new musical creations. The concept of the **cantus firmus,** or fixed song, became a regular feature in most sacred compositions for the next several hundred years. Composers found innovative ways to incorporate older Gregorian chant melodies with what eventually became densely polyphonic music. You should also be aware of the term *clausulae*, which is one more way to refer to early attempts at polyphonic music. (In truth, all of these definitions are a bit simplistic. There can be *organum* with three or four voices as well, *clausulae* can be quite *melismatic* or closely tied to the original chants, one can be *substituted* for another, etc. . . . , but it all gets way too confusing, so let's keep things simple.) **Organum:** two-voice compositions. **Motets:** three- and four-voice compositions. Two composers' names keep showing

polyphonic

cantus firmus

organum

motets

up on scores from the Notre Dame School of composition, Léonin and Pérotin. Around 1272, an early historian known to posterity as "Anonymous IV" wrote the first important recorded history of these two composers:

Exterior view of the Notre Dame Cathedral in Paris.
© Shutterstock.com

> Master Leoninus was generally known as the best composer of organum, who made the great book (Magnus Liber) of organa for Mass and Office for the enhancement of the Divine Service. This book was in use until the time of the great Perotinus who shortened it and substituted a great many better *clausulae*, because he was the best composer of discant and better than Leoninus. Moreover, this same master Perotinus wrote excellent compositions for four voices, such as *Viderunt* [*omnes,* the Gradual for the third Mass of Christmas Day] and *Sederunt* [*principes,* the Gradual of the Feast of St. Stephen, Martyr], replete with artful musical turns and figures, as well as a considerable number of very famous pieces for three voices, such as the Alleluias *Posui adiutorium, sigillum summi patris,* and monophonic conductus, e.g., *Beata viscera* and lots more. The book, or rather books, of Master Perotinus have remained in use in the choir of the church of Our Blessed Virgin in Paris [i.e., Notre Dame] until the present day.[2]

Hodie beata virgo Maria

Interior view of the Notre Dame Cathedral in Paris.
© Shutterstock.com

This work is a two-voice *organum* in the Notre Dame style most commonly credited to Léonin. The lower voice, performed with longer duration notes, is the original Gregorian chant. The melody above was brand new in the early thirteenth century. This particular performance features voices only, but there is a great deal of argument among scholars as to exactly how these early polyphonic compositions would have been performed. There is some material that suggests instruments would have been used for the *cantus firmus,* but other historians are sure instruments were never used in this situation. It seems that the best answer is most likely somewhere in the middle. Keep in mind that this was not an era of modern convenience and rapid travel such as we enjoy today. These early musicians and composers probably made do with what they had. If they had plenty of good voices, they used them, and if not, they filled in with instruments. In subsequent listening examples found in this chapter, you will be introduced to recordings that actually offer elements of both musical solutions.

Listening Guide

Hodie beata virgo Maria (excerpt)
Anonymous—Notre Dame School (early thirteenth century)

Format: Organum
Performance: Trigon Ensemble
Recording: *Music for Candlemas* (Passacaille 932)

Performance Notes: The Trigon Ensemble is a group of women who specialize in the performance of music from the Middle Ages. They got their start at the Brabant Conservatory of Tillburg in the Netherlands. Recorded April 12-15, 2000 in Siran, France.

NOTE: Text included in this listening example in italics.

:00	*Hodie beata virgo Maria puerum*	*Today the blessed virgin Mary*
	Ihesum presentavit in templum:	*presented the boy, Jesus, in the temple;*
	et Symeon, repletus Spiritu Sancto,	and Simeon, filled with the Holy Spirit,
	accepit eum in ulnas suas	took him in his arms
	et benedixit Deum et dixit:	and blessed God, saying:
	Nunc dimittis, Domine,	Lord, now let your
	servum tuum in pace.	servant depart in peace.

El mois de mai/De se debent/Kyrie

This is a three-voiced motet. As the motet evolved, it began to make use of multiple texts, sometimes even in different languages. This particular performance will offer you two different versions of how a motet might have been performed (and composed, for that matter). You will hear the tenor part, or *cantus firmus*, performed exclusively on instruments. This particular tenor part is based on the Gregorian chant *Kyrie "Cum Jubilo"* (the same chant found in your first listening example), but the old melody has been stretched into long durations while new melodies have been composed over the top. The first time through you will only hear the tenor and *duplum* parts. The second time through the *triplum* (highest) part is added with a second set of lyrics. Note also that there are fairly strict, repeated rhythmic patterns at play in this work. This is called *isorhythm*, which is a technique generally credited first to a composer and music theorist named Philippe de Vitry (see next section).

Listening Guide

El mois de mai/De se debent/Kyrie
Anonymous (thirteenth century)

Format: Isorhythmic Motet
Performance: Joculatores Upsalienses (Upsala Jesters)
Recording: *The Four Seasons* (BIS 75)

Performance Notes: Recorded in 1976 at Wik's Castle (Wiks Slott), Sweden.

:00
De se debent bigami
Non de papa queri
Qui se privilegio
Spoliarunt cleri
Sed de facto proprio
Nunc possunt doceri
Et hoc cum Ovidio
Pro vero fateri:
"Non minor est virtus,
 quam quaerere, parta tueri."

Bigamists should complain against themselves,
not against the pope,
for they despoil themselves
of the privilege of clergy
but now from their own deed
they can learn
and with Ovid
confess this to be the truth:
"Virtue is no less
 to guard possessions than to seek them."

:56
El mois de mai,
 que chante la malvis,
Que flourist la flour de glai,
La rose et lilis,
Lors doit bien joie mener
 qui d'amours est espris;
Si m'envoiserai,
Car je suis loiaus amis
A la plus belle
 qui soit en ce pais;
En lié amer ai tout mon cuer mis;
Je n'en partirai,
Tant com serai vis;
La grant biauté de son cler vis;
Sen cors le gai,
 qui est fait par devis,
Mi font a lié penser tous dis.

In the month of May,
when the thrush sings,
When the gladiolus,
and the rose and lily bloom,
Then those in love
should be joyful;
I will rejoice,
for I am the faithful lover
of the most beautiful
one in all these lands;
I have set my whole heart on loving her;
I will never cease,
for as long as I live;
The great beauty of her shining face;
her pretty body,
made so wonderfully,
make me always think of her.

Philippe de Vitry (1291–1361)

In music history circles, the late Middle Ages is sometimes called the *Ars nova* (new art), which was a term taken from a theoretical treatise commonly credited to Philippe Vitry (through some modern scholars disagree). In turn, earlier music from the same period is referred to as *Ars antiqua* or "old art." Only the last 10 chapters of Vitry's text have been found, but they helped codify a new form of rhythmic notation. It is thought that Vitry was one of the first to use the technique of *coloration*, where red notes in the score indicated alternations from normal note duration values. Philippe Vitry is also credited with the creation of the *isorhythmic motet*. The actual term "isorhythm" is a twentieth-century creation, but it is a simple way of describing Vitry's technique of writing out the *cantus firmus* of a given motet in strict, repeated, long-duration notes while the upper voices follow along at what seems like twice the tempo. In fact, all voices are written in the same basic tempo, but Vitry alternates between long and short rhythmic durations between

the different voices. Very little of Vitry's music survives. In all, there are 12 motets, one of which carries a French text, with the rest being in Latin.

Guillaume de Machaut (ca. 1300-1377)

Guillaume de Machaut is generally considered to be the most important composer of the fourteenth century, and in many ways, his music is viewed as something of a bridge into the Renaissance. Among other "firsts," Machaut is credited with composing the first fully polyphonic setting of all five movements of the mass Ordinary. He was an active composer of both sacred and secular music in a wide variety of forms. His motets, both sacred and secular, are considered some of his finest compositions. In them, he expands harmony to include more intervals of the 3rd and 6th, which had the overall effect of softening the typical harmonies heard during the Middle Ages. Many of his motets, particularly the ones in Latin, embraced de Vitry's concept of isorhythm. Beyond some of his motets, Machaut's most important secular compositions were love songs called *lais, chansons balladées* (or *virelais*), and *Rondeaux*. To get a better sense of Machaut and his views regarding secular music, see the related article in the following section.

DIG DEEPER

BOOK
Poetry and Music in Medieval France: From Jean Renart to Guillaume de Machaut
by Ardis Butterfield

Messe de Nostre Dame (Our Lady's Mass)

This mass is said to be the oldest complete polyphonic mass Ordinary composition. There are individual mass movements preserved throughout Europe that pre-date this one, but no complete works. It is also one of the longest multi-movement compositions still in existence from the Middle Ages. Machaut's mass contains almost thirty minutes of music, the various movements of which would have been performed at their appropriate points throughout the entire mass service. The *Kyrie* alone lasts over seven minutes. Your example contains the entire first statement of "Kyrie eleison," or "Lord have mercy." Like the previous motet example, this mass makes use of isorhythmic techniques, with a strict use of rhythm throughout the five movements of the mass Ordinary. Compared to the rest of the mass, the opening *Kyrie* is actually somewhat tame, but, even here, you can get a real sense of Machaut's use of rhythmic and harmonic color.

Listening Guide

Messe de Nostre Dame (Our Lady's Mass)
Kyrie (excerpt)
Guillaume de Machaut (ca. 1300-1377)

Format: Four-voice mass
Performance: Ensemble Gilles Binchois, Dominique Vellard, director
Recording: *Messe de Nostre Dame* (Cantus 9624)

Performance Notes: Recorded September 1990 in Seine et Marne, France.

:00	*Kyrie eleison* (Lord have mercy). Polyphonic treatment.
1:11	Brief homophonic statement of the same text.
1:31	Independent polyphonic lines return.

Secular Music in the Middle Ages

Manuscript fragment from a secular song about Robin and Marion by trouvére *Adam de la Hall.*
Source: Jupiterimages, Corp.

Compared to sacred music during the Middle Ages, very little is known about the development of secular music in general and instrumental secular music in particular. The most popular forms of secular music were performed by poet/musicians called *troubadours, trouvères, minnesingers,* or *jongleurs,* depending on which part of Europe they came from. The first three groups were generally members of the nobility or were in some way attached to a particular court. The *jongleurs* were lower-class wandering minstrels who, in many ways, functioned as the *CNN* of the Middle Ages, telling the latest heroic tales and passing gossip from court to court. For both classes of musicians, their compositions were generally monophonic, though it is commonly believed that they almost always accompanied themselves with some sort of chordal instrument such as a lute, harp, or mandolin. Their poems could be sung to full melodies—some of which were written out and are still in use today—or they could be recited in a lyrical voice over a musical accompaniment. Polyphonic secular music was also popular, with Machaut being one of the most famous composers in this genre. Instrumental music frequently made use of vocal music, simply playing the individual melodic lines rather than singing them. In addition, there was a good deal of instrumental music created for use at dances and other festivals though little of it survives today. What does exist is generally in a monophonic form, indicating that most of the music other than the melody, and particularly percussion accompaniments, would have been improvised. The following article is an excerpt from a letter of "courtly love" written from a very old Machaut to a 19-year-old female admirer in which he discusses his compositions.

Troubadours taking part in a singing competition.
Source: Jupiterimages, Corp.

Machaut's Letter Regarding Secular Vocal Music

My sovereign lady, a knight must have no calling or science other than: arms, lady, and conscience. Therefore I swear to you and promise that I shall serve you loyally and diligently to the best of my power with all I do and can do, and all to your honor, as Lancelot and Tristram never served their ladies; and have your likeness as my earthly deity and as the most precious and glorious relic that ever I did see in any place. And henceforth it shall be my heart, my castle, my treasure, and my comfort against all ills in truth. If it please God, I shall see you before Pentecost; for you and your sweet likeness have brought me to such a point that, the Lord be thanked, you have healed me completely. And I should have left before now; but there is a great company of soldiers a few leagues from us; therefore riding is most perilous, I send you my book, *Morpheus*, which they call *La Fontaine amoureuse*, in which I have made a song to your order, and by God it is long since I have made so good a thing to my satisfaction; and the tenors are as sweet as unsalted pap. I beg therefore that you deign to hear it, and learn the thing just as it is, without adding or taking away; and it is to be sung in a goodly long measure (i.e., a broad tempo); and if anyone play it on the organs, bagpipe, or other instrument, that is its right nature. I am also sending you a *ballade*, which I made before receiving your sweet likeness: for I was a little hurt because of some words which had been said to me; but as soon as I saw your sweet likeness I was healed and free of melancholy. My most sovereign lady, I would have brought you my book to amuse you, wherein are all the things which I have ever made, but it is in more than twenty portions, for I had it made for one of my lords; and so I am having the notes put to it, and that is why it has to be in portions. And when the notes will have been put to it, I shall bring it or send it to you, if it please God. My most sovereign lady, I pray God that he may give you your heart's desire and such honor as I wish you may have; and God give you solace and joy, such as I might wish for myself.

From *Letters of Composers through Six Centuries by Piero Weiss.* Copyright © 1967 by Piero Weiss. Reprinted by permission.

Ce fu en mai (It Happened in May)

Composer Moinot D'Arras was a monk from an abbey in northern France, but, in spite of that fact, he managed to write a pretty good love song here. Actually, it's a fairly sad love song, and the main character does end up turning to God in the last stanza. This is a typical example of a strophic *trouvère* song, with a catchy melody that is repeated five times. The only written music in existence for this tune is the melody. Anything other than the melody you might hear in a performance or recording is being improvised by the musicians. In an interesting side note, twentieth-century composer Paul Hindemith borrowed this particular tune for use in his composition *Nobilissima Visione* (Noblest Vision).

Listening Guide

Ce fu en mai (It Happened in May)
Moinot D'Arras (fl. 1213-1239)

Format: Strophic *trouvère* song
Performance: Ensemble für frühe Musik Augsburg
Recording: *Amours & Desirs: Songs of the Trouvères* (Christophorus 77117)

Performance Notes: This particular recording presents the different verses of this song as they might have been performed by a solo male or female voice as well as by a group of singers. The rhythmic complexity of this particular performance is quite engaging, but as with all recordings of music from the Middle Ages and Renaissance, this is a "best guess" as to how the work might have been performed. Of all the musical elements you hear in this performance, only the melody was actually preserved in a manuscript from the Middle Ages. The rest is being improvised by members of the *Ensemble für frühe Musik Augsburg.* Recorded December 1991 in Augsburg, Germany.

:00 Verse one. Solo female voice, followed by viol.

Ce fu en mai	In early May
Au douz tens gai	When skies are gay
Que la saisons est bele,	And green the plains and mountains
Main me levai,	At break of day
Joer m'alai	I rose to play
Lez une fontenele.	Beside a little fountain
En un vergier	In garden close
Clos d'aiglentier	Where shone the rose
Oi une viele;	I heard a fiddle played, then:
La vi dancier	A handsome knight
Un chevalier	That charmed my sight
Et une damoisele.	Was dancing with a maiden.

:31 Verse two. Solo male voice, followed by recorder.

Cors orent gent	Both fair of face,
Et avenant	They turned with grace
Et molt très bien dançoient;	To tread their Maytime measure;
En acolant	The flowering place,
Et en baisant	Their close embrace,
Molt biau se deduisoient.	Their kisses brought them pleasure.
Au chief du tor,	Yet shortly they
En un destor,	Had slipped away
Doi et doi s'en aloient;	And strolled among the bowers;
Le jeu d'amor	To ease their heart
Desus la flor	Each played his part
A lor plaisir faisoient.	In love's games on the flowers.

1:01 Verse three. A different solo male voice accompanied by recorder heard at the end of verse two. After statement of the lyrics concludes, recorder is joined by viol and tambourine.

J'alai avant.	I crept ahead
Molt redoutant	All chill with dread
Que nus d'aus ne me voie,	Lest someone there should see me,
Maz et pensant	Bemused and sad
Et desirrant	Because I had
D'avoir ausi grant joie.	No joy like theirs to please me.
Lors vi lever	Then one of those
Un de lor per	I'd seen there, rose
De si loing com j'estoie	And from afar off speaking
Por apeler	He questioned me
Et demander	Who I might be
Qui sui ni que queroie.	And what I came there seeking.

1:30 Verse four. Both male voices along with recorder and other instruments. Viols play melody after voices conclude.

J'alai vers aus,	I stepped their way
Dis lor mes maus,	To sadly say
Que une dame amoie,	How long I'd loved a lady
A cui loiaus	Whom, all my days
Sanz estre faus	My heart obeys
Tot mon vivant seroie,	Full faithfully and steady.
Por cui plus trai	Though still I bore
Peine et esmai	A grief so sore
Que dire ne porroie.	In losing one so lovely
Et bien le sai,	That surely I
Que je morrai,	Would come to die
S'ele ne mi ravoie.	Unless she deigned to love me.

2:00 Verse five. Male voices continue as in verse four, accompanied by all instruments.

Tot belement	With wisdom rare,
Et doucement	With tactful air,
Chascuns d'aus me ravoie.	They counselled and relieved me;
Et dient tant	They said their prayer
Que Dieus briement	Was God might spare
M'envoit de celi joie	Some joy in love that grieved me
Por qui je sent	Where all my gain
Paine et torment:	Was loss and pain
Et je lor en rendoie	So I, in turn, extended
Merci molt grant	My thanks sincere
Et en plorant	With many a tear
A Dé les comandoie.	And them to God commended.

Trotto

This particular work is preserved in a fourteenth-century manuscript housed in the British Museum. Unlike dance forms such as the *estampie* or *saltarello*, the "trotto" is not a common dance title, but its rhythmic character is quite similar to other dance music styles of the period. The formal structure of the work is a bit unique in its complexity as it basically follows a five-part rondo form, A-B-A-C-A, which we won't be investigating in depth until the Classical period in Chapter 5. Very little notated instrumental music was included in manuscripts from the Middle Ages, but people did write about instrumental performances. In addition, instrumental musicians were often featured in

Dancing was a popular form of courtly entertainment throughout the Middle Ages and the Renaissance.
Source: Jupiterimages, Corp.

artistic works of the day. In fact, some music historians have managed to make educated guesses about performance practice and period instrument design simply by looking at artworks from the Middle Ages and early Renaissance. Precursors of the string, wind, and percussion instruments you saw in Chapter One were all in their early stages of development during both the Middle Ages and Renaissance. Without going into too much detail, there were basically two groups of instruments

in use during both time periods, loud ones and soft ones. Soft instruments would be used in smaller court or church settings; loud ones would be used for large indoor banquets and most outdoor functions. The following listening example will demonstrate several different types of instruments, all from the loud groups of instruments. As with the previous example, only the melody of this tune is actually preserved in a written manuscript. Musicians simply improvise the rest of a given performance.

Listening Guide

Trotto
Anonymous (Italy, ca. 1300s)

Format: Instrumental dance music
Performance: Joculatores Upsalienses (Upsala Jesters)
Recording: *Antik Musik På Wik (Early Music at Wik)* (BIS 3)

Performance Notes: Recorded in 1973 at Wik's Castle (Wiks Slott), Sweden. The CD title "Early Music at Wik" is a little misleading in that it refers to the castle in Sweden where the recording was made, which is not necessarily where the music was first performed.

Joculatores Upsalienses (Upsala Jesters) are a group of musicians devoted to bringing to life music of the past—primarily from the 13th to the beginning of the 17th centuries. Their repertoire consists of both sacred music and secular songs, dance music etc., sung and played on more or less exotic sounding instruments of old design. The group started in 1965 as a pure spare-time venture, but soon became engaged in public performances and has appeared with increasing frequency in concerts and on both international and domestic radio and television. . . . Over the years the number and nature of the group has changed, but of its five founder members, four are still active. Several are music teachers, but there is an astronomer, a librarian, a computer specialist, a chemist, one museum director, and even a musician(!), all joined by their enthusiasm for old music.

Liner notes from BIS 3

:00	Letter A, or refrain. 12 measures in duple time. (Count 1,2; 2,2; etc . . .)
:12	Letter B. 9 measures.
:21	Letter A. 12 measures.
:33	Letter C. 5 measures.
:38	Letter A. 12 measures.

Endnotes

1. Joseph Machlis and Kristine Forney, *The Enjoyment of Music*, 7th ed. (New York: W. W. Norton, 1995), 76.

2. "Anonymous IV," in *Music in the Western World: A History in Documents,* eds. Piero Weiss and Richard Taruskin (New York: Schirmer Books, 1984), 61-62.

Study Guide

Chapter 2 Review Questions

True or False

___ 1. The mass text is divided into two sections called the Proper and the Ordinary.

___ 2. Most scholars agree that the earliest church music was monophonic.

___ 3. Most scholars agree that the earliest church music was polyphonic.

___ 4. Guillaume de Machaut is considered a minor composer from the 14th century.

___ 5. Hildegard von Bingen founded a convent in Rupertsberg, Germany.

___ 6. Early music from the Middle Ages is sometimes referred to as the *Ars nova.*

___ 7. Early music from the Middle Ages is sometimes referred to as the *Ars antiqua.*

___ 8. Machaut's *Messe de Nostre Dame* is said to be the oldest complete polyphonic mass.

___ 9. Compared to sacred music during the Middle Ages, a great deal is known about the creation of secular music during this same time frame.

___10. *Jongleurs* were lower-class wandering minstrels.

Multiple Choice

11. The most popular forms of secular music during the Middle Ages were performed by poet/musicians called
 a. *troubadours.*
 b. *trouvères.*
 c. *minnesingers.*
 d. *jongleurs.*
 e. all of the above.

12. Hildegard von Bingen's *O lucidissima Apostolorum turba* found in your listening guide is a/an:
 a. Introit.
 b. Collect.
 c. Offertory.
 d. Response.
 e. none of the above.

13. This composer was the tenth child of a noble family, and as such was promised to the church from childhood.
 a. Hildegard von Bingen
 b. Léonin
 c. Guillaume de Machaut
 d. Moinot D'Arras

14. Léonin and Pérotin were early composers of polyphonic music at the:
 a. Cathedral of St. Mark.
 b. Cathedral of St. Peter.
 c. Notre Dame Cathedral.
 d. Bob's Church of the Middle Ages.

Fill in the Blank

15. The term _____ was taken from a theoretical treatise by Philippe de Vitry.

16. 20th-century composer _____ _____ included the melody *Ce fu en mai* in his composition *Nobilissima Visione.*

17. Philippe de Vitry is credited with the creation of the _____ motet.

18. The concept of the _____, or fixed song, became a regular feature in most polyphonic sacred compositions during the Middle Ages.

19. The earliest form of two-voice sacred polyphony was called _____.

20. Around 1272, an early historian known to posterity as _____ wrote the first important recorded history of Léonin and Pérotin.

21. As the polyphonic _____ evolved, it began to make use of multiple texts, sometimes even in different languages.

22. Composer _____ was a monk from an abbey in northern France.

Short Answer

23. List the five sections of the mass Ordinary.

24. List the three basic categories of Gregorian chant melodic texture.

25. How many verses does the strophic trouvère song *Ce fu en mai* contain?

Essay Questions

1. Discuss the evolution of Mass composition during the Middle Ages.

2. Discuss the role of the *troubadours, trouvères, minnesingers,* and *jongleurs* in the court life of the Middle Ages.

Chapter 3

The Renaissance

"If music be the food of love, play on . . ."

Shakespeare

\mathcal{D}uring the Renaissance, music continued to be dominated by sacred church compositions, but a growing interest in *humanism* led to more attention being paid to secular music as well. Vocal music was still dominant, but toward the end of the Renaissance period instrumental music was growing more popular in both the church and at court. Isorhythmic techniques began to fall out of favor, and harmony grew thicker. Polyphony continued to be the dominant musical texture, popular in both sacred and secular works. In terms of harmony, composers continued to write in the accepted modal patterns of church music, but throughout the period a subtle shift was being made that continued to hint at the major/minor tonal system that would come into common use during the Baroque period. In 1501, a man named Ottaviano Petrucci began printing music, making it widely available for the first time to anyone who could afford it. Later in the period, movable type for music was developed, and a number of composers began publishing collections of their works. With published music, secular vocal music such as the madrigal and four-part instrumental ensemble music became quite popular as a form of home entertainment.

The term *Renaissance* refers to a rebirth of interest in Greek and Roman antiquity, which influenced not just music but all of the arts. In the world

Nineteenth-century illustration of the Sistine Chapel as painted by Michelangelo.
© Shutterstock.com

at large, this was a time of great exploration and expansion. Notable figures from the Renaissance include Columbus, Leonardo da Vinci, Michelangelo, Martin Luther, Copernicus, and Shakespeare. Historians used to mark the beginning date of the Renaissance with the fall of Constantinople in 1453. In truth, many factors came together within a fifty-year period between 1420 and 1470 that, taken together, really mark the beginning of a new era in history in general and the arts in particular. It has been suggested by many that the true *Renaissance* began in Italy. Music historian Donald J. Grout describes life in Italy during the early Renaissance:

The rulers, many of whom had gained their positions by force, sought to glorify themselves and magnify their cities' reputations. They did so by erecting impressive palaces and country houses decorated with new artworks and newly unearthed artifacts from ancient civilizations; by maintaining chapels of talented singers and ensembles of gifted instrumentalists; and by lavishly entertaining neighboring potentates. Meanwhile the citizenry, no longer in feudal service to a lord . . . accumulated wealth through commerce, banking, and crafts. Although they prayed and attended church, these people gave priority to worldly matters. They wanted prosperity for their families, property and beautiful objects for themselves, and education for their children along classical rather than religious lines. Personal fulfillment through learning, public service, and accomplishment motivated their individual lives and their social contacts and institutions.[1]

Detail from the Sistine Chapel of Michelangelo's painting depicting God creating Adam.
© Shutterstock.com

Poet and playwright William Shakespeare.
© Shutterstock.com

Music in the Church

The composition of sacred music continued to be dominated by new settings of the mass Ordinary for use in the Roman Catholic service. Sacred motets composed with a single Latin text also continued to be quite popular. In both cases, the bulk of the compositions would be based on a pre-existing *cantus firmus*, which was most frequently a well-known Gregorian chant. As the period progressed, composers continued to increase the thickness of their polyphonic music, and secular musical materials also found their way into the church. In response, the Council of Trent (1545-1563) was established to make reforms to the entire church service, with particular emphasis placed on new "rules" about composition. In defiance of the Catholic Church, a man named Martin Luther led a religious movement called the *Protestant Reformation*, which, among many other things, called for more simplicity in church music with more participation by the congregation.

Guillaume Dufay (ca. 1397-1474)

As with Machaut in the last chapter, Burgundian master Guillaume Dufay may be viewed as a transitional composer. His early works bear the marks of the late Middle Ages, whereas his later compositions move progressively toward more modern styles of writing. Dufay was prolific in both sacred and secular forms of composition, leaving behind eight complete masses, various individual mass movements, 22 motets, and over 80 secular songs. Other works, such as a *requiem* mass, are known to have existed, but musical scores have yet to be found by modern scholars. Dufay's masses continued to make use of *cantus firmus* techniques, but he sometimes used popular secular tunes as a basis for his compositions rather than the more traditional Gregorian chants. His early motets made use of isorhythmic techniques, but in his later compositions he abandons them in favor of a free-flowing rhythmic scheme. In some of his later masses and motets, Dufay also began to make use of a new harmonic technique called *faux bourdon* (false bass), which is difficult to describe in lay terms but added a different texture to the upper polyphonic lines. Most of Dufay's secular works were for three independent voices singing poetry written in French, and many of them followed romantic traditions established by the *trouvères*. Dufay, however, did move forward stylistically with multiple voices and score indications for instrumental accompaniment.

Missa "Ecce ancilla domini" (Behold the Handmaid of the Lord)

Marian worship, or worship of the Virgin Mary, was quite popular during the Renaissance, and this mass was composed in celebration of her. The mass makes use of two Gregorian chant melodies for its *cantus firmus, Ecce ancilla domini* (See, I am the handmaid of the Lord, let what you have said be done to me) and *Beata es Maria* (Blessed is she who believed that the promise made her by the Lord would be fulfilled). The first chant represents the angel who visited Mary before the birth of Christ, and the second chant represents the Virgin Mary. Dufay makes use of both chants in order to create a sort of musical "dialogue" between the angel and Mary.[2] This excerpt starts at the beginning of the work and runs through the end of the first *Kyrie* statement. Notice how much thicker the vocal texture at the beginning and end of this section is when compared to the Machaut example in the previous chapter.

Listening Guide

Missa "Ecce ancilla domini" (Behold the Handmaid of the Lord)
 Kyrie (excerpt)

Guillaume Dufay (ca. 1400-1474)

Format: Four-voice mass
Performance: Schola Cantorum Stuttgart, Clytus Gottward, director
Recording: *Musica mensurabilis I* (Bayer Records 100271)

Performance Notes: Recorded January 27, 1976 at the Villa Berg, Stuttgart, Germany.

:00 *Kyrie eleison* (Lord have mercy). Opens with a brief passage of two-voice polyphony, followed by an expansion to four-voice texture.

:40 Texture reduces back down to two independent voices.

1:39 Four-voice texture returns.

Johannas Ockeghem (ca. 1420-1497)

Ockeghem was a student of Dufay and subsequently a leader in the Flemish school of composition. He was a master of "seamless" counterpoint, as displayed in his polyphonic mass compositions. Ockeghem is also remembered for his harmonic expansion, which frequently added a fifth voice line (bass) to his mass and motet compositions, giving his works a richer, deeper musical texture. As with Dufay, Ockeghem made use of both sacred and secular melodies for the creation of his *cantus firmus* lines though he frequently made significant alterations to the original melodies. Ockeghem was a master at creating musical drama in his works. He would use faster rhythms and more dissonant harmonies as cadences were approaching, thus building extra tension to the point of resolution. In his secular compositions, Ockeghem excelled at the three-voice chanson, most of which were designed for one singer and two instruments. Among his most important compositions are the sacred works *Missa Cuiusvis toni* (Mass in Any Tone, a title relating to the harmonic implications of the work), *Missa Prolationum* (Prolation Mass), and a *Requiem Mass*. In addition, he composed a number of Marian-related motets including an excellent *Ave Maria*.

Josquin des Prez (ca. 1440–1521)

Although a number of gifted composers emerged during the first half of the Renaissance period, Josquin is usually singled out as the true master above all others. His works were highly influential and revered during his day, and his reputation as a genius in the art of both secular and sacred composition has done nothing but grow ever since. Little is known of his early life, but most scholars agree he was born in northern France. A church record from 1459 lists him as a singer employed by the cathedral in Milan, Italy. From there he worked as a singer in several different chapels around Europe until he accepted a post at the Notre Dame Cathedral in Condé-sur l'Escaut, where he would remain for the rest of his life. Historians speculate that Josquin studied with Ockeghem, and many of his compositions do embrace the Flemish style. Many of Josquin's works were printed and collected during his lifetime, including three volumes of masses and motets published by Petrucci. His vast compositional output (by early Renaissance standards) includes 18 masses, around 100 sacred motets, and over 70 secular vocal works.

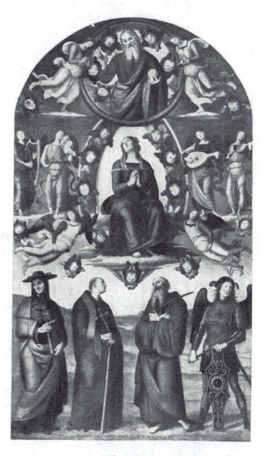

Josquin des Prez.
Source: Jupiterimages, Corp.

Josquin's masses include works based on both secular tunes and Gregorian chants. Among other innovations, he began to alter the use of the *cantus firmus* significantly, sometimes preferring to incorporate elements of a pre-existing melody into all of his polyphonic vocal lines rather than leave it in one part. Compared to the works of other Renaissance composers, harmonies are fuller in Josquin's compositions and his melodic writing is more graceful and lyrical. Many of his motets reflect the same musical traits as his masses, but with motet composition Josquin could go even farther. His motets often focus on the adoration of the Virgin Mary (as with the following listening example), and he also appears to have been the first composer to create motet settings based on the Psalms.

Ave Maria … benedicta tu

This work is the shorter of two *Ave Maria* settings Josquin composed. The motet is based on a Gregorian chant, but rather than use the old melody in one voice, Josquin weaves the original melody in and out of all four polyphonic voices of the composition. As with many of the works of Ockeghem, Josquin's motet builds in both harmonic and rhythmic intensity toward the final resolution. This is the first of several settings of *Ave Maria* texts spaced throughout your listening examples. These are provided both for their individual importance as great compositions in their own right and also to give you a chance to compare and contrast different styles of musical composition.

The Annunciation of Mary *by Pietro Perugino. Notice all the different musicians surrounding Mary.*
Source: Jupiterimages, Corp.

Listening Guide

Ave Maria . . . benedicta tu
Josquin des Prez (ca. 1450-1521)

Format: Four-voice motet
Performance: Pomerium, Alexander Blachly, director
Recording: *Josquin* (Glissando 779 043-2)

Performance Notes: Recorded in August 2001 at the Bowdoin College Chapel, Brunswick, Maine. From the CD liner notes:

Pomerium was founded by Alexander Blachly in New York in 1972 to perform music composed for the famed chapel choirs of the Renaissance. (The name—medieval Latin for "garden" or "orchard"—derives from the title of a treatise by 14th-century music theorist Marchettus of Padua, who explained that his book contains the 'fruits and flowers' of the art of music.)

Liner notes from Glissando 779 043-2

| :00 | Ave Maria, gracia plena, dominus tecum, benedicta tu in mulieribus, et benedictus fructus ventris tui, Jesus Christus, filius dei vivi. Et benedicta sint ubera tua que lactaverunt regem regum et dominum deum nostrum. | Hail Mary, full of grace, the Lord is with you. You are blessed among women, and blessed is the fruit of your womb, Jesus Christ, the son of the living God. And blessed be your breasts, which nursed the King of Kings and our Lord God. |

Giovanni Pierluigi da Palestrina (ca. 1525-1594)

Palestrina spent the bulk of his life working for the Catholic Church, and most, though not all, of his music is sacred in nature. Unlike some of the previous composers we have examined in this section, Palestrina rarely made use of secular material in his sacred compositions, and the overall tone of his works tends to be more serious and reverent. Many of Palestrina's masses are said to be *parody* masses. In this style of composition, not just the *cantus firmus* but all of the melodies were drawn from earlier works, frequently from his own motets. Palestrina was not the first composer to use this technique, but he certainly mastered the style. Over half of his 104 mass compositions are parody masses, 22 of which, again, borrow from his own earlier motets. The rest of his compositional output includes over 375 motets, large cycles of hymns and offertories, 35 *Magnificats,* and more than 140 madrigals (many secular, though some have decidedly spiritual overtones).[3]

As things heated up with the Council of Trent, there was a very real threat that polyphonic music would be removed from all Catholic Church services. Though his participation in all of the events surrounding the Council of Trent and its actions is frequently exaggerated, Palestrina is often credited with "saving" polyphonic music in the church. While it is true that Palestrina did make some very conscious changes to his polyphonic style when writing sacred settings of

Giovanni Pierluigi da Palestrina.
Source: Jupiterimages, Corp.

the mass Ordinary, the image history tends to give us of Palestrina running in breathless at the eleventh hour and presenting his music to the Council for their consideration is incorrect. In point of fact, Palestrina never appeared before the Council of Trent, and it seems that none of his music was ever performed during their meetings. The following historical documents may help explain how rumors such as this get started. The first article is a letter sent to Palestrina and another composer regarding church music reforms. That letter is followed with excerpts of two documents from later points in history.

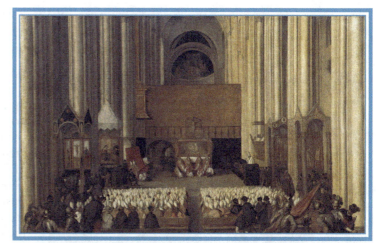

Worship service during a meeting of the Council of Trent. The results of the council's deliberations would have a profound effect on the world of sacred music.
© Shutterstock.com

Brief on the Reform of the Chant [October 25, 1577]

To Palestrina and Zoilo

Beloved Sons:

Greetings and apostolic benediction!

Inasmuch as it has come to our attention that the Antiphoners, Graduals, and Psalters that have been provided with music for the celebration of the divine praises and offices in plainsong (as it is called) since the publication of the Breviary and Missal ordered by the Council of Trent have been filled to overflowing with barbarisms, obscurities, contrarieties, and superfluities as a result of the clumsiness or negligence or even wickedness of the composers, scribes, and printers: in order that these books may agree with the aforesaid Breviary and Missal, as is appropriate and fitting, and may at the same time be so ordered, their superfluities having been shorn away and their barbarisms and obscurities removed, that through their agency God's name may be reverently, distinctly, and devoutly praised; desiring to provide for this in so far as with God's help we may, we have decided to turn to you, whose skill in the art of music and in singing, whose faithfulness and diligence, and whose piety toward God have been fully tested, and to assign to you this all-important task, trusting confidently that you will amply satisfy this desire of ours. And thus we charge you with the business of revising and (so far as shall seem expedient to you) of purging, correcting, and reforming these Antiphoners, Graduals, and Psalters, together with such other chants as are used in our churches according to the rite of Holy Roman Church, whether at the Canonical Hours or at Mass or at other divine services, and over all of these things we entrust you for the present with full and unrestricted jurisdiction and power by virtue of our apostolic authority, and in order that you may pursue the aforesaid more quickly and diligently you have our permission to admit other skilled musicians as assistants if you so desire. The Apostolic Constitutions and any other regulations that may be to the contrary notwithstanding. Given at St. Peter's in Rome under Peter's seal this twenty-fifth day of October, 1577, in the sixth year of our pontificate.

To our beloved sons Giovanni Pierluigi da Palestrina and Annibale Zoilo Romano, musicians of our private chapel.

Palestrina at his writing table. This composer became one of the most beloved musicians of the entire Renaissance.
Source: Jupiterimages, Corp.

By the early years of the Baroque era, Palestrina's reputation as the man who "saved" polyphony in the church was beginning to grow. A Jesuit named Lodovico Cresollio wrote the following in 1629:

> Pius IV, a most serious-minded pontiff of the church, had noticed for some time that music and singing in sacred places was very little else than an abundance of delicate diminutions and vain adornments to the words, from which no benefit of piety came forth to the listeners. He then determined to set the question of banishing sacred music from the church before the Council of Trent. When word of this came to the ears of Giovanni Palestrina, he quickly set himself to compose Masses in such a way that not only should the combinations of voices and sounds be grasped by the listeners, but that all the words should be plainly and clearly understood. When the pontiff had heard these works and had seen how useful they could be for the divine service, he changed his mind and determined not to banish sacred music but to maintain it. This was told by Palestrina himself to a certain member of our society [i.e., the Jesuits], from whom I heard it.[4]

Stylized painting of Palestrina creating a new composition.
Source: Jupiterimages, Corp.

By the1800s, Palestrina's feats as a composer had become the stuff of legend. Historian Giuseppe Baini told a story of how Palestrina was "summoned" before Cardinal Borromeo and basically told to "save" polyphonic music in the church. The writer continues: "Poor Pierluigi! He was placed in the hardest straits of his career. The fate of church music hung from his pen, and so did his own career, at the height of his fame."[5] The story continues, saying that on a given day Palestrina, facing a papal commission, led a choir in the performance of three masses, the last of which was his *Pope Marcellus Mass*. Basically, that one performance saved the day, and the tradition of polyphonic music for the church would continue. It's a great story, but it just isn't true.

Missa Pape Marcelli

 This example begins with a monophonic intonation of the word "gloria." It is a standard introduction to the *Gloria* movement of the mass used throughout the Renaissance and Baroque periods, and in many cases right up through today. As this six-voice mass gets started, you will immediately notice less movement among the individual polyphonic voices. Composers for many years had written densely polyphonic sacred music under the theory that everyone in the congregation knew all the texts of the mass. The Council of Trent disagreed, suggesting that the thickly-textured polyphonic music was obscuring any clear understanding of the words. In this composition, Palestrina continues to make use of polyphonic techniques in his writing, and he does expect prior knowledge of the text, but he keeps certain key words of that text clearly audible. In particular, he starts and ends every phrase of text in a homophonic fashion, with all voices singing the same rhythm in harmony. Only after the line of text is clearly established does he break off into polyphonic composition, but even then only two or three voices move at any one time.

Listening Guide

Missa Pape Marcelli
Gloria (excerpt)
Giovanni Pierluigi da Palestrina (ca. 1525-1594)

Format: Six-voice mass
Performance: Vienna Motet Choir, Bernhard Klebel, director
Recording: *Giovanni Pierluigi da Palestrina* (Christophorus entrée 0106-2)

Performance Notes: Recorded in 1981. From the CD liner notes: "The **Wiener Motettenchor** (Motet Choir of Vienna) is an ensemble affiliated with the *Internationale Gesellschaft für Alte Musik* (International Society for Early Music). . . . The choir focuses its musical effort on three periods: the Renaissance, the Baroque, and the Classical period up to Mozart."

Liner notes from Christophorus entrée 0106-2

Note: Text included in this listening example in italics.

:00

Gloria in excelsis Deo — *Glory be to God on high,*
et in terra pax hominibus — *and on earth peace to men*
bonae voluntatis. — *of goodwill.*
Laudamus te. — *We praise Thee.*
Benedicimus te. — *We bless Thee.*
Adoramus te. — *We adore Thee.*
Glorificamus te. — *We glorify Thee.*
Gratias agimus tibi propter — *We give Thee thanks for*
magnam gloriam tuam. — *Thy great glory.*
Domine Deus, Rex caelestis, — *Lord God, heavenly King,*
Deus Pater omnipotens. — *God the Father Almighty.*
Domine Fili — *O Lord, the only-begotten Son*
unigenite, Jesu Christe. — *Jesus Christ.*
Domine Deus, Agnus Dei, — *Lord God, Lamb of God,*
Filius Patris. — *Son of the Father.*

Qui tollis — Thou that takest
peccata mundi, — away the sins of the world,
miserere nobis, — have mercy on us,
Qui tollis peccata mundi, — Thou that takest away the sins
suscipe deprecationem nostram. — of the world, receive our prayer.
Qui sedes ad dexteram Patris, — Thou that sittest at the right hand
miserere nobis. — of the Father, have mercy on us.
Quoniam tu solus sanctus. — For thou along art holy.
Tu solus Dominus. — Thou only art the Lord.
Tu solus Altissimus. — Thou alone art most high.
Jesus Christe, cum Sancto Spiritu — Jesus Christ, along with the Holy Spirit
in gloria Dei Patris. — in the glory of God the Father.
Amen. — Amen.

William Byrd (1543~1623)

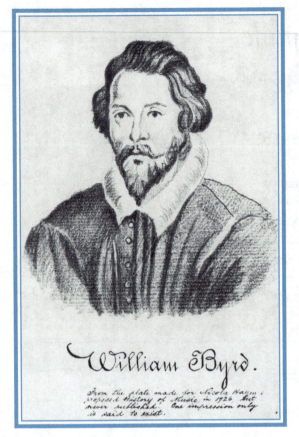

Source:
Courtesy of the Library of Congress.

As with some of the other composers in this chapter, little is known about the early life of English composer William Byrd. Although Byrd was Catholic, he first came to prominence as organist and choirmaster at the Anglican Church in Lincoln in the year 1563. In the early 1570s he moved to London, where he joined the Chapel Royal. As a composer, Byrd led something of a double life. By this time, the Anglican Church was the official Church of England, and the open practice of Catholicism was punishable by fines and even imprisonment. Because of this religious split, Byrd composed a great deal of dramatic music on a large scale for use in the Anglican Church service. In fact, many of his Protestant compositions are still in use today. At the same time, working in semi-secrecy, Byrd composed smaller, intimate vocal works for use in private Catholic services that were being held behind closed doors throughout England. The most famous of these latter works include three small settings of the mass Ordinary, one each for three, four, and five voices. These compositions avoid the use of any *cantus firmus* techniques. They are all very direct, with simple polyphonic sections and even simpler homophonic passages. These works could have easily been sung with one person to a part and are quite beautiful and powerful in their simple expression of faith. In addition, Byrd also composed a series of over 100 sacred motets, which were collected into two books called *Gradualia*. He even went so far as to publish much of this music, and it was only his public notoriety as a composer and performer in the Anglican Church that kept him out of any serious trouble throughout his lifetime. Finally, Byrd also composed many popular secular compositions, the most important of which are his works for solo keyboard instruments. Many of his most famous keyboard pieces were collected in a set titled *My Ladye Nevells Booke*.

Mass for Five Voices

Imagine yourself as a devout Catholic living in England during the late sixteenth and early seventeenth centuries. The practice of your religion has been officially outlawed by the state, forcing you to practice your religion in secret, often holding services behind closed doors in private homes. It was under these circumstances that Byrd composed his three mass settings. The music abandons most of the thick, contrapuntal texture and compositional artifice present in many Renaissance compositions in favor of simpler musical forms. As mentioned above, the music is quite direct and very powerful in its simplicity. The following listening example is the last movement of the mass, the *Agnus Dei*. In this short movement, Byrd uses simple melodic imitation between the individual voices, sections of homophonic composition, and gentle sections of polyphonic writing. Picture yourself sitting around a table quietly singing this mass with one person to a part. In some ways it is ironic that this music, by force of secrecy and perhaps totally unintentionally, responds in many ways to the earlier demands of both Martin Luther *and* the Council of Trent.

Listening Guide

Mass for Five Voices
Agnus Dei
William Byrd (1543-1623)

Format: Five-voice mass
Performance: Parthenia XVI, Mary Jane Newman, conductor
Recording: *William Byrd: The Three Masses for Five, Four, and Three Voices* (Centaur 2471)

Performance Notes: Recorded in March and May, 1999 at Saint Matthew's Episcopal Church, Bedford, New York.

:00	Agnus Dei,	Lamb of God,
	qui tollis peccata mundi	who takest away the sins of the world
	miserere nobis.	have mercy upon us.
	Agnus Dei,	Lamb of God,
	Dona nobis pacem.	Grant us peace.

Giovanni Gabrieli (ca. 1555-1612)

Giovanni Gabrieli followed in the footsteps of his uncle, Andrea Gabrieli, as music master at St. Mark's Cathedral in Venice, one of the greatest musical jobs on the planet at that time. At St. Mark's, a special type of polyphonic composition using multiple choirs of singers and/or instrumentalists had developed that made use of the unique acoustic properties of the Cathedral. The natural time-delayed echo in the Cathedral is just over four seconds. Gabrieli would place two or three separate groups of musicians around the Cathedral performing music in a sort of call and response pattern that surrounded the members of the congregation. This may have been the first "surround sound" experience, over 300 years before such techniques were possible in a movie theatre. Gabrieli was one of the first composers to designate specific instruments in his scores, and he was also the first to place dynamic indications (loud, soft, etc.) in both his scores and the individual musician's parts. Although he only fully embraced major/minor tonality in some of his later works, much of his music contains hints in that progressive direction. Gabrieli composed multiple-

An external view of St. Mark's Cathedral in Venice. A number of the finest composers and musicians worked here throughout the Renaissance and the Baroque era.
© Shutterstock.com

An interior view of St. Mark's Cathedral in Venice. Imagine a choir of musicians on the left and a separate choir on the right as they echo Gabrieli's music back and forth across the hall.
© Shutterstock.com

choir, polyphonic compositions for voices only, instruments only, and incredible mixtures of the two, as you will hear in the listening example below. Over the years, Gabrieli's music has become a favorite of brass players. In its original format, much of his music called for early brass and other wind instruments, and in modern transcriptions, the music lends itself well to performance by mixed choirs of modern brass instruments.

In te Domine speravi (a 8) (In thee, O Lord, do I put my trust)

The following piece is a great example of how Gabrieli composed double choir works for mixed voices and instruments. This particular composition is included in a 1597 collection of published works titled *Sacrae Symphoniae*. Note the interplay between the two individual groups as they pass musical ideas back and forth between one another. Only at several particularly dramatic moments in the entire composition do the two groups unify their musical materials.

Listening Guide

In te Domine speravi (a 8) (In thee, O Lord, do I put my trust)
Giovanni Gabrieli (ca. 1555-1612)

Format: Eight-voice work for double choirs of both voices and instruments
Performance: Currende (choir) and Concerto Palatino (instruments), Erik Van Nevel, conductor
Recording: *Venetian Music for Double Choir* (Accent ACC 93101 D)

Performance Notes: Recorded October 1993 at the Onze-Lieve-Vrouw Presentatie Church, Ghent, Belguim

:00	In te Domine speravi	In thee, O Lord, do I put my trust,
	non confundar in aeternum:	Let me never be ashamed:
	in justitia tua libera me.	Deliver me in thy righteousness.
	Inclina ad me aurem tuam,	Bow down thine ear to me;
	accelera ut eruas me:	Deliver me speedily:
	esto mihi in Deum protecterum,	Be thou my strong rock,
	et in domum refugii,	For an house of defence
	ut salvum facias.	To save me.

Martin Luther (1483-1546)

When Martin Luther nailed his *95 Theses* on the church door in Wittenberg he was looking for a discussion, but what he got instead was a fight that ended with him being excommunicated from the Catholic Church. He continued to preach and teach, inspiring the development of a number of Protestant denominations including the Lutherans. To Luther's way of thinking, music was a gift from God that should play an integral role in people's religious lives. Luther composed simple hymns that were to be sung by the congregation in the local language rather than Latin, which was the official language of the Catholic Church. It is a common misconception, however, to think that Martin Luther wanted to do away with all Latin in his church services. Instead, he intended for German hymns to be added to a modified mass service. Luther's impact on music during the Renaissance was felt throughout Europe, but during the Baroque era that followed, it led to masterpieces of composition by men such as J. S. Bach and George Frideric Handel. The following historic excerpt is taken from Luther's introduction to the *Wittenberg Gesangbuch* (Wittenberg Song Book), which was a collection of hymns, many of which are still in use today.

Martin Luther nails his 95 Theses *to the door of the Wittenberg church.* **Source:** Jupiterimages, Corp.

Wittenberg Gesangbuch by Martin Luther [1524]
Foreword to the first edition

That the singing of spiritual songs is a good thing and one pleasing to God is, I believe, not hidden from any Christian, for not only the example of the prophets and kings in the Old Testament (who praised God with singing and playing, with hymns and the sound of all manner of stringed instruments), but also the special custom of singing psalms, have been known to everyone and to universal Christianity from the beginning. Nay, St. Paul establishes this also, I Corinthians 14, and orders the Colossians to sing psalms and spiritual songs to the Lord in their hearts, in order that God's word and Christ's teaching may be thus spread abroad and practised in every way.

Accordingly, as a good beginning and to encourage those who can do better, I and several others have brought together certain spiritual songs with a view to spreading abroad and setting in motion the holy Gospel which now, by the grace of God, has again emerged, so that we too may pride ourselves, as Moses does in his song, Exodus 15, that Christ is our strength and song and may not know anything to sing or to say, save Jesus Christ our Savior, as Paul says, I Corinthians 2.

These, further, are set for four voices for no other reason than that I wished that the young (who, apart from this, should and must be trained in music and in other proper arts) might have something to rid them of their love ditties and wanton songs and might, instead of these, learn wholesome things

DIG DEEPER

VIDEO
Empires: Martin Luther
(PBS DVD Video)

and thus yield willingly, as becomes them, to the good; also, because I am not of the opinion that all the arts shall be crushed to earth and perish through the Gospel, as some bigoted persons pretend, but would willingly see them all, and especially music, servants of Him who gave and created them. So I pray that every pious Christian may bear with this and, should God grant him an equal or a greater talent, help to further it. Besides, unfortunately, the world is so lax and so forgetful in training and teaching its neglected young people that one might well encourage this first of all. God grant us His grace. Amen.

From *Source Readings in Music History: From Classical Antiquity through the Romantic Era,* translated by Oliver Strunk. Copyright © 1950 by Oliver Strunk, W. W. Norton & Company, Inc.

Secular Music in the Renaissance

Secular music during the Renaissance, as in the Middle Ages, continued to be a less important form of musical composition though its popularity grew steadily throughout the period. With vocal music, secular motets continued to be written, and later in the Renaissance, a new polyphonic format called the *madrigal* became very popular in both Italy and England. Other popular regional vocal styles included the *frottola* and *canzonetta* (Italy), *chanson* (France), *Tenorlied* (Germany), and *consort songs* and *lute songs* or *ayres* (England). It was not uncommon for instrumental ensembles to "borrow" secular polyphonic vocal music for use in performance, and some composers wrote secular music that was intended to include both voices and instruments. Early in the period, purely instrumental music was rarely written down, but with the increased emphasis placed on the publication of sheet music for commercial sale later on, a great deal of instrumental music began to appear.

Flemish tapestry depicting secular musicians in action.
Source: Jupiterimages, Corp.

Keyboard and lute music was especially popular, and the end of the Renaissance also saw the creation of more "consort" music, or music for families of instruments. In addition, there were some publications for "broken consorts," or groups of mixed instruments. Throughout the period, instrumental music for the dance was particularly popular. Dance movements were frequently paired, with slower dances such as the *allemande* or *pavane* being immediately followed by fast ones, such as the *galliard*, *gigue*, or *saltarello*.

Heinrich Isaac (ca. 1450–1517)

Isaac was a Flemish composer, though he spent time as a court musician in both Austria and Italy. His compositional style is frequently compared to that of Josquin. He composed music for use in both the mass Ordinary and Proper, including a number of motets, and he is often credited with joining together elements of the Franco-Flemish styles with German musical forms. Unlike some Italian mass services, in German lands it was quite common to use polyphonic music in the mass Proper, and Isaac was commissioned by Emperor Maximilian I to compose new liturgical settings for this purpose. As a composer of secular music, Isaac created works in the German polyphonic *Tenorlied* style, which places the important musical line in the tenor part. Included in this style is perhaps Isaac's most famous composition, *Innsbruck, ich muss dich lassen* (Innsbruck, I Must Now Leave You).

Emperor Maximilian I.
Source: Jupiterimages, Corp.

Innsbruck, ich muss dich lassen (Innsbruck, I Must Now Leave You)

Believe it or not, Isaac actually composed this work when he was about to leave Innsbruck, a town of which he was apparently quite fond. The melody was later adapted and re-harmonized by J. S. Bach as the hymn *O Welt, ich muss dich lassen* (O World, I Must Now Leave You). In this form, the tune has appeared in a number of different hymnals with several different texts over the past few hundred years.

Early photograph of Innsbruck, Austria, the town Isaac did not want to leave.
© Shutterstock.com

Listening Guide

Innsbruck, ich muss dich lassen (Innsbruck, I Must Now Leave You)
Heinrich Isaac (ca. 1450-1517)

Format: Multiple versions for voices, instruments, voices with instruments, and organ
Performance: Ensemble Hofkapelle, Michael Procter, director
Recording: *Time of the Dawn* (CD sampler of various artists) (Christophorus 77003)

Performance Notes: This particular recording will offer you multiple examples of how vocal and instrumental music might have been performed during the Renaissance. There are schools of thought that say works such as this were only performed *a cappella* while others will tell you that instruments were always used. Recent scholarship seems to be taking more of a practical approach, suggesting that during the Renaissance period musicians usually just made do with what they had. It is true that there was a lot more vocal music written when compared to purely instrumental compositions, but as this recording demonstrates, it was quite common for instruments to simply play the vocal lines, with or without the voices added.

:00 Voices only.

Innsbruck, ich muss dich lassen,
ich fahr dahin mein Strassen,
in fremde Land dahin.
Mein Freud ist mir genommen,
die ich nit weiss bekommen,
wo ich im Elend bin.

Innsbruck, I must leave you
I am going on my way
into a foreign land.
My joy is taken from me,
I know not how to regain it,
while in such misery.

1:01 Same music, instruments only.

1:57 Voices and instruments together.

Gross Leid muss ich jetzt tragen,
das ich allein tu klagen
dem liebsten Buhlen mein.
Ach Lieb, nun lass mich Armen
im Herzen dein erbarmen,
dass ich muss dannen sein.

I must now endure great pain
which I confide only
to my dearest love.
O beloved, find pity
in your heart for me,
that I must part from you.

2:40 Small organ alone plays tune with added embellishments.

3:26 Last time through with a return to voices and instruments doubling all parts.

Mein Trost ob allen Weiben,
dein tu ich ewig bleiben,
stet treu, der Ehren fromm.
Nun muss dich Gott bewahren,
in aller Tugend sparen,
bis dass ich wiederkomm.

My comfort above all other women,
I shall always be yours,
forever faithful in honor true.
May the good Lord protect you
and keep you in your virtue
for me, till I return.

ℑocus on ℑorm
The Madrigal

Throughout the Renaissance a new polyphonic secular vocal form called the *madrigal* was evolving. This format reached its apex in the music of late Renaissance composers in both Italy and England. The style is marked by richly polyphonic music, set with poetry that speaks of love and other popular courtly topics. A compositional technique called **text painting** became quite popular as a means of heightening the dramatic impression of the words through musical "tricks." For example, the words "pain" or "death" would be coupled with harsh, clashing dissonances while the words "love" or "sigh" would feature music that gently rocked back and forth between two pleasant sounding intervals. Text passages such as "up and down" would be set with rapid musical lines that quickly ran up and down the melodic scale.

The first madrigals appeared in Italy in the 1500s. These were mostly poems of love set in a homophonic or simple polyphonic style. Later madrigals set by Palestrina, Marenzio, Gesualdo, and Monteverdi became quite expressive, with a highly developed sense of chromaticism and dramatic text settings. The invention of the printing press made it possible for a collection of Italian madrigals to find their way to England. The collection was titled *Musica Transalpina* (Music Across the Alps), which featured Italian madrigals set with texts that had been translated into English. Under the spell of these Italian madrigals, English composers such as Morley, Tomkins, and Weelkes all began composing original English madrigals. In their hands, the mood of many of these madrigals lightened considerably as both the text and compositional style frequently became more playful and humorous in nature. Finally, as the transition was made into the Baroque era, some composers continued to write madrigals in a polyphonic style while beginning to embrace new harmonic concepts of the period. At the same time, composers such as Monteverdi began to write entirely new vocal compositions for one or two individual voices with instrumental accompaniment. The new style was a total departure musically, but the kinds of poetic texts used remained similar.

text painting

Carlo Gesualdo da Venosa (ca. 1561–1613)

Nobleman and composer Carlo Gesualdo da Venosa is often considered the "bad boy" of the late Renaissance. He had a great passion for music, composing a number of innovative madrigals on topics of love and loss. His reputation stems from an incident in which he caught his wife having an affair with another man. Reports differ as to whether he killed them himself or had someone else do it, but either way they both ended up not alive. As the Prince of Venosa, he, of course, got

away with it, and some seemed to feel he was well within his rights to protect his honor. Gesualdo's madrigals are full of melancholy and are great (though somewhat extreme) examples of the late Italian madrigal. He was a master of text painting techniques, making use of extreme dissonances, chromatic passages, dramatic melodic and harmonic leaps, and other non-conventional techniques whenever he felt it suited the words of the poem he was setting to music. In all, he composed six collected books of madrigals, as well as a handful of sacred compositions.

Che fai meco mio cor (What do you do to me, my heart?)

This work comes from Gesualdo's fourth book of madrigals, which was published in 1596. As you listen, pay close attention to the text and its translation. Be aware of words such as *solo* (alone) and the passage *Amor da due belgli occhi piove* (Love rains down his favors), and notice how he clearly expresses those particular words with specific musical gestures.

Listening Guide

Che fai meco mio cor (What do you do to me, my heart?)
Carlo Gesualdo da Venosa (ca. 1561-1613)

Format: Italian Madrigal
Performance: La Venexiana
Recording: *Il quarto libro di madrigali, 1596 (4th book of madrigals)* (Glossa 920907)

Performance Notes: Recorded March 2000 in Roletto, Italy.

:00	Che fai meco mio cor, misero e solo?	What do you do to me my heart, wretched and alone?
	Deh, vanne omai là dove	Ah, anon to go to where
	sue grazie Amor da due begli occhi piove;	Love rains down his favors from two lovely eyes;
	Apri a la gioia il seno,	Open the heart to joy,
	nè ti doglia il morir se verrai meno,	so that Death not harm you should you swoon,
	poi che non è ch'aspire mortal	for what mortal could wish to
	di girne al Ciel e non morire.	go to Heaven and not to die.

Thomas Morley (1557-1602)
Thomas Weelkes (1556-1623)
Thomas Tomkins (1572-1656)

The "three Toms" all contributed greatly to the growing body of lighter English madrigals that grew quite popular during the last two decades of the Renaissance and the first few years of the Baroque era. Thomas Morley, in particular, is credited with many of the finest compositions in this genre. In general, English madrigals tended to be lighter in both musical tone and poetic substance. They made less use of dissonance as an expressive element and added more "nonsense" syllables such as "fa la la." These simple word patterns would be treated in a polyphonic manner and were used as prominent refrain material in many popular English madrigals.

Thomas Morley published a number of excellent madrigals during his lifetime, as well as some very good instrumental music. He also created teaching materials, including the famous *A Plaine and Easie Introduction to Practicall Musicke*. Thomas Weelkes's madrigals tended to be a bit more serious in nature when compared to the music of Morley, and his works also made more use of text painting. Like Morley, Weelkes excelled at instrumental composition, and he also wrote some very fine sacred works for use in the Anglican Church service. Welsh composer Thomas Tomkins also created a wealth of great sacred music (95 anthems) and some interesting secular instrumental music. As with Morley and Weelkes, however, he is best remembered today for his innovative madrigal compositions, of which you have an example below.

To the Shady Woods

This is a typical polyphonic madrigal in the popular English style. As you listen, notice how the individual musical lines weave in and out of one another. Singers will tell you that these works are as much fun to sing as they are to hear. In fact, madrigal singing, particularly in England, became a very popular form of amateur music making during this time. Regarding the use of the nonsense syllables "fa la la," conductor János Dobra suggests: "[Tomkins's] lyrics are about not only the customary stories of life and Love; they will also convey to the listener some intrinsic philosophical message, with the purpose of education many times not hidden. His 'Fa la las' will provide vast opportunity for the readers and listeners to complete an idea with any self-favoured interpretation personally worked out."[6] The work is composed in two sections, with each section being repeated and both sections ending with polyphonic "fa la las."

As printed music became more accessible during the late Renaissance, amateur music-making continued to grow in popularity. This is the cover page from an English collection published during the early days of the Baroque era.
Source: Jupiterimages, Corp.

Listening Guide

To the Shady Woods
Thomas Tomkins (1572-1656)

Format: English Madrigal
Performance: Budapest Tomkins Vocal Ensemble, János Dobra, director
Recording: *Thomas Tomkins: Songs of 4, 5, & 6 Parts (1622)* (Hungaroton Classic 31514)

Performance Notes: Recorded October 1992 at the Hungarian Radio Studio No. 22.

:00	To the shady woods now wend we And there the mid-day spend we. Fa la la …
:36	There Phoebus' self is colder, and we may be the bolder. Fa la la …

Endnotes

1. Donald Jay Grout and Claude V. Palisca, *A History of Western Music*, 6th ed. (New York: W. W. Norton, 2001), 150.

2. Clytus Gottwald, *Musica mensurablus I*, Schola Cantorum Stuttgart, compact disc liner notes, Bayer Records BR 100 271.

3. K. Marie Stolba, *The Development of Western Music: A History,* 3rd ed. (Boston: McGraw-Hill, 1998), 204-205.

4. Lodovico Cresollio (1629), in *Music in the Western World: A History in Documents,* eds. Piero Weiss and Richard Taruskin (New York: Schirmer Books, 1984), 141.

5. Giuseppe Baini (1828), in *Music in the Western World: A History in Documents,* eds. Piero Weiss and Richard Taruskin (New York: Schirmer Books, 1984), 142.

6. János Dobra, *Thomas Tomkins: Songs of 4, 5, & 6 Parts,* Tomkins Vocal Ensemble, compact disc liner notes, Hungaroton Classic CD 31514.

Study Guide

Chapter 3 Review Questions

True or False

___ 1. William Byrd composed a series of over 100 sacred motets.

___ 2. Giovanni Gabrieli composed little or no polyphonic music.

___ 3. Josquin Des Prez composed the secular song *Innsbruck, ich muss dich lassen.*

___ 4. In 1501, a man named Ottaviano Petrucci began printing music.

___ 5. Martin Luther led a religious movement during the Renaissance that came to be called the Protestant Reformation.

___ 6. Johannas Ockeghem was a student of J. S. Bach.

___ 7. Many of Palestrina's masses are said to be parody masses.

___ 8. Palestrina frequently made use of secular material in his sacred compositions.

___ 9. Most of Dufay's secular works were for three independent voices singing poetry written in French.

___10. William Byrd composed smaller intimate vocal works for use in private Catholic services in England.

Multiple Choice

11. A collection of madrigals that featured Italian works set with texts that had been translated into English.
 a. Musica Transenglandia
 b. Musica Transalpina
 c. Musica Transeuropa
 d. Musica Elvisonia

12. Church governing council that considered banning polyphonic music from the mass.
 a. The Council of Trent
 b. The Council of Palestrina
 c. The Council of Paris
 d. The Council of Rome

13. Composed 104 masses, 375 motets, large cycles of hymns and offertories, 35 Magnificats, and more than 140 madrigals.
 a. Josquin Des Prez
 b. William Byrd
 c. Guillaume Dufay
 d. Giovanni Palestrina

14. Catholic composer who wrote music for the Anglican Church.
 a. Josquin Des Prez
 b. William Byrd
 c. Guillaume Dufay
 d. Giovanni Palestrina

15. Over the years, Gabrieli's music has become a favorite of:
 a. brass players.
 b. percussionists.
 c. jazz bands.
 d. none of the above.

Fill in the Blank

16. In the madrigal, a compositional technique called _____ became quite popular as a means of heightening the dramatic impression of the words through musical "tricks."

17. The term _____ refers to a rebirth of interest in Greek and Roman antiquity.

18. Palestrina's _____ mass was (incorrectly) said to have single-handedly saved polyphonic church music during the Renaissance.

19. Burgundian master _____ may be viewed as a transitional composer.

20. _____ worship, or worship of the Virgin Mary, was quite popular during the Renaissance.

21. William Byrd composed a series of over 100 sacred motets, which were collected into two books called _____.

22. Italian madrigal composer _____ was a master of text painting techniques, making use of extreme dissonances, chromatic passages, dramatic melodic and harmonic leaps, and other non-conventional techniques.

Short Answer

23. List three important compositions by Johannas Ockeghem.

24. Other than the madrigal, list four secular vocal styles popular during the Renaissance.

25. Name three popular English composers of the madrigal.

Essay Questions

1. Discuss the life of composer William Byrd. How do you think his religious convictions influenced his compositional output?

2. Discuss the evolution of the mass during the Renaissance.

Chapter 4

The Baroque Era

"The aim and final end of all music should be none other than the glory of God and the refreshment of the soul."

J. S. Bach

It has been said that for every successful revolution there must be an eventual evolution that incorporates elements of both the old and new styles.[1] That statement certainly applies to much of the music written during the Baroque era. Around 1600, most composers adopted a new system of harmonic organization, built on major and minor scale patterns to the exclusion of the rest of the older "church" modes. Of course, as you saw in Chapter 3, this was something of a gradual process, as composers for the past 100 years had been hinting more and more at tonic/dominant axis harmony. Beyond harmony issues, many composers, particularly the Italians, began to alter the basic texture of music, and these texture and harmony changes together led to the development of a new style of accompaniment called *basso continuo*. For the first time in music, there was a wide divergence in compositional styles. Due to religious conflicts (Catholics vs. Protestants) that eventually led to the Thirty Years War, composers in northern and central Europe continued to write in the older polyphonic styles of the Renaissance. In particular, there was an expanded focus on polyphonic vocal music for the Protestant church, but most composers did embrace the new harmonic ideas of the Baroque era. Meanwhile, the Italians were busy developing a thinly textured style called *monody* (one song) that made use of one clear melodic idea supported by a simple accompaniment called *basso continuo* (continuous bass). The older, polyphonic styles were referred to as *prima pratica* or *stile antico*, while the more modern styles were called *seconda pratica* or *stile moderno*. As music during the Baroque era continued to evolve, transitional composers such as Claudio Monteverdi and later masters including J. S. Bach and George Frideric Handel moved freely between these two styles.

Purely instrumental music became much more important during the Baroque era. Instrumental techniques (as well as the instruments themselves) were improving

Example of Baroque architecture. The intricate scrollwork found in Baroque architecture would eventually be expressed musically in the complex counterpoint of composers such as J. S. Bach. This image is actually from Linderhof Castle in Bavaria and is a nineteenth-century copy of the Baroque style. **Source:** Jupiterimages, Corp.

quickly, and composers wrote a great deal of music for use in both court performances and church services. Amateur music making was on the rise, and playing instrumental music was viewed as an enjoyable pastime in many wealthy and aristocratic households. In addition to music designed purely for performance, composers such as J. S. Bach created a wealth of music to be used for instruction as well. Vocal music also continued to be very popular, playing a major role in all church services and many secular court functions. For court entertainment (and later for public consumption), a new style of drama set to music called opera became the popular style of entertainment in many of the great European palaces. For the Catholic church, composers continued to write new settings of the five sections of the mass Ordinary, while J. S. Bach composed hundreds of cantatas for use in the Protestant church. Meanwhile, Handel began writing large oratorios for vocal soloists, chorus, and orchestra, which were somewhat similar to his operas but based on sacred topics and performed without most of the dramatic trappings found in a typical Baroque opera.

Giulio Caccini (ca. 1545–1618)

Caccini was a member of the *Florentine Camerata*, which was an informal group of writers, artists, philosophers, and musicians that met in the home of Count Giovanni de' Bardi. Other members of this group included humanist Girolamo Mei, Vincenzo Galilei (Galileo's father), and Jacopo Peri. Mei in particular had done research into how the ancient Greeks might have used music in their dramas. In an attempt to revive this style of setting drama to music, the members of the Camerata basically created the first operas. Oddly enough, it turns out that history has proven the Camerata incorrect regarding their theories about the Greeks, but the happy mistake has become one of the most dominant formats for music performance from then until now. Caccini is normally credited with the creation of **monody**, which is best defined as a single melody over a simple accompaniment. Without the dense polyphonic melodies common in the Renaissance, the text of a song could now be clearly understood, thus making it possible to set drama to music. The accompaniment developed for this new style is usually referred to as ***basso continuo***. Originally, the *continuo* would have been one instrument such as a harpsichord or a lute, but it quickly evolved into a two-instrument ensemble that most frequently featured a harpsichord and some sort of bass instrument. For many sacred works, the continuo instrument would be the pipe organ, on which a performer had the ability to play chords with their hands on the main keyboards while their feet played the bass line on a pedal keyboard. With the adoption of the major/minor tonal system, a style of musical shorthand quickly developed called **figured bass**. In this system, the bass

monody

basso continuo

figured bass

recitative

line would be written out along with numbers and musical symbols to indicate what notes the harpsichord was to play above the bass. The actual accompaniment would be improvised, or *realized*, during the performance according to the standard musical styles of the day. Caccini also takes credit for developing a style of singing referred to as *stile rappresentativo*, which, particularly in opera, turned into **recitative**, a singing pattern closer to speech that allowed the drama to unfold at a much faster pace. In 1601, Caccini published a collection of songs titled *La Nuove musiche* (The New Music). The following article is an excerpt from the introduction Caccini wrote for the collection.

The Birth of New Music by Caccini

In the days when the most excellent Camerata of the Very Illustrious Mr. Giovanni Bardi, Count of Vernio, was thriving in Florence, where not only much of the nobility but also the city's first musicians, intellects, poets, and philosophers met together, I can state, having frequented it myself, that I learned more from their savant speeches than I had in over thirty years' study of counterpoint. For those most knowledgeable gentlemen were always urging me, and with the clearest arguments persuading me, not to prize the sort of music which, by not letting the words be properly understood, spoiled both the sense and the verse, now lengthening, now shortening syllables to suit the counterpoint (that mangler of poetry), but rather to adhere to the manner so much praised by Plato and other philosophers, according to whom music consists of speech, rhythm, and, last, sound—not the contrary. They further urged me to aspire that it might penetrate the minds of others, working those wonders so admired by the ancient writers, which counterpoint, in modern compositions, rendered impossible: and especially so when singers sang alone to a stringed instrument, and the words could not be understood for the profusion of embellishments on both short and long syllables, and in any sort of music whatever, provided by this means the multitude exalted them and cried them up for worthy songsters. Having, I say, observed that such music and musicians afforded no other pleasure than that which the harmony might impart to the sole sense of hearing (the intellect being unaffected so long as the words were incomprehensible), it occurred to me to introduce a

View of Florence from the home of Count Bardi.
Source: Jupiterimages, Corp.

sort of music in which one might, so to say, speak musically, making use (as I have said elsewhere) of a certain noble negligence in the singing, passing occasionally through a dissonance, the bass staying firm, and the middle parts reduced to instrumental harmony that expressed some affection, for otherwise they are useless. Wherefore, having made a beginning with songs for one voice alone, since it seemed to me they had more power to delight and move than songs for several voices together, I composed in those days certain madrigals and, in particular, an aria in the very style which was to serve me later for the stories put on stage with singing in Florence (i.e., the first operas). These madrigals and this aria, having been heard by the Camerata with loving applause and with exhortations to me that I pursue my goal by that path, prompted me to go to Rome so that they might be sampled there too. There I performed the madrigals and aria at Mr. Nero Neri's house in the presence of many gentlemen who frequented it, and all can testify how much they urged me to continue my undertaking, saying that they had never before heard music sung by a single voice to a mere stringed instrument that had as much power to move the soul's affections as did those madrigals, both because of their novel style and because, it being then the fashion to sing many-voiced madrigals with a single voice, it seemed to them that a soprano thus singled out from the other parts was wholly devoid of any affection, the parts having been designed to act upon each other reciprocally. Returning to Florence, and seeing that in those days, too, musicians were accustomed to certain little songs (set for the most part to vile words) which I felt were improper and not relished by connoisseurs, it occurred to me, in order occasionally to lift men's drooping spirits, to compose some little songs by way of airs, to be used with consorts of strings; and having imparted this thought to many gentlemen of the city, I was obligingly favored by them with many rhymes in a variety of meters, all of which I set to different airs from time to time, and they have proved welcome enough to all of Italy, their style having now been found serviceable by anyone wishing to compose for a single voice, particularly here in Florence.

It should be observed that passages (of embellishment) were not invented because they were necessary to the right way of singing, but rather, I think, for a certain titillation they afford the ears of those who do not know what it is to sing with affection; for were this understood, then passages would no doubt be abhorred, since nothing can be more contrary to producing a good effect.

From *Le Origini del melodramma: testimonianze dei contemporanei, Turin: Fratelli Bocca*, 1903. translated by P.W.

Ave Maria

The following musical selection is an interesting example of hoaxes in the world of music and the power of the printed word on CD liner notes, program notes, and the Internet. The following *Ave Maria* was most likely first attributed to Baroque composer Giulio Caccini sometime in the late 1980s or early 1990s. It was actually written in the early 1970s by Russian composer Vladimir Vavilov, who was known for creating new works in an older style and attributing them to an

earlier composer or simply to "Anonymous." Vavilov labeled this *Ave Maria* composition as being written by "Anonymous," but at some point another performer credited Caccini with the composition. The work was recorded several times and became quite popular in the world of classical music. Within a few years, it had been recorded by the likes of Inessa Galante, Lesley Garrett, Charlotte Church, Andrea Bocelli, and cellist Julian Lloyd Webber, among many others. After the first published attribution to Caccini, everyone else simply took the composition as an authentic early Baroque masterpiece.[2]

As the author of this text, I will admit that I was also taken in by the deception when I used it in the first edition of this book. In this new edition of the text, I have elected to keep this example in the book and on the accompanying recordings for two simple reasons—almost everyone really loves this piece, and it is still a solid example of early Baroque monody. It was just written a few hundred years too late! This is a fairly straightforward version of what Caccini and the other composers of the Florentine Camerata intended, and it offers a good example of the clarity of text with monody as compared to the polyphonic styles of the Renaissance. For a quick comparison of styles, listen back and forth a few times between Josquin's motet version of *Ave Maria* found in Chapter 3 and this example. Baroque composers often wrote simple melodic lines, all the while expecting performers to add their own embellishments or, less commonly, adding their own in the manuscript (as Caccini liked to do). Notice how a few simple groups of extra notes added later in the following performance enhance the composer's original melody.

Listening Guide

Ave Maria
Vladimar Vavilov (1925-1973)

Attributed to Anonymous and Giulio Caccini (ca. 1545-1618)
Format: Aria
Performance: Elżbieta Towarnicka, Soprano; Marek Stefański, organ
Recording: *Ave Maria: w Bazylice Mariackiej w Krakowie* (DUX 0196)

Performance Notes: Recorded June 2000 at St. Mary's Basilica in Cracow, Poland.

:00	Rather than set the entire *Ave Maria* text, the composer simply focuses on the first two words. The direct translation of *"Ave Maria"* is "Hail, Mary." The melody is in two parts (8 bars each), and the entire structure is performed twice through. In between the two full melodic statements there is a 4-bar instrumental interlude.
1:17	Instrumental interlude.
1:36	Second melodic statement. Text remains the same.

Focus on Form

Opera

In the movie *Pretty Woman,* when Richard Gere takes Julia Roberts out for their big night on the town, it is a Romantic period opera by Verdi, *La traviata,* they attend. She asks, "You said this is in Italian, so how am I gonna know what they're saying?" He replies, "You'll know, believe me, you'll understand—the music is very powerful. Peoples' reactions to opera the first time they see it, it's very dramatic . . . they either love it or they hate it. If they love it, they will always love it. If they don't, then they may learn to appreciate it, but it will never become part of their soul."[3] Opera truly is a unique art form, combining music with drama in a way never seen before the dawn of the Baroque era in music.

As you read previously, the first real operas were created by the Florentine Camerata in an attempt to recreate ancient Greek dramas set to music. Along the way, the Camerata developed a musical texture called *monody,* which abandoned the polyphonic styles of the Renaissance in favor of a clear, melodic vocal line with a simple accompaniment. The **aria** became the popular solo vocal style, of which there are several different types including *da capo* (ABA) and *strophic* (same melody over and over). Composers wrote some of their most dramatic music in these solo aria sections, and a great singer could stop the show cold. As operatic styles progressed, popular singers would sometimes go so far as to substitute one of their favorite arias from another opera because they could sing it more dramatically. The fact that the audience rarely noticed speaks to the thinness of some of these early opera plots. Composers also developed a technique called **recitative**, which is close to normal patterns of speech, thus allowing the singers to deliver the dramatic text quickly in order to keep the story moving along. Eventually, two types of recitative were created: *secco* (dry), with a very basic accompaniment usually played on the harpsichord, and *accompangnato* (accompanied), in which the singer still had a lot of words but the composer wrote out a more elaborate accompaniment for the orchestra.

The Italians created both dramatic and comic opera styles. Later, the French borrowed some operatic concepts from the Italians but developed their own unique styles of opera, which often incorporated ballet scenes along with all of the other spectacles of opera. Most German composers copied both the style and language of the Italians, though eventually there were some operas with both spoken dialogue and music sung in German called *Singspiele* (song plays). Plots for these early operas were based on well-known figures from history or on stories drawn from mythology. Storylines could be quite complex (though they didn't always make a lot of sense), and most of the characters were usually very two-dimensional, that is, really good or really bad. Stage designs frequently included huge mechanical devices to add more "spectacle" to the proceedings.

Of particular interest was the growth in popularity, especially in Italy, of the use of *castrato* singers as the heroic male operatic leads. Young boys who displayed a gift for music and (hopefully) had a beautiful soprano or alto voice would be castrated before they reached puberty and their voices changed. This process led to the development of a high-pitched voice in the normal range of a female singer, coupled with the power and endurance of an adult male. The most famous castrato singers became international celebrities and, oddly enough, the occasional objects of

aria

recitative

female sexual desire. The practice was always controversial, as British historian Charles Burney discovered when he visited Italy during the Baroque era.

> I enquired throughout Italy at what places boys were chiefly qualified for singing by castration, but could get no certain intelligence. I was told at Milan that it 00000was at Venice; at Venice, that it was at Bologna, but at Bologna the fact was denied, and I was referred to Florence; from Florence to Rome, and from Rome I was sent to Naples. The operation most certainly is against (the) law in all these places, as well as against nature; and all the Italians are so much ashamed of it, that in every province they transfer it to some other.[4]

The bottom line is, someone was doing it. Great castrato singers were available, and composers wrote a wealth of opera roles for them throughout the Baroque era. Today these roles are performed by women or by male counter-tenors who have trained their naturally high voices to sing in falsetto, meaning they are simply forcing their voices into a woman's normal vocal range.

With the exception of the castrato singers, most of the conventions developed for opera during the Baroque era continue to be used in one form or another even today. As you will learn in subsequent chapters of this book, opera undergoes numerous changes and alterations during the next four centuries. Nonetheless, the basic concept of drama set to music will continue to be around for many years to come.

DIG DEEPER

MOVIE
Farinelli

WEBSITES
www.metoperafamily.org;
http://opera.stanford.edu

BOOKS
Who's Afraid of Opera by Michael Walsh;
Opera For Dummies by David Pogue

Claudio Monteverdi (1567-1643)

Monteverdi's compositions bridge the Renaissance and Baroque periods in music. His early works are polyphonic and are built on modal harmonic patterns, whereas his later compositions are based on monody, with *basso continuo* accompaniments using major/minor harmonic patterns. Today he is best remembered for his nine books of madrigals and his works for the operatic stage. His first five books of madrigals are in the Renaissance style of unaccompanied vocal polyphony (usually five voices), but a few songs in book five begin making use of *basso continuo* accompaniment. From book six forward Monteverdi makes more use of monody, composing mostly solos and duets with clear melodies and simple accompaniments. Monteverdi composed a number of ballets and operas though many of the scores to these works are now lost. His two most famous operas still in existence are *L'Orfeo* and *L'incoronazione di Poppea* (The Coronation of Poppea). Building on the traditions of the Florentine Camerata, Monterverdi increased the size of the orchestra and added some polyphony back to his music. The text is still quite clear, but for modern ears, the music seems to hold more interest. In modernized versions, both of these operas are still performed from time to time. In addition, several modern composers have created performing versions of another Monteverdi opera titled *Il ritorno d'Ulisse in patria* (Ulysses's Return to his Native Land). *Ulysses* is somewhat interesting in that Monteverdi does away with some of the already established norms of aria and recitative in favor of a more continuous drama.

Si dolce è 'l tormento (So Sweet the Torment)

This aria example demonstrates Monteverdi's adaptation to the principles of monody at the beginning of the Baroque era. This particular solo aria comes from a collection of solos and duets Monteverdi published in 1632 titled *Scherzi musicali*.

strophic

This aria is composed in a format referred to as **strophic**, meaning that the same melody keeps repeating over and over. There are four verses, all of which use exactly the same melody, each with new text.

Listening Guide

Si dolce è 'l tormento (So Sweet the Torment)
Claudio Monteverdi (1567-1643)

Format: Strophic Aria
Performance: Ilaria Geroldi, Soprano
Recording: *Monteverdi: motetti e madrigali a 2 soprani* (Christophorus 77189)

Performance Notes: Recorded June 10-12, 1993 in Cremona, Italy.

:00 Verse One	
Sì dolce è 'l tormento che in seno mi sta	So sweet the torment in my breast,
ch'io vivo contento per cruda beltà.	that I am joyful despite my cruel lovely one.
Nel ciel di bellezza s'accreschi fierezza	In the heaven of beauty pride may wax
et manchi pietà, che sempre quel scoglio	and pity be lacking; this cliff - for ever
all'onda d'orgoglio mia fede sarà.	lashed by breakers of pride - shall remain my assurance.
:29 Verse Two	
La speme fallace rivolgami il piè,	Vain hope has turned her back on me,
diletto nè pace non scendano a me.	so neither joy nor peace may enter me.
E l'empia ch'adoro mi nieghi ristoro	And she, perfidious one whom I love, in recompense denies me
di buona mercè. Tra doglia infinita	all comfort; twixt constant pangs
tra speme tradita vivrà la mia fè.	of hope betrayed, persists my faith.
:57 Verse Three (Note: the "bump" in the sound at this point is actually a bad edit on the original source recording.)	
Per foco e per gelo riposo non ho,	Nor in fire nor in ice can rest I find,
nel porto del cielo riposo haverò.	in the haven of heaven I shall at last find peace.
Se colpo mortale con rigido strale	And though the fatal thrust with unyielding arrow
il cor m'impiagò cangiando mia sorte,	may pierce my heart and change my fate,
col dardo di morte il cor sanerò.	I will heal my heart with the love-dart of death.
1:26 Verse Four	
Se fiamma d'amore già mai non sentì	That hard heart has never felt the flame of love
quel rigido core ch'il cor mi rapì.	which robbed me of mine.
Se nega pietate la cruda beltate	If pity's withheld by my hard-hearted beauty,
che l'alma invaghì, ben fia che dolente	who entrances my soul, it shall serve me right when, suffering,
pentita e languente sospirmi un dì.	and with remorse and waning strength I do some day perish.

Henry Purcell (1659-1695)

Henry Purcell is frequently referred to as the last great English composer until the twentieth century, and his opera *Dido and Aeneas* is considered the first great opera written in the English language. Purcell's father was one of the King's musicians, and young Henry quickly entered the family business. By the age of 18 he was tuning the organ at Westminster Abbey, and a few years later he replaced John Blow (yes, that was really his name) as organist at Westminster. Purcell wrote instrumental music for the King's Violins (a small string orchestra), keyboard music for both harpsichord and organ, and sacred music for the church. Among his other compositional gifts, Purcell was a master at writing music over a ground bass, which is a simple repeated pattern over which the rest of the work is created. The aria *When I am Laid in Earth* found in the following listening guide is a very famous example of a song composed upon a ground bass.

Dido and Aeneas

Purcell based his opera on a portion of the old Roman epic tale *Aeneid* by Virgil. Your listening selection comes from late in the opera where the Carthagenian Queen, Dido, must release her true love, Aeneas, so that he may travel to Italy. The gods have decreed that Aeneas is to be the founder of Rome. She would rather die than live without him, and in this aria she prepares to meet her fate. The recitative here is pretty straightforward, with the accompaniment growing more active throughout. As mentioned above, this aria is composed above a ground bass. Count the first ten notes you hear at the start of the aria. This is the ground bass pattern. Notice also that it descends in a chromatic pattern, which was often used as a symbol of grief in music of the Baroque period. You will hear this pattern ten more times as the aria progresses.

Baroque era tapestry depicting Dido and Aeneas.
Source: Jupiterimages, Corp.

Listening Guide

Dido and Aeneas
Act III—*Thy Hand, Belinda/When I am Laid in Earth*
Henry Purcell (1659-1695)

Format: Recitative, followed by an aria over ground bass
Performance: Le Concert Spirituel, Laura Pudwell, mezzo-soprano
Recording: *Purcell: Dido & Aeneas* (Glossa 921601)

Performance Notes: Recorded May 2000 in Paris, France. Le Concert Spirituel is an authentic performance practice group based in France. They perform on original or reproduction seventeenth- and eighteenth-century instruments tuned to the lower pitch used during the Baroque period. While some modern singers find low-pitched recordings like this one a bit unnerving, they offer our ears a very different view of how this music should be sung. Because the voice parts are lower in a given singer's range, the parts can sound more "earthy" and direct.

Accompanied Recitative

:00 Thy hand, Belinda, darkness shades me,
 On thy bosom let me rest.
 More I would, but death invades me.
 Death is now a welcome guest.

Aria

:37 Ground bass functions as introduction to the aria. Ten notes total, with the voice entering simultaneously over note number ten of the first ground bass statement.

:49 When I am laid in earth, may my wrongs create
 No trouble in thy breast,
 Remember me, but ah! forget my fate.

2:58 Coda. Orchestra only.

Focus on Form
Instrumental Music

Original compositions for instrumental forces became very popular during the Baroque period. Unlike the Renaissance, a time when instrumental music was usually something of an afterthought, instrumental music in the Baroque period became a very popular form of entertainment in homes, concert halls, and even in many churches. Again, unlike the Renaissance, Baroque composers usually specified which instruments were to be played, though in some instances instrumental forces did remain somewhat interchangeable. For example, most keyboard works could be played on harpsichord, clavichord (a much smaller instrument), or pipe organ. With instrumental forces, it was very popular to compose for one or two violins with continuo accompaniment; however, again, flutes or oboes could sometimes be substituted for the violins. Early versions of the cello, string bass, and bassoon could substitute for one another in both solo works and works where their job was to provide the bass line in a continuo ensemble.

For keyboard instruments, there were a number of popular single-movement formats including sonata (sound piece), toccata (touch piece), prelude, fugue, ricercar, and fantasia. To make things more confusing, the term *sonata* could also indicate a multi-section or multi-movement work for solo keyboard or instrumental ensemble. One of the most popular instrumental formats during the Baroque era was the **Trio Sonata**, which generally consisted of two violins with continuo accompaniment. Two important terms to be familiar with are **Sonata da Chiesa** (church sonata) and **Sonata da Camera** (chamber sonata). Whether they use these titles or not, most multi-movement instrumental works composed in the Baroque era adhere to one of these two formats. Most of the "church" sonatas featured alternating slow and fast movements, several of which usually had some contrapuntal writing. "Chamber" sonatas most commonly had some sort of generic introductory movement followed by a series of dance movements. Be clear on the fact that while rhythms and formal structures were "borrowed" from older styles of dance music, this was music for listening, not for dancing. A few common dance movement styles included *allemande, courante, sarabande, gigue, minuet, gavotte, bourrée* and *passepied*.

Two other popular instrumental formats during the Baroque era were the solo concerto and the concerto grosso. The **solo concerto** was usually a three-movement work (fast-slow-fast) for one solo instrument, such as violin, flute, or oboe, with an orchestral accompaniment. By modern standards, Baroque orchestras were quite small, and today are usually referred to as chamber orchestras. The **concerto grosso** was similar, but it pitted a small group of instruments (the *concertino*) against the full orchestra (the *tutti* or *ripieno*). Generally, the small group of soloists also played along during the tutti orchestral sections. With just a few exceptions, the concerto grosso fell out of favor after the Baroque era.

Trio Sonata

Sonata da Chiesa

Sonata da Camera

solo concerto

concerto grosso

Arcangelo Corelli (1653~1713)
Allessandro Scarlatti (1660~1725)
Domenico Scarlatti (1685~1757)

All totaled, these three prolific Italian composers turned out thousands of compositions for both instrumental and vocal forces. Arcangelo Corelli's strengths were in performing and composing for the violin. In fact, he is frequently referred to as the father of modern violin technique. Among other innovations, he developed new techniques for playing double stops (more than one note at once) and other bowing techniques designed for improved virtuosity. His most famous works include several sets of trio sonatas, written for two violins and continuo accompaniment, and a set of 12 *Concerti grossi* for two violins and cello with chamber orchestra. Allessandro Scarlatti divided his compositional life between Naples and Rome, moving back and forth between the two cities several times during his career. He was an extremely prolific vocal composer, writing well over 100 operas, 20 oratorios, a large number of masses and motets, and at least 600 solo vocal works with continuo he called cantatas. Of particular note in his operas was his use of the **Italian Overture**, used to introduce his productions. These overtures followed a three-section pattern of fast-slow-fast, which laid the groundwork for the development of the multi-movement sonata cycle popular in almost all instrumental forms of the Classical era.

Italian Overture

Arcangelo Corelli.
Source: © 2009
Jupiterimages, Corp.

Allessandro also composed for purely instrumental forces, including a number of chamber concertos and a wide array of keyboard works. As a keyboard composer, however, he can't hold a candle to his son, Domenico, who wrote over 550 single-movement sonatas for harpsichord. Many of these works were designed as teaching pieces, and although Domenico labeled them *Essercizi (Exercises)*, don't be fooled by the title: these works are very appropriate for the concert stage. Several historians later tried to catalog Domenico's keyboard works, and some of the individual movements were grouped into pairs. It is not unusual in concert today to hear a solo pianist play an even larger group of these single-movement pieces as a set. These works broke new ground in keyboard performance techniques with more complex embellishments, rapid repetitions of notes, and frequent crossing of the right and left hand (which doesn't sound all that hard but really is). Taken together, these three composers will offer even the casual listener a solid introduction to Italian Baroque musical styles.

Domenico Scarlatti.
Source: © 2009 Jupiterimages, Corp.

Jean-Baptiste Lully (1632–1687)
François Couperin (1668–1733)
Elisabeth Jacquet de la Guerre (ca. 1666–1729)

One of France's most famous Baroque composers, Jean-Baptiste Lully, was actually Italian (his real name was Giovanni Battista Lulli), but he changed his name to better suit French tastes. Perhaps most famously, Lully has the unfortunate honor of being the first orchestral conductor to accidentally kill himself with his baton.

Back in those days, conductors helped the orchestra keep time by banging a big walking stick (or *bâton* in French) on the floor. One day Lully missed the floor and hit his foot instead. He contracted blood poisoning and died a few days later. Prior to his untimely death, Lully excelled in the composition of music for the stage. He wrote works for the ballet, and he also composed a number of successful operas. His early compositional style was Italian in nature, but his later works embraced the lighter French styles popular during the Baroque period. Lully is credited with establishing a true French operatic style with shorter arias and more crowd scenes that involved processions, dances, or staged battles.

Jean-Baptiste Lully.
Source: © 2009 Jupiterimages, Corp.

French Overture

Both his ballet and opera scores made use of the **French Overture**, which is something of a mirror to the Italian Overture in that the section tempos are slow, fast, slow.

François Couperin (sometimes referred to as *Le Grand* to distinguish him from other family members who were also composers) was a fan of both the French and Italian styles of composition, and many of his works bring together musical elements of the two. He composed a number of trio sonatas for two violins and continuo, as well as several volumes of works for harpsichord titled *Pièces de Clavecin*. Couperin made use of the **French Suite** format in some of his works, composing an overture for the first movement followed by a number of individual dance movements, which might include styles such as the *allemande, courante, sarabande, gigue*, or several other popular dance rhythms. Remember, however, that these were compositions for listening, not for dancing. They simply borrowed the rhythm of the dance as a basis for composition.

French Suite

François Couperin.
Source: © 2009
Jupiterimages, Corp.

As with Couperin, Elisabeth Jacquet de la Guerre is best remembered today for her keyboard compositions (mostly French suites), but she also composed at least one opera, three volumes of cantatas, and a variety of instrumental pieces. In her day, she was widely regarded as one of the finest keyboard players in all of France, and if the difficulty of her compositions is any indication, she did possess amazing technique. Historians today are particularly interested in the fact that she was a woman in what was a totally male-dominated profession, but her works stand the test of time regardless of gender. As with the three Italian composers grouped together in the previous section, the music of these three composers will offer even the casual listener a good view into the world of French Baroque music.

Heinrich Schütz (1585-1672)
Georg Phillipp Telemann (1681-1767)

German composer Henrich Schütz is best remembered today for his polyphonic vocal music. He studied with Giovanni Gabrieli, embracing the polyphonic styles of the old master but moving forward to the modern system of major/minor tonality in most of his compositions. It has been suggested that Schütz may have written the first German opera, *Dafne*, but no such score currently exists. Most of Schütz's music available today displays his gifts as a composer of sacred, multi-voiced, and often multi-choir compositions. His numerous works include pieces for a cappella choir, as well as compositions for both vocal and instrumental forces. Some of his most important compositions come from a series of pieces

he labeled *Symphoniae sacrae* (Sacred Symphonies). The earliest of these compositions were for trio sonata and choir, and many of his later works added more instruments to the accompaniment. Finally, Schütz also created two well-known oratorios, *The Seven Last Words of Christ* and a work originally titled *Die Historia von der freuden und gnadenreichen Geburth Gottes und Marien Sohnes, Jesu Christi* (Story of the Birth of God's and Mary's Son, Jesus Christ) but universally known as the *Christmas Oratorio.*

During his lifetime, Georg Phillipp Telemann was considerably more famous than J. S. Bach both in Germany and throughout much of Europe. He was also more prolific (though one can argue that he kept writing the same basic composition over and over and over), composing more than 4,000 works that we know about. Like Bach, Telemann's music represents the culmination of the late Baroque style, but some of Telemann's compositions actually go even farther, embracing elements of the pre-Classical styles that will lead us to the music of Haydn and Mozart. During his long career as a musician, composer, and teacher, he worked in Leipzig, Sorau (Poland), Eisenach, Frankfurt, and Hamburg. Telemann's compositional output contains important works in almost every genre, including more than 1,100 sacred cantatas, 56 secular cantatas (and bits and pieces of many more), seven complete operas, oratorios, passions, keyboard music, and a wealth of instru-

Heinrich Schütz.
Source: © 2009 Jupiterimages, Corp.

Georg Phillipp Telemann.
Source: © 2009 Jupiterimages, Corp.

mental music including over 600 Italian Overtures, solo concertos, *concerti grossi*, suites, trio sonatas, and a series of lighter works he called *Tafelmusik* (Table Music).

Johann Sebastian Bach (1685–1750)

J. S. Bach lived and worked during the second half of the Baroque era, and today he is generally considered to have been the period's greatest composer. During his day, however, Bach was best known for his ability to improvise on keyboard instruments, particularly the pipe organ. His compositions were frequently performed but

sparsely published during the Baroque era, and his music was not widely known outside the circle of his current employment. At the time, both Handel and Telemann were considerably more famous. Bach came from a long line of musicians, and several of his sons were famous composers well into the Classical period. J. S. Bach composed extensively in every genre of music, both sacred and secular, with the exceptions of ballet and opera. He was a master of polyphonic composition, and he was also able to appreciate more modern styles of composition. Arias, recitatives, and a number of other contemporary techniques (at least by Baroque standards) find their way into his music on a regular basis.

Commemorative postage stamp featuring Johann Sebastian Bach.
© Shutterstock.com

Here is a brief overview of Bach's career. His first real job was as a violinist at the court of Duke Johann Ernst in Weimar, beginning in 1703. He quickly left that position, however, to become organist at the *Neukirche* (New Church) in Arnstadt. While there he composed a number of his most famous works for that instrument. After a few years on the job, Bach requested some time off to travel to Lübeck so he could hear organist (and composer) Dietrich Buxtehude perform. He was given a four-week leave of absence, but to the consternation of his employers Bach stayed away over four months. The truth of the matter was that Bach was hoping to replace the aging Buxtehude in Lübeck, but when he found out that a marriage to one of Buxtehude's unattractive, middle-aged daughters went with the gig, he thought better of it. (Several other musicians, including Handel, turned the job down for the very same reason.) Bach returned to Arnstadt for a brief time until he won the post of organist at Mühlhausen, where he would stay for just over one year. Next he returned to Weimar, where he became court organist for Duke

Wilhelm. In 1714, he was also named concertmaster, taking over the duties of managing and composing new music for the court orchestra. At this time, he developed a lifelong friendship with Telemann, who was working in nearby Eisenach. In 1717, Bach moved on to the position of *Kapellmeister* at the court of Prince Leopold in Cöthen. In both Weimar and Cöthen, Bach composed a great deal of secular instrumental music, including the suites for cello and violin as well as the famous *Brandenburg Concertos.* In 1722, Bach applied for a job opening in the City of Leipzig. The job included work in several churches, preparing performances and providing new compositions, as well as some teaching duties. City officials offered the job first to Telemann and next to a man named Graupner. Bach was their third choice, as the committee considered his talents mediocre at best. Bach would stay in Leipzig for the rest of his life, a place where he would compose or complete many of his most famous masterpieces. The following document features an English translation of Bach's job description in Leipzig.

J. S. Bach at the piano, surrounded by his family.
Source: Jupiterimages, Corp.

*B*ach's Duties at Leipzig

Their worships, the Council of this town of Leipzig, having accepted me to be Cantor of the School of St. Thomas, they have required of me an agreement as to certain points, namely:

1. That I should set a bright and good example to the boys by a sober and secluded life, attend school, diligently and faithfully instruct the boys.
2. And bring the music in the two chief churches of this town into good repute to the best of my ability.
3. Show all respect and obedience to their worships the Council, and defend and promote their honor and reputation to the utmost, and in all places; also, if a member of the Council requires the boys for a musical performance, unhesitatingly to obey, and besides this, never allow them to travel into the country for funerals or weddings without the foreknowledge and consent of the burgomaster in office, and the governors of the school.
4. Give due obedience to the inspectors and governors of the school in all they command in the name of the Worshipful Council.
5. Admit no boys into the school who have not already the elements of music or who have no aptitude for being instructed therein, nor without the knowledge and leave of the inspectors and governors.
6. To the end that the churches may not be at unnecessary expense I should diligently instruct the boys not merely in vocal but in instrumental music.
7. To the end that good order may prevail in those churches I should so

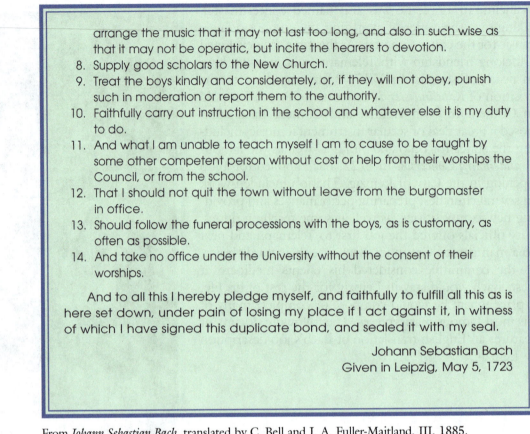

arrange the music that it may not last too long, and also in such wise as that it may not be operatic, but incite the hearers to devotion.

8. Supply good scholars to the New Church.
9. Treat the boys kindly and considerately, or, if they will not obey, punish such in moderation or report them to the authority.
10. Faithfully carry out instruction in the school and whatever else it is my duty to do.
11. And what I am unable to teach myself I am to cause to be taught by some other competent person without cost or help from their worships the Council, or from the school.
12. That I should not quit the town without leave from the burgomaster in office.
13. Should follow the funeral processions with the boys, as is customary, as often as possible.
14. And take no office under the University without the consent of their worships.

And to all this I hereby pledge myself, and faithfully to fulfill all this as is here set down, under pain of losing my place if I act against it, in witness of which I have signed this duplicate bond, and sealed it with my seal.

Johann Sebastian Bach
Given in Leipzig, May 5, 1723

From *Johann Sebastian Bach*, translated by C. Bell and J. A. Fuller-Maitland, III, 1885.

Marktplatz in Leipzig, the final home of J. S. Bach.
Source: Jupiterimages, Corp.

Finding your way in Bach's music is really not that difficult: you just have to listen. The clarity of form and the directness of his melodic writing are immediately accessible by almost everyone. About the only complaint one ever hears about Bach's compositions it that sometimes the polyphony is a bit too complex, leaving some listeners confused about where to focus their attention first. One of Bach's greatest gifts as a composer of polyphonic music lay in the creation of fugues. As a formal structure, the fugue had been around since the early Renaissance, but in the hands of J. S. Bach, the fugue reached its zenith as a compositional tool. In performance, Bach was able to improvise intricate three- and four-voice fugues from a melody someone in the audience had just given him. The fugues he actually wrote down (and there are many) are even better.

Focus on Form
The Fugue

Some of Bach's most famous compositions are fugues. He wrote two books of 24 preludes and fugues (two each in every major and minor key center) titled *Das Wohltemperierte Klavier* (The Well-Tempered Clavier), along with a number of fugues both large and small for the organ. He also made use of fugues in many of his sacred cantatas and some of his secular orchestral writing. People usually think of the fugue as a formal structure, but, in truth, the fugue is really more of a texture than a formal structure. Particularly with Bach's fugues, there were some pretty hard and fast rules about how the fugue was supposed to start and end, but inventing complex ways to deliver all the fun material in the middle of the work was left up to the composer. The only real "rule" was that once a voice entered at the beginning of the piece, it rarely stopped being played or sung until the very end of the composition.

To get a basic idea of how a fugue begins, think of a group of people singing a round such as *Row, Row, Row Your Boat* or *Frére Jacques,* and you are on the right track. In a fugue by Bach, that would be called the **exposition**, a place where the main **subject** (or melody) and **countersubject** (a contrasting melody designed to complement the first melody) would be presented in each individual voice of the fugue. Most fugues typically have three, four, or, in some cases, five individual voices, or melodic lines. During the exposition, there is one more term you should be aware of called an *answer*. The **answer** follows the same melodic shape as the subject, but it usually starts on the dominant note (up the interval of a fifth). As each voice enters one after the other, it makes its first statement of the subject or answer, quickly followed by a statement of the countersubject *while* another voice enters with its own statement of the subject or answer, and so on. As the individual voices enter and stack up, they alternate subject, answer, subject, answer until all of the voices are in. Unlike a simple round, however, Bach would keep going, spinning out new material, usually built on little motives and figures from the original subject and countersubject. These sections of the work are called **episodes**. The rest of the fugue would then alternate between these developmental *episodes* and full statements of the original melody starting at various pitch levels, and ultimately culminating in one final statement of the full subject at the original pitch level.

exposition

subject

countersubject

answer

episodes

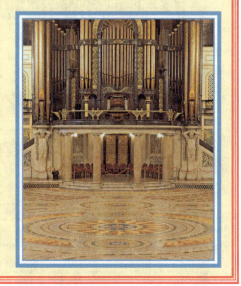

The illustration on the left side of this page is a typical Baroque pipe organ console, and the image on the right is a full view of a large pipe organ.
Left:
Source: Jupiterimages, Corp.
Right: © Shutterstock.com

Bach's Keyboard Compositions

As a composer of challenging polyphonic keyboard works, Bach had no equal. It is a mistake, however, simply to think of Bach as a technical composer. His works are also full of beautiful melodies of great elegance. A short list of his most famous keyboard compositions includes the *Goldberg Variations*, collections of *Two-* and *Three-Part Inventions*, and two volumes of preludes and fugues titled *Das Wohltemperierte Klavier* (The Well-Tempered Clavier). For organ, Bach composed several collected sets of works, including books of preludes and fugues, chorale preludes, and sonatas. There are also many famous independent works such as the *Toccata and Fugue in d minor* and the *"Little" Fugue in g minor* (featured below).

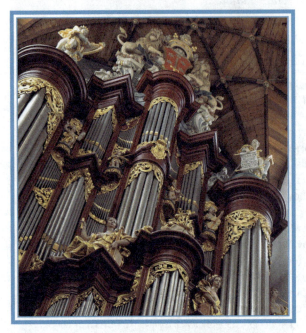

Detail of a Baroque pipe organ case in the Grote Kerk *(Great Church) in Haarlem, North Holland.*
© Shutterstock.com

Pipe organs in the Baroque era came in all sizes. In his day, Bach was best known for his skills as an organist.
Source: Jupiterimages, Corp.

Fugue in g minor, "Little," BWV 578

Bach's "little" *Fugue in g minor* is so named because he also composed a much longer organ fugue in the same key. This particular work was written in Bach's earlier years as an organist, but an actual date of composition is unknown. The main four-bar melody, or subject, of this fugue is frequently referred to as "catchy," and it is often used as a teaching piece because the melody is so clearly identifiable throughout the composition. This is a four-voice fugue, featuring a standard exposition, followed by alternating episodes and full statements of the subject.

Listening Guide

Fugue in g minor, "Little," BWV 578
J. S. Bach (1685-1750)

Format: Four-voice fugue
Performance: Ton Koopman, organ
Recording: *Bach: Organworks IV* (Novalis 150052-2)

Performance Notes: This particular performance was recorded in 1989 on the historic *Trinity* organ at the basilica in Ottobeuren, Germany. The instrument, completed in 1766, was built by Karl-Joseph Riepp, who modestly exclaimed, "I'll be damned if better ones are found in [all of] Europe." Over the centuries the instrument fell into disrepair but was restored to its former glory in 1914. Unlike most of our "best guesses" when it comes to authentic performance practice sounds from other instruments, this is pretty much what a late Baroque organ would have sounded like at the hands of a master performer/ composer like J. S. Bach.

Liner notes from Novalis 150052-2

:00	First voice enters with subject.
:16	Answer (statement of the subject at the dominant) in a second, lower voice. First voice continues on with a new, contrasting melody above called a countersubject.
:37	Third voice enters with subject. Second voice plays the countersubject while the first voice carries on with some free material and periods of rest.
:52	Fourth voice enters with another statement of the answer played on the pedals (lowest voice). Third voice carries on with a statement of the countersubject while the first and second voices present free, contrapuntal material along with periods of rest in voice two.
1:07	As the exposition ends, the first episode begins. In this section, Bach experiments with the thematic material presented above. The rest of the fugue will be alternating sections of episodes like this one and statements of the original theme (the subject) at various pitch levels.
1:16	False entry of subject statement in voice three. Main subject presented in the top voice.
1:33	Episode.
1:41	Main subject presented in a middle voice.
1:56	Episode.
2:06	Main subject presented in the bottom voice.
2:20	Episode.
2:35	Main subject presented in the top voice, but this time in a minor key.
2:49	Episode.
3:14	Final statement of the subject, again presented in the bottom voice and played on the pedals. On the very last chord, Bach slips in a G major chord in place of the expected g minor tonic by simply raising the middle note of the chord by one half step. This is a little trick Bach picked up from the French called a *tierce de Picardie,* or Picardy third.

The Well-Tempered Clavier, Books 1 & 2, BWV 846 – 893

Here is one of Bach's most famous prelude and fugue sets from one of his most famous teaching works. Both keyboard and composition students have been studying this work for over two centuries now. In Bach's original copy of his manuscript he wrote about his intentions for its use as a teaching piece:

> The Well-Tempered Clavier,
> or Preludes and Fugues through all the tones and semitones
> For the Use and profit of the Musical Youth Desirous of Learning
> as well as for the Pastime of those Already Skilled in this Study
> drawn up and written by Johann Sebastian Bach,
> Capellmeister to His Serene Highness the Prince of
> Anhalt-Cöthen, etc. and Director of His Chamber Music.
> Anno 1722[5]

Typical example of a two-manual harpsichord.
Source: Jupiterimages, Corp.

Beyond its use as a teaching piece, however, it is simply a beautiful collection of music. The following example is the first prelude and fugue in book one. The prelude is a harmonic study of subtly shifting chords within a steady rhythmic pattern. As with the Fugue in g minor, this fugue demonstrates Bach's ability to weave a simple theme into a dense polyphonic texture. This fugue, however, is more compact, taking only about two minutes to work out.

Listening Guide

The Well-Tempered Clavier, Book 1, BWV 846
Prelude and Fugue in C Major

J. S. Bach (1685-1750)

Format: Free-form prelude and three-voice fugue

Performance: Masaaki Suzuki, harpsichord

Recording: *J. S. Bach: Das wohltemperierte Klavier, Book 1* (BIS 813/814)

Performance Notes: Recorded May 1996 at the Kobe Shoin Women's University in Japan. Masaaki Suzuki is playing a harpsichord built by Willem Kroesbergen in 1982. The instrument is a modern copy based on an enlarged 2 manual (2 keyboard) Rukers harpsichord.

:00 *Prelude.* This simple 35-measure work is basically a meditative harmonic study. A broken chord is played over a group of eight 16th-notes that are than repeated to form one measure of music. Then the harmony shifts while the rhythmic pattern remains constant from the beginning until measure 33. Measures 33 and 34 are still one chord per bar, but the melodic structure is altered as we come to the end of the composition. The last bar, measure 35, is a simple whole note tonic chord.

:00 *Fugue.* Voice one enters, followed six seconds later by the answer played in a higher voice. A third voice enters at :13 while the other two voices carry on with a countersubject and other contrapuntal material. The last entrance comes in the lowest voice a few seconds later.

:25 The first episode seamlessly begins here, and the rest of this densely polyphonic composition is a rapid series of alternating statements of the main theme with brief developmental episodes.

1:36 A pedal point is established in the lowest voice while the counterpoint continues to unfold above. If you listen carefully, at this same point in the music Bach offers the last full statement of the subject on tonic in the voice just above the long pedal point note. This can be tough to pick out at first because both ideas start on the very same note.

Bach's Instrumental Compositions

Bach's instrumental works include collections of solo suites for violin and cello, solo sonatas, solo concertos, *concerti grossi*, and a number of orchestral suites in both French and English styles. As with most of his compositions, Bach relies heavily on polyphonic writing techniques, but he is also willing to explore the latest compositional styles, including elements drawn from Italian, French, and even English music. The following two examples will serve as a brief introduction to Bach's instrumental compositions.

Suite No. 1 in G Major for solo cello, BWV 1007

Bach wrote a set of six multi-movement suites for solo cello in Cöthen, probably in 1722. Each suite is made up of a prelude followed by a series of dance movements in various rhythmic styles and tempos. The following listening example is for the first movement of the first suite. Bach also wrote a similar set of works for solo violin. In both cases, he uses double-stops (playing harmony on more than one string at once). He also writes lines that imply polyphonic counterpoint even though there is only a single instrument playing a single line of music. This prelude is an excellent example of Bach's "implied" counterpoint.

Reproduction of a famous oil painting of J. S. Bach by Elias Gottlieb Haussmann.
Source: Jupiterimages, Corp.

<div style="border:1px solid;">

Listening Guide

Suite No. 1 in G Major for solo cello, BWV 1007
Prelude

J. S. Bach (1685-1750)

Format: Free-form prelude from a six-movement suite
Performance: Martin Burkhardt, baroque cello
Recording: *Bach Solosuiten f. Violoncello BWV 1007-1012* (Amati 9903/2)

Performance Notes: Recorded in 1999 at the *Evangelische Kirche*, Honrath, Germany. Cellist Martin Burkhardt writes:

The established way of playing the cello today is based primarily on the ideals of "sound" and "line". This, however, seems to me inappropriate when confronting the **harmonically** and **vertically** orientated conception of these suites. For this reason I use instruments which come close to those of Bach's day when interpreting this music: a **short [fingerboard]** instrument with **gut strings,** tuned at **415 Hertz** (in contrast to the customary 440-442 Hertz), with a **Baroque bow** (with a convex shape instead of the modern concave), . . . I accept a general sound with more excess noise than is usual today in the hope that you, the listener, will find that the advantages to this approach outweigh the disadvantages. The advantages are a longer lingering sound, a richer overtone spectrum and more varied degrees of articulation.

Liner notes from Amati 9903/2

:00 This simple, through-composed prelude consists almost entirely of a gentle series of running broken chords. Close your eyes and you can feel the harmonic shifts as they pass by. As you focus your mind on all of the different high, low, and middle notes you hear flashing by, notice how little melodies and countermelodies begin to suggest themselves to your ear.

</div>

Brandenburg Concerto No. 2, BWV 1047

This work is an excellent example of the *concerto grosso* concept of pitting a small group of soloists (the *concertino*) against the forces of the full orchestral group (the *tutti* or *ripieno*). The six works that comprise the *Brandenburg Concertos* are dedicated to the Margrave of Brandenburg, but the chances are very good that Bach did not originally compose them for the nobleman. On a visit to Cöthen, the Margrave met Bach and casually requested that Bach send some new music his way at some point in the future. It would appear that Bach had these concertos lying around, so he collected them into a set (six being a common number for collections of works intended for presentation) and shipped them off. Each of the works called for different instrumental forces, and a few of them required instruments the Margrave did not have at his court. There is some question as to whether the works were ever performed in Brandenburg during Bach's lifetime; however, there is no question that all of the six concertos are frequently performed today. The six *Brandenburg Concertos* are among Bach's most famous compositions.

Listening Guide

Brandenburg Concerto No. 2, BWV 1047
 Movement 3—Allegro assai
J. S. Bach (1685-1750)

Format: Orchestral suite
Performance: Ars Rediviva Orchestra, Milan Munclinger, conductor
Recording: *Bach: Brandenburg Concertos/Suites for Orchestra* (Supraphon 11 1875-2 013)

Performance Notes: This orchestra is not an authentic performance practice group as they are playing on modern instruments at today's standard pitch, but they do play with proper Baroque musical styles and with an appropriately sized orchestra. In particular, notice how the piccolo trumpet part is performed with great accuracy, which, while still very challenging today, is much more difficult on the types of instruments Bach's players had at their disposal. Given the difficulty of this part, Bach must have had access to a *really* good trumpet player. Recorded in 1965 at the Domovina Studios in Prague, Czechoslovakia.

:00	Primary melody introduced by solo trumpet accompanied by orchestra and continuo.
:08	Oboe joins trumpet, creating a duet with simple accompaniment.
:25	Subsequent statements of melody passed around to various solo instruments with accompaniment. In this section, Bach begins to cut up his melodic ideas into smaller fragments.
:50	Trumpet returns with an altered statement of the main theme.
1:11	Episode featuring flute and violin.
1:22	Oboe enters with theme in a minor key. Other instruments follow.
1:56	As trumpet enters, piece begins to gravitate back to a major key center.
2:14	Duet between oboe and trumpet returns, followed quickly by a strong flute entrance. Lower voices follow as work builds to a final climax.
2:51	Final statement of the main melody played by the trumpet, accompanied by all the other soloists along with the full orchestra and continuo instruments.

Bach's Vocal Compositions

Bach's cantatas number over 200 today, but researchers believe he actually composed many more that were lost or simply destroyed after the old master's death. In a way, Bach's sacred cantatas can be viewed as the Lutheran equivalent to musical settings of the Catholic mass, but there are significant differences between the two. Bach essentially composed a new cantata for every week of the year, creating works with texts drawn mostly from Biblical sources that were appropriate for use at their appointed time in the liturgical calendar, which means that we have around four years worth of Bach's cantatas still in existence! In his cantatas, Bach explored every style of composition popular during the Baroque period. Obviously there is a great deal of inventive contrapuntal writing, but you can also find examples of aria and recitative styles taken right out of the opera house, as well as instrumental writing that borrows from the latest Italian and French fashions. Bach also composed secular cantatas, most of which are written for a few solo voices and instrumental accompaniment. Many of Bach's secular cantatas have been lost to history, but two that remain very popular (and frequently appear together on recordings) are the *Coffee* cantata and the *Peasant* cantata.

Memorial statue of J. S. Bach in front of St. Thomas Church, Leipzig.
© Shutterstock.com

While we are on the topic of Bach's vocal writing, it should also be noted that Bach composed a powerful series of independent sacred choral works he labeled *motets*. He also wrote oratorios for Easter and Christmas, a *Magnificat* in D Major, the *St. John Passion* and the *St. Matthew Passion*, and the monumental *Mass in b minor*. This mass is written in the Catholic tradition of setting the text of the five movements of the mass Ordinary, but Bach composed this work for the concert hall, not for use in a church service. Of particular interest in a number of his vocal works, and particularly in the *Mass in b minor*, is Bach's extensive use of instrumental writing in what were "supposed" to be vocal works. Bach was a deeply religious man, and he felt that the power of music was such that it could convey deep emotions with or without words.

Cantata No. 147 - Herz und Mund and Tat und Leben, BWV 147

As you read in the previous historical document, one of Bach's main jobs in Leipzig was to provide new music for church services. Because of this enormous demand for "new" material, Bach sometimes recycled older works by adding new lyrics, new melodies, and/or creating extra movements for a work that already existed. *Cantata No. 147*, excerpts of which are found in the following listening guide is a good example of how Bach might rework an older piece of music. The original *Herz und Mund und Tat und Leben* cantata was completed at Weimar in 1716 and was intended for use in the church service on the Sunday before Christmas. When Bach got to Leipzig, however, it was the custom there to *not* perform a cantata just before Christmas. Bach added three recitatives and the chorale as we know it today for use at the Feast of the Visitation of the Blessed Virgin Mary, which took place in early July.[6]

These three movements are from one of Bach's longer cantatas, and the title is from the lyrics of the first movement, which translates to *Heart and Mouth and Deed and Life*. The entire work is only moderately famous among Bach's vast

catalog of works, but the accompanying melody (or counter-melody if you prefer) that Bach uses for both of his chorale movements in this cantata represents one of his most frequently adapted tunes. It is most commonly referred to as *Jesu, Joy of Man's Desiring*, and you frequently hear it used during the Christmas holidays, at funerals, and at big church weddings when the grandmothers are being seated. As you will hear when you listen to movement 10, the running line we all think of as the melody is actually a beautifully elaborate accompaniment for the real melody being sung by the choir.

Listening Guide

Cantata No. 147 - Herz und Mund and Tat und Leben, BWV 147
Movements 1, 8, and 10
J. S. Bach (1685-1750)

Format: Sacred cantata originally for the Lutheran church
Performance: Bach Collegium Japan, Masaaki Suzuki, director
Recording: *Johann Sebastian Bach: Cantatas Vol. 12* (BIS 1031)

Performance Notes: The Bach Collegium Japan is an authentic performance practice group. Their splendid performance here is just one more testament to the universality of Bach's music. In fact, their performances are receiving widespread acclaim for both their historical accuracy and spectacular musicianship, and they are currently in the process of recording all of Bach's cantatas for the BIS label. Recorded June 1999 at the Kobe Shoin Women's University, Japan.

Movement 1 – Chorus

:00 Introduction featuring the trumpet and bassoon.

:30 The four voice parts enter one after the other in the manner of a fugue. The sopranos enter first, followed by the altos. Next the tenors enter, with the basses joining close behind. As the movement develops, polyphonic episodes are contrasted by some brief homophonic passages and instrumental interludes.

2:41 At this point, Bach copies the fugal exposition heard when the voices first entered. This time, however, the voices enter in reverse order, with the basses going first, followed by the tenors, then the altos, and the sopranos entering last.

3:37 To close the movement, Bach returns to the same instrumental material heard at the beginning of the movement.

Full Text

Herz und Mund und Tat und Leben	Heart and Mouth and Deed and Life
Muß von Christo Zeugnis geben	Must bear witness to Christ
Ohne Furcht und Heuchelei,	Without fear or hypocrisy
Daß er Gott und Heiland sei.	That he is God and Saviour.

Movement 8 – Accompanied Recitative for solo alto Robin Blaze, countertenor

Performance Note: Although Bach wrote this movement for a female alto voice, it is actually sung here by a man trained to sing in the same musical range. Most countertenors have naturally high voices, which they then develop to sing well into their falsetto range. To explore your own "falsetto" range, alter your voice as you would when you are trying to imitate the voice of a small child. What you are really doing is changing the basic natural function of your vocal chords, causing them to vibrate in a different pattern.

:00

Der höchsten Allmacht Wunderhand	The miraculous hand of the almighty
Wirkt im Verborgenen der Erden.	Acts in the secrecy of the world.
Johannes muß mit Geist erfüllet werden,	John had to be filled with the spirit,
Ihn zieht der Liebe Band	The bond of love drew him
Bereits in seiner Mutter Leibe,	While he was still in his mother's womb,
Daß er den Heiland kennt,	So that he knew the saviour,
Ob er ihn gleich noch nicht	Though he did not yet
Mit seinem Munde nennt,	Name him with his mouth.
Er wird bewegt, er hüpft und springet,	He was moved, he skipped and hopped,
Indem Elisabeth das Wunderwerk ausspricht,	While Elizabeth expressed the miracle,
Indem Mariä Mund der Lippen Opfer bringet.	While Mary's mouth brought offerings to the lips.
Wenn ihr, o Gläubige, des Fleisches Schwachheit merkt,	For you, O faithful, perceive the weakness of the flesh,
Wenn euer Herz in Liebe brennet,	When your heart burns with love,
Und doch der Mund den Heiland nicht bekennet,	And yet your mouth does not proclaim the saviour,
Gott ist es, der euch kräftig stärkt,	God it is who mightily strengthens you,
Er will in euch des Geistes Kraft erregen,	He wants to excite in you the power of the Spirit,
Ja Dank und Preis auf eure Zunge legen.	Yes, to lay thanks and praise on your tongue.

Movement 10 – Chorale

This same melody and accompaniment also appear in movement 6 with a different set of lyrics. The hymn melody sung by the choir is one that everyone in the congregation would have known.

:00 Movement begins with an instrumental version of the melody everyone knows as *Jesu, Joy of Man's Desiring.* This is actually the accompaniment, and it will continue throughout the movement.

:19 Voices enter with the actual chorale melody of this movement. Portions of the chorale melody will be interspersed throughout the entire movement as the continues unbroken from beginning to end.

Jesus bleibet meine Freude,	Jesus is ever my joy
Meines Herzens Trost und Saft,	The comfort and sap of my heart,
Jesus wehret allem Leide,	Jesus defends me against all ills,
Er ist meines Lebens Kraft,	He is the strength of my life,
Meiner Augen Lust und Sonne,	The joy and sunshine of my eyes,
Meiner Seele Schatz und Wonne;	The jewel and delight of my soul;
Darum laß ich Jesum nicht	Therefore I never let Jesus
Aus dem Herzen und Gesicht.	Out of my heart and my view.

Commemorative postage stamp featuring George Frideric Handel. As you can see from the spelling on the stamp, Handel's name has undergone a number of different spelling variations over the years, mostly due to the different countries with which he was associated.
© Shutterstock.com

George Frideric Handel (1685–1759)

When compared to J. S. Bach, as he often is, George Frideric Handel is frequently identified as being the more "cosmopolitan" of the two. Here was a German, trained in Italy, who spent almost fifty years of his life as a star of the London musical scene. As with Telemann, Handel was much better known to the general public throughout Europe when compared to Bach, both as a composer and a performer. Handel's early years were spent in Halle and Hamburg. In 1706 he traveled to Italy, where he mastered the local operatic style and began composing his first oratorios. Handel returned to Germany in 1710 to become *Kapellmeister* for the Elector of Hanover. Over the course of the next few years, he took several trips to London, where his compositions met with great success. When Queen Anne died in 1714, the Elector of Hanover (Handel's employer) became the next king of England (King George I), and Handel stayed in London for the rest of his life. He became the toast of the town, composing successful operas in the Italian style for the Royal Academy of Music, new music commissioned for the English court and Royal Chapel, and, toward the end of his career, some of the most famous oratorios ever written, most notably, *Messiah*.

Handel approached composition with a flair for improvisation and innovation but also with a businessman's eye for potential commercial success. When Italian operas were in favor in London, that was what he composed. When they fell out of favor, he switched to oratorios, which offered him the double commercial advantage of being performed during Lent (when the opera houses were dark) and being written in the local language, which gave the works more mass audience appeal. Again, a comparison with J. S. Bach proves interesting. When Bach died, his compositions were largely forgotten, but today, almost everything he wrote is considered a masterpiece. Because of his enormous popularity during his lifetime, a great deal more of Handel's music was published and, therefore, preserved for history. Nonetheless, much of Handel's music has since fallen out of favor. Today he is best remembered for the previously mentioned oratorio, *Messiah*, and a handful of other works including the two orchestral pieces *Music for the Royal Fireworks* and *Water Music*. Of his 40 plus operas and 30 plus oratorios, only a few are still performed today. Handel also composed over 150 cantatas, of which 100 are still extant, but they are rarely performed today outside of academic and historic performance circles. Likewise, there are hundreds of purely instrumental compositions by Handel, but outside of the previously mentioned orchestral works, a few of his *concerti grossi,* and some of his solo concertos for organ and orchestra, only few of them are performed on a regular basis.

Focus on Form
Cantata and Oratorio

The terms *cantata* and *oratorio* are general terms used throughout the Baroque era to refer to an array of vocal works both sacred and secular. The biggest thing all of them have in common is that they are clearly not operas. The two terms are featured here because both the cantata and the oratorio reach the height of their artistic creativity in the hands of the late Baroque masters Bach and Handel. As was previously mentioned, Bach composed well over 200 sacred and secular cantatas, and Handel composed more than 30 popular oratorios, including *Messiah*, which is one of the most famous compositions of all time.

The first cantatas were solo vocal works accompanied by a lute or *basso continuo*. Some were similar to early Baroque madrigals, where as others began to incorporate elements of operatic composition—particularly the aria and recitative. These early cantatas were based on both sacred and secular subjects. When Bach began using the format, he raised the level of composition and overall scope of his sacred works to the point where they have actually been referred to as short oratorios. Bach made use of impressive contrapuntal writing for both voices and orchestra; he also incorporated operatic-style arias, duets, and recitatives. All of his sacred cantatas are written for solo voices, chorus, and orchestral accompaniment with *basso continuo*. Many of his sacred cantatas are based on pre-existing hymn tunes, which usually show up written as a four-part chorale in the last movement. Most of Bach's cantatas were written to be performed during the course of a church service just before the sermon. Some are longer (such as the *Cantata No. 147*) and would have been split into two parts before and after the sermon. Today they are most frequently heard in the concert hall rather than the church. After Bach, the term *cantata* again diversified, being applied to a variety of works for the combined forces of voice(s) and orchestra.

The strict definition for oratorio is a vocal work with many of the same characteristics as an opera but based on a sacred topic and containing little or no dramatic action on the stage (no sets, costumes, or drama). In practice, most oratorios during the Baroque era adhered to this principle though there were exceptions. For example, some of the earliest oratorios were liturgical dramas (morality plays) that did include some costumes and acting. As the style progressed, however, the oratorio became a work for the concert hall. Handel had composed oratorios throughout his long career in music, and in the late 1730s when Italian opera fell out of favor in London, he began to focus more of his attention toward them. In most cities, it was forbidden for operas to be composed on overtly religious topics. Also, during the Lenten season, many opera houses were closed, producing no revenue. Handel took all of these issues into account and began mounting oratorio performances based on sacred topics, written in the local language of English, during Lent. At first, works with sacred topics being performed in the concert hall were considered in bad taste, but audiences eventually came around and Handel's oratorios became very popular.

Scene from The Beggar's Opera *by John Gay. This work was one of the major reasons Italian opera fell out of favor in England during the late Baroque era. The artwork is by Hogarth.* **Source:** Jupiterimages, Corp.

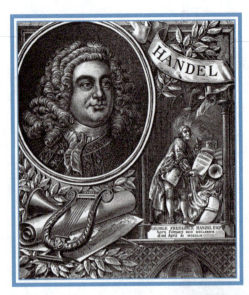

Detail from a publication of Handel's music.
Source: Jupiterimages, Corp.

Depiction of King George standing during the Hallelujah Chorus.
Source: Jupiterimages, Corp.

DIG DEEPER

MOVIES
Handel's Last Chance;
The Great Mr. Handel

Messiah (HWV 56)

Today, Handel's *Messiah* is generally thought of as a work for Christmas, but it actually tells stories from the entire life of Christ. The work is over two and a half hours long and is rarely performed in its entirety today. Now it is common for ensembles to extract the Christmas portions of the work, stick the *Hallelujah Chorus* on the end, and perform the work only during the Christmas season. Handel composed the work in less than a month, but he continued to revise the oratorio until his death in 1759. The work makes use of all the conventions found in operatic compositions of the day, including *secco* and *accompangnato* recitatives, arias, duets, and dramatic choruses such as the famous *Hallelujah Chorus*. Over the years, it has become a tradition for the audience to stand during a performance of the *Hallelujah Chorus*, and there are several interesting stories as to how that tradition came to be. In the oratorio's original format, this movement happens about two-thirds of the way through the work. The basic story goes that the King stood up during the performance of the *Hallelujah Chorus*, so quite naturally the rest of the audience stood with the King. One theory has it that the King had fallen asleep, and the loud chorus woke him with a start. More recent scholarship has suggested that the King had a new girlfriend seated in the audience below, and he stood up to get a better look at her.

During Handel's day, oratorio performances were marathon events, which frequently included the performance of other works during the intermissions between the different parts of the main work. In a letter home, a French traveler named Madame Fiquet wrote of her experience attending a performance of Handel's greatest oratorio:

London, April 15, 1750

The Oratorio, or pious concert, pleases us highly. HANDEL is the soul of it: when he makes his appearance, two wax lights are carried before him, which are laid upon his organ. Amidst a loud clapping of hands he seats himself, and the whole band of music strikes up exactly at the same moment. At the interludes he plays concertos of his own composition, either alone or accompanied by the orchestra. These are equally admirable for the harmony and the execution. The *Italian* opera, in three acts, gives us much less pleasure.[7]

Listening Guide

Messiah (HWV 56)

from **Part one:** *Ev'ry valley shall be exalted*—tenor aria
from **Part two:** *Hallelujah*—chorus

George Frideric Handel (1685-1759)

Format: Oratorio
Performance: Bach Collegium Japan, Masaaki Suzuki, director
Recording: *Handel: Messiah* (BIS 891/892)

Performance Notes: Recorded December 1996 at the Kobe Shoin Women's University, Japan. In the liner notes for this particular recording, Bach Collegium Japan Director Masaaki Suzuki writes:

The difficulty of performing *Messiah*, in sincerity, lies in the fact that Handel himself changed the instrumentation and the vocal parts each time he performed it, and consequently he never performed it the same way as in the 1741 première. In short, one has to face the problem of which version one should revive today, when even the composer's performances let the work evolve like a living creature. In his day, Handel probably chose the most appropriate way, bearing in mind the merits of the singers and the characteristics of the choir and orchestra that were available to him on each occasion. This recording is based on the performance at Covent Garden in 1753 with four soloists, a choir of the same size and an orchestra with probably slightly fewer oboes and bassoons.

Liner notes from BIS 891/892

Ev'ry valley shall be exalted – tenor aria

:00	Orchestral introduction that introduces both major melodic ideas.
:20	Singer enters with letter A melody and the text "Ev'ry valley shall be exalted . . ."
:32	Two extended melodic extensions over the word "exalted." These extensions are an example of text painting, bringing extra melodic attention to one specific word.
:52	New text painting ideas are introduced with the text " . . . and ev'ry mountain and hill made low." The disjunctive melody imitates the shape of mountains and hills. Notice also that the singer ends this passage on the word "low," and he is singing the lowest note of the passage as he does so.
:58	New melodic idea, letter B, begins with the text "The crooked straight and the rough places plain." Text painting techniques continue to be clearly evident in this section of the aria.
1:35	Letter A melodic ideas return.
2:12	Letter B melodic ideas return.
2:54	Work concludes with the orchestra repeating the same material it presented in the introduction to the aria.

Full Text

Ev'ry valley shall be exalted,
and ev'ry mountain and hill made low,
the crooked straight and the rough places plain.
(text drawn from Isaiah 40:4)

Hallelujah! – chorus and orchestra

:00 "Hallelujah" presented in a homophonic fashion sung by full choir with orchestral accompaniment.

:23 "For the Lord God Omnipotent reigneth" sung in unison with homophonic statements of "Hallelujah."

:45 Texture changes to polyphonic as different voices of the choir, with orchestral accompaniment, enter one after the other.

1:09 Homophonic texture returns for "The kingdom of this world . . ."

1:26 Polyphonic texture returns for "and he shall reign . . ."

1:47 Unison statements of "King of Kings and Lord of Lords . . ."

2:26 Polyphonic texture returns for more statements of "and he shall reign . . ."

2:36 Work culminates with alternating unison and homophonic statements of "King of Kings . . ." together with "and he shall reign . . ."

Full Text

Hallelujah! For the Lord God Omnipotent reigneth!
Hallelujah! (Revelations 19:6)
The kingdom of this world is become the Kingdom
of our Lord and of His Christ,
and he shall reign for ever and ever. (Revelations 11:15)
King of Kings and Lord of Lords. (Revelations 19:16)

The court of King George as they float down the river listening to Handel's Water Music. *Notice the musicians on the second barge in the background.*
Source: Jupiterimages, Corp.

Music for the Royal Fireworks (HWV 351)

Handel composed two extended suites of instrumental music for the English court. The first was the *Water Music*, which was actually played on the water. King George I liked to float down the river out to the countryside for picnics, so Handel wrote music for the court's outdoor enjoyment. The king and his party would be on one barge while the musicians floated along behind, functioning as a sort of late eighteenth-century boom box. The music was a hit, and, in modern orchestrations, it continues to be popular in concert today. Later, King George II commissioned Handel to compose some new music for a huge outdoor event planned to celebrate the signing of a treaty with Austria. This time, however, the first performance didn't go so well.

For this special occasion, the king hired an architect to build a huge backdrop for the concert, which was to culminate with a spectacular fireworks display. The architect obliged with a building 400 feet long and 100 feet

high, crowned with an enormous sun on a 200-foot pole. . . . When the day came, Handel himself began conducting the piece. Everything went great for the first half of the piece. And then the fireworks began. Handel was probably annoyed enough that the fireworks were shooting off during his lovely music. But to make matters worse, some of the fireworks landed on the brand new building, which responded the only way it knew how: by catching fire. The crowd panicked, running for their lives as Handel doggedly continued conducting. Handel was livid. He had a notoriously explosive temper, so we're guessing that he provided the king with a display of private fireworks the next morning.[8]

As with the previously mentioned *Water Music*, modern orchestrations of *Music for the Royal Fireworks* remain quite popular in the concert hall and on recordings. The following recording, however, attempts to recreate the music as it might have sounded at that first performance (minus the fireworks, the collapsing building, and the crowd noises, of course). This is the concept of authentic performance practice taken to the extreme. While this is an interesting historical exercise, rest assured that if you buy any other recording of *Music for the Royal Fireworks*, it won't sound like this one.

Listening Guide

Music for the Royal Fireworks (HWV 351)
La Réjouissance
George Friedrich Handel (1685-1759)

Format: Orchestral suite
Performance: Le Concert Spirituel, Hervé Niquet, conductor
Recording: *Haendel:* [sic] *Water Music & Fireworks* (Glossa 921606)

Performance Notes: This performance represents an attempt to recreate the sound Handel's orchestra created at the premiere of this work. The musicians of Le Concert Spirituel commissioned the creation of a number of exact reproductions of the types of instruments musicians of Handel's day would have used. This performance features 24 oboes, 15 soprano and alto recorders, 12 bassoons, 2 contrabassoons, 9 natural trumpets (no valves), 9 natural horns, 2 percussionists, and a full string section with 42 players. Remember that the premiere performance took place outside and needed to be heard by an enormous audience. The only sound reinforcement of 1749 was the addition of extra instruments. This recording is historically accurate both in ensemble size and instrumental tone colors Handel used at the premiere. Recorded September 2002 at l'Arsenal de Metz, France.

:00	Letter A, 16 measures, repeated. Count in groups of 2 beats-per-measure and be aware that each section begins with an eighth-note pick-up. Think "*and* **1**, 2; **2**, 2; **3**, 2; etc . . ."
:35	Letter B, 20 measures, repeated.
1:20	Letter A, 16 measures.
1:37	Letter B, 20 measures.

Antonio Vivaldi (1678–1741)

Vivaldi was another very prolific composer during the Baroque era. He composed over 50 operas, more than 40 works for choir and orchestra, around 100 works for orchestra, and 500 or so concertos for a variety of solo instruments with orchestral accompaniment. Vivaldi was very true to his stylistic ideal, leading twentieth-century composer Igor Stravinsky to offer one of the most famous insults in all of classical music when he suggested that Vivaldi didn't write 500 concertos, but rather, he just kept writing the same one over and over again. Born in Venice, Vivaldi entered the priesthood as a young man, where his bright red hair earned him the nickname "The Red Priest." Vivaldi, however, was not a very *good* priest. Apparently, he would sometimes leave church during the middle of a worship service to write down his latest musical idea. Eventually, the church stopped allowing him to say Mass, and Vivaldi devoted the rest of his life to composition and teaching. He took a job as violin teacher at the *Ospedale della Pietà*, which, among other things, was an orphanage for indigent, illegitimate, and orphaned girls. The girls received extensive training in music performance, and Vivaldi composed a great deal of his music for performances held at the orphanage. The concerts became popular social events, and Vivaldi's music became well known. Outside the orphanage, Vivaldi pursued an active career as an opera composer and producer. Today, many of his operas are lost or incomplete, and they are rarely performed. Perhaps more than any other composer besides Couperin, Vivaldi gave many of his works programmatic titles such as *Storm at Sea, The Hunt,* and, of course, his most famous composition, *The Four Seasons.*

Antonio Vivaldi.
Source: © 2009
Jupiterimages, Corp.

The Four Seasons

This work is actually a series of four individual three-movement concertos for violin and chamber orchestra. Vivaldi wrote introductory poems for each of the concertos found in *The Four Seasons*. The music vividly portrays the images in the poem although some recent research indicates that he actually wrote the poems after he composed the music. Either way, Vivaldi included hints in the score as to what the music represented, and, in turn, the music clearly imitates the sentiments of the text. For example, in the first movement of *Spring* (which can be found in the following listening example), bird songs, the wind, and sounds of thunder and lightning are clearly heard in both the solo and orchestral parts. The following is an English translation of an excerpt from Vivaldi's poem for *Spring:*

Spring
(excerpt)

Spring has come, and joyfully
the birds welcome it with cheerful song,
and the streams at the breath of zephyrs
flow swiftly with sweet murmurings.
But now the sky is cloaked in black
and thunder and lightning announce themselves;
when they die away, the little birds
turn afresh to their sweet song.[9]

Listening Guide

The Four Seasons, Op. 8
La Primavera (Spring)—Movement 1
Antonio Vivaldi (1678-1741)

Format: Solo concerto
Performance: The Drottningholm Baroque Ensemble, Nils-Erik Sparf, Baroque violin
Recording: *Antonio Vivaldi: The Four Seasons* (BIS 275)

Performance Notes: Recorded in 1984 at the Petrus Church in Stocksund, Sweden.

:00	Theme one. "Spring has come . . ."
:13	Theme two (ritornello). Violin soloist featured with orchestral accompaniment. Get to know this theme well, as it is the one Vivaldi will continue to use throughout the movement.
:27	Effect of bird calls introduced in main solo part along with 1st violins. ". . . joyfully the birds welcome it with cheerful song . . ."
1:00	Theme two returns.
1:07	Quiet, smooth melody represents a small stream.
1:29	Theme two returns, this time in a new (but closely related) key center.
1:36	Bold rhythmic melody represents a thunderstorm. Fast ascending passages in violins represent lightning strikes. Broken note patterns in solo violin represent rain failing. " But now the sky is cloaked in black and thunder and lightning announce themselves . . ."
2:01	Theme two returns, but this time played in a sad sounding minor key center.
2:08	Bird calls return. ". . . the little birds turn afresh to their sweet song."
2:51	Theme Two returns to close out the movement.

Endnotes

1. Joseph Sylvan, "History of Baroque Music" (lectures, New Mexico State University, Las Cruces, NM, Fall, 1987).

2. "Vladimir Vavilov," "Giulio Caccini," and "Ave Maria," articles posted on *Wikipedia,* http://www.wikipedia.org (accessed July 27, 2009). This story has become quite common in the world of classical music, and there are numerous, and sometimes conflicting, tales of the *"Ave Maria* hoax" on the Internet.

3. *Pretty Woman*, videocassette, directed by Gary Marshall (Burbank, CA: Touchstone Home Video D410272, 1990).

4. Charles Burney, "Castrato Singers," in *Music in the Western World: A History in Documents,* eds. Piero Weiss and Richard Taruskin (New York: Schirmer Books, 1984), 225.

5. J. S. Bach, *Das wohltemperiete Klavier*, Book 1, introduction translated and quoted in *Johann Sebastian Bach: Complete Keyboard Works,* Vol. 1, Masaaki Suzuki, compact disc liner notes, BIS 813/814.

6. Tadashi Isoyama, *Bach Cantatas, Vol. 12*, Bach Collegium Japan, compact disc liner notes, BIS 1031, 6-7.

7. Madame Fiquet to her sister, London, April 15, 1750, in *Music in the Western World: A History in Documents,* eds. Piero Weiss and Richard Taruskin (New York: Schirmer Books, 1984), 246.

8. David Pogue and Scott Speck, *Classical Music for Dummies* (Foster City, CA: IDG Books Worldwide, 1997), 23.

9. Stig Jacobsson, translated by John Skinner, *Antonio Vivaldi: The Four Seasons*, The Drottningholm Baroque Ensemble, compact disc liner notes, BIS CD 275.

Study Guide

Chapter 4 Review Questions

True or False

___ 1. Henry Purcell is frequently referred to as the last great English composer until the twentieth century.

___ 2. J. S. Bach composed about 25 sacred cantatas.

___ 3. Compared to J. S. Bach, Handel was considered more "cosmopolitan."

___ 4. Most oratorios used sets and costumes in their productions.

___ 5. Vivaldi was nicknamed "The Red Priest."

___ 6. Religious conflicts led to the Thirty Years War.

___ 7. Purely instrumental music was not very popular during the Baroque era.

___ 8. Monody features 3-5 individual voice parts.

___ 9. Allessandro Scarlatti's operas made use of the Italian Overture.

Multiple Choice

10. The first operas were created by the:
 a. Greeks.
 b. Germans.
 c. Notre Dame School.
 d. Florentine Camerata.

11. Popular instrumental form during the Baroque era.
 a. Trio Sonata
 b. Sonata da Camera
 c. Sonata da Chiesa
 d. Concerto grosso
 e. All of the above

12. Frequently referred to as the father of modern violin technique.
 a. Arcangelo Corelli
 b. Allessandro Scarlatti
 c. Domenico Scarlatti
 d. Joseph Sylvan
 e. none of the above

13. Conductor who died after accidentally hitting his foot with his baton.
 a. Jacquet de la Guerre
 b. François Couperin
 c. Jean-Baptiste Lully
 d. Gregory-Baptiste Lisemby

14. Prolific German composer who wrote over 4,000 works, including a series of lighter works he called *Tafelmusik*.
 a. Heinrich Schütz
 b. Georg Phillipp Telemann
 c. J. S. Bach
 d. J. C. Bach

15. Handel's *Messiah* is an:
 a. opera.
 b. oratorio.
 c. art song.
 d. organum.

Fill in the Blank

16. Caccini is normally credited with the creation of _____.

17. _____'s compositions bridge the Renaissance and Baroque periods in music.

18. Purcell based his opera *Dido and Aeneas* on a portion of the _____ by Virgil.

19. The _____ pitted a small group of instruments against the full orchestra.

20. The _____ was usually a three-movement work for one solo instrument with an orchestral accompaniment.

21. Handel was born in _____, trained in _____, and spent most of his adult life working as a professional composer in _____.

Short Answer

22. List the five major parts of a typical fugue.

23. List three important operas by Claudio Monteverdi.

24. List four towns where J. S. Bach worked.

25. Other than opera, list three vocal forms popular during the Baroque era.

Essay Questions

1. Discuss the development of opera during the Baroque era.

2. Discuss the development of instrumental music during the Baroque era.

Chapter 5
The Classical Era

"If the King loves music, there is little wrong in the land."
Meng-Tzu (ca. 372-289 B.C.)

The Classical period (1750-1825) encompasses the careers of Haydn, Mozart and Beethoven. The music of these masters occurs in an era that saw a growing middle class, a change in philosophical thinking, and revolutions in both America and France. During this period we see a continued rise in the popularity of instrumental music. In addition, opera undergoes a major reformation that culminates with the masterpieces of Mozart. Other vocal music also continues to be popular, including masses by all three of the above composers, a very special (and somewhat controversial) requiem mass by Mozart, oratorios by Haydn, and the creation of a "choral" symphony by Beethoven. Beyond these three famous artists, a number of talented musicians produced a wealth of music that unfortunately continues to labor in the shadow created by these musical giants, or worse, is now lost to us forever because no one bothered to publish their music and preserve it for history. Of course, that fact is true even for the big three, as we have written reports of works, particularly by Haydn and Mozart, for which no musical scores currently exist. In many ways, both artistically and politically, this period laid the groundwork for the society we continue to enjoy today.

This timeframe is frequently referred to as the "Age of Reason" or the "Enlightenment." Building on the scientific advances made during the Baroque era, philosophers Voltaire (1694-1778), Denis Diderot (1713-1784), and Jean-Jacques Rousseau (1712-1778) began to promote social reforms that gave more rights to individuals, regardless of class distinctions. Building on their teachings,

Voltaire (François Marie Arouet).
© Shutterstock.com

Jean-Jacques Rousseau.
© Shutterstock.com

rulers including Frederick the Great, Catherine the Great, and Emperor Joseph II, who were all patrons of the arts, began, at least in some ways, to embrace social change. There was a growing emphasis on the education of the masses, reduced power for the church, and a general embrace of more humanitarian ideals. History now refers to these leaders, including French king Louis XVI during the early years of his reign, as "enlightened despots," meaning they still ruled with absolute power, but they generally treated their subjects better than their predecessors. It remains a fascinating time in world history, and the arts played a major role in both the noble courts and public life of the day. As the smaller courts of Europe were losing their real political might, they frequently embraced artistic power, using their wealth to provide their guests with the best music, fine art, and architecture money could buy. Musicians such as Mannheim composer Johann Stamitz, Leopold Mozart (Wolfgang's dad), and even Haydn during most of his career were little more than servants to the noble aristocratic courts of Europe. In his book *Listening To Music,* Jay Zorn describes a big party day in the life of a typical European court:

Once a court function was scheduled, servants delivered ornate invitations and returned with acceptances. On the appointed day, guests arrived in the afternoon for drinks, snacks, and chit-chat. Later, they retired to the guest rooms for a nap before changing their clothes for dinner . . . After overindulging in food and drink, the entourage strolled into the music room. During the short concert, several guests would talk incessantly, others would doze noisily, and the rest would listen intermittently. With the concert over, guests would again nap and change their clothes for the ball, where they would dance into the morning hours.[1]

While there is a great deal of truth to the above statement, there were certain courts where music was taken very seriously. In fact, some of the greatest courts for music were led by noblemen who were gifted musicians themselves. Emperor Joseph II played the cello (although the movie *Amadeus* shows him hacking away at a keyboard), Frederick the Great was a talented flutist, and Haydn's boss, Prince Nicolas Esterházy, frequently performed chamber music on the *baryton,* which was an early cousin of the cello. As you can well imagine, composers created a number of works for their masters to perform, and you can bet the people of the court were listening then.

Many historians view the birth of "Classical" music as a reaction against the overly complex polyphonic music being composed during the late Baroque period. As you saw in Chapter One, general dates such as 1750-1825 do a good job of defining the start and end of a major style period, but in truth, history is nowhere near that simple. Composers such as Couperin and even Vivaldi were writing music with "Classical" elements as early as 1730 or so. This period marks the high point of the patronage system, but the era also saw its downfall.

Emperor Joseph II.
Source: Jupiterimages, Corp.

More and more, public concerts became both an important source of exposure and financial income for composers of the day. The growing middle class throughout Europe and England had a great love for music, and this period saw a large growth in amateur music making. To our twenty-first-century minds the term "amateur" translates to "not very good," but the word really indicates a person with a great passion for something. Composers altered their styles to write music that was, in some cases, easier to play, but more importantly, immediately engaging and "singable" by their newfound audiences. Music was a hot topic of debate and discussion. New concerto performances by Mozart and Beethoven, or Haydn's public debuts of new symphonic composi-

The coronation of Emperor Joseph II. The Emperor was a great patron of the arts and a talented musician in his own right.
Source: Jupiterimages, Corp.

tions and oratorios in London and Paris, became major social events. Throughout Europe, trained professional musicians were in demand for private instruction, both public and private performances, and commissions of new compositions.

Composers such as C. P. E. Bach, J. C. Bach, and Johann Stamitz were gifted composers during the transition between the Baroque and Classical periods in music history. Today, their music is mostly overlooked or relegated to a few "historical" performance practice recordings, frequently on minor record labels that never hit store shelves outside major cities. Nonetheless, these pioneering composers broke ground for what was to become the "classic" styles and forms used by Haydn, Mozart, and Beethoven. The formal structures described in the following *Focus on Form: Sonata Cycle* were in their infancy and had not yet attained the sophistication and intricacies they would display as they matured. Regardless, these early works are genuine masterpieces in their own right. Perhaps the problem is that historians are trying to judge them by the wrong set of criteria. In the liner notes for a recent recording of "pre-Classical" symphonies, conductor Milan Munclinger offered the following observations:

> Historians of music have occasionally tended to treat somewhat less than generously those composers whom they find difficult to bracket within a clearly defined style. They may categorize them as "precursors", whereupon, judging their work by the same yardstick as that employed in assessing the achievements of the subsequent generation, they concentrate on determining those aspects where the composers in question "still lag behind", or where in their work this or other feature "appears only in its seminal form". But then, artists themselves seldom aspire to being "precursors and predecessors" of a new style; much rather, they engage in seeking such means of expression and forms as would most faithfully convey their own innermost feeling of music . . . It would therefore be a mistake to apply to [their] music the same criteria as those used in assessing the production of the Viennese Classical school, and then to identify [their] output [as] a "still undeveloped" sonata form which "lacks" either a subordinate idea or Classical-style development.[2]

harmonic rhythm

galant

Empfindsamkeit

Sturm und Drang

As previously mentioned, many of the compositional changes that took place during the mid-1700s were reactions to older, Baroque musical traditions. J. S. Bach had taken the art of polyphonic music about as far as it could go, and in the hands of lesser composers polyphony had become "over-ripe," leaving music in need of a fresh start. Beyond philosophical considerations, public demand for a more direct, single melody with a simple accompaniment was growing. Heightened emotional content became very important to musical consumers, and composers had to alter their musical styles to meet this new demand. These new textures were thin, with clear melodies built around short phrases of symmetrical lengths. Perhaps most importantly, the **harmonic rhythm**, or frequency with which the chords change, slowed dramatically. Where a fugue by J. S. Bach might change chords on every beat or two, these new works sat on the same basic harmony for a measure or two (and sometimes more) while the melody unfolded above. Another major change was the decline in the use of the *basso continuo* style accompaniment. This technique continued to be used in most orchestral settings, but it fell out of favor in almost all examples of chamber music and solo vocal works written during the Classical period.

Three stylistic alterations in particular are worth mentioning: *galant*, *Empfindsamkeit*, and *Sturm und Drang*. The *galant* style is musically just what the name implies. The music is graceful, gentle, sometimes playful, and always pleasant to the ear. *Empfindsamkeit* (sentimentality or sensibility) allowed composers more musical freedom to express powerful emotions in their music. This technique, found most commonly in slow movements, featured composers making sudden harmonic and/or rhythmic shifts while writing free-flowing, highly expressive melodies. *Sturm und Drang,* literally "storm and stress," was a popular literary style, and the ideas spilled over into both music and the fine arts. In multi-movement works, composers would frequently use two or even all three of these emotive compositional styles. Some good examples include the keyboard sonatas of C. P. E. Bach, where he would write a first movement in the *galant* style, a slow, emotionally charged second movement in the *Empfindsamer* style, and finally, close out with a fast "crash and bash" *Sturm und Drang* final movement. Later, Haydn, Mozart, and Beethoven would go much farther, blending all these individual emotional techniques into a single, streamlined musical statement, but their compositional ideas are built upon the works of these early pre-Classical masters.

Of particular importance was the birth of the modern symphony as a compositional format, along with the modern full symphony orchestra to play it. Throughout the Baroque era, operas had been accompanied by a symphony orchestra made up of a full string section that included violins, violas, cellos and basses, along with various wind and percussion instruments. We also saw similar orchestral layouts in various Baroque instrumental works, but there was no consistency to the format. Bach's orchestral suites and *Brandenburg* concertos, as well as Vivaldi's *Four Seasons* and numerous concertos for soloists and orchestra come to mind as examples of the diversity found in orchestal forces used in the Baroque era. In the earliest days of the Classical period, Johann Stamitz and the Mannheim orchestra codified both which instruments would be used in the orchestra and what format

the music would take. It is true that other composers played major roles in the evolution of the sonata cycle, but almost all of them modeled their orchestral layouts on the group at Mannheim. The idea of the symphony as an independent composition for instrumental forces grew out of the Baroque tradition of the Italian opera overture, or *sinfonia*. The overture was originally created in three sections, fast-slow-fast, and was instrumental music played before the drama began. Eventually these three-section pieces became works of three independent movements, and they made their way out of the opera house and into the concert hall. The idea of a "modern" symphony concert was off and running.

Perhaps more than any other era, form and clarity of musical structure during the Classical period played a major role in an audience's enjoyment of the music. Most concert audiences, both middle and upper class, were musically educated. They knew all the popular musical structures of the day, and when they were actually paying attention to the music, enjoyed picking out how different composers made subtle changes to expected musical conventions. Instrumental music in particular operated under a set of commonly used basic forms and formats that continue to be used by composers today. Here are a few definitions that will help you understand the formal structures used for instrumental music during the Classical period. The forms evolved first, and music historians and theorists slapped convenient terms on them later. Unfortunately, what is convenient for a classical musician can be quite confusing for a beginning audience member. Here are the three most confusing terms: *sonata, sonata cycle,* and *sonata form* (sometimes referred to as *sonata-allegro form*). The **sonata** is a multi-movement work for solo piano, or a work for one solo instrument with piano accompaniment. The term **sonata cycle** is the multi-movement format mentioned in the previous sentence. The confusing part here is the fact that the sonata cycle is not just used for sonatas. In fact, the sonata cycle is used in almost every type of Classical instrumental music you care to name. The symphony, the string quartet, the piano trio, the concerto, and the previously mentioned *sonata* all make use of some kind of multiple-movement layout. The typical sonata cycle format is made up of three or four contrasting movements with tempos that are usually (1) fast, (2) slow, (3) medium, and (4) really fast. As you will see in the following *Focus on Form*, the sonata cycle makes use of a number of different formal structures that help composers organize their thematic and harmonic ideas. By far the most common of these formal structures is the one traditionally used in the first movement of almost every sonata cycle called *sonata form*. **Sonata form** is a one-movement structure that must have an exposition, a development and a recapitulation. In addition, it can also have an introduction and a coda, but these two sections are optional. Because the first movement of almost every *sonata cycle* is fast, the first movement form was frequently called a *sonata-allegro form*. It means the same thing as *sonata form*, but the word "allegro" was added to remind you that the first movement in a *sonata cycle* is fast, which you already know, so that's it for all this "sonata-allegro form" stuff. Just be aware that you may still see the term used in the program notes at your local symphony concert or piano recital. From now on we will simply refer to it as sonata form, regardless of the tempo.

DIG DEEPER

BOOK
The Classical Style: Haydn, Mozart, Beethoven
by Charles Rosen

sonata

sonata cycle

sonata form

Focus on Form
The Sonata Cycle

As you just learned, the typical sonata cycle is a three- or four-movement format used by every instrumental combination found in the Classical period. The following chart will show you the most common single-movement forms used, as well as the tempos found in each individual movement. The real key to understanding both the overall sonata cycle format and the different sections found in each individual movement is to realize composers are always looking for contrast. They seek to offer the listener contrast by changing tempos, emotional content, and tonal centers, both sometimes within and always between each individual movement.

Movement	Form(s) Used	Common Tempos
First	sonata form	allegro (fast)
Second	sonata form	andante (walking tempo),
	rondo	adagio (slow), or largo
	theme and variation	or grave (really slow)
	simple three-part form (ABA)	
	sonata-rondo	
Third	minuet and trio (Haydn and Mozart)	allegretto (medium fast)
	scherzo and trio (Beethoven)	allegro (fast)
Fourth	sonata form	allegro (fast), vivace (really fast),
	rondo	or presto (really, really fast)
	theme and variation	
	sonata-rondo	

As far as instrumental music goes, the following single-movement forms are the most important formal structures you can learn. Get to know some of these basic thematic layouts, and you can listen to almost any symphony, string quartet, or solo sonata and have a pretty good idea of what is going on.

Sonata Form

Fast or slow, to have a sonata form you must have an exposition, a development, and a recapitulation. You can also have an introduction at the beginning of the movement and a coda tacked on to the end of the movement; however, both these sections are considered optional. The different sections of the movement do exactly what the titles imply.

exposition

The **exposition** "exposes" the thematic material to the listener for the first time. The first theme will be presented in the tonic key, followed by a transition where the composer will change from one key center to another. This transition is followed by a second and sometimes a third theme presented in a closely related key center. For contrast between the two themes, the first one tends to be dramatic and rhythmically active, whereas the second theme is usually more lyrical. During the Classical period (1750-1825) the entire exposition is normally repeated, a practice that ends as we move into the Romantic era. Also note that we are using the terms *first theme* and *second theme* to describe the different melodies found in the exposition. Other common terms that are frequently used to describe the same melodies include *subject, theme group* (especially during the Romantic and modern eras), and simply using the *letters A, B,* and *C* to represent the different themes as they go by.

In the **development,** the composer has a chance to experiment with the themes from the exposition. Here the composer frequently changes key centers and alters the thematic material by slightly changing the basic shape of the theme. For example, themes may go up instead of down, use faster or slower note lengths, use *stretto* (stacking of themes in different instrumental voices), or *dismemberment/fragmentation, where* the composer chops the theme up into tiny little bits and pieces, sometimes passing it around to different instruments.

Next comes the **recapitulation**, which is a restatement of the material mostly as you heard it in the exposition, with one exception: this time the composer won't change keys as he moves from the first to the second theme. The entire recapitulation will be presented in the tonic key. Of the two optional sections, the coda is the most commonly used. It will usually be seamlessly attached to the end of the recapitulation and serves to drive home the final tonic chords. Composers make use of an introduction only when the sonata form is a fast movement, and even then only occasionally. Since the movement is fast, composers typically write a slow introduction, again searching for the maximum musical contrast. Here is a little chart to help you understand the sonata form.

Optional introduction (slow)

Exposition	Development	Recapitulation
FIRST THEME (A) Tonic key	This area differs from work to work and composer to composer. This is the composer's chance to experiment with both melodic and harmonic ideas. Typically the composer will work with themes you heard in the exposition. Eventually, there will be a *retransition* that will shift the tonal center back to the original tonic key for the recapitulation.	FIRST THEME (A) Tonic key
Transition (changing key centers)		Bridge (transition) (no change of key center in recap.)
SECOND THEME (B) Closely related key		SECOND THEME (B) Tonic key
CLOSING THEME (C) Same closely related key (optional, but not uncommon)		CLOSING THEME (C) Tonic key
		Coda (optional, but very common)

Rondo Form

After the sonata form, the next most commonly used single-movement form is the rondo. This form is typically used in the second and fourth movements of the sonata cycle. There are two basic types of rondo structures, the five-part rondo and the seven-part rondo, and the real trick to both of them is the back and forth contrasting of the first theme with all of the subsequent themes. It's really all about letter A (the first theme). Memorize the thematic layout of the seven-part rondo, and you will also learn the five-part structure. We use simple letters to identify the different themes. The typical seven-part rondo layout is A-B-A-C-A-B-A. The quickest way to memorize it is to say it out loud, "ABACABA." The typical five-part rondo format simply leaves off the last statements of the B and A themes, or A-B-A-C-A. In general, you will find five-part rondos in the slow second movement of a typical sonata cycle, and the seven-part version tends to be used in the fast final movement; however, be aware that you can find a lot

development

recapitulation

of exceptions to the previous statement. There is a less common seven-part format that uses four themes instead of three, A-B-A-C-A-D-A. In addition, you will sometimes see apostrophe marks after the letters, which indicates some type of major alteration to the melodic, rhythmic, and/or harmonic structure of the melody. For example, the five-part rondo Beethoven uses in the second movement of the *Pathétique* sonata is A-B-A-C-A', with the last letter A' keeping the same melody as before but using a new rhythmic structure derived from the letter C theme. As with the sonata form, composers seeking maximum contrast will have one of the themes be more rhythmic, while another is more lyrical. The big difference with most rondo forms is the level of importance placed on the third theme (letter C). Particularly with the seven-part rondo, this will usually be the most dramatic part of the rondo. Since it is located in the middle of the structure (but it only happens once), the composer generally writes more material for letter C when compared to letters A or B because you will get to hear letter A three times and letter B twice. They only get one shot at letter C, so they better make it good.

Minuet and Trio
Scherzo and Trio

The minuet and trio is something of a stylistic holdover from the Baroque dance suite, which was actually something of a stylistic holdover from the Renaissance. The minuet is a triple meter waltz-styled dance. In the Baroque period, composers such as Bach and Handel used the rhythmic feel of some of these dance forms in their concert music. In the Classical period, the minuet was the only one composers kept using on a regular basis. Don't be confused by the term *trio*. Back in the Renaissance, and to some extent even during the Baroque period, if you wanted a group to play softer you simply wrote music for fewer instruments. They wanted the middle section of this particular dance softer, so they wrote the music for a trio instead of the full group. This same technique was not used in the Classical period, but the term continued to hang around. This movement typically functions as what we call a *compound form*. All this really means is that formal structures are functioning on two different levels. On the larger scale, the entire movement functions like a big three-part (ternary) form, or A-B-A. On a smaller scale, both the minuet and trio each function as individual two- or three-part forms called *rounded binary* and *ternary* respectively. Don't worry: it sounds more complicated than it is. We've already said that ternary follows an A-B-A format, or literally, play a theme, play a different melody (often in a different key center) and then go back to the first melody. *Rounded binary* simply means that the B theme is literally "rounded" off by an incomplete return to the letter A melody. The same is true in the trio, but here letter D is coupled with an incomplete return to part of the letter C melody. Finally, to make things just a little more complicated, individual sections would be repeated, except not always when the minuet comes back after the trio. Again, it sounds a lot more complicated than it actually is. Here's a little chart to help you visualize the structure. Of the two formats, the rounded binary is the more commonly used of the two.

Minuet (A)	Trio (B)	Minuet (A)
A-B-A	C-D-C	A-B-A
or	or	or
A-BA	C-DC	A-BA

This movement, almost always played as the third movement of a sonata cycle, tends to be the lightest and most symmetrical of the traditional four movements. If a composer decides to leave out a movement of the sonata cycle, this is the movement that gets omitted. For example, listen to Beethoven's *Pathétique* sonata. Notice that it is a three-movement work with no minuet and trio. In addition, this movement is always left out of solo concertos.

Beethoven created the **scherzo and trio** in an attempt to give the third movement of a four-movement sonata cycle more drama and to help it stand on a more equal footing with the other three movements. The literal translation of *scherzo* is joke, but in general Beethoven's "jokes" are more thought provoking than funny. With the scherzo, Beethoven increased the tempo of his third movements and intensified the melodic and harmonic content as well. Most of his symphonies and many of his string quartets have excellent examples of scherzo movements.

scherzo and trio

Theme and Variations

The title really explains it all here. Play a theme; then create some variations on that theme. Variation techniques include changing the accompaniment, changing the rhythm, varying the melodic shape, and changing the melody and harmony from a major key to a minor key. You have one of the most famous theme and variations ever written in your listening guides, the second movement of Haydn's *Symphony No. 94*, the "Surprise" symphony. As we move forward into the Romantic and modern eras, you will notice composers taking more liberties with the theme and variations format. Most of the early theme and variation movements are what we call *sectional,* where one variation clearly follows another. Later we'll start to see *continuous* variations where the individual variation techniques can be harder to pick up on. In the twentieth century you can also catch composers writing all the variations before they ever show you the actual theme, which makes things even more interesting.

Sonata-Rondo Form

The *sonata-rondo form* is the most famous of what are called "hybrid" forms. In its most common presentation the first A-B-A represents the exposition, letter C represents the development, and the last A-B-A will function as the recapitulation. Of course it's rarely that simple, and composers make subtle, and sometimes not-so-subtle, changes in their various compositions. For the purposes of this book, let's keep it simple. Like the regular rondo, the real key to understanding this format is hearing the first theme (letter A) as it keeps coming back throughout the movement. Find the letter A melody, and by listening through the piece a few times everything should pretty much fall into place for you. (Hint: It's really O.K. if you don't always hear every nuance in a formal structure. In fact, sometimes it's a nice surprise when you get a little lost in the music only to have the first letter A melody sneak up on you again.)

Carl Philipp Emanuel Bach (1714~1788)

Carl Philipp Emanuel Bach.
Source: Jupiterimages, Corp.

Known as the "Berlin Bach," Carl Philipp Emanuel Bach spent much of his career providing music for the court of Frederick the Great. In 1768 he moved to Hamburg, where he served as music director for all of the major churches in that city for the last 20 years of his life. Over the course of his career he composed early symphonies, concertos, oratorios, various music for the church, and a great deal of chamber music. His symphonies embrace both the *Empfindsamkeit* style and *Sturm and Drang*. Perhaps most important to the evolution of the Classical style were his keyboard sonatas. Early in his career C. P. E. Bach favored the clavichord, which was a softer, more intimate sounding instrument when compared to the harpsichord. As the second son (and musical student) of J. S. Bach, he first encountered this instrument in his father's home, where it was a favored instrument. His later works, however, are clearly written for the more modern *fortepiano*, which is the direct precursor to the grand piano we use today. This new instrument had a wider, more expressive dynamic range (soft to loud), as well as a greater sensitivity to touch, which allowed for a vast array of attacks from very gentle to quite percussive and harsh. His most famous keyboard sonatas include two collections of works titled the *Prussian* sonatas and the *Württemburg* sonatas, both of which laid the foundations for the mature sonata cycle and the single-movement sonata form found throughout the Classical period. In addition, C. P. E. Bach also contributed a major text on the subject of performance practices, titled *Versuch über die wahre Art das Clavier zu spielen* (Essay on the True Art of Playing Keyboard Instruments), which was published in two parts in 1753 and 1762.

Johann Christian Bach (1732~1795)

Johann Christian Bach, usually referred to as the "London" Bach, was the youngest son of J. S. Bach.[3] Upon the death of his father in 1750, J. C. Bach moved to Berlin where he continued his musical apprenticeship with his older brother, C. P. E. Bach. After continued studies in Italy, J. C. Bach took up residence in London where he became a professional opera composer and music master for the Queen of England. For many years he was in great demand as a composer, a teacher, and a pianist. Like his older brother, J. C. Bach wrote symphonies, keyboard works, and chamber music in the latest styles of *galant*, *Empfindsamkeit* and *Sturm und Drang*. Unlike both his father and his older brothers, he also enjoyed some success as an opera composer. His most important contributions lay in the area of keyboard compositions. He wrote over 40 solo concertos for *fortepiano* and orchestra, and these works had a direct impact on the compositions of Mozart. As a young child, Mozart spent almost a year in London, where he met J. C. Bach and admired his music. In fact, the young Mozart converted three of J. C. Bach's piano sonatas into concertos for piano and orchestra. It has also been suggested that Mozart's first piano concerto (K. 175), written in 1773, was directly modeled on the works of J. C. Bach.[4]

Johann Stamitz (1717~1757)

In 1720, Karl Philip, Elector of Palatine, moved his entire court to the city of Mannheim in southwestern Germany. Upon his death in 1742, Prince Karl Theodor, who ruled the court until 1799, succeeded him. Both rulers enjoyed

music, and Karl Theodor was actually a talented performer. Johann Stamitz joined the growing court orchestra as a violinist in 1741. He soon became concertmaster of the orchestra, and by 1750 was the Director of Instrumental Music for the entire court.[5] Stamitz was a strict director who demanded the highest levels of musicianship from his performers. As a composer, he exploited their talents with a wide range of musical gestures, all of which had a direct impact on the major Classical composers who followed. He developed compositional techniques such as the "Mannheim sigh," a gentle downward movement from one note to another, thus imitating a person sighing; the "Mannheim rocket," a fast ascending scale and/or broken chord passage; and the "Mannheim roll," which was a fast tremolo over a given passage of notes. Historian K. Marie Stolba describes Stamitz and his orchestra as follows:

> The orchestra at Mannheim became the largest and finest in Europe. In 1756 Stamitz had at his disposal 56 instrumentalists. The ensemble was famous for precision of attack, uniform bowing in the string sections, and the ability to produce the slightest dynamic nuances. Among the effective special effects that brought acclaim to the orchestra were (a) extended crescendos and diminuendos, ranging from softest *pianissimo* to loudest *fortissimo;* (b) unexpected general pauses that created great windows of silence; (c) measured tremolo; (d) the "roll," scale passages in measured tremolo, coupled with crescendo; and (e) the "Mannheim rocket," the rapid upward arpeggiation of a chord over a wide range. Discipline lay at the heart of the orchestra's fine performances. Stamitz controlled the ensemble with slight movements of his bow, a nod of his head, or a glance . . . Most of the musicians were exceptional in being virtuoso soloists as well as superb ensemble players; many were excellent composers.[6]

Stamitz is credited with many "firsts." In addition to the compositional techniques described above, he was one of the first composers to add extra wind players to the orchestral mix and to write for them in a more independent manner. He consistently adopted a three- or four-movement compositional plan (sonata cycle) that included a fast first movement, a slow second movement, a dance-like third movement, and a fast and exciting closing movement. Many historians point to Stamitz as the first to add the dance-like minuet and trio to the sonata cycle, but in all fairness, other composers have also been given credit for this distinction. Regardless, Stamitz used this four-movement format in a very consistent manner. Of particular importance was his treatment of the first movement formal structures, which were clear prototypes for the single-movement sonata form that dominated instrumental Classical music and is still used by many composers today. When Stamitz passed away in 1757, he was followed at Mannheim by Christian Cannabich (1731-1798). The great orchestral traditions Stamitz helped establish continued, and the orchestra became a model for all the great orchestras of Europe and eventually the entire western world.

František Benda (1709~1786)

The Benda family name has been associated with classical music for well over 200 years. Even today, there is a Benda family ensemble that continues to perform classical chamber music, much of it written by earlier generations of composers with the last name Benda. Our particular Benda, František (or Franz) served for many years at the court of Frederick the Great in Berlin, along with the likes of noted composers Johann Joachim Quantz and the previously mentioned C. P. E. Bach. Benda was internationally known as a virtuoso violinist, but he was also well respected as both a composer

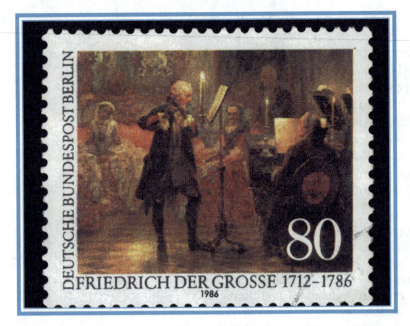

Commemorative postage stamp depicting Frederick the Great performing a flute concerto with C. P. E. Bach at the keyboard. It is possible that Franz Benda is one of the violinists. This is a detail from a much larger painting by Adolf Menzel.
© Shutterstock.com

and teacher. Like many gifted but lesser-known composers of this early Classical period, Benda was forced to wear many hats in order to support himself with a profession in music. For the sake of brevity, this book purposefully omits the stories of many talented musicians in each period of music. Consider Franz Benda as but one example of a musical life similar to those of composers such as Quantz, Sammartini, Dittersdorf, and Boccherini.

Using many of the techniques and orchestral ideas created by Stamitz and the Mannheim orchestra, the symphonic compositions of Franz Benda, along with those of C. P. E. Bach and the flute concertos of Quantz, helped define the sound and style of Berlin's royal court orchestra. Benda wrote at least ten *sinfonias,* and may well have composed others that are lost to us today or are of questionable origin. These early "symphonies" were three-movement works in the fast-slow-fast arrangement of the Italian opera overture. They are full of the emotional music techniques mentioned above in the discussion of the Mannheim school and the concepts of *galant, Empfindsamkeit,* and *Sturm und Drang.* His first movements are the most dramatic, followed by slow, emotional second movements and catchy, almost folk-like fast finales. In his autobiography, Benda, downplaying his own talents, wrote: "Never have I dreamed of composing strong and fugued works. Realizing the limitations of my talent, I have striven all the more to strip my violin sonatas of all elaboration, and write them in a song-like manner [the same can be said about his symphonies] . . . I feel no shame in confessing publicly that I will not be ranked among great contrapuntalists. Everyone is endowed with his own capacity, and may he do his utmost to excel in accord with this endowment."[7] Like the other composers mentioned above, Benda's formal structures served as "prototypes" for the mature works of master composers like Haydn, Mozart, and Beethoven.

Sinfonia in D Major (sine num.)

Franz Benda's *Sinfonia in D Major* serves as an excellent example of an early Classical symphony. Written in the three-movement format described above, the work is slightly unusual in Benda's collection of compositions in that he adds pairs of flutes and horns to his typical string orchestra. The work is very much in line with other contemporary compositions that were expanding both the size and tonal palette of the symphony orchestra. The first movement follows the sonata form, but it omits the development. It is this first movement that you will find as an example in the following listening guide. The second movement is written in a rounded binary form, and the bouncy last movement is a true sonata form complete with a development. Now the whole final movement is less than a minute and a half long, so you can imagine that the development is pretty short—four measures long and lasting about six seconds to be exact—but it's really cool how he pulls it off. Spend some time researching the "lesser" composers like Franz Benda, and you will discover hundreds of excellent little works like this one.

Listening Guide

Sinfonia in D Major (sine num.)
Movement 1—*allegro*
František Benda (1709-1786)

Format: Pre-Classical Symphony
Performance: Ars Rediviva, Milan Munclinger, conductor
Recording: *František Benda: 10 Sinfonie* (Supraphon 3646-2 012)

Performance Notes: Recorded between May 1969 and June 1973 at the Domovina Studios in Prague, Czechoslovakia. Extended recording dates encompass ten different three-movement *Sinfonias* composed by Benda and presented on the Supraphon label in a two CD box set.

Exposition

:00 Letter A, presented in the tonic key of D Major.

:22 Transition (or bridge)

:27 Letter B, presented in the dominant key center of A Major. Strong cadences on non-tonic chords.

:42 Closing theme. Music is now clearly in A Major.

Development

1:08 This movement has no "real" development, just a full cadence in the key of A Major, followed by an immediate return to the letter A melody in D Major.

Recapitulation

1:09 Letter A, presented in the tonic key of D Major.

1:31 Bridge. This time the piece does not transition to the dominant key center but, rather, stays in the tonic key for the last two themes.

1:36 Letter B, presented in the tonic key. As in the exposition, you will hear two strong cadences on non-tonic chords.

1:51 Closing theme. Music is now clearly in D Major.

2:16 Coda. Brief return to opening thematic material.

Christoph Willibald Gluck (1714-1787)

Though largely self-taught as a musician and composer, Gluck managed to revolutionize opera during the early days of the Classical period. Tired of the excesses singers, set designers, and, in some cases, dancers were imposing on opera during the late Baroque period, Gluck set out on a program to reform opera. Working in conjunction with the poet Raniero de Calzabigi and the choreographer Gasparo Angiolini, Gluck created operas such as *Orfeo ed Euridice* where the dramatic plotline was clearly defined and the singers were forbidden from making any major changes to the music, including taking out the intended arias only to substitute them with music they liked to sing, whether the lyrics had anything to do with the opera plot or not. The dance and the drama were clearly integrated into the plot, and every detail of the opera made sense, a big improvement over most late Baroque operas. Gluck's other major work, *Alceste*, marked another major

turning point for opera. In the introduction to the work, Gluck outlined some of the major changes he had made to the basic operatic format: "(1) to compose music devoid of superfluous ornamentation, expressive of the text, and appropriate to the circumstances in the drama; (2) to construct each aria in a form suited to the situation, rather than relying on traditional *da capo* [which many people thought stopped the flow of the drama, as you had to go back and sing the beginning of an aria again at the end of the song]; (3) to remove the sharp contrast between recitative and aria by using more *accompagnato* recitative and *arioso;* [and] (4) to relate the overture to the ensuing drama."[8] Historian K. Marie Stolba summed up Gluck's contributions to opera this way: "A master of characterization and the portrayal of human emotions, he was keenly aware of the importance of timing and adeptly positioned details in exact relationship to the total effect of the drama . . . Gluck's historical significance lies principally in his ability to establish an equilibrium between music and drama, to effect some reforms of opera seria, to revitalize *opéra comique,* and to blend elements of French *tragédie lyrique,* Italian opera seria, and German opera into a cosmopolitan Classic opera style."[9]

Christoph Willibald Gluck.
Source: Jupiterimages, Corp.

Franz Joseph Haydn (1732-1809)

Joseph Haydn was born in a small Austrian town near the border with Hungary. He demonstrated an early gift for music, studied the art briefly with his uncle, then entered St. Stephen's Cathedral in Vienna, where he served as a choirboy until his voice changed. For a time he supported himself working as both a performing musician and teacher. He apprenticed himself to the Italian composer and voice teacher Nicola Porpora, with whom he studied and served as accompanist for a time. Next he joined the court orchestra of Count Morzin, a minor nobleman, who split his time between Vienna and his native Bohemia (modern day Czechoslovakia). In 1761, Haydn accepted a court orchestra position with the powerful Esterházy family. His employer, Paul Anton Esterházy, and his brother and eventual successor, Prince Nicholas Esterházy, were both major patrons of the arts, especially music. Prince Nicholas in particular was a talented musician in his own right, frequently performing compositions Haydn wrote for him on the now obsolete *baryton,* which was a string instrument most closely related to the cello and string bass. As a court composer, musician, and eventually head of the entire musical empire at the Esterházy court, Haydn was a favored servant for over thirty years. He created a wealth of music in all the major genres, a great deal of which is sadly lost today.

Haydn's music reflects a playful sense of humor, which is readily apparent in many of his works, including the "Surprise" symphony (No. 94), part of which is found in one of the following listening guides. Haydn would intentionally write music in a suddenly unexpected key center, just to confuse the ears of his audiences. He would ask the string players to "mis-tune" one of their strings so they would always be playing "wrong" notes. In one of his most famous works, the "Farewell" symphony, he used a very unusual compositional technique to make

St. Stephen's Cathedral in Vienna where Haydn received his early training in the musical arts.
Source: Jupiterimages, Corp.

protest to his employer. Prince Esterházy and his family lived for much of the year in a palace in the countryside outside of Vienna. Haydn and the entire court orchestra came along, but as servants, the musicians were forced to leave their loved ones behind. One year the Esterházy's stayed out of town longer than usual, and the musicians began to complain to Haydn. As servants during this time, they could not simply file a complaint with the management. Instead, Haydn wrote a new symphony in the typical sonata cycle format. The last movement began as normal, in a fast, lively manner. As the work progressed, the tempo slowed down, and then all of a sudden a couple of musicians got up, blew out the candles on their music stands, and left the room. The music continued, but every few measures another musician or two would drop out, get up, and leave the room. By the end of the work there were only two violinists left on stage, and their gentle duet ends the work. The message to the Prince was, "Hey, dude, time to go home. Some of us would like to see our wives and/or girlfriends." The Prince got the message, and the musicians were allowed some time off. Only Haydn could have gotten away with such a stunt.

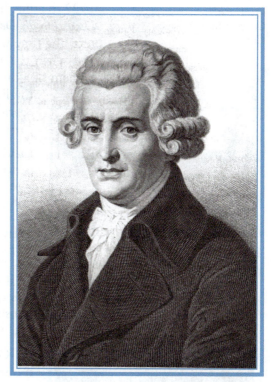

Franz Joseph Haydn.
Source: Jupiterimages, Corp.

DIG DEEPER

BOOK
Exploring Haydn – A Listener's Guide to Music's Boldest Innovator by David Hurwitz (with two listening CDs)

While still in the employ of the somewhat isolated Esterházy court, publications of some of Haydn's works began to circulate throughout Europe and England. His reputation as a master of composition spread rapidly, eventually influencing other composers including Mozart and Beethoven. Beginning in the 1780s, Haydn began to fulfill outside commissions in addition to his regular duties at court. When Prince Nicholas died in 1790, his son, Anton, no lover of great music apparently, released all of the musicians attached to his court. In a display of respect for Haydn, however, the composer was given a pension from the court. Haydn quickly found himself in great demand in both Paris and London, among other major musical centers. In two extended trips to London between 1791 and 1795, Haydn composed a number of his late masterpieces for use in public subscription concerts and on commission. His last 12 symphonies, known collectively as the *London* symphonies, are considered perfect expressions of the mature Classical symphonic style. In addition, Haydn composed oratorios, string quartets, and a number of other works that still enjoy regular performances in concert halls and recordings around the world today. During the last few years of his life, music returned to the Esterházy court, and Haydn again served as court composer in a limited capacity. Though in failing health during his later years, Haydn continued to write a series of very successful works, including his last string quartets and the oratorios *Die Schöpfung* (The Creation) and *Die Jahreszeiten* (The Seasons). Haydn died during the French occupation of Vienna in 1809. Though he never knew it, Napoleon Bonaparte had given his men strict instructions that the old composer was not to be disturbed in any way.

Instrumental Music

Haydn's catalog of instrumental compositions includes solo keyboard works, various duets and trios, 82 string quartets, concertos for violin and piano among other instruments, and 104 (really at least 107) compositions for full symphony orchestra. As was previously mentioned, historians are still discovering works Haydn may have written, as well as written documentation about, a number of

works for which we have no musical scores available. Haydn played a major role in codifying all of the individual forms discussed in the previous *Focus on Form*, as well as helping firmly establish the use of the sonata cycle format in a number of different instrumental configurations from the solo sonata, through the string quartet, to the concerto and symphony. Of particular importance from his vast output are the sets of String Quartets Op. 20, 33, 55, 76, and 77, which form the backbone of the entire repertory performed by most modern professional quartets. Also important are the last twelve *London* symphonies, which include such masterpieces at No. 92 (*Oxford*), No. 94 (*Surprise*), and No. 100 (*Military*). The following two listening examples will serve as a limited introduction to the instrumental compositions of Joseph Haydn.

A portrait of Franz Joseph Haydn in his later years.
Source: Jupiterimages, Corp.

String Quartet No. 77 in C major, "Emperor," Op. 76, No. 3

While traveling in England, Haydn heard that country's national anthem and decided Austria also needed such a national song for people to sing. He created the now famous melody titled *Gott erhalte Franz den Kaiser* (God protect Franz the Kaiser). The song was, in fact, adopted as the Austrian national anthem. In 1922 the tune had a new set of lyrics added to it, and it became a Nazi party song, *Deutschland, Deutschland, über alles* (literally, Germany over all). Again with new text, the tune was used as the national anthem for the German Federal Republic, and when the Berlin wall came down in the early 1990s, the song became the anthem of a unified Germany. In a letter to Haydn dated August 19, 1799, noted English music historian and critic Dr. Charles Burney wrote about hearing the new *Opus 76* string quartets and the "Emperor" theme in particular.

I had the great pleasure of hearing your new *quartetti (opera 76)* well performed before I went out of town, and never received more pleasure from instrumental music: they are full of invention, fire, good taste, and new effects, and seem the production, not of a sublime genius who has written so much and so well already, but of one of highly-cultivated talents, who had expended none of his fire before. The Divine Hymn [the Austrian national anthem and the "Emperor" theme in the No. 77 quartet], written for your imperial master, in imitation of our loyal song, "God save great George our King", [you know it as *God Save Our Royal Queen*] and set so admirably to music by yourself, I have translated and adapted to your melody, which is simple, grave, applicating, and pleasing.[10]

Haydn's home in Vienna.
Source: Jupiterimages, Corp.

Our listening example is the last movement of the work. Haydn messes with our ears a little bit at the start of this movement. This quartet is listed as being in a major key center, so the first and last movements should start and end using that key as tonic, or home base. Instead, Haydn starts us off in a minor key center, which has the subtle effect of making this closing movement even more dramatic than it might have been had he written the same melodic and rhythmic shapes in a major key. The first theme gives in to the "expected" major key only as we approach the very end of the movement. Also of particular interest are Haydn's subtle gestures toward the *Emperor* theme, which is the basis for the entire second movement.

Listening Guide

String Quartet No. 77 in C Major, "Emperor," Op. 76, No. 3
Movement IV—*Finale. Vivace assai*
Franz Joseph Haydn (1732-1809)

Format: Sonata form
Performance: Panocha Quartet
Recording: *Haydn: String Quartets Op. 76, Nos. 1–3* (Supraphon 11 1408-2)

Performance Notes: "The Panocha Quartet was founded by students of the Prague Conservatory under the guidance of their teacher, Josef Micka, subsequently operating for some time under the sponsorship of the Smetana Quartet. Its present lineup dates from 1971. Over the years the Panocha Quartet has built up a broad repertoire centered on the world's quartet classics. Its concert performances and numerous recordings have earned the ensemble high acclaim of critics and the public at home and internationally." This particular recording, made in 1991 and released in 1993, includes the first three quartets from the Opus 76 set of six.

Liner notes from Supraphon 11 1408-2

Exposition

:00 Theme one begins with three strong chords, followed by a brief lyrical gesture derived from the *Gott erhalte* melody. This is followed by subsequent alternations in a similar manner.

:24 Transition (bridge). Simple turning figure in the top violin part is an expanded reference to the *Gott erhalte* theme.

:38 Theme two continues the more lyrical melodic ideas but now in a closely related major key center. Haydn segues very smoothly out of the transition and into the second theme, which is itself built on material you have already heard. The easiest way to pick it up is to hear it start in the top violin part, and notice how it is passed down quickly to the rest of the quartet. Don't worry if you don't quite catch the start because it is very easy to find the end of it.

:53 Theme three returns to the stronger rhythmic ideas of the first theme, but we stay in the closely related major key center established with theme two.

1:24 Exposition repeats.

Development

2:48 Haydn begins the development by working on theme two. Quickly he introduces the triplet rhythmic feel that accompanies both theme one and theme three, but he uses it with theme two. All the while the harmony keeps shifting around, making our ears feel quite unsettled.

3:01 The farther Haydn gets into his development, the more the lyrical theme gives way to more active rhythmic figures. Finally, we come crashing into the recapitulation, where we find the opening three chords still played in c minor instead of C Major, where they ought to be.

Recapitulation

3:41 Theme one returns, but the second half is significantly altered.

4:04 Transition (bridge). In a typical sonata form we would not be changing key centers at this point, but who said Haydn was ever "typical?" The active triplet feel from theme one is used in contrast with the more lyrical idea as we move from the minor key to C Major, where we should have been all along. When compared to the exposition, Haydn spends more time on this section in the recapitulation. Once again, don't worry if you can't hear all of these harmonic shifts. Just be aware that they are going on. It's little alterations like this that make Haydn's music so special.

4:20 Haydn comes to a full stop and changes key centers, but the first few bars after the break are still part of the transition. As before, the actual point of arrival for theme two is a bit hard to pick out.

Coda

4:58 Coda. We don't really get back to theme three in all its glory as we heard it in the exposition. Instead, Haydn uses this time to close out the work with a strong focus on the tonic chord in the key of C Major.

Symphony No. 94 in G Major, "Surprise"

This symphony was written during Haydn's first successful trip to London, where the composer enjoyed great success late in his career. This four-movement composition is a typical example of Haydn's final symphonic works with the exception of the second movement. One story goes that he was trying to insert something novel into this piece that would distract the London public from the music of one of his rivals. Another version of this work's creation suggests that Haydn became frustrated with how people would fall asleep during the slower and softer movements of his works, as with most typical second movements found in sonata cycles. The listening example below addresses this problem head on. You can almost hear Haydn's thoughts about the audience as he watches them during the performance: "Come on, try to sleep through this one. I *dare* you!" It's a pretty good story either way and a truly unique second movement of a symphony.

Listening Guide

Symphony No. 94 in G Major, "Surprise"
Movement II—*Andante*
Franz Joseph Haydn (1732-1809)

Format: Theme and variations
Performance: Wiener Akademie, Martin Haselböck, conductor and continuo
Recording: *Haydn: Symphonies No. 73, 94 & 30* (Novalis 150045-2)

Performance Notes: This recording was made in 1989, but if there had been a good tape recorder around during one of Haydn's concerts this is what his orchestra might have sounded like. The musicians of the *Wiener Akademie,* or Vienna (Austria) Academy, all play on original instruments from the 1700s or exact modern copies of these traditional instruments. Now that we have reached the Classical period (1750-1825), you can really hear some big differences between a "modern" versus an "authentic" performance. The overall pitch (tonal center) of the orchestra is lower. The string instruments have softer "gut" strings as compared to the steel strings used today. Furthermore, their bows are "looser" and place less pressure on these softer strings. In general, the wind instruments have more gentle sounds, though they can be a great deal more difficult to play. Overall, the orchestra is much smaller when compared to

a modern orchestra like the Chicago Symphony. Finally, you'll notice that the conductor, Martin Haselböck, is also listed as a continuo player. As you learned in the Baroque era, the most common instruments for continuo playing are some sort of bass-voiced instrument along with a keyboard instrument to fill in the notes of the chords. Modern performances of Classical works rarely make use of a keyboard for continuo, but during the time of Haydn, Mozart, and Beethoven the practice of using a keyboard for extra support of the orchestra was quite common. Most common was the early *fortepiano*, which was growing in popularity throughout the Classical era. For a quick comparison of the sound differences between "modern" and "authentic" performance practices, go back and forth between this recording (and Mozart's Symphony No. 40) and the 1960 Czech Chamber Orchestra recording of the *Eine Kleine Nachtmusik*.

Theme

:00 The main theme is introduced. If you ever studied beginning piano, this is the famous "Papa Haydn's dead and gone, but his music lingers on . . ." theme.

:17 Haydn repeats the entire theme, but this time he adds a big chord at the end to wake up all the patrons who kept falling asleep during the second movements of other works that he composed. Surprise!

:35 A contrasting theme is introduced, which Haydn also repeats. This melody is simply to lull you into a false sense of security.

Variation 1

1:08 In this first variation, Haydn keeps his original theme in the lower strings while adding a new theme above in the 1st violins.

1:39 The contrasting theme from above is also treated in a similar manner.

Variation 2

2:11 This is mostly a harmonic variation. Haydn changes the entire mood of the piece by moving the melody from a happy sounding major key to a more somber and dramatic minor one. Notice also that the orchestration is darker sounding here and that he messes around with the rhythmic accompaniment a bit.

Variation 3

3:19 Haydn goes back to a major key center here and really starts to experiment by adding more rhythmic complexity to the original melody. Notice the addition of lots of percussion to this section. This part really gets rocking for a movement that is supposed to be slow, quiet and pretty. No one is going to sleep through this one.

Variation 4

4:21 This is the "kitchen sink" variation. Here, Haydn pulls out all the stops. Again, Haydn seems to be saying "no sleeping, please" to his audience.

Coda

5:36 Now that we have reached the end of the movement, Haydn reigns things in a little bit, with a return to re-harmonized statements of the original melody. These final statements sound kind of poignant after all the big stuff we have just been through.

Vocal Music

Haydn's output of vocal music continues to grow in both popularity and the esteem of musicologists as the years go by. As a court composer, Haydn was required to create operas in the popular styles of the day. It has been said that he was not very comfortable writing in this particular genre, and although his works were well received at the time, they are rarely performed today. In fact, at least five of them have been lost to history. His most famous operatic work was the heroic drama *Armida,* which he completed in 1784. The work is noted for its powerful accompanied recitatives and arias.[11] Most of his opera output was in Italian, but he also created several operatic works in German that were to be performed by a marionette theatre (yes, puppets, but with live singers), which was a popular court diversion of the day. Haydn wrote a number of very successful masses and oratorios for soloists, chorus, and orchestra, some of which are still performed on a regular basis. The most famous of these works were written for performance in London during the later years of Haydn's life, and they include the previously mentioned oratorios and the *Missa in angustiis* (Mass for Troubled Times), which is also known as the *Lord Nelson* mass.

Mozart's birthplace in Salzburg, Austria.
Source: Jupiterimages, Corp.

Wolfgang Amadeus Mozart (1756~1791)

Although he is universally known as Wolfgang Amadeus Mozart, he was actually christened Johannes Chrysotomus Wolfgangus Theophilus, which must have been tough to get printed up on a business card. Considered by many to be the single most gifted composer of all time, Mozart was a child prodigy whose genius burned brightly and flamed out before he turned 36 years old. In many ways his work represents the culmination of the Classical era. Haydn codified the groundwork for the period, and Beethoven escorted the Classical style into a new era of Romanticism, thus leaving the "perfected" middle ground to Mozart. The truth is not nearly that simple, of course, but it makes for a neat and tidy story. Historically, it also places Mozart right where he needs to be, smack in the middle of everything.

His father, Leopold, was a talented composer and performer in his own right, who made a name for himself as a court musician in Salzburg. Both Wolfgang and his older sister, named Maria Anna but always referred to as Nannerl, displayed an early gift for the musical arts. Wolfgang was successfully performing as a pianist by age three, and by the time he was five years old he had written his first compositions. He wrote his first symphony at age nine, and by age twelve he had finished his first opera. Realizing the fact that he had something of a goldmine on his hands, Leopold set aside his own career and, after receiving permission from his employer, took his children on extended tours of all the great courts of Europe. As a very

young boy Mozart had the opportunity to perform for numerous heads of state as well as most of the wealthy aristocrats who surrounded the great courts. He enjoyed musical encounters with composers including J. C. Bach and Haydn, from whom he learned a great deal. He studied counterpoint with the Italian composer and theorist Martini and studied the symphonic practices of G. B. Sammartini while in Milan. Mozart was able to improvise entire new works when given a simple theme, and he could reproduce from memory the works of other musicians after just one hearing. He was, by every definition of the term, a child prodigy. The following article is a contemporary account written in 1769 by Daines Barrington (an English lawyer) for the Royal Society in London.

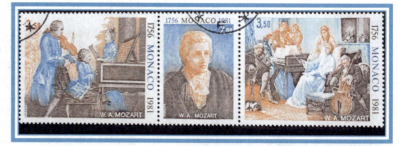

Commemorative postage stamps featuring Leopold Mozart and his children (far left) along with other images from the life of W. A. Mozart.
© Shutterstock.com

 eport on Mozart by Daines Barrington

Received November 28, 1769.
Account of a very remarkable young musician.

In a Letter from the Honourable Daines Barrington,
F.R.S. to Mathew Maty, M.D. Sec. R.S.
Read Feb. 15, 1770.

Sir,

If I was to send you a well attested account of a boy who measured seven feet in height, when he was not more than eight years of age, it might be considered as not undeserving the notice of the Royal Society.

The instance which I now desire you will communicate to that learned body, of as early an exertion of most extraordinary musical talents, seems perhaps equally to claim their attention.

Joannes Chrysostomus Wolfgangus Theophilus Mozart, was born at Saltzbourg in Bavaria, on the 17th of January, 1756[1].

[1] I here subjoin a copy of the translation from the register at Saltzbourg, as it was procured from his excellence Count Haslang, envoy extraordinary and minister plenipotentiary of the electors of Bavaria and Palatine:

"I, the under-written, certify, that in the year 1756, the 17th of January, at eight o'clock in the evening, was born Joannes Chrysostomus Wolfgangus Theophilus, son of Mr. Leopold Mozart, organist of his highness the prince of Saltzbourg, and of Maria Ann his lawful wife (whose maiden name was Pertlin), and christened the day following, at ten o'clock in the morning, at the prince's cathedral church here; his godfather being Gottlieb Pergmayr, merchant in this city. In truth whereof, I have taken this certificate from the parochial register of christenings, and under the usual seal, signed the same with my own hand.

Saltzbourg,
Jan. 3, 1769.

Leopald Comprecht,
Chaplain to his Highness in this city."

I have been informed by a most able musician and composer, that he frequently saw him at Vienna, when he was little more than four years old.

By this time he not only was capable of executing lessons on his favorite instrument the harpsichord, but composed some in an easy stile and taste, which were much approved of.

His extraordinary musical talents soon reached the ears of the present empress dowager, who used to place him upon her knees whilst he played on the harpsichord.

This notice taken of him by so great a personage, together with a certain consciousness of his most singular abilities, had much emboldened the little musician. Being therefore the next year at one of the German courts, where the elector encouraged him, by saying, that he had nothing to fear from his august presence; Little Mozart immediately sat down with great confidence to his harpsichord, informing his highness, that he had played before the empress.

At seven years of age his father carried him to Paris, where he so distinguished himself by his compositions, that an engraving was made of him.

The father and sister who are introduced in this print, are excessively like their portraits, as is also little Mozart, who, is stiled "Compositeur et Maitre de Musique, agé de sept ans."

After the name of the engraver, follows the date, which is in 1764; Mozart was therefore at this time in the eighth year of his age.

Upon leaving Paris, he came over to England, where he continued more than a year. As during this time I was witness of his most extraordinary abilities as a musician, both at some publick concerts, and likewise by having been alone with him for a considerable time at his father's house; I send you the following account, amazing and incredible almost as it may appear.

I carried to him a manuscript duet, which was composed by an English gentleman to some favourite words in Metastasio's opera of Demofoonte.

The whole score was in five parts, viz. accompaniments for a first and second violin, the two vocal parts, and a base. I shall here likewise mention, that the parts for the first and second voice were written in what the Italians stile the *Contralto* cleff; the reason for taking notice of which particular will appear hereafter.

My intention in carrying with me this manuscript composition, was to have an irrefragable proof of his abilities, as a player at sight, it being absolutely impossible that he could have ever seen the music before.

The score was no sooner put upon his desk, than he began to play the symphony in a most masterly manner, as well as in the time and stile which corresponded with the intention of the composer.

I mention this circumstance, because the greatest masters often fail in these particulars on the first trial.

The symphony ended, he took the upper part, leaving the under one to his father.

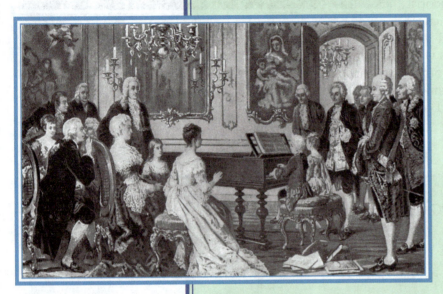

While still young children, Mozart and his sister entertained royalty throughout Europe.
Source: Jupiterimages, Corp.

His voice in the tone of it was thin and infantine, but nothing could exceed the masterly manner in which he sung.

His father, who took the under part in this duet, was once or twice out, though the passages were not more difficult than those in the upper one; on which occasions the son looked back with some anger pointing out to him his mistakes, and setting him right.

He not only however did complete justice to the duet, by singing his own part in the truest taste, and with the greatest precision: he also threw in the accompaniments of the two violins, wherever they were most necessary, and produced the best effects.

It is well known that none but the most capital musicians are capable of accompanying in this superior stile.

As many of those who may be present, when this letter may have the honour of being read before the society, may not possibly be acquainted with the difficulty of playing thus from a musical score, I will endeavour to explain it by the most similar comparison I can think of.

I must at the same time admit, that the illustration will fail in one particular, as the voice in reading cannot comprehend more than what is contained in a single line. I must suppose, however, that the reader's eye, by habit and quickness, may take in other lines, though the voice cannot articulate them, as the musician accompanies the words of an air by his harpsichord.

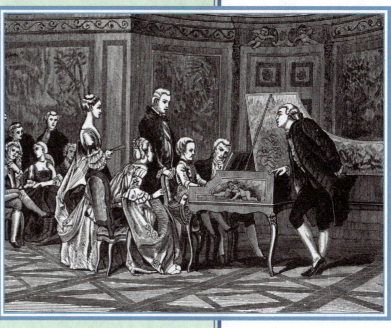

Another scene of the young Mozart performing for royalty. **Source:** Jupiterimages, Corp.

Let it be imagined, therefore, that a child of eight years old was directed to read five lines[1] at once, in four[2] of which the letters of the alphabet were to have different powers.

For example, in the first line A, to have its common powers.

In the second that of B. In the third of C. In the fourth of D.

Let it be conceived also, that the lines so composed of characters, with different powers, are not ranged so as to be read at all times one exactly under the other, but often in a desultory manner.

Suppose then, a capital speech in Shakespeare[3] never seen before, and yet read by a child of eight years old, with all the pathetic energy of a Garrick.

Let it be conceived likewise, that the same child is reading, with a glance of his eye, three different comments on this speech tending to its illustration; and that one comment is written in Greek, the second in Hebrew, and the third in Etruscan characters.

Let it be also supposed, that by different signs he could point out which comment is most material upon every word; and sometimes that perhaps all three are so, at others only two of them.

[1] By this I mean, The two parts for the violins. The upper part for the voice. The words set to music. And lastly, the base.
[2] By this I mean, The violin parts in the common treble cleff. The upper part for the voice in the contralto cleff as before-mentioned. The words in common characters. And the base in its common cleff.
[3] The words in Metastasio's duet, which Mozart sung, are very pathetic.

When all this is conceived; it will convey some idea of what this boy was capable of, in singing such a duet at sight in a masterly manner from the score, throwing in at the same time all its proper accompaniments.

When he had finished the duet, he expressed himself highly in its approbation, asking with some eagerness whether I had brought any more such music.

Having been informed, however, that he was often visited with musical ideas, to which even in the midst of the night, he would give utterance on his harpsichord; I told his father that I should be glad to hear some of his extempory compositions.

The father shook his head at this, saying, that it depended entirely upon his being as it were musically inspired, but that I might ask him whether he was in humour for such a composition.

Happening to know that little Mozart was much taken notice of by Manzoli, the famous singer, who came over to England in 1764, I said to the boy, that I should be glad to hear an extempory *Love Song,* such as his friend Manzoli might choose in an opera.

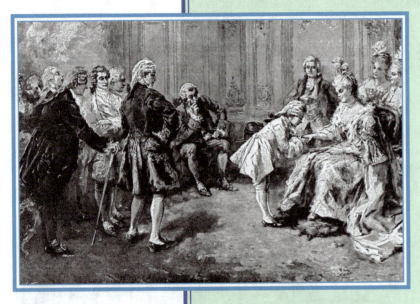

Mozart meets Madame Pompadour.
Source: Jupiterimages, Corp.

The boy on this (who continued to sit at his harpsichord) looked back with much archness, and immediately began five or six lines of a jargon recitative proper to introduce a love song.

He then played a symphony which might correspond with an air composed to the single word, *Affetto.*

It had a first and second part, which, together with the symphonies, was of the length that opera songs generally last: if this extempory composition was not amazingly capital, yet it was really above mediocrity, and shewed most extraordinary readiness of invention.

Finding that he was in humour, and as it were inspired, I then desired him to compose a *Song of Rage,* such as might be proper for the opera stage.

The boy again looked back with much archness, and began five or six lines of jargon recitative proper to precede a *Song of Anger.*

This lasted also about the same time with the *Song of Love;* and in the middle of it, he had worked himself up to such a pitch, that he beat his harpsichord like a person possessed, rising sometimes in his chair.

The word he pitched upon for this second extempory composition was, *Perfido.*

After this he played a difficult lesson, which he had finished a day or two before[1]: his execution was amazing, considering that his little fingers could scarcely reach a fifth on the harpsichord.

[1] He published six sonatas for the harpsichord, with an accompaniment for the violin, or German flute, which are sold by R. Bremner, in the Strand, and are intituled, Oeuvre Trois*me*.
 He is said in the title page to have been only eight years of age when he composed these sonatas.
 The dedication is to the Queen, and is dated at London, January 8, 1765.
 He subscribes himself, "tres humble, et tres obeissant *petit* serviteur."
 These lessons are composed in a very original stile, and some of them are masterly.

His astonishing readiness, however, did not arise merely from great practice; he had a thorough knowledge of the fundamental principles of composition, as, upon producing a treble, he immediately wrote a base under it, which, when tried, had very good effect.

He was also a great master of modulation, and his transitions from one key to another were excessively natural and judicious; he practised in this manner for a considerable time with an handkerchief over the keys of the harpsichord.

The facts which I have been mentioning I was myself an eye witness of; to which I must add, that I have been informed by two or three able musicians, when Bach the celebrated composer had begun a fugue and left off abruptly, that little Mozart hath immediately taken it up, and worked it after a most masterly manner.

Witness as I was myself of most of these extraordinary facts, I must own that I could not help suspecting his father imposed with regard to the real age of the boy, though he had not only a most childish appearance, but likewise had all the actions of that stage of life.

For example, whilst he was playing to me, a favourite cat came in, upon which he immediately left his harpsichord, nor could we bring him back for a considerable time.

He would also sometimes run about the room with a stick between his legs by way of a horse.

I found likewise that most of the London musicians were of the same opinion with regard to his age, not believing it possible that a child of so tender years could surpass most of the master(s) in that science.

I have therefore for a considerable time made the best inquiries I was able from some of the German musicians resident in London, but could never receive any fur-

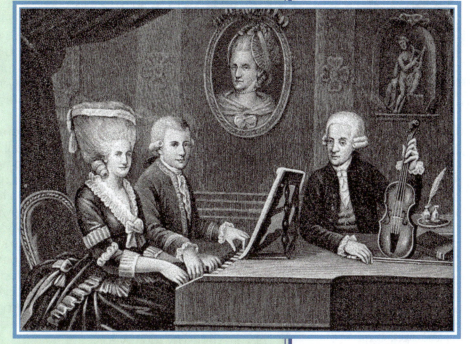

A later painting of Mozart and his sister at the piano with their father, Leopold Mozart, holding the violin.
Source: Jupiterimages, Corp.

ther information than he was born near Saltzbourg, till I was so fortunate as to procure an extract from the register of that place, through his excellence count Haslang.

It appears from this extract, that Mozart's father did not impose with regard to his age when he was in England, for it was in June, 1765, that I was witness to what I have above related, when the boy was only eight years and five months old.

I have made frequent inquiries with regard to this very extraordinary genius since he left England, and was told last summer, that he was then at Saltzbourg, where he had composed several oratorios, which were much admired.

I am also informed, that the prince of Saltzbourg, not crediting that such masterly compositions were really those of a child, shut him up for a week,

during which he was not permitted to see any one, and was left only with music paper, and the words of an oratorio.

During this short time he composed a very capital oratorio, which was most highly approved of upon being performed.

Having stated the above-mentioned proofs of Mozart's genius, when of almost infantine age, it may not be improper perhaps to compare them with what hath been well attested with regard to other instances of the same sort.

Amongst these, John Barratier hath been most particularly distinguished, who is said to have understood Latin when he was but four years old, Hebrew when six, and three other languages at the age of nine.

This same prodigy of philological learning also translated the travels of Rabbi Benjamin when eleven years old, accompanying his version with notes and dissertations. Before his death, which happened under the age of twenty, Barratier seems to have astonished Germany with his amazing extent of learning; and it need not be said, that its increase in such a soil, from year to year, is commonly amazing.

Mozart, however, is not now much more than thirteen years of age, and it is not therefore necessary to carry my comparison further.

The Rev. Mr. Manwaring (in his *Memoirs of Handel*) hath given us a still more apposite instance, and in the same science.

This great musician began to play on the clavichord when he was but seven years of age, and is said to have composed some church services when he was only nine years old, as also the opera of Almeria, when he did not exceed fourteen.

Mr. Manwaring likewise mentions that Handel, when very young, was struck sometimes whilst in bed with musical ideas, and that, like Mozart, he used to try their effect immediately on a spinnet, which was in his bedchamber.

I am the more glad to state this short comparison between these two early prodigies in music, as it may be hoped that little Mozart may possibly attain to the same advanced years as Handel, contrary to the common observation that such *ingenia praecocia* are generally short lived.

I think I may say without prejudice to the memory of this great composer, that the scale most clearly preponderates on the side of Mozart in this comparison, as I have already stated that he was a composer when he did not much exceed the age of four.

His extemporary compositions also, of which I was a witness, prove his genius and invention to have been most astonishing; least however I should insensibly become too strongly his panegyrist, permit me to subscribe myself, Sir,

> Your most faithful
> humble servant,
> *Daines Barrington.*

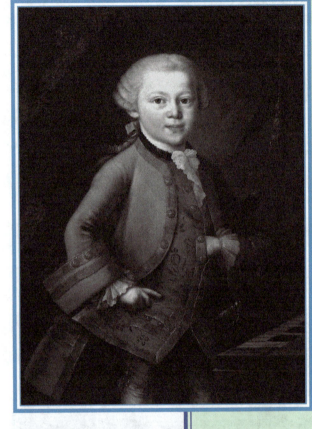

Portrait of Mozart as a boy.
Source: © 2009 Jupiterimages, Corp.

From Deutsch, Otto Erich, translated by Eric Blom, Peter Branscombe, and Jeremy Noble. *Mozart: A Documentary Biography.* Copyright © 1965 by A. and C. Black Ltd.

As Mozart grew older, the novelty of his amazing talent wore off and he returned to Salzburg, where he had a contentious relationship with the Archbishop. He labored in relative obscurity for several years, composing some interesting early symphonies as well as some successful violin concertos. The Archbishop continually denied him permission to travel, so in 1777 Mozart requested his outright release from the court. Traveling with his mother, Mozart struck off on another major tour. Leopold remained in Salzburg in order to protect his position with the court. Mozart visited the famous musical court at Mannheim, where he received commissions for a number of works that featured the flute. He only completed two concertos (and one of those was a transcription of his oboe concerto) and two quartets, perhaps owing to the fact that he was never particularly fond of the instrument. He was, however, quite taken with the clarinet, which he saw being used in the Mannheim orchestra. Also in Mannheim he met and fell in love with the singer Aloysia Weber. Later, in Munich, she rejected him, but he would eventually marry Constanze Weber, Aloysia's younger sister. While visiting Paris on the same trip, Mozart's mother passed away, which was a tremendous blow to the entire family.

Interior view of the cathedral in Salzburg. Mozart performed here frequently as a young man.
Source: Jupiterimages, Corp.

Mozart eventually returned to Salzburg, where he assumed the post of organist for the Archbishop. For the next few years he trained the church choirboys and composed whatever music was required of him, including both sacred and secular works. After encountering more problems with the Archbishop, Mozart again asked for his release. At first his request was denied, but he finally angered the Archbishop enough that some reports tell us he was literally kicked out the door. This time Mozart abandoned the patronage system for good. He moved to Vienna, married Constanze, and spent the rest of his short life creating one masterpiece after another. Unfortunately, the creation of great musical works does not always translate into great personal wealth. Mozart did make money. In fact, he could have lived a rather comfortable existence on his income, but he had grown quite fond of the finer things in life and money just seemed to slip through his fingers. He was forever borrowing money from friends and offering subscription concerts where he

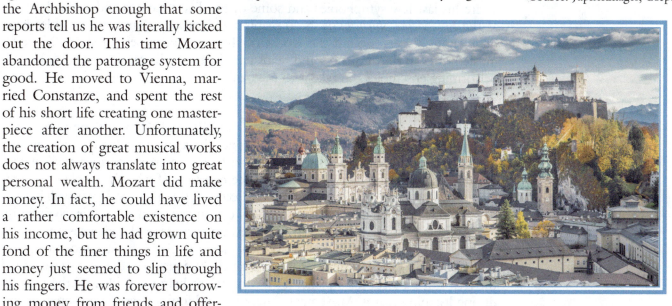

Panoramic view of Salzburg and the surrounding mountains. The large structure in the middle of the photograph is Hohensalzburg fortress.
© Shutterstock.com

received the proceeds from the sale of tickets. Mozart actually wanted to attach himself to the court of Emperor Joseph II, but a full-time appointment never came.

Mozart's greatest public successes came with his composition of operas, both German *Singspiele* and Italian *operas buffa*, and in the creation and performance of piano concertos. As a composer, however, he applied his genius to every musical

form in existence during the Classical era. His last three symphonies are considered to be perfect examples of the mature Classical style, and his string quartets are equal in stature to the works of Haydn. In fact, the two composers had the greatest respect for one another and were actually known to have played each other's quartets in a group together. Another one of his late compositions, the *Clarinet Concerto in A Major*, K. 622, is considered by many to be the finest concerto ever written for any instrument. Mozart died less than a year after he completed this work, along with his last two operas, *Die Zauberflöte* (The Magic Flute) and *La Clemenza di Tito* (The Clemency of Titus). Beyond these last works, he also left behind a partially completed *Requiem*, K. 626, from which you have two listening examples. The story that upon his death, Mozart was unceremoniously buried in a pauper's grave has been somewhat blown out of proportion. While it is true that he was buried in a communal grave, this was actually the typical burial practice of the day in Vienna, as decried by Emperor Joseph II in 1784. He actually had a "proper" funeral conducted at St. Stephen's Cathedral in the heart of Vienna.

Instrumental Music

Mozart's extensive output of instrumental music would be impressive for any composer, but it is especially amazing when you take into consideration the young age at which he died. He wrote at least 41 symphonies (some historians now place that number at over 50), 27 concertos for piano and orchestra, solo concertos for various other instruments, and over 20 string quartets. His instrumental output also includes a wide array of other chamber music, as well as various other compositions for the full symphony orchestra. Finally, his works for solo piano, which include 35 sonatas along with a large number of other works, are mainstays of solo piano literature. In any given orchestral season, you are bound to hear several works by Mozart programmed. His piano concertos in particular are very popular, as are his last few symphonies and some of his divertimentos and serenades such as the *Eine kleine Nachtmusik*. Solo pianists and various chamber ensembles have built entire careers around the works of this one composer. In short, Mozart's music brings in the audiences and helps pay the bills. His music is solid gold, and performing ensembles can take it to the bank.

Symphony No. 40, K. 550

Mozart's last three symphonies, Nos. 39, 40, and 41, were composed in a very short amount of time in 1788. Historians have been unable to find any sort of commission for these works, and Mozart had no pressing performances where new works of this nature were needed. The question of why the works were created may always go unanswered, but the success of the final product is well known to all lovers of great music. The second work in the group of three, Symphony No. 40 in g minor, is particularly well liked by both general audiences and music students alike. The work's first movement has one of the most famous opening themes in all of Classical music, to which music students over the years have added the lyrics "it's a bird, it's a plane, it's a Mozart" to help them identify the melody during listening exams. Movements one, two, and four are written in sonata form, while the third movement is a particularly dramatic little minuet and trio. This is a work that rewards repeated hearings with the continued discovery of new and ever more intricate musical details. In particular, notice how Mozart manipulates the first theme you hear, offering us brief glimpses of its basic elements in the subsequent themes of the exposition, followed by a development that is completely devoted to this one melody.

Listening Guide

Symphony No. 40, K. 550
Movement I—*Allegro molto*
W. A. Mozart (1756-1791)

Format: Sonata form
Performance: Zürcher Kammerorchester, Howard Griffiths, conductor
Recording: *Mozart: Sinfonien Nr. 38 & 40* (Novalis 150 148-2)
Performance Notes: Recorded April 1998 in Zürich-Altstetten, Switzerland.

Exposition

:00 First theme (A) in the tonic key. This is the famous theme for which generations of music students have used the lyrics "it's a bird, it's a plane, it's a Mozart." Try it. It really works, and if you can pick out this theme throughout the movement you will really get a good sense of how Mozart worked with thematic material.

:28 Transition (or bridge). Notice how active and unsettled the rhythm and harmony of the piece have become. Mozart is using all this activity to move from one key center to another. As we arrive in the new key center and get ready for the second theme, notice that Mozart marks this arrival very clearly with a strong cadence followed by a brief but very effective silence.

:44 Second theme (B) in a closely related key (in this case it is the relative major). Notice that this theme is more lyrical and "happier" sounding, as it is presented in a major key. This theme is followed by a closing theme—sometimes called letter C or sometimes referred to as a codetta—that actually hints at the "it's a bird, it's a plane" idea found in the first theme. Nonetheless, we are still in the new key center.

1:46 Repeat of the entire exposition.

Development

3:31 Development begins with Mozart exploring theme one. Notice how the harmony keeps shifting. This part of the movement is nowhere near as harmonically stable as either the exposition or the recapitulation. As we get into the development, notice how Mozart stacks the theme on top of itself using different sections of the orchestra. The composer reaches a point where he cuts down the "it's a bird, it's a plane, it's a Mozart" theme to a shorter statement that is basically just "it's a bird." Also, if you listen very carefully, you can catch Mozart turning the "it's a bird" melody upside down. So far throughout the movement the melody has always gone down, but towards the end of the development some of the instruments start taking the melodic line up instead, but the rhythmic gesture remains the same.

4:24 Notice how some of the lower-voiced instruments are sitting on a single note from here to the end of the development. This technique is called a **pedal point,** and the note they are sitting on is actually the dominant note of the original tonic key. Long before the end of the development Mozart is already setting your ear up for a return to tonic at the beginning of the recapitulation.

Recapitulation

4:36 Here again is the first theme presented exactly as you heard it at the beginning of the movement.

5:03 Bridge. When compared to the transition you heard in the exposition, this theme is a little longer and has some slightly different melodic ideas. The term **bridge** indicates the fact that unlike the exposition, this time Mozart is not going to change key centers. Now you will hear theme two (B) presented in the original tonic key, which in this case happens to be a minor (some would say sadder sounding) key.

5:40 Second theme (B) presented in the tonic key.

6:44 Coda. Mozart adds a few extra measures that help him close out the movement and focus our ears on tonic, or home base.

Eine Kleine Nachtmusik (A Little Night Music), K. 525

The technical term for this piece is a *serenade*. It is basically "party music," which in reality usually translates to "background music." The work was originally created with five movements, but the first of two minuet and trio movements was later removed, leaving us with a conventional four-movement sonata cycle. The music for the movement still exists, and some authentic performance groups play the work with all five movements in place. The work is written in such a way that it can be performed by a full string orchestra or by a string quartet. It is most common to hear the orchestra version in performance, but if you ever get a chance, the work offers even the casual listener a great deal of musical clarity (it just sounds cleaner and more crisp) when performed in the string quartet version.

The following movement is a typical example of the minuet and trio format. If you look at the guide below, you will notice a lot of different sections to this movement. Don't worry: each section is very symmetrical, and they all go by quite fast. In fact, in this particular example, each section is eight measures long. Find the basic beat, count to four eight times, and you will have just covered one statement of an entire section of the piece. This trick won't work in every minuet and trio movement you study, but with most composers something similar will happen. The form of both the minuet and the trio are *rounded binary,* which simply means that the B theme is literally "rounded" off by an incomplete return to the letter A melody. The same is true in the trio, but here letter D is coupled with an incomplete return to part of the letter C melody. Again, it sounds a lot more complicated than it actually is.

Listening Guide

Eine Kleine Nachtmusik (A Little Night Music), K. 525
Movement III—*Menuetto*
W. A. Mozart (1756-1791)

Format: Minuet and Trio
Performance: Czech Chamber Orchestra, Josef Vlach, conductor
Recording: *Mozart/Tchaikovsky* (Supraphon SU 3565-2 011)

Performance Notes: Recorded in 1960 at the Dvořák Hall in Prague, Czechoslovakia. Even though this is technically a chamber orchestra, the sound is strictly that of an "old school" Romantic-style orchestra. Please understand that there is nothing "wrong" with this sound. It's just a very different sound when compared to the authentic performance practice examples found elsewhere in your listening assignments.

Minuet
:00 Minuet begins with theme A. Melody is played twice.
:12 Repeat of letter A.
:24 Minuet continues with theme B, which is coupled with an incomplete return of letter A.
:35 Repeat of letter B.

Trio
:47 Trio begins with theme C played in a closely related dominant key center. Melody is played twice.
:59 Repeat of letter C.
1:11 Trio continues with theme D, which is coupled with an incomplete return of letter C.
1:28 Repeat of letter D.

Minuet (played without repeats)
1:46 Minuet returns exactly as presented above except this time the two sections are played without repeats.

Focus on Form
The Solo Concerto

The typical Classical concerto will be presented in a three movement fast-slow-fast arrangement. The first movement in a concerto works just like the other first movement sonata forms we have already studied with the following two exceptions. In most Classical concertos we have what is called a **double exposition**. The first time through the exposition, all of the themes are presented by the orchestra only, and the second theme (and third theme if there is one) does not move to a new key center. The second time through the exposition the soloist enters and dominates the texture. This time the first theme will be played by the soloist with orchestral accompaniment, and the second theme will change key centers as the soloist continues to dominate the texture. The development and recapitulation will happen like normal, with the soloist continuing to dominate the texture. (Please make a mental note right here that after the Classical period the concept of the double exposition goes away, never to be used again.) At the end of the recapitulation and just before the start of the coda, the orchestra will drop out, and the soloist will play a **cadenza.** During the Classical period the artist often improvised these cadenzas. For example, Mozart wrote most of his piano concertos for his own use, and he would simply improvise his cadenzas on the spot. When other performers—such as his sister, for example—would perform these concertos, Mozart actually went back and wrote out cadenzas for them to play. Subsequent generations of soloists have taken great pleasure in putting their own spin on a composer's work, and you will frequently read that the artist at a concert you attend is playing this or that famous cadenza. Even today, you can occasionally see a more adventurous musician who will still improvise his or her cadenza on the spot. Those are usually fun evenings at the concert hall.

The second and third movements of the concerto will generally feature the soloist throughout. The second movement will almost always be slow and very lyrical. This is the soloist's chance to demonstrate their emotional side. (Sometimes it is also the place where you get to find out that the artist actually does not have an emotional side.) The third movement will usually be the fastest of the three and is almost always the most playful. This movement will often follow a rondo form or some kind of hybrid sonata-rondo form. There is often a cadenza in the third movement as well, but it will usually be much shorter than the one in the first movement.

double exposition

cadenza

Mozart's Concertos

Mozart's 27 piano concertos are considered by many pianists to be the finest works ever written for their instrument. Beyond his works for piano, Mozart also wrote solo concertos for violin (5), flute, clarinet, oboe, bassoon, and horn (4). By studying his piano concertos alone, you can actually hear all of the progressions Mozart made as a composer. His early works build on the compositional techniques of other composers, whereas his later works display his new outlook on orchestration, which featured more interplay between the soloist and the orchestra,

especially some of the wind players. These new ideas show up about the same time in his opera compositions and his later symphonies. He wrote most of his piano concertos for his own use, and his public performances of these works were very well received. He often wrote extended first movements that introduced several great themes, which he would then develop in the most creative of ways, always building toward the eventual cadenza at the end of the first movement. His slow, second movements were often simple melodic ideas of exquisite beauty, which he would then embellish with simple added figures not written into the score. His last movements were usually dazzling, technical showpieces, frequently presented in some sort of rondo or sonata-rondo form.

Piano Concerto No. 23 in A Major, K. 488

This work is one of Mozart's most famous piano concertos, containing a great example of a Classical concerto first movement format. Written in 1786, this is one of the piano concertos Mozart wrote around the time he was also working on his opera *The Marriage of Figaro*. He starts to explore more interplay between the orchestral instruments and the singers with this opera, and the technique seems to overlap into his concerto writing as well. Prior to the composition of these concertos, the orchestra was relegated to a very basic accompaniment role with little musical interplay between the soloist and the individual instruments in the orchestra. Notice how throughout this movement there are small solos for flute, oboe, and clarinet that are like little musical conversations with the soloist. Leopold Mozart paid a visit to his son at the time this work was first performed, and he wrote to his daughter about his experiences living in Vienna:

We never go to bed before one o-clock and I never get up before nine. We lunch at two or half past. The weather is horrible. Every day there are concerts; and the whole time is given up to teaching music, composing and so forth. I feel rather out of it all. If only the concerts were over! It is impossible for me to describe the rush and bustle. Since my arrival your brother's fortepiano has been taken at least a dozen times to the theatre or to some other house . . . On Friday we went in the evening to Wolfgang's first subscription concert where there was a large assemblage of persons of rank. The concert was incomparable, the orchestra splendid . . . There was a superb new Concerto by Wolfgang which was still being copied out when we arrived and your brother had not had time to play through the Rondo because he had to supervise the copying . . ."[12]

The piano became the most popular solo instrument of the Classical era, thanks in large part to Mozart's concertos and his ability as a performer.
Source: Jupiterimages, Corp.

Listening Guide

Piano Concerto No. 23 in A Major, K. 488
Movement I—*Allegro*
W. A. Mozart (1756-1791)

Format: First movement concerto form (sonata form with double exposition)
Performance: Collegium Musicum, Michael Schønwandt, conductor; Elisabeth Westenholz, piano
Recording: *W. A. Mozart: Piano Concertos No. 20 & No. 23* (BIS 283)

Performance Notes: This 1984 recording was made in Copenhagen using modern instruments. Ms. Westenholz plays a Steinway model "D" piano, one of the most popular concert grand pianos of the past 100 years. Nonetheless, this recording reflects the growing popularity of "authentic" performance practices. Unlike the large, lush sounding Romantic-styled orchestras, this group uses a much smaller string section. Tempos, in general, are slightly quicker, and fewer liberties are taken with tempo fluctuations within the faster movements.

Double Exposition

:00 First theme presented in the tonic key by the orchestra without the piano soloist.

:34 Bridge (transition). Remember, in a double exposition key centers don't change the first time through. The composer waits until the soloist is in to move to a closely related key center for the second theme. Remember also that this stylistic trick only happens during the Classical period. Romantic and modern concertos usually feature the soloist playing right from the beginning of the work.

:57 Second theme group presented in the tonic key by the orchestra without the piano soloist.

2:07 First theme presented in the tonic key by the soloist with orchestral accompaniment.

2:36 Transition.

3:08 Second theme group presented in the dominant key by the soloist with orchestral accompaniment.

Development

4:46 Development begins, featuring the piano soloist with orchestral accompaniment. Notice the increased interplay here between selected instruments of the orchestra and the piano soloist.

Recapitulation

6:21 Recapitulation begins with the orchestra, followed by the soloist, restating the first theme in the tonic key, just as you heard it the second time through the exposition.

6:50 Bridge. Note that even though the soloist is playing, key centers don't change between the first and second themes of the recapitulation. In this respect, it works just like any other first movement sonata form.

7:19 Second theme group played in the tonic key featuring the piano soloist with orchestral accompaniment.

Cadenza

9:33 Here the orchestra drops out, and the spotlight is on the soloist. Mozart usually improvised a cadenza like this one. In this particular performance, Ms. Westenholz is playing a cadenza written by Beethoven, who is known to have played this concerto in concert.

Coda

10:46 Just like any other coda, the composer adds a little more material to focus our ears and help them settle in on the final tonic chord of the original key center.

Mozart's Operas

Between April of 1783 and January 1790 Mozart enjoyed a total of 35 performances of his two *opera buffa* pieces, *The Marriage of Figaro* and *Don Giovanni*, at the Burg Theater in Vienna. During that same timeframe, Antonio Salieri had 138 performances of eight different operas. Today, the only way most people have ever heard of Salieri is if they have seen the movie or stage play *Amadeus*. Judging by performance numbers alone, the most popular Italian *opera buffa* composer of the day was one Giovanni Paisiello, who, again in the same timeframe as above, composed 11 different operas that had at least 166 total performances.[13] As far as the fickle Viennese audiences were concerned, Mozart had talent, but he was not up to the standards of an *Italian* composer, even if he did understand the language and compose circles around them. Fortunately, Mozart enjoyed success in other theatres and in other towns, but around Vienna during his lifetime he was considered "good, but no Paisiello."

Mozart composed 21 operas during his brief career, several of which continue to be among the most famous operas ever written. He composed in three basic styles, Italian *opera seria* and *opera buffa* and German *Singspiel*. The first two are serious and comic operas, written in the Italian language where everything, including all the recitatives, are sung. *Singspiel*, or song play, is written in German and has spoken dialogue to help move the drama along, coupled with the typical arias, duets, and choruses found in any opera. These operas tend to be a bit more "lowbrow" and comic in nature. Many historians, however, have pointed out that Mozart's operas in the *Singspiel* genre, such as *Die Entführung aus dem Serail* (The Abduction from the Harem) and *Die Zauberflöte* (The Magic Flute), are far from the typical *Singspiele* of the day. Mozart's compositions took the art form to an entirely new level.

Mozart's most well known operas are the three *opera buffa* works he created with librettist Lorenzo da Ponte: *Le nozzze di Figaro*, *Don Giovanni*, and *Così fan tutte*. In all three operas, but especially with *Don Giovanni*, Mozart goes beyond the traditional comic operas of the day to create more of a comedy/drama with fully developed characters of great emotional content. For example, in *Don Giovanni* (Don Juan) the main character is a terrible man who takes advantage of women and lives his life in a very cavalier fashion. As an audience, we should hate him, but because of the way Mozart writes music for this character, we can't help but give a little nod and wink to secretly admit we like the guy.

Opera star Ezio Pinza in costume as Don Giovanni.
Source: Jupiterimages, Corp.

Conversely, Donna Anna, the heroine of the story, is an innocent who has lost her father after Don Giovanni kills the old man while he is trying to defend his daughter's honor. We should all feel very sorry for her and love her as an operatic character. Mozart gives her wonderful music to sing, but after a while it seems to just go on and on a bit, leaving the audience to think that we all kind of wish she would stop whining so much and get on with her life. In all three of these operas, the music becomes integral to the story, helping us understand the motivations and true nature of each character.

Le Nozze Di Figaro (The Marriage of Figaro), K. 492

Mozart wrote *Le Nozze Di Figaro* (The Marriage of Figaro) in 1785/6. Lorenzo da Ponte based the libretto for the opera on a very controversial play written by Beaumarchais. The original play poked fun at the aristocratic and noble class and was considered to have "revolutionary" overtones, but Mozart's opera downplays the more controversial aspects of the story. In a November 1785 letter from Leopold Mozart to his daughter the new opera was discussed:

> At last I have received a letter of twelve lines from your brother, dated November 2nd. He begs to be forgiven, as he is up to the eyes in work at his opera "Le Nozze di Figaro." . . . I know the piece; it is a very tiresome play and the translation from the French will certainly have to be altered very freely if it is to be effective as an opera. God grant that the text may be a success. I have no doubt about the music. But there will be a lot of running about and discussions before he gets the libretto so adjusted as to suit his purpose exactly. And no doubt according to his charming habit he has kept on postponing matters and has let the time slip by . . .[14]

Lorenzo da Ponte, the man who wrote librettos for some of Mozart's most important operas.
Source: © 2009 Jupiterimages, Corp.

In the spring of 1786, Leopold again wrote to his daughter on the subject of *Figaro:* " 'Le Nozze di Figaro' is being performed . . . for the first time. It will be surprising if it is a success, for I know that very powerful cabals have ranged themselves against your brother. Salieri and all his supporters will again try to move heaven and earth to down his opera."[15] In this particular case, Leopold's fears were mostly unfounded. The opera met with modest success in Vienna and was a big hit elsewhere, especially in Prague. From that time until this, the opera has rarely been out of circulation. Today, numerous performances of the opera are given around the world from university opera companies to the Metropolitan Opera in New York and the Vienna State Opera on a regular basis. You can't swing a dead cat around an opera house without hitting *Figaro* in one form or another.

The following listening guide features two scenes from the opera. The first example is the opening duet and recitative between Figaro and his bride-to-be, Susanna. After a brief orchestral introduction (the audience would have also just heard the instrumental overture to the entire work), Figaro begins the duet by measuring the couple's new quarters. Susanna takes over while admiring her new wedding bonnet. Eventually, Figaro joins her. The following recitative is a further conversation about their new living arrangements.

The second example is one of the most famous arias in all of opera, *Non so piu cosa son, cosa faccio* (I don't know what I am, what I'm doing), which is the ultimate homage to young love. The aria is sung by a young page named Cherubino who is in love with the concept of love. The character is what is called a *pants role*, as it is usually played by a woman. The audiences of Mozart's day would have recognized Cherubino's first theme here as it was "borrowed" from a popular *Singspiel* of the day.[16] In the hands of Mozart, however, the theme is transformed from a bouncy little tune to a flowing, melodic masterpiece. Cherubino's aria follows a somewhat unusual form. It actually works like a typical da capo aria (A-B-A) except Mozart keeps going at the end of the normal structure with a new melody (C), almost as if Cherubino is so overwhelmed with his thoughts of love that he just can't stop singing when he is supposed to.

Listening Guide

Le Nozze Di Figaro (The Marriage of Figaro), K. 492
Act I, scene 1—Duet and Recitative: *Cinque...dieci...venti...trenta*
Act I, scene 6—Aria: *Non so piu cosa son, cosa faccio*
W. A. Mozart (1756-1791)

Format: Opera Buffa

Performance: La Petite Bande, Sigiswald Kuijken, conductor; Werner Van Mechelen, Figaro; Christiane Oelze, Susanna; Monika Groop, Cherubino

Recording: *Le Nozze Di Figaro* (Accent ACC 98133/135 D)

Performance Notes: Here is another authentic performance practice group performing opera as it might have sounded at the premiere. This particular performance was recorded live on June 5, 1998 at the *Palacio de Congresos y Auditios* in La Coruna, Spain.

Act I, scene 1 – Duet and Recitative: *Cinque...dieci...venti...trenta*

:00 Orchestra introduces two little thematic snippets. The first is an elaborate take on Figaro's initial melodic material.

:16 The second, more extended thematic idea is introduced by the orchestra. Susanna will sing this melody first, later to be joined by Figaro.

:35 Figaro begins by singing a simple version of the first theme while he is measuring the new quarters he and Susanna will move into once they are married.

FIGARO	FIGARO
(Misuranda la camera)	*(Measuring the room)*
Cinque … dieci … venti … trenta …	Five … ten … twenty … thirty …
Trentasei … quarantatré …	Thirty-six … forty-three …

:54 Susanna enters singing the second melodic idea as she praises her new hat. Figaro continues on with his measuring.

SUSANNA	SUSANNA
(Fra sè, guardandois nello specchio)	*(To herself, gazing into the mirror)*
Ora sì ch'io son contenta;	Yes, I'm very pleased with that;
Sembra fatto inver per me.	It seems just made for me.
Guarda un po', mio caro Figaro,	Take a look, dear Figaro,
Guarda adesso il lmio cappello.	Just look at this hat of mine.
(Seguitando a guardarsi)	*(She continues to gaze at herself)*

1:29 Figaro joins Susanna in singing the second melodic idea as he also begins to admire her new hat.

FIGARO	FIGARO
Sì, mio core, or è più bello:	Yes, my dearest, it's very pretty:
Sembra fatto inver per te.	It looks just made for you.
SUSANNA E FIGARO	SUSANNA AND FIGARO
Ah, il mattino alle nozze vicino	On this morning of our wedding
Quanto è dolce al mio (tuo) tenero sposo,	How delightful to my (your) dear one
Questo bel cappellino vezzoso	Is this pretty little hat
Che Susanna ella stessa si fè.	Which Susanna made herself.

Recitative

2:46 In this section, Figaro and Susanna discuss their new quarters. Susanna is not crazy about the room, but Figaro points out that it is one of the better rooms in the house and that it is conveniently located right between the rooms of the Count and Countess, whom they both serve.

SUSANNA	SUSANNA
Cosa stai misurando,	What are you measuring,
Caro il mio Figaretto?	My dearest Figaro?

FIGARO
Io guardo se quel letto
Che ci destina il Conte
Farà buona figura in questo loco.

FIGARO
I'm seeing if this bed
Which the Count has put aside for us
Will go well just here.

SUSANNA
In questa stanza?

SUSANNA
In this room?

FIGARO
Certo, a noi la cede
Generoso il padrone.

FIGARO
Of course; his lordship's
Generously giving it to us.

SUSANNA
Io per me te la dono.

SUSANNA
As far as I'm concerned, you can keep it.

FIGARO
E la ragione?

FIGARO
What's the matter?

SUSANNA
(Toccandosi la fronte)
La ragione l'ho qui.

SUSANNA
(Tapping her forehead)
I've my reasons in here.

FIGARO
(Facendo lo stesso)
Perchè non puoi
Far che passi un po' qui?

FIGARO
(Doing the same)
Why can't you
Let me in on them?

SUSANNA
Perchè non voglio.
Sei tu mio servo, o no?

SUSANNA
Because I don't choose to.
Are you my slave, or not?

FIGARO
Ma non capisco
Perchè tanto ti spiaccia
La più comoda stanza del palazzo.

FIGARO
But I don't understand
Why you so dislike
The most convenient room in the palace.

SUSANNA
Perchè io son la Susanna e tu sei pazzo.

SUSANNA
Because I'm Susanna and you're a dolt.

FIGARO
Grazie, non tanti elogi: guarda un poco
Se potria meglio stare in altro loco.

FIGARO
Thanks, you're too flattering: just see
If it could go better anywhere else.

Act I, scene 6 – Aria: *Non so piu cosa son, cosa faccio*

:00 **A theme.**

Non so più cosa son, cosa faccio …
Or di foco, ora sono di ghiaccio …
Ogni donna cangiar di colore,
Ogni donna mi fa palpitar.

I no longer know what I am or what I'm doing …
Now I'm burning, now I'm made of ice …
Every woman makes me change colour,
Every woman makes me tremble.

:17 **B theme.**

Solo ai nomi d'amor, di diletto
Mi si turba, mi s'altera il petto
E a parlare mi sforza d'amore
Un desìo ch'io non posso spiegar!

At the very word love or beloved
My heart leaps and pounds,
And to speak of it fills me
With a longing I can't explain!

:42 **A theme.**

Non so più cosa son, cosa faccio …
Or di foco, ora sono di ghiaccio …
Ogni donna cangiar di colore,
Ogni donna mi fa palpitar.

I no longer know what I am or what I'm doing,
Now I'm burning, now I'm made of ice …
Every woman makes me change colour,
Every woman makes me tremble.

:58 **C theme.**

Parlo d'amor vegliando,
Parlo d'amor sognando,
All'acqua, all'ombra, ai monti,
Ai fiori, all'erbe, ai fonti,
All'ecco, all'aria, ai venti,
Che il suon dei vani accenti
Portan via con sè …
E se non ho chi m'oda
Parlo d'amor con me.

I speak of love when I'm awake,
I speak of it in my dreams,
To the stream, the shade, the mountains,
To the flowers, the grass, the fountains,
To the echo, the air, the breezes,
Which carry away with them
The sound of my fond words …
And if I've none to hear me
I speak of love to myself.

Die Zauberflöte (The Magic Flute), K. 620

The Magic Flute is full of supernatural overtones and mystic rites of passage. The two main love interests in the story, Tamino and Pamina, are destined by the gods to be married, but Pamina's evil mother, the Queen of the Night, has other plans. She tries to get her daughter to kill Tamino's primary protector, Sarastro, who is one of the good guys in the opera. The famous *Queen of the Night* aria is one of the most challenging vocal compositions ever written by Mozart. Many singers have crashed and burned over the years trying to sing this one. The overt drama of the music only serves to heighten the already dramatic content of the lyrics.

Listening Guide

Die Zauberflöte (The Magic Flute), K. 620
Act II—Der Hölle Rache

W. A. Mozart (1756-1791)

Format: Singspiel (song play), coloratura soprano aria
Performance: Vienna Philharmonic, George Szell, conductor; Queen of the Night, Erika Köth
Recording: *W. A. Mozart: Die Zauberflöte* (Gala GL 100.502)

Performance Notes: This is an historic, live recording from the 1959 Salzburg festival. Soprano Erika Köth was born in Darmstadt in 1927. Over her long and distinguished career she sang in most of the major opera houses in Europe including the Vienna State Opera, La Scala in Milan, Covent Garden in London, and Wagner's opera house, Bayreuth. She was particularly noted for her performances of Mozart's operas and was a favorite at the annual Salzburg festival. Conductor George Szell enjoyed a long career as both an opera and orchestral conductor around the world. He is perhaps best remembered for the recordings he made with the Cleveland Symphony Orchestra. Szell conducted the orchestra from 1946 until his death in 1970 and is credited with helping that orchestra rise to the international prominence it still enjoys today.

Liner notes from Gala GL 100.502

:00	Aria begins with a dramatic opening statement, followed by melodic expansions with new lines of text.

Der Hölle Rache kocht in meinem Herzen	The vengeance of hell rages in my heart
Tod und Verzweiflung flammet um mich her!	Death and desperation burn all around me!
Fuhlt nicht durch dich Sarastro Todesschmerzen	If Sarastro does not through you suffer death's torments
So bist du meine Tochter nimmermehr.	you will nevermore be my daughter.

:38 New section begins with coloratura soprano singing vowel sounds only, extremely high and fast, followed by a closing statement of the line "so bist du meine Tochter nimmermehr."

1:20 Next section of text begins.

Verstoben sei auf ewig, verlassen sei auf ewig	You will be disowned, forsaken forever,
Zertrümmert sei'n auf ewig alle Bande der Natur,	all nature's bonds will be forever shattered,

1:47 Lyrical coloratura passage over the words "alle Bande" (all bonds …), which leads into the next line of text at 2:11.

Wenn nicht durch dich Sarastro wird erblassen!	if Sarastro does not through you meet his end!

2:21 Final declamatory statements.

Hört, Rachegötter!	Hear, ye gods of vengeance!
Hört der Mutter Schwur!	Hear a mother's vow!

Requiem, K. 626

The story of Mozart's *Requiem* is one of the most controversial points in all of music history. Mozart accepted a commission from an obscure count named von Walsegg, and the story goes that the count was planning to put his name on it and present it as his own. The movie *Amadeus* has done nothing but confuse the issue even farther, as it makes the gross speculation that another rival composer, Antonio Salieri, commissioned the work with the same evil intent. This is not true. It's also not true that Salieri poisoned Mozart. Salieri went nuts toward the end of his life and "confessed" to killing Mozart, but he didn't do it. Anyway, regardless of how the work got started, we do know for a fact that Mozart never finished the mass before he died. History tells us that one of Mozart's students, Franz Xaver Süssmayr, finished the work at the request of Mozart's widow, Constanze. There is a great deal of controversy over just how much of the work was actually composed by Süssmayr and which other composers might have also been briefly involved in the completion of the work. Many scholars take Süssmayr to task for not being as good a composer as Mozart (as if anyone ever could be), often overlooking the fact that had Süssmayr not undertaken the completion of this project the entire work might be lost to us forever. We are pretty sure that Mozart wrote most everything up through the *Confutatis* (movement six), and we know he at least wrote all the melody and harmony ideas for the *Lacrimosa*, both of which appear in the following listening guide. Beyond these movements, who wrote what becomes less clear, but it is generally agreed that Süssmayr wrote the last three movements, *Sanctus, Benedictus,* and *Agnus dei*. The *Confutatis* is a masterpiece of emotional contrasts, and the *Lacrimosa* contains one of the most touching melodies ever composed for voices. If Mozart really did know he was dying, and he really did think he was composing his own requiem, this is as good a way as any to say goodbye.

DIG DEEPER

MOVIE
Amadeus

BOOKS
Mozart's Letters, Mozart's Life by Robert Spaethling; *1791, Mozart's Last Year* by H. C. Robbins Landon.

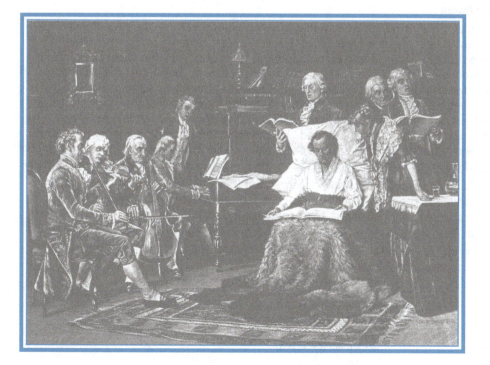

Mozart on his deathbed listening to a portion of his Requiem, *a work he left incomplete.*
Source: Jupiterimages, Corp.

Listening Guide

Requiem, K. 626
Movement VII—*Confutatis*
Movement VIII—*Lacrimosa*
W. A. Mozart (1756-1791)

Format: Requiem Mass, chorus movements

Performance: Chamber Choir and Baroque Orchestra Stuttgart, Frieder Bernius, conductor

Recording: *Wolfgang Amadeus Mozart: Requiem K. 626* (Carus 83.207)

Performance Notes: The Baroque Orchestra Stuttgart is an original performance practice orchestra, with all the musicians performing on original instruments. This live recording was made at the *Stuttgarter Liederhalle* in 1999.

Movement VII – *Confutatis*

:00 Mozart contrasts two dramatically different lines of text with two distinct emotional styles. He plays the strength of the male voices accompanied by full orchestra against a pleading, simple melodic line sung by the women of the chorus. These contrasting sections are each presented twice.

Confutatis maledictis,	When the damned are cast away
Flammis acribus addictis:	and consigned to the searing flames,
Voca me cum benedictis.	call me to be with the blessed.

1:23 As the accompaniment moderates itself between the two styles heard at the beginning of the work, the male and female voices of the chorus join together to offer a prayer.

Oro supplex et acclinis,	Bowed down in supplication I beg Thee,
Cor contritum quasi cinis:	my heart as though ground to ashes:
Gere curam mei finis.	help me in my last hour.

Movement VIII – *Lacrimosa*

:00 Mozart wrote the simple string introduction, as well as the first eight measures you hear the chorus singing Beyond this spot, it becomes less clear as to who wrote what. Regardless, Süssmayr continues on with Mozart's melodic ideas and his basic accompaniment style. Critics say the later music in this movement is overly dramatic and "plodding" when compared to Mozart's, but it gets the point across in no uncertain terms. Listen and decide for yourself. Just because they are music scholars doesn't mean they aren't full of it sometimes. If you like it, you like it, and that's o.k. Regardless, notice the cool little text painting trick Mozart pulls with the words *"qua resurget ex favilla, judicandus homo reus,"* or " . . . when guilty man rises from the embers to be judged." He sneaks in this ascending line for the second four bars of the phrase that builds to a powerful climax, clearly demonstrating in the music the concept of men rising to be judged. It's a musical commentary on the power of God and the weakness of man.

:48 The same line of text is repeated in the next few measures, but this time the rising line is only clear in the harmonic accompaniment. The chorus melody has changed, and this time it continues on with the thought *"huic ergo parce, deus,"* or " . . . from this, then, spare us, O God."

2:02 After a brief orchestral interlude the last line of text, *"Pie Jesu Domine, dona eis requiem,"* or "Merciful Lord Jesus, grant them rest," is presented. The first time it is almost like a demand, followed by a more peaceful, resolved request and a final "Amen."

Lacrimosa dies illa,	On this day full of tears,
Qua resurget ex favilla	when from the ashes arises
Judicandus homo reus.	guilty man, to be judged:
Huic ergo parce, Deus:	Or Lord, have mercy upon him.
Pie Jesu Domine,	Gentle Lord Jesus,
Dona eis requiem. Amen.	grant them rest. Amen.

Ludwig van Beethoven (1770-1827)

Beethoven was born into a musical family attached to the court in Bonn, Germany. Like Mozart, he showed an early gift for music, which Beethoven's father attempted to exploit. When Beethoven didn't progress as quickly as his father would have liked, the young child would be beaten in order to "encourage" him to practice harder. In spite of this abuse, Beethoven did enjoy some success as a pianist early in his career. In fact, had he not lost his hearing, Beethoven might be remembered more as a concert pianist rather than the master composer we know him as today. In 1787 he visited Vienna, where he impressed Mozart with his gift for improvisation. The visit was cut short, however, when Beethoven's mother took sick and eventually died. His father began drinking heavily and was subsequently dismissed from his court position. At the age of 18, Beethoven took over as head of the family, supporting both his two younger brothers and his father. In 1792, Haydn visited the court in Bonn and extended an invitation for Beethoven to study with him in Vienna. Their student-teacher relationship was a bit rocky, but Beethoven's early works clearly reflect Haydn's impact on his music. Beethoven also studied music theory with Johann Schenk, counterpoint with Albrechtsberger, and Italian musical styles with Mozart's rival, Salieri. Beethoven had hoped to study with Mozart, but the composer died in 1791, almost a year before Beethoven was able to return to Vienna.

Beethoven's birthplace in Bonn, Germany.
Source: Jupiterimages, Corp.

Throughout Beethoven's life he found support from wealthy patrons of the arts but was never tied to a major court post of any kind. He played solo piano recitals, accompanied other musicians in concert, taught music lessons to wealthy students, and fulfilled various commissions. At the height of his performing powers Beethoven discovered that he was losing his hearing, one of the greatest fears of every musician. Beethoven's deafness was a gradually progressive problem. His hearing actually came and went to a certain extent for years, but in general it was always getting worse. In 1802, Beethoven wrote a sort of suicide note, the *Heiligenstadt Testament*, which historians frequently point to as a major turning point in the composer's compositional style. This document was not actually discovered until after the composer's death, but it explains a great deal about his life and his later works.

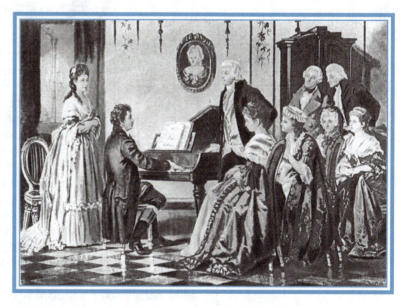

As a young man, Beethoven had the opportunity to perform for Mozart.
Source: Jupiterimages, Corp.

Ludwig van Beethoven's Heiligenstadt Testament

For my brothers Carl and (Johann) Beethoven.

O ye men who think or declare that I am hostile stubborn or Misanthropic, how you wrong me you do not know the secret motive of what seems thus to you, from Childhood my Heart and Mind were inclined to the Gentle Feeling of goodwill, indeed I was ever disposed to accomplish great Feats, but only reflect that for the last 6 years an incurable condition has seized me, worsened by senseless physicians, cheated from year to year in the Hope of improvement, finally compelled to the prospect of a *lasting Ailment* (whose Curing may perhaps take years or indeed be impossible). Born with a fiery Lively Temperament susceptible even to the Diversions of Society, I soon had to keep to myself, pass my life in solitude, if I attempted from time to time to rise above all this, o how harshly then was I repulsed by the doubly sad Experience of my bad Hearing, yet I could not say to People: speak louder, shout, for I am deaf, alas how could I then acknowledge the Weakness of *a Faculty* which ought to be more perfect in me than in others, a Faculty I once had to the highest degree of Perfection, such Perfection as only few of my Calling surely have or have had—o I cannot do it. Therefore forgive me if you see me withdrawing when I should gladly join you. My misfortune afflicts me doubly, since it causes me to be misunderstood. Diversion in Human Society, civilized Conversation, mutual Effusions cannot take place for me. All but alone, I enter society no more than is required by the most urgent Necessity. I must live like a Banished man; if I approach a company, a hot anxiety invades me, because I am afraid of being exposed to the Danger of letting my Condition be noticed—and thus has it been this half-year too, which I have spent in the country, my wise Physician having ordered me to spare my Hearing as much as possible. He nearly met my present Disposition, even though I have sometimes let myself be led astray by an Urge for Society. But what Mortification if someone stood beside me and heard a flute from afar and I heard *nothing;* or someone *heard a Shepherd Singing,* and I heard nothing. Such Happenings brought me close to Despair; I was not far from ending my own life—only Art, only art held me back. Ah, it seemed impossible to me that I should leave the world before I had produced all that I felt I might, and so I spared this wretched life—truly wretched; a body so susceptible that a somewhat rapid change can take me from the Best Condition to the worst. *Patience*—so now I must choose Her for my guide, I have done so—I hope that my decision to persevere may endure until it please the inexorable Fates to break the Thread; perhaps I will improve, perhaps not. I am resigned—to be forced already in my 28th year to become a Philosopher is not easy, and harder for an Artist than for anyone else. Deity, thou lookest down into my innermost being; thou knowest it, thou seest that charity and benevolence dwell within,—o Men, when you read this some day, think then that you have wronged me, and let any unhappy man console himself by finding another one like himself, one who, despite Nature's Impediments, yet

Sketch of Beethoven's house in Heiligenstadt.
Source: Jupiterimages, Corp.

did what was in his Power to do to be admitted to the Ranks of worthy Artists and Men. And so it is done—I hasten with joy towards my Death—should it come before I have had an Opportunity to disclose all my Artistic Capacities, then it shall still have come too soon despite my Hard Destiny, and I should indeed wish it came later—yet even then am I content. Does it not free me from an endless Suffering State? Come *when* you will, I'll meet you bravely— farewell and do not wholly forget me in Death. I have deserved it of you, for in Life I thought of you often, in order to make you happy, so may you be—

Heiligenstadt Ludwig van Beethoven
6th october
1802

From *Letters of Composers through Six Centuries by Piero Weiss.* Copyright © 1967 by Piero Weiss. Reprinted by permission.

DIG DEEPER

MOVIES
Immortal Beloved; Copying Beethoven

BOOK/PLAY
Beethoven As I Knew Him by Anton Felix Schindler (play features pianist/actor Hershey Felder)

Aside from a few minor trips into the countryside, Beethoven spent the rest of his life in Vienna. He was a strong-willed, highly opinionated person who many people, even his closest friends and relatives, found very difficult to get along with. The composer never married, though he did have various relationships over the course of his life. His most famous love is unknown to us by name but is frequently referred to as his "immortal beloved." There was even a good but highly speculative (in fact partly fictional) movie titled *Immortal Beloved* that offered glimpses into the composer's complicated life. After one of Beethoven's brothers died, Beethoven fought an extended court battle to win custody of his nephew, Karl. As a young man Karl attempted suicide, and the act sent Beethoven into his own deep depression from which he never really recovered. Beethoven died less than a year later on March 26, 1827, leaving his entire estate to his nephew. Over 30,000 people attended his funeral services, and his works have never fallen out of favor with the public.

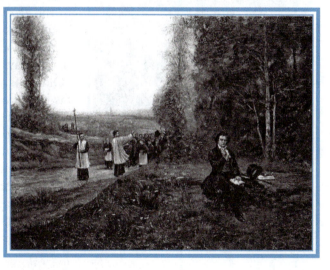

Scholars frequently group Beethoven's compositional output into three or four style periods, but there is some controversy as to exactly what goes where. Most of his later works are considered Romantic in nature, and as such, they really ought to be included in the next chapter. For the sake of focusing all of our attention on Beethoven's music in one spot, we will cover everything right here. To keep it simple, think of Beethoven's music as being grouped together in three large periods that we will simply call early (1782-1802), middle (1803-1815), and late (1816-1827). Works from the early period that are still frequently performed include the Op. 18 string quartets, a number of solo piano sonatas such as the *Pathétique* and *Moonlight,* the Op. 16 piano quintet, and his first two symphonies. The middle style period includes Symphonies Nos. 3-8, Piano Concertos Nos. 4 & 5 (*Emperor*), the Violin Concerto in D, Op. 61, the Op. 59 "Rasoumovsky" string quartets, and his only opera, *Fidelio.* The late style period gave us a number of intense string quartets (including the Op. 133 *Grosse Fuge*), the gigantic *Missa solemnis,* the *Hammerklavier* piano sonata, and the ever popular Symphony No. 9, (*Choral*), which took him over five years to compose (1817-1823).

This painting depicts Beethoven writing in one of his sketchbooks as he sits in the countryside outside Bonn. There is a funeral procession passing in the background. The original artist is Paul Leyendecker, but this work has been reproduced in many different forms. **Source:** Jupiterimages, Corp.

The further you go in exploring the art of Beethoven as a composer, the more you will begin to see an overwhelming drive for self-expression as the primary motivating factor in his work. That fact alone is even more incredible when you take into consideration that he never heard any of his later works except in what must have been the raging silence of his own mind. For most musicians, to go one day without hearing or making music is painful. To have the gift of hearing taken away forever would be completely unbearable. The *Oxford Dictionary of Music* makes the point by saying: "He emancipated and democratized the art, composing out of spiritual inner necessity rather than as provider of virtuoso display material."[17] The point should also be made that while Beethoven frequently created new works on commission, his process of creation had nothing to do with an employer demanding a new work for a specific concert at a specific court event. Beethoven wrote music to express the otherwise inexpressible; it is as simple—and as complicated—as that.

Beethoven's Chamber Music

Ludwig van Beethoven.
©Shutterstock.com

Beethoven's vast production of chamber music includes 32 piano sonatas, various other works for solo piano, 16 string quartets, plus the previously mentioned *Grosse Fuge, Op. 133*. He wrote seven sonatas for violin and piano, a wide variety of duets, trios, piano quartets, string quintets, and even a very unusual septet for strings and winds. His early piano sonatas are firmly rooted in the Classical style, but they already display extended compositional ideas, as you will hear in the *Pathétique* sonata presented below. His later works push the boundaries of what the piano could do, even going so far as to write notes in some of his later compositions that didn't exist on the pianos of the day. Bach's *Well-Tempered Clavier* has been referred to as the "Old Testament" of keyboard playing, and Beethoven's 32 piano sonatas have been similarly designated as the "New Testament." During Beethoven's day, some of his late works were deemed "unplayable," and in fact they didn't enter the regular piano repertory until Franz Liszt began performing them during the middle of the Romantic era. Likewise, audiences and musicians alike found his late string quartets quite inaccessible. Beethoven was said to have replied, "This is music for a later age." In fact, he did write some things in these late quartets that we would not see again until the twentieth century. He was truly a man ahead of his time.

Sonata No. 8 in c minor, "Pathétique," Op. 13

Written between 1798 and 1799, the Sonata No. 8 in c minor, *"Pathétique,"* Op. 13 is unusual in several respects. First, unlike most "titled" works of this period, the composer applied the subtitle *Pathétique* to his own work, a practice that was not common during the Baroque and Classical eras. Second, he added an extended, slow introduction in the first movement, a technique that was usually reserved for the symphony and occasionally the string quartet. Even more amazing, he actually keeps referring back to this slow introduction, a practice that was completely unheard of at the time. This is a work that Beethoven would have performed himself, and it is a powerful expression of his emotional state during the early onset of his deafness. Unlike most examples contained in your listening assignments, this example contains the entire three-movement sonata as opposed to one or two extracted movements or sections of a larger work. You will find a detailed description of this sonata in the following listening guide.

Listening Guide

Sonata No. 8 in c minor, "Pathétique," Op. 13
Movement I—*Grave. Allegro di molto e con brio*
Movement II—*Adagio cantabile*
Movement III—*Rondo. Allegro*

Ludwig van Beethoven (1770-1827)
Format: Piano Sonata
Performance: Ivan Moravec, piano
Recording: *Ivan Moravec Plays Beethoven* (Supraphon SU 3582-2 111)

Performance Notes: This 1964 recording was made at the Manhattan Towers Studio in New York. It is at once a vibrant historic recording and a demonstration of the superior digital sound transfer found with modern compact disc recordings. The tone of the CD retains its "warm" analog roots while enjoying the added clarity of being re-created in the digital domain. From the CD's liner notes:

The Czech pianist **Ivan Moravec** (b. 1930) is ranked among the present time's foremost representatives of the art of the piano. Following studies in Prague and at master classes of Arturo Benedetti-Michelangeli in Italy, he made his debut in Prague, with the Czech Philharmonic Orchestra under Karel Ancerl, and embarked on his international career in London . . . and in the U.S.A., with the Cleveland Orchestra under Georg Szell, and at New York's Carnegie Hall, in 1964 . . . His achievements on U.S. concert platforms earned Ivan Moravec a nomination by the American Radio Broadcasters union for the title Player of the Year in 1997. Philips record company included two of his recordings in its anthology of *Great Pianists of the 20th Century*. The President of the Czech Republic, Václav Havel, conferred on Mr. Moravec the State Order of Merit for Culture.

Liner notes by Vít Roubícek from Supraphon SU 3582-2 111

Movement I – *Grave. Allegro di molto e con brio*

Introduction
:00 This slow, dramatic introduction sets a somewhat ominous tone for the work to come. The rhythm here is quite free, with most performers making use of *tempo rubato*, which literally translates to borrowed time. The performer adjusts the tempo in a very fluid manner in an attempt to heighten the musical tension. Pay close attention to the opening few measures, as you will hear them again.

Exposition
1:47 Theme one begins with a firm, rapid tempo and an ascending melody in the right hand.
1:59 Transition. Unlike Mozart, Beethoven's transitions often flow smoothly from the first to the second theme with no clear-cut pauses or breaks.
2:16 Theme two begins with a more relaxed, lyrical feel, but the underlying rhythmic feel remains.
2:44 Theme three, or closing theme (in two parts).
3:20 Exposition repeats.

Development
4:54 Beethoven, never one to play by the "rules," starts his development not with one of the themes from the exposition but with a return to the opening sounds of the introduction. For audiences who were used to fast movements staying rhythmically secure once they got rolling, this must have been a heart-stopping moment the first time they heard the work.
5:38 Development continues with a return to the fast tempo and melodic material from the first theme.

Recapitulation

6:20 All three themes come back in their original order. As usual in a first movement sonata form, this time themes two and three don't change tonal centers as they did in the exposition.

Coda

7:46 In what is perhaps the most dramatic pause of the entire movement, Beethoven once again brings the rhythm to a screeching halt and begins the coda with a return to material from the slow introduction. Then, just as you settle back into this slow material, he pulls the rug out from under you and slams into the fast, final cadence. This is musical whiplash at its finest.

Movement II – *Adagio cantabile*

Letter A

:00 Letter A begins with one of Beethoven's most beautiful melodies. If you want to count along, it is a simple eight-bar tune with four beats per measure.

:36 Beethoven gives you a second full statement of the letter A melody one octave higher.

Letter B

1:11 Letter B continues with a more angular, but still lyrical, melody in a contrasting key center.

Letter A

2:09 Letter A returns for one full statement of the melody.

Letter C

2:46 Letter C is considerably more dramatic in both melody and rhythmic accompaniment. Throughout the letter A and B material, the rhythmic feel has been duple (two-note groupings), and the melodies are in major key centers. Now the rhythmic feel has shifted to a triplet feel (three-note groupings), and Beethoven has moved to a minor key.

Letter A'

3:31 Letter A returns for the final time, but with a significant alteration to the rhythmic accompaniment. Even though Beethoven has returned to a major key and the original theme, he keeps the triplet rhythmic feel he established with letter C.

4:02 Melody is repeated one octave higher but is still presented with the new triplet rhythmic feel.

4:54 Beethoven closes out the movement with a brief coda that focuses the ear on the final tonic chord by using a simple melodic shape while rocking back and forth between the dominant and tonic chords. When he settles on the final tonic chord, it's like taking in a big breath and letting out a long, relaxing sigh. Try it as you listen to these final seconds of the movement. It should help lower your heart rate and blood pressure, which is a good thing.

Movement III – *Rondo. Allegro*

Letter A

:00 This distinctive first melody begins in a minor key with a group of three quick ascending notes. Get to know this little musical gesture. It works like a convenient handle with which you can hold on to the letter A melody. If you already know Beethoven's Fifth Symphony, you might also notice that this "three shorts and a long" note configuration feels similar to the main theme of that masterpiece.

Letter B

:19 Beethoven transitions to a major key and presents two different melodic ideas for letter B. The first one is made up mostly of chord notes played one at a time up and down the keyboard. The term for this technique is *arpeggio*.

Letter A

1:05 Letter A returns in the original minor key.

Letter C

1:23 Tricky old Beethoven (who was actually pretty young when he wrote this piece) starts what should be the most dramatic part of a typical seven-part rondo with nothing but a series of soft, simple chords. Quick ears may also notice that he uses the three short pick-up notes from letter A to start these chords. Slowly but surely he builds this section up to a dramatic climax that explodes into a fast, descending line that takes us to the next statement of letter A.

Letter A

2:08 Letter A returns in the original minor key but in a shortened form.

Letter B'

2:22 Both parts of letter B return, but this time Beethoven gives them to us in the reverse order of what he presented the first time.

Letter A'

3:03 Beethoven begins this final letter A statement with a musical technique called **elision.** Stated simply, he leaves off the three short pick-up notes, and instead, the last chord of letter B doubles as the first chord of letter A. This can be a little tricky to hear the first couple of times through. There is also some added rhythmic complexity this time around.

3:41 Beethoven sums everything up with a simple little coda.

Beethoven's Symphonies

Beethoven composed nine symphonies and had started a tenth at the time of his death. His first two symphonies are well-crafted expressions of the Classical ideal though they have a few twists thrown in for good measure. The Third Symphony, *Sinfonia Eroica* (Heroic Symphony), marks a major turning point in symphonic composition. The work is almost twice as long as any symphony that came before it, and the writing is full of dramatic outbursts that go well beyond the Classical ideal. This is also the first symphony that replaces the standard third movement minuet and trio with the faster and more complex *scherzo*. The *Eroica* symphony was originally dedicated to Napoleon Bonaparte, but after Napoleon declared himself "Emperor," Beethoven angrily destroyed his dedication of the work, changing it to read "to the memory of a great man." Though often over-looked, the light Fourth Symphony is a clever little piece that shows Beethoven in a somewhat happier mood. The Fifth Symphony is by far his most famous, and it is described in detail in the following listening guide. The Sixth Symphony, *Pastoral*, also breaks a great deal of new ground. Not since Vivaldi's *Four Seasons* have we seen such a distinctly programmatic work. The translated movement titles are (1) "Awakening of pleasant feelings on arriving in the country," (2) "Scene by the brook," (3) "Happy gathering of country folk," (4) "Thunderstorm," and (5) "Shepherd's song: Happy and thankful feelings after the storm." These last three movements are performed *attacca*, which means they are to be performed without pause or break. The Seventh and Eighth Symphonies are presented in the standard sonata cycle format and are, once again, works that bridge the gap between the Classical and Romantic styles. The Ninth Symphony, usually called the *Choral* symphony, lasts over one hour and blends together the purely instrumental with vocal

Sketch by Adolf Menzel of the room where Beethoven died.
Source: Jupiterimages, Corp.

Friedrich Schiller, the poet whose Ode to Joy *inspired the finale of Beethoven's Symphony No. 9.*
Source: Jupiterimages, Corp.

soloists and a chorus for the first time. Of course there had been many concert vocal works (as opposed to operas) that made use of orchestral accompaniment, but this work was very different. It is a four-movement instrumental symphony in every respect except that a third of the way through the final movement people start singing. The final movement sets a Romantic poem by Schiller titled *An die Freude* (To Joy), and the main melody of the movement is usually referred to as the *Ode to Joy*. It is a powerful moment in the history of music and a high point of Beethoven's career. Though he was stone deaf by the time of the work's premiere, he stood next to the conductor to help with the many complex tempo changes the work requires. At the completion of the performance the crowd erupted in applause, but Beethoven was completely unaware of the ovation until one of the musicians turned him around so he could see the audience's reaction to his new work. In a 1941 article for the *New York Herald Tribune*, noted composer and music critic Virgil Thomson summed up Beethoven's symphonies (and his sonatas and string quartets as well) like this:

> Beethoven really was an old bachelor. But he never liked it. All his music is cataclysmic, as if he were constantly trying to break out of his solitude. His first movements state the problem squarely. His slow movements are less interesting, because they try unsuccessfully to avoid; they tread water. His minuets and scherzos reopen the problem and announce the hope of a solution. The finales, almost always the finest and certainly the most characteristic movements in Beethoven, are the solution that the whole piece has been working up to. That solution is usually of a religious nature. It represents redemption, the victory of soul over flesh. It varies from calm serenity to active triumph, but joy is its thesis. In the Ninth Symphony a German ode on that subject is inserted to clinch the matter. The bonds of solitude are broken because they are imagined as being broken. That breaking is of a purely mystical nature, a temporary identification of the self with God or with all humanity. The form of the musical expression is free and infinitely varied. The finales show Beethoven at his most personal and most masterful. They are grand, terribly serious, and, for the most part, inspiring.[18]

As Beethoven focused more of his energies on his music, his personal life began to suffer. An image of one of Beethoven's studies.
Source: Jupiterimages, Corp.

cyclic

Symphony No. 5 in C minor, Op. 67

Put simply, this is the best known and most universally loved piece of Classical music ever created. The piece has an impact on almost every performer, composer, and audience member who comes in contact with it. The work is created in the standard four-movement sonata cycle format, to which Beethoven adds a **cyclic** component, meaning that a melodic and/or rhythmic idea presented in the first movement returns in the subsequent movements. In the case of this particular symphony, the recurring idea functions as both a rhythmic and melodic motive. The part that keeps coming back is the motive consisting of three short notes and one long note heard at the very beginning of the first movement and, again, in various forms throughout the entire composition. Beethoven manages to give us a number of different "looks" at this little figure throughout the four-movement structure. The first movement is written in the traditional sonata form, although as usual, Beethoven plays around with the form a bit. The slow second movement is a set of variations based on two different themes. The third movement is a scherzo and trio, which leads right into the last movement. This monumental last movement adds a piccolo, a contrabassoon, and a full trombone section to the symphony orchestra for the first time. Trombones had been used for years in church music but had never made their way into the symphony before. The orchestra would never be the same.

Listening Guide

Symphony No. 5 in c minor, Op. 67
Movement I—*Allegro con brio*
Ludwig van Beethoven (1770-1827)

Format: Symphony, sonata form

Performance: Swedish Chamber Orchestra, Thomas Dausgaard, conductor

Recording: *The Complete Orchestral Works of Ludwig Van Beethoven, Volume 2* (Simax PSC 1180)

Performance Notes: "The Swedish Chamber Orchestra (38 musicians), founded in 1995, is Scandinavia's only full time professional Chamber Orchestra and is based in Örebro, an idyllic city (pop. 120,000) situated on the Black River near Stockholm. It gives some 130 concerts each season." This group is yet another example of the high level of excellent musicianship that exisists around the world today. This under-appreciated, hard-working orchestra is largely unknown in the U.S., even among the strongest fans of Classical music. It is also another good example of a "modern" orchestra making use of authentic performance practice techniques such as returning to original marked tempos and limiting orchestra size. Recorded in May 1999 at the Örebro Concert Hall, Sweden.

Liner notes by George Hall, Simax PSC 1180

Exposition

:00 Theme one begins in a minor key with two sequential statements of the most famous four-note musical figure ever written. It has been said that, for Beethoven, this motive represented fate knocking at the door. How's that for drama? After the first two dramatic pauses, the movement gets rolling with successive statements of the four-note idea played at various pitch levels.

:28 Transition (bridge). As we mentioned earlier, unlike Mozart, Beethoven's transitions often flow smoothly from the first to the second theme with no clear-cut pauses or breaks.

:37 Theme two begins in a major key with a brassy horn call, followed by a more lyrical contrasting melody. Notice that the opening rhythmic gesture of three short notes and a long one are still to be found in both the accompaniment, and later, in the melody, but always presented in the new major key.

1:17 Exposition repeats.

Development

2:34 The entire development will focus on variations on the opening motive. Beethoven stacks it up using various parts of the orchestra. He changes the melodic shape while keeping the same rhythm, and he even cuts the theme up to the point that a couple of times we get down to the orchestra passing one or two notes back and forth. Just sit back and enjoy; Beethoven knows what he his doing. He'll get you back to a statement of the original melodic idea soon.

Recapitulation

3:48 All three themes come back in their original order. Unlike most first movement sonata forms, however, themes two and three change tonal centers, moving from what should be the original minor key to the "happier" sounding parallel major key center. Throughout the recapitulation, Beethoven makes alterations to the themes and orchestration when compared to the exposition. In particular, note the little oboe cadenza right at the beginning of the recap. Technically, this is so *wrong,* but Beethoven always gets away with stuff like this. In fact, it's little gestures like this one that made Beethoven a genius while most of his "play by the rules" contemporaries are long forgotten. (Can you say "Dittersdorf?")

Coda

5:16 Beethoven comes up with one heck of a coda, where he actually introduces a new thematic idea and then, right at the end, makes it sound as though he is going to repeat the entire recapitulation *again*. What a guy! Some scholars actually call the middle part of this section a "second development," but that kind of terminology just seems to cloud the issue. The issue, of course, is the fact that Beethoven was just different . . . and that's really o.k. Everyone relax.

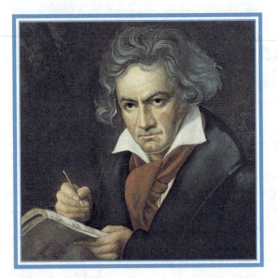

Famous painting of Beethoven holding the score to his Missa solemnis.
©Shutterstock.com

The concertos, Fidelio, *and the* Missa solemnis

As with the symphonies, piano sonatas, and string quartets, Beethoven's early concertos are very much Classical in nature, where as his later works enter the world of Romanticism. Along with the piano concertos of Mozart, Beethoven's Fourth and Fifth Piano Concertos are some of the most frequently performed and recorded works in the entire repertory. The fifth concerto, sub-titled the *Emperor* (though not by the composer), is the first major work to break the double exposition mold described in the *Focus on Form*. In the first movement, the orchestra plays one big chord, and the soloist comes right in with a dramatic opening line. In addition, Beethoven created the cadenza for this work and wrote a note to the soloist that it was to be performed as he wrote it, without improvisation. Beyond the piano, Beethoven also composed a very important concerto for violin and orchestra that is, once again, one of the finest ever written for the instrument.

Beethoven only wrote one opera, and he struggled mightily to get it right. First completed in 1805, the work was titled *Léonore*, but Beethoven withdrew the work after it was not well received. He undertook an extensive revision of the work, going so far as to write four different overtures for the opera before he found one he really liked. He also renamed the work *Fidelio*. The work is what is called a "rescue" opera, with the typical themes of good vs. evil. Written in German, the piece is a *Singspiel*, with both spoken dialogue and regular operatic singing. About this work, Beethoven wrote: "My *Fidelio* was not understood by the public, but I know that it will yet be valued; nevertheless, although I know what *Fidelio* is worth, I know just as clearly that the symphony is my true element. When sounds stir within me, I always hear the full orchestra; I know what to expect of instrumentalists, who are capable of almost everything, but with vocal compositions I must always keep asking myself: can this be sung?"[19] Though not considered the greatest opera ever written, it is still frequently performed in opera houses around the world.

Toward the end of his life, Beethoven composed a giant setting of the five movements of the mass Ordinary, which he called the *Missa solemnis* (Solemn Mass). He considered it his greatest compositional achievement, and it is a work of extreme beauty and power. The work is far too long to be used in a normal religious setting, and from the beginning, Beethoven intended it for the concert hall. Like Mozart's *Requiem* mentioned earlier, this work is a magnificent final statement from a life dedicated to music.

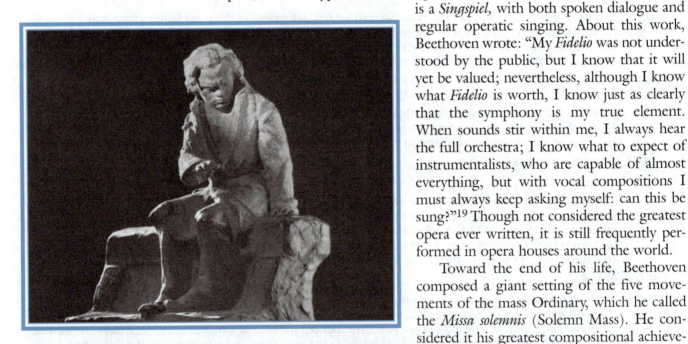

A modern sculpture of Beethoven by Jeno Juszko (1880-1954).
Source: Jupiterimages, Corp.

Endnotes

1. Jay Zorn, *Listening To Music*, 3rd ed. (Upper Saddle River, NJ: Prentice Hall, 2000), 115.

2. Milan Munclinger, translated by Ivan Vomácka, *František Benda: 10 Sinfonie*, compact disc liner notes, Supraphon 3646-2 012.

3. Not counting P.D.Q. Bach (1807-1742?), of course! P.D.Q. Bach is the fictitious 21st son of J. S. Bach, which was created as a comedic alter ego by Prof. Peter Schickele.

4. Donald Jay Grout and Claude V. Palisca, *A History of Western Music*, 6th ed. (New York: W. W. Norton, 2001), 457.

5. K. Marie Stolba, *The Development of Western Music: A History,* 3rd ed. (Boston: McGraw-Hill, 1998), 342-344.

6. Ibid., 343.

7. Frantisek Benda, quoted in Milan Munclinger, translated by Ivan Vomácka, *Frantisek Benda: 10 Sinfonie*, compact disc liner notes, Supraphon 3646-2 012, 7.

8. Stolba, *The Development of Western Music,* 368.

9. Ibid., 369.

10. H.C. Robbins Landon, ed., *The Collected Correspondence and London Notebooks of Joseph Haydn* (Fair Lawn, NJ: Essential Books, 1959), 164.

11. Grout and Palisca, *A History of Western Music,* 485.

12. Leopold Mozart, quoted in *W. A. Mozart: Piano Concertos,* compact disc liner notes, BIS 283.

13. Michael F. Robinson, "Mozart and the Opera Buffa Tradition," in *W.A. Mozart: Le nozze di figaro,* ed. Tim Carter (Cambridge: Cambridge University Press, 1987), 12.

14. Emily Anderson, ed., *The Letters of Mozart and His Family,* vol. II, (New York: St. Martin's Press, 1966), 893.

15. Ibid., 897.

16. Siegmund Levarie, *Mozart's Le Nozze di Figaro* (Chicago: The University of Chicago Press, 1952), 50.

17. Michael Kennedy, ed., "Beethoven," *The Concise Oxford Dictionary of Music* (Oxford, England: Oxford University Press, 1985), 59.

18. Virgil Thomson, "Haydn, Beethoven, and Mozart," in *Words on Music,* Jack Sullivan, ed., (Athens, OH: Ohio University Press, 1990), 108-109.

19. Beethoven to Georg August Griesinger, ca. 1824, in *Composers on Music,* ed. Sam Morgenstern (New York: Greenwood Press, 1956), 88.

Study Guide

Chapter 5 Review Questions

True or False

___ 1. Beethoven composed 32 piano sonatas.

___ 2. Classical concertos usually feature a double exposition in the first movement.

___ 3. Classical concertos never feature a double exposition in the first movement.

___ 4. Mozart's last three symphonies were composed in a very short amount of time in 1788.

___ 5. Haydn was a very dull and unimaginative composer.

___ 6. Composer Franz Benda comes from a large family of musicians.

___ 7. During the Classical period, the orchestra at Mannheim became one of the largest and finest in all of Europe.

___ 8. The typical seven-part rondo form is A-B-C-C-A-D-A.

___ 9. Beethoven was a pioneer in the use of the scherzo and trio.

___10. Many historians view the birth of "Classical" music as a reaction against the overly complex polyphonic music of the late Baroque.

Multiple Choice

11. The frequency with which chords change is referred to as:

 a. galant style.
 b. dissonance.
 c. harmonic rhythm.
 d. sonata cycle.

12. The English translation for the term *Sturm und Drang* is:

 a. storm and stress.
 b. stop and drag.
 c. stop, drop, and roll.
 d. none of the above.

13. A multi-movement work for solo piano, or a work for one solo instrument with piano accompaniment.

 a. sonata
 b. fugue
 c. symphony
 d. concerto grosso

14. Known as the London Bach.

 a. J. S. Bach
 b. C. P. E. Bach
 c. P. D. Q. Bach
 d. J. C. Bach

15. Haydn's catalog of instrumental compositions includes:

 a. solo keyboard works.
 b. various duets and trios.
 c. 82 string quartets.
 d. 104 symphonies.
 e. all of the above.

16. The portion of a solo concerto where the orchestra drops out and the soloist continues.

 a. exposition
 b. development
 c. coda
 d. rondo
 e. none of the above

Fill in the Blank

17. In a typical sonata form the _____ allows the composer to experiment with the theme from the exposition.

18. The _____ style is graceful, gentle, sometimes playful, and always pleasant to the ear.

19. The Austrian national anthem was composed by _____.

20. As a composer, Mozart's greatest public successes were _____.

21. _____ wrote his *Heiligenstadt Testament* in 1802, although it was not discovered until after the composer's death.

22. Beethoven used a compositional technique called _____ in which themes from a previous movement return in later movements of a sonata cycle.

Short Answer

23. List the three major composers of the Classical period.

24. List the major differences between a typical Classical concerto sonata form and other sonata forms.

25. List the five parts of a typical sonata form.

Essay Questions

1. Discuss the evolution of the patronage system during the Classical era.

2. List and define the major components found in a typical sonata cycle. Include information about individual movement forms and tempos.

Chapter 6

The Romantic Era

"Music washes away from the soul the dust of everyday life."

Berthold Auerbach

The Romantic era in music was a time marked by revolution, innovation, and an increased awareness of individuality. The French Revolution, along with Napoleon Bonaparte's subsequent actions, stirred political passions throughout much of Europe. The Congress of Vienna (1814-15) created new territorial boundaries in an attempt to restore an equal balance of power throughout Europe. This "counter-revolution" restored the French monarchy, and many artists and philosophers reacted with a heightened sense of the "romantic ideal:" a life focused on God and nature, driven by emotion rather than the rational thought of the Enlightenment. Beyond political considerations, the industrial revolution led to a large increase in the middle and upper classes. Consequently, financial support for the arts shifted from the traditional form of court and church patronage to more of a consumer-driven economy for the arts. Composers were now free to write pretty much whatever they wanted, but their works were often influenced by a desire to be accepted by the public or by direction of a specific commission. Still, composers began to explore more personal styles of self-expression, building on many of the formal structures made popular during the Classical period while finding new ways to create works that were unique to their personal style.

A new sense of romanticism had already made its way into most of the other arts by the late 1700s, and by the second decade of the 1800s many composers and performers were responding to these new ideals. Romantic literature—especially the poetry of Goethe and Heine, among others—had a profound effect on composers such as Schubert, Mendelssohn, and Schumann. There was an

Liberty Leads the
People to the Barricades
by Eugene Delacroix.
© Shutterstock.com

increased interest in amateur music-making, as large choral societies sprang up all over Europe. These ensembles, especially popular in England, led to the creation of a number of monumental compositions for the combined forces of voices and orchestra. The *salon* became a fashionable pastime for upper middle class and wealthy patrons of the arts, who would meet in small groups to discuss the arts, politics, and other gossip of the day. The performance of chamber music was a mainstay of the *salon* culture, and artist/composers including Chopin and Liszt became very popular at such events.

Composers began to focus their efforts toward the extremes of music. Symphonies and concertos became longer and more technically demanding, and the orchestral forces required to play these works increased as well. A new single-movement orchestral work called a tone poem offered composers another outlet for musical expression using large instrumental groups. Toward the other end of the spectrum, small chamber music formats became very popular as well. Single-movement character pieces for solo piano and art songs (settings of romantic poetry for voice and piano) became the order of the day. Many instrumental pieces took on "extra-musical" ideas as programmatic compositions were designed to convey images and emotions or even to tell complete stories through music. Operatic styles continued to evolve, and most of the major works performed in opera houses around the world today were written during the nineteenth century. The general level of musicianship was on the rise

*Statue of the poets
Schiller and Goethe in
Weimar, Germany.*
© Shutterstock.com

during the Romantic era, both among amateurs and professionals. Mechanical improvements enabled performers to play with more virtuosity on many instruments, and conservatories opened throughout Europe, offering anyone with talent the ability to receive a solid education in the art of music.

Beyond purely formal and technical considerations, the concept of *nationalism* began to influence the works of many composers during the Romantic era. **Nationalism** in music was brought on in some instances by a patriotic spirit fueled by revolution and political upheaval. In other cases, it was a reaction to the dominance of Austrian/German instrumental music (and, to a lesser extent, Italian opera) at the end of the Classical period. Nationalistic elements in music can include: (1) the use of local folk tunes, dance rhythms, and/or the creation of new melodies that resemble the music of a composer's homeland; (2) programmatic music (especially tone poems) that paint musical portraits of local folk tales or scenes from the countryside; and (3) the creation of nationalist operas, written in the local language and telling stories of folk life or local mythology. As you will see throughout this chapter, many composers, including some who are German and Italian, infuse at least some of their music with a sense of nationalism.

Nationalism

Franz Schubert (1797-1828)

Franz Schubert is a bit like Beethoven in that his compositions span the transition from the Classical period to the Romantic era. In fact, they were living in Vienna at the same time, but it seems they only met once. In general, Schubert's music is considerably lighter, but the overt emotional content that clearly marks the Romantic period is evident in the works of both composers. Of all the important composers associated with Vienna during the Classical and early Romantic periods, Schubert was the only one actually born there. Schubert grew up in a suburb of Vienna, the son of a middle class schoolteacher. He displayed an early gift for music, singing soprano in the church choir while still a young boy. He also mastered the violin and the piano. After completing school, he tried to follow in his father's footsteps as a schoolteacher, but he never cared for the discipline the lifestyle required. He made several attempts to secure an official position as a court composer or music instructor, but nothing permanent ever came his way. He spent the rest of his short life devoted to the art of composition, no matter what his current employment situation might have been. Schubert's music was not well known during his lifetime, and little of it was published while he was alive. At times he lived in near poverty, while at others he would have been considered financially secure.

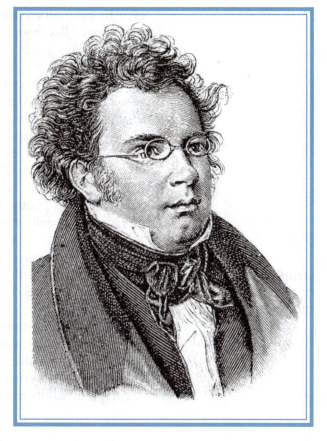

Franz Schubert.
Source: Jupiterimages, Corp.

Schubert's personality was somewhat shy and reserved. In some ways he tended to be a loner, but he had many friends and artistic acquaintances. In fact, he was frequently the center of creative gatherings, which came to be called "Schubertiads" (literally "Evenings with Schubert"), where he would join friends in intimate performances of his latest works. Lively discussion, debate, and possibly some drinking were the order of the day. The older he got, the more he felt his lonely existence helped him "suffer" for his art, giving him a deep well of emotion from which to draw inspiration. The following story comes from a book titled *Schubert: Memoirs by his Friends.*

> Once when he was invited, with Baron Schönstein [who had an excellent tenor voice], to a princely house in order to perform his songs before a very aristocratic audience, the enraptured audience surrounded Baron Schönstein with the most ardent appreciation and with congratulations on his performance. But when no one showed any sign of granting so much as a look or a word to the composer sitting at the piano, the noble hostess, Princess K[insky], tried to make up for this neglect and greeted Schubert with the highest praise, at the same time suggesting that he overlook the fact that the audience, quite carried away by the singer, complimented only him. Schubert replied that he thanked the Princess very much but she was not to bother herself in the least about him, he was quite used to not being noticed, indeed he was really very glad of it, as it caused him less embarrassment.[1]

Schubert died at the tender age of 31, even younger in death than Mozart. Scholars disagree on the cause of his death, some saying typhoid fever and others citing syphilis as the cause. Either way, he was sick for a while, and he died young,

even by early nineteenth-century standards. His final wish was to be buried near the grave of Beethoven, a wish that was granted. A friend provided the following epitaph for his gravestone: "Here the art of music has buried a rich possession but even more promising hopes."[2]

Schubert was relentless in his production of new works. All totaled, he composed over 900 works, including more than 600 art songs, 3 major song cycles, 9 symphonies, 7 masses, 15 string quartets, and various other chamber music. He even tried his hand at opera though he enjoyed little success in that particular genre. His symphonies, and much of his chamber music, are full of the clear-cut formal structures popular throughout the Classical period. It is in his extensive output of art songs (*Lieder* in German) that his romantic spirit completely reveals itself. From his youth, Schubert was quite taken with the romantic movement in literature, especially poetry. Not content to simply read and enjoy these poems, Schubert set a great many of them to music. Rather than forcing the poetry into a preconceived formal musical structure, the composer allowed the shape of the poem to determine the shape of his music. Some of the works are **strophic** (the same tune over and over), **modified strophic** (basically the same tune, but with significant alterations where the text requires), or **through-composed**. The concept of through-composition makes it sound as though the composer starts writing at the beginning and never returns to the opening material. Usually that is not true, as a recognizable theme often keeps returning, but through-composed works have no clear, discernable structure. A good example of through-composition is a masterpiece Schubert wrote when he was only 18 years old, *Der Erlkönig*.

strophic

modified strophic

through-composed

Der Erlkönig, D. 328

Der Erlkönig (The Erlking) is an excellent example of the German *Lied* (art song in English). The **Lied** is a romantic poem set to music for a solo voice with piano accompaniment. As you will hear in the following example, the piano part is frequently not just a simple accompaniment with the voice part dominating

Lied

The poet Goethe, whose poem Der Erlkönig *Schubert set to music.*
Source: Jupiterimages, Corp.

over the top of the structure. Based on a poem by Goethe, Schubert's *Der Erlkönig* presents four individual characters with one voice. By using different musical accompaniments and changing from high to low areas of the singer's voice, Schubert manages to clearly distinguish all four characters of the poem. The four individual characters include the narrator, a father and son riding through the countryside on horseback, and the evil Erlking or "king of the elves." The legend goes that any child touched by the Erlking dies. Cool, huh? Get used to it. Death was a very popular topic with most romantic artists.

Listening Guide

Der Erlkönig, D. 328
Franz Schubert (1797-1828)

Format: Lied (art song)
Performance: Dietrich Fischer-Dieskau, baritone; Karl Engel, piano
Recording: *Goethe-Lieder* (Orfeo D'or C389 951 B)

Performance Notes: Dietrich Fischer-Dieskau is considered one of the finest interpreters of German *Lied* to ever take the stage. He is particularly well known for his artful renditions of Schubert's song cycles. Here is a historic recording that was made during a live concert in Stockholm in 1970. This performance comes from Fischer-Dieskau's private collection. Originally, it appears not to have been intended for the public; however, unlike many rock "bootlegs," this artist was very supportive of its commercial release.

:00 Piano introduction. It has been said that the piano accompaniment imitates the horse's hooves as they hit the ground. You may recognize this little motive from cartoons and movie soundtracks, where it still shows up from time to time. With apologies to Bugs Bunny fans, Schubert did it first.

:23 The first voice you hear is the narrator, who sets the scene.

Wer reitet so spät durch Nacht und Wind?	Who rides so late through night and wind?
Es ist der Vater mit seinem Kind;	It is a father with his child:
er hat den Knaben wohl in dem Arm,	he has the boy close in his arm,
er fasst ihn sicher, er hält ihn warm.	he holds him tight, he keeps him warm.

:56 This next section is a dialogue between father and son. Notice that Schubert writes the father's voice low and the son's voice high.

"Mein Sohn, was birgst du so bang dein Gesicht?"	"My son, why do you hide your face in fear?"
"Siehst, Vater, du den Erlkönig nicht?	"Father, don't you see the Erlking?
den Erlenkönig mit Kron' und Schweif?"	The Erlking with his crown and train?"
"Mein Sohn, es ist ein Nebelstreif."	"My son, it is a streak of mist."

1:29 Here is the voice of the Erlking. This melody is best described as *sinuous* or perhaps *reptilian*. It really does feel kind of slimy with undertones of pure evil, sort of like a theme song for a lawyer or a car salesman.

"Du liebes Kind, komm, geh mit mir!	"You dear child, come with me!
gar schöne Spiele' spiel' ich mit dir;	I'll play very lovely games with you.
manch' bunte Blumen sind an dem Strand;	There are lots of colorful flowers by the shore;
meine Mutter hat manch' gulden Gewand."	my mother has some golden robes."

1:53 The son shouts out in a high, frightened voice. The father answers in lower, comforting tones.

"Mein Vater, mein Vater, und hörest du nicht,	"My father, my father, and don't you hear
was Erlenkönig mir leise verspricht?"	the Erlking whispering promises to me?"
"Sei ruhig, bleibe ruhig, mein Kind;	"Be still, stay calm, my child;
in dürren Blättern säuselt der Wind."	it's the wind rustling in the dry leaves."

2:16 Now the Erlking returns, trying ever harder to "recruit" the little boy.

"Willst, feiner Knabe, du mit mir geh'n?	"My fine lad, do you want to come with me?
meine Töchter sollen dich warten schön;	My daughters will take care of you;
meine Töchter führen den nächtlichen Reih'n	my daughters lead off the nightly dance,
und wiegen und tanzen und singen dich ein."	and they'll rock and dance and sing you to sleep."

2:33 The son shouts again, asking his father if he doesn't now see what is going on. The father continues to comfort his child.

"Mein Vater, mein Vater, und siehst du nicht dort,	"My father, my father, and don't you see
Erlkönigs Töchter am düstern Ort?"	the Erlking's daughters over there in the shadows?"
"Mein Sohn, mein Sohn, ich seh' es genau,	"My son, my son, I see it clearly,
es scheinen die alten Weiden so grau."	it's the gray sheen of the old willows."

3:02	This time the Erlking starts out sounding nice, but in the end, decides to use force instead.

"Ich liebe dich, mich reizt deine schöne Gestalt, "I love you, your beautiful form delights me!
und bist du nicht willig, so brauch' ich Gewalt." And if you are not willing, then I'll use force."

3:14	The Erlking's brief final statement is immediately followed by a final, desperate outburst from the son.

"Mein Vater, mein Vater, jetzt fasst er mich an! "My father, my father, now he's grasping me!
Erlkönig hat mir ein Leids gethan! The Erlking has hurt me!"

3:27	The narrator returns to finish out the story. In particular, notice the last notes Schubert uses in the voice over the words *war todt* (was dead). This spot really captures both the ultimate tragedy and finality of death.

Dem Vater grauset's, er reitet geschwind, The father shudders, he rides swiftly,
er hält in Armen das ächzende Kind, he holds the moaning child in his arms;
erreicht den Hof mit Müh und Noth: with effort and urgency he reaches the courtyard:
in seinen Armen das Kind war todt. in his arms the child was dead.

Felix Mendelssohn (1809-1847)
Fanny Mendelssohn Hensel (1805-1847)

Perhaps even more than Schubert, Felix Mendelssohn may be viewed as a transitional composer whose works help bridge the Classical and Romantic style periods in music. He adheres closely to the styles of Haydn and Mozart in terms of formal structures, but the heightened emotional content of his works, his interest in nature, and his use of general programmatic ideas in his instrumental works all point to the Romantic era. Felix Mendelssohn was born into a wealthy Jewish family. His grandfather was the famous philosopher Moses Mendelssohn, and his father, Abraham, was a successful banker. Abraham Mendelssohn made the decision to have his family convert to Christianity in the hopes that they could avoid some of the prejudice many Europeans felt toward the Jewish community. After conversion, the family added the last name Bartholdy, and today you will sometimes see concert programs and recordings that list the composer as Felix Mendelssohn-Bartholdy.

Mendelssohn began to excel in the arts when he was quite young. He played the piano and the violin, composed music, wrote poetry, and even took up painting. While still a teenager, he composed a number of successful works that are still performed today, including the *Octet*, Op.20, and the overture *A Midsummer Night's Dream*, Op. 21, based on Shakespeare's play. Mendelssohn traveled extensively, particularly exploring England, Scotland, and Italy. These travels led to the composition of several popular programmatic works including his Symphony No. 3 (*Scottish*), Symphony No. 4 (*Italian*), and the *Hebrides Overture*, which is also known as *Fingal's Cave*. At the age of 26, Mendelssohn was appointed conductor of the Leipzig Gewandhaus Orchestra. Under his direction the orchestra became a very successful performing organization, a position it maintains in the world of music to this day. While in Leipzig, Mendelssohn also became the director of a new music conservatory there. Throughout all of his travels and conducting activities, Mendelssohn continued to be a very prolific composer. In terms of compositional temperament, he has been compared to Mozart. Music flowed easily from his pen, and he seemed to always have a perfect sense of orchestration and formal structure.

Felix and Fanny Mendelssohn.
Source: © 2009 Jupiterimages, Corp.

Another important aspect in the life of Mendelssohn is his interest in older music. In particular, it is Mendelssohn who is usually credited with the resurgence in the popularity of J. S. Bach and his music. After Bach's death in 1750 his music was largely forgotten. With the exception of music students, who studied Bach's contrapuntal keyboard works, J. S. Bach's music was rarely performed in public. Mendelssohn organized a performance of Bach's *St. Matthew Passion*, which led to the gradual "re-discovery" of many of Bach's masterpieces. From that day to this, Bach's music has done nothing but grow in popularity and historical importance. Mendelssohn also studied and performed the oratorios of Handel, which inspired the young composer to create two major oratorios of his own, *St. Paul*, Op. 36 and *Elijah*, Op. 70.

Over the past 20 years or so, music historians have become fascinated with Felix Mendelssohn's older sister, Fanny. In many ways, she seems to represent an entire era of female composers and performers who have been completely overlooked, their works unpublished and now lost to history. Like her famous younger brother, Fanny Mendelssohn demonstrated a tremendous early talent for music. Young women in middle and upper class society during the nineteenth century were encouraged to educate themselves in the arts, but society demanded that they remain "amateurs," never to pursue music as a profession. In Fanny Mendelssohn's case, both her father and her brother disapproved of her interest in music as a career, encouraging her to take the more traditional roles of wife and mother. Nonetheless, Felix Mendelssohn did publish several of her compositions under his name in collections of his works. After the death of her mother, it was Fanny who took over the organization of the weekend musical concerts in the Mendelssohn household. At the age of 24 she married Wilhelm Hensel, an artist attached to the court in Berlin. In spite of her duties running the family household, she continued to compose. She eventually wrote over 400 works, many of which have still not been published. With the increased interest in the study of her music, more and more works are coming to light and are enjoying their first public performances. Fanny Mendelssohn and her brother Felix remained close throughout their entire lives. She died at the age of 41 after suffering a stroke, and, distraught over his sister's death and suffering from exhaustion, Felix Mendelssohn passed away a few months later.

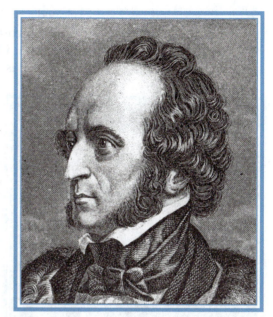

Felix Mendelssohn.
Source: Jupiterimages, Corp.

Niccolò Paganini (1782-1840)

Violinist Niccolò Paganini revolutionized the world of the solo musician. In the Romantic era his playing techniques were unparalleled. He had something of a mystical hold on his audiences, and rumors circulated that he sold his soul to the devil in exchange for his phenomenal abilities. In addition to his skills as a violinist, he also became an exceptional performer on viola, mandolin, and guitar. Paganini was a flamboyant figure on stage, with long fingers, aristocratic features, and a flashy demeanor, which he used to make his performances seem effortless and yet incredibly dramatic at the same time. Always the showman, Paganini had

Niccolò Paganini.
Source: Jupiterimages, Corp.

developed a skill for playing entire works on just one string of his violin. In concert he would intentionally use a weak string or two, so when the string suddenly broke in concert, he would flawlessly complete the work using just one string, always to the thunderous applause of the stunned audience. People, especially women, were drawn to him. His skill as a performer had a major impact on the careers of Schumann, Chopin, and Liszt, among many others. As Chopin and Liszt would later do for the piano, Paganini developed a number of new techniques for the violin, including ricochet bowings, use of double- and triple-stops (playing two or three notes at once), and plucking the strings with his left hand while still playing regular notes with the same hand *and* simultaneously bowing the violin with his right hand. London music critic Leigh Hunt wrote the following in a series of articles about performances Paganini gave in London in 1831.

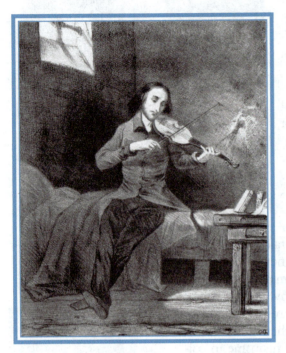

Painter Louis Boulanger created this image of Paganini playing violin in what appears to be a jail cell. Paganini wrote a letter to the Parisian newspaper that printed the image and denied he had ever been in jail. They replied that the image was "simply an artistic interpretation and not meant to be slanderous." Even in the nineteenth century it was tough to be a public figure!*
Source: Jupiterimages, Corp.
***Quote Source:** *www. markets.hpcwire.com/ taborcomm*

His playing is indeed marvellous [sic]. What other players can do well, he does a hundred times better. We never heard such playing before, nor had we imagined it. His bow perfectly talks. It remonstrates, supplicates, answers, holds a dialogue. It would be the easiest thing in the world to put words to his music . . . In a word, we never heard anything like *any* part of his performance, much less the least marvel we have been speaking of. The people sit astonished, venting themselves in whispers of "Wonderful!"—"Good God!"—and other unusual symptoms of English amazement; and when the applause comes, some of them take the opportunity of laughing, out of pure inability to express their feelings otherwise . . . how are we to endure hereafter our old violins and their players? How can we consent to hear them? How crude they will sound, how uninformed, how like a cheat! When the Italian goes away, violin-playing goes with him, unless some disciple of his should arise among us and detain a semblance of his instrument. As it is, the most masterly performers, hitherto so accounted, must consent to begin again, and be little boys in his school.[3]

Beyond his skills as a performer, Paganini's work as a composer also had an impact on a number of romantic composers who would follow him. Almost all of his compositional output was focused on the instruments he could play, especially the violin. By today's standards, his concertos are a bit "over the top" in terms of being showpieces, but they are still performed on a regular basis. His *24 Caprices* for solo violin have become regular features in every violinist's repertory and something every serious violin student will eventually study in depth.

Moto Perpetuo No. 2 in C Major

Paganini created several different versions of the *Moto Perpetuo* (Perpetual Motion) including versions for violin and chamber orchestra, violin and string quartet, and at least two versions accompanied by piano or guitar. Each version is slightly different, but they are all non-stop technical showpieces. Lots of notes at a very fast tempo equals "crowd pleaser" every time. These works are the musical equivalent of going to a NASCAR race, enjoying the thrill of the power, but all the time secretly waiting for a crash.

Listening Guide

Moto Perpetuo No. 2 in C Major
Niccolò Paganini (1782-1840)

Format: Character piece for solo violin with piano accompaniment
Performance: Stefan Milenkovich, violin; Massimo Paderni, piano
Recording: *Paganini Recital* (Dynamic CDS 165)

Performance Notes: Recorded in Genoa, Italy, June 1996. Stefan Milenkovich plays a violin built in 1738 by C. Camilli.

:00 This little showpiece is exactly what the title implies, non-stop musical motion. Along the way Paganini passes through several different sections, including a brief flirtation with a minor key center instead of the advertised major one. Regardless of what happens thematically, however, the notes never stop flowing.

Robert Schumann (1810-1856)
Clara Wieck Schumann (1819-1896)

Robert Schumann came from a literary background, thoroughly steeped in the romantic poetry and novels of the day. This romantic spirit would inform all of his compositions. In addition to literature, Schumann studied music as a young man. Though undisciplined, he displayed a certain gift for both piano performance and composition. After seeing both the young pianist Clara Wieck and the famous violinist Paganini in concert, Schumann decided to dedicate his life to becoming a piano soloist. He began an intense program of study with Clara Wieck's father, Friedrich, a noted teacher in his day. He threw himself headlong into his studies, and in order to focus all of his attention on practice and lessons he even moved into the Wieck household. By today's standards, Schumann would be considered somewhat obsessive, with definite manic-depressive tendencies. Some stories say that Schumann damaged his hand through extensive repetitive practice, while others suggest his hand damage was caused by a side effect from a treatment he took in an attempt to cure syphilis. Regardless, his hopes for a career as a solo pianist were gone, and he eventually turned his attention to composition. During that same time period he also continued his lifelong interest in writing, most notably by joining a small group of artists who founded the *Neue Zeitschrift für Musik*, or the *New Journal for Music*. At a time when the arts were a heavily discussed topic in society, music criticism and commentary were very popular, and the journal was a success. Through his writings, Schumann was an early champion of composers such as Chopin, Berlioz, and Brahms.

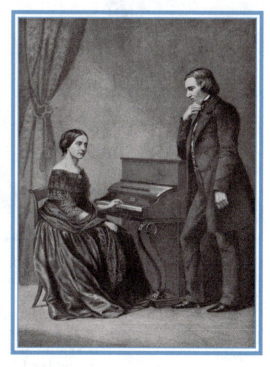

Robert and Clara Schumann.
Source: © 2009 Jupiterimages, Corp.

DIG DEEPER

MOVIE
Spring Symphony
(A love story about
Robert and Clara
Schumann)

Over the years, a love affair blossomed between Clara Wieck and Robert Schumann. As a young girl, Clara was already accepted throughout much of Europe as one of the finest pianists of the day. From her early childhood, her father had Clara on a strict regimen of practice and music study, and with her natural inclination for music she became a spectacular performer, on a par with Chopin and Liszt. Schumann eventually asked Friedrich Wieck for his daughter's hand in marriage. Wieck thought little of Schumann's prospects as a potential husband and son-in-law and refused his consent. He also knew that Clara had the opportunity for a major career as a piano soloist and possibly as a composer (a real revolution at that time for a woman), and he didn't want to miss out on the opportunity to be involved in her life. The couple eventually had to petition the courts for permission to marry over the objections of Clara's father.

Robert Schumann excelled in many areas of composition. He wrote symphonies, string quartets, music for choirs, solo art songs, and piano music in formats large and small. Many of his instrumental works had programmatic titles, but the composer frequently kept these hidden from the audience for fear they might unduly influence his listeners. His art songs are frequently compared to Schubert's, and together they form the backbone of all Romantic vocal repertory. Most important are his song cycles *Frauenliebe und Leben,* Op. 42 (Woman's Love and Life), and *Dichterliebe,* Op. 48 (A Poet's love). Likewise, his many piano compositions are mainstays in almost every solo pianist's performing career. His Piano Concerto in a minor, Op. 54, and his four symphonies are regularly performed in orchestral halls around the world.

As a soloist, Clara Schumann enjoyed more public acclaim than her husband during their life together. In fact, it was her work that often supported the family, which eventually included seven children. Through her concerts she tirelessly promoted the works of her husband, often overlooking her own compositions in favor of his. She also frequently performed the works of Chopin and Brahms. In fact, Chopin was reported to have said that Clara Schumann was the only woman in all of Europe who could really play his music correctly. She was one of the first prominent female solo instrumental art-

Clara Schumann at the piano with violinist Joseph Joachim performing a concert in Berlin in 1854.
Source: Jupiterimages, Corp.

ists, and she played numerous concerts throughout Europe over her long career. She continued playing public concerts until she was in her 70s. Clara Schumann also broke new ground as a composer, publishing works under her own name. Given the generally accepted view in the nineteenth century that women were not suited to composition, these works are somewhat unique. At times, even Clara had doubts about her skills as a composer, stating: "I once believed that I possessed creative talent, but I have given up this idea; a woman must not desire to compose—there has never yet been one able to do it. Should I expect to be the one? To believe this would be arrogant, something which my father once, in former days, induced me to do."[4] Though her overall output of compositions is small, her works display great skill and training and are all quite engaging. The bulk of her works were written for

the piano, most of which she used in her own performances, but she also wrote a number of *Lieder,* and, at the age of 15, a successful piano concerto with a versatile accompaniment that can be played by a string orchestra or in a chamber music version by a quintet.

Robert Schumann suffered great bouts of depression, followed by manic periods of activity where he would create a flurry of new compositions. He eventually became so insane that he attempted suicide by throwing himself into the Rhine River. Clara had no choice but to allow him to be institutionalized, where he died a few years later. Both Robert and Clara Schumann had befriended a young Johannes Brahms, and that friendship continued for Clara long after Robert's death. In fact, Clara frequently turned to Brahms for advice on the publication of her late husband's music, and Brahms relied on her both for moral support and as a regular performer of his new piano compositions. The compositions of both Robert Schumann and Johannes Brahms represent some of the most important of the entire Romantic era. Clara's works are just beginning to enjoy more public acclaim. The couple's relationship and their friendship with Brahms is one of the most fascinating and heartbreaking stories of the entire period. Through all their trials and tribulations it seems to be Clara's emotional strength that sees them all through.

Robert Schumann.
© Shutterstock.com

Focus on Form
Character Pieces

Small, single-movement pieces were nothing new to music in the Romantic era, but they became a central focus in the output of some composers during this period. Works for the solo piano are the most important for this particular discussion, but small character pieces were composed for a number of solo instruments with piano accompaniment as well. Many of these works were absolute though some did carry programmatic titles. Programmatic or absolute, they were almost always highly evocative works that conveyed one or two clear emotions. Some compositions were influenced by popular dance rhythms including the *polonaise,* the *mazurka,* or the waltz, whereas others carried more generic titles such as prelude, nocturne, intermezzo, impromptu, scherzo, or etude. Many of these pieces were through-composed, while others followed simple ABA or rondo schemes, although the returning letter A themes frequently underwent significant alterations. The individual compositions could be as short as 30 seconds or last beyond 15 minutes. Frequently, composers would publish collections of individual character pieces in a set, which they often intended to be performed together. Some good examples of these collections include the *11 Impromptus* by Schubert; *Preludes,* Op. 28, by Chopin; the *Kinderszenen,* Op. 15 (Scenes From Childhood), by Robert Schumann; *24 Caprices* by Paganini; and the *Transcendental Etudes* by Liszt.

Frédéric François Chopin.
Source: Jupiterimages,
Corp.

Frédéric François Chopin (1810–1849)

Chopin is often referred to as the "poet of the piano," and almost all of his compositional output is for that instrument. Chopin's father was French, and his mother was Polish. Together they ran a boarding school in Warsaw, Poland. His father taught French language and literature, and his mother taught music. Chopin displayed early gifts for music, giving public performances and publishing his first works before he was a teenager. During his teenage years he entered the Warsaw Conservatory and continued to compose new music, which he used for his own perfor-mances. Much of his music drew on traditional Polish dance influences, including the *polonaise* and the *mazurka*. In 1830, Chopin left Poland for a series of concerts throughout Europe. While traveling, he learned that Warsaw had been taken over by the Russian army. Unable to return to his homeland, he settled in Paris where he performed, composed, and taught music. Over the years, Chopin became increasingly frustrated with performing for large public gatherings, and he eventually retired almost completely from the public eye. Like Schubert, he preferred to perform for small groups of friends and musically knowledgeable listeners. He became a favorite in Paris's most fashionable *salons*, where patrons of the arts would gather to experience and discuss the arts.

Chopin's compositional output includes two piano concertos, *ballades, polonaises*, three sonatas, and a wide array of small character pieces. Although some of his works carry programmatic titles or have direct ties to traditional dance forms, Chopin insisted that all of his music was absolute, carrying no extra-musical programmatic elements. Chopin's devotion to the piano revolutionized many of the common techniques for playing the instrument, and his works have become a mainstay of most solo pianists' repertory. His use of the sustaining pedal allowed for extended harmonic ideas, pushing soloists to reach beyond their normal physical limitations to achieve greater depths of sonority from the instrument. Chopin was also a pioneer in the use of ***tempo rubato***, using subtle tempo fluctuations to heighten the emotional content of his music. The composer described it this way: "The hand playing the accompaniment adheres to strict tempo; the hand playing the melody relaxes the tempo, then unobtrusively accelerates it in order to resume synchronization with the accompaniment."[5] Although many in the musical world considered him a genius, some of the more traditional music critics of the day were not so kind to Chopin and his new music:

tempo rubato

> Monsieur Frederic Chopin has, by some reason or other which we cannot divine, obtained an enormous reputation but too often refused to composers of ten times his genius. M. Chopin is by no means a putter-down of commonplaces; but he is, what by many would be esteemed worse, a dealer in the most absurd and hyperbolical extravagances. It is a striking satire on the capacity for thought possessed by the musical profession that so very crude and limited a writer should be esteemed, as he is very generally, a profound and Classical musician. M. Chopin does not want for ideas, but they never extend beyond eight or sixteen bars at the utmost, and then he is invariably *in nubibus* [literally "in the clouds," meaning Chopin's music was vague and undefined] . . . indeed, the works of [Chopin] invariably give us the idea of

**DIG
DEEPER**

MOVIES
*A Song To Remember;
Impromptu*
(Story of Chopin,
Sand, and Liszt)

an enthusiastic schoolboy whose parts are by no means on a par with his enthusiasm, who *will* be original, whether he *can* or not. There is a clumsiness about his harmonies in the midst of their affected strangeness, a sickliness about his melodies, despite their evidently forced unlikeness to familiar phrases, an utter ignorance of design everywhere apparent in his lengthened works, a striving and straining after an originality which, when obtained, only appears knotty, crude and ill-digested, which wholly forbid the possibility of Chopin being a skilled or even a moderately proficient artist . . . the entire works of Chopin present a motley surface of ranting hyperbole and excruciating cacophony.[6]

It was in Paris that fellow pianist Franz Liszt introduced Chopin to the female writer Aurore Dudevant, who published her works under the name George Sand. Their relationship became one of the most discussed associations of the entire Romantic era and has become the subject of plays, novels, and films. His musical output was strong during their relationship, but sadly, at the height of his compositional powers, he contracted tuberculosis: his health began to deteriorate. In addition, his relationship with Sand ended in 1847. Ill, but in desperate need of money, he gave a rare public performance in Paris and then traveled to London, giving concerts there as well. He returned to Paris in 1849, where he passed away. As Chopin requested, Mozart's *Requiem* was performed at his funeral service, and he was buried along with a box of Polish soil, a final symbol of his homeland.

Statue of Chopin in Wroclaw, Poland.
Source: © 2009 Jupiterimages, Corp.

Author George Sand (Aurore Dudevant).
Source: Jupiterimages, Corp.

24 Preludes, Op. 28

This set of *Preludes*, inspired to some extent by the *Well-Tempered Clavier* books of J. S. Bach, are wonderful examples of Chopin's skill at creating miniature masterpieces. Like Bach's work, each piece is composed in a different major or minor key center. Chopin planned the 24 individual works as a complete cycle to be performed together, but performers frequently extract a smaller set of the pieces or simply play an individual work as an encore piece after the performance of a major composition. The following three examples should give you some sense of the wide array of contrasting material contained among the 24 individual movements.

Listening Guide

24 Preludes, Op. 28
 No. 7 in A Major—*Andantino*
 No. 3 in G Major—*Vivace*
 No. 4 in e minor—*Largo*

Frédéric François Chopin (1810-1849)

Format: Solo piano character pieces
Performance: Ivan Moravec, piano
Recording: *Chopin: 24 Preludes* (Supraphon SU 3165-2 111)

Performance Notes: Recorded March 1976 at the Dvořák Hall in Prague, Czechoslovakia. This recording is another fine example of an analog vinyl recording being transferred and re-released in the digital compact disc format. Recordings like this one offer the listener fine performances at affordable prices. Proof positive that it doesn't have to be new to be good.

No. 7 in A Major – *Andantino*

:00 This simple waltz is a perfect example of the *tempo rubato* concept. The piece is written in a major key but still manages to convey a real sense of melancholy. Try to listen not only to the beautiful melody but also to the constantly shifting harmonies that play a major role in creating the overall mood of the piece

No. 3 in G Major – *Vivace*

:00 This movement demonstrates a total contrast from the previous one. It is like an unending flow of rippling water. Notice how the performer makes a very difficult composition sound effortless.

No. 4 in e minor – *Largo*

:00 This is one of the saddest and most thought-provoking pieces Chopin ever wrote. The work could not be simpler, and yet it conveys extremely complex emotions. As with the A Major example above, pay close attention to the subtle harmonic shifts that take place throughout this work. Chopin moves one finger on the keyboard and changes the entire emotional content of the moment.

The art of photography was only a few years old when Frédéric Chopin posed for this portrait. As you may have noticed, this is the first composer photograph you've seen in this book.
Source: © 2009 Jupiterimages, Corp.

Franz Liszt (1811-1886)

Franz Liszt is often referred to as the "Paganini of the piano," a nickname he earned and embraced during his lifetime. Liszt is frequently mentioned as the greatest pianist that ever lived. During the Romantic era he astonished audiences with his performance of Beethoven's late works, some of which were considered "unplayable" at the time they were written. He pushed piano technique even further, composing one dramatic masterpiece after another. Among other "firsts," it was Liszt who took the piano out of the center of the orchestra set-up when he performed concertos. Liszt knew the audience came to see *him*, so he put the piano sideways in front of the orchestra. Like a rock star, Liszt dressed with some flamboyance and kept a head of wild, long hair, which he would swing in time with the music. He wore long gloves, which he would give to his legion of female fans, just like Elvis used to pass out his used towels. Writer Moritz Saphir said the following about attending a concert by Liszt:

Portrait of Franz Liszt as a young man.
Source: Jupiterimages, Corp.

> After the concert, he stands there like a conqueror on the field of battle, like a hero in the lists; vanquished pianos lie about him, broken strings flutter as trophies and flags of truce, frightened instruments flee in their terror into distant corners, the hearers look at each other in mute astonishment as after a storm from a clear sky, as after thunder and lightning mingled with a shower of blossoms and buds and dazzling rainbows; and he the Prometheus, who creates a form from every note, a magnetizer who conjures the electric fluid from every key, a gnome, an amiable monster, who now treats his beloved, the piano, tenderly, then tyrannically; caresses, pouts, scolds, strikes, drags by the hair, and then, all the more fervently, with all the fire and glow of love, throws his arms around her with a shout, and away with her through all space; he stands there, bowing his head, leaning languidly on a chair, with a strange smile, like an exclamation mark after the outburst of universal admiration: this is Franz Liszt![7]

Liszt's compositions fall into two categories, those written for piano and those composed for other forces. His piano compositions include works both large and small. Put simply, they are some of the most important pieces ever composed for the instrument. He wrote two concertos for piano and orchestra, along with several other major compositions including *Todtentanz, Hungarian Fantasia,* and the *Rapsodie espagnole* (which was later orchestrated by Busoni). A few of his most important works for solo piano include several *Albums d'un Voyageur* (Traveler's Journals), *Mephisto Waltz,* Sonata in b minor and 20 *Hungarian Rhapsodies.* Unlike Chopin, Liszt also explored the world of composition beyond the piano keyboard. He wrote two programmatic symphonies for voices and orchestra and a number of compositions he called **symphonic poems**, or **tone poems**. These works were programmatic, single-movement orchestral works. In addition to helping develop this instrumental genre in general, Liszt conceived the idea of what he called **thematic transformation.** Similar to Berlioz's *idée fixe*, Liszt wrote music that focused on one major thematic idea, which he would constantly develop throughout the course of a given piece. One of the clearest examples of this technique can be found in his most famous symphonic poem titled *Les Préludes*. The composer also reworked a number of his solo piano *Hungarian Rhapsodies* into compositions for orchestra.

symphonic poems

tone poems

thematic transformation

Like so many other composers in this chapter, Franz Liszt's life is the stuff of legend. He seems a character much larger than life. Noted pianist and humorist Victor Borge devoted an entire chapter of his book *My Favorite Comedies in Music* to the life and music of Liszt. The following article will give you a good sense of Liszt from a gifted pianist's point of view while giving you a few good chuckles as well.

Franz Liszt
by Victor Borge

Since Franz Liszt was probably the greatest pianist of all time, I've set aside a whole chapter just for him. But we must begin with Prince Esterhazy. You remember my telling you about him.[1] What happened is that one of the servants in his employ was a man named Adam Liszt. Adam played the piano, violin, and guitar, although evidently not too well, because the prince sent him away from the main palace to take charge of some properties in Raiding, a little Hungarian village about thirty miles from Vienna, and therefore safely out of earshot. There wasn't much else to do in Raiding, so on October 22, 1811, Adam's wife gave birth to a baby boy. His name was Franz Liszt.[2]

Slow Start

At first, Franz didn't seem to be any great bargain, even as children go. He was sickly, nervous, weak, and he fainted a lot. He really liked music, though, and when his father started giving him piano lessons, Franz would sit practicing scales and exercises for hours at a time.[3]

At the age of nine he gave his first concert, and Adam was so proud of his son that he arranged to have him perform for Prince Esterhazy. The prince in turn was impressed enough to invite Franz to play for other members of the aristocracy at one of his palaces. His wife, Princess Esterhazy, was so enchanted that she gave the boy a valuable autograph book that he lost almost immediately, even though it had belonged to the immortal Haydn himself.[4] At the concert, Franz not only improvised on themes called out to him by the audience, but he sight-read some very difficult pieces that the noblemen placed before him. They were so astonished and impressed that afterward, the counts Apponyi, Amadee, Erdody, Szapary, and Viczay put their pocketbooks together and gave Franz six hundred gulden a year, for six years, to help with his studies.[5] Papa Liszt was even more thrilled than his son. With visions of his little *wunderkind* reaping huge fortunes for him, Adam Liszt quit his job and took Franz to Vienna, the musical capital of Europe.

Prodigy at Work

Liszt's first teacher in Vienna was Karl Czerny, who wrote hundreds and hundreds of compositions, but whose name will always be associated with those finger-breaking exercises that all student pianists have slaved over from his day to ours.[6] Czerny was at it then, too, standing over ten-year old Franz for three hours every day, smoking his pipe and making him repeat passages over and over again until the boy was ready to scream.[7] If Franz was getting impatient with all those finger exercises, Papa Liszt was fairly jumping out of his skin. He wanted his son to perform and be admired and earn piles of money, and not stay home all day doing "dull and uninspired" practice work.

[1] If not, reread the chapter on Haydn, but please stay awake this time.
[2] Actually, his name was Liszt Ferencz, because the Hungarians sign in backwards, but we'll call him Franz Liszt and that's that.
[3] He worked at them so hard that he started to get weak, faint, etc., until papa stopped the lessons. That made Franz even more nervous, sickly, etc., so papa started them again.
[4] Easy come, easy go.
[5] In those days, an Austrian gulden was worth about 50 cents.
[6] Czerny arranged the *William Tell* Overture for thirty-two hands on eight pianos.
[7] Czerny called Liszt "Putzi." I'd hate to know what Liszt called Czerny.

Finally he couldn't stand it any longer and organized a big concert for little Franz on April 13, 1827—the date when Liszt's career really started. Franz had been well prepared by Czerny, and he was a tremendous success, playing a Piano Concerto by Hummel and his own Fantasia based on the slow movement of Beethoven's Fifth Symphony.[8] After that, Papa Liszt took his boy on tour. He played in Munich, Stuttgart, and Strasbourg. In Paris he appeared before dukes and duchesses; in London he was welcomed by King George IV. Papa collected the money, Franz was happy when he could get a nice plate of gooseberry pie, and the Liszt legend had begun.

In 1827 Adam Liszt died suddenly, and Franz moved back to Paris dedicated to a career as pianist, teacher, and composer. He was now sixteen. "Women will bring you under their sway and give you trouble all your life," was his father's last prediction, although Liszt had no idea what he was talking about. "I didn't even know what a woman was," he wrote, many years later, "and in my simplicity I asked my priest to explain the sixth and ninth commandments to me, for I was afraid I might have broken them without knowing I had done so." A few months later, he knew. He had started giving piano lessons and he fell in love with one of his students, seventeen-year old Carolyn de Saint-Cricq. The first indication came when the lessons began getting longer and longer.[9] They were now reading mushy poems to each other, underlining romantic novels, and talking until midnight. It was all very lovely until her father caught them one night and kicked Liszt out of the house. Poor Franz was so upset that he went into hiding and moped around the house for two years, reading Byron and books on socialism. He stayed in seclusion for so long that a Paris newspaper actually printed his obituary. Fortunately, Liszt decided that women were more fun than socialism after all, so eventually he joined the rest of the world.

A Touch of the Fiddler

On March 9, 1831, Liszt went to the first concert given in Paris by Niccolo Paganini. The famous violinist played his fantastic virtuoso pieces with everybody cheering like crazy and women were swooning left and right. Liszt was so overwhelmed by the experience that he vowed then and there to become the Paganini of the Piano. Let women throw themselves at *his* feet for a while. He studied and he read and he practiced. "My mind and my fingers are working like two lost souls," he wrote to one of his students. "I learn, I meditate, and in addition I work four of five hours every day at thirds, sixths, repeated notes, and other exercises. If only I don't go mad, you will find an artist in me." After several years of this kind of slavery, Liszt started playing in public again with women swooning left and right for him, too.[10]

A Liszt of Romances

Equally true to Paganini's image as a Don Juan, Liszt allowed his own love life to get terribly complicated. Let's see, there was a pianist named Camille, an actress named Charlotte, and a singer named Sabatier. There was the Baroness Olga and the Princess Belgiojoso. There was Marie Duplessis, the courtesan whose life became the model for *La Traviata,* and Marie Mouchanoff-Kalergis,

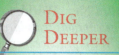

DIG DEEPER

BOOKS
My Favorite Comedies in Music and *My Favorite Intermissions* by Victor Borge; two of the funniest books ever written about the world of classical music

MOVIES
Lisztomania; Song Without End

[8] Beethoven was in the audience that day, and since he was too deaf to hear what Liszt had done to his symphony, he came up onstage and kissed the boy on the forehead.

[9] And with less and less playing (piano, that is).

[10] Sometimes Liszt was so carried away that he himself would swoon right in the middle of a performance. According to one eyewitness, "he fainted in the arms of a friend who was turning pages for him, and we bore him out in a strong fit of hysterics."

A Hungarian caricaturist created these drawings of Franz Liszt for a local periodical called New World. *The captions translate: 1. With practiced smile and rather shabby clothes, Liszt makes his bow to a tumult of applause. 2. Opening chord. Pause. He looks over his shoulder, as if to say: "Watch out! It's coming!" 3. With closed eyes, he forgets his audience and plays to and for himself. 4. Radiant pianissimo. Donning the mantle of Saint Francis of Assisi, he preaches to the birds. 5. He wrestles like Hamlet, struggles like Faust. 6. Chopin brings memories of sweet youth, fragrances, moonlight and love. 7. In Dante's Hell. Storms of sound that slam Hell's gates. Even the piano is penitent. 8. Concert ends with rowdy acclaim. Liszt bows modestly, conveying that he has been playing not only for us but with us.*
Images: Public Domain
Caption Translations:
Charles Reid in *The Music Monster*
Source: Jupiterimages, Corp.

From *New World,* January 1, 1876.

who stood six-feet tall, and Lady Blessington, who said "What a pity to put such a handsome man at a piano." There was Robert Franz and George Sand and Daniel Stern, all of whom were women, Liszt said.[11] There was the famous dancer Lola Montez, who once followed Liszt to an all-male banquet, burst into the room and proceeded to dance a fandango on a dinner table. There was Agnes, a spy who traded her charms for information about political refugees, and Olga, a Cossack horsewoman from the Ukraine,[12] who was so jealous of Liszt that she tried to stab him with a poisoned dagger. When Liszt played at private homes, women would press around him at the piano and pull souvenir hairs out of his head with little tweezers. They would enter his hotel bedroom in his absence and carry off in bottles some of the water from his washbowl. At fancy restaurants women fought each other for the privilege of drinking the leftover tea in his cup. One American woman stripped the covering off a chair Liszt had been sitting on, framed it, and hung it on her wall. An elderly lady caused a good deal of comment because she always exuded a curious tobacco odor even though she never smoked or took snuff.

Typical grand piano from around 1850. **Source:** Jupiterimages, Corp.

Finally she confessed that, twenty-five years earlier, after a public dinner, she had stolen the stump of Liszt's cigar and had been carrying it around in her corsage ever since.

Make Mine Marie

The first of Liszt's major love affairs started in 1833, when he went to a party at Chopin's apartment in Paris, and met the Countess Marie Catherine Sophie d'Agoult. She was a bit older than he (twenty-eight to his twenty-two), well-educated, charming, sophisticated, beautiful and, by nineteenth century standards, a trifle forward. Right after that first meeting, she wrote Liszt a letter asking him to come up and see her some time.[13] Liszt remembered what one writer called Marie's "bewitchingly graceful movements" and the profusion of blonde hair that fell over her shoulders like a shower of gold," grabbed his hat and rushed right over. "We embarked at once upon serious conversations," wrote Marie in her diary. "We talked of the destiny of mankind, of its sadness and uncertitude, of the soul, and the future life."[14] As time went by, Marie and Franz stopped pretending that their relationship was purely platonic[15] and ran off to Geneva together. There, Marie tried to improve Liszt's mind by making him read books on religion and attend philosophy lectures, and Liszt tried to improve his eyesight by giving free piano lessons to some of the prettiest students at the university. He even marked down the special attributes of his pupils in a little notebook. For instance, "Julie Raffard: very small hands, but brilliant fingerwork." "Jenny Gambini: gorgeous eyes." "Marie Demallayer: lots of enthusiasm. Makes faces and contortions."

[11] Come to think of it, he had three children with Daniel Stern, so he wasn't completely mistaken.

[12] Her first piano teacher died when her pet tiger bit him.

[13] She also sent a similar note to Chopin, saying that she had a cold and "one of your nocturnes would complete my cure. If you can't come tomorrow," she added, "make it Saturday. If not Saturday, Sunday." Some people have no patience at all.

[14] Sure they did.

[15] It had become more and more difficult, especially after Marie became pregnant.

On the Road Again

Marie would probably have been content to stay home indefinitely, but applause was in Liszt's blood and he quickly became itchy for the stage. This was all the more true because reports had filtered back from Paris that a pianist named Sigismond Thalberg was challenging his supremacy as the most famous virtuoso of the day.[16] So Liszt returned to the French capital, and in March, 1837, the two pianists undertook a series of musical duels, culminating in a concert where both of them performed their most difficult pieces. The verdict was not long in coming: Thalberg was an exceptionally fine artist, but Franz Liszt stood alone. Soon afterward, he embarked on an extended series of European concert tours that brought him even more smashing successes. He was cheered from Constantinople to Copenhagen, from Milan to Moscow. He performed for Queen Victoria at Buckingham Palace and at the court of Czar Nicholas I of Russia; he was welcomed by the nobility in Poland, Italy, and Austria.[17]

Upper Class

Perhaps the greatest triumph of all came when Liszt returned to his native Hungary, to be greeted by military bands, torchlight processions, serenades, cheering crowds, ceremonies, dinners, dances, and the gift of a sabre inlaid with precious stones. The only bad part was that Liszt had to shell out one thousand francs for an elegant Hungarian uniform, and then say thank you in French because he had completely forgotten his childhood Hungarian. He was disappointed in one other matter, too. Cavorting with all those noble men and women around Europe made him all the more keenly aware of his own lowly birth, and he had mounted a campaign to have the Hungarians bestow a title of nobility upon him. As a matter of fact, he was just trying to decide whether to put a lyre, a harp, a roll of manuscript paper, or perhaps an owl (for wisdom) on his coat of arms, when the whole deal fell through. A disappointed Liszt had to content himself with *behaving* like a nobleman. He started to wear fancy clothes,[18] he let his hair grow until it reached his shoulders, and he walked onstage with all sorts of medals and decorations dangling from his coat lapel. At some concerts he would have garlands and wreaths strewn around the piano, or he might casually toss his doeskin gloves on the ground before beginning his first piece.[19]

[16] I am not much for gossip, but did you know that Thalberg was the illegitimate son of Prince Moritz Dietrichsten and the Baroness von Wetzlar? Remember, you heard it here first.

[17] Actually, he had a little trouble in Austria because the empress heard of some of his adventures, and insisted that he be investigated by her police minister. The report says that Liszt had raised some eyebrows by eloping with Marie, but otherwise found no reason "to cause him to be suspected of holding revolutionary opinions. He rather appears," added the police minister, "to be simply a vain and frivolous young man who affects the fantastic manners of the French. Apart from his merits as an artist, he is of no significance."

[18] At one point he was traveling with three hundred and sixty different ties.

[19] He became pretty uppity, too. He once stopped playing in the middle of a concert because the Czar of Russia was talking too loudly, and he refused to play for Queen Isabella of Spain altogether because court etiquette didn't allow him to be presented to her personally.

And Then He Wrote

Touching upon the career of Franz Liszt as a composer is a problem for me because I don't know where to start. Liszt wrote well over a thousand different pieces, and on top of that, when he wasn't writing his own music Liszt was rewriting other people's, like Mozart arias, Schubert songs, and all the Beethoven Symphonies.[20] A lot of his music was romantic, of course. The Liszt list includes an opera called *The Castle of Love,* a song called "The Song of Love" and a piano piece called "The Dream of Love."[21] Just to make sure he touched all bases, Liszt also made piano transcriptions of Mendelssohn's "Wedding March" and the Bridal Scene from Wagner's *Lohengrin.* Other Liszt inventions were the tone poem, which is a kind of mini-symphony that tells a story, and the rhapsody, which is a kind of tone poem that doesn't. The most popular Liszt compositions are probably the Hungarian Rhapsodies, based on Gypsy themes and styles.[22]

Round Two

In 1847, Liszt decided to give up his hectic life as a concertizing pianist and settle down in the city of Weimar, where he could spend more time composing. Before taking up his new position as conductor and musical director at the Grand Ducal Court, however, he made one final, triumphal tour of Russia. And there, in Kiev, he met the second great love of his life. This was Her Serene Highness, the Princess Carolyne Jeanne Elisabeth von Sayn-Wittgenstein, and like Marie d'Agoult before her, Carolyne didn't waste any time in inviting Liszt to spend the weekend at her place.[23] Naturally, he accepted, and found himself at the princess' palace in Woronence, which she shared with her ten-year old daughter and the thirty thousand serfs she had inherited from her father. Carolyne had a few quirky habits, like smoking strong cigars and listening to music while sprawled on bearskin rugs, but she was such a refreshing change from all the other run-of-the-mill princesses Liszt had been in touch with, that he invited her to move in with him at Weimar. It took almost a year, but eventually Carolyne got permission to leave Russia and she joined Liszt in Weimar, where everybody was happy for about twelve years.

Busier by the Dozen

It was an incredibly productive twelve years. For a while, Liszt and Carolyne lived in separate quarters to keep up appearances, but then he simply moved into her villa, adding his collection of swords, silver breakfast trays, and pipes to her collection of oriental tables, rugs, and cigars.[24] There,

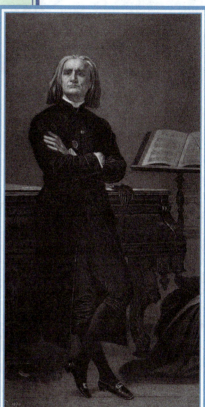

Portrait of Franz Liszt after he had taken minor religious orders.
Source: Jupiterimages, Corp.

[20] These transcriptions were enormously popular, but at a dinner party once, somebody berated him for wasting his time on them instead of composing immortal new works. "Ah, my friend," said Liszt wisely, "if I had only written great symphonies, I couldn't afford to serve you trout and champagne tonight."

[21] Or "Liebestraume." Try the recording by the J. H. Squire Celeste Octet.

[22] He wrote about twenty of them, and orderly as he was, called them Rhapsody no. 1, Rhapsody no. 2, Rhapsody no. 3, and so forth.

[23] "I kiss your hands and kneel before you," the princess wrote in one of her many letters to Liszt, "prostrating my forehead to your feet to assure you that my whole mind, all the breadth of my spirit, all my heart exist only to love you. I adore you, dear Masterpiece of God–so beautiful, so perfect, so made to be cherished, adored and loved to death and madness." They don't write letters like that any more.

[24] Even after the move, the court pretended that Liszt wasn't there, and continued to address all official communications to him at his former room in the Erbprinz Hotel.

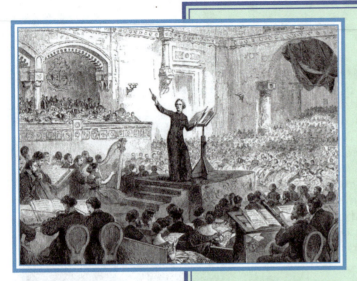

*Later in his career,
Franz Liszt began to
take a more active role
as a conductor, both of
his own works and the
compositions of other
Romantic composers.*
Source: Jupiterimages,
Corp.

*Liszt at the piano in
Bayreuth with Richard
and Cosima Wagner
(his son-in-law and
daughter) and a roomful
of others. Wagner is
mid-left in the painting
holding an open score,
while Cosima is to the far
left with her arm around
their son, Siegfried.*
Source: Jupiterimages,
Corp.

Liszt studied and taught and composed many of his most important works, including the dozen tone poems he dedicated to Carolyne, the Hungarian Rhapsodies, the Faust and Dante Symphonies, and the marvelous Piano Sonata in B Minor. Meanwhile, he was also busy preparing and conducting the German premieres of such milestone masterpieces as Berlioz' *Symphonie Fantastique* and Wagner's *Lohengrin,* plus a whole roster of operas and symphonic scores by the likes of Schubert, Schumann, Mozart, and Beethoven. I'm not sure how impressed we would be today by Liszt's performing forces,[25] but unquestionably he put his stamp on a whole generation of composers and pianists.

Wedding Bells?

As he neared his fiftieth birthday, Liszt made two major resolves; one was to leave the court at Weimar, the other to marry Carolyne, whose divorce decree had finally come through from Russia. They went to Rome for the ceremony and the Church of San Carlo was hung with flowers when, at the very last moment, as if in a scene from a bad opera, a messenger rushed in at midnight to say that there were complications in the decree. The wedding could not go on after all. There are those who say that Liszt heaved a great sigh of relief at that point, and I wouldn't be surprised. As he told a friend, "I am certain that the best thing for me is to keep my freedom—it is dangerous to bind me either to one person or to one place." On the other hand, Carolyne, who had always been a little on the eccentric side anyway, really flipped. She withdrew into total isolation, filled her apartment to smothering with plants, palms, and flowers, sealed up all the windows, and issued an edict to the effect that under no circumstances was fresh air to be admitted.[26] And there, by candlelight, in a swirl of cigar smoke, Carolyne spent her last years writing a book. It was in twenty-four volumes, of more than a thousand pages each, and it was entitled *The Interior Causes of the Exterior Weakness of the Church.*[27]

Abbé Liszt

Within a few years, Liszt himself had turned to religious thought and he actually studied for the priesthood, receiving four of the seven decrees on April 25, 1865. At one point he lived in the Vatican, and then later moved into the monastery of Santa Francesca Romana. He doesn't seem to have been anything like your typical abbé, though. We have reports that he would start

[25] He put on Wagner's *Tannhäuser* with a tinkly little orchestra of thirty-seven, and Berlioz once described his chorus as "a lot of wretches squalling out of tune and out of time."
[26] Even Liszt had to wait outside in an anteroom for at least fifteen minutes before he was allowed to enter the apartment, to make sure he was properly de-ventilated.
[27] No comment.

each day properly with prayers and meditation, but his routine became less and less strict as the hours went along. By evening he was ready to enjoy good company and wine, and even to entertain his friends at the piano. Soon he began traveling again—to Florence, to Munich, to Budapest—and Abbé or no Abbé, Franz Liszt still loved the ladies. He had a nice time comforting the recently widowed Princess Gortschakoff, for instance, and then in 1869 he became ensnared in the charms of Olga Janina. They had quite a tempestuous romance,[28] but when Liszt grew tired of her, Olga blew her stack, as they say. She tracked him down to his hideaway in the Villa d'Este. Gaining admittance disguised as a gardenboy, she planned to stab him to death if he didn't make love to her.[29] Later she threatened Liszt with a revolver, and on yet another occasion she tried to poison him, only to wind up swallowing the stuff herself by mistake. Luckily she recovered after two days in a coma, figured it wasn't worth the trouble, and disappeared forever.

Finale

In his last years, Liszt was deeply revered as one of the world's most inspiring teachers. His list of students included such celebrities-to-be as Bizet, Saint-Saens, Albeniz, and Smetana. I am proudly aware, by the way, that one of my own piano teachers, Frederic Lamond, was one of those Liszt proteges. Liszt also continued composing until the very end, and he never lost his magic at the keyboard. When he visited London again, in February 1886, only a few months before his death, he inserted an ad in the papers saying that he had come purely as a guest, not a performer.[30] Nonetheless, he couldn't resist playing a few numbers at various parties and soirees, and everyone agreed that his powers had not diminished. Among the appreciative listeners was Queen Victoria, at Windsor Castle. It was a fitting conclusion to the career of Franz Liszt, who never did realize his goal of being ennobled, yet was universally hailed as the king of pianists. "My mission will be to have introduced poetry into piano music with some brilliance," he said. "You see, my piano is for me what his ship is to a sailor; more indeed: it is my very self, my mother tongue, my life."

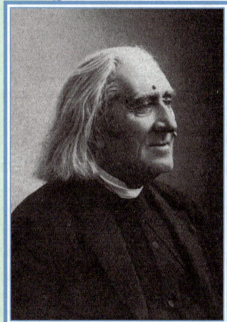

Photo of the Abbé Liszt as an old man.
Source: Jupiterimages, Corp.

[28] Somebody asked Olga if she had ever read the Biblical "Song of Songs" aloud to Liszt. "No," she replied. "The Abbé prefers the real thing."
[29] Fortunately, Liszt did what came naturally, so Olga put the knife away.
[30] "My fingers are seventy-five years old," said Liszt, "and Saint-Saens and Rubinstein play my compositions much better than my dilapidated self."
 "In comparison with Liszt," was Anton Rubinstein's reply, "the rest of us are children."

From *Victor Borge's My Favorite Comedies in Music* by Victor Borge and Robert Sherman. Reprinted by permission of Franklin Watts Publishers.

Études d'exécution transcendante (Transcendental Etudes)

The creation of these etudes has a long history that spans most of Liszt's career. He started composing them when he was only 15 years old. His original plan was for 48 studies in all of the major and minor key centers, much like what Bach had done in his two volumes of the *Well-Tempered Clavier.* This number was later reduced to 24 and eventually down to the 12 that make up the *Transcendental Etudes* as we know them today. Each etude is a *tour de force* of piano techniques, many of which Liszt developed or at least perfected. After viewing an intermediate version of what would become the final set of etudes, Robert Schumann remarked:

"They are genuinely stormy and horrific studies, études for ten or twelve people in this world at most . . ."[8] The following two listening examples are taken from the beginning of the work. As you will hear, Liszt seems to be holding virtually nothing back from the very start of the composition. Notice in both the *Prelude* and the *Molto vivace* (very, very fast) how Liszt is using dense textures, as well as rapid transitions from the very top to the very bottom of the piano keyboard. Each work requires an amazing display of extreme technical skills and expressive musicianship. Although these two examples don't carry them, a number of the etudes have programmatic titles, which serve to heighten the dramatic content even more. Some of these titles include *Wild Hunt, Will o' the Wisps, Evening Harmonies,* and *Snow Flurries.*

Listening Guide

Études d'exécution transcendante (Transcendental Etudes)
I—Preludio. Presto.
II—Molto vivace (in a minor)
Franz Liszt (1811-1886)

Format: Solo piano character pieces
Performance: Freddy Kempf, piano
Recording: *Franz Liszt: Études d'exécution transcendante* (BIS 1210)

Performance Notes: From the CD liner notes:

Now established as one of the most sought after young pianists in the world, **Freddy Kempf** was born in London in 1977. He began playing the piano at the age of four and first came to national prominence aged eight when he performed Mozart's piano concerto KV 414 with the Royal Philharmonic Orchestra at London's Royal Festival Hall . . . In 1987 he won the first National Mozart Competition in England and in 1992 the biennial BBC Young Musician of the year Competition. His award of third prize in the 1998 Tchaikovsky International Piano Competition in Moscow provoked an outcry in the Russian press, which described him as 'the hero of the competition' . . . In May 2001 he was voted Best Young Classical Performer in the Classical Brit Awards.

Liner notes from BIS 1210

Prelude

:00 This short *prelude* is something of a warning shot. Get out of the way or this piece is going to run right over you. Without getting too technical, he spends most of this brief example playing with dominant sounding harmonies, really only coming to rest on the very last chord.

Movement II – *Molto vivace*

:00 If the first example was a warning shot, this etude is a shotgun blast right to the face. This etude is through-composed, although Liszt does revisit certain thematic material more than once. Notice how he uses the extreme range of the piano, rapidly jumping from the highest to the lowest notes on the keyboard as quickly as possible. Liszt was the pioneer of these extreme piano techniques.

Hector Berlioz (1803-1869)

Hector Berlioz was the first major Romantic composer in France, and his skills at orchestration established new techniques from which most Romantic composers borrowed. Berlioz was the son of a physician, and his family expected Hector to follow in his father's footsteps. Berlioz entered medical school in Paris, but he was not thrilled with his studies. As a child he had taken music lessons and studied music theory, and as a young adult he thoroughly enjoyed the Parisian music scene. Eventually, he dropped out of medical school to pursue music as a career and was subsequently cut off from his family. Berlioz supported himself by performing music and teaching lessons. He eventually entered the Paris Conservatory of Music, where he studied composition. As a young composer, he fell under the spell of both Beethoven and Shakespeare. There was a very popular touring Shakespeare theatre company visiting Paris, and Berlioz enjoyed all of the plays, many of which would later inspire compositions. In particular, Berlioz was quite taken with an Irish actress named Harriet Smithson, who would have a profound effect on his life.

At the age of 26, Berlioz won the *Prix de Rome*, a prize for composition that included an extended residency in Rome, where the artist was free to create new works while taking in Italian culture. Before leaving for Rome, Berlioz had attempted to establish a relationship with Harriet Smithson, but she showed little interest in him. His distress over his unsuccessful attempts at love led to the creation of the *Symphonie fantastique*. This work was a semi-autobiographical creation about a troubled artist in a tragic love affair. In a fit of despair, the artist in the story takes an overdose of opium and has a series of powerful dreams. In these dreams he kills the woman he loves, and then she turns out to be a witch. Berlioz eventually returned to Paris, where he again pursued Smithson. This time Smithson gave in to Berlioz's advances—some say after she realized the *Symphonie fantastique* was about her—and the two were married in 1833. It quickly became apparent to Berlioz that he was in love with the characters Harriet Smithson played and not the actress who played them. Their relationship was disastrous, and after a few years they went their separate ways. They never divorced, however, and Berlioz did not remarry until after the actress's death in 1854.[9]

Hector Berlioz.
Source: Jupiterimages, Corp.

Beyond the *Symphonie fantastique*, Berlioz wrote a number of large compositions, including the program symphonies *Harold in Italy* (featuring a solo viola) and *Romeo and Juliet*. In an interesting side note, the solo viola part was actually suggested by and written for Paganini, but by the time the composition was finished, he was too ill to perform the work. Berlioz also wrote a number of one-movement overtures, and he composed several operas and some very powerful works for voices and orchestra, including his *Requiem Mass*. Like a number of Romantic composers, Berlioz had to supplement his income by writing music criticism. He also wrote a book explaining his concepts about orchestration that composers still study today. Toward the end of his life Berlioz composed little music, but he did write his *Memoirs*, which read like a Romantic novel. If you enjoy gossipy books with lots of sharp commentary, you will really enjoy this book.

DIG DEEPER

BOOKS
Memoirs and *Treatise on Instrumentation* by Hector Berlioz

Symphonie fantastique, Op. 14

Throughout his career, Beethoven was constantly adding new instruments to the orchestra and gradually increasing the overall size of the symphonic forces required to perform his works. In the years immediately following Beethoven's death, Berlioz kicked the expansion of orchestral size into overdrive. Beyond asking for more instruments, Berlioz developed a number of new orchestration techniques, pushing each instrument of the orchestra to its absolute limits. Of particular interest is Berlioz's introduction of a recurring theme he called an ***idée fixe***, or fixed idea. The composer uses this theme in all five movements to represent his love interest. Berlioz modifies the theme to match the story as the work progresses. What starts as a lush, romantic tune in movement one ends up being a harsh, almost cartoon-like melody by the time his girlfriend turns out to be a witch in the last movement. Other composers and fans of music were heavily divided about Berlioz's compositions in general and the *Symphonie fantastique* in particular. Composer Felix Mendelssohn wrote the following letter to his mother after hearing the work.

idée fixe

Felix Mendelssohn.
Source: © 2009
Jupiterimages, Corp.

Mendelssohn's Letter to his Mother, Rome, March 15, 1831

But now you shall hear about Berlioz and his music. He makes me sad, because he is really a cultured, agreeable man and yet composes so very badly.

The day after tomorrow he is going back to Paris. He seems terribly in love, and this has been the inspiration for a symphony which he calls *Episode de la vie d'un artiste*. When it was performed, 2000 copies of explanatory notes were distributed. In them he says that the composer has imagined the theme of the first movement as depicting a charming young lady who has fascinated the artist, and that his rage, jealousy, tenderness and tears are pictured in it. The second movement describes a ball where everything seems empty to him because she is missing. The third is called *scène aux champs*; the cowherds play a *ranz de vaches*, the instruments imitating the rustle of the leaves (all this in the printed program). Fear and hope are mixed in the artist's soul. Before the fourth movement (so continues the program), the artist, having poisoned himself with opium but misjudged the quantity, instead of dying has the most horrible visions. The fourth movement is just such a vision where he is present at his own execution; it is called *marche au supplice*. The fifth and last is called *songe d'une nuit*, in which he sees the witches dancing on the Blocksberg, his beloved among them. At the same time he hears the distorted *cantus firmus* of the "Dies Irae," to which the witches are dancing.

How utterly loathsome all this is to me, I don't have to tell you. To see one's most cherished ideas debased and expressed in perverted caricatures would enrage anyone. And yet this is only the program. The execution is still more miserable: nowhere a spark, no warmth, utter foolishness, contrived passion represented through every possible exaggerated orchestral means: four tympani, two pianos for four hands, which are supposed to imitate bells, two harps, many big drums, violins divided into eight parts, two parts for the double basses which play solo passages, and all these means (to which I would not object if they were properly employed) used to express nothing but indifferent drivel, mere grunting, shouting, screaming back and forth.

And when you see the composer himself, that friendly, quiet, meditative person, calmly and assuredly going his way, never for a moment in doubt of his vocation, unable to listen to any outside voice, since he wishes to follow only his inner inspiration, when you see how keenly and correctly he evaluates and recognizes everything, yet is in complete darkness about himself—it is unspeakably dreadful, and I cannot express how deeply the sight of him depresses me. I have not been able to work for two days.

From *Felix Mendelssohn-Bartholdy:* Lebensbild mit Vorgeschichte, Zurich, 1949.

All of Berlioz's new orchestration techniques are clearly evident in his masterpiece, the *Symphonie fantastique*. This massive work is a five-movement program symphony lasting almost one hour. As mentioned in Mendelssohn's letter, Berlioz wrote a detailed program, or story, which he had printed up and distributed to the audience before the performance began in an attempt to help people understand his work. The following is an English translation of what Berlioz wrote.

*S*ymphonie fantastique *by Hector Berlioz*

It has been the composer's goal to develop different situations in the life of an artist, insofar as they are susceptible of musical treatment. The plot of the instrumental drama, lacking the help of the spoken word, needs to be presented beforehand. The following program* must accordingly be viewed as the spoken text of an opera (e.g. of a French *opéra comique,* where spoken dialogue was used instead of recitative), serving to introduce musical pieces whose character and expression it motivates.

First Part: Daydreams—Passions

The author imagines that a young musician, affected by the moral malady which a famous writer calls *le vague des passions* (i.e., seemingly rootless emotions), sees for the first time a woman who possesses all the charms of the ideal being he had fancied in his dreams, and falls hopelessly in love. Through a singular oddity, the image of the beloved never presents itself to the artist's imagination except tied to a musical idea, in which he perceives a certain impassioned quality, though noble and shy, as he imagines the object of his love to be.

This musical reflection and its model pursue him incessantly like a double *idée fixe* (obsession). This is why the melody that opens the first *allegro* reappears constantly in all the other movements of the symphony. The passage from that state of dispirited daydreaming, occasionally interrupted by baseless transports of joy, to one of delirious passion, with its gusts of fury, of jealousy, its relapses into tenderness, its tears, its religious consolations, forms the subject of the first movement.

* The distribution of this program to the audience, at concerts in which this symphony is to be played, is indispensable for the complete understanding of the work's dramatic plan [Berlioz's footnote].

Second Part: A Ball

The artist finds himself in the most diverse situations of daily life: amid *the tumult of a festivity,* in the peaceful contemplation of the beauties of nature. But everywhere, whether in the town or in the fields, the image of the beloved obtrudes on him, bringing trouble to his spirit.

Third Part: Country Scene

Finding himself in the country one evening, he hears two shepherds playing a *ranz de vaches* (an Alpine cattle-call) in dialogue, far away; this pastoral duet, the scenery, the slight murmuring of the trees gently swayed by the wind, some recently formed grounds for hope—everything contributes to bringing an unaccustomed calm to his heart and a brighter color to his thoughts. He thinks of his loneliness; he hopes soon not to be alone any more . . . But what if she were deceiving him? . . . This mixture of hope and fear, these visions of happiness troubled by dark forebodings, form the subject of the *adagio.* In the end, one of the shepherds resumes the *ranz de vaches;* the other no longer answers . . . Distant sound of thunder . . . solitude . . . silence . . .

Fourth Part: March to the Scaffold

Having become convinced that his love is not returned, the artist poisons himself with opium. The dose of narcotic, too weak to kill him, plunges him into a sleep beset with the most horrible visions. He dreams he has murdered the one he loved; he has been sentenced, is being led to the scaffold, is *witnessing his own execution.* The procession moves forward to the sounds of a march now somber and ferocious, now brilliant and stately, during which the muffled noise of heavy footsteps follows without transition upon the noisiest outbursts. At the end of the march, the first four measures of the *idée fixe* reappear like a last thought of love interrupted by the fatal blow.

Fifth Part: Dream of a Sabbath Night

He sees himself at the sabbath, surrounded by a hideous crowd of spirits, sorcerers, monsters of every kind, assembled for his funeral. Strange noises, moans, bursts of laughter, distant cries to which other cries apparently respond. The beloved melody reappears again, but it has lost its noble and shy quality; now it is only a vile dance tune, trivial and grotesque; it is she, arriving at the sabbath . . . Road of joy at her arrival . . . She joins the diabolic orgy . . . Funeral knell, ludicrous parody of the *Dies irae,* sabbath round dance. The sabbath round dance and the *Dies irae* combined.

From *New Edition of the Complete Works,* XVI, Kassel: Barenreiter, 1972, translated by P. W.

Listening Guide

Symphonie fantastique, Op. 14
Movement V—*Dream of a Witches' Sabbath*
Hector Berlioz (1803-1869)

Format: Programmatic Symphony
Performance: Czech Philharmonic Orchestra, Zdeněk Košler, conductor
Recording: *Berlioz: Symphonie fantastique* (Supraphon SU 3059-2 031)

Performance Notes: Recorded November 1984 at the Dvořák Hall in Prague, Czechoslovakia.

:00	Movement begins with haunting, soft strings while other parts of the orchestra depict what Berlioz described as "unearthly sounds, groans and shrieks of laughter."
1:44	The *idée fixe* returns, played by the clarinet. What started as a beautiful melody in the first movement has now been transformed into what Berlioz described as "a vulgar tune, trivial and grotesque."
3:22	"Bells toll for the dead." Berlioz introduces the old Gregorian chant *Dies irae* (God's Wrath). He offers the listener three statements of each section of the melody. Each time we hear the tubas and other low voices play the melody first with very long notes. Then Berlioz harmonizes the melody and plays it twice as fast in the middle voices of the orchestra, followed by another harmonized version in the upper voices of the orchestra that is twice as fast as the last mid-range statement. Then he moves on to the next part of the *Dies irae* melody and does the whole pattern over again.
5:27	Transition to the next section.
5:46	Berlioz titled this section of the work *Ronde du Sabbat* (Witches' Round Dance). Some scholars have referred to this section as being "fugal" in nature. While it doesn't work like a fugue by Bach, or even Beethoven for that matter, Berlioz does stack up his main theme in various parts of the orchestra with plenty of counterpoint.
7:40	Brief return of the *Dies irae* theme, followed by a dramatic buildup to the next section.
8:51	Berlioz combines the *Witches' Dance* themes with the *Dies irae*. Sort of a supernatural battle of good versus evil.
9:22	At this point in the score, Berlioz asks the strings to *"frappez avec les bois de l'archet,"* literally to turn their bows sideways and strike the strings with the wooden part of the bow. The effect is that of the witches' fingernails scratching on a windowpane, or perhaps their last dying gasp as they scratch on their coffin lids.
10:04	This last section functions like a coda of sorts. It starts with another bold statement of the *Dies irae,* followed by a dramatic few seconds of music that focus on final statements of the dominant and tonic chords. Notice that the witches' dance theme is nowhere to be found. In the end, God pretty much wins this one.

Johannes Brahms (1833–1897)

You may recall Brahms from the previous discussion of Robert and Clara Schumann. Both of these gifted artists played a crucial role in Brahms's life, Robert as he was beginning his career as a composer, and Clara throughout his life. The following article, titled *New Paths,* was written by Robert Schumann to introduce Brahms to the world. The writing is typical of flowery, Romantic prose, but it is worth the time it takes to read. It was this article that catapulted Brahms into the spotlight.

An early photograph of a young Johannes Brahms.
Source: © 2009 Jupiterimages, Corp.

New Paths *by Robert Schumann* [1853]

Years have passed—nearly as many as I devoted to the former editorship of this journal, namely ten—since last I raised my voice within these covers, so rich in memories. Often, despite my intense creative activity, I have felt myself stimulated; many a new and significant talent has appeared; a new musical force has seemed to be announcing itself—as has been made evident by many of the aspiring artists of recent years, even though their productions are chiefly familiar to a limited circle.[f] Following the paths of these chosen ones with the utmost interest, it has seemed to me that, after such a preparation, there would and must suddenly appear some day one man who would be singled out to make articulate in an ideal way the highest expression of our time, one man who would bring us mastery, not as the result of a gradual development, but as Minerva, springing fully armed from the head of Cronus. And he is come, a young creature over whose cradle graces and heroes stood guard. His name is *Johannes Brahms,* and he comes from Hamburg where he has been working in silent obscurity, trained in the most difficult theses of his art by an excellent teacher who sends me enthusiastic reports of him,[g] recommended to me recently by a well-known and respected master. Even outwardly, he bore in his person all the marks that announce to us a chosen man. Seated at the piano, he at once discovered to us wondrous regions. We were drawn into a circle whose magic grew on us more and more. To this was added an altogether inspired style of playing which made of the piano an orchestra of lamenting and exultant voices. There were sonatas—veiled symphonies, rather; lieder, whose poetry one could understand without knowing the words, although a deep vocal melody ran through them all; single piano pieces, in part of a daemonic nature, most attractive in form; then sonatas for violin and piano; string quartets—and every work so distinct from any other that each seemed to flow from a different source. And then it seemed as though, roaring along like a river, he united them all as in a waterfall, bearing

[f] Here I have in mind Joseph Joachim, Ernst Naumann, Ludwig Norman, Woldemar Bargiel, Theodor Kirchner, Julius Schäffer, Albert Dietrich, not to forget that profoundly thoughtful student of the great in art, the sacred composer C. F. Wilsing. As their valiant advance guard I might also mention Niels Wilhelm Gade, C. F. Mangold, Robert Franz, and Stephen Heller.
[g] Eduard Marxsen, in Hamburg.

aloft a peaceful rainbow above the plunging waters below, surrounded at the shore by playful butterflies and borne along by the calls of nightingales.

Later, if he will wave with his magic wand to where massed forces, in the chorus and orchestra, lend their strength, there lie before us still more wondrous glimpses into the secrets of the spirit world. May the highest genius strengthen him for what expectation warrants, for there is also latent in him another genius—that of modesty. His comrades greet him on his first entrance into the world, where there await him wounds, perhaps, but also palms and laurels; we welcome him as a valiant warrior.

In every time, there reigns a secret league of kindred spirits. Tighten the circle, you who belong to it, in order that the truth in art may shine forth more and more brightly, everywhere spreading joy and peace.

R.S.

From *Source Readings in Music History: From Classical Antiquity through the Romantic Era,* translated by Oliver Strunk. Copyright © 1950 by Oliver Strunk, W. W. Norton & Company, Inc.

There was something of a rift between more modernistic composers such as Chopin and Liszt, who were writing works sometimes referred to as "music of the future," and more conservative composers similar to Brahms, who were viewed as a continuation of the "old school," meaning Beethoven in particular. You can get a subtle hint at the controversy from Schumann's article as he encourages "kindred spirits" to "tighten the circle." Compared to other composers of the day, Brahms was more conservative. Not everyone thought so highly of Brahms. Famed Russian composer Tchaikovsky, whom you will meet in the next section of this chapter, wrote the following in the October 9, 1886 entry of his diary:

> Played over the music of that scoundrel Brahms. What a giftless bastard! It irritates me that this self-conscious mediocrity should be recognized as a *genius*. In comparison with him, Raff [a very minor composer] was a giant, not to mention Rubinstein, a much bigger and more vital personality. And Brahms is so chaotic, so dry and meaningless![10]

Brahms focused most of his attention on absolute music, but he also displayed a gift for the composition of Romantic art songs. Like Schubert and Mendelssohn before him, Brahms maintained a clear sense of Classical formal structure while embracing a more modern sense of both harmony and rhythm. As a symphony composer, he felt he was living in the shadow of Beethoven. Brahms started his first symphony many times, only to throw the material out or turn it into something completely different. He didn't feel the material was good enough to follow in the footsteps of Beethoven. Brahms was over 40 years old before he wrote his first symphony, a work he felt was worthy to carry on the mantle of the Germanic tradition of symphonic composition. He went on to compose three more symphonies, and all four are considered masterpieces of orchestral literature. Rarely does a major orchestra's season go by without at least one of Brahms's symphonies on a program. He also composed several major concertos, including those for piano and violin. Beyond large formats, Brahms wrote a number of very successful chamber pieces, including sonatas for various instruments, string quartets, quintets, and other assorted works with piano. Brahms created a number of excellent compositions for choir and orchestra, the most important being his *German Requiem*, which we will study in depth. He also composed a number of smaller choral works, as well as over 200 of the previously mentioned *Lieder.*

Brahms at the piano.
Source: © 2009 Jupiterimages, Corp.

A distinguished Johannes Brahms in a photograph from the late 1800s.
Source: Jupiterimages, Corp.

Ein Deutsches Requiem (A German Requiem), Op. 45

Brahms wrote his requiem as a response to the deaths of both his mentor, Robert Schumann, and later his own mother. The work is written from a Protestant point of view. It is a work composed to offer consolation to the living. The seven-movement requiem is composed in something of an arch form, with movements one and seven, two and six, and three and five sharing musical connections. At the center of the work stands one of Brahms's most famous pieces. Movement four is written for full chorus with a text taken from Psalm 84, *How Lovely Is Thy Dwelling Place.* Aside from being the center point of the *Requiem,* this movement is often performed separately, and it stands alone quite nicely. This movement follows a five-part rondo format of A-B-A'-C-A'. If you examine enough material about Brahms, you might read that he really wasn't capable of composing extended melodies very well. Listen to this movement and see how you feel about Brahms's melodies. The moral here is "Don't believe everything you read" (except in this book, of course).

Listening Guide

Ein Deutsches Requiem (A German Requiem), Op. 45
Movement IV—*Wie lieblich sind deine Wohnungen (How Lovely is Thy Dwelling Place)*
Johannes Brahms (1833-1897)

Format: Multi-movement work for soloists, choir, and orchestra
Performance: Chamber Choir and Classical Philharmonic Stuttgart, Frieder Bernius, conductor
Recording: *Johannes Brahms: Ein deutsches Requiem op. 45* (Carus 83.200)

Performance Notes: Like the Mozart *Requiem* found in Chapter 5, this is a live performance recording made at the Stuttgarter Liederhalle in 1997.

:00	**Letter A.**	
	Wie lieblich sind deine Wohnungen, Herr Zebaoth!	How lovely is Thy dwelling place, O Lord of Hosts!
1:20	**Letter B.**	
	Meine Seele verlanget und sehnet sich nach den Vorhöfen des Herrn; mein Leib und Seele freuen sich in dem lebendigen Gott.	My soul longs and even faints for the courts of the Lord; my flesh and soul rejoice in the living God.
2:24	**Letter A'. The melody is basically the same, but there are some variations here and there, along with some new text.**	
	Wie lieblich sind deine Wohnungen, Herr Zebaoth! Wohl denen, die in deinem Hause wohnen,	How lovely is Thy dwelling place, O Lord of Hosts! Blessed are they that live in Thy house,
3:32	**Letter C. With the text "die loben dich immerdar!" (that praise Thee evermore!) Brahms picks up the tempo and adds more polyphonic interest to the choral parts.**	
	die loben dich immerdar!	that praise Thee evermore!
4:18	**Letter A'. As we come to the end of the movement, the primary melody returns, presented in a similar manner to the beginning of the work but with an altered melodic line. The piece ends with a gentle, orchestral statement.**	
	Wie lieblich . . .	How lovely . . .

Focus on Form

Tone Poems, Concert Overtures, and other Symphonic Program Music

Like the character pieces discussed in the previous *Focus on Form*, single-movement orchestral works were nothing new in the Romantic era. They do, however, take on an added significance to romantic composers, who pushed single-movement orchestral formats to dramatic new heights. In the Romantic period, almost all of these works were programmatic. Some carried general descriptive titles like *Les Préludes* by Liszt, while others, including Smetana's *The Moldau* and Tchaikovsky's *1812 Overture,* told overtly descriptive tales. *The Moldau,* for example, paints a vivid musical portrait of a trip down the main river that runs through the composer's homeland. Along the way we see (really hear) peasants dancing at a wedding, a hunting trip, and we even take a wild ride through the rapids. Tone poems tended to carry programs about new topics or to in some way concern themselves with nature, while concert overtures and overture-fantasias frequently drew their inspiration from earlier literary works. For example, the plays of Shakespeare were, and for that matter continue to be, frequent topics for composers. These include works such as the *Overture to A Midsummer Night's Dream,* Op. 21, by Mendelssohn; *Overture to Shakespeare's Julius Caesar*, Op. 128, by Schumann; *Macbeth,* Op. 23, by Richard Strauss; and three works by Tchaikovsky, *The Tempest,* Op. 18, *Hamlet,* Op. 67a, and the composer's very famous treatment of *Romeo and Juliet.* In some cases, these works would actually be used within the production of Shakespeare's plays, but more commonly, these works were conceived for use in the concert hall.

Beyond single-movement works, composers in both the Romantic era and twentieth century wrote multi-movement compositions with programmatic themes. The program symphony and the orchestral suite are the most common of these multi-movement orchestral schemes though there are others. Some of the most famous program symphonies include the *Symphonie fantastique,* by Berlioz; The *Scottish* and *Italian* Symphonies (Nos. 3 & 4), by Mendelssohn; and the *Alpine Symphony* by Richard Strauss. Many of the suites were also conceived for the concert hall, but others were drawn from music for the ballet, incidental theatre music and, in the twentieth century, music for film. Examples of programmatic suites include *Pictures at an Exhibition,* by Mussorgsky, orchestrated by Ravel; *The Planets,* Op. 32, by Holst; and *Lieutenant Kijé,* Op. 60, by Prokofiev.

Peter Ilyich Tchaikovsky (1840-1893)

Peter Ilyich Tchaikovsky.
© Shutterstock.com

Tchaikovsky is by far the most famous of all Russian romantic composers. The nationalistic spirit was particularly strong among a group of five Russian composers—Balakirev, Borodin, Cui, Mussorgsky, and Rimsky-Korsakov—and while Tchaikovsky shared their ideals in general, his music was considered more "cosmopolitan," drawing inspiration from Italian, German, and French music as well as his native Russia. Tchaikovsky was born in a small Russian village, destined, it seemed, for the life of a civil servant. That all changed when he made the decision to study composition with Anton Rubinstein at the new St. Petersburg Conservatory. Rubinstein recommended Tchaikovsky for a teaching position at the new conservatory in Moscow. Tchaikovsky suffered great bouts of depression, frequently attributed to his self-disappointment about his secret homosexual tendencies. In an effort to "cure" himself, or perhaps simply to provide a respectable facade for his lifestyle, Tchaikovsky married a female student who was madly in love with the composer. The marriage was a complete disaster and pushed Tchaikovsky to the edge of a nervous breakdown.

Salvation came in the form of a wealthy patron of the arts named Madame Nadezhda von Meck. She provided the composer an annual stipend, as well as regular commissions of new works. Her only stipulation was that she and Tchaikovsky never meet. They did, however, carry on an extensive, intimate correspondence, and many of their letters still exist. It was a great personal blow to the composer's emotional state when he lost von Meck's support in 1890 though by that time he was quite secure financially. There is some controversy surrounding Tchaikovsky's death. The composer had gone to St. Petersburg to conduct his sixth symphony, which he had subtitled *Pathétique*. The work did not meet with great acceptance. At this time in St. Petersburg there was a deadly outbreak of cholera, and Tchaikovsky was warned against drinking untreated water. Some suggest that he drank a glass of infected water as a sort of suicide attempt, while others say it was pure carelessness. Still other historians suggest Tchaikovsky simply committed suicide by taking poison in an attempt to avoid being exposed in a homosexual scandal that would have involved the composer and a wealthy aristocrat.

Tchaikovsky's extensive compositional output includes major works in almost every important musical genre. His operas, symphonies, concert overtures, concertos, ballets, string quartets, and various vocal music are some of the most frequently performed works in the entire world of classical music. His works are powerful, emotion-filled crowd pleasers. Among his most famous compositions are the 4th, 5th, and 6th Symphonies; the concert overtures *Romeo and Juliet* and the *1812 Overture* (yes, it really does have a part for a cannon); the operas *Eugene Onegin* and *The Queen of Spades*; the ballets *Swan Lake* and *The Nutcracker*; concertos for piano and violin, as well as the *Variations on a Rococo Theme* for cello and orchestra; and the choral work *Liturgy of St. John Chrysostom*. Tchaikovsky's formal structures aren't always perfect, his orchestration is sometimes cumbersome and thick, but for sheer listening pleasure and musical drama, he will always remain an audience favorite.

DIG DEEPER

MOVIE
The Music Lovers

Bedřich Smetana (1824~1884)

Compared to the other composers mentioned in this chapter, Bedrich Smetana's compositional output is less important. This in no way is to imply that his creations are inferior, merely that they are generally less well known. Several of his works are excellent examples of the nationalistic movement of the nineteenth century, and his composition titled *The Moldau* is one of the most picturesque tone poems ever composed. Smetana is from Bohemia, which is now part of the Czech Republic, and he is frequently mentioned as their greatest composer. Today, his most important works are his two string quartets, a folk opera titled *The Bartered Bride,* and the aforementioned tone poem, *The Moldau.*

Vltava (The Moldau)

The Moldau comes from a cycle of six individual tone poems Smetana titled *Má vlast* (My Homeland), which he composed between 1872 and 1880. Each work carries a programmatic story drawn from Bohemian history, folklore, or, in cases such as *The Moldau*, inspiration was simply drawn from scenes in the countryside. This particular work traces the Moldau River from its headwaters, as two small streams converge to create the river, all the way to its arrival in the city of Prague, as we travel past the castle Vyšehrad. Along the way, different sections of the composition paint vivid musical portraits of scenes including a peasant wedding, a hunting party, a gentle scene from the river at night, and a wild ride through the rapids of St. John. Each musical scene is tied together with one main theme that represents the river itself. In addition, right at the end of the work a new theme is introduced, the *Má vlast* theme, which Smetana used to unify all six of his tone poems in the cycle.

A statue, in the city of Prague, of composer Bedrich Smetana.
© Shutterstock.com

The upper reaches of the Moldau River, Smetana's inspiration for a tone poem of the same name.
Source: Jupiterimages, Corp.

Listening Guide

Vltava (The Moldau)
Bedřich Smetana (1824-1884)

Format: One-movement tone poem
Performance: Czech Philharmonic Orchestra, Václav Smetáček, conductor
Recording: *Bedřich Smetana, My Country: A Cycle of Symphonic Poems* (Supraphon 11 1981-2 031)

Performance Notes: Smetana is one of Czechoslovakia's most famous composers, and the Czech Philharmonic has recorded this work numerous times with several different conductors over the years. Conductor Václav Smetáček rose from the orchestra's ranks where he started his career as an oboist. While it is a completely subjective opinion, orchestra musicians sometimes respond better to "one of their own," and this recording seems to bear that theory out. There is an immediacy and directness in this recording that you don't always hear from a large symphony orchestra. Most classical music fans who listen to the Czech Philharmonic tend to lean toward recordings made with Karel Ančerl, making recordings such as this one something of an undiscovered gem.

:00	*The Two Springs.* Two solo flute lines represent the two small streams that come together to form the Moldau river.
:57	This theme represents the river. Presented in a minor key, it is reminiscent of folk music even though it is a newly composed theme. Get to know it well, as it will keep returning throughout the work.
2:33	*Hunting in the Forest.* The horn section announces the arrival of a new section by imitating the "horn calls" a hunting party might use as they pursue animals through the forest.
3:32	*Peasant Wedding.* As we move on down the river we come upon the scene of a country peasant wedding. Notice how the rhythm changes as Smetana imitates a folk dance in this section.
5:02	*Moonlight: Dance of the Water-Nymphs.* Smetana portrays the placid, mildly rippling waters of the river at night.
7:19	As dawn breaks, we continue down the river. The main theme returns.
8:06	*The Rapids of St. John.* As the water becomes more and more unsettled, Smetana uses loud brass fanfares and rumbling tympani to portray the turbulent waters.
9:16	*The Moldau at its Greatest Breadth.* As we move on down river toward the city the main theme returns, this time presented in a major key.
9:44	*The Ancient Castle Vyšehrad.* The river reaches its widest point as it enters the city, and it is here that Smetana introduces the *Má vlast* (My Homeland) theme that shows up in all six tone poems of the set.

The Moldau River as it runs through the city of Prague.
© Shutterstock.com

Charles Gounod (1818~1893)

French composer Charles Gounod can be considered a minor Romantic composer at best. He is included here for one reason only, his creation of an *Ave Maria*, which he based on the C Major prelude from Bach's *Well-Tempered Clavier*, a work you will recall from Chapter 4. The inclusion of this piece is to help you trace the evolution of a traditional text and to explore a different composer's treatment of similar material. Beyond this composition, Gounod is perhaps best remembered for his lyric operas such as *Faust* (which is actually an opera with spoken dialogue) and *Roméo et Juliette*. He also composed three requiem masses, one of which is still performed from time to time.

Composer Charles Gounod conducting one of his operas.
Source: Jupiterimages, Corp.

Ave Maria (based on Bach's WTC, Book 1, Prelude in C Major)

The actual title of this work is *Méditation sur le prélude de Bach*, but everyone simply calls it *Ave Maria* because of Gounod's use of that famous text. The work is a very straightforward setting of the text to a beautiful melody composed by Gounod and sung directly over Bach's prelude. In an article about Mozart where he was discussing the "modernization" of older works, Composer Edvard Grieg managed to take a powerful sideways shot at Gounod's adaptation of Bach's music: " . . . but provided a man does not follow the example of Gounod, who transformed a Bach prelude into a modern, sentimental, and trivial show piece, of which I absolutely disapprove, but seeks to preserve the unity of style, there is surely no reason for raising an outcry over his desire to attempt a modernization as one way of showing his admiration for an old master."[11] Basically, it's o.k. to update the works of other composers, but not as Gounod did it. Fortunately, other composers, and certainly audience members, do not share Grieg's low opinion of this work. Perfect for weddings, funerals, and most other sacred occasions, this is one of those pieces with which you can never go wrong.

Listening Guide

Ave Maria (WTC, Book 1, Prelude in C Major)
Charles Gounod (1818-1893)/J. S. Bach (1685-1750)

Format: Aria melody written over Bach's prelude
Performance: Yoshikazu Mera, countertenor; Hisako Matsui, harp
Recording: *Romance* (BIS 949)

Performance Notes: Do not adjust your stereo, this really is a guy. As you learned in Chapter 4, male countertenors have naturally high-pitched voices, which they then train to sing even higher. The result can be a beautiful tone with the added depth and power of a male voice. This work has been arranged for voice and piano, voice and guitar, voice and various chamber ensembles and orchestras, voice and organ and, as you hear in this recording, voice and harp. This recording was made in 1997 at the Fuch-n-Mori Theatre, Vienna Hall in Tokyo, Japan. In addition to the *Romance* CD from which this excerpt is taken, Mera has made several successful recordings for the BIS label including an ethereal album titled *Mother's Songs: Japanese Popular Songs*.

:00 Gounod uses the first four measures of Bach's prelude as an instrumental introduction. When the voice enters, the prelude actually begins again from the beginning. This time Bach's prelude is played straight through, note-for-note, while a new melody by Gounod, set with the famous *Ave Maria* text, unfolds above in the voice part.

Ave Maria, gratia plena	Hail Mary, full of grace,
Dominus tecum benedicta tu	Blessed are you among women
in mulieribus et benedictus	And blessed is
fructus ventris tui Jesus.	The fruit of your womb, Jesus.
Sancta Maria, Sancta Maria, Maria.	Holy Mary, mother of God,
Ora pronobis nobis peccatoribus	Pray for us sinners
nunc et in hora, in hora mortis nostræ,	Now and at the hour of our death,
Amen, Amen.	Amen, amen.

Antonín Dvořák.
Source: Jupiterimages, Corp.

Antonín Dvořák (1841-1904)

Like Smetana before him, Antonín Dvořák was a Bohemian composer with nationalistic tendencies. In some ways, however, his works share a certain amount of the "cosmopolitan" approach that also tempers many of Tchaikovsky's compositions. Today, his most important works include a number of string quartets, the Cello Concerto in d minor, Op. 104, and his famous *New World Symphony* (No. 9), which he composed during an extended stay in America. Dvořák made use of American folk idioms in this symphony with the hope that he would inspire American composers to write with a more nationalistic mindset. Of particular interest to many Americans is the fact that Dvořák was one of the first major European musicians to spend an extended amount of time in the United States. He came to America in 1895 to serve as director of the newly founded National Conservatory of Music in New York City, a position he held for three years. The following article was written by Dvořák during his stay in America and was first published in the February 1895 issue of *Harper's Magazine*.

The article discusses American artistic life around the turn of the last century, as well as the need for more "home grown" American music. Composers such as William Grant Still, George Gershwin, Howard Hanson, Aaron Copland, and, in his own way, Charles Ives later met this need quite successfully. Dvořák's comments about private vs. public support for the arts are particularly interesting. In many ways we are still fighting these same battles today.

Music in America *by Antonín Dvořák*

It is a difficult task at best for a foreigner to give a correct verdict of the affairs of another country. With the United States of America this is more than usually difficult, because they cover such a vast area of land that it would take many years to become properly acquainted with the various localities, separated by great distances, that would have to be considered when rendering a judgment concerning them all. It would ill become me, therefore, to express my views on so general and all-embracing a subject as music in America, were I not pressed to do so, for I have neither travelled extensively, nor have I been here long enough to gain an intimate knowledge of American affairs. I can only judge of it from what I have observed during my limited experience as a musician and teacher in America, and from what those whom I know here tell me about their own country. Many of my impressions therefore are those of a foreigner who has not been here long enough to overcome the feeling of strangeness and bewildered astonishment which must fill all European visitors upon their first arrival.

The two American traits which most impress the foreign observer, I find, are the unbounded patriotism and capacity for enthusiasm of most Americans. Unlike the more diffident inhabitants of other countries, who do not "wear their hearts upon their sleeves," the citizens of America are always patriotic, and no occasion seems to be too serious or too slight for them to give expression to this feeling. Thus nothing better pleases the average American, especially the American youth, than to be able to say that this or that building, this or that new patent appliance, is the finest or grandest in the world. This, of course, is due to that other trait—enthusiasm. The enthusiasm of most Americans for all things new is apparently without limit. It is the essence of what is called "push"—American push. Every day I meet with this quality in my pupils. They are unwilling to stop at anything. In the matters relating to their art they are inquisitive to a degree that they want to go to the bottom of all things at once. It is as if a boy wished to dive before he could swim.

At first, when my American pupils were new to me, this trait annoyed me, and I wished them to give more attention to the one matter in hand rather than to everything at once. But now I like it; for I have come to the conclusion that this youthful enthusiasm and eagerness to take up everything is the best promise for music in America. The same opinion, I remember, was expressed by the director of the new conservatory in Berlin, who, from his experience with American students of music, predicted that America within twenty or thirty years would become the first musical country.

Only when the people in general, however, begin to take as lively an interest in music and art as they now take in more material matters will the arts come into their own. Let the enthusiasm of the people once be excited, and patriotic gifts and bequests must surely follow.

It is a matter of surprise to me that all this has not come long ago. When I see how much is done in every other field by public-spirited men in America—how schools, universities, libraries, museums, hospitals, and parks spring up out of the ground and are maintained by generous gifts—I can only marvel that so little has been done for music. After two hundred years of almost unbroken prosperity and expansion, the net results for music are a number of public concert-halls of most recent growth; several musical societies with orchestras of noted excellence, such as the Philharmonic Society in New York, the orchestras of Mr. Thomas and Mr. Seidl, and the superb orchestra supported by a public-spirited citizen of Boston; one opera company, which only the upper classes can hear or understand; and a national conservatory which owes its existence to the generous forethought of one indefatigable woman.

It is true that music is the youngest of the arts, and must, therefore be expected to be treated as Cinderella, but is it not time that she were lifted from the ashes and given a seat among the equally youthful sister arts in this land of youth, until the coming of the fairy godmother and the prince of the crystal slipper?

Art, of course, must always go a-begging, but why should this country alone, which is so justly famed for the generosity and public spirit of its citizens, close its door to the poor beggar? In the Old World this is not so. Since the days of Palestrina, the three-hundredth anniversary of whose death was celebrated in Rome a few weeks ago, princes and prelates have vied with each other in extending a generous hand to music. Since the days of Pope Gregory the Church has made music one of her own chosen arts. In Germany and Austria princes like Esterhazy, Lobkowitz, and Harrach, who supported Haydn and Beethoven, or the late King of Bavaria, who did so much for Wagner, with many others, have helped to create a demand for good music, which has since become universal, while in France all governments, be they monarchies, empires, or republics, have done their best to carry on the noble work that was begun by Louis the Fourteenth. Even the little republic of Switzerland annually sets aside a budget for the furtherance of literature, music, and the arts.

A few months ago only we saw how such a question of art as whether the operas sung in Hungary's capital should be of a national or foreign character could provoke a ministerial crisis. Such is the interest in music and art taken by the governments and people of other countries.

The great American republic alone, in its national government as well as in the several governments of the States, suffers art and music to go without encouragement. Trades and commerce are protected, funds are voted away for the unemployed, schools and colleges are endowed, but music must go unaided, and be content if she can get the support of a few private individuals like Mrs. Jeannette M. Thurber and Mr. H. L. Higginson.

Not long ago a young man came to me and showed me his compositions. His talent seemed so promising that I at once offered him a scholarship in our school; but he sorrowfully confessed that he could not afford to become my pupil, because he had to earn his living by keeping books in Brooklyn. Even if he came on but two afternoons in the week, or on Saturday afternoon only, he said, he would lose his employment, on which he and others had to depend. I urged him to arrange the matter with his employer, but he only received the answer: "If you want to play, you can't keep books. You will have to drop one or the other." He dropped his music.

Cover art from the first issue of Harper's Magazine.
Source: Jupiterimages, Corp.

In any other country the state would have made some provision for such a deserving scholar, so that he could have pursued his natural calling without having to starve. With us in Bohemia the Diet each year votes a special sum of money for just such purposes, and the imperial government in Vienna on occasion furnishes other funds for talented artists. Had it not been for such support I should not have been able to pursue my studies when I was a young man. Owing to the fact that, upon the kind recommendation of such men as Brahms, Hanslick, and Herbeck, the Minister of Public Education in Vienna on five successive years sent me sums ranging from four to six hundred florins, I was able to pursue my work and to get my compositions published, so that at the end of that time I was able to stand on my own feet. This has filled me with lasting gratitude towards my country.

Such an attitude of the state towards deserving artists is not only a kind but a wise one. For it cannot be emphasized too strongly that art, as such, does not "pay," to use an American expression—at least, not in the beginning—and that the art that has to pay its own way is apt to become vitiated and cheap.

It is one of the anomalies of this country that the principle of protection is upheld for all enterprises but art. By protection I do not mean the exclusion of foreign art. That, of course, is absurd. But just as the State here provides for its poor industrial scholars and university students, so should it help the would-be students of music and art. As it is now, the poor musician not only cannot get his necessary instruction, in the first place, but if by any chance he has acquired it, he has small prospects of making his chosen calling support him in the end. Why is this? Simply because the orchestras in which first-class players could find a place in this country can be counted on one hand; while of opera companies where native singers can be heard, and where the English tongue is sung, there are none at all. Another thing which discourages the student of music is the unwillingness of publishers to take anything but light and trashy music. European publishers are bad enough in that respect, but the American publishers are worse. Thus, when one of my pupils last year produced a very creditable work, and a thoroughly American composition at that, he could not get it published in America, but had to send it to Germany, where it was at once accepted. The same is true of my own compositions on American subjects, each of which hitherto has had to be published abroad.

No wonder American composers and musicians grow discouraged, and regard the more promising condition of music in other countries with envy! Such a state of affairs should be a source of mortification to all truly patriotic Americans. Yet it can be easily remedied. What was the situation in England but a short while ago? Then they had to procure all their players from abroad, while their own musicians went to the Continent to study. Now that they have two standard academies of music in London, like those of Berlin, Paris, and other cities, the national feeling for music seems to have been awakened, and the majority of orchestras are composed of native Englishmen, who play as well as the others did before. A single institution can make such a change, just as a single genius can bestow an art upon his country that before was lying in unheeded slumber.

Our musical conservatory in Prague was founded but three generations ago, when a few nobles and patrons of music subscribed five thousand florins, which was then the annual cost of maintaining the school. Yet that little school flourished and grew, so that now more than sixfold that amount is annually expended. Only lately a school for organ music has been added

to the conservatory, so that the organists of our churches can learn to play their instruments at home, without having to go to other cities. Thus a school benefits the community in which it is. The citizens of Prague in return have shown their appreciation of the fact by building the "Rudolfinum" as a magnificent home for all the arts. It is jointly occupied by the conservatory and the Academy of Arts, and besides that contains large and small concert-halls and rooms for picture-galleries. In the proper maintenance of this building the whole community takes an interest. It is supported, as it was founded, by the stockholders of the Bohemian Bank of Deposit, and yearly gifts and bequests are made to the institution by private citizens.

If a school of art can grow so in a country of but six million inhabitants, what much brighter prospects should it not have in a land of seventy millions? The important thing is to make a beginning, and in this the State should set an example.

Rudolfinum Concert Hall (also known as Dvořák Hall) in the city of Prague. This is the home of the Czech Philharmonic heard on several tracks of the listening assignments that accompany this textbook.
© Shutterstock.com

They tell me that this cannot be done. I ask, why can't it be done? If the old commonwealths of Greece and Italy, and the modern republics of France and Switzerland, have been able to do this, why cannot America follow their example? The money certainly is not lacking. Constantly we see great sums of money spent for the material pleasures of the few, which, if devoted to the purposes of art, might give pleasure to thousands. If schools, art museums, and libraries can be maintained at the public expense, why should not musical conservatories and playhouses? The function of the drama, with or without music, is not only to amuse, but to elevate and instruct while giving pleasure. Is it not in the interest of the State that this should be done in the most approved manner, so as to benefit all of its citizens? Let the owners of private playhouses give their performances for diversion only, let those who may, import singers who sing in foreign tongues, but let there be at least one intelligent power that will see to it that the people can hear and see what is best, and what can be understood by them, no matter how small the demand.

That such a system of performing classic plays and operas pleases the people was shown by the attitude of the populace in Prague. There the people collected money and raised subscriptions for over fifty years to build a national playhouse. In 1880 they at last had a sufficient amount, and the "National Theatre" was accordingly built. It had scarcely been built when it was burned to the ground. But the people were not to be discouraged. Everybody helped, and before a fortnight was over more than a million had been collected, and the house was at once built up again, more magnificent than it was before.

In answer to such arguments I am told that there is no popular demand for good music in America. That is not so. Every concert in New York, Boston,

Philadelphia, Chicago, or Washington, and most other cities, no doubt, disproves such a statement. American concert-halls are as well filled as those of Europe, and, as a rule, the listeners—to judge them by their attentive conduct and subsequent expression of pleasure—are not a whit less appreciative. How it would be with opera I cannot judge, since American opera audiences, as the opera is conducted at present, are in no sense representative of the people at large. I have no doubt, however, that if the Americans had a chance to hear grand opera sung in their own language they would enjoy it as well and appreciate it as highly as the opera-goers of Vienna, Paris, or Munich enjoy theirs. The change from Italian and French to English will scarcely have an injurious effect on the present good voices of the singers, while it may have the effect of improving the voices of American singers, bringing out more clearly the beauty and strength of the *timbre*, while giving an intelligent conception of the work that enables singers to use a pure diction, which cannot be obtained in a foreign tongue.

The American voice, so far as I can judge, is a good one. When I first arrived in this country I was startled by the strength and the depth of the voices in the boys who sell papers on the street, and I am still constantly amazed at its penetrating quality.

In a sense, of course, it is true that there is less of a demand for music in American than in certain other countries,. Our common folk in Bohemia know this. When they come here they leave their fiddles and other instruments at home, and none of the itinerant musicians with whom our country abounds would ever think of trying their luck over here. Occasionally when I have met one of my countrymen whom I knew to be musical in this city of New York or in the West, and have asked him why he did not become a professional musician, I have usually received the answer, "Oh, music is not wanted in this land." This I can scarcely believe. Music is wanted wherever good people are, as the German poet has sung. It only rests with the leaders of the people to make a right beginning.

When this beginning is made, and when those who have musical talent find it worth their while to stay in America, and to study and exercise their art as the business of their life, the music of America will soon become more national in its character. This, my conviction, I know is not shared by many who can justly claim to know this country better than I do. Because the population of the United States is composed of many different races, in which the Teutonic element predominates, and because, owing to the improved methods of transmission of the present day, the music of all the world is quickly absorbed by this country, they argue that nothing specially original or national can come forth. According to that view, all other countries which are but the results of a conglomeration of peoples and races, as, for instance, Italy, could not have produced a national literature or a national music.

A while ago I suggested that inspiration for truly national music might be derived from the negro melodies or Indian chants. I was led to take this view partly by the fact that so-called plantation songs are indeed the most striking and appealing melodies that have yet been found on this side of the water, but largely by the observation that this seems to be recognized, though often unconsciously, by most Americans. All races have their distinctively national songs, which they at once recognize as their own, even if they have never heard them before. When a Tsech, a Pole, or a Magyar in this country suddenly hears one of his folk-songs or dances, no matter if it is for the first time in his life, his eye lights up at once, and his heart within him

responds, and claims that music as its own. So it is with those of Teutonic or Celtic blood, or any other men, indeed, whose first lullaby mayhap was a song wrung from the heart of the people.

It is a proper question to ask, what songs, then, belong to the American and appeal more strongly to him than any others? What melody could stop him on the street if he were on a strange land and make the home feeling well up within him, no matter how hardened he might be or how wretchedly the tune were played? Their number, to be sure, seems to be limited. The most potent as well as the most beautiful among them, according to my estimation, are certain of the so-called plantation melodies and slave songs, all of which are distinguished by unusual and subtle harmonies, the like of which I have found in no other songs but those of old Scotland and Ireland. The point has been urged that many of these touching songs, like those of Foster, have not been composed by the negroes themselves, but are the work of white men, while others did not originate on the plantation, but were imported from Africa. It seems to me that this matters but little. One might as well condemn the Hungarian Rhapsody because Liszt could not speak Hungarian. The important thing is that the inspiration for such music should come from the right source, and that the music itself should be a true expression of the people's real feelings. To read the right meaning the composer need not necessarily be of the same blood, though that, of course, makes it easier for him. Schubert was a thorough German, but when he wrote Hungarian music, as in the second movement of the C-Major Symphony, or in some of his piano pieces, like the Hungarian Divertissement, he struck the true Magyar note, to which all Magyar hearts, and with them our own, must forever respond. This is not a *tour de force*, but only an instance of how much can be comprehended by a sympathetic genius. The white composers who wrote the touching negro songs which dimmed Thackeray's spectacles so that he exclaimed, "Behold, a vagabond with a corked face and a banjo sings a little song, strikes a wild note, which sets the whole heart thrilling with happy pity!" had a similarly sympathetic comprehension of the deep pathos of slave life. If, as I have been informed they were, these songs were adopted by the negroes on the plantations, they thus became true negro songs. Whether the original songs which must have inspired the composers came from Africa or originated on the plantations matters as little as whether Shakespeare invented his own plots or borrowed them from others. The thing to rejoice over is that such lovely songs exist and are sung at the present day. I, for one, am delighted by them. Just so it matters little whether the inspiration for the coming folk songs of America is derived from the negro melodies, the songs of the creoles, the red man's chant, or the plaintive ditties of the homesick German or Norwegian. Undoubtedly the germs for the best of music lie hidden among all the races that are commingled in this great country. The music of the people is like a rare and lovely flower growing amidst encroaching weeds. Thousands pass it, while others trample it under foot, and thus the chances are that it will perish before it is seen by the one discriminating spirit who will prize it above all else. The fact that no one has as yet arisen to make the most of it does not prove that nothing is there.

Not so many years ago Slavic music was not known to the men of other races. A few men like Chopin, Glinka, Moniuszko, Smetana, Rubinstein, and Tschaikowski, with a few others, were able to create a Slavic school of music.

American composer Stephen Foster.
Source: © 2009 Jupiterimages, Corp.

Chopin alone caused the music of Poland to be known and prized by all lovers of music. Smetana did the same for us Bohemians. Such national music, I repeat, is not created out of nothing. It is discovered and clothed in new beauty, just as the myths and the legends of a people are brought to light and crystallized in undying verse by the master poets. All that is needed is a delicate ear, a retentive memory, and the power to weld the fragments of former ages together in one harmonious whole. Only the other day I read in a newspaper that Brahms himself admitted that he had taking existing folk-songs for the themes of his new book of songs, and had arranged them for piano music. I have not heard or seen the songs, and do not know if this be so; but if it were, it would in no wise reflect discredit upon the composer. Liszt in his rhapsodies and Berlioz in his *Faust* did the same thing with existing Hungarian strains, as, for instance, the Racokzy March; and Schumann and Wagner made a similar use of the Marseillaise for their songs of the "Two Grenadiers." Thus, also, Balfe, the Irishman, used one of our most national airs, a Hussite song, in his opera, the *Bohemian Girl,* though how he came by it nobody has as yet explained. So the music of the people, sooner or later, will command attention and creep into the books of composers.

An American reporter once told me that the most valuable talent a journalist could possess was a "nose for news." Just so the musician must prick his ear for music. Nothing must be too low or too insignificant for the musician. When he walks he should listen to every whistling boy, every street singer or blind organ-grinder. I myself am often so fascinated by these people that I can scarcely tear myself away, for every now and then I catch a strain or hear the fragments of a recurring melodic theme that sound like the voice of the people. These things are worth preserving, and no one should be above making a lavish use of all such suggestions. It is a sign of barrenness, indeed, when such characteristic bits of music exist and are not heeded by the learned musicians of the age.

I know that it is still an open question whether the inspiration derived from a few scattering melodies and folk-songs can be sufficient to give a national character to higher forms of music, just as it is an open question whether national music, as such, is preferable. I myself, as I have always declared, believe firmly that the music that is most characteristic of the nation whence it springs is entitled to the highest consideration. The part of Beethoven's Ninth Symphony that appeals most strongly to all is the melody of the last movement, and that is also the most German. Weber's best opera, according to the popular estimate, is *Der Freischütz.* Why? Because it is the most German. His inspiration there clearly came from the thoroughly German scenes and situations of the story, and hence his music assumed that distinctly national character which has endeared it to the German nation as a whole. Yet he himself spent far more pains on his opera *Euryanthe,* and persisted to the end in regarding it as his best work. But the people, we see, claim their own; and, after all, it is for the people that we strive.

An interesting essay could be written on the subject how much the external frame-work of an opera—that is, the words, the characters of the

Carl Maria von Weber,
composer of the opera
Der Freischütz.
Source: © 2009
Jupiterimages, Corp.

personages, and the general *mise en scène*—contributes towards the inspiration of the composer. If Weber was inspired to produce his masterpiece by so congenial a theme as the story of *Der Freischütz*, Rossini was undoubtedly similarly inspired by the Swiss surroundings of William Tell. Thus one might almost suspect that some of the charming melodies of that opera are more the product and property of Switzerland than of the Italian composer. It is to be noticed that all of Wagner's operas, with the exception of his earliest work, *Rienzi*, are inspired by German subjects. The most German of them all is that of *Die Meistersinger*, that opera of operas, which should be an example to all who distrust the potency of their own national topics.

Of course, as I have indicated before, it is possible for certain composers to project their spirit into that of another race and country. Verdi partially succeeded in striking Oriental chords in his *Aïda*, while Bizet was able to produce so thoroughly Spanish strains and measures as those of *Carmen*. Thus inspiration can be drawn from the depths as well as from the heights, although that is not my conception of the true mission of music. Our mission should be to give pure pleasure, and to uphold the ideals of our race. Our mission as teachers is to show the right way to those who come after us.

My own duty as a teacher, I conceive, is not so much to interpret Beethoven, Wagner, or other masters of the past, but to give what encouragement I can to the young musicians of America. I must give full expression to my firm conviction, and to the hope that just as this nation has already surpassed so many others in marvellous inventions and feats of engineering and commerce, and has made an honorable place for itself in literature in one short century, so it must assert itself in the other arts, and especially in the art of music, Already there are enough public-spirited lovers of music striving for the advancement of this their chosen art to give rise to the hope that the United States of America will soon emulate the older countries in smoothing the thorny path of the artist and musician. When that beginning has been made, when no large city is without its public opera-house and concert-hall, and without its school of music and endowed orchestra, where native musicians can be heard and judged, then those who hitherto have had no opportunity to reveal their talent will come forth and compete with one another, till a real genius emerges from their number, who will be as thoroughly representative of his country as Wagner and Weber are of Germany, or Chopin of Poland.

To bring about this result we must trust to the ever-youthful enthusiasm and patriotism of this country. When it is accomplished, and when music has been established as one of the reigning arts of the land, another wreath of fame and glory will be added to the country which earned its name, the "Land of Freedom," by unshackling her slaves at the price of her own blood.

Note.—The author acknowledges the co-operation of Mr. Edwin Emerson, Jr., in the preparation of this article.

From *Harper's Magazine,* 1895.

Focus on Form
Romantic Opera

France

Toward the end of the Classical era, French opera styles began to grow in popularity. There are several different styles of particular importance including the *opéra comique, grand* opera, and *opéra lyrique.* Don't let the title *opéra comique,* or comic opera, fool you. These were not slapstick, laugh-a-minute jokefests. These were mostly dramatic operas with lighter, comic moments and some humorous characters. As the Romantic era was taking shape, many of these operas took on political overtones, full of revolutionary ideals and patriotic spirit. Some were simply thinly veiled propaganda pieces. Later versions of the *opéra comique* include works such as *Carmen,* by Georges Bizet. In fact, *Carmen* has proven to be one of the most famous operas of all time and one that foreshadows a new style of opera called *verismo* (realism), which you will learn more about in Chapter 7.

Beyond the *opéra comique, French Grand Opera* began to evolve at the beginning of the Romantic era. These mammoth spectacles featured multiple acts, and the whole show could last more than five hours. The topics were frequently historic, with ample room for large crowd scenes (which would be performed by a big chorus) and scenes that featured ballet. Use of the typical aria/recitative format was replaced with a more lyrical but less elaborate style of singing, which helped keep the story moving. Wagner would later adapt some of the basic grand opera formats into his epic *music dramas* toward the end of the Romantic period. Some of the most famous grand operas include *Les Huguenots* by Giacomo Meyerbeer and *La Juive* (The Jewess) by Jacques Halévy.

French opera composer Georges Bizet.
Source: Jupiterimages, Corp.

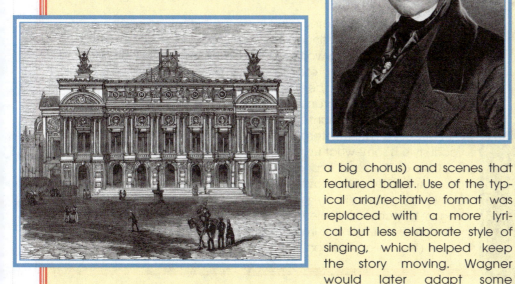

French Grand Opera composer Giacomo Meyerbeer.
Source: Jupiterimages, Corp.

Woodcut of the Grand Opera House in Paris.
Source: Jupiterimages, Corp.

The concept for the *opéra lyrique,* or lyric opera, was to present dramatic opera in a somewhat lighter style (and shorter works). Examples of these works include operas by Bizet and Charles Gounod. Some of Gounod's operas in particular included lines that were spoken instead of sung and were called *opéra dialogué.*

Opéra bouffe, pure comic opera, didn't come around in France until after 1850. Its main proponent was Jacques Offenbach, with works including *Orphée aux enfers* (Orpheus in the Underworld) and *La belle Hélène* (Beautiful Helen). Offenbach composed over 90 operas and operettas (little operas), but most of them are rarely performed today.

Austria and Germany

Mozart and Beethoven set the stage for German opera in the local language by composing works such as *Die Zauberflöte* (The Magic Flute) and *Fidelio.* Composers Ludwig Spohr, Carl Maria von Weber, and Richard Wagner picked up the mantle of German romanticism in opera, but some of their works moved beyond the *Singspiel* tradition of using spoken dialogue. Weber's most famous opera, *Der Freischütz* (The Free Marksman, which is still a *Singspiel*) mixes magic and romance in a tale that Germans found appealing. Most of these operas included elements of Germanic nationalism, including folk tales, typical scenes of folk life, and simple "German" melodies. Richard Wagner's earlier operas in the German Romantic opera tradition include the works *Tannhäuser* and *Lohengrin.* Eventually, Wagner would go on to create a completely new style of opera that he called *music drama.* Discussion of this style will be reserved for the following section devoted specifically to Wagner's life and music. The second half of the Romantic era in Austria and Germany also saw a growth in popularity for the lighter operetta. The most noted of these works is *Die Fledermaus* (The Bat) by famed waltz composer Johann Strauss II.

Italy

As you saw in Chapter 4, Italy was the birthplace of opera, and the Romantic era continued the long-standing tradition of Italian operas being fully sung works that prominently featured the aria and recitative. The Italians preferred clearly defined dramatic or comic operas, *opera seria* or *opera buffa* respectively though the Romantic era began to see a gradual overlap of the two styles from some composers. Many Romantic operas in Italy placed a great emphasis on *bel canto* singing (literally beautiful, melodic singing). This lyrical vocal style is somewhat unique to operas from Italy.

One of the most important early Romantic Italian opera composers was Gioachino Rossini, who wrote over 35 operas in both the comic and dramatic styles. Later he spent time in Paris, where he began to incorporate elements of the French grand opera into his works. A few of his most important compositions include *L'Italiana in Algieri* (The Italian Woman in Algiers), a comic opera; *Il barbiere di*

Italian opera composer Gioachino Rossini.
Source: Jupiterimages, Corp.

Siviglia (The Barber of Seville), a comic opera; and *Guillaume Tell* (William Tell), a grand opera in the French tradition. This last opera tells the story of a man involved in the Swiss struggle for independence, a tale that really appealed to the French romantic sensibility. This was the guy who shot the apple off his son's head. This is also the opera from which the famous "Lone Ranger" movie and television theme song was taken.

Other important Italian composers and operas include *Lucia di Lammermoor* and *Don Pasquale* by Gaetano Donizetti, and *Norma* and *La sonnambula* (The Sleepwalker) by Vincenzo Bellini. By far the most important Italian opera composer from the Romantic era, and some would argue the most famous opera composer of all time, was Giuseppe Verdi. Over his long career Verdi became a national hero, composing 28 operas, many of which are still performed on a regular basis in opera houses around the world. Like Wagner, Verdi's career in music will be examined in depth in the following section of this chapter.

Russia

The Russian opera tradition blends together elements drawn from many of the styles listed above but rarely fits neatly into any one category. Most of these Romantic works are full of Russian history and nationalism, and many of the librettos are based on the texts of Russian playwrights, particularly Alexander Pushkin. A few important romantic Russian operas include *Eugene Onegin* by Tchaikovsky, *A Life for the Tsar* by Mikhail Glinka, *Prince Igor* by Alexander Borodin, and *Boris Godunov* by Modest Mussorgsky.

Legendary opera star Chaliapin dressed to play the title role in Modest Mussorgsky's Boris Godunov. **Source:** Jupiterimages, Corp.

Giuseppe Verdi (1813-1901)

Opera in Italy is almost on a par with sports in terms of public acceptance. Until recently, almost everyone in Italy could sing an opera aria or two, and most of their favorite tunes were written by Giuseppe Verdi. Born in the village of Roncole in Northern Italy, Verdi displayed an early talent for music, studying composition with several local musicians and taking part in area band concerts. Verdi eventually made his way to Milan, where he hoped to study at the conservatory. He was denied admission because of his weak piano skills, but Verdi hung around La Scala (one of the world's most famous opera houses) and studied privately with a composer whose operas were performed there. Verdi's first opera, *Oberto,* was performed at La Scala in 1839, and after its premiere he was commissioned to compose an additional three operas. He tried his hand at a comic opera, which flopped, and decided that perhaps comedy wasn't for him. After a

bit of trial and error, Verdi hit upon a dramatic formula that served him well for the creation of most of his important works. Historian K. Marie Stolba offers an exploration of the building blocks Verdi frequently used in the creation of his operatic masterpieces:

A basic skeletal structural scheme is common to almost all of Verdi's operas. Most of them are constructed in four acts, in three acts with a prologue, or in three acts so organized that a fourfold division of structure is visible. In the first main division (prologue or first act), one of the principal characters other than the heroine sings a solo with chorus; in the second or third scene, the heroine is introduced in a solo (usually of narrative character) with chorus. In either the second or third act, there is a large duet; both middle acts conclude with ensemble finales, one of which might center on a stirring duet. At or near the beginning of the last act, there is a prayer scene for the heroine, and there is a death scene for the hero or a rondo finale for the heroine.[12]

Among Verdi's vast catalog of compositions, there are, of course, subtle variations on the above format, but Verdi did tend to stick with the things he knew would please his audience. In particular, his last two operas break away from the formula described above.

Composer Giuseppe Verdi conducting his opera Aïda *in Paris.*
Source: Jupiterimages, Corp.

Audiences loved Verdi's direct musical lines, with great sweeping choruses and soaring, dramatic arias that were always crowd pleasers. Gossip has it that Verdi became frustrated with singers who would forget their lines, add inappropriate additions to his music in order to show off, or in some other way cause problems in one of his opera performances. It is said that to get even, he started composing vocal parts that were very difficult to sing. He wrote long arias at the very top of singer's ranges, all the while giving them little or no break in the songs to catch their breath. Author and music critic George Bernard Shaw once said that Verdi "wrote so abominably for the human voice that the tenors all had goat-bleat (and were proud of it); the baritones had a shattering vibrato and could not, to save their lives, produce a note of any definite pitch; and the sopranos had the tone of a locomotive whistle, without its steadiness."[13]

There is a sense of Italian nationalism in many of Verdi's operas, another aspect of his music that greatly pleased his Italian audiences. Even the composer's name became politicized, coming to stand for *Vittorio Emanuele, Re D'Italia*, which meant "Victor Emanuel, ruler of Italy." This was a rallying cry for Italian independence during the Romantic era. Many of Verdi's operas carried double messages, never totally overt, but clear enough to his fiercely loyal Italian audiences. A number of his operatic tunes became unofficial patriotic songs, known throughout the country. Nationalism was an important topic throughout much of Verdi's life. In a letter to Contessa Clarina Maffei, one of Verdi's closest friends and a great patron of the arts, Verdi openly discussed his concerns about the strength of German or German-influenced instrumental music and its growing impact on composers in Italy.

Verdi's Letter to Clarina Maffei, *April 20, 1878*

We are all working, without meaning to, for the downfall of our theater. Perhaps I myself, perhaps you and the others, are at it, too. And if I wanted to say something that sounds foolish, I should say that the Italian Quartet Societies were the first cause; and that a more recent cause was the success of the performances (not the works) given by the Scala orchestra in Paris. I've said it—don't stone me! To give all the reasons would take up too much time, But why, in the name of all that's holy, must we do German art if we are living in Italy? Twelve or fifteen years ago I was elected president of a concert society, I don't remember whether in Milan or elsewhere. I refused, and I asked: "Why not form a society for vocal music? That's alive in Italy—the rest is an art for Germans." Perhaps that sounded as foolish then as it does now; but a society for vocal music, which would let us hear Palestrina, the best of his contemporaries, Marcello, and such people, would have preserved for us our love of song, as it is expressed in opera. Now everything is supposed to be based on orchestration, on harmony. The alpha and omega is Beethoven's *Ninth Symphony,* marvellous in the first three movements, very badly set in the last. No one will ever approach the sublimity of the first movement, but it will be an easy task to write as badly for voices as is done in the last movement. And supported by the authority of Beethoven, they will all shout: "That's the way to do it. . . ."

Never mind! Let them go on as they have begun. It may even be better; but it's a "better" that undoubtedly means the end of opera. Art belongs to all nations—nobody believes that more firmly than I. But it is practiced by individuals; and since the Germans have other artistic methods than we have, their art is basically different from ours. We cannot compose like the Germans, or as least we ought not to; nor they like us. Let the Germans assimilate our artistic substance, as Haydn and Mozart did in their time; yet they are predominantly symphonic musicians. And it is perfectly proper for Rossini to have taken over certain formal elements from Mozart; he is still a melodist for all that. But if we let fashion, love of innovation, and an alleged scientific spirit tempt us to surrender the native quality of our own art, the free natural certainty of our work and perception, our bright golden light, then we are simply being stupid and senseless.

Giuseppe Verdi.
Source: Jupiterimages, Corp.

From *Verdi: the Man in His Letters,* New York, 1942.

Portrait of Verdi in his later years.
Source: Jupiterimages, Corp.

Verdi's most important dramatic operas in the Italian tradition include *Nabucco, Macbeth, Rigoletto, Il trovatore* (The Troubadour), and *La traviata* (The Fallen Woman). By the early 1850s, the composer began to branch out a bit, introducing elements of the French grand opera style to his compositions. Operas from this period include *Les vêpres siciliennes* (Sicilian Vespers), *Simon Boccanegra, Un ballo in maschera* (A Masked Ball), *La forza del destino* (The Force of Destiny), *Don Carlos,* and, in 1871, the work that is perhaps his most famous, *Aïda.* After the amazing international success of *Aïda,* Verdi took some time off from composing operas. While helping mount a production of *Aïda* in Naples during the winter of 1872-3, he wrote a clever little string quartet for his own amusement. Next came the creation of a monumental *Requiem* mass to honor the passing of the writer Alessandro Manzoni. Though Verdi was a professed agnostic, his work is nonetheless a powerful statement of religious faith, deeply moving to most listeners. In creating the *Requiem,* Verdi used most of the writing techniques that made his operas so successful, including beautiful solo melodies and dramatic choruses. Recently, portions of this work have been prominently featured in television commercials and movie soundtracks. Toward the end of his life, Verdi again drew inspiration from the plays of Shakespeare for his final two operas, *Otello* and *Falstaff* (based on *The Merry Wives of Windsor*). With *Otello,* Verdi entered something of a new phase of compositional style, writing a work that is more of a continuous drama with considerably less emphasis placed on arias and recitatives but still full of powerful human emotions. It is still very "Italian" in nature, but it differs from his earlier dramatic operas. For his final work, Verdi made a triumphant return to comic opera with his treatment of *Falstaff.* The opera is a clever comedy, full of puns and subtle jokes. Unfortunately, some of the jokes are lost in translation, so unless you have a keen understanding of Italian, you may miss out on some of the humor. In any case, it is a wonderful opera that, like *Otello,* is more of a continuous drama. *Falstaff* concludes with an intricate fugue that is in some ways reminiscent of the finale of his only string quartet, which was written around the same time.

Rigoletto

This opera is a typical tragedy, full of intricate plot twists that center around curses, court intrigues, and a bad case of mistaken identity. Set in Mantua in the 1600s, the story is focused on a lecherous duke, his hunchbacked court jester, Rigoletto, and the jester's beautiful daughter, Gilda. At the beginning of the opera an old nobleman named Monterone visits the court to complain about the duke's cruel treatment of his daughter. Rigoletto insults Monterone, and in retaliation the old man places a curse on both Rigoletto and the duke. Rigoletto tries to keep his own daughter hidden from the world, but the duke, pretending to be a poor student, has found her and attempts to seduce her. Later, friends of the duke kidnap Gilda and take her to the duke's

Singer Richard Bonelli in the role of Rigoletto.
Source: Jupiterimages, Corp.

bedchamber. Rigoletto tries to find her and help her escape, but she appears on her own, admitting that she has been "dishonored." In act three Gilda overhears the duke singing the famous aria *La donna è mobile* (Woman is Fickle), where he clearly displays his low regard for women. Compared to the rest of the opera, this catchy aria is almost on the level of "folk" music. Nonetheless, it is the tune everyone knows. Rigoletto sets a plot in motion to kill the duke, but in the end Gilda, disguised as a man, sacrifices herself to save the life of the duke, whom she inexplicably still loves. She dies in her father's arms, the curse fulfilled.

Singer Tito Schipa in the role of the Duke from the opera Rigoletto. **Source:** Jupiterimages, Corp.

Listening Guide

Rigoletto
Act III—*La donna è mobile (Woman is Fickle)*
Giuseppe Verdi (1813-1901)

Format: Tenor Aria
Performance: Plácido Domingo, tenor with the Hamburg State Opera Orchestra
Recording: *Serenata Romantica* (Digital Concerto CCT 2832)

Performance Notes: This historical recording was made directly from the stage of the Hamburg State Opera in 1969. While the microphone placement and orchestra execution are not perfect, this recording is a great example of Plácido Domingo at the beginning of his career. Notice how the audience responds to his performance.

:00

La donna è mobile	A woman is fickle
qual piuma al vento,	like a feather in the breeze,
muta d'accento e di pensiero.	changes her mind at the drop of a hat.
Sempre un amabile	Always shows a charming,
leggiadro viso,	pretty face,
in pianto o in riso	but whether weeping or laughing
è menzognero.	she is deceitful.
La donna è mobil	A woman is fickle
qual piuma al vento	like a feather in the breeze,
muta d'accento e di pensier.	changes her mind at the drop of a hat.
E sempre misero	You will be miserable
qui a lei s'affida,	if you trust her,
chi le confida,	if you confide in her
mal cauto il core!	without guarding your heart!
Pur mai non sentesi	And yet you'll never
felice appieno	feel happy
qui sul quell seno	if you don't sip love
non liba amore!	from her breast!
La donna è mobil	A woman is fickle
qual piuma al vento	like a feather in the breeze,
muta d'accento e di pensier.	changes her mind at the drop of a hat.

Richard Wagner (1813–1883)

Composer Richard Wagner as a young man.
Source: Jupiterimages, Corp.

leitmotiv

music drama

Richard Wagner came late to the world of music and never truly mastered any instrument. His training in music can be considered "limited" at best, and yet, by the end of his career he had completely revolutionized the world of music in general, and opera in particular. All of Wagner's major compositions are operatic in nature, although within his mighty compositions exists some of the most powerful instrumental writing of the entire Romantic era. As you will read in music critic Michael Walsh's article, Wagner was not the nicest guy in the world, nor was he the most honorable, but his numerous innovations in the world of music cannot be overlooked.

Wagner's early operas were built along traditional operatic formats, drawing on both French grand opera and romantic German opera models. These operas include *Der fliegende Holländer* (The Flying Dutchman), *Tannhäuser*, and *Lohengrin*. It is the opera *Lohengrin* that begins pointing toward some of Wagner's most important innovations. The work lays some of the groundwork for an all-encompassing artistic creation that Wagner would eventually call *music drama*, and it also shows Wagner making increased use of the *leitmotiv*. The term **leitmotiv** (leading motive) is said to have been originated by the biographer of early romantic composer Carl Maria von Weber to describe the composer's practice of the systematic use of recurring thematic material.[14] Wagner extended the practice to embrace Berlioz's concept of the *idée fixe* and Liszt's idea of *thematic transformation*. He uses the recurring themes to identify characters, places, and things in his operas, as well as to keep a sort of musical commentary running throughout his works. For example, someone may sing of his or her love for another character in the opera, and that love interest's *leitmotiv* would be heard in conjunction with the character doing the singing.

Wagner's concept of a **music drama**, where all the elements of the artistic world would be unified into one fully synthesized work of art, came to fruition in his epic 18-hour masterpiece titled *Der Ring des Nibelungen* (The Ring of the Nibelung). The work, which is actually made of four individual operas, tells the story of the rise and fall of the gods in Valhalla. It is a mystical story of good versus evil, centering on the greed for wealth and power. In these works, Wagner does away with the aria/recitative format found in most operas. Instead, he uses *leitmotivs* to unify his opera as his characters sing a string of new melodies over these identifiable themes. The orchestral accompaniment takes on a heightened significance in Wagner's later operas, often playing a major role in helping convey the true meaning of the action on stage. Intricate formal structures also play a big role in helping Wagner unify his ideas although these forms are not always readily apparent to the audience. Beyond the music, Wagner controlled

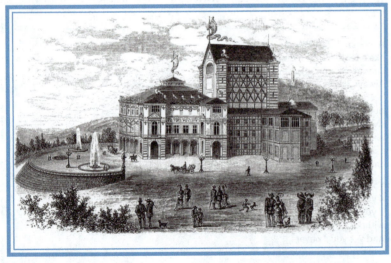

Wagner's specially constructed opera house at Bayreuth.
Source: Jupiterimages, Corp.

every aspect of his music dramas. He was meticulous in creating all of the text, the stage design (including some great innovations in set design and lighting), and even the costumes. Because of these new innovations, Wagner's operas didn't work very well in typical opera houses of the day. To solve his staging problems, he built a new festival hall in the town of Bayreuth, with the support of a crazy king named Ludwig II. The theatre still stands today, and every summer a festival is held where, over the course of an entire week, the *Ring* cycle is performed (usually with Wagner's final opera, *Parsifal,* thrown in for good measure).

One other important aspect of Wagner's music is his alteration of some of the basic harmonic concepts composers had been using since 1600. With works such as the *Ring* cycle, *Tristan and Isolde*, and *Parsifal*, Wagner begins the "breakdown" of tonality by intentionally postponing cadence points until the ear becomes hopelessly confused. The music is still quite beautiful, but it is designed to portray a longing for something that is never quite achieved. This relaxation of tonality will be continued in works of Gustav Mahler, found in Chapter 7, as well as in the complex and controversial works of Schoenberg, Berg, and Webern, all of whom are discussed in Chapter 8.

In his book *Who's Afraid of Classical Music?*, author and music critic Michael Walsh paints a somewhat irreverent but very realistic view of Wagner. The following selection offers insights into the man and his music, as well as an interesting glance at Wagner's life as a very prolific author.

DIG DEEPER

MOVIE
Wagner—
The Complete Epic
(mini-series)

RING CYCLE FESTIVALS
Bayreuth, Germany;
Seattle Opera Company

BOOKS
Richard Wagner: The Last of the Titans by Joachim Kohler;
Richard and Cosima Wagner: Biography of a Marriage by Geoffrey Skelton

Interlude: Richard Wagner *by Michael Walsh*

What are we going to do about Wagner? Terrible man, terrific music. Can't live with him, can't live without him.

Composers generally fall into two categories: those with great natural talent, who may or may not eventually make something out of it; and those lacking innate, God-given gifts who succeeded by dint of sheer hard work. Mozart and Saint-Saens are examples of the former, Beethoven and Wagner patron saints of the latter. Current musical ethos, reflecting sturdy Protestant egalitarian thinking, tends to prize the strivers over the gifted; they, after all, had to try harder. And, in any case, American society remains suspicious of natural ability, preferring to seek empirical, environmental explanations for each and every difference among persons this side of blue eyes.

Which is why Beethoven, for example, is the democrat's delight, a musical Horatio Alger story. Wagner had even less talent than Beethoven—Beethoven, after all, was a genuine keyboard prodigy, whereas Wagner never did learn how to play an instrument very well. The greatest and most influential musician—in fact, it can be argued, one of the most influential people, period—of the late nineteenth century was essentially an autodidact. (On his deathbed, Wagner's grandfather heard the young man torturing a piano in the next room. "And they say he has talent," muttered the old man, speeding toward the grave.) He didn't even decide to become

Richard Wagner.
Source: Jupiterimages, Corp.

a composer until he was fifteen years old, after hearing performances of Beethoven's *Ninth Symphony* (a work that remained a talisman to him all his life) and *Fidelio.* The only professional musical instruction he had came from a few short sessions in 1831 with the cantor of the Thomaskirche (Bach's church) in Leipzig. So: an inspiring success story, right?

Well. No.

Wagner was a bastard—figuratively, certainly; literally, probably. In all likelihood, his father was Ludwig Geyer, an actor in Leipzig who was a great and good friend of his mother. Geyer, who may have been Jewish, married her after Friedrich Wagner died, soon after Richard's birth in 1813, and the family moved to Dresden, where Wagner polished the strong, Saxon accent that his contemporaries made such sport of. All his adult life, Wagner was a virulent anti-Semite; perhaps this was his Oedipal revenge.

Like most composers, Wagner was short—about five feet five inches tall. But he thought big. He took what he wanted—money, women, opportunity—whether it belonged to someone else or not. He ran up huge debts, and outraged every community he ever lived in. He didn't care a fig for what anybody else thought. Rules, whether social or musical, were for other people; Wagner ordered his own reality. He got mad King Ludwig II of Bavaria to become his patron and when that wasn't enough, he built his own theater in the sleepy Franconian town of Bayreuth and created his own quasi-religious cult. He had two children by Cosima von Bülow, Liszt's illegitimate daughter, while she was still married to her husband, Hans, and he to his first wife, Minna. He borrowed money and rarely repaid it.

In short, he raised hell. At one point he was even a wanted man—wanted by the state of Saxony for his activities during the anti-monarchial revolution of 1848, which swept Europe. Wagner was an inveterate pamphleteer and, under the influence of the anarchist Mikhail Bakunin, fired off a broadside: "I will destroy the existing order of things," he warned. In short order, he found himself a refugee, first with Lizst, his patron, in Weimar and then in a safe haven in Zurich, Switzerland, until the fuss died down. (He wasn't legally allowed back in Germany until 1862.) Later, he lived under King Ludwig's patronage in Munich, where several of his most important operas were premiered, and then in Bayreuth. He died in Venice in 1883, having retreated south for the winter.

Wagner's life was a peripatetic odyssey of jobs: music director in Magdeburg in 1834, where he met and married Minna Planer and wrote his second opera, *Das Liebesverbot* (The Proscription Against Love), based on Shakespeare's *Measure for Measure,* which failed. Earlier, he had begun but not finished an opera called *Die Hochzeit* (The Wedding) and in 1833 completed *Die Feen* (The Fairies), which remained unproduced in his lifetime. But that was the extent of his compositional apprenticeship.

After a stop in Königsberg, Kant's hometown in East Prussia (now a postwar spoil of the Soviet Union), it was on to Riga, where he conceived *Rienzi,* an opera about an ancient Roman tribune that became his first big international success. But the good Latvians did not take kindly to Wagner's

The eccentric King Ludwig II of Bavaria.
Source: Jupiterimages, Corp.

radical plans for restructuring their musical life, and in 1839 he was fired. He and Minna headed for Paris, the operatic capital of the world and the home of the most eminent practitioner of grand opera, Giacomo Meyerbeer. Meyerbeer, a German Jew whose real name was Jakob Beer, had made his reputation with spectacles like *Robert le Diable*—Liszt made a barnburning transcription of themes from this opera, which features a ghostly chorus of lascivious dead nuns rising from their graves—and *Les Huguenots,* and Wagner needed his help if he was to make an impression on Paris.

He got it, but nothing much happened; all his life Wagner hated poor Meyerbeer for, as he saw, not helping enough. Broke, the Wagners bottomed out, Richard working on *The Flying Dutchman,* until the word came from Dresden that *Rienzi* had been accepted for performance. It was a hit, and, by 1842, Wagner's reputation was made.

Throughout the *wanderjahre,* he never stopped writing. Came the operas based on Germanic myth: *Tannhäuser,* about a song contest on the Wartburg, the great castle that towers over the town of Eisenach, where Bach was born. *Lohengrin,* Wagner's first treatment of sacred redemption that found full flower in *Parsifal. Der Ring des Nibelungen,* the sprawling four-opera mythological epic that consists of *Das Rheingold, Die Walküre, Siegfried,* and *Götterdämmerung.* Between the second and third acts of *Siegfried,* Wagner took a ten-year break and wrote both *Tristan und Isolde* (having fallen violently in love with Mathilde Wesendonk, the wife of one of his Swiss patrons), and his only comedy, *Die Meistersinger von Nürnberg.*

Wagner worked like a dog. How did he find the time to not only write his operas—and their librettos—but to issue a steady stream of broadsides and letters, keep one step ahead of his creditors, and find time to chase other men's wives and travel across Europe repeatedly? Wagner was almost as important a philosopher as a musician—in his own mind, he *was* as important, if not more so (Nietzsche thought so, too)—and his theories ranged on everything from *The Art Work of the Future* (he was for it)—the famous *Gesamtkunstwerk* that combines music, drama, poetry, and myth in one glorious package—to his revenge on Meyerbeer, the notorious *Jewishness in Music* (he was against it). As Peter Viereck points out in his exemplary study, *Metapolitics: The Roots of the Nazi Mind,* Wagner's theories were very much a part of the intellectual climate of the time, and would fine lethal expression in the deeds of a Wagner fanatic, Adolf Hitler, who declared: "Whoever wants to understand National Socialistic Germany must know Wagner."

The god Wotan, who is a central character in Wagner's Ring Cycle. **Source:** Jupiterimages, Corp.

In fairness to Wagner, he cannot be blamed for something that happened half a century later (there's the Historical Fallacy again)—and his avowed anti-Semitism did not prevent him from engaging Hermann Levi to conduct the premiere of his last opera, the ultra-Christian *Parsifal*—but it does account for why admiration for Wagner is always tempered by a kind of wariness. Even today in Bayreuth, Hitler's ghost is never very far away; Wagner's

The stage at Bayreuth.
Source: Jupiterimages, Corp.

daughter-in-law, the English-born Winifred, was a close personal friend of the Austrian corporal, and after the war she was banned from having anything to do with the freshly denazified Wagner Festival.

But an even stronger ghost is Wagner's. It seems incredible, but the man who today runs the Wagner Festival, Wolfgang Wagner, is the *grandson* of a man born in 1813. Wagner's villa, Wahnfried (the name means "freedom from folly"), still stands, although it was severely damaged by bombing during World War II. The streets are named after members of the Wagner family and characters in the Wagner music dramas. There is even a "Parsifal-Apotheke," the Parsifal Drug Store. No composer in history had as audacious a vision as Wagner's and made it stick.

Why is his vision so powerful? Why does his music have the effect on people that it does? Wagner did destroy the existing order of things, only not quite the way he pictured during his days as a firebrand. He soon lost his revolutionary fervor, as far as politics were concerned, and soon enough was nattering about the "vulgar egotism of the masses." But he never forsook his revolutionary art. Wagner was the great poet of sex, the seeker after Goethe's Eternal Feminine, and his music seethes with desire and longing, the violent clash between the sexes, the final struggle between Eros and Thanatos. No wonder it makes people uncomfortable.

Almost from the beginning, opinion was sharply divided. The philosopher Friedrich Nietzsche was first an acolyte and then an enemy. In 1876, at the first performance of the *Ring* in Bayreuth, he wrote (in *Richard Wagner in Bayreuth*) that the *Ring* "contains the most highly moral music I know." Later (in his book *Human, All Too Human*), he called Wagner, "a Romantic in despair, decaying and rotten." (A few months later, Wagner exclaimed to Cosima, "Everything that wicked man has comes from me, even the weapons he uses against me. How perverse he is, how cunning, yet how shallow!")

Another foe was the Viennese music critic, Eduard Hanslick, whose perceived small-mindedness and petty nitpicking Wagner lampooned as Beckmesser in *Die Meistersinger* (Wagner almost called the character Hans Lich). After the first performance of the *Ring* at Bayreuth in 1876, Hanslick cabled his opinion: "a distortion, a perversion of basic musical laws, a style contrary to the nature of human hearing and feeling. One could say of this tone poetry: There is music in it, but it is not music." Leo Tolstoy called the *Ring*, "a model work of counterfeit art so gross as to be even ridiculous." More poetically, Debussy said: "Wagner was a beautiful sunset that has been mistaken for a sunrise."

An outside view of Wagner's opera house at Bayreuth. The hall still stands today and continues to host a major festival of Wagner's music each year.
Source: Jupiterimages, Corp.

Wagner's defenders, of course, are legion; they include Thomas Mann (who employed the Wagnerian leitmotif technique in his novels) and George Bernard Shaw (who wrote *The Perfect Wagnerite*), among many others. Virgil Thomson, the American composer and critic, observed that the very number of Wagner's enemies pointed to his influence. "Wagner's pretensions to universal authority are inadmissible from the very fact that the music world is not unanimous about admitting them," [Virgil Thomson] wrote in *Dissent from Wagner* (1943). "Mozart is a great composer, a clear value to humanity, because no responsible musician denies that he is. But Wagner is not an absolute value from the very fact that Rossini denied it, and Nietzsche denied it, and Brahms denied it, and, in our own time, Debussy and Stravinsky have denied it. This does not mean that, with the exception of Rossini, all these composers (including Nietzsche) have not stolen a trick or two from Wagner or accepted him as a major influence on their style. They have. But the fact that they have accepted his work with reservations is what proves my thesis. . . ."

It has been said that more has been written about Wagner than about any other man who ever lived,

Wagner in his study at Bayreuth, with his wife Cosima (left) and his father-in-law Franz Liszt (with score on his right).
Source: Jupiterimages, Corp.

with the exceptions of Napoleon and Jesus. Wagner was a man of such immense personal magnetism, such overweening ambition, such irresistible drive, that he took the nineteenth century by the throat and shook it until its brains rattled. Women made no secret of their attraction to him, crowned heads gave him money, an entire town willingly became his personal fiefdom.

Even today, the force of his blow is still being felt. The state of Wagner singing is constantly addressed, and fretted over. A new production of the *Ring* draws worldwide press coverage (and is impossible to get into). Books about him and his works are still published, studies of his techniques and influence continually being written. Cosima's diaries, two volumes of daily details of the Master's life from 1869 to 1883 (Cosima's diaries end the night before Wagner's death, and she never picked up a pen again in the forty-seven years of life—or professional widowhood—she had left), were issued in 1977 to wide acclaim. We have not yet lost our fascination with Wagner.

At the end of his life, Wagner was writing an essay on *The Eternal in the Feminine*, a subject that, in one way or another, is at the heart of all his major works. As he lay in bed, he spoke of the Rhinemaidens, the cause of so much grief in the *Ring,* and he remarked to Cosima, "I feel loving toward them, these subservient creatures of the deep, with all their yearning." He dreamed of receiving a letter from Mathilde, but in his dream did not open it: "What if Cosima is jealous?"

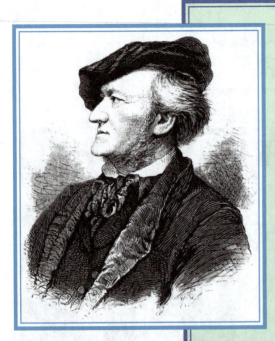

The next day, in his study, he skipped lunch to work on his essay. The last words he wrote were: "All the same, women's emancipation is proceeding only in an atmosphere of ecstatic convulsions. Love—tragedy." A massive heart attack felled him, the orgasm of death, and he died in Cosima's arms. She held him the rest of that day and all through the night. In the autopsy report, the attending physician noted, "It cannot be doubted that the innumerable psychical agitations to which Wagner was daily exposed on account of his particular mental outlook, his sharply pronounced attitude toward a whole series of burning problems in the fields of art, science, and politics, and his noteworthy social position, contributed much to his unfortunate end." He was 69.

Perhaps the last word on Wagner belongs to Nietzsche. "I can understand perfectly when a musician says today" 'I hate Wagner, but I cannot stand any other music,'" he wrote in *The Case of Wagner* (1888). "I would also understand a philosopher who said: 'Wagner summarizes the modern age. There is nothing for it—one has got to be a Wagnerian.'"

The classic image of Richard Wagner wearing his scholarly robes and hat.
Source: Jupiterimages, Corp.

Reprinted by permission of Don Congdon Associates, Inc. Copyright © 1989 by Michael Walsh.

Der Ring des Nibelungen

The four operas that make up the *Ring* cycle include *Das Rheingold* (The Rhine Gold), *Die Walküre* (The Valkyrie), *Siegfried*, and *Götterdämmerung* (The Twilight of the Gods). It is difficult to get any real sense of an 18-hour opera from a six minute excerpt, but this brief example does a good job of showing you how Wagner wrote for voices and orchestra, as well as how the orchestra itself played an important role in the unfolding drama. This scene takes place at the end of *Siegfried*. At this point in the drama Siegfried has just awakened Brünnhilde from the deep sleep her father, the god Wotan, placed her in when he surrounded her by magic fire at the end of *Die Walküre*. She is pretty happy to be awake and lets everyone know it. As an FYI, everyone here will be dead by the end of the last opera. In the immortal words of Bugs Bunny, "Well, what did you expect from an opera?"

Antique illustration depicting Siegfried as he awakens Brünnhilde.
Source: Jupiterimages, Corp.

Listening Guide

Siegfried
Act III—*Heil dir, Sonne!*
Richard Wagner (1813-1883)

Format: Music Drama (opera)

Performance: La Scala (1950), Wilhelm Furtwängler, conductor; Kirsten Flagstad, Brünnhilde; Set Svanholm, Siegfried

Recording: *Der Ring des Nibelungen* (Gebbardt JGCD 0018-12)

Performance Notes: Opera fans—especially those of Wagnerian opera—are obsessive about the "best" performance or recording of a given opera. The following excerpt, taken from the original liner notes, will give you a greater understanding of how these opera fans feel: "The only cycles of Wagner's *Ring* that Wilhelm Furtwängler conducted in the opera house after World War II were the three in Milan [at La Scala] in the Spring of 1950. They have, over the decades . . . achieved prodigious status, and are widely referred to simply as 'the La Scala *Ring*' one of the few performances which is instantly identifiable by so short a tag." The notes go on to point out that many opera fans sang the praises of these "historic" recordings in spite of the fact they had never actually *heard* them. Opera fans can be that way. In this particular case, however, they happen to be right. Like the previous Verdi example, this is a live recording made directly from the stage. The overall sound quality is questionable at best, and the orchestra is powerful but not perfect. None of it matters. This is the original "heavy metal" music.

Liner notes from Gebbardt JGCD 0018-12

:00 Rather than getting too technical, this listening guide will simply follow along with an English translation of the lyrics. You should be aware, however, that there are several different *leitmotiv* passages in use throughout this excerpt. If you become a serious fan of Wagner opera, you will get to know all of them quite well.

(He kisses her on the lips long and passionately.)

BRÜNNHILDE	BRÜNNHILDE
(awaking and sitting up)	
Heil dir, Sonne!	Hail to thee, oh sun!
Heil dir, Licht!	Hail to thee, light!
Heil dir, leuchtender Tag!	Hail to thee, shining day!
Lang war mein Schlaf,	Long was my sleep,
ich bin erwacht:	I have been awoken.
wer ist der Held,	Who is the hero,
der mich erweckt'?	who has awoken me?
SIEGFRIED	SIEGFRIED

(entranced by her voice and appearance)

Durch das Feuer drang ich,	I forced my way through the fire,
das den Fels umbrann;	that burned round the rock.
ich erbrach dir den festen Helm:	I broke open your strong helmet.
Siegfried bin ach	Siegfried am I,
der dich erweckt'.	who have awakened you.
BRÜNNHILDE	BRÜNNHILDE
Heil euch, Götter!	Hail to you, Gods!
Heil dir, Welt!	Hail to thee, world!
Heil dir, prangende Erde!	Hail to thee, shining earth!
Zu End' ist nun mein Schlaf;	My sleep is at an end;
erwacht, seh' ich:	awakened, I see:
Siegfried ist es	Siegfried it is
der mich erweckt!	who has awoken me!

SIEGFRIED	SIEGFRIED
	(in ecstasy)
O Heil der Mutter, die dich gebar; . . .	Oh, hail to the mother, who gave you birth; . . .
BRÜNNHILDE	BRÜNNHILDE
(in a state of intense exaltation)	
O Heil der Mutter, die dich gebar; . . .	Oh, hail to the mother, who gave you birth; . . .
SIEGFRIED	SIEGFRIED
. . . Heil der Erde, die mich genährt: hail to the earth, that nourished me: . . .
BRÜNNHILDE	BRÜNNHILDE
. . . Heil der Erde, die dich genährt: hail to the earth, that nourished you: . . .
SIEGFRIED	SIEGFRIED
. . . dass ich das Aug' that those eyes I may . . .
(drawing out his words, whilst Brünnhilde's pour forth more swiftly)	
. . . erschaut, das jetzt mir Seligem lacht!	. . . see, which laugh to me now, blessed that I am!
BRÜNNHILDE	BRÜNNHILDE
. . . nur dein Blick durfte mich schau'n, erwachen durft' ich nur dir! only your eyes might look on me, I was to awake for you alone! . . .
. . . O Siegfried! Siegfried!	. . . Oh Siegfried! Siegfried!

Endnotes

1. Josef von Spaun, "Schubert Remembered by a Friend," in *Music in the Western World: A History in Documents,* eds. Piero Weiss and Richard Taruskin (New York: Schirmer Books, 1984), 339.

2. Jeremy Yudkin, *Understanding Music* (Upper Saddle River, NJ: Prentice Hall, Inc., 1996), 238.

3. Leigh Hunt, "Paganini, the Spectacular Virtuoso," in *Music in the Western World: A History in Documents,* eds. Piero Weiss and Richard Taruskin (New York: Schirmer Books, 1984), 343-345.

4. Joseph Machlis and Kristine Forney, *The Enjoyment of Music,* 7th ed. (New York: W. W. Norton, 1995), 342.

5. K. Marie Stolba, *The Development of Western Music: A History,* 3rd ed. (Boston: McGraw-Hill, 1998), 462.

6. James William Davison, "Souvenirs de Pologne," *Musical World,* October 28, 1841, in *The Music Monster*, ed. Charles Reid (London: Quartet Books, 1984), 148-49.

7. "Liszt, the All-Conquering Pianist," in *Music in the Western World: A History in Documents,* eds. Piero Weiss and Richard Taruskin (New York: Schirmer Books, 1984), 365.

8. Robert Schumann, as quoted in Horst A. Scholz, *Franz Liszt: Études d'exécution transcendante*, Freddy Kempf, piano, compact disc linder notes, BIS CD 1210, 3.

9. Yudkin, *Understanding Music,* 244.

10. Tchaikovsky, personal diary, October 9, 1886, in *Words about Music,* eds. John Amis and Michael Rose (New York: Marlow & Co, 1995), 208.

11. Edvard Grieg, "Mozart," in *The Composer as Listener*, ed. Irving Kolodin, (New York: Collier Books, 1962), 87.

12. Stolba, *The Development of Western Music,* 505.

13. George Bernard Shaw, quoted in Robert Sherman and Philip Seldon, *The Complete Idiot's Guide to Classical Music* (New York: Alpha Books, 1997), 286.

14. Stolba, *The Development of Western Music,* 436.

Study Guide

Chapter 6 Review Questions

True or False

___ 1. With regard to instrumental compositions, Brahms focused most of his attention on absolute music.

___ 2. The Romantic period in music was a time marked by revolution, innovation, and an increased awareness of individuality.

___ 3. Schubert's personality was somewhat shy and reserved.

___ 4. Felix Mendelssohn never traveled outside of Vienna.

___ 5. Composer Robert Schumann also worked as a music critic.

___ 6. As a soloist, Clara Schumann enjoyed more public acclaim than her husband during their life together.

___ 7. Chopin never made use of *tempo rubato*.

___ 8. Franz Liszt is often referred to as the "Paganini of the piano."

___ 9. Berlioz's *Symphonie fantastique* is an absolute symphony.

Multiple Choice

10. Gounod's *Ave Maria* is really a new melody based on a earlier composition by:
 a. Mozart.
 b. Beethoven.
 c. Josquin Des Prez.
 d. J. S. Bach.
 e. none of the above.

11. Famous Russian Romantic composer.
 a. Tchaikovsky
 b. Smetana
 c. Schumann
 d. Berlioz

12. Schubert's Lieder are written in the following formal structure(s):
 a. strophic.
 b. modified strophic.
 c. through-composed.
 d. all of the above.
 e. none of the above.

13. At the age of 26, _____ was appointed conductor of the Leipzig Gewandhaus Orchestra.
 a. Mendelssohn
 b. Brahms
 c. Berlioz
 d. Chopin

14. Compositional technique developed by Franz Liszt.
 a. *idée fixe*
 b. thematic transformation
 c. *leitmotiv*
 d. none of the above

15. Single-movement, programmatic symphonic composition.
 a. concerto
 b. symphony
 c. fugue
 d. tone poem

Fill in the Blank

16. Wagner's concept of _____ attempts to combine all the elements of the artistic world into one fully synthesized work of art.

17. The concept for the French _____ was to present dramatic opera in a somewhat lighter style.

18. Bohemian composer _____ served as director for the national Conservatory of Music in New York City.

19. The German term for art song is _____.

20. _____ organized a performance of Bach's *St. Matthew Passion*, which led to the gradual "re-discovery" of many of Bach's masterpieces.

21. Violinist _____ revolutionized the world of the solo musician.

22. Chopin is often referred to as the _____ _____.

23. Berlioz introduced a recurring theme in his *Symphonie fantastique* called an _____.

Short Answer

24. List five important operas composed by Verdi.

25. List the four individual operas that make up Wagner's *Ring* cycle.

Essay Questions

1. Discuss Wagner's transformation of opera.

2. Discuss the development of nationalism in the Romantic era.

Chapter 7

Impressionism and Post-Romanticism

"I don't choose what I compose. It chooses me."

Gustav Mahler

*T*hirty years ago, you would rarely see an independent chapter with the title *Impressionism and Post-Romanticism* in any classical music text. Impressionism as a style would show up at the end of the Romantic chapter or at the start of the twentieth century. The term "Post-Romanticism" was not in common use in the world of classical music. Times change, however, and as we continue to move forward in the history of music a grouping of these styles seems to make sense. The composers featured in this chapter drew heavily on the musical styles of the Romantic era, but there were significant changes in their approach to musical composition. With the exception of Anton Bruckner, all of the composers in this chapter lived into the twentieth century. Particularly for the composers who are considered "Post-Romantic," often the time-frame in which the composer lived is a major consideration for their being labeled as such. Even today, there are composers writing music very reminiscent of nineteenth-century styles and techniques. Current composers of this type of music are called "Neo-Romantic" composers, but you will learn more about them in Chapter 9.

Impressionism was a term that came into use in the 1870s to describe the artworks of painters such as Monet, Renoir, and Degas. Vincent Van Gogh is also grouped into the Impressionist school, but many of his works go beyond the typical definition of the style and are frequently referred to as "Post-Impressionistic." These artists avoided sharp lines and hard images in favor of a "washy" looking painting, designed to "impress" upon the viewer a general sense of the scene without vivid detail. It was intended to show what the eye might capture in a glance, with special attention paid to light and color. In poetry, a style called *Symbolism* sprang up toward the end of the Romantic era that in many ways paralleled Impressionism in the art world. Inspired by the poet Baudelaire and led by Stéphane Mallarmé, this poetry had a powerful impact on composer Claude Debussy. In fact, Debussy referred to his music by the term "Symbolism" rather than the more commonly used "Impressionism," which he felt implied that his works were vague and unfo-

Commemorative postage stamp featuring a self-portrait by the artist Vincent Van Gogh.
Source: Shutterstock, Inc.

Postcard image from the Pushkin Museum of Fine Arts featuring Van Gogh's. *The Sea at Saint-Marie.*
Source: Shutterstock, Inc.

A dramatic woodcut impression of the poet Stéphane Mallarmé.
Source: Jupiterimages, Corp.

cused. Nonetheless, it is the term Impressionism that stuck and is still in common use today. Debussy's music is full of rhythmic complexities that obscure the basic beat of many of his works. In addition, the composer makes use of extended harmonies and "non-Western" scales that further aid his music in achieving a beautiful but slightly blurred effect. Following in Debussy's footsteps, composers such as Maurice Ravel, Eric Satie, Arthur Honegger and even, to a certain extent, Igor Stravinsky, made use of Debussy's Impressionistic techniques. Like the painter Van Gogh, most of these artists, and particularly Ravel, are frequently referred to as "Post-Impressionists," or they are most commonly associated with other artistic movements in the twentieth century.

Post-Romanticism as a style is a little harder to pin down, but most scholars point to Austrian composer Gustav Mahler as being first. Like the concept of Post-Impressionism above, this is a difficult style on which to place firm, descriptive boundaries. The composers grouped in the Post-Romantic school frequently wrote works on a massive scale. Symphonies that reached well over an hour in length; long song cycles (or *Lieder*), often set with large orchestral accompaniments; and loud, dramatic operas that drew heavily on orchestral forces and pushed singers to their absolute limits were all quite common. A few of the composers grouped into this style include Mahler, Anton Bruckner, Jean Sibelius, and Richard Strauss. The Russian composer and pianist Sergei Rachmaninov is often not included with this group, but his compositional output certainly makes him a worthy candidate for inclusion. Finally, the early works of Arnold Schoenberg could also be considered in this same grouping, but a full discussion of Schoenberg and his music will be reserved for the next chapter. Conductor and composer Leonard Bernstein wrote the following in a 1967 article for *High Fidelity* magazine:

The first spontaneous image that springs to my mind at the mention of the word "Mahler" is of a colossus straddling the magic dateline "1900." There he stands, his left foot (closer to the heart!) firmly planted in the rich, beloved nineteenth century, and his right, rather less firmly, seeking solid ground in the twentieth. Some say he never found this foothold; others (and I agree with them) insist that twentieth-century music could not exist as we know it if that right foot had not landed there with a commanding

thud. Whichever assessment is right, the image remains: he straddled. Along with Strauss, Sibelius and, yes, Schoenberg, Mahler sang the last rueful songs of nineteenth-century [r]omanticism. But Strauss's extraordinary gifts went the route of a not very subjective virtuosity; Sibelius and Schoenberg found their own extremely different but personal routes into the new century. Mahler was left straddling; his destiny was to sum up, package, and lay to ultimate rest the fantastic treasure that was German-Austrian music from Bach to Wagner.[1]

Claude Debussy (1862–1918)

Claude Debussy attended the Paris Conservatory, and while he was a student there, his radical harmonic concepts earned him the disapproval of the theory and composition faculty. He spent two summers working in Russia as a pianist for Tchaikovsky's patron, Madame von Meck. Like the unconventional Berlioz before him, Debussy won the *Prix de Rome* in 1884 and spent two years in Italy, where he met both Verdi and Liszt. Not long after, Debussy began to explore the writings of Symbolist poets Mallarmé and Verlaine, among others. In 1899 he attended the Paris World Exhibition where he was introduced to music from a number of Eastern cultures, most importantly, the Javanese gamelan. The gamelan is a type of Asian orchestra that makes use of a number of percussion instruments and plays with rhythmic and harmonic structures that are very different from typical Western music. Debussy began introducing some of these "non-Western" Oriental elements into music. Most important to our discussion are the use of non-Western scale patterns including the whole-tone and pentatonic (five-note) scales. The whole-tone scale is kind of "dreamy" sounding, and, in fact, is frequently used to indicate a dream sequence in a movie or on TV. The pentatonic scale is commonly used to portray the Japanese army/navy/air force in WW II action movies. Debussy also began to incorporate a technique called **parallelism,** which he would use to move large, extended-harmony chords up and down in direct parallel motion. Beyond these harmonic techniques, which in and of themselves lead to a general breakdown of tonality, Debussy also made use of a heightened sense of chromaticism, using more notes that do not "belong" to a given key center, again helping to weaken the ear's ability to clearly identify a particular chord as tonic.

Debussy's first composition to bring him any major attention was the tone poem *Prélude à l'après-midi d'un faune* (Prelude to the Afternoon of a Faun), which is presented in the following listening guide. Next, Debussy threw himself into the

Claude Debussy.
Source: Library of Congress.

parallelism

A typical Javanese gamelan similar to the one that inspired Debussy at the Paris World Exhibition.
Source: Jupiterimages, Corp.

*The Great Wave
Off Kanagawa by
Katsushika Hokusai.
This work inspired
Debussy to compose
his three-movement
program symphony*
La Mer (The Sea).
Source: Shutterstock, Inc.

composition of his only opera, *Pelléas et Mélisande*, which was based on Maurice Maeterlinck's Symbolist play of the same title. Debussy had visited Wagner's famed Bayreuth festival, and he drew some inspiration from that composer's concept of *music drama*. Unlike Wagner, however, Debussy placed more emphasis on the text and made no prominent use of the *leitmotiv* concept though the opera does have some clear recurring themes. Between 1903 and 1905 Debussy composed a three-movement work titled *La Mer* (The Sea), which is in effect a program symphony. The English translations of the movement titles are *From Dawn to Noon on the Sea, Play of the Waves*, and *Dialogue of the Wind and Sea*. Each movement paints an evocative sonic portrait of the ocean, with complex cross-rhythms and non-traditional harmony structures that convey the basic instability of water. The work is one of Debussy's most effective pieces and is a regular on symphonic programs. Works like these had enormous impact on a number of twentieth-century composers, including Igor Stravinsky. One often overlooked fact about Debussy's compositional style for orchestra is the impact his music had on film composition during the twentieth century. Although Debussy's works were not always readily accepted in his day, almost every composer who ever wrote music for a film score borrowed ideas about orchestration and lush (but inconclusive) harmonic structures from his music.

Aside from compositions for large forces, Debussy also created a number of chamber music works, most importantly his works for solo piano. Debussy's piano compositions have taken their place beside the works of Beethoven, Chopin, and Liszt as basic literature every classical pianist must study and perform. Some of his most popular compositions for piano include *Suite bergamasque* (which contains his tribute to the moon, the famous *Clair de lune*), *Estampes* (Engravings), *L'Ile joyeuse, Children's Corner Suite*, as well as two books each of *Préludes* and *Études*. His writing for piano clearly expresses his intent to push older Romantic concepts about harmony and rhythm to their breaking point. Debussy also wrote a masterful String Quartet in g minor,

*Mythical image of a
faun playing a reed
flute.*
Source: Jupiterimages,
Corp.

a number of very good art songs for voice and piano, and a haunting piece for solo flute titled *Syrinx*.

Prélude à l'après-midi d'un faune (Prelude to the Afternoon of a Faun)

Symbolist poet Stéphane Mallarmé's picturesque poem *Prélude à l'après-midi d'un faune* served as Debussy's inspiration for this famous symphonic work. The book *Classical Music for Dummies* explains the basic story for the piece as follows: "The music fits the mood of the poem, which concerns the afternoon adventures of a faun (half man, half goat). It's dreamy, sensuous, and vague; the story is your basic Goat-Meets-Nymph, Goat-Chases-Nymph, Goat-Loses-Nymph, Goat-Eats-Grapes."[2] After hearing this work, the poet Mallarmé stated: "I was not expecting anything quite like this. This music extends the impression created by my poem and conveys its atmosphere with greater poeticism than colour itself could do."[3]

Debussy uses a three-part A-B-A' format to organize the basic thematic material of this work. Beyond a general thematic formal structure, however, Debussy seems to go out of his way to obscure any clear sense of a basic beat or other major unifying element in this work. Throughout the tone poem you will hear plenty of rhythmic activity, but you can never really tell exactly how it is organized. This is not what you would call a "toe-tapper."

Source: ©Shutterstock.com

Listening Guide

Prélude à l'après-midi d'un faune (Prelude to the Afternoon of a Faun)
Claude Debussy (1862-1918)

Format: Tone poem
Performance: Czech Philharmonic Orchestra, Serge Baudo, conductor
Recording: *Serge Baudo Conducts Debussy* (Supraphon Archiv SU 3478-2 011)

Performance Notes: Recorded in the Dvořàk Hall, Prague in 1966.

:00	Letter A. Opening melody starts with a solo flute and is passed around to various other instruments. Brief new melodic ideas are introduced here and there to add more color to the primary tune.
3:03	Letter B. This section of the work presents three contrasting themes. The first one is introduced by the woodwinds and then repeated in part by the strings.
4:41	The music continues to ebb and flow, but in general, Debussy still has the orchestra building toward a huge musical climax. At this point, an expansive new theme is introduced by the woodwinds and then picked up by the strings. Some scholars label only this particular theme as "letter B."
6:18	Letter A returns. We call this an A' because the material presented is shorter compared to what Debussy gave us the first time, and he has altered the orchestration as well. Debussy allows the work to fade away gradually, with subtle reminders of the major thematic material.

Maurice Ravel (1875-1937)

Maurice Ravel is a great example of a successful composer who drew inspiration from the work of Claude Debussy but who followed his own musical course, branching out into a blending of old and new styles. He was particularly fond of traditional dance rhythms, and he often made use of more clear-cut formal structures reminiscent of the Classical period. Today he is considered a "Post-Impressionist." Ravel grew up in Paris, where he received training as a pianist. In 1889 he entered the Paris Conservatory, where he spent many years studying composition with Gabriel Fauré, among others. Like Debussy before him, Ravel's sense of extended harmony did not sit well with his teachers, but in all other respects he excelled as a student. Although he was primarily a pianist, Ravel displayed a particular gift for the art of orchestration. He had a knack for blending the diverse instruments of the symphony orchestra in a myriad of different ways, giving himself a wide palate of tone colors with which to create. Many of his greatest orchestral works actually began their lives as compositions for solo piano, which Ravel would then go back and cleverly arrange for the entire orchestra. Some of these works include the *Pavane pour une infante défunte* (Pavane for a Dead Infant), *Valses nobles et sentimentales* (Noble and Sentimental Waltzes), and *Le tombeau de Couperin* (Lament for Couperin). Ravel also created some very successful orchestrations of other composers' works for solo piano, the most important of which is his setting of Russian composer Modest Mussorgksky's *Pictures from an Exhibition*. Two of Ravel's most famous original compositions—*Daphnis et Chloé* and *Boléro*—were written for the ballet, though they are most frequently heard now in concert performances. The

Maurice Ravel.
Source: © 2009
Jupiterimages, Corp.

Boléro in particular is an interesting study in orchestration, as it is the same two 16-bar melodies, played over and over again. Throughout the work there is no significant thematic or harmonic development (although it does make a dramatic shift in key center right at the end of the piece). The piece sustains the audience's interest with a constantly shifting, always swelling, orchestration that builds throughout the piece from a whisper to a thunderous ending. The work is one giant crescendo, which many people (including Bo Derek's character in the movie *10*) believe is highly erotic. Ravel wrote compositions for almost every important musical genre. Both of his operas are critically acclaimed though they are rarely performed. Aside from his purely orchestral works, he wrote two successful concertos for piano, the one in D Major for left hand only (written for soloist Paul Wittgenstein, who had lost his right arm in WWI) and the Concerto in G Major (written for Marguerite Long). He also composed a number of wonderful chamber works, including a string quartet, various smaller works for solo piano, and a number of excellent art songs.

verismo

Verismo opera composer Pietro Mascagni.
©Shutterstock.com

Famous opera star Enrico Caruso in the role of Canio from I Pagliacci *by Ruggiero Leoncavallo.*
©Shutterstock.com

Focus on Form
Verismo Opera

Toward the end of the nineteenth century some composers began to create works with a more realistic tone. Unlike the historical settings used by Verdi or the mythical ones favored by Wagner, these new operas were set in modern times and avoided focusing on "known" characters. This new operatic style was called **verismo** (literally *realism* in Italian) although scholars debate the actual boundaries of this term. Some say the operas of Puccini and Bizet should be included under this banner, whereas others feel that the term *verismo* should be reserved for the works of composers such as Pietro Mascagni (1863-1945) and Ruggiero Leoncavallo (1858-1919). The difference between the two is that longer operas by Puccini and Bizet have more of an emotional ebb and flow, while shorter works such as Mascagni's *Cavalleria rusticana* (Rustic Chivalry) and Leoncavallo's *I Pagliacci* (The Clowns) are relentless and draining emotional workouts. In fact, due to their short length and similarity of style, these two works are frequently performed together. Beyond the two operas just mentioned, Giacomo Puccini wrote most of the important works in this genre. In fact, if you take out Puccini and Bizet, there really isn't much left to *verismo,* so let's keep them here. Perhaps most important to this discussion, all of the works that normally fall under the *verismo* heading have plenty of murder, sex, intrigue, and just plain crazy people, which is what you want in a good opera plot.

Giacomo Puccini (1858~1924)

After Verdi, Giacomo Puccini is Italy's most famous composer of opera. Puccini's style is direct and personal. His characters are not major historical figures. They are relatively normal people placed in emotionally charged situations, making his operas "realistic" slices of life. As you will hear in the following

listening example, Puccini had a gift for writing beautiful melodies with powerful emotional content, to which audiences were immediately drawn. Some of Puccini's most famous works include *Tosca, Madama Butterfly,* and *La Bohème. Tosca* tells the story of an actress whose lover's life is threatened by a police chief as he seeks her favors. *La Bohème* is an examination of the Bohemian lifestyle in Paris through the life of Mimi, a poor seamstress who is dying of consumption. (This is another one of those situations where you have to suspend reality a little to get into the opera. Mimi is dying of tuberculosis, but she still manages to sing very well without coughing up a lung.) Other important Puccini operas that are still frequently performed include *Manon Lescaut* and *La fanciulla del West* (The Girl of the Golden West). The following listening

Giacomo Puccini.
Source: Jupiterimages, Corp.

example comes from *Madama Butterfly*, which Puccini completed in 1904. As you saw with Debussy, this was a time of growing interest in all things exotic, especially those drawn from Oriental culture.

Madama Butterfly

This opera features an American sailor, Lieutenant Pinkerton, who marries a young geisha named Cho-Cho-San, whom he refers to as "Madame Butterfly." Pinkerton returns to America, ignoring his Japanese marriage vows and leaving

Cho-Cho-San and a young son behind. She suffers, dreaming of the day he will return. Her aria *Un bel di* (One fine day) is one of the most famous opera tunes ever composed. In it, she daydreams about how their ultimate reunion will unfold. Unfortunately, when Pinkerton does return in act three he brings his new American wife with him. In a fit of humiliation and desperation, Cho-Cho-San agrees to give up the child and kills herself after singing another heart-wrenching aria. For my money, it's the best suicide scene in all of opera.

Singer Geraldine Farrar in the role of Cho-Cho-San from Puccini's opera Madama Butterfly. *Farrar, who was also a well-known silent film star, was a regular performer at the Metropolitan Opera in New York from 1906 to 1922.*
Source: © 2009 Jupiterimages, Corp.

Listening Guide

Madama Butterfly
Act II—Un bel di (One fine day)
Giacomo Puccini (1858-1924)

Form: Da capo aria (for soprano)
Performance: Ljudmila Hadjieva, soprano, with the Orchestra of the Sofia Opera
Recording: *Lover's Concerto* (Digital Concerto CCT 2833)

:00 Letter A melody is introduced. Notice that the vocal melody is doubled in the orchestral parts, which adds extra richness to the musical texture. (It also helps the singer stay on pitch, but you won't ever hear a professional singer admit that fact.)

Un bel dì vedremo	One lovely day we'll see
levarsi un fil di fumo	a thread of smoke rise
sull'estremo confin del mare.	at the distant edge of the sea.
E poi la nave appare—	And then the ship appears—
Poi la nave bianca	then the white ship
entra nel porto, romba	enters the harbor, thunders
il suo saluto. Vedi?	its salute. You see?
È venuto!	He's come!
Io non gli scendo incontro.	I don't go down to meet him.
Io no.	Not I.

1:17 Letter B melody begins as the aria becomes more animated. Toward the end of this section, notice the wonderful interplay between the voice, the clarinet, and a solo violinist. Notice also how at the end of this section he returns to the Letter A melody in the middle of the word *morir (die)*.

Mi metto là	I place myself there
sul ciglio del colle e aspetto,	at the brow of the hill and wait,
e aspetto gran tempo	I wait a long time,
e non mi pesa	but the long waiting
la lunga attesa.	doesn't oppress me.
E . . . uscito dalla folla cittadina	And . . . coming out of the city's crowd
un uom, un picciol punto	a man, a tiny speck,
s'avvia per la collina.	starts towards the hill.
Chi sarà? chi sarà?	Who will it be? Who?
E come sarà giunto—	And when he arrives—
che dirà? che dirà?	What, what will he say?
Chiamerà Butterfly	He'll call *Butterfly*
dalla lontana.	from the distance.
Io senza dar risposta	Without answering him,
me ne starò nascosta,	I'll stay hidden,
un po' per celia	partly to tease him,
e un po' per non mor—	and partly not to die—

2:36 Letter A melody returns with new text. This final statement of the melody is finished off with a brief orchestral postlude.

—ir	—die
al primo incontro,	at our first meeting,
ed egli alquanto in pena	and a little worried,
chiamerà, chiamerà:	he'll call, he'll call
Piccina mogliettina,	*Little wife,*
olezzo di verbena—	*verbena-blossom,*
i nomi che mi dava	the name he gave me
al suo venire.	when he came here.
Tutto questo averrà,	All this will happen,
te lo prometto.	I promise you.
Tienti la tua paura,	Keep your fear to yourself,
io con sicura fede l'aspetto.	with certain faith I'm waiting for him.

Gustav Mahler (1860-1911)

Gustav Mahler was born and grew up in Bohemia, and the bulk of his musical life was centered in the nearby city of Vienna, Austria and the surrounding countryside. He entered the conservatory in Vienna at age 15 and began his university studies three years later. As a young professional musician, he took a summer job conducting for a mediocre light opera company, but with this first job, Mahler quickly realized that he had a true gift for conducting. Over the next few years the young man moved steadily up through the ranks of conductors, eventually landing the post of director for the Royal Opera in Budapest. He moved from there to Hamburg, and finally, in 1897, to every opera conductor's dream job as director of the Vienna State Opera. Because Mahler was Jewish, anti-Semitism would have kept him from being awarded this important post; therefore, he made a public conversion to Catholicism before accepting the position. After the conversion ceremony was complete Mahler is said to have remarked, "I have merely changed my coat." He enjoyed ten musically successful years in Vienna, until health and political infighting at the opera house forced him to resign. Mahler was an exacting perfectionist as a conductor and director, and he didn't mind stepping on a few toes to see that things were done his way. He made a number of enemies over the years. As a conductor, Mahler next accepted the opportunity to come to America where he conducted both the Metropolitan Opera and the New York Philharmonic. He made a great deal of money in America, but he had even less freedom to program works and mount productions with an iron fist. He again found himself in conflict with management. In 1911, Mahler's weak heart condition was made worse by an infection in his bloodstream. He left New York in mid-season, visited Paris—where he took an unsuccessful treatment for his health—and eventually returned to Vienna, where he passed away.

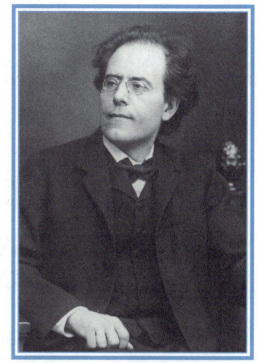

Composer and conductor Gustav Mahler.
Source: Library of Congress.

Throughout his successful career as an internationally acclaimed conductor, Mahler was always composing as well. His general work habit was to take several months off during the summer, when the opera was not in season, to compose. Mahler's compositions are often viewed as the end of a Viennese tradition of great orchestral works, which included the symphonies of Mozart, Beethoven, Schubert, Brahms, and Bruckner. He can also be viewed, however, as a bridge into the twentieth-century musical world of composers such as Schoenberg, Berg, and Webern. His music clearly draws inspiration from earlier composers, but it also moves further along the path started by Wagner, leading toward the eventual breakdown of tonality. Like his idol, Wagner, Mahler wrote extended passages of lushly Romantic music, which, while extraordinarily beautiful, lacked any real sense of a firm tonal center. His music was full of exuberant outbursts, followed by melancholy passages. His melodies could be simple, almost child-like gestures at one instant, then turn on a dime and become profoundly deep, soul-wrenching musical moments the next. Mahler had a gift

The Vienna State Opera house where Mahler achieved his greatest fame and endured some of his biggest headaches.
© Shutterstock.com

for creative orchestration, but he struggled with each of his compositions. He was constantly making revisions, frequently re-writing entire sections, changing basic orchestrations, and, at times, even redoing (or simply removing) entire movements of his major works.

Mahler's life was marked by tragedy, from his earliest childhood right up to his death in 1911. His father was abusive, several of his siblings died of illness (and one from suicide), and he never quite seemed to "fit in." Mahler had several complicated love affairs, including a tumultuous marriage to Alma Schindler, with whom he had two children. Their oldest daughter died in 1907, not long after Mahler completed work on a song cycle for voice and orchestra titled *Kindertotenlieder* (Songs on the Death of Children). Mahler began to blame himself for the death, as if his composition somehow preordained the actual event. Not long after the death of their child, Mahler was diagnosed with a weak heart, and from then on he was preoccupied with the subject of mortality.

Each of Mahler's nine symphonies is a true masterpiece of orchestral, and, in some cases, vocal writing. His Symphony No. 1 is known as the *Titan*. With Symphony No. 2, named *Resurrection*, Mahler follows in the footsteps of Beethoven's last symphony, as he introduces two vocal soloists and a choir of mixed voices in the last movement. Symphony No. 3 also follows this same pattern, using a full symphony orchestra, along with a soloist and two choruses, one made up of women and the other of children. Symphony No. 4 is generally considered to be one of Mahler's most reserved, but elegantly beautiful, works. It features a solo soprano voice in the final movement. With the massive Symphony No. 5, Mahler returned to purely instrumental forces. He again borrowed an idea from Beethoven, introducing this piece with a trumpet fanfare that sounds three short notes and one long one, the same "fate" motive Beethoven used in his Fifth Symphony. As with his earlier symphonic works, Mahler may have had an extended program in mind here, but he eventually decided to let the music stand on its own as an absolute composition. Symphonies No. 6 and 7 follow in the same path as purely instrumental compositions. Symphony No. 8, subtitled the *Symphony of a Thousand*, makes use of one of the largest performing ensembles ever assembled. In fact, the premiere of this massive work actually featured 1,379 instrumentalists and singers.[4] The work calls for an extra-large symphony orchestra, eight vocal soloists, and two choirs, one made up of mixed voices and the other a boys' choir. Anything after the eighth symphony might have seemed like a letdown, but Mahler successfully returned to a purely instrumental ensemble for his Symphony No 9. At the time of his death, Mahler was working on a tenth symphony, of which only two movements were complete. Years later, British historian Derrick Cooke discovered a reduced score of the entire symphony and subsequently prepared a fully orchestrated performing version. It is a great symphony that sounds a lot like Mahler. If you like his other nine symphonies, you'll enjoy this one as well.

Beyond his symphonies, Mahler wrote a number of song cycles, many of which can be performed with a full symphony orchestra or with piano accompaniment. These works include *Kindertotenlieder* (Songs on the Death of Children), *Lieder eines fahrenden Gesellen* (Songs of a Wayfarer), and *Des Knaben Wunderhorn* (The Youth's Magic Horn). Mahler also composed a slightly different kind of cycle, which would later be referred to as a "song-symphony," *Das Lied von der Erde* (The Song of the Earth). It is in this work that Mahler borrows a few tricks from Debussy's playbook and makes an exploration of Eastern mysticism. The six-movement work, written for two vocal soloists and orchestra, is based on a text by Hans Bethge titled *Chinese*

A caricature of Mahler from his time in New York City.
Source: Jupiterimages, Corp.

Flute, which in itself was a sort of adaptation of poems by the eighteenth-century Chinese poet Li Po. This work was composed in the time period directly after the death of Mahler's daughter and the diagnosis of his own heart condition. There is a sense of sadness, resignation, and an eventual sense of joy-beyond-tragedy in this work. Mahler said, "I see everything in a new light. I thirst for life more than ever before, and find the 'habit of existence' more sweet than it ever was."[5] Profound words from a man who suffered so much tragedy throughout his life.

Anton Bruckner (1824–1896)

Anton Bruckner may have been the oldest composition student the professional music world ever experienced. Bruckner displayed early talent as a singer, a violinist, and particularly as an organist, but it took him years to perfect his approach to composition. Like J. S. Bach before him, Bruckner was highly respected as a great improviser on the pipe organ, playing both for church services and in general public performances. Bruckner also worked for many years as a teacher, but he continued his personal studies in composition. After discovering the music of Richard Wagner, Bruckner found his "mature" writing style. His compositions reflect Wagner's influence, but they are not as heavy as the works of the operatic master. They also display a firmer grasp of finely honed skills in the areas of contrapuntal writing and orchestration. Bruckner followed typical sonata cycle formats, but he was innovative in both the depth of his thematic transformation and the overall scope of his works. All of his symphonies are an hour or more in length. His first mature compositions did not appear until after 1860, and, even then, Bruckner was frequently unsatisfied with his finished product. Many of his most important works, particularly his symphonies, underwent numerous revisions throughout the composer's lifetime. The existence of these multiple revisions does cause some confusion, but if you like large, powerful symphonic music, Bruckner's symphonies are worth the trouble to discover. There are nine "numbered" symphonies, composed between 1865 and 1896, plus an early work he dubbed "0" that is usually referred to as the *Naught.* There is also an even earlier symphony he completed in 1863, but it is rarely performed. Bruckner was a deeply religious man, and he composed many wonderful sacred choral works including three numbered masses (number two was written for an outdoor ceremony and uses a wind band accompaniment), a requiem mass, and various smaller works based on both liturgical and secular texts. Of particular note for this book, he created two different settings of the *Ave Maria* text (1861 and 1882), which drew inspiration from the contrapuntal writing techniques of the Renaissance master Palestrina.

Memorial sculpture of Jean Sibelius by Eila Hiltunen. This stainless steel monument is a major feature of an entire park dedicated to Sibelius in Helsinki, Finland.
© Shutterstock.com

Jean Sibelius (1865–1957)

Sibelius is Finland's most famous composer. A number of his works are nationalistic in nature including his most important tone poem, *Finlandia.* Words used to describe his music include "somber," "grand," "bold," and "sweeping." There are also those who suggest that even when he was not writing overtly nationalistic music, he still managed to invest in his music a sense of the countryside surrounding him.

Sibelius studied violin, an instrument on which he hoped to become a respected soloist. He began composing at a young age and eventually turned all of his attention in that direction. Sibelius's compositional style was inspired in part by the works of Tchaikovsky and, later, Bruckner. Sibelius's approach to thematic development was decidedly different, however, and became one of the most unique marks of his compositional style. He wrote seven symphonies between the years 1898 and 1924, each of which delved further into his exploration of declamatory orchestral statements built around a constant stream of thematic development. Historian Donald Jay Grout wrote the following: "Most original in Sibelius's music are his themes, his technique of thematic development, and his treatment of form. Instead of full periodic melodies, a theme may be built on short motives that first sound separately, then gradually coalesce into a complete entity. . . . Motives from one theme may be transferred to another, or themes may be dissolved and their motives recombined in such a way that the original theme is gradually transformed, its motivic units replaced one by one until a new structure results."[6] At times, Jean Sibelius also took an interesting approach to orchestration. He made unusual pairings of various woodwind and brass instruments, often mixing them with strings, though sometimes just with each other. He would also frequently double parts in unison or at the octave, giving the orchestra a thick and powerful texture (although some critics suggested this approach was overly simplistic). All of Sibelius's symphonies are still performed in concert, and there are several fine collected sets of recordings as well. His most popular symphonies are the second and the fifth, but most historians seem to agree that the sixth symphony is his true masterpiece. He titled his last (7th) symphony *Fantastica sinfonica,* and in this piece he did away with the traditional four-movement structure in favor of a more fluid single-movement composition that, nonetheless, still displays four distinct sections. It is also rumored that he composed an eighth symphony later in his life, but the manuscript was either lost or destroyed. Sibelius also composed a very popular violin concerto, a number of works for violin in chamber settings, and a popular string quartet.

Richard Strauss (1864–1949)

The music of Richard Strauss continues to be popular in symphony halls and opera houses everywhere. Like Mahler, Strauss was a respected conductor of both symphonic works and operas, but the two differed in compositional approaches. While Mahler used loose programmatic ideas to organize many of his compositional thoughts, Strauss wrote a number of vivid programmatic tone poems and symphonies that tell specific musical stories or draw on deep philosophical points of view. Some of his most famous symphonic poems include *Tod und Verklärung* (Death and Transfiguration), *Also sprach Zarathustra* (So Spoke Zarathustra), *Till Eulenspiegels lustige Streiche* (Till Eulenspiegel's Merry Pranks), *Don Quixote, Don Juan, Ein Heldenleben* (A Hero's Life, which he wrote about himself in response to music critics), *Sinfonia domestica,* and *Eine Alpensinfonie.* Perhaps Strauss's most famous musical gesture is the opening sequence from *Also sprach Zarathustra,* which was used in the opening of the film *2001: A Space Odyssey.* The work itself is not as well known, but that opening has been used or parodied by everyone from comedians to cartoon characters to political figures (not really that much difference sometimes when you think about it). This symphonic poem was based on a prose-poem by philosopher Friedrich Nietzsche and is somewhat "moody" when compared to most of Strauss's other symphonic poems.

Richard Strauss.
Source: Jupiterimages, Corp.

Till Eulenspiegel remains Strauss's most popular and easily accessible program piece. The work tells a humorous story in the manner of a children's folk tale. The opening notes imply "once upon a time . . ." and are quickly followed by a rousing tune on the horn that represents our main character, the impish Till Eulenspiegel. His antics are followed with great comic effect throughout the piece. He puts on a priest's robes, and the music takes on a mock-sacred character; he makes daring escapes, and we hear descending glissandos in the violins; and, elsewhere in the work, he looks for love, pokes fun at academia, and is eventually brought before a judge and sentenced to death. Similar to the fourth movement of Berlioz's *Symphonie fantastique*, you can actually hear the main character's sentence being carried out, complete with the final twitches of his dangling feet. Unlike Berlioz's work, however, the scene is played to comic effect. Strauss reminds us that this is only a folk tale and hints that *Till* can never really die.

Beyond symphonic poems, Strauss wrote several other popular instrumental works that are still frequently heard in performance. Strauss's father was a professional horn player, and, early in his life as a composer, Richard Strauss wrote a major concerto for horn and orchestra. Toward the end of his career, he followed with a second, smaller horn concerto that embraces the Neo-Classical style. (The horn section also plays a prominent role in most of Strauss's symphonic works.) There is also an early concerto for violin, an oboe concerto, and a number of instrumental chamber works, some of which were composed for winds only.

Strauss's success as an opera composer spanned almost 40 years, and his works are mainstays of operatic repertory. His first major success came in 1905 with *Salome,* which he based on a controversial play by Oscar Wilde. He followed up with the dissonant *Elektra*, which is a chilling story of insanity and revenge based on a play by Sophocles. *The Complete Idiot's Guide to Classical Music* has the following to say about Strauss's early operas:

> . . . Next came *Salome,* after the Oscar Wilde play, with such a shocking plot and such sensual music, including the stripteasing "Dance of the Seven Veils," that the Viennese censors banned it altogether. Even the presumably less prudish and more enlightened Metropolitan Opera [New York] bowed to a storm of protests and removed it after only two performances. . . . The critic in *The New York Times* referred to the "moral stench with which *Salome* fills the nostrils of humanity"; a letter to *The New York Times* called it "a detailed and explicit exposition of the most unmentionable features of degeneracy that I have ever heard, read of, or imagined"; and a minister preached a sermon to his Boston congregation railing against this "degrading, loathsome opera whose theme cannot be discussed in mixed audience." Needless to say, *Salome* turned into a tremendous hit. . . . Still on a roll in terms of offending genteel sensibilities, Strauss next turned to the cheery subject of matricide with *Elektra* in 1909. The critics had had three years to recuperate from *Salome*, but they were still shocked by the vivid musical portrayal of a sensational subject ("a prodigious orgy," was the verdict of the critic at *The New York Times,* guaranteeing yet another sold out house).[7]

In 1911, Strauss toned things down a bit with his satiric *Der Rosenkavalier* (The Knight of the Rose). Set in eighteenth-century Vienna, the intense chromaticism and orchestral power of his earlier works is softened here, placing an increased emphasis on lyrical singing. The work features beautiful arias, duets, and trios, including a very famous trio found at the end of act three. This opera features a

The Peacock Skirt (1894), an illustration by Aubrey Beardsley for Oscar Wilde's Salome.
© Shutterstock.com

"pants" role, meaning a woman playing a male character. Strauss uses three soaring female voices to convey powerful emotions on themes of love, guilt, and resignation to fate. Critics and fans alike were immediately drawn to *Der Rosenkavalier*, and it remains Strauss's most popular opera. Some of his other important operas include *Ariadne auf Naxos, Die Frau ohne Schatten* (The Woman Without a Shadow), *Intermezzo, Arabella, Die schweigsame Frau* (The Silent Woman), and *Capriccio*. Strauss's later operas, like his instrumental works, are more reserved in nature. These compositions made a return to smaller orchestral forces and clearer formal structures reminiscent of the Classical era. *The Oxford Dictionary of Music* refers to these later works as "a curious but satisfying blend of eighteenth-century elegance and Wagnerian richness."[8] At the end of his life, Strauss composed a song-cycle for soprano and orchestra titled *Vier letzte Lieder* (Four Last Songs), which is considered one of the finest compositions ever written for the combined forces of voice and orchestra. It is a work of profound beauty.

Sergei Rachmaninov (1873-1943)

After Tchaikovsky, Rachmaninov has one of the most frequently abused names in all of Classical music. In the CD bin of any decent record store you will see labels using some of the following versions of the man's name: Sergey Rakhmaninov, Sergei Rachmaninoff, or Serge Rachmaninoff. They are all the same guy. Rachmaninov is perhaps best remembered today for his piano concertos and the *Rhapsody on a Theme of Paganini* (also for piano and orchestra), all of which are considered masterpieces and remain quite popular in the concert hall today. He was an accomplished pianist, and in addition to the large works for piano and orchestra, he also composed a number of smaller works for that instrument. The rest of his compositional output is considered less important, but in many ways, as Mahler was the end of the line for Germanic Romanticism, Rachmaninov's music marks the end of the true Romantic spirit in Russia. Unlike some of his more nationalistic counterparts, however, his music is more universal in nature, but he did make use of Russian liturgical music from time to time. He composed three operas, three symphonies (the second is particularly good), several symphonic poems/concert overtures, various chamber pieces, and some excellent choral works.

The Great Vespers of the Russian Church op. 37/1

Rachmaninov's choral works are frequently overlooked, but, as you can hear from this brief excerpt, they are astoundingly beautiful music. *Vespers*, or *All-Night Vigil*, was a tradition of the early church. The overnight service of prayer and reflection was held before the main feast days of the church. This new composition was based on the old traditions of Russian liturgical chant. Although the Russian service movements differ somewhat from the standard mass movements we have studied, the concept of Proper and Ordinary sections remains. As with most of the other masses we have studied, this work presents new music for the Ordinary sections only. Without getting too deeply into the concepts of music theory, Russian music makes use of slightly different harmonic schemes, and these are clearly represented here. When you watch an adventure movie such as *The Hunt for Red October*, how do you know when the Russian sub is about to come into view? Put simply, the music "sounds" Russian. Well, it sounds Russian because of these slightly "non-Western" harmonic structures. Just listen. The music will tell you everything you need to know. The following movement, *Ave Maria*, is sometimes performed independently of the larger work, and it has also been transcribed for performance by various instrumental ensembles.

Listening Guide

The Great Vespers of the Russian Church op. 37/1
 ### *Ave Maria*
Sergei Rachmaninov (1873-1943)

Format: A cappella choral work

Performance: Johannes-Damascenus-Choir, Karl Linke, conductor; The Choir of the Russikum, Ludwig Pichler, conductor

Recording: *Sergei Rachmaninov: The Great Vespers of the Russian Church op. 37/1* (Christophorus entrée CHE 0090-2)

Performance Notes: Recorded in Essen, Germany in 1967.

:00 There is no real need for a detailed listening guide here. The work is a short, through-composed piece of glorious vocal perfection. Put another way, it's really quite nice. Just listen and enjoy.

Edward Elgar (1857~1934)
Gustav Holst (1874~1934)

Both of these British composers wrote a number of excellent works that are frequently overlooked by the general concert-going public, and for the most part, they must be overlooked in this brief text as well. The following two composers are included here, however, because each has at least one specific work that you really should know about, and, in both cases, their compositional output fits quite neatly under the "Post-Romantic" heading.

Edward Elgar wrote *Pomp and Circumstance*, which everybody knows as the tune almost every school in America uses for graduation. Actually, there are five *Pomp and Circumstance* marches, and the theme we all know is but a brief portion of one of them. Elgar is also remembered for a piece titled *Enigma Variations*, which musicians (at least brass players) seem to have a great deal of fun mispronouncing whenever the work is programmed on a symphony concert. For a new listening adventure, investigate his Concerto for Cello and Orchestra in e minor, Op. 85.

In the symphonic world, Gustav Holst is remembered for one major work, a programmatic suite titled *The Planets*. Listen to this piece, and then watch the movie *Star Wars*. You will quickly begin to figure out where noted film composer John Williams drew some of his inspiration for the soundtrack. Beyond the symphony orchestra, Holst is revered as one of the most important early twentieth-century composers for wind band. His Suite No. 1 in E-Flat, Suite No. 2 in F, and *Hammersmith* are still performed by high school, college, and professional wind ensembles everywhere. Holst also composed a number of excellent vocal works, both large and small.

DIG DEEPER

MOVIES

Elgar (by Ken Russell); *Brassed Off!* (This film does not deal directly with Elgar or Holst, but it is a great example of life in a British brass band.)

Sir Edward Elgar.
Source: © 2009 Jupiterimages, Corp.

Endnotes

1. Leonard Bernstein, "Mahler: His Time Has Come," *High Fidelity,* September, 1967, in *Words on Music*, ed. Jack Sullivan (Athens, OH: Ohio University Press, 1990), 269-270.

2. David Pogue and Scott Speck, *Classical Music for Dummies* (Foster City, CA: IDG Books Worldwide, 1997), 78.

3. Stéphane Mallarmé, quoted in *Claude Debussy/CPO & Serge Baldo,* Czech Philarmonic Orchestra, compact disc liner notes, Supraphon Archiv SU 3478-2 011.

4. Pogue and Speck, *Classical Music for Dummies,* 60.

5. Joseph Machlis and Kristine Forney, *The Enjoyment of Music,* 7th ed. (New York: W. W. Norton, 1995), 430.

6. Donald Jay Grout and Claude V. Palisca, *A History of Western Music*, 6th ed. (New York: W. W. Norton, 2001), 656.

7. Robert Sherman and Philip Seldon, *The Complete Idiot's Guide to Classical Music* (New York: Alpha Books, 1997), 209.

8. Michael Kennedy, ed., "Richard Strauss," *The Concise Oxford Dictionary of Music* (Oxford: Oxford University Press, 1985), 628.

Study Guide

Chapter 7 Review Questions

True or False

___ 1. Debussy's first composition to bring him any major attention was the tone poem *Prélude à l'après-midi d'un faune*.

___ 2. Edward Elgar wrote *Pomp and Circumstance*.

___ 3. Gustav Holst wrote *Pomp and Circumstance*.

___ 4. Strauss's tone poem *Also sprach Zarathustra* was used in the movie *2001: A Space Odyssey*.

___ 5. Anton Bruckner is Finland's most famous composer.

___ 6. Mahler was a brilliant conductor, as well as a master composer.

___ 7. Composers Leoncavallo and Mascagni are best remembered as composers of *Verismo* opera.

___ 8. Bruckner actually has a Symphony No. 0.

___ 9. The compositions of Mahler can be viewed as a bridge into the twentieth century.

___10. Jean Sibelius studied the violin, an instrument on which he hoped to become a respected soloist.

___11. Anton Bruckner played the pipe organ.

___12. *Tod und Verklärung* remains Strauss's most popular and easily accessible program piece.

Multiple Choice

13. Debussy's *Prélude à l'après-midi d'un faune* was based on a poem by:
 a. Walt Whitman.
 b. Edgar Allan Poe.
 c. Stéphane Mallarmé.
 d. Stéphane Degas.

14. Opera style with a more realistic approach to plot and character development.
 a. Opera buffa
 b. Nationalism
 c. Verismo
 d. none of the above

15. Famous song cycle for voice and orchestra by Gustav Mahler.
 a. *Ariadne auf Naxos*
 b. *Symphony No. 1 (Titan)*
 c. *Till Eulenspiegel*
 d. all of the above
 e. none of the above

16. Considered by many to be the last of the great Russian Romantic/Post-Romantic composers.
 a. Tchaikovsky
 b. Rachmaninov
 c. Elgarovsky
 d. Stravinsky

17. Gustav Mahler conducted:
 a. The Royal Opera in Budapest.
 b. The Vienna State Opera.
 c. The Metropolitan Opera in New York.
 d. all of the above.
 e. none of the above.

Fill in the Blank

18. In the symphonic world, Gustav Holst is remembered for one major work, a programmatic suite titled _____.

19. Strauss's first success as an opera composer came with *Salome*, which was based on a controversial play by _____.

20. The one-act verismo operas _____ and _____ are frequently performed together in one evening.

21. _____ is revered as one of the most important early twentieth-century composers for wind band.

22. At the end of his life, Strauss composed a song-cycle for soprano and orchestra titled

_____.

Short Answer

23. List three important operas by Giacomo Puccini.

24. List three important tone poems by Richard Strauss.

25. List four important compositions by Gustav Mahler.

Essay Questions

1. Discuss the compositions of Gustav Mahler. Consider their impact on later twentieth-century composers.

2. Describe some of the major compositional developments of Debussy.

Chapter 8

Modern Music, 1900~1950

"There are only twelve tones. You must treat them carefully."

Paul Hindemith

The twentieth century brought a number of new musical innovations to the art of composition and performance. Some of these diverse new elements included a heightened sense of dissonance, complex new rhythmic elements, the use of polytonality, early experimentation with electronic instruments, the introduction of random chance elements, and an entirely new system of musical organization. This was a time when some composers exercised total control over all the parameters of music, whereas others allowed performers (and in some cases even the audience) to make decisions that would affect the outcome of a composition's performance. In fact, this was a time of intense experimentation in all of the arts. Unlike previous generations, where developments in music followed far behind other major artistic and literary movements, in the twentieth century music was often right on the cutting edge. The twentieth century is sometimes referred to as the era of "isms." A few important early twentieth-century artistic movements include Primitivism, Dadaism, Expressionism, Formalism, Neo-Classicism, and Nationalism, which was a holdover from the nineteenth century (though the musical styles continue to evolve). More recent developments (which we will examine fully in Chapter 9)

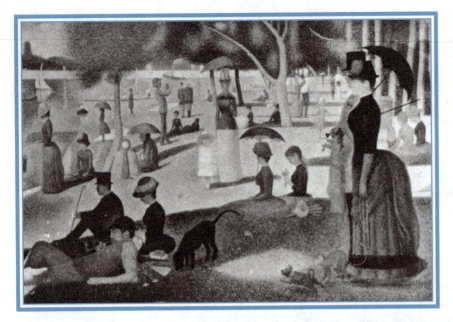

Sunday Afternoon on the Island of La Grande Jatte *by Georges Seurat.* **Source:** Jupiterimages, Corp.

include Abstract Expressionism, Post-Modernism, Minimalism, Post-Minimalism, Neo-Romanticism, and Eclecticism. There are also a few "non-isms" that are important to know about. In the art world there is pop art, and in music there is aleatoric, or chance music (also known as indeterminacy), and an early approach to electronic music called *Musique concrète*. Music critic Alan Rich offered the following view regarding the arts at the dawn of the twentieth century:

No time in recorded history could match the euphoria, the eager curiosity about the future that gripped the Western world right around 1900. The previous two decades had given the world the telephone, the light bulb, the phonograph, the automobile and, in 1903, the airplane; these were not merely improvements on things already in existence (as the compact disc might seem an improvement on the 78-rpm shellac disc, or the Concorde on the DC-3); they added up to an explosive expansion beyond what had previously been assumed the limits of human possibility. All the arts seemed to draw new energy from the spirit of innovation in the land; in the decade and a half from 1900 to the outbreak of the First World War, the air crackled with the shock of the new.[1]

As we begin our exploration of the last 100 years or so of classical music, there are a few things to keep in mind. More than any other time in music history, composers were very quick to make dramatic stylistic changes in their music. It is impossible to tie most modern composers down to one or even two specific styles. As you read above, this was a time of great experimentation, and many composers found themselves on an ever-evolving quest to find the most expressive new mode of composition. Also, perhaps more than ever before, a number of composers were willing to place the desires and the opinions of the audience a distant second to their own desire to create works that were completely unique. Consequently, composers wrote a lot of new music that, even by today's standards, is considered inaccessible to the typical concert audience. Translated, the previous sentence means that a lot of composers wrote harsh sounding, unpleasantly dissonant works and really didn't care much if the audience understood or not. In fact, at times it was almost as if they were daring the audience to "try and get it." Finally, history has not given us nearly as much time to break down the "best of the best" from these numerous recent artistic developments. It is easy to look back over 200 years and know that Bach was a musical genius whose works revolutionized the world of music. It is far more difficult to make that kind of absolute distinction about contemporary trends. You will meet more composers and examine diverse artistic styles in Chapters 8 and 9, but you may also find a few popular names missing. The goal of this text is to give a basic working overview of the entire world of classical music, and some successful composers who continued writing in older musical languages must sadly be omitted.

Igor Stravinsky (1882~1971)

Historians frequently mention Russian composer Igor Stravinsky as the most influential composer of the twentieth century. In recent years, some scholars are beginning to point to Béla Bartók as being just as important, but that is an argument not easily settled in a textbook of this nature. Stravinsky's music, and especially his first three ballets written for the *Ballets Russes* (Russian Ballet) in Paris, had a very definite effect on every composer who came in contact with the music. Some were inspired by its many technical innovations; others were repulsed and basically called for Stravinsky's head on a platter. Stravinsky's early success in Paris led to a long career as an internationally acclaimed figure in the world of classical music. Over the course of his life in music he traveled frequently, playing piano, conducting, and composing new works (mostly on commission). When he was not on the road, he lived in Paris, Switzerland (during World War One), and, from the outbreak of World War Two until the end of his life, in America.

Claude Debussy (standing) and Igor Stravinsky photographed in Paris in 1911.
Source: © Bettmann/Getty Images

Stravinsky's father was one of the principal bass singers in the Russian Imperial Opera house, so music came very naturally to him. He had some training in the musical arts during his childhood, but as a young man he entered the University of St. Petersburg to study law. While in law school he came in contact with the Russian Romantic Nationalist composer Nicolai Rimsky-Korsakov. Stravinsky shared some of his early attempts at composition with the old master and eventually spent three years studying composition and orchestration techniques with Rimsky-Korsakov. In 1908, Stravinsky composed a festive little orchestral work titled *Fireworks,* which he wrote to celebrate the marriage of Rimsky-Korsakov's daughter. The impresario Serge Diaghilev, who had recently founded the *Ballets Russes,* heard the piece and commissioned Stravinsky to write some orchestrations of piano works by Chopin for use in a new ballet.

Not long after, Diaghilev also commissioned a new original score from Stravinsky, *The Firebird*. With its premiere in Paris in 1910, Stravinsky became an overnight sensation. The score was full of interesting rhythmic complexities and bold harmonic gestures. Stravinsky followed this first triumph with a second ballet based on a Russian version of the Pierrot tale (which is kind of an adult version of Pinocchio, but not really) titled *Petrouschka*. The dissonance in this work is even more striking to the ear. At times, Stravinsky writes for different parts of the orchestra in totally different key centers, and he also superimposes completely different rhythmic patterns on top of one

A Russian Ballet costume created for Stravinsky's The Firebird.
Source: © 2009 Jupiterimages, Corp.

another. In spite of its groundbreaking new musical challenges, this ballet was also a major success. Then, in 1913, Stravinsky unleashed *Le Sacre du Printemps* (The Rite of Spring), which he subtitled "Scenes From Pagan Russia." In this new score, Stravinsky continued to increase his use of extreme dissonances and complex rhythms. The difference with *Rite,* however, is that he added a new sense of primitive rhythmic intensity, which, when coupled with the erotic intensity of the dance, caused a firestorm of controversy at the premiere. The first performance of *The Rite of Spring* has become the stuff of legend, so much so it is sometimes difficult to separate fact from fiction. It is said that almost as soon as the ballet started, certain audience members began yelling in protest. As the work progressed, men began to argue, even to the point of challenging each other to duels; women fainted, and, in general, all heck broke loose. There is even a story that Diaghilev, Stravinsky, and the conductor, Pierre Monteux, were forced to flee from the enraged crowd. It is said that they made their escape through a backstage window, and, in the process, Monteux, who was a man of some girth, actually got stuck in the window. (And you thought classical music was boring!) In retrospect, the score to *The Rite of Spring* has become one of the most respected compositions of the twentieth century, but at the time of its first performance, the ballet was the hottest topic in the world of music. There were some enlightened audience members, including Debussy and Ravel, who immediately acclaimed the work as genius. Others, however, were not convinced.

After seeing a performance of *Le Sacre du Printemps,* composer Giacomo Puccini wrote the following in a letter to a friend: "I went to hear the *Sacre du Printemps*: the choreography is ridiculous, the music sheer cacophony. There is some originality, however, and a certain amount of talent. But taken altogether, it might be the creation of a madman. The public hissed, laughed, and—applauded."[2] Russian composer César Cui seemed to share the same feelings, though he does make some acknowledgement of musical progress when he wrote:

> Recently Sergei Koussevitzky has performed Stravinsky's *Rite of Spring*, which has broken all records for cacophony and hideousness. It is a treasure chest in which Stravinsky has lovingly collected all sorts of musical filth and refuse. In French I would put it that "M-r Stravinsky est un vendangeur musical." [Mr. Stravinsky is a musical wrecker.] This "Rite" has been booed everywhere abroad, but among us it found some applauders—proof that we are ahead of Europe on the path of musical progress."[3]

In 1924, a poem appeared in the *Boston Herald* after the work was performed in concert. Like many others of the day, the unnamed poet, who was apparently a season ticket holder of the Boston Symphony, was not a fan of Mr. Stravinsky and his modern music. Several modern composers, including Henry Cowell, have subsequently set the poem to music.

> Who wrote this fiendish "Rite of Spring,"
> What right had he to write the thing,
> Against our helpless ears to fling
> Its crash, clash, cling, clang, bing, bang, bing?

> And then to call it "Rite of Spring."
> The season when on joyous wing
> The birds melodious carols sing
> And harmony's in everything!

> He who could write the "Rite of Spring"
> If I be right, by right should swing![4]

Le Sacre du Printemps (The Rite of Spring)

This ballet offers a vivid portrayal of a pagan ritual human sacrifice. The plot line follows the abduction of a young girl who is eventually forced to literally dance herself to death. Along the way, the audience is treated to various dances that celebrate the return of spring and help set the scene for the final *Sacrificial Dance*. The music is rhythmically and harmonically complex. Stravinsky asks various parts of the orchestra to play music in two or more different key centers at the same time, a technique called *polytonality*. He keeps changing the basic beat of the work, writing complicated mixed-meter passages with seemingly random beat groupings of 3, 2, 5, 7, 5, 3, and so on. This heightened complexity helps Stravinsky create a frantic, primitive mood that still has people talking every time the work is programmed. The ballet is presented in two large sections titled *The Adoration of the Earth* and *The Sacrifice*. The individual dances are titled:

First Part: The Adoration of the Earth	**Second Part: The Sacrifice**
Introduction	Introduction
Harbingers of Spring	Mystical Circles of the Adolescents
Dance of the Adolescents	Glorification of the Chosen One
Dance of Abduction	Evocation of the Ancestors
Spring Rounds	Ritual Performance of the Ancestors
Games of the Rival Tribes	Sacrificial Dance
Procession of the Sage	
Dance of the Earth	
Adoration of the Earth	

The Rite of Spring has arguably been the most influential composition of the past 100 years. It is difficult to overestimate the importance of this work. The harmonic and rhythmic complexity used here had a tremendous impact on subsequent works created by composers the world over. In addition, Stravinsky asks for virtuoso performances from every player of the orchestra. Almost every wind instrument has complex solo moments at some point in the work, and the string parts are extremely difficult as well. Put simply, Stravinsky's two previous ballets were warning shots. This work represents a whole new musical day. While there were many musical "firsts" during the early years of the twentieth century, a great deal of historical scholarship seems to split the fledgling history of modern music as pre- and post-*Rite*.

Stravinsky later spoke about how he first conceived of this ground-breaking work: "As I was writing the last page of the Firebird in St. Petersburg, I had a vision—quite unexpected as I was preoccupied with quite different matters—of a pagan feast: old wise men sitting in a circle watching a young girl's dance of death; she is to be sacrificed to propitiate the god of spring."[5] Stravinsky actually started writing this entire ballet knowing exactly how it would end. In a way, the entire work is one big, dramatic build-up to the final sacrificial dance. Regarding the final scene, musicologist Per Skans once wrote:

> In his old age Stravinsky made a very revealing comment on the final dance in the Rite of Spring. "I knew how to play it, but not how to write it."—With these words he effectively put an end to all theories suggesting that the Rite of Spring was a result of refined intellectual speculation. We now know instead that this music is a synthesis of technical mastery and the musical fantasy of a great genius, a fantasy that he first converted into notes and subsequently wrote down on paper.[6]

Today, it is much more common to hear this work in a concert setting rather than seeing a performance of the actual ballet. In fact, Stravinsky made numerous revisions to the work over the years in an attempt to make it more "performance friendly" in the concert setting.

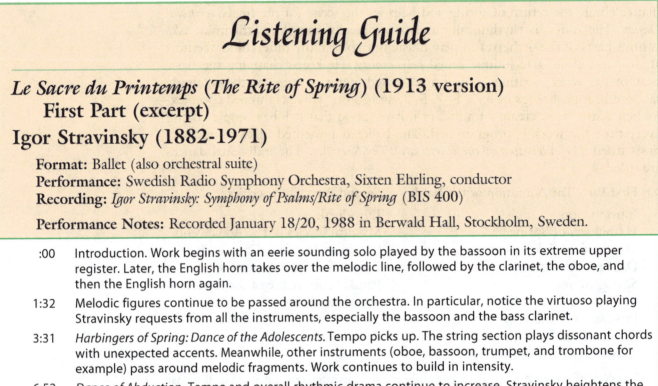

Listening Guide

Le Sacre du Printemps (The Rite of Spring) (1913 version)
First Part (excerpt)
Igor Stravinsky (1882-1971)

Format: Ballet (also orchestral suite)
Performance: Swedish Radio Symphony Orchestra, Sixten Ehrling, conductor
Recording: *Igor Stravinsky: Symphony of Psalms/Rite of Spring* (BIS 400)

Performance Notes: Recorded January 18/20, 1988 in Berwald Hall, Stockholm, Sweden.

:00 Introduction. Work begins with an eerie sounding solo played by the bassoon in its extreme upper register. Later, the English horn takes over the melodic line, followed by the clarinet, the oboe, and then the English horn again.

1:32 Melodic figures continue to be passed around the orchestra. In particular, notice the virtuoso playing Stravinsky requests from all the instruments, especially the bassoon and the bass clarinet.

3:31 *Harbingers of Spring: Dance of the Adolescents.* Tempo picks up. The string section plays dissonant chords with unexpected accents. Meanwhile, other instruments (oboe, bassoon, trumpet, and trombone for example) pass around melodic fragments. Work continues to build in intensity.

6:52 *Dance of Abduction.* Tempo and overall rhythmic drama continue to increase. Stravinsky heightens the musical complexity by writing extremely difficult, asymmetrical rhythms.

When World War One broke out, Stravinsky moved his family to the neutral country of Switzerland. For a while, he continued to write works with some nationalistic Russian tendencies but for reduced forces. He finished *Les noces* (The Wedding) in 1917 and *Mavra* in 1922. *Mavra* is a one-act opera that relies on a small orchestra dominated by wind instruments. *Les noces* is a ballet in four scenes that uses four vocal soloists, a four-part chorus, four pianos, and percussion.[7] Works of this type were

Neo-Classical

starting to be labeled **Neo-Classical**, a general term that could refer to the reduced size and/or instrumental make-up of a chosen ensemble, a return to the use of simpler formal structures, consciously altered melodic and/or harmonic concepts, or any combination of the above elements. Another important work from this time period and in this new style is *L'histoire du soldat* (The Soldier's Tale), which Stravinsky said was to be "read, played, and danced." There are several different versions of this work that require between three and twelve performers, depending on the version. The most common version of this clever little theatre piece calls for three actors, one dancer, and a mixed chamber ensemble of seven instrumentalists. The ensemble is particularly unique, as the score calls for violin, string bass, clarinet, bassoon, trumpet, trombone, and a variety of percussion instruments.

After the war ended, Stravinsky made his way back to Paris, which he would call home until 1939. The composer renewed his relationship with Diaghilev for the creation of the ballet *Pulcinella*, the music of which is also very popular on chamber orchestra concerts in the form of a suite. Stravinsky also began to perform

as a solo pianist in an effort to make more money, and he composed a series of new works for his own use. All of these works are more-or-less in the Neo-Classical style, and they include the Concerto for Piano and Wind Instruments, Capriccio for Piano and Orchestra, and the Concerto for Two Solo Pianos, which the composer performed with his son, Soulima. With the growing Nazi threat looming over much of Europe, Stravinsky relocated to America on the eve of World War Two. He became a naturalized citizen in 1945 and called America his home for the rest of his life.

Unlike some composers, Stravinsky was never content to keep writing works in exactly the same style, and thus the catchall term of Neo-Classical applies to varying degrees depending on the composition. *Dumbarton Oaks Concerto*, Symphony in C, and Symphony in Three Movements are accessible to most any audience, but some listeners find more dissonant compositions such as the opera-oratorio *Oedipus Rex* and the choral work *Symphony of Psalms* more challenging. His last important work in what is considered the Neo-Classical style is an opera titled *The Rake's Progress*, which he completed in 1951. The work is written to a libretto by W. H. Auden and Chester Kallman, inspired by a series of satirical engravings done by eighteenth-century English artist William Hogarth.

As you will learn in the upcoming section about Arnold Schoenberg and his music, a completely different system of musical organization called serialism, or 12-tone music, was beginning to take hold in the early twentieth century. Based on mathematical formulas, with a complete disregard for the old ideas of consonance and dissonance, this new style was even more radical in some ways than Stravinsky's *Rite of Spring*. Stravinsky rejected the new methods at first, but as early as the 1920s he was already making some tentative experiments with the new style. In America, Stravinsky began a long association with music historian Robert Craft, who had a deep interest in 12-tone composition. Their association led Stravinsky into a deeper exploration of this challenging new style, but Stravinsky was not always as strict with his treatment of serial techniques as composers you will meet in some of the following sections of this chapter. Works from this last period of Stravinsky's life include *Agon, In Memoriam Dylan Thomas* (which is based on a five note tone row), and the choral work *Threni: Lamentations of the Prophet Jeremiah*.

Works similar to this one by 18th-century artist William Hogarth inspired Stravinsky to compose The Rake's Progress.
Source: Jupiterimages, Corp.

Béla Bartók (1881-1945)

Hungarian pianist and composer Béla Bartók raised the concept of national-ism in music to a new level. Born in an era when Hungarian nationalist pride was on the rise throughout the country, Bartók spent a great deal of his career devoted to collecting and preserving the music of his homeland. Bartók first studied piano with his mother and later entered the Budapest Academy of Music, where he trained for a career as a classical pianist. While still at the Academy, Bartók began to realize that most of the nationalistic music being passed off as "Hungarian" was actually drawn from the minority gypsy culture and not the predominant Magyars. Beginning in 1905, Bartók set out through the countryside with fellow composer and music educator Zoltán Kodály, recording and cataloging a wealth of folk songs. Bartók was inspired to delve more deeply into the world of composition after hearing the music of Richard Strauss, among others. One of his first major works was a nationalistic tone poem titled *Kossuth,* which was written to honor political activist Lajos Kossuth. In the years that followed, Bartók divided his time between an active life as a concert pianist, a composer, a teacher, and a budding ethnomusicologist.

A number of Bartók's compositions were written to feature the piano, whether as a soloist, a member of a chamber ensemble, or functioning as a member of the percussion section in orchestral and chamber music works. Some of his most famous compositions that feature the piano include three solo concertos, as well as the *Music for Strings, Percussion, and Celesta*; *Sonata for Two Pianos and Percussion; Contrasts for Violin, Clarinet, and Piano;* and a number of smaller works for solo piano. Between 1926 and 1939 Bartók composed an extended series of teaching pieces for piano titled *Mikrokosmos,* which goes from simple one- and two-line studies all the way to extremely difficult character pieces. The pieces that make up the *Mikrokosmos* are a compendium of all of the elements that make Bartók's music unique, including the use of polytonality, polyrhythms, random dissonance, non-traditional scale patterns, and elements of Hungarian folk music. Early in Bartók's career he composed three works for the stage that are still performed from time to time including a one-act opera, *Duke Bluebeard's Castle,* and two ballet scores, *The Wooden Prince* and *The Miraculous Mandarin.* Both of the ballet scores can also be heard in concert performances by symphony orchestras.

Spanning his entire career, Bartók wrote a series of six string quartets that are frequently compared to the masterful string quartets of Beethoven. Like the *Mikrokosmos,* these six quartets, written between 1908 and 1939, encompass all of the compositional techniques that help make Bartók's music so unique. Among other compositional developments, Bartók pioneered the use of a new formal structure in the twentieth century called *arch form.* A simplified explanation of **arch form** might be to think of a five- or seven-part rondo where the thematic order has been altered to form an arch, for example A-B-C-B-A or A-B-C-D-C-B-A. Bartók applied the arch concept not only to the thematic (and in some cases dynamic) material of individual movements but to the overall structure of multi-movement works as well. For example, in his most famous work, *Concerto for Orchestra,* the first and fifth movements are related in various ways to one another. The same is true with movements two and four, while movement three, presented at the center of the multi-movement structure, stands alone with all new material. In truth, Bartók was not the first composer to use this arch structure in composition, but his works are such masterful applications of the principle that they have become synonymous with the form.

arch form

During World War Two, Bartók was an outspoken opponent of fascism, even going so far as to protest performances of his music on German radio. In 1940, after his mother's death, Bartók finally left Hungary and immigrated to America. By this time, the composer was in poor health, suffering from a form of leukemia. Though Bartók was respected in America as a concert pianist, his compositions were not well known. Friends and admirers did what they could to help the financially strapped Bartók, in particular providing him with some commissions, including one by Boston Symphony Orchestra conductor Serge Koussevitsky that resulted in the creation of Bartók's ultimate masterpiece, the previously mentioned *Concerto for Orchestra*. Completed in 1943, *Concerto for Orchestra* is one of the finest symphonic compositions ever created. In fact, many consider it the greatest single composition of the entire twentieth century. The work demands virtuoso performances from every member of the orchestra, hence the title. Instead of one featured soloist as you would find in a normal concerto, here the orchestra members themselves are the featured soloists. As mentioned above, the work clearly displays all of the components that help make Bartók's music special, but, beyond the purely academic, this is simply a wonderful work to experience. Sadly, the composer passed away just two years after the premiere of this composition, but with it he secured his place among the most famous musical geniuses of all time.

Music for Strings, Percussion, and Celesta

Written in 1936, Bartók's *Music for Strings, Percussion, and Celesta* is considered a masterpiece of twentieth-century chamber music though you will most commonly see it programmed on a major symphony orchestra concert. The composition successfully blends complex formal structures and harmonies with elements of folk music. Bartók, known for his meticulously crafted scores and interesting manipulation of forms, created a work that is at once musically engaging and yet challenging for musicians and audiences alike. His creative use of percussion instruments, along with his percussive use of both the piano and the harp, add a wide array of new sounds to the tonal palate of his orchestra. His use of the celesta, a small keyboard instrument that produces bell-like tones, is also of particular interest in this work.

The first movement is a fugue, in which the composer not only carefully manipulates thematic material but dynamics as well. The movement starts extremely soft, builds to a crashing, loud climax at the middle, and returns to the super-soft *pianississimo* by the end. Movement two is a quick little sonata form that borrows some thematic ideas from the preceding movement. The third movement, sub-titled *Night Music,* is written in an arch form. The last movement is a seven-part rondo, but unlike a Classical rondo, Bartók uses four themes instead of three and takes a lot more liberties with how those themes are presented as the work goes along. In spite of Bartók's manipulation of the thematic material, the basic rondo formal structure remains intact and can be easily identified with a little careful listening. If you study the entire work, you may notice that this last movement also contains clever thematic references to melodies used in the previous three movements.

Listening Guide

Music for Strings, Percussion, and Celesta
Movement IV—Allegro molto
Béla Bartók (1881-1945)

Form: Modified seven-part rondo (A-B-A-C-B-D-A)

Performance: Bavarian Radio Symphony Orchestra, Leonard Bernstein, conductor

Recording: *Leonard Bernstein in Budapest* (Hungaroton Classic 12631)

Performance Notes: Recorded live at the Erkel Theatre, Budapest, November 15-16, 1983. American composer, pianist, and conductor Leonard Bernstein seems to have had a very special relationship with Budapest. In 1943, Bernstein became an "overnight" sensation by stepping in for Bruno Walter at the last minute to conduct the New York Philharmonic. Just a few years later, Bernstein conducted a series of very successful concerts in Hungary. He remembers:

One of my brightest musical memories is my visit to Budapest in 1948. I was totally unknown, and the auditorium at the Academy was half-full. But because our concert was being broadcast on the radio, people who heard the first piece over the air came flocking to the hall, so that when I reappeared on the stage for the second piece, the hall was full. And when I reappeared after the intermission for the last work, the hall was bursting its wall, and there was a large crowd outside screaming to come in. The climax was an impromptu musical gathering with numerous young people from the audience in my dressing room, during which I played for them, and talked about jazz and modern music. All this was topped by my being carried back to my hotel on their shoulders. This had never happened to me before, nor has it since.

Conductor and composer Leonard Bernstein.
Source: Library of Congress.

Although he did not return for many years after this triumph, Bernstein always longed to visit Budapest again. In 1983, just seven years before his death, he finally got the chance to return to Hungary. Composer Béla Bartók is Hungary's most famous composer, a man Bernstein actually met on two occasions; therefore, it was only appropriate that when he conducted a series of concerts in Budapest, Bartók's music was on the program. As mentioned above, this recording was made from a live performance, and there are a few minor flaws, particularly some crowd noise that can momentarily distract from the music. The jubilant immediacy of the performance, however, more than makes up for any sonic deficiencies in this recording.

:00	Letter A – Strings introduce a folk-like melody based on a recurring pattern of eight short notes grouped 2+3+3.
:27	Letter B – New thematic idea begins with a timpani solo, followed by a playful tune introduced by the piano. Notice how Bartók asks the pianist to play with strong accents that lends a more "percussive" quality to the instrument.
:45	Letter A' – The first theme returns with different accompaniment figures.
1:37	Letter C – As the tempo picks up, the strings introduce yet another "folk-like" theme.
2:41	Letter B' – The second theme returns but continues to build on the faster tempo introduced in letter C.
3:47	Letter D – This section functions like a little fugue. Bartok shows us a new melodic figure, then he inverts it (literally turns it upside down), and overlaps thematic entries (stretto) in various parts of the orchestra.
6:02	Letter A'' – The final statement of the letter A material presents the theme in its same rhythmic configuration, but the melodic content is inverted.

Serge Prokofiev (1891-1953)

Like Bartók, Prokofiev established himself as a successful concert pianist as well as an important composer. Over his numerous compositions, Prokofiev experimented with Neo-Classicism, Nationalism, and various twentieth-century compositional techniques. His music is frequently referred to as being "witty," some would even say "sarcastic." Even today, his prodigious compositional output continues to gain acceptance among the concert-going and record-buying public. Over his career, Prokofiev wrote eight operas, seven ballets, seven symphonies, five piano concertos, two violin concertos, seven major choral works, ten piano sonatas, and a wealth of other music for ensembles both large and small. By title, some of his most historically important works include *Romeo and Juliet* (both a ballet and an orchestral suite), Symphony No. 1 (*Classical*), Symphony No. 5, *Lieutenant Kijé, Peter and the Wolf* (children's tale for narrator and orchestra), Concerto No. 3 for Piano and Orchestra, and *Alexander Nevsky* (both a film score and a cantata). For the purposes of this text, this last work holds particular interest, as it represents an entirely new approach to composition in the twentieth century, music for film. Although Prokofiev only composed a few scores for use in films, a number of lesser-known but in many cases no less talented composers made a good living writing music for film.

Serge Prokofiev.
Source: © Popperphoto/ Getty Images

Alexander Nevsky, Op. 78

Alexander Nevsky was a thirteenth-century Russian duke who defended the motherland against several attacking armies. Prokofiev originally composed this music to be used as the soundtrack of a patriotic film about the life of Nevsky made in 1938, just before the outbreak of World War II. Of particular importance was Nevsky's victory over an invading German army on the frozen waters of Lake Peipus in 1242, hence the title of movement five, *The Battle on Ice*. Today, performing ensembles are mounting live performances of works like this one while scenes from the film are displayed in the hall. Prokofiev later reworked his music from the film and turned it into a seven-movement cantata for mezzo-soprano soloist, chorus, and orchestra. It is this version that is most commonly performed today and from which your next listening example is taken. Movement seven, *Alexander's Entry in Pskov,* depicts Nevsky and his men returning from their victory. This movement is an excellent example of musical nationalism in the twentieth century.

The individual movement titles are:

I. *Russia under the Mongolian Yoke*
II. *Song about Alexander Nevsky*
III. *The Crusaders in Pskov*
IV. *Arise, Ye Russian People*
V. *The Battle on Ice*
VI. *Field of the Dead*
VII. *Alexander's Entry in Pskov*

Listening Guide

Alexander Nevsky, Op. 78
 Movement VII—*Alexander's Entry in Pskov*
Serge Prokofiev (1891-1953)

Format: Cantata (also film music)
Performance: Czech Philharmonic Chorus and Orchestra, Karel Ančerl, conductor
Recording: *Prokofiev-Alexander Nevsky/Stravinsky-Le Sacre du Printemps* (Supraphon 11 1948-2 911)

Performance Notes: Recorded at the Dvořák Hall, Prague, January 30-February 2, 1962
 NOTE: Due to copyright restrictions, the full text of this selection and its English translation were unavailable for publication.

The Most Orthodox Prince Saint Alexander Nevsky.
Source: © 2009 Jupiterimages, Corp.

:00 Dramatic opening with full chorus and orchestra.

1:04 New material in a faster tempo, sung by women only.

1:33 Men's voices return to answer the female voices. Violins hint at "Mother Russia" theme, which will be sung in the next section.

1:42 Theme for Mother Russia (drawn from the fourth movement) is introduced in the lower choir voices. The English translation of the lyrics for this section includes the line "In our great native Russia no foe shall live!"

1:51 Orchestral interlude.

2:43 Mother Russia theme returns sung by the full choir.

3:07 Tempo slows for typical dramatic Russian ending. Russian composers have a flair for this kind of overtly emotional music, of which this is but one excellent example. The lyrics here contain patriotic statements such as "Celebrate and sing, native mother Russia!"

Dmitri Shostakovich.
Source: Library of Congress.

Dmitri Shostakovich (1906-1975)

Dmitri Shostakovich spent the bulk of his compositional life battling between trying to be an artist who served the needs of the Soviet state and being true to his own artistic vision. His early works were quite modernistic in nature, reflecting many of the new compositional trends of the twentieth century. Two early operas, *The Nose* and *Lady Macbeth of the Mtsensk District,* were both very innovative. During the 1930s, his music drew harsh criticism from the state, prompting the composer to withdraw his Symphony No. 4 in C Major before its premiere. (The work would not be performed in public until 1961.) An article titled "Chaos instead of Music" in the state newspaper, *Pravda,* referred to Shostakovich's music as "leftist distortion" and "petty bourgeois sensationalism."[8] It has even been suggested that Joseph Stalin played a direct role in the creation of the article. The official party line on music at this time in Soviet history was that music should be direct, not overly complicated, and instill in the people a sense of nationalistic pride. Shostakovich responded to his critics

with Symphony No. 5, which he subtitled "A soviet artist's practical creative reply to just criticism." The symphony was a success. For a time, Shostakovich was back in the good graces of the government, but it has been suggested that he included veiled jabs at the state. *From Classical Music for Dummies:*

> Shostakovich, however, had the last laugh. Despite the subtitle, the *music* was anything but a tribute to the creeps running the country. If you really listen to the piece, you hear musical metaphors that describe a totalitarian regime battering down the optimism of its people. Years later, in fact, the composer admitted that he had indeed intended a scathing condemnation of Stalin's regime: "I think it is clear to everyone what happens in the Fifth Symphony. You've got to be a complete oaf not to hear it. . . . The rejoicing is forced, created under a threat. It's as if someone were beating you with a stick and saying, 'Your business is rejoicing, your business is rejoicing.' You get up, stunned, saying, 'My business is rejoicing, my business is rejoicing. . . .'"[9]

During World War Two, Shostakovich composed his Symphony No. 7 (*Leningrad*), which was a direct reaction to Hitler's invasion of Russia. During the war years this work was popular not just in Russia but in England and America as well. After the war, Shostakovich again ran afoul of the Soviet government, even losing his position at the Moscow Conservatory for a time. After Stalin's death, state "rules" for music compositions were relaxed a bit, and Shostakovich again found favor with both the state and the general public. After 1969, the composer was in fragile health, but he continued to write masterful works (including his last symphonies and string quartets) right up until the time of his death in 1975.

Shostakovich's most important compositions are his 15 symphonies and 15 string quartets. His symphonies are a varied lot, including extended single-movement compositions, standard four-movement sonata cycle formats, and assorted works for voices and orchestra. The Fifth Symphony is perhaps his most popular today, but Nos. 1, 2, 7, 9, and 10 are all frequently performed as well. His other works, though less frequently performed, are all considered masterpieces of symphonic (and in some cases vocal) composition. Several of his string quartets have become regular parts of the standard repertory, and all of them are still performed from time to time. The composer also wrote two concertos each for piano, violin, and cello. A few other important compositions include *Festive Overture*, Piano Quintet in g minor, and 24 Preludes and Fugues for solo piano. Beyond these well-known compositions, there are over 100 other works, including a wealth of music for film, which are just beginning to see the light of day in the West. Hopefully, people will continue exploring Shostakovich's vast compositional output for years to come.

DIG DEEPER

MOVIE
Testimony: Tony Palmer's film about Shostakovich

Nevski Prospect in St. Petersburg (Leningrad), the city that inspired Shostakovich's Symphony No. 7. The street is named after Alexander Nevsky, who was the inspiration for the cantata of the same name by Prokofiev.
Source: Jupiterimages, Corp.

Chamber Symphony, Op. 110a
adapted from *String Quartet No. 8, Op. 110*

Shostakovich wrote the String Quartet No. 8, Op. 110 in 1960, after a visit to the city of Dresden, Germany. The work speaks to the many atrocities of war, inflicted upon both people and places. Prior to a blanket firebombing toward the end of World War II, Dresden was one of the most beautiful cities in all of Europe. By the time Shostakovich saw it after the war, the city had been rebuilt as a series of expressionless concrete blockhouses. He wrote a dedication on the score that reads "To the victims of fascism and war." He also placed a clever thematic device in the work by using the notes D, E-flat, C, and B, in that particular order. Translated into German those notes read D-Es-C-H, which means "German." The composer also made occasional use of this same thematic structure to represent the first few letters in both his first and last names. Several adaptations of the quartet have been made for chamber orchestra over the years, and Shostakovich eventually sanctioned the idea of playing the work with a larger group. Beyond string groups, other chamber ensembles, including the Boston Brass (a brass quintet), have also adapted the work for performance. That these translations work so successfully speaks to the integrity of Shostakovich's compositions.

Zwinger Palace in Dresden, Germany, before World War II. The sad transformation of that city after the war moved Shostakovich to compose his String Quartet No. 8, Op. 110.
© Shutterstock.com.

This quartet is composed in five movements that are designed to be performed without any pauses between one another. Your listening example extracts the second movement from the work. This is why the recording seems to begin so abruptly and also feels a bit incomplete at the end. Shostakovich wrote the conclusion for movement two with the clear implication that the music should immediately continue with movement three. Some would suggest that this second movement is through-composed, whereas others might argue for some sort of highly modified binary or ternary structure. Without careful score study, it is the modified two-part structure that seems to present itself most clearly to the ear. For the purposes of developing a clear listening guide, we will identify two major themes that we will call letter "A" and letter "B." Understand that there will be thematic overlap throughout this movement, and both themes will be undergoing thematic transformation all the way through this brief section of the work.

Listening Guide

Chamber Symphony, Op. 110a
Movement II—*Allegro molto*
Dmitri Shostakovich (1906-1975), adapted by Rudolf Barshay

Format: Symphony for String Orchestra (adapted from the *String Quartet No. 8,* Op. 110)
Performance: Stuttgart Chamber Orchestra, Dennis Russell Davies, conductor
Recording: *Rückblick Moderne: 20th Century Orchestral Music* (Col Legno WWE 8 CD 20041)

Performance Notes: This recording comes from an eight CD box-set that documents the *Rückblick Moderne* festival, which was a celebration of twentieth-century music that took place in Stuttgart, Germany in November 1998. The entire set is made up of live recordings from the concerts. If you have any interest in the music presented in Chapters 8 and 9, you will find something you like in this set. The performances are all of the highest caliber, and the recordings are of superior sound quality while still managing to capture the spontaneity of a live performance.

:00	Movement begins with letter A material.
1:17	Basic key center changes and a new, more lyrical melody appears (letter B).
2:23	First key center returns with a restatement of the letter A material in an altered format.
2:55	Key center changes again and movement comes to an abrupt close with a restatement of letter B material.

Paul Hindemith (1895-1963)

Paul Hindemith enjoyed a diverse life in the world of music. He was a successful performer on violin and viola, a noted teacher and music theorist, a successful author, a skillful conductor, and a brilliant composer in every classical genre. His voluminous output of compositions includes operas, symphonies, choral works, instrumental chamber works, and a large number of teaching pieces. Regarding his compositional style, it has been said that Hindemith "began as an *enfant terrible* and ended by being regarded by the *avant-garde* as an ultra-conservative."[10] Hindemith's early compositions were quite dissonant, and his operas contained scenes that were considered too overtly sexual for the German public. In later years, though his music was growing in public acceptance, Hindemith provoked the ire of the Nazi regime. Eventually, all public perfor-mances of his works were banned. Hindemith fled Germany and settled in America, where he took a teaching position at Yale University. Several years

Paul Hindemith at a press conference in Munich, 1957.
Source: © Erich Auerbach/ Hulton Archive/Getty Images

after the war ended, Hindemith returned to Europe, where he focused more of his attention on conducting though he continued to compose new works right to the end of his life. His mature compositional style is marked by a freely dissonant sense of tonality, a gift for intricate contrapuntal writing, and a somewhat veiled lyrical sensibility that is frequently overlooked in discussions of his music. A few of Hindemith's most popular compositions include *Mathis der Maler* (Mathis the Painter, a symphony based on themes drawn from his opera of the same name), *Nobilissima Visione* (Noblest Vision), and *Symphonic Metamorphosis of Themes by Carl Maria von Weber.* Compared to many other major twentieth-century composers, Hindemith was particularly generous in creating works for instruments that had been frequently overlooked. He wrote sonatas for a number of different instruments, including harp, English horn, trumpet, and tuba. In his instrumental compositions, Hindemith frequently looked beyond the conventional ensemble set-ups, composing works featuring large brass ensembles and unusual chamber ensembles of various string, wind, and percussion instruments. He also composed an important symphony for wind band, the Symphony in B-flat for Concert Band.

Symphony in B-flat for Concert Band

Building on the success of the Sousa and Goldman bands just after the turn of the century, the band movement in America became an integral part of the music education process. In addition, America had a long-standing tradition of excellent military bands (which was actually where John Philip Sousa got his start). Much of the literature played by these bands consisted of marches and orchestral transcriptions. There were few extended compositions of a serious nature composed specifically for wind band before the twentieth century. With the composition of this work, Hindemith did his part to set things right. This work was commissioned by the U. S. Army Band and was premiered in Washington D. C. in 1951 with the composer conducting. The work follows a typical three-movement sonata cycle format.

Your listening example features movement three of this excellent wind band composition. This last movement is an intricate twentieth-century fugue. While it draws on the Baroque traditions of the contrapuntal writings of J. S. Bach, among others, the format here is more complex, and the composer takes more liberties with the form. The following listening guide will attempt to point out the main features of Hindemith's fugue while avoiding too many complex terms and concepts. The bottom line when listening to a work such as this one is to familiarize yourself with the main theme of the movement and simply try to notice all the different ways the composer manipulates that theme throughout the movement.

Listening Guide

Symphony in B-flat for Concert Band
Movement III—*Fugue*
Paul Hindemith (1895-1963)

Format: Multi-movement work for winds and percussion
Performance: Bavarian Radio Symphony Orchestra, Paul Hindemith, conductor
Recording: *Hindemith: Symphonie in B, Die 4 Temperamente* (Orfeo D'or C197 891 B)

Performance Notes: This recording was made from a live radio broadcast on October 8, 1959 in Munich, Germany. Recordings of Hindemith conducting his own music are somewhat rare today (though several were released on vinyl), and to hear him conducting his masterpiece for wind band is even more unique. Hindemith offers us a glimpse of exactly how he wanted his work performed, and this group responds in fine fashion. This is a very special recording.

:00	Introduction. Hindemith opens the movement with a clear statement of the main subject, followed by some other lyrical introductory material.
:14	Exposition begins with a statement of the subject in the trumpet parts.
:22	Answer is stated in the horn and baritone parts.
:35	Final exposition of the subject is heard in the baritone and tuba parts.
:46	Link to the first episode.
:51	Episode begins. Portions of the main subject are passed back and forth between various woodwind and brass instruments.
1:13	Lyrical treatment of the subject in solo alto sax line.
1:25	Hindemith introduces a new lyrical theme derived from the original subject. This theme is passed around to various parts of the band and developed. Notice also a few clear hints of the original subject making brief appearances from time to time during this section.
2:56	Transition back to another statement of the original subject.
3:25	Clear statement of the subject in lower woodwind and horn parts. Work quickly builds to a final climax as the original subject and its more lyrical, altered version are joined together.
3:45	Climax continues to build as the trumpets and trombones introduce a theme borrowed from the first movement of the work. Other voices continue to build in intensity playing with thematic material from the third movement.

Charles Ives (1874–1954)

Charles Ives and his music do not fit neatly into any chronological discussion about the history of music. His music is so different from everything else that was happening around him, and in many cases so far ahead of its time, it is some-

times difficult to believe this guy was even on the same planet. Like so many other composers, Ives displayed an early gift for music. Trained by his father, who was a bandmaster and a talented musician, young Charles was performing in public and writing arrangements for his father's ensembles by the time he was in his early teens. Ives attended Yale University, where he studied composition with Horatio Parker. After completing his studies, Ives realized that the kind of music he wanted to write would never support him financially; therefore, he went into the insurance business instead. Within a few years, he was running one of the largest insurance firms in the country and became a wealthy man. Throughout his successful years in business, Ives was writing music in private, composing at night, on the

weekends, and during family vacations. The music he was writing was extremely dissonant and rhythmically complex, and much of it was full of odd little quotations of folk tunes and other bits of mostly American music. Joseph Machlis writes:

> The few conductors and performers whom he tried to interest in his compositions pronounced them unplayable. After a number of these rebuffs, Ives gave up showing his manuscripts. When he felt the need to hear how his music sounded, he hired a few musicians to run through a work. Except for these rare and quite inadequate performances, Ives heard his music only in his imagination. He pursued his path undeflected and alone, piling up one score after another in his barn in Connecticut. When well-meaning friends suggested that he try to write music that people would like, he could only retort, "I can't do it—I hear something else!"[11]

After a health scare in 1918, Ives cut back on his creation of new compositions. Instead, he began to promote his works quite actively. He paid to have his *Concord Sonata* for solo piano published, and he wrote a long companion text titled *Essays Before a Sonata* where he attempted to explain his artistic views. Next, he printed a large three-volume collection titled *114 Songs*, which he made available free of charge to libraries, musicians, and critics. These works did not immediately gain him a large public following, but they did open the door for a deeper inspection of his works. Finally, in 1947, his Third Symphony (*The Camp Meeting*) won the Pulitzer Prize for Music, over 35 years after the work was completed. To give you a better sense of the man and his music, the following is an excerpt from Ives's *Memos*, which are a collection of writings that attempted to answer people's questions about his music.

American composer Horatio Parker, who was Charles Ives's composition teacher at Yale University.
Source: Jupiterimages, Corp.

Dig Deeper

WEBSITE
www.charlesives.org

*M*emos by Charles Ives

Just one or two more things, and then these memoranda, I hope, are about over. Exception has been taken by some (in other words there have been criticisms, often severe) to my using, as bases for themes, suggestions of old hymns, occasional tunes of past generations, etc. As one routine-minded professor told me, "In music they should have no place. Imagine, in a symphony, hearing suggestions of street tunes like *Marching Through Georgia* or a Moody and Sankey hymn!"—etc. Well, I'll say two things here: (1) That nice professor of music is a musical lily-pad—he never took a chance at himself, or took one coming or going. (2) His opinion is based on something he'd probably never heard, seen, or experienced. He knows little of how these things sounded when they came "blam" off a real man's chest. It was the *way* this music was sung that made them big or little—and I had the chance of hearing them big. And it wasn't the music that did it, and it wasn't the words that did it, and it wasn't the sounds (whatever they were—transcendent, peculiar, bad, some beautifully unmusical)—but they were sung "like the rocks were grown." The singers weren't singers, but they knew what they were doing—it all came from something felt, way down and way up—a man's experience of men!

Once a nice young man (his musical sense having been limited by three years' intensive study at the Boston Conservatory) said to Father, "How can you stand it to hear old John Bell (the best stone-mason in town) sing?" (as he used to at Camp Meetings) Father said, "He is a supreme musician." The young man (nice and educated) was horrified—"Why, he sings off the key, the wrong notes and everything—and that horrible, raucous voice—and he bellows out and hits notes no one else does—it's awful!" Father said, "Watch him closely and reverently, look into his face and hear the music of the ages. Don't pay too much attention to the sounds—for if you do, you may miss the music. You won't get a wild, heroic ride to heaven on pretty little sounds."

Charles Ives.
Source: © Bettmann/Getty Images

I remember, when I was a boy—at the outdoor Camp Meeting services in Redding, all the farmers, their families and field hands, for miles around, would come afoot or in their farm wagons. I remember how the great waves of sound used to come through the trees—when things like *Beulah Land, Woodworth, Nearer My God To Thee, The Shining Shore, Nettleton, In the Sweet Bye and Bye* and the like were sung by thousands of "let out" souls. The music notes and words on paper were about as much like what they "were" (at those moments) as the monogram on a man's necktie may be like his face. Father, who led the singing, sometimes with his cornet or his voice, sometimes with both voice and arms, and sometimes in the quieter hymns with a French horn or violin, would always encourage the people to sing their own way. Most of them knew the words and music (theirs) by heart, and sang it that way. If they threw the poet or the composer around a bit, so much the better for the poetry and the music. There was power and exaltation in these great conclaves of sound from humanity. I've heard the same hymns played by nice celebrated organists and sung by highly-known singers in beautifully upholstered churches, and in the process everything in the music was emasculated—precise (usually too fast) even time—"ta ta" down-left-right-up—pretty voices, etc. They take a mountain and make a sponge cake (out)

of it, and sometimes, as a result, one of these commercial travellers gets a nice job at the Metropolitan. Today apparently even the Camp Meetings are getting easy-bodied and commercialized. There are not many more of them here in the east, and what is told of some of those that still survive, such as Amy McPherson & Co., seems but a form of easy entertainment and silk cushions—far different from the days of the "stone-fielders."

⌒ † ⌒

But the Camp Meetings aren't the only things that have gone soft. How about some of the seed of 1776? There are probably several contributing factors. Perhaps the most obvious if not the most harmful element is commercialism, with its influence tending towards mechanization and standardized processes of mind and life (making breakfast and death a little too easy). Emasculating America for money! Is the Anglo-Saxon going "Pussy"?—the nice Lizzies—the do-it-proper boys of today—the cushions of complacency—the champions of bodily ease—the play-it-pretty minds—the cautious old gals running the broadcasting companies—those great national brain-softeners, the movies—the mind-dulling tabloids with their headlines of half-truths and heroic pictures of the most popular defectives—the ladybirds—the femaled-male crooners—the easy-ear concert-hall parlor entertainments with not even one "god-damn" in them—they are all getting theirs, and America is not! Is she gradually losing her manhood? The Puritans may have been everything that the lollers called them, but they weren't soft. They may have been cold, narrow, hard-minded rock-eaters outwardly, but they weren't effeminates.

Richy Wagner did get away occasionally from doh-me-soh, which was more than some others did. He had more or less of a good brain for technical progress, but he seems to put it to such weak uses—exulting, like a nice lady's purple silk dress, in fake nobility and heroism, but afraid to jump in a mill pond and be a hero. He liked instead to dress up in purple and sing about heroism—(a woman posing as a man.)

Music has been, to too large an extent, an emasculated art—and Wagner did his part to keep it so. What masculation he has in it, is make-believe. Even today probably about 83% of the so-called best musical programs—that is, of the large city symphony orchestras, of educational institutions, and of the opera—lean more to the molly-coddle than the rough way up the mountain. And 98¼% of all radio music is worse than molly-coddle—it's the one-syllable gossip for the soft-ears-and-stomachs, easy for their bodies, and is fundamentally art prostituted for commercialism.

Men (that is, women and men) are so constituted that they are at first more inclined to buy the easy (to hear and look (at) it) than the difficult. Toward art in general, especially music, they are like the five year old boy who comes down to breakfast. He sees two tables in the dining room: (1) nice lollypops, (2) oatmeal. He goes to #1, if he has his way. But most of them don't always have their own way (as everybody does on the radio. For that reason most boys go to #2, and they grow up strong, more or less. But towards music, and to a certain extent towards literature and art in general, the majority still go to table #1 (lollypops etc.), because the president, the directors, and stockholders of the Rollo companies are weak sisters, and not strong fathers and mothers—for there is more money in selling #1, because it's easier to sell. Look at the faces of the people who go every night to the movies, the next A.M.

When I think of some music that I liked to hear and play 35 or 40 years ago—if I hear some of it now, I feel like saying, "Rollo, how did you fall for that

sop, those 'ta tas' and greasy ringlets?" In this I would include the *Preislied, The Rosary,* a certain amount of Mozart, Mendelssohn, a small amount of early Beethoven, with the easy-made Haydn, a large amount of Massenet, Sibelius, Tchaikovsky, etc. (to say nothing of Gounod), most Italian operas (not exactly most of the operas, but most of each opera), some of Chopin (pretty soft, but you don't mind it in him so much, because one just naturally thinks of him with a skirt on, but one which he made himself). Notwithstanding the above slants, which many would say are insults, it seems to me, as it did then and ever, that still today Bach, Beethoven, and Brahms (No) are among the strongest and greatest in all art, and nothing since is stronger or greater than their strongest and greatest—(not quite as strong and great as Carl Ruggles, because B., B., and B. have too much of the sugar-plum for the soft-ears—but even with that, they have some manhood of their own). I won't say that their best is better or worse than any music before or since—I won't say, because I don't know—and nobody knows, except Rollo!

My brother says, "That's rather conceited of you, isn't it, to criticize the great men (as Mozart, Wagner, etc.), especially when (you) do some composing yourself. Some might say that you imply that your music is greater, less emasculated, and more to the point than any of the so-called great masters!" I don't imply any such thing—I don't have to—I state (that) it is better! Ask any good musician—those who don't agree with me are not good musicians—but if some of the poor musicians (that is, Ossip, Arthur, and Kitty) should agree with me, then I'd begin to think I was wrong.

(Sep. 4 (rightly 5), '34—in London (18 Half Moon St.). Last evening Harmony, Edie, and singer (Laurence) Holmes, and Daddy went to a Promenade Concert (at) Queen's Hall—a Sibelius program. The music on the boats and Green Park didn't bring it home to me more strongly and hopelessly surely, than sitting there for an hour or so and hearing those groove-made chewed-cuds (those sound-sequences tied to the same old nice apron-strings, which have become greasy in the process),—that music (and all art, like all life) must be a part of the great organic flow, onwards and always upwards, or become soft in muscles and spirit, and die! I was never more conscious of the vapidity of the human minds that accept anything, round, soft, fat, or bazoota, which somebody else with a nicer silk hat than theirs hands them—commercial silk hatters—music conservatories (the better known the worse)—the paid newspaper critics—the prima donna monopolists—and perhaps the lowest of all, the publishing, the broadcasting, and recording for profit. The *Valse Triste* (as brown-sugar-coddle as it is) is bigger than what (we) heard last night—for the first is a nice lollypop, and it doesn't try to be something else—but these symphonies, overtures, etc. are worse because they give out the strut of a little music making believe it's big. Every phrase, line, and chord, and beat went over and over the way you'd exactly expect them to go—even when it didn't go as you'd expected, you didn't expect it would—trite, tiresome awnings of platitudes, all a nice mixture of Grieg, Wagner, and Tchaikovsky (et al, ladies). But the worst part—a thing hinting that music might some day die, like an emasculated cherry, dead but dishonored—was to see those young people standing downstairs, seriously eating that yellow sap flowing from a stomach that had never had an idea. And some of them are probably composing, and you can see them going home, copying down those slimy grooves and thinking they are creating something—helping music decline—dying—dying—dead.)

DIG DEEPER

BOOKS
Essays Before a Sonata and *Memos* by Charles Ives

The music of Charles Ives eventually had an enormous effect on many of the more radical composers who came after him. Ives explored various aspects of polytonality and polyrhythms, foreshadowing the works of a number of different composers. He experimented with extremely dissonant quarter-tone intervals, inspiring the works of some of the most *avant-garde* experimentalists of the later twentieth century. As you read in the previous article, Ives's music frequently makes use of quotations from other musical sources, and his music may have served as an inspiration for the contemporary works of composers such as Joan Tower and John Corigliano. Ives also wrote music that contained "chance" elements, where no two performances of a work would be exactly the same. In this regard, his groundbreaking experiments predated those of composer John Cage by over 40 years. As you will learn in Chapter 9, Cage would go on to write a number of works that had "chance" elements, culminating in a new stylistic term called *indeterminacy,* but Ives did it first.

String Quartet No. 2

In a note written in the score of his second string quartet, Ives called this work a "String Quartet for four men—who converse, discuss, argue (in re 'Politick'), fight, shake hands, shut up—then walk up the mountainside to view the firmament!"[12] The first movement is titled *Discussions* and features melodic quotes from diverse tunes including *Dixie, Turkey in the Straw,* and one of Ives' favorites, *Columbia, Gem of the Ocean.* Ives titled the second movement *Arguments,* and this is the example found on your listening example. In the liner notes for the CD from which this listening example is taken, Peter Burkholder explains how Ives organized the movement:

> According to Ives's notes in the score, the second violinist plays the role of "Rollo," a character Ives borrowed from a 19th-century children's reader, who represents all that is safe, "nice," and conservative. Near the beginning, each instrument shouts out its own ideas. (As Ives comments in the margin, "saying the same thing over & over & louder & louder— ain't arguing." "Rollo" tries to calm things down with solo cadenzas in a sweetly sentimental style, marked "Andante emasculata (Pretty Tone, Ladies!). The others shout him down: "Cut it out, Rollo!" All four parts engage in some complex atonal canons, but the going gets too hard for Rollo, who drops out ("Too hard to play—so it just can't be good music, Rollo") . . . Toward the end there is another series of quotations, from Tchaikovsky's *Pathetique Symphony,* Brahms's Second, and Beethoven's Ninth, with "Columbia, the Gem of the Ocean" and "Marching Through Georgia" thrown in as well."[13]

The third movement, titled *The Call of the Mountains,* assumes a more spiritual tone. The individual parts are less combative, and overall, more peaceful in nature. Along with a great deal of newly composed contrapuntal music, Ives quotes the hymn *Nearer My God To Thee,* and he also imitates the ringing bells of the Westminster chimes. This movement is a haunting finale to a very interesting work.

Listening Guide

String Quartet No. 2
Movement II—*Arguments*
Charles Ives (1874-1954)

Format: String Quartet
Performance: The Lydian String Quartet
Recording: *Charles Ives: The String Quartets* (Centaur CRC 2069)

Performance Notes: Recorded September 17-18, 1988 at Slosberg Auditorium, Brandeis University.

:00	Work starts right off with strongly dissonant thematic statements as suggested in the previous quote. This is a musical argument. Fits of anger are interspersed with quieter, more lyrical sections. As mentioned above, listen for brief quotations from other compositions as Ives weaves them into his own music. Most of these only appear toward the end of the movement, but the tune *Columbia, Gem of the Ocean* (one of Ives's favorites) can be heard at several points throughout this selection. Other tunes to listen for include melodies drawn from Tchaikovsky's *Pathetique* Symphony, the Second Symphony of Brahms, the *Ode to Joy* melody from Beethoven's Ninth Symphony, and the Civil War tune *Marching Through Georgia*.
1:33	First clear statement of *Columbia, Gem of the Ocean* heard in the viola and cello parts. Once the line is established, you will realize that Ives has been working with this thematic rhythm for some time now.
1:50	Rhythmic idea begins to slip away as the musical argument continues.
3:16	Other melodic quotations become clearly audible.

Aaron Copland (1900-1990)

For many years, Aaron Copland was considered America's greatest living composer; then he died and became simply America's greatest composer. In the opinion of audience members who experienced his early and very late works, however, he certainly didn't start or end in that manner. Copland's first compositions were dissonant, modernistic works that won him approval in contemporary music circles but were not popular with the general concert-going public. After a performance of his Symphony for Organ and Orchestra, conductor Walter Damrosch remarked, "If he can write like that at 23, in five years he will be ready to commit murder."[14] Copland experimented with jazz elements and passed through a Neo-Classical phase before embarking on a conscious stylistic change that helped make his music accessible to a wide audience. Copland began writing music that

Conductor Walter Damrosch.
Source: Jupiterimages, Corp.

Aaron Copland.
Source: Library of Congress.

American composers at the home of Virgil Thomson. Seated, left to right, are Virgil Thomson, Gian Carlo Menotti, and William Schuman. Standing, left to right, are Samuel Barber and Aaron Copland.
Source: © Bettmann/Getty Images

was considerably more tonal, making use of American folk music styles, and, in some cases, utilizing actual folk melodies for his thematic material. Working with Agnes de Mille, Copland composed scores for two new ballets titled *Billy the Kid* and *Rodeo*. Not long after, in collaboration with Martha Graham, he wrote a third new ballet score titled *Appalachian Spring*, which was built around the old Shaker hymn *Simple Gifts*. All three of the compositions were later converted to suites for orchestra and quickly became extremely popular on the concert stage and on record. Copland continued in this Americana vein with works including *Fanfare for the Common Man* (a theme he used again in his Third Symphony), *The Tender Land* (a full-length opera), and film scores for the movies *Of Mice and Men, Our Town, The Red Pony,* and *The Heiress*. During this period Copland also drew musical inspiration from Latin music, composing the popular works *El Salón México* and *Danzón Cubana,* as well as portions of the previously mentioned score for *Billy the Kid*.

Copland became a prominent member of the American artistic community, writing books, articles, and even hosting a radio show focused on the world of classical music. Although he had made a clear break with the dissonant side of twentieth-century classical music during the 1940s and 50s, he continued to be an active supporter of new music. An excerpt from one of his most famous books, *What to Listen for in Music*, appears in Chapter 1 of this textbook. Copland continued to enjoy the success of these popular compositions for the rest of his life, but he again made a stylistic change starting in the 1950s when he began exploring Schoenberg's system of 12-tone composition. These late works are well crafted, but they are extremely dissonant and difficult for most audience members to embrace. Works in this final style include *Twelve Poems of Emily Dickinson, Inscape, Connotations,* and *Emblems* (for symphonic band). Written in 1964, *Emblems* is an interesting mixture of 12-tone techniques and the hymn *Amazing Grace*. The work is essentially a theme and variations on the old hymn, but a clear version of the theme does not appear until the very end of the composition. For the most part, Copland stopped composing in the early 1970s, but he kept conducting and making public appearances into the early 1980s. Among other honors, Copland received the Pulitzer Prize for Music (1944), an Academy Award for the film score to *The Heiress* (1950), the Presidential Medal of Freedom (1964), and the Congressional Medal of Honor (1977).

Rodeo (Ballet and Symphonic Suite)

The score for the ballet *Rodeo* was commissioned by famed dancer and choreographer Agnes de Mille, who premiered the work in 1942. The ballet tells the story of a cowgirl who is trying to capture the fancy of the head wrangler. Although she can rope and ride with the best of them, none of the cowboys really pay any attention to her until she shows up in the last scene dressed in "girl clothes," as opposed to the western outfits she wears through most of the ballet. Copland later adapted much of the musical material used in the ballet into a four-movement symphonic suite. The four sections are titled *Buckaroo Holiday, Corral Nocturne, Saturday Night Waltz,* and *Hoe Down.* Of the four, *Hoe Down* is by far the most popular, and it frequently appears alone on symphony "pops" concerts. Throughout the work, Copland makes use of old western folk tunes for melodic themes, as well as composing new material that manages to capture that "western" feel.

Your listening example is the closing section of the ballet, and it follows a simple A-B-A formal structure. The main theme for this last section of the work is based on an old square dance tune titled *Bonaparte's Retreat,* which we will call letter A. Copland plays the melody, writes a variation on that melody, sets you up with a little rhythmic groove, and then back we go to the original melody. Later, he introduces a second (B) theme in the trumpets and plays around with it for a while, but we quickly return to another statement of the letter A melody. And by the way, you aren't hearing things, this is the "beef, it's what's for dinner" theme song. Needless to say, it wasn't written for the commercial.

Listening Guide

Rodeo
Hoe Down
Aaron Copland (1900-1990)

Format: Ballet (also symphonic suite)
Performance: Sinfonia Varsovia, Mariusz Smolij, conductor
Recording: *Gershwin-Copland-Bernstein* (CD Accord ACD 119-2)

Performance Notes: Recorded March 20-23, 2001 at the Polish Radio Concert Hall, Warsaw. Here is another recording that features one of the best little orchestras no one in America seems to have ever heard of. This group performs an extensive series in Poland and tours Europe on a regular basis. Many of the finest conductors in the business have served as guest conductors with this orchestra over its almost 20-year history.

:00	Brief introduction based on the opening melodic material of letter A melody.
:37	Full statement of the A theme, followed by subsequent repetitions and melodic expansions on this thematic idea.
1:32	New melody, letter B, is introduced by the trumpets and picked up by other sections of the orchestra.
2:41	First melody returns, building to a rousing conclusion.

George Gershwin.
Source: © Bettmann/Getty Images

DIG DEEPER

MOVIES
Rhapsody in Blue; An American in Paris

George Gershwin (1898–1937)

American composer George Gershwin is frequently credited with being the first artist to successfully blend jazz elements with classical music. While there are other composers who should also be mentioned in this regard (Scott Joplin, William Grant Still, Will Marion Cook, and James P. Johnson), it is true that Gershwin enjoyed the most public acclaim during his lifetime. Gershwin began his career as a composer in New York City, where he was working as a songwriter for popular Broadway shows. Many of his early songs, including *Swanee, Lady Be Good, Strike Up the Band,* and *I've Got Rhythm,* became international hits. In 1931, his political satire *Of Thee I Sing* became the first Broadway show to win a Pulitzer Prize.

In 1924, Gershwin collaborated with bandleader Paul Whiteman to compose an extended one-movement piano concerto titled *Rhapsody in Blue* that would blend jazz and classical styles. Gershwin composed the outline sketch of the piece and the piano part, and the final version of the piece was orchestrated for the Whiteman band, and later for full symphony orchestra, by Ferde Grofé (famed composer of the *Grand Canyon Suite*). After the overwhelming success of *Rhapsody in Blue,* Gershwin made a commitment to write his own orchestrations for his more extended classical compositions.

Having had minimal formal training, Gershwin approached "classical" music with a great deal of trepidation, obsessed with the notion that his work was full of technical flaws. He sounded out Stravinsky about taking some composition lessons (the Russian master, upon determining Gershwin's annual salary, suggested that he take lessons from Gershwin instead), and when the American approached Ravel on a similar mission, the composer of *Bolero* supposedly responded, "Why do you want to be a secondhand Ravel when you're already a first rate Gershwin?" [Other scholars attribute this story to Schoenberg rather than Ravel.][15]

His other orchestral works include the Concerto in F for piano and orchestra, the Second Rhapsody for piano and orchestra, the *I Got Rhythm Variations* for piano and orchestra, and two tone poems titled *An American In Paris* and *Cuban Overture.* Gershwin also composed one opera titled *Porgy and Bess.* This work features an all black cast and blends together blues, gospel, jazz, and classical elements in its music. The work was labeled a "folk opera" by some critics and initially enjoyed mixed reviews. Over the passage of time, however, it has become one of the most important American operas ever written. Unfortunately, Gershwin died in his late 30s of a brain tumor, thus depriving the world of a truly unique composer in the prime of his career. In the jazz and popular music world, Gershwin's songs form the backbone of what is now frequently referred to as "The Great American Songbook." In the classical world, his compositions are always a popular addition to any symphony program or opera season.

Focus on Form
Expressionism, Atonality, and Serialism

Expressionism as an artistic movement flourished in the early years of the twentieth century. Painters such as Edvard Munch, Wassily Kandinsky, and Paul Klee along with playwrights August Strindberg and Ernst Toller began to explore the inner workings of the mind in their artistic creations. Their works were dark, sometimes horrific *expressions* of the tortured inner soul. Composer (and painter) Arnold Schoenberg altered his compositional style from lush Post-Romanticism to embrace these new artistic concepts. Along with this new stylistic approach, Schoenberg attempted to develop a new musical language with which he could better convey his musical message. At first, he began writing compositions in a harsh, freely atonal format. These works were increasingly chromatic and intentionally quite dissonant, with Schoenberg going to great lengths to have his music avoid any implications of tonality. He began using extreme musical techniques such as *Klangfarbenmelodie* (tone-color melody) and *Sprechstimme* (speech-song) to add even more intensity to many of his compositions. **Klangfarbenmelodie** is the technique of assigning certain tone colors to certain notes in an effort to create identifiable melodic patterns through timbre changes. **Sprechstimme** is a dramatic form of vocal delivery that is half-spoken, half-sung on specific, notated musical pitches. The composition *Pierrot Lunaire* comes from this atonal period.

Klangfarbenmelodie

Sprechstimme

Schoenberg was happy with some of the dramatic results he got from his atonal compositions, but he found it difficult to organize his melodic materials in such a way as to clearly avoid any real sense of tonality. Consequently, he developed a new, mathematical system of musical organization that would guarantee him absolute atonality in his compositions—**serialism**. The octave, which is a basic building block for all Western music, can be divided into 12 equal half-steps. As you learned in Chapter 1, scale patterns are derived and chords are built in such a way that there is an established hierarchy of consonance and dissonance. Schoenberg used a matrix formula to organize each of the 12 individual notes into a pattern called a **tone row**. He then established a basic set of principles for the application of these tone rows so that they could be used to develop all the melodic and harmonic material to be used in a given composition. It can be a complicated system to understand, but the basic rules are as follows:

serialism

tone row

- All twelve notes of the tone row must be used before the first note of that row can be used again.
- You can repeat the same note more than once, but you can never move back in the tone row, only forward toward the end.
- Depending on instrumentation and/or vocal ranges, notes can be played or sung in any octave and still be considered the same in relation to its position in a given tone row.
- With the use of a matrix, the original tone row may be altered in any of the following ways: it may be played in retrograde (12 – 1), each interval may be inverted or turned upside down (resulting in a new 1 – 12 note pattern), and/or the inverted tone row may also be played in retrograde (new inverted pattern played 12 – 1). Finally, each of these patterns may be transposed (moved up or down) so that they can begin on any of the 12 notes and be played with the proper interval relationships from start to finish. The finished tone row matrix would offer the composer 48 different permutations of the tone row, which

was a great deal more material than any composer would ever use in a single composition. The following chart is an example of a typical 12-tone matrix.

	0	**1**	**2**	**3**	**4**	**5**	**6**	**7**	**8**	**9**	**10**	**11**	
I⁰↓	11	8	10	3	7	1	9	4	2	5	6		
P0 →	C	B	Ab	Bb	Eb	G	C#	A	E	D	F	F#	**R** ←
1 1	C#	C	A	B	E	G#	D	Bb	F	Eb	F#	G	
2 4	E	Eb	C	D	G	B	F	C#	G#	F#	A	Eb	
3 2	D	C#	Bb	C	F	A	Eb	B	Gb	E	G	Ab	
4 9	A	G#	F	G	C	E	Bb	F#	C#	B	D	Eb	
5 5	F	E	C#	D#	G#	C	F#	D	A	G	Bb	B	
6 11	B	Bb	G	A	D	F#	C	Ab	Eb	C#	E	F	
7 3	Eb	D	B	C#	F#	Bb	E	C	G	F	Ab	A	
8 8	Ab	G	E	F#	B	Eb	A	F	C	Bb	C#	D	
9 10	Bb	A	F#	G#	C#	F	B	G	D	C	Eb	E	
10 7	G	F#	Eb	F	Bb	D	Ab	E	B	A	C	C#	
11 6	F#	F	D	E	A	C#	G	Eb	Bb	Ab	B	C	
RI ↑													

From the collection of composer Samuel Hollomon.
Used by permission.

Different composers applied Schoenberg's new principles of composition in a number of different ways. Even his two students, Anton Webern and Alban Berg, were not unified in their approach to 12-tone composition. Webern made extremely strict use of the system, whereas Berg brought more of a Post-Romantic sensibility to the new techniques. Stravinsky, Bartók, Copland, and Hindemith all experimented with serial techniques. For Schoenberg and his followers, only the order of notes being used was serialized. Choices about the other normal parameters of music were still left up to the composer. In the late 1940s, younger composers including Pierre Boulez and Milton Babbitt began to experiment with **total serialism**, where not only the notes but also the dynamics, rhythm, formal structure, and even decisions about which instruments would be played when could all be serialized.

total serialism

The following article, which is an English translation of a lecture given by Anton Webern, will give you a better understanding of the evolution of 12-tone techniques.

The Path to Twelve-Note Composition
by Anton Webern

I didn't invent the title you've seen. It's Schoenberg's. This year I was to talk in Mondsee on this subject, so I had a brief correspondence with Schoenberg about what such a lecture should be called. He suggested "The path to twelve-note composition."

We must know, above all, what it means: "twelve-note composition." Have you ever looked at a work of that kind? It's my belief that ever since music has been written, all the great composers have instinctively had this before them as a goal. But I don't want to trust you with these secrets straight away—and they really are secrets! Secret keys. Such keys have probably existed in all ages, and people have unconsciously had more or less of an idea of them.

Today I want to deal generally with these things. So what has in fact been achieved by this method of composition? What territory, what doors have been opened with this secret key? To be very general, it's a matter of creating a means to express the greatest possible unity in music. There we have a word we could discuss all day. Perhaps, after all, it's important to talk about these things—I mean things so general that everyone can understand them, even those who only want to sit and listen passively. For I don't know what the future has in store . . .

Unity is surely the indispensable thing if meaning is to exist. Unity, to be very general, is the establishment of the utmost relatedness between all component parts. So in music, as in all other human utterance, the aim is to make as clear as possible the relationships between the parts of the unity; in short, to show how one thing leads to another.

Turning now to music, it's to some extent historical. What is this "twelve-note composition?" And what preceded it? This music has been given the dreadful name "atonal music." Schoenberg gets a lot of fun out of this, since "atonal" means "without notes;" but that's meaningless. What's meant is music in no definite key. What has been given up? The key has disappeared!

Let's try to find unity! Until now, tonality has been one of the most important means of establishing unity. It's the only one of the old achievements that has disappeared; everything else is still there. Now we shall try to probe deeper into this story.

So: what is music? Music is language. A human being wants to express ideas in this language, but not ideas that can be translated into concepts—*musical* ideas. Schoenberg went through every dictionary to find a definition of an "idea," but he never found one. What is a musical idea?

(whistled) "Kommt ein Vogerl geflogen"*

That's a musical idea! Indeed, man only exists insofar as he expresses himself. Music does it in musical ideas. I want to say something, and obviously I try to express it so that others understand it. Schoenberg uses the wonderful word "comprehensibility" (it constantly occurs in Goethe!). Comprehensibility is the highest law of all. Unity must be there. There must be means of ensuring it.

All the things familiar to us from primitive life must also be used in works of art. Men have looked for means to give a musical idea the most comprehensible shape possible. Throughout several centuries one of these means was tonality, since the seventeenth century. Since Bach, major has been distinguished from minor. This stage was preceded by the church modes, that's to say seven keys in a way, of which only the two keys, like genders, finally remained. These two have produced something that's above gender, our new system of twelve notes.

Returning to tonality: it was an unprecedented means of shaping form, of producing unity. What did this unity consist of? Of the fact that a piece was written in a certain key. It was the principal key, which was selected, and it was natural for the composer to be anxious to demonstrate this key very explicitly. A piece had a keynote: it was maintained, it was left and returned to. It constantly reappeared, and this made it predominant. There was a main key in the exposition, in the development, in the recapitulation, etc. To crystallize out this main key more definitely, there were codas, in which the main key kept reappearing. I have to keep picking out these things because I'm discussing something that's disappeared. Something had to come and restore order.

There are two paths that led unavoidably to twelve-note composition; it wasn't merely the fact that tonality disappeared and one needed something new to cling to. No! Beside that, there was another very important thing! But for the moment I can't hope to say in one word what it is. Canonic, contrapuntal forms, thematic development can produce many relationships between things, and that's where we must look for the further element in twelve-note composition, by looking back at its predecessors.

The most splendid example of this is Johann Sebastian Bach, who wrote the "Art of Fugue" at the end of his life. This work contains a wealth of relationships of a wholly abstract kind; it's the most abstract music known to us. (Perhaps we are all on the way to writing as abstractly). Although there's still tonality here, there are things that look forward to the most important point about twelve-note composition: a substitute for tonality.

What I'm telling you here is really my life-story. This whole upheaval started just when I began to compose. The matter became really relevant during the time when I was Schoenberg's pupil. Since then a quarter of a century has already gone by, though.

If we want to find historically how tonality suddenly vanished, and what started it, until finally, one day, Schoenberg saw by pure intuition how to restore order, then it was about 1908 when Schoenberg's piano pieces Op. 11 appeared. Those were the first "atonal" pieces; the first of Schoenberg's twelve-note works appeared in 1922. From 1908 to 1922 was the interregnum: 14 years, nearly a decade and half, this stage lasted. But already in the spring of 1917—Schoenberg lived in the Gloriettegasse at the time, and I lived quite near—I went to see him one fine morning, to tell him I had read in some newspaper where a few groceries were to be had. In fact I disturbed him with this, and he explained to me that he was "on the way to something quite new." He didn't tell me more at the time, and I racked my brains—"For goodness' sake, whatever can it be?" (The first beginnings of this music are to be found in the music of "Jacob's Ladder.")

I'm sure it will be very useful to discuss the last stage of tonal music. We find the first breach in sonata movements, where the main key often has some other key forced into it like a wedge. This means the main key is at times pushed to one side. And then at the cadence. What is a cadence? The attempt to seal off a key against everything that could prejudice it. But composers wanted to give the cadence an ever more individual shape, and this finally led to the break-up of the main key. At first one still landed in the home key at the end, but gradually one went so far that finally there was no longer any feeling that it was necessary really to return to the main key. At first one did think, "Here I am at home—now I'm going out—I look around me—I can wander off as far as I like while I'm about it—until I'm back home at last!" The fact that cadences were shaped ever more richly, that instead of chords of the sub-dominant, dominant and tonic, one increasingly used substitutes for them, and then altered even those—it led to the break-up of tonality. The substitutes got steadily more independent. It was possible to go into another tonality here and there. (When one moved from the white to the black keys, one wondered, "Do I really have to come down again?") The substitutes became so predominant that the need to return to the main key disappeared. All the works that Schoenberg, Berg and I wrote before 1908 belong to this stage of tonality.

"Where has one to go, and does one in fact have to return to the relationships implied by traditional harmony?"—thinking over points like that, we had the feeling, "We don't need these relationships any more, our ear is satisfied without tonality too." The time was simply ripe for the disappearance of tonality. Naturally this was a fierce struggle; inhibitions of the most frightful kind had to be overcome, the panic fear, "Is that possible, then?" So it came about that gradually a piece was written, firmly and consciously, that wasn't in a definite key any more.

You're listening to someone who went through all these things and fought them out. All these experiences tumbled over one another, they happened to us unselfconsciously and intuitively. And never in the history of music has there been such resistance as there was to these things.

Naturally it's nonsense to advance "social objections." Why don't people understand that? Our push forward *had* to be made, it was a push forward such as never was before. In fact we have to break new ground with each work: each work is something different, something new. Look at Schoenberg! Max Reger certainly developed, too, as a man develops between his fifteenth year and his fortieth, but stylistically there were no changes; he could reel off fifty works in the same style. We find it downright impossible to repeat anything. Schoenberg said, and this is highly revealing, "Suppose I'd written an opera in the style of the 'Gurrelieder?' "

How do people hope to follow this? Obviously it's very difficult. Beethoven and Wagner were also important revolutionaries, they were misunderstood too, because they brought about enormous changes in style.

I've tried to make this stage really clear to you and to convince you that just as a ripe fruit falls from the tree, music has quite simply given up the formal principle of tonality.

Arnold Schoenberg (1874~1951)

Expressionist composer, painter, and the father of 12-tone music, Arnold Schoenberg.
Source: Library of Congress.

Composer Arnold Schoenberg created a new system for musical organization during the twentieth century that continues to revolutionize music to this day. Viewed as a radical in his native Vienna and throughout Germany, Schoenberg's techniques eventually found a home both in academia and in the hands of a number of different modern composers who applied his techniques in a variety of ways. Schoenberg began his compositional career firmly rooted in the Post-Romantic style of the day. He was fond of the music of Wagner, Mahler, and Richard Strauss. In fact, long after he broke with the loosely tonal Post-Romantic style, he continued to view his compositions (and his teachings) as a logical musical progression along the path toward atonality started by Wagner. Early Post-Romantic works by Schoenberg include *Verklärte Nacht* (Transfigured Night, a chamber work, also done later for string orchestra), *Pelleas und Melisande* (a tone poem), and *Gurre-Lieder* (a large work for five solo voices, narrator, chorus, and orchestra).

As Schoenberg began to incorporate more of the artistic principles of Expressionism into his compositions, his music became increasingly dissonant, with thinner textures and a harsher overall sound. He created two one-act works for the stage during this period, a monodrama titled *Erwartung* (Expectation) and *Die glückliche Hand* (The Lucky Hand). Another important composition from around this same time is the chamber work *Pierrot Lunaire* (Moonstruck Pierrot), from which you have a listening example and a detailed listening guide. In discussing *Pierrot Lunaire* Schoenberg wrote the following: "The sounds become here a nearly animalistical, immediate expression of sensual and emotional movements. . . . The colors meant everything, the notes nothing at all."[16] The underlined passages in the previous statement are by Schoenberg. Musically, this is a new way of thinking about composition. To say the notes themselves—thus implying all concepts of harmony as it has been known over the past 200 years—are not important is a pretty radical concept. As you heard in the Charles Ives listening example, Ives had also made that decision to a certain extent, but he didn't go as far out on the musical limb as Schoenberg, and he certainly didn't do so in such a public manner on the international stage.

These works were not at all popular with the general public. Put simply, as historian K.Marie Stolba wrote "[e]xpressionist works were not intended to be beautiful, pleasing, or realistic. Rather, every detail of such a work is exploited to convey, as penetratingly as possible, inner thoughts, emotions, and experiences."[17] Consequently, Schoenberg retreated from the public eye, but he continued to compose new works and develop a new system of musical organization. He also continued his work as a teacher, surrounding himself with students who shared his passion for this complex new music. His most important disciples were Anton Webern and Alban Berg, both of whom you will meet in the following sections of this chapter. As the 12-tone method became standardized, Schoenberg began to reveal some of his new works to the public. Some of Schoenberg's compositions using the 12-tone method of composition include *Suite für Klavier* (Piano Suite), *Variations for Orchestra*, *Concerto for Violin*, *Theme and Variations* (originally for wind band, later arranged for orchestra), *A Survivor from Warsaw*, and the opera *Moses und Aron*.

Schoenberg was Jewish, but he converted to both Catholicism and Protestantism during portions of his life. Regardless of his religious affiliations, his music alone was more than enough to put him on the wrong side of the Nazis. When Hitler

came to power, Schoenberg moved first to Paris and later to America, where he accepted a teaching position at the University of California. Schoenberg's techniques became a regular part of the compositional training process for several generations of music students across America. For many in academia, 12-tone composition became *the* new compositional method, almost to the exclusion of other styles and techniques. From the 1940s forward, most audiences disliked this music, yet universities kept turning out more students trained in 12-tone composition. It is a gross oversimplification of the issue, but basically, the audience went one direction and many composers went the other. 12-tone composition played a major role in helping turn opera houses and symphony halls into "living museums" where only music written before 1900 was regularly performed.

Pierrot Lunaire, Op. 21

Schoenberg wrote *Pierrot Lunaire* in 1912. The 21-movement work is based upon German translations of poems by the Belgian poet Albert Giraud. The work is freely atonal in nature, with the composer intentionally avoiding any strong sense of a tonal center or harmonic focal point. As previously mentioned, of particular interest in this work is Schoenberg's use of this new half-speaking, half-singing technique called *Sprechstimme*. The character of Pierrot, the ever-tragic clown figure, is played to good advantage in these poems. There is some question, however, as to why Schoenberg included the term *Lunaire* (lunar, or having to do with the moon) in the title. Noted scholar Joseph Kerman addresses this point in his book *Listen:* "In some of the strange poems that constitute this cycle, Pierrot is obsessed with the moon; in others, he 'moons' in an inconsequential, melancholy way; in still others, he indeed seems lunatic."[18]

The brief movement in the following listening guide, *Der Mondfleck* (The Moon Speck), paints a vivid portrait of the clown Pierrot as he tries to rub a white spot off his black jacket. The problem is that the white spot is actually moonlight shining on his clothing. He rubs and rubs but the spot won't come off. It makes him a little bit crazy, as you can hear in the music Schoenberg created to support this poem. He sets up a fugue in the piano and uses all kinds of contrapuntal devices to heighten the sense of Pierrot's frustration. Perhaps the coolest thing about this brief movement is the fact that the instrumental parts form a palindrome, meaning they are the same forward and backward. From the mid-point of the movement to the end it is an exact mirror, or note-for-note retrograde, of the first half. This can be difficult to hear, but it is nonetheless a clever little compositional trick.

A nineteenth-century woodcut of the clown Pierrot.
Source: © Shutterstock.com

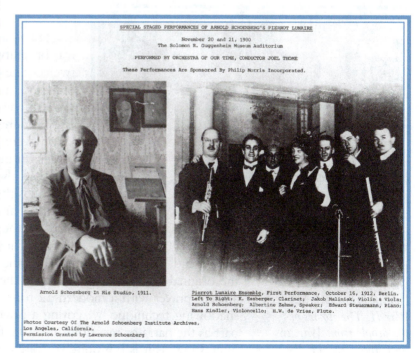

Photos of composer Arnold Schoenberg in his studio and the ensemble that premiered Pierrot Lunaire *in 1912.*
Source: Library of Congress.

Listening Guide

Pierrot Lunaire, Op. 21
Der Mondfleck

Arnold Schoenberg (1874-1951)

Format: Chamber ensemble with solo voice
Performance: Ensemble >das neue werk< Hamburg, Dieter Cichewiecz, conductor; Edith Urbanczyk, Sprechstimme-voice
Recording: *Pierrot: Ein CLOWN hinter den Masken der MUSIK* (Musicaphon M56837)
Performance Notes: Recorded February 15-19, 1999 in Hamburg, Germany.

:00

Einen weissen Fleck des hellen Mondes
Auf dem Rücken seines schwarzen Rockes,
So spaziert Pierrot im lauen Abend,
Aufzusuchen Glück und Abenteuer.

Plötzlich—stört ihn was an seinem Anzug,
Er beschaut sich rings und findet richtig—
Einen weissen Fleck des hellen Mondes
Auf dem Rücken seines schwarzen Rockes.

Warte! denkt er: das ist so ein Gipsfleck!
Wischt und wischt, doch—bringt ihn nicht herunter!
Und so geht er, giftgeschwollen, weiter,
Reibt und reibt bis an den frühen Morgen—
Einen weissen Fleck des hellen Mondes.

A white spot of the bright moon
On the back of his black coat,
Pierrot goes for a stroll on a mild evening
To seek fortune and adventure.

Suddenly, something disturbs him about his suit,
He looks around and sure enough finds—
A white spot of the bright moon
On the back of his black coat.

Wait! he thinks: it's a spot of plaster!
He wipes and wipes, but—he cannot remove it!
And so he goes on, filled with venom,
Rubs and rubs until the early morning
A white spot of the bright moon.

Vivid photo of the Jewish ghetto in Warsaw, Poland before World War II. The stories of the people from Warsaw that lived through the war moved Schoenberg to compose A Survivor from Warsaw.
Source: Jupiterimages, Corp.

A Survivor from Warsaw, Op. 46 (1947)

This is an extremely powerful work, full of the terror, brutality, and senselessness of war. The piece is a twelve-tone composition for narrator, male chorus, and orchestra. Schoenberg wrote the text himself, based on stories he was told by survivors from the Warsaw ghettos. Hundreds of thousands of Warsaw's Jewish population were gathered up and taken to concentration camps during the war years. The Warsaw ghetto, however, was also one of the few areas of true revolt against the Nazis though in the end it led to nothing but more suffering and death. In this work, Schoenberg writes most of the narration in English, but he includes the German language where it is appropriate to the story. At the end, the chorus joins in to sing the prayer *Shema Yisroël* (Hear, Israel) in the original Hebrew language. Like the rest of the work, Schoenberg has set this ancient prayer with a modern 12-tone melody. Early in the work, he uses a foreshadowing technique by writing a brief snippet of the prayer's melody in a brass part as the narrator mentions it for the first time. The narrator's part is particularly interesting, as it is not quite so "pitch specific" as the *Sprechstimme* used in *Pierrot Lunaire*, but Schoenberg is very explicit about the rhythm with which the words are spoken. This is very dramatic music used to tell an even more dramatic story. As wonderfully expressive as his music was, Mozart could never have written this piece.

Listening Guide

A Survivor from Warsaw for Speaker, Men's Chorus and Orchestra, Op. 46
Arnold Schoenberg (1874-1951)

Format: Orchestra with narration and men's chorus

Performance: Czech Philharmonic Chorus and Orchestra, Karel Ančerl, conductor; Richard Baker, narrator

Recording: *The Last World War* (Supraphon SU 0177-2 911)

Performance Notes: Recorded November 13-15, 1966 in Prague.

:00 Most of the text for this listening example is in English, so there is no need to reproduce the full lyrics in this listening guide. There are, however, several lines that the composer wanted to leave in German. These words or phrases occur at several different spots throughout the composition.

"Achtung! Stilljestanden! Na wirds mal? Oder soll ich mit dem Jewehrkolben nachhelfen? Na jutt; wenn ihrs durchaus haben wollt!" (Stand at attention! Hurry up! Or do you want to feel the butt of my gun? Okay, you've asked for it!)

"Abzählen!" (Count off!)

"Rascher! Nochmal von vorn anfangen! In einer Minute will ich wissen, wie viele ich zur Gaskammer abliefere! Abzählen . . ." (Quicker! Start again! In one minute I want to know how many I'm going to deliver to the gas chamber! Count off . . .)

Anton Webern (1883~1945)

Like his mentor, Schoenberg, in the early days Anton Webern was composing richly textured Post-Romantic compositions. Unlike his teacher, Webern retracted his early works from public view though he never destroyed them. Several of his early scores surfaced in the mid-1960s and had their world premieres at that time, over 20 years after the composer's death. After falling under the spell of Schoenberg, Webern completely embraced the concepts of atonality and serialism. He became fascinated with shifting tone colors and frequently made use of *Klangfarbenmelodie* techniques. Some historians refer to Webern's music as "pointillistic," a term that does seem to apply to his habit of extremely sparse orchestrations, creative uses of silence, and desire to create very concise works. Webern is best known for his strict treatment of Schoenberg's concepts for 12-tone composition. He was meticulous in his writing, frequently editing and revising his compositions over and over again. You can get a sense of his personality from the printed lecture beginning on p. 267 titled *The Path to 12 Note Composition*. Like Schoenberg, Webern's music put him on the outs with the Nazis. He lost his teaching position, but he remained in Germany, surviving the war by taking in work from a major music publishing house.

Webern died in a tragic misunderstanding during the American occupation at the end of World War II. For many years, the facts surrounding his death were rather obscure, but Dr. Hans Moldenhauer set the record straight in 1961 with a book titled *The Death of Anton Webern*. It seems that unbeknownst to Webern, his son-in-law was involved in the black market after the war. The Americans had

Anton von Webern.
Source: © Bettmann/Getty
Images

been watching the son-in-law and had planned a covert operation to catch him, using an army cook with whom he was acquainted as a decoy. Anyway, on the night of the trap, Webern innocently ended up in the wrong place at the wrong time. Apparently, he accidentally bumped into the cook in a darkened hallway at the home of his daughter and son-in-law. Thinking himself under attack, the nervous soldier shot Webern three times. In a statement to the U.S. Army officials directly after the incident, Webern's widow recalled:

> At 21:45 [9:45 p.m.] exactly, my husband said we have to leave soon for our home, because we have to arrive there at 22:30 [10:30 p.m. There was a military curfew in effect.]. He wanted to smoke the cigar which he had received the same evening from our son-in-law. He stated that he wanted to smoke it only partly (*einige Züge*) and outside the room in order not to bother the children. This was the first time that he left the room.

> My husband was only outside for 2-3 minutes, when we heard 3 shots. I was very much frightened but did not think that my husband could be involved in any way.

> Then the door to our room was opened by my husband, who said "I was shot." Together with my daughter I laid him down on a mattress and started opening his clothes. My husband could still say the words "It's over" (*es ist aus*) and started losing consciousness.

> . . . My husband was reconvalescent and weighed only about 50 kilos (110 lbs.); he is about 160 cms (5'4") high. According to my belief it would be against his nature to attack anybody, especially a soldier.

> (signed) Wilhelmine von Webern[19]

Fünf Orchesterstücke (Five Pieces for Orchestra), Op. 10 (1911-1913)

This is not a full-blown work of 12-tone composition but rather an earlier, freely atonal work. Even for trained ears it can sometimes be difficult to tell the difference. The most important thing to get out of the following listening example is a sense of Webern's melodic economy. He says a great deal musically while making use of very little melodic material. As was typical with Webern, this little work took him a great deal of time and revision to perfect. He created a number of other movements that were later rejected or reworked and used in other compositions. Likewise, some of these movements were actually created for his Opus 6 work, which ended up being titled *6 Pieces for Orchestra, Op. 6.* Webern makes use of a small chamber orchestra with each player functioning as a soloist, meaning one to a part. In addition to the standard orchestral instruments, Webern asks for some unusual ones including harmonium (a small organ), mandolin, guitar, and a rather wide array of percussion instruments, including tuned cowbells. The piece is so concise it actually takes longer to explain with words than it does to listen to it. Keep an open mind as you study this work. Most people find it quite inaccessible, but it really can give you a very special peek inside the unlimited possibilities in orchestral timbres if you allow it to.

Listening Guide

Fünf Orchesterstücke (Five Pieces for Orchestra), Op. 10 (1911-1913)
Movement I—*Sehr ruhig und zart*
Movement II—*Lebhaft und zart bewegt*
Movement III—*Sehr langsam und äußerst ruhig*
Movement IV—*Fließend, äußert zart*
Movement V—*Sehr fließend*

Anton Webern (1883-1945)

Format: Orchestral suite
Performance: Orchester der Musikhochschule Stuttgart, Thomas Ungar, conductor
Recording: *Rückblick Moderne: 20th Century Orchestral Music* (Col Legno WWE 8 CD 20041)

Performance Notes: This recording comes from the same boxed set as the previous Shostakovich example. These live concerts took place as part of a festival in Stuttgart, Germany in November 1998.

:00 Movement I – *Sehr ruhig und zart* (Very quietly and delicately). The first few notes you hear are considered the first important theme. The violin line you hear at :17 is the second important thematic idea.

:36 Movement II – *Lebhaft und zart bewegt* (Lively and with great emotion). There are three main thematic ideas presented in this movement, so like movement one above, every melodic gesture you hear holds formal and thematic importance in Webern's mind. Nothing is "simple" accompaniment here.

1:14 Movement III – *Sehr langsam und äußerst ruhig* (Very slowly and extremely quiet). Compared to most of his other work, Webern is almost effervescent here, using the bells and cow bells to depict the Alpine countryside. The formal structure is actually a three-part A-B-A', but it can be tough to pick out. The letter B section only lasts for two measures, but it is contrasting material compared to the beginning and end of the work. It does fall roughly in the middle. Again, it takes longer to talk about than it does to listen to.

2:32 Movement IV – *Fließend, äußert zart* (Flowing, with expression). It has been suggested that this movement should be in the *Guinness Book of World Records* as the shortest orchestral movement in history. It is only six measures long and lasts less than thirty seconds. Believe it or not, this little movement still has an identifiable A-B-A' formal structure, with the first and last rhythmic ideas being the same. The middle three measures are different. Cool, huh?

2:58 Movement V – *Sehr fließend* (Very flowing). Scholars have described this movement as a sort of cryptic sonata form. The first four measures serve as an introduction, which concludes with a very clear pause. Measures five through ten function as the exposition, which begins with a long violin note at 3:06. The development begins with a very distinct melodic idea played by the horn at 3:15. Once again, there is a very clear pause before the recapitulation begins at 3:28 though some would argue the true recapitulation doesn't start for two more measures with the return of a long note played this time by the cello. Feel free to make your own call on this one. This example is kind of like one of those little inkblot tests; if you stare at it long enough you really will start to see something.[20]

Alban Berg.
Source: © Bettmann/Getty Images

Alban Berg (1885–1935)

Alban Berg began his formal compositional studies with Schoenberg in 1904. His early works were Post-Romantic in nature, and though the progression of his compositional techniques followed Schoenberg's concepts of atonality and serialism, Berg's music managed to maintain a certain Romantic spirit. His compositional output was relatively small, but it was very influential. His most important works include the operas *Wozzeck* and *Lulu, Lyric Suite* (originally for string quartet and later arranged for string orchestra), Chamber Concerto (for piano, violin, and an ensemble of 14 wind instruments), and the Concerto for Violin and Orchestra. Berg died from an infected insect bite, just as he was hitting his stride as a composer.

Wozzeck, Op. 7

Most people consider *Wozzeck* to be Berg's masterpiece. It is certainly his best-known and most frequently performed work. Based on a fragmentary drama by early nineteenth-century playwright Georg Büchner, the opera is a powerful story of betrayal and murder, and Berg's music only serves to heighten the drama. Beyond dramatic considerations, the opera makes interesting use of formal structures that are generally considered instrumental in nature. For example, the first act resembles a suite of five character pieces, act two is like a five-movement symphony, and act three is a set of five inventions. Throughout the opera, Berg uses formal structures including the rondo, the fugue, and theme and variations. The opera is freely atonal, with both tonal elements and some 12-tone passages.

The opera tells the story of a common soldier, Franz Wozzeck, who is abused by almost everyone in his life. His captain is pure evil, the regimental doctor uses him for medical experiments, and Wozzeck is having nightmarish visions. Worst of all, his wife, Marie, is having an affair with a handsome military drum major. When Wozzeck complains, Marie's lover beats him up. Eventually, Wozzeck goes completely insane, murders his wife, and drowns himself in a fit of despair. After the powerful drowning scene, Berg writes an orchestral interlude that both comments on recent events and also lays the emotional groundwork for the next disturbing image. This brief, final scene is a little vignette of the child of Marie and Wozzeck playing on a hobbyhorse. Other children enter the scene and tease the boy that his mother is dead. They run off to view the body, and the opera closes with the now-orphaned child chasing behind the other children. Strong stuff.

The following excerpt from *Wozzeck* is a powerful monologue featuring Marie as she battles with remorse about her actions. She reads a passage from the Bible, then touches her child, and tells him a story. The scene is a contrast of gentle *Sprechstimme*, occasionally interrupted with loud, dramatic outbursts of full-voiced singing as Marie cries out to God. In a poignant moment of foreshadowing, Marie calls her child a brat, pushes him away, then changes her tone and tells her boy a heart-breaking story about a child with no parents. A few scenes later he gets to be that child.

DIG DEEPER

VIDEOS
Wozzeck, performed by The Vienna State Opera;
Lulu, performed by the Glyndebourne Festival Opera

Listening Guide

Wozzeck, Op. 7
Act III, Scene 1: *Und ist kein Betrug (And Out of His Mouth)*
Alban Berg (1885-1935)

Format: Expressionist opera
Performance: Marilyn Horne, soprano, with Lukas Foss, conducting
Recording: *Marilyn Horne: Recordings 1959-1973* (Gala GL 100.568)

Performance Notes: Here is another historic live opera recording. Made in 1966, it features American soprano Marilyn Horne in one of her most famous roles.

:00 *(Mariens Stube. Es ist Nacht. Kerzenlicht. Marie sitzt am Tisch, blättert in der Bibel; das Kind in der Nähe. Sie liest in der Bibel.)*

Marie

"Und ist kein Betrug in seinem Munde erfunden worden" . . . Herr-Gott! Herr-Gott! Sieh* mich nicht an! *(blättert weiter)* "Aber die Pharisäer brachten ein Weib zu ihm, so im Ehebruch lebte. Jesus aber sprach: 'So verdamme ich dich auch nicht, geh' hin, und sündige hinfort nicht mehr." Herrgott! *(schlägt die Hände vors Gesicht. Das Kind drängt sich an Marie.)*

Der Bub' gibt mir einen Stich in's Herz. Fort! *(stösst das Kind von sich)* Das brüst' sich in der Sonne! *(plötzlich milder)* Nein, komm, komm her! *(zieht das Kind an sich)* Komm zu mir! "Es war einmal ein armes Kind und hatt' keinen Vater und keine Mutter . . . war Alles tot und war Niemand auf der Welt, und es hat gehungert und geweint Tag und Nacht. Und weil es Niemand mehr hatt' auf der Welt . . ." Der Franz ist nit kommen, gestern nit, heut' nit . . . *(blässert hastig in der Bibel)* Wie steht es geschrieben von der Magdalena? . . . "Und kniete hin zu seinen Füssen und weinte und küsste seine Füsse und netzte sie mit Tränen und salbte sie mit Salben." *(schlägt sich auf die Brust)* Heiland! Ich möchte Dir die Füsse salben! Heiland! Du hast Dich ihrer erbarmt, erbarme Dich auch meiner!

**Verwandlung—Orchester-Nachspiel*

(Marie's room. It is night. Candle-light. Marie, alone with her child, is sitting at the table, turning the pages of the Bible and reading.)

Marie

"And out of His mouth there came forth neither deceit nor falsehood." . . . Lord God! Lord God! Look not on me! *(She turns the pages)* "Wherefore the Pharisees had taken and brought to Him an adulterous woman. Jesus said to her: 'Thus condemned shall you not be. Go forth, go forth in peace, and sin no more.'" Lord God! *(Covers her face with her hands. The child presses up to Marie)*

The boy looks at me and stabs my heart. Be off! *(pushes the child away)* Go proudly in the sunlight! *(suddenly more gentle)* Ah, no! Come here! *(draws him closer)* Come to me. "And once there was a poor wee child and he had no father, nor any mother . . . for all was dead, there was no-one in the world, therefore he did hunger and did weep day and night. Since he had no-one else left in the world . . ." But Franz has not come yet, yesterday, this day . . . *(She hastily turns the leaves of the Bible)* What is written here of Mary Magdalene? . . . "And falling on her knees before Him and weeping, she kissed His feet and washed them, and washed them with her tears, anointing them with ointment!" *(Beats her breast)* Saviour! Could I anoint Thy feet with ointment! Saviour! As Thou hadst mercy on her, have mercy now on me, Lord!

Scene Change—Orchestral Postlude

Other Composers and Works of Interest

Ernest Bloch (1880-1959) – Swiss-born, naturalized American citizen. Post-Romanticism, Neo-Classicism. *Schelomo* (rhapsody for cello and orchestra), five string quartets.

Carlos Chávez (1899-1978) – Mexican. Twentieth-century nationalism. Six symphonies, concertos for violin and piano.

Henry Cowell (1897-1965) – American. Experimental twentieth-century composer. Wrote important text on new techniques titled *New Musical Resources*. Pupils included George Gershwin and John Cage. Composed numerous works for solo piano including *The Aeolian Harp* and *The Banshee*, as well as 20 symphonies, five string quartets, and a wide array of other works.

Manuel de Falla (1876-1946) – Spanish. Mix of Impressionistic techniques with elements of Spanish nationalism. *Nights in the Gardens of Spain, El sombrero de tres picos* (The Three-Cornered Hat, ballet).

Howard Hanson (1896-1981) – American. Post-Romanticism. Six symphonies, including the *Romantic* (No. 2), *Merry Mount* (an opera). Also important music educator, serving as director of the Eastman School of Music from 1924-1964.

Arthur Honneger (1892-1955) – Swiss. Post-Impressionism, Neo-Classicism. *Pacific 231.*

Leos Janácek (1854-1928) – Czechoslovakian. Late works are decidedly modern in nature. *Sinfonietta.*

Ernst Krenck (1900-1991) – Austrian, long-time American resident. Experiments with jazz elements in modern twentieth-century music, serialism. *Jonny spielt auf* (an opera), choral works, five symphonies, eight string quartets.

Darius Milhaud (1892-1974) – French. Post-Impressionism with added jazz elements. *La Création du monde.*

Carl Orff (1895-1982) – German. Conservative, tonal twentieth-century composer. Also important contributions to music education. *Carmina Burana* (for solo voices, chorus, and orchestra).

Ottorino Respighi (1879-1936) – Italian. Post-Romanticism. *Sinfonia drammatica, Fountains of Rome, Pines of Rome.*

Erik Satie (1866-1925) – French. Post-Impressionism. Most important works for solo piano. *Gymnopédies, Gnossiennes.*

Ruth Crawford Seeger (1901-1953) – American. Experimental twentieth-century composer. Important collector of American folk music. *String Quartet* (1931), numerous piano accompaniments for collected folk songs.

William Grant Still (1895-1978) – American. Twentieth-century nationalism. Important African-American composer. *Afro-American Symphony* (Symphony No. 1).

Ralph Vaughan Williams (1872-1958) – English. Post-Romanticism with some elements of Impressionism/Post-Impressionism as well. Nine symphonies, including *A Sea Symphony, A London Symphony,* and *A Pastoral Symphony*; also concertos for piano, violin, oboe, and tuba; numerous important works for chorus and also for solo voice.

Heitor Villa-Lobos (1887-1959) – Brazilian. Twentieth-century nationalism. *Bachianas Brasileira.*

Endnotes

1. Alan Rich, "Music at the Turn," *LA Weekly* (January 8-14, 1999), http://www.laweekly.com/ink/printme.php?eid=3294.

2. Puccini to Tito Ricordi, Paris, no date, in *Composers on Music*, ed. Sam Morgenstern, (New York: Pantheon Books, 1956), 291.

3. Cui to M. S. Kerzina, February 16, 1914, in *Music in the Western World: A History in Documents,* eds. Piero Weiss and Richard Taruskin (New York: Schirmer Books, 1984), 442.

4. Letter to the editor, *Boston Herald*, 1924, quoted in John Amis & Michael Rose, eds., *Words about Music*, Marlowe Press: New York, 1995, p. 340.

5. Per Skans, *Igor Stravinsky: Symphony of Psalms/Rite of Spring,* compact disc liner notes, BISCD 400.

6. Ibid.

7. K. Marie Stolba, *The Development of Western Music: A History,* 3rd ed. (Boston: McGraw-Hill, 1998), 611.

8. Michael Kennedy, ed., "Dmitry Shostakovich," *The Concise Oxford Dictionary of Music* (Oxford: Oxford University Press, 1985), 592.

9. David Pogue and Scott Speck, *Classical Music for Dummies* (Foster City, CA: IDG Books Worldwide, 1997), 84.

10. Michael Kennedy, ed., "Paul Hindemith," *The Concise Oxford Dictionary of Music* (Oxford: Oxford University Press, 1985), 300.

11. Joseph Machlis and Kristine Forney, *The Enjoyment of Music,* 7th ed. (New York: W. W. Norton, 1995), 506.

12. J. Peter Burkholder, *Charles Ives: The String Quartets,* The Lydian String Quartet, compact disc liner notes, Centaur CRC 2069.

13. Ibid.

14. Michael Kennedy, ed., "Aaron Copland," *The Concise Oxford Dictionary of Music* (Oxford: Oxford University Press, 1985), 147.

15. Robert Shearman and Philip Seldon, *The Complete Idiot's Guide to Classical Music* (New York: Alpha Books, 1997), 231.

16. Claudia Maria Knispel, *Pierrot: Schönberg, Vrieslander, Kowalski, Künneke,* Ensemble >das neue werk<, compact disc liner notes, Musicaphon 56837.

17. Stolba, *The Development of Western Music*, 598.

18. Joseph Kerman, *Listen*, 3rd ed. (New York: Worth Publishers, Inc., 1980), 423.

19. Hans Moldenhauer, *The Death of Anton Webern* (New York: Philosophical Library, 1961), 88-89. This book is a fascinating read and is highly recommended for anyone interested in the day-to-day history of World War II and its aftermath.

20. Allen Forte, *The Atonal Music of Anton Webern* (New Haven: Yale University Press, 1998), 204-232.

Study Guide

Chapter 8 Review Questions

True or False

___ 1. *The Rite of Spring* has become one of the most respected compositions of the twentieth century.

___ 2. Prokofiev's *Alexander Nevsky* was both a film score and a cantata.

___ 3. The music of Charles Ives is very consonant and predictable.

___ 4. In the late 1940s, composers including Pierre Boulez and Milton Babbitt began to experiment with total serialism.

___ 5. Schoenberg wrote *Pierrot Lunaire* in 1912.

___ 6. Anton Webern moved to America before the start of World War II.

___ 7. Shostakovich's Symphony No. 7 (*Leningrad*) was composed as a direct reaction to Hitler's invasion of Russia.

___ 8. Bartók was a fine pianist as well as a gifted composer.

Multiple Choice

9. System of musical organization developed by Arnold Schoenberg to guarantee absolute atonality.
 a. *Klangfarbenmelodie*
 b. *Sprechstimme*
 c. Serialism
 d. Neo-Classicism

10. Composed *Wozzeck, Lulu,* and the *Lyric Suite.*
 a. Arnold Schoenberg
 b. Anton Webern
 c. Alban Berg
 d. none of the above

11. Hungarian composer who was a master of the arch form.
 a. Igor Stravinsky
 b. Béla Bartók
 c. Dmitri Shostakovich
 d. Alban Berg

12. Russian composer who spent the bulk of his compositional life battling between trying to be an artist who served the needs of the Soviet state and being true to his own artistic vision.
 a. Igor Stravinsky
 b. Béla Bartók
 c. Dmitri Shostakovich
 d. Alban Berg

13. Composed the *Symphony in B-flat for Concert Band.*
 a. Igor Stravinsky
 b. Aaron Copland
 c. Anton Webern
 d. Paul Hindemith

14. Written by Aaron Copland in 1964, _____ is an interesting mixture of 12-tone techniques and the hymn *Amazing Grace.*
 a. *The Tender Land*
 b. *Fanfare for the Common Man*
 c. *Emblems*
 d. *Appalachian Spring*

15. Founder of the *Ballets Russes.* Commissioned works from Igor Stravinsky.
 a. Serge Diaghilev
 b. Alan Rich
 c. Rimsky-Korsakov
 d. César Cui

Fill in the Blank

16. Compared to many other major modern composers, _____ was particularly generous in creating works for instruments that had been frequently overlooked.

17. The score for Copland's ballet *Rodeo* was commissioned by famed dancer and choreographer _____.

18. _____ is a dramatic form of vocal delivery that is half-spoken, half-sung on specific, notated musical pitches.

19. Bartók's _____ demands virtuoso performances from every member of the orchestra.

20. Stravinsky's middle style period is usually referred to as _____.

21. In addition to his numerous compositions, American composer _____ wrote the books *Essays Before a Sonata* and *Memos.*

22. Early compositions by Schoenberg, Berg, and Webern were written in the _____ style.

Short Answer

23. List four artistic genres that developed during the twentieth century.

24. List three important ballet scores by Igor Stravinsky.

25. List three important ballet scores by Aaron Copland.

Essay Questions

1. Discuss Aaron Copland's decision to alter his compositional style in an attempt to find a larger audience.

2. Discuss Schoenberg's development of serialism and its impact on general classical music audiences.

Chapter 9
Modern Music, 1950~Present

"There is no such thing as dissonance:
it is only an extreme form of consonance."

Arnold Schoenberg

*T*he second half of the twentieth century and the first few years of the new millennium have seen a number of innovations in the world of classical music. All of the musical styles discussed in Chapter 8 continue to be explored by various composers, and several distinctly new idioms have been introduced as well. In particular, a number of composers began utilizing the latest technical developments to enhance their compositions, including the use of tape-recording equipment (and now, digital), experiments with computer-generated materials, and by the use of a wide variety of electronic keyboards and other tone-generating devices. From the earliest synthesizers in the late 1950s to the newest digital sound-sampling computers (which can also be disguised as keyboards), some modern composers have been very quick to incorporate the latest scientific developments into their music.

Over the past fifty years or so, some composers have continued to retreat into academia, composing music that is technically challenging and extremely intricate, but, ultimately, lacking in broad audience appeal. In a very real sense, universities and conservatories have become the newest patrons of the arts. Other artists have been bold to experiment with more freedom in their works, sometimes going so far as to create multi-media spectacles that often cross into what is commonly referred to today as "performance art." Again, many of these artists feel they are being true to a higher calling, but frequently audiences have not responded favorably to these works. Finally, a younger generation of composers has come along in the past four decades who seem to be managing a somewhat delicate balancing act: mixing together a number of diverse musical elements but still managing to find favor with a broader audience, and, in some cases, with a frequently conservative classical music community as well. As classical music continues to evolve, composers are enjoying

more freedom from artistic boundaries than at any time in the history of music. In the world of music, at least, technology is truly creating a "global community," where musicians have instant access to literally thousands of different musical styles and millions of individual pieces of music. In a recent interview, composer Ellen Zwilich commented on this growing universal language of music:

> This is a time that requires a new way of looking at things, and for the composer, a new way of existing. . . . It seems to me that there are still a lot of people talking about what the music of our era is, what is the language of our day. . . . But that's an attitude that comes from a time when people were insulated and isolated [1600-ca. 1825, for example]. At that time in central Europe, for example, they had no idea as to what was going on in Asia or Africa, nor even in North America. The world they knew then was circumscribed and it was therefore easy to know what the music of that time and place was. But now, when we have the world at our fingertips, it's running away from reality to suggest that it will ever come out one way again, that there [can be a single musical style of] this era, this decade, or even this year. When you have a perhaps bewildering array of choices, you must cultivate a habit not only of experiencing the pleasures of exploring, but also the burdens of choosing the existential journey, of putting yourself, your music (if you are a composer) together. And the listener can do the same thing, as can the performer.[1]

A few of the most important stylistic developments and some of the composers responsible are discussed in the following pages. Be aware that this chapter is by no means "exhaustive," but rather, a brief overview of a few of the more recent trends in the world of classical music. The following artists and their works are introduced in a roughly chronological order, but be aware from the outset that in many instances there is a tremendous overlapping of styles. In particular, you should be aware of movements toward total control in music (total serialism) and toward a greater freedom (aleatoric music), and, in some cases, unusual mixtures of the two. The development of a wide array of electronic musical elements began in the late 1940s and continues to have an impact on the work of a number of different composers. Of particular note is the development of a technique called musique concrète, which was conceived in the late 1940s by composer and electrical engineer Pierre Schaeffer at the Radiodiffusion-Television Francaises (RTF) studios. Originally, the term musique concrète referred to the recording of sounds made in nature or created by man, and then subsequently arranging these recorded elements into a sort of musical collage. Over the years, the term has evolved to include significant electronic alterations of a variety of recorded sounds, both natural and man-made, which can then be put on tape as a completed work or used in conjunction with other methods of musical production. Musique concrète techniques have found their way into the works of many modern composers, including recent artists who use the latest digital computers to sample sounds and play them back at any pitch level, in any rhythm pattern, and as a single melodic line or as a harmonic and/or polyrhythmic device. Basically, if you can think of it today, there is a computer that can make it happen. Finally, you will also be introduced to composers who have begun to embrace a variety of musical techniques, from the latest cutting-edge technology to a return to a more "audience friendly" Romantic sensibility. Beyond the popular term Neo-Romanticism, a new term, eclecticism, is beginning to take hold in the world of classical music. This term is sometimes being used to refer to composers who are no longer using one clearly definable musical style, but rather, are freely mixing elements from a wide array of styles and techniques to create their compositions.

musique concrète

eclecticism

John Cage (1912~1992)

John Cage's musical journey as a composer took him from total control over his early works to a newfound sense of almost total freedom in his later compositions. Along the way he experimented with a number of new sounds, total silence, and the introduction of electronic elements into some of his creations. Cage was a student of both Arnold Schoenberg and Henry Cowell, and their influences can clearly be seen in his early compositions. During this early period of creativity, Cage's most important compositions were for percussion ensemble, and he also created several innovative works for piano. Drawing inspiration from Henry Cowell, Cage began to experiment with altering the basic timbre of the piano by placing various objects inside the instrument.

John Cage, playing a piano at the CBS Television Studio, 1967. Photographer: Unknown. **Source:** *Courtesy of the John Cage Trust.*

His discovery of "prepared" piano techniques happened almost in a moment of desperation. He had been asked to write new music for a dance created by Syrilla Fort titled *Bacchanale*. Cage tells the story:

> I was still writing twelve tone music for piano then and I knew that it wouldn't work for the Bacchanale which was rather primitive, almost barbaric. My percussion music was fine, but there was no room in the dance theatre for all those instruments. I worked and worked without getting anywhere. The performance was only three days off. Then suddenly I decided that what was wrong was not me—it was the piano. I remembered that Henry Cowell had used his hands inside the piano and had even used a darning egg to slide along the strings, so I began trying things inside the piano too—magazines, newspapers, ash trays, pie plates. These seemed to change the sound in the right direction, making it percussive, but they bounced around too much. I tried using a nail, but it slipped around. Then I realized that a bolt or a large wood screw, inserted between two strings, was the answer. This changed every aspect of the sound. I soon had a whole new gamut of sounds, which was just what I needed. The piano had become, in effect, a percussion orchestra under the control of a single player.2

Cage would go on to write a number of works for prepared piano, including *Bacchanale, Meditation, The Perilous Night, Sonatas and Interludes, Music for Marcel Duchamp,* and the *Concerto for Prepared Piano and Chamber Orchestra*.

The Perilous Night (New York City, Winter 1943-44)

This particular work for prepared piano calls for over 35 preparations of the instrument, including bolts, nuts, screws, and pencil erasers arranged around selected strings inside the instrument. John Cage said that *The Perilous Night* was written to represent "the loneliness and terror that comes to one when love becomes unhappy."3 Everything you hear in this brief movement is played on a conventional acoustic grand piano. There are no electronic effects of any kind. The only alterations are the objects mentioned above.

Listening Guide

The Perilous Night (New York City, Winter 1943-44)
Movement IV
John Cage (1912-1992)

Format: Suite for solo prepared piano
Performance: William Grant Naboré, piano
Recording: American Piano Music of the 20th Century (Doron DRC3002)

Performance Notes: Recorded in Geneva, Switzerland in January 1993. African-American pianist William Grant Naboré serves as the Director of the International Foundation for the Piano at Lake Como, Italy.

:00 Although this piece may sound quite random to your ears, Cage's early works are actually completely notated. He calls for specific placement of each of the foreign objects placed within the body of the piano, and all of the rhythms, accents, and dynamic markings are notated on the score as well. The right hand plays two notes over and over in a straight eighth-note pattern while the left hand plays lines of much longer duration below. The rhythmic structure is actually quite simple, but the altered tones make it sound more rhythmically complex than it really is.

aleatoric

Drawing from his studies into Zen philosophy, Cage began to develop a new musical language that made use of random chance elements. He called this new method *indeterminacy,* but most composers and historians have adopted the term **aleatoric** music. In this system, such as it is, elements of pieces, or even the preparation of entire compositions and performances, are left up to chance operations. Most frequently, Cage made use of the *I Ching* (Book of Changes), which is an ancient Chinese method of tossing three coins to arrive at random conclusions. Cage developed a system of organization so that selections of musical instruments, durations for musical events, and even entire compositions could be created by random chance. In 1951, Cage spent time in an anechoic chamber (basically a sound-proof room) at Harvard University. He expected to hear only silence, but instead, he heard two sounds, one high and one low. The high-pitched sound was his nervous system, and the lower pitch was the blood coursing through his veins. It was a moment of revelation for the composer, who began to theorize that as long as we are alive, there could never be "total silence." He therefore redefined silence as "the absence of intended sound."[4] One of his most famous chance compositions is a work made up entirely of "non-intentional sounds," titled *4'33"* (Four Minutes and Thirty-Three Seconds). The sheet music is published with three individual movements, each is marked "tacet," which means "don't play anything." The concept for the work is that all sounds have a musical component, and whatever occurs during the given timeframe "becomes" the music. A typical performance of the work on solo piano, for example, would have the performer opening the piano lid to indicate the beginning of the work, and then closing the lid four minutes and thirty-three seconds later to indicate the conclusion of the piece. To indicate the individual movements, the performer places his or her hands above the keyboard but makes no sound on the instrument. Admittedly, this was an extreme example, even for John Cage, but his point that musical elements can exist in nature is well taken. As Cage once said, "Silence is not acoustic. It is a change of mind."[5]

Over the course of his long career, John Cage created a number of controversial works that continue to influence composers and other artists today. Cage experimented with various aspects of electronic music, including *musique concrète*. He created multi-media works that might include dance, music, visual elements, and even active audience participation. Beyond the previously mentioned compositions, a short list of Cage's most influential works includes *Construction 1 in Metal* (for percussion sextet), *Imaginary Landscape IV* (for 12 radios, 24 players and conductor), and *Fontana Mix* (for electronic tape, sometimes performed in conjunction with other works and/or with multi-media elements). He was also a prolific writer, creating artistic books of free-form poetry and commentaries about the arts. His most important book is titled *Silence: Lectures and Writings*. In 1985, writer, music critic, and occasional radio personality Tim Page had the chance to interview John Cage for a radio program called *Meet the Composer*. The following is a transcript of that conversation.

DIG DEEPER

BOOKS
Silence: Lectures and Writings by John Cage; *The Music of John Cage* by James Pritchett; *The Boulez-Cage Correspondence* ed. by Robert Samuels

A Conversation with John Cage by Tim Page

John Cage and I spoke in WNYC studios, New York, for a nationally syndicated radio program called *Meet the Composer*. We began our discussion with the onset of Mr. Cage's career in the mid-1930s.

John Cage: I remember when I applied for a job with the WPA in San Francisco, the music department told me I wasn't a musician. I said I needed a job and I worked with sound, so where could I go? They told me to try the recreation department. I got a job with a San Francisco hospital, a job keeping children quiet. Since I was interested in sound, they said, I could try to stop the children from making any. So I went to the hospital and taught the children rhythmic games. I had them be very quiet, take their shoes off and walk around the room.

Tim Page: But you had already studied composition with Arnold Schoenberg, and *he* certainly knew you were a musician. As a matter of fact, he took you on as a scholarship student.

Cage: When I asked Schoenberg if he could teach me, he said his price was probably beyond my means. I said don't mention it, because I don't have any money at all. He asked me if I would devote my life to music; I said yes, and he agreed to teach me for nothing.

Page: What did you learn from Schoenberg?

Cage: He was an extraordinary teacher, and I don't know if I can answer your question and do him full justice. Once he sent us to the blackboard to solve a problem in counterpoint. He gave us all the same *cantus firmus:* We knew it by heart because in the two years we'd been working with him, he'd never changed it. It was C-D-F-E-D-C. So I solved the problem; he said I was correct and told me to do another. And then another. Anyway, I gave him about eight or nine solutions and he continued to ask for more. Finally I said—not at all sure of myself—that there weren't any more solutions. He told me I was correct. Then he asked what

the principle underlying all of the solutions was. I couldn't answer. I had always worshipped Schoenberg as though he were superior to other human beings, but at this moment he seemed so vastly superior that I was speechless. This happened in 1935, and it would be at least 15 more years before I could answer his question. Now I would answer that the principle underlying all of our solutions is the question we ask.

Page: Schoenberg later characterized you as an inventor of genius and you rose to prominence with some intriguing works for bones, rattles, specially designed percussion instruments and the prepared piano.

Cage: Well, I had become convinced that everything has a spirit and that everything sounds. I became so curious about the world in which I lived, from a sonic point of view, that I began hitting and rubbing everything I came near—whether I was in the kitchen or outdoors, and I gradually assembled a large collection of unconventional instruments.

Page: How do you prepare a piano?

Cage: If you put a plate on the strings it will bounce around and you can't keep it in position. If you put a nail between two strings, it will slide out. But a wood screw, with its grooves, will stay. The objects work as mutes, and the sound becomes softer than an ordinary piano, and quite a bit different. I find it as fascinating to prepare a piano as it is to walk along a beach and pick up shells.

Page: Your most famous piece is "4:33", which a lot of people think is simply the ultimate Cage put-on. Should an ideal performance of this work take place in a soundproof room? Are we supposed to hear silence, or is the work's duration simply a frame into which we can pour the ambiance of the room and our surroundings?

Cage: It doesn't matter where you are—whether you are in a soundproof chamber or outdoors on the streets of Manhattan. There are always sounds to hear. There is no such thing as silence. That has now been proven scientifically. There's no way to stop the reception of sound. If you keep out the sounds coming from outside, then you hear the sounds coming from inside.

Page: But is this a real composition? We traditionally think of composition as the careful ordering of sounds, and here there is no ordering going on.

Cage: "4:33" was written by means of chance operations. We first performed it in Woodstock, New York, in a theater out in the woods. You can hear the breeze through the trees in the first movement. During the second movement, you could hear drops of rain hitting the roof. In the third movement, people started talking because they realized that the group wasn't going to make any sound, so the sound of people talking became the third movement.

 The silent piece actually comes from my study of oriental philosophy—Zen Buddhism in particular. I had noticed that nobody understood what I was doing in my music: I'd write a sad piece and the audience would laugh or I'd write something funny and nobody would even smile. Then I'd go to a concert of works by some other composer, and it wouldn't be clear to

me what was happening there. The difficulty of understanding musical language bothered me, so I decided that if music were the language and what we were to do, while listening, was to understand it, then I would stop writing. I needed to find a more satisfactory reason for composing than to think of it as communication or language or something to be understood. And then a friend of mine, who had been studying Indian music, came up with a new definition for me. She said the purpose of music is to sober and quiet the mind, thus making it susceptible to divine influences. And Lou Harrison found a similar quote from 17th-century England. So this is a proper and tested reason for writing music—not a question of communication or something to be rationally understood, but a question of changing our minds about the fact of being alive.

I became deeply concerned about finding quietude. I knew that, living in the United States in the 20th century, there was no quiet place left, so a quiet mind has to be quiet in a noisy place. I have a friend who owns a lake in northern California and even there he hears airplanes flying overhead. And his refrigerator makes a lot of noise. So we simply can't get away from sound in this century. What we must do is change our minds and hear those sounds with enjoyment in order to live in a manner that makes us glad to be alive.

Page: But this seems simplistic. You are an expert mycologist—an expert on gathering mushrooms. And obviously one mushroom is not as good as another: One will feed you, the other will kill you. So why are sounds necessarily as good as each other?

Cage: What's *not* good is trying to decide which one is good and which one is bad. The whole concept of value judgment is a mistake, and if you insist on eating dessert every time instead of eating your vegetables, then you can just listen to the sounds that please you. I like to listen to all sounds; I haven't heard any that I dislike. In fact, I like music less than other sounds I can think of. I don't like regular beats in music. I know that my "Third Construction" has a lot of rhythmic patterns in it, but now I prefer a kind of unpredictability about where the next sound will come from.

John Cage, seated before a chessboard at the New York City loft, 1988. Photographer: Young Kyun Lim. Courtesy of John Cage Trust.

Page: I find it very interesting that so many of the minimalist and jazz composers—most of whom work with a very regular beat—look up to you as a father figure.

Cage: Well, I've produced a large body of work. And that work has different aspects and some of those aspects could lead a composer in the direction of regular beats. But, for me and my own experience now, I don't need any music at all. I have enough to listen to, with just the sounds of the environment. I listen to the sounds of Sixth Avenue.

Page: How do you respond to those listeners and critics who hear a work like "4:33" and insist that this is not music? Do you still get angry letters?

Cage: When you finish a work, it really isn't finished. The person who finishes a piece is the person who uses it, who listens to it. Now if somebody is angry with something I've done, they're unable to finish it, unable to do anything with it. So, as far as they're concerned, it oughtn't to exist. I received a very angry letter recently, written by a young composer from California who said I had ruined the art of music for him. I told him that if he had that feeling about my work, then he shouldn't pay any attention to it. He should work on what he can do and what he believes it necessary to do. I've worked that way all my life.

Page: One thing that I think is important about your work is that you've helped us out of the idea of a historical continuum, which had become a kind of cul-de-sac. Instead of the idea of one forward thrust, one vanguard, as it were, we now accept the idea of a personal music.

Cage: When I was young, there were only two things that you could do if you wanted to be a serious composer: follow Schoenberg or follow Stravinsky. They didn't even give Bartok a chance! Now, not only because of my work but because of the great changes and interpretation of cultures, I think you can go in many directions.

Page: Where *are* we going? Will music continue to spatter in all different directions?

Cage: I wouldn't say "spatter." I would say "delta." Instead of a mainstream, we now have a river dividing itself into many streams. There are countless possibilities and they all lead to the ocean. The book Joyce was going to write after *Finnegans Wake* was going to have to do with ocean. Not just tides, not just "here comes everybody" but "here we are, everywhere."

Page: One thing Joyce said about *Finnegans Wake* has always intrigued me. He said that it took him more than a decade to write the book, and that he didn't see any reason why it shouldn't take somebody more than a decade to read it.

Cage: I would hope it would take longer.

Interview with John Cage from "Meet the Composer" radio interview. Used with permission of WNYC Radio.

Thirty Pieces for Five Orchestras

This work was commissioned by the organizers of the New Music Festival in Metz, France. In creating this work, Cage undertook a number of different chance operations to determine ensemble makeup, musical materials, and part assignments. Each of the 30 individual pieces is roughly one minute in length, so the entire performance lasts about thirty minutes. Each of the five orchestras plays independent of one another, with periods of silence and overlapping music between the five different groups. No conductor has a copy of the entire score, but Cage does suggest that each conductor familiarize themselves with the other orchestras' material so as to avoid any "surprises" at the performance. The composer's goal in this system of organization was to keep any one conductor from "pre-determining" the outcome of a given performance. Ideally, Cage wanted the five orchestras set up as far apart from each other as possible, with the audience surrounded by the musicians.

Listening Guide

Thirty Pieces for Five Orchestras (excerpt)
John Cage (1912-1992)

Format: Aleatory work for multiple ensembles
Performance: Savaria Symphony Orchestra. Conductors: László Tihanyi, 1st orchestra; Dieter Kempe, 2nd orchestra; Zsolt Serei, 3rd orchestra; Katalin Doman, 4th orchestra; and Mark Foster, 5th orchestra
Recording: *Cage: Thirty Pieces for Five Orchestras/Music for Piano* (Hungaroton HCD 12893)
Performance Notes: Recorded July 26-28, 1986 in the Szombathely Cultural and Sports Centre, Hungary.

:00 No listening guide could ever prepare you for a work such as this one. You will hear periods of intense musical material followed by near or even total silence. Some of the material should sound "structured" to your ear while other moments will feel quite random. This unsettled feeling is exactly what the composer intended. Each "piece" lasts approximately one minute. The listening example presented here is an excerpt from the first five minutes of the composition.

George Crumb (b. 1929)

Composer George Crumb has made a career out of doing the predictably unpredictable. He writes music for unusual instruments, calls for extended performance techniques from both traditional instruments and the human voice, and uses electronic amplification as a performance element in many of his compositions. Meanwhile, his works, no matter how "far out," manage to maintain a sense of organization and accessibility unavailable to the average listener in most *avant-garde* modern music. Crumb mixes together chance elements with meticulously controlled music to achieve highly original works that are full of drama, beauty, and powerful emotional content. Historian Joseph Kerman summed up Crumb's music quite nicely when he wrote:

Composer George Crumb (right) pictured with guitarist and Bridge Records co-founder/producer David Starobin. Bridge Records is currently in the process of creating a complete recorded edition of Crumb's works in direct collaboration with the composer.
Courtesy: www. BridgeRecords.com

> George Crumb has created his own unique new sound world—quiet, precise, vibrant, endlessly changing, a controlled musical kaleidoscope of fascinating elegance. In some other respects, his music is relatively conservative. Although his rhythms often become highly complex and although he likes to punctuate his pieces with vague, meditative silences, there is always a clear sense of direction in his music, a sense of beginning, evolving, and ending.6

Over the years, George Crumb has made use of "non-conventional" instruments such as the toy piano, harmonica, musical saw, banjo, and a wide array of percussion instruments from various cultures. Working in collaboration with extraordinarily gifted singers including the late Jan DeGaetani, Crumb's works have also pushed vocal techniques to new extremes. Among his most notable developments, Crumb requires vocalists to sing microtonal intervals, to sing into plastic tubes, to sing into the body of an open piano, and to use a variety of special effects including screams, sighs, whispers, tongue clicks, and fluttering effects.

Crumb has also composed a number of important works that amplify traditionally acoustic instruments, thus allowing for more diversity in the tone colors available. Some of his best-known compositions are *Echoes of Time and the River* (for orchestra, which won the 1968 Pulitzer Prize for Music), *Black Angels: 13 Images from the Dark Land* (for electrified string quartet), and *Ancient Voices of Children* (for mezzo-soprano, boy soprano, and mixed chamber ensemble). Crumb has also written extensively for piano, including a four-volume set titled *Makrokosmos*, and individual solo works titled *Gnomic Variations, Processional,* and, most recently, *Eine Kleine Mitternachtmusic* (A Little Midnight Music).

Ancient Voices of Children

This work was composed in 1970 in response to a commission from the Elizabeth Sprague Coolidge Foundation. Based on poems by Federico Garcia Lorca, the piece is written for mezzo-soprano, boy soprano, oboe, mandolin, harp, amplified piano, toy piano, and three percussionists. At various points in the work, the composer also calls for a musical saw and a harmonica. In the introduction to the score, the composer wrote:

> The instruments employed in ANCIENT VOICES were chosen for their particular timbral potentialities. The pianist also plays toy piano (in the 4th song), the mandolinist musical saw (2nd song) . . . and the oboist harmonica (4th song). Certain special instrumental effects are used to heighten the "expressive intensity" – e.g., "bending" the pitch of the piano by application of a chisel to the strings (2nd song); use of a paper-threaded harp (in "Dances of the Ancient Earth"); the frequent "pitch-bending" of the oboe, harp and mandolin. The mandolin has one set of strings tuned a quarter-tone low in order to give a special pungency to its tone. The three percussionists command a wide range of instruments, including Tibetan prayer stones, Japanese temple bells and tuned tom-toms. The instrumentalists are frequently called upon to sing, shout and whisper.

> In composing ANCIENT VOICES OF CHILDREN I was conscious of an urge to fuse various unrelated stylistic elements. I was intrigued with the idea of juxtaposing the seemingly incongruous: a suggestion of Flamenco with a Baroque quotation ("Bist du bei mir," from the Notebook of Anna Magdalena Bach), or a reminiscence of Mahler with a breath of the Orient.[7]

Perhaps most interesting in this work is Crumb's writing for the human voice. The mezzo-soprano part was written with Jan DeGaetani in mind, and the work is dedicated to her. DeGaetani had impressed Crumb with her amazing voice control, as well as her ability to bend pitches, make large interval leaps, and run her voice from a whisper to a scream without ever breaking. He also calls for the singer to sing into the amplified piano while the damper pedal is released from the strings, thus allowing "a shimmering aura of echoes."[8] Several portions of the text are written in such a way as to imply a child's voice, and Crumb calls for a boy soprano, who performs offstage until the last page of the score, lending an even more distant "ethereal" quality to his voice.

Listening Guide

Ancient Voices of Children
Movement III—*¿De dónde vienes, amor, mi niño? Dance of the Sacred Life-Cycle (From where do you come, my love, my child?)*
Movement IV—*Todas las tardes en Granada, todas las tardes se muere un niño (Each afternoon in Granada, a child dies each afternoon)*

George Crumb (b. 1929)

Format: Multi-movement chamber work for mezzo-soprano, boy soprano, oboe, mandolin, harp, amplified piano, toy piano and three percussionists

Performance: Ensemble New Art, Fuat Kent, director; Marie-Louise Bourbeau, mezzo-soprano; Veronika Schaaf, boy soprano

Recording: *George Crumb: Gnomic Variations/Processional/Ancient Voices of Children* (Col Legno 31876)

Performance Notes: This particular performance uses an adult female voice in place of the boy soprano called for in the score. The way this performance was given and recorded, however, the changes in effect are hardly noticeable. The sonic intent of the composer is maintained. Recorded October 28-29, 1992 at the *Musikhochschule* in Munich, Germany.

Movement III

:00 This movement stands at the center of the entire composition and is built around a driving bolero rhythm that is heard throughout most of the movement. The work has meticulously noted sections that relate to one another, which have been placed around a central circle on the score. There is a brief opening for solo voice, followed by the entrance of the rest of the ensemble. As the voice sings through all of its material, other instruments enter and leave the texture at approximate moments relative to what is going on around them. Thus we see the incorporation of both chance elements and exacting twentieth-century compositional techniques.

¿De dónde vienes, amor, mi niño?	From where do you come, my love, my child?
De la cresta del duro frío	From the ridge of the hard frost.
¿Qué necesitas, amor, mi niño?	What do you need, my love, my child?
La tibia tela de tu vestido.	The warm cloth of your dress.
¡Que se agiten las ramas al sol	Let the branches ruffle in the sun
y salten las fuentes alrededor!	and the fountains leap all around!
En el patio ladra el perro,	In the courtyard a dog barks,
en los árboles canta el viento.	in the trees the wind sings.
Los bueyes mugen al boyero	The oxen low to the ox-herd
y la luna me riza los cabellos.	and the moon curls my hair.
¿Qué pides, niño, desde tan lejos?	What do you ask for, my child, from so far away?
Los blancos montes que hay en tu pecho.	The white mountains of your breast.
¡Que se agiten las ramas al sol	Let the branches ruffle in the sun
y salten las fuentes alrededor!	and the fountains leap all around!
Te diré, niño mío, que sí,	I'll tell you, my child, yes,
tronchada y rota soy para ti.	I am torn and broken for you.
¡Cómo me duele esta cintura	How painful is this waist
donde tendrás primera cuna!	where you will have your first cradle!
¿Cuándo, mi niño, vas a venir?	When, my child, will you come?
Cuando tu carne huela a jazmín.	When your flesh smells of jasmine-flowers.
¡Que se agiten las ramas al sol	Let the branches ruffle in the sun
y salten las fuentes alrededor!	and the fountains leap all around!

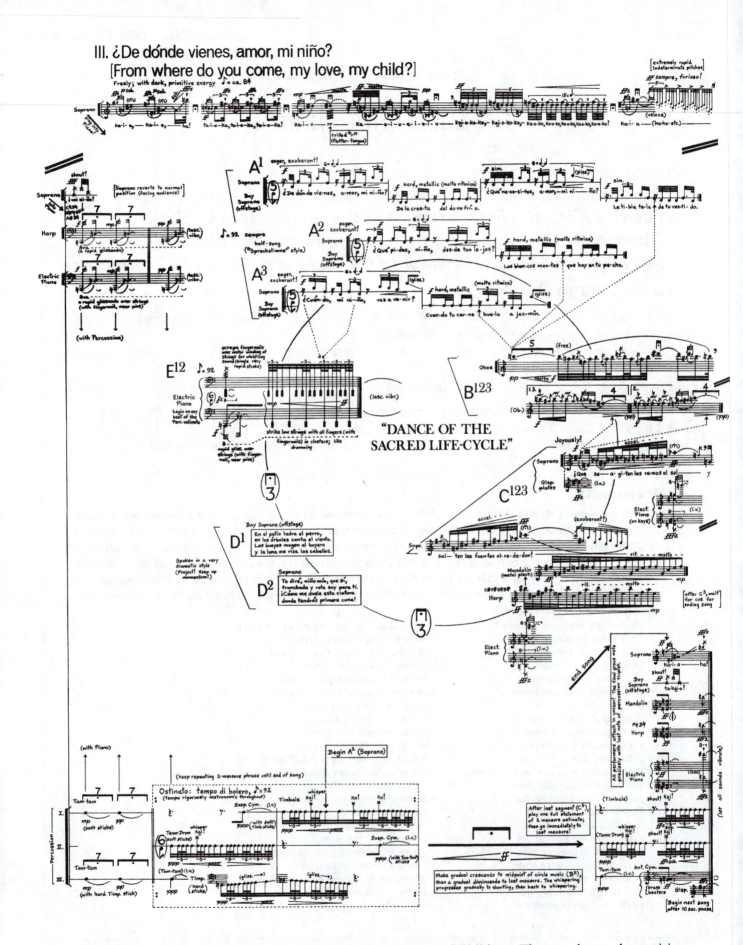

Reduced sample of a score page from George Crumb's Ancient Voices of Children. *The actual score the musicians read is over twice as large.*
Reprinted by permission of C. F. Peters Corp.

Movement IV

:00 This brief, haunting movement is built upon drone notes provided by the marimba and harmonica. Toward the end of the movement, Crumb introduces a toy piano, playing a quote from *Bist du bei mir (If Thou Be Near)* from the *Anna Magdalena Songbook* by J. S. Bach. The original piece speaks to the acceptance of death, and when played on toy piano as it is here, the excerpt provides a powerful counterpoint to Lorca's text.

Todas las tardes en Granada,	Each afternoon in Granada,
todas las tardes se muere un niño.	a child dies each afternoon.

By Federico Garcia Lorca, translated by Edwin Honig, copyright © 1955 by New Directions Publishing Corp. Reprinted by permission of New Directions Publishing Corp. George Crumb lyrics by permission of C.F. Peters Corporation.

Edgard Varèse (1883~1965)

Though he was born in France, studied in Paris and Turin, and lived for a time in Berlin, Edgard Varèse is generally considered an American composer. He immigrated to the United States in 1915 and spent most of his life teaching and composing in America. It is said that in his earliest days as a composer, Varèse's works were Post-Romantic in nature, but all of those pieces have been lost. The Varèse compositions that had a major impact on the world of modern music are full of experimentation and were written in the 1920s and 30s. Varèse was very interested in rhythm and "non-traditional" sounds. In fact, he didn't even care for the term "music," preferring to call his works "organized sound."[9] He composed extensively for percussion ensemble, frequently making use of non-pitch specific instruments and unusual sounds including small and large fire engine sirens. His best-known work in this genre is *Ionisation*. Composed between 1929 and 1931, this piece calls for over 40 different percussion instruments, plus the previously mentioned sirens. Another important work from this time period is *Ecuatorial,* written for bass voice with an orchestra that included an early electronic instrument called the *Ondes Martenot.* In 1936, he completed a groundbreaking work for solo flute titled *Density 21.5,* which made use of a number of new extended techniques for the instrument, including percussive effects. The title refers to the density of the metal from which a particular platinum flute was made.

Composers Edgard Varèse and Aaron Copland shaking hands during the presentation of an award.
Source: Library of Congress.

After the completion of *Density 21.5,* Varèse did not compose for a number of years though he continued to teach composition and orchestration. The composer had a long-standing interest in music produced by electronic means, and in the early 1950s he began to write electronic music. Working at the RTF studios, Varèse cre-

ated a *musique concrète* piece titled *Déserts*. The composer suggested that title of the work referred to all deserts, ". . . on earth, in space, in city streets, and in the minds of humans."[10] His last major composition, *Poème électronique*, was composed at the Philips Research Laboratories for use in the Philips Pavilion at the 1958 World Exhibition in Brussels. The pavilion itself was an experiment in radical design, created by the French architect Le Corbusier. He was assisted by Iannis Xenakis, who was both an architect and a composer. *Poème électronique* was recorded onto a multiple-track tape using sounds generated by *musique concrète* techniques and purely electronic means. The concept was that by separating the different sounds on the tape into various speakers throughout the building, visitors would literally be surrounded by sound. In addition, the tape controlled various lighting effects as well, making for a fully integrated artistic experience.

Olivier Messiaen (1908-1992)

Olivier Messiaen at the La Trinité Church organ console in Paris, 1973.
Source: Photo from the private collection of Nigel Simeone

Olivier Messiaen is important to the history of modern music as both a teacher and a composer. In addition, he was a very successful organist who helped expand pipe organ repertory and techniques throughout the course of his long career in music. His best known composition is the *Quatuor pour la fin du temps* (Quartet for the End of Time), which he wrote while in a Nazi prisoner-of-war camp during the early days of World War II. This work is full of deeply religious sentiments, drawing inspiration from biblical passages taken from the book of *Revelations*. After being released from prison in 1941, Messian returned to his post as a professional organist and teacher. Soon after, he accepted a new position at the Paris Conservatory where he taught a number of successful students including Pierre Boulez, Iannis Xenakis, and Karlheinz Stockhausen. Messiaen's compositional style was fiercely independent. He never adhered to one musical school of thought, and he encouraged his students to do likewise. He occasionally made use of serial techniques, frequently used complex rhythmic ideas, and made some experiments with electronic music, including *musique concrète* techniques. Messiaen was an avid bird watcher, and he made a practice of recording birdsongs in musical notation. These birdsongs frequently found their way into his compositions. Some of his most famous works include *Turangalîla-symphonie* (a large symphonic work that made use of the *Ondes Martenot*), *Ascension* (for organ, later arranged for orchestra), *Chronocromie* (for orchestra), and a number of compositions for organ.

Pierre Boulez (1925-2016)

Pierre Boulez divided his career in music between conducting and composing. He was a student of Olivier Messiaen at the Paris Conservatory in the 1940s, and he also studied methods of 12-tone composition with René Leibowitz, who studied with Schoenberg. Building on the works of Anton Webern, Boulez was one of the early pioneers of a system called **total serialism**, where not only the notes of a given composition were treated in a serial manner but also rhythm, dynamics, and even orchestration could be organized through mathematical formulas. Later, Boulez branched out even farther, incorporating aleatoric elements into his compositions. His most famous composition is *Le marteau sans maître* (The Hammer Without a Master) based on poems by the Surrealist writer René Char. The 9-movement piece features a contralto voice part with a chamber ensemble made up of alto flute, xylophone, vibraphone, guitar, viola, and various percussion instruments. Each movement calls for different instrumental forces, and only three of them feature the voice. The voice part in particular is quite challenging, requiring the singer to make wide leaps, sing glissandos, and at times make use of *Sprechstimme*. A few of Boulez's other important compositions are his three early piano sonatas (1946, 1948, and 1957), a composition for chamber orchestra and soprano titled *Pli selon pli* (Fold Upon Fold), and two works for orchestra titled *Rituel* and *Répons* (which also makes use of digital electronics).

total serialism

As a conductor, Boulez was a champion of modern music. Among other important posts, he served as the principal conductor for the BBC Symphony Orchestra from 1971-1975 and the New York Philharmonic from 1971-1974. He has also enjoyed a long association with the opera house at Bayreuth, where he conducted several productions of Wagner's *Ring* cycle. Boulez was also very active in the recording studio. As a conductor and a pianist, he made it a point to preserve performances of many of the twentieth century's most important compositions. In the mid-70s, at the invitation of French President Georges Pompidou, Boulez founded the *Institut de Recherche et de Coordination Acoustique/ Musique* (IRCAM), which is a sort of "think tank" for the exploration of *avant-garde* music. In particular, this organization has played an active role in the development of electronic music. One outgrowth of the IRCAM was the development of a professional chamber ensemble called *Ensemble InterContemporain*. Boulez served as director of the IRCAM until 1991, and he continued to conduct and record with that ensemble throughout the rest of his career chamber ensemble from time to time. In more recent years, Boulez continued to compose and conduct on a regular basis, serving as a regular guest conductor for both the London Symphony Orchestra and the Chicago Symphony Orchestra, to name but a few among his many guest conducting duties.

Karlheinz Stockhausen (1928-2007)

Karlheinz Stockhausen ran the gamut of modern compositional techniques over the course of his long career. He explored serialism and total serialism, aleatoric music, free-form notation, use of quotations, and a wide array of electronic music techniques. In much of what he wrote, he brought together diverse elements of these compositional styles. Some of his most influential works are *Kontra-Punkte* (*Counterpoint*, for 10 solo instruments), *Klavierstüke XI* (a piano work made up of 10 fragments that can be performed in any order), and *Gesang der Jünglinge* (*Song of the Youths*, which is for electronic tape). As Stockhausen's music evolved over the years, he has developed a theatrical flair in many of his performances. Here is a description of one of his works from the early 1970s. "Stockhausen wants to write music that is representative of the entire universe. One of his endeavors to depict activity outside the planet Earth is *Sternklang* (*Star Sound;* 1971), which is park music designed for five groups of performers (21 singers and instrumentalists). As names of stars or constellations are called out by the director, a group looks at the night sky and is supposed to read and perform the music emanating from that star or constellation."[11] Beginning in 1977, Stockhausen was working on a massive cycle of seven operas titled *Licht* (*Light,* which he subtitled *The Seven Days of the Week*). Each opera is focused on one day of the week, and the composer intended to perform the entire work over the course of a single week, something like what Wagner did with performances of his *Ring* cycle at Bayreuth. "Performance forces for these operas include solo voices, solo instruments, solo dances, choirs, orchestras, ballet and mimes, and electric and concrete music [*musique concrète*]."[12] The work was completed in 2003, and individual sections have now been performed, but a complete performance of the entire work has yet to be undertaken. Always one to embrace the latest technical innovations, Stockhausen has developed a very interesting presence on the Internet with a site that includes photos and other historical data, MP3 excerpts of his performances, and a full catalog of his scores and recordings. Today, the site continues to be well maintained and has new material added to it on a regular basis. The website address is www.stockhausen.org.

Milton Babbitt (1916-2011)

Perhaps more than any other composer in the twentieth century, Milton Babbitt fully embraced the concept of *total serialism.* A mathematician as well as a composer, Babbitt developed complex formulas that controlled every possible parameter in some of his compositions. A few of his early compositions include *Composition for Twelve Instruments, All Set* (for jazz ensemble), *3 Compositions* (for solo piano), and his first two string quartets. Babbitt was also the first composer to write extensively for the first generation of functional synthesizers in the early 1960s. Babbitt was hired as a composer/consultant by RCA to help develop their new Mark II synthesizer. He wrote several compositions specifically for this instrument, including *Composition for Synthesizer* and *Vision and Prayer* (for soprano and synthesizer). In performance, the synthesizer part would be played by means of a reel-to-reel tape recording, while, depending on the composition, any other performers would deliver their parts live from the stage. Another important work with electronic tape and soprano voice is *Philomel.* The tape for this work makes use of synthesized electronic sounds, as well as pre-recorded portions from the soprano. In performance, the singer is, in effect, singing a duet with a duplicate of her own voice. The work is somewhat unique

among the composer's compositions. From the 1970s forward, Babbitt focused his energies toward non-electronic compositions. He continued, however, to write in a very formalized, serialized musical language that most audiences find quite challenging. Consequently, Babbitt spent most of his life in academia, teaching at both Princeton and The Juilliard School of Music.

Outside of a very small group of "serious" musicians around the world, Milton Babbitt is perhaps best remembered for an article published in *High Fidelity* magazine in 1958 titled "Who Cares If You Listen." Babbitt had actually titled his article "The Composer as Specialist," but an editor, unbeknownst to Babbitt, thought the composer's title boring and changed it before publication. The article was actually a very accurate assessment of cutting-edge classical music at that time, but unfortunately, most people never got past the title. In a 1986 radio interview, Babbitt said:

> My original idea had been to tell the general public what it was like to be a composer—or at least to be my kind of composer. Call it a personal document. I simply had to face the fact that we had a tiny audience for our music, one made up mainly of professionals. I even made a great point out of the fact that we *were* trying to increase the audience but not by sensationalism, not by misrepresenting the music, not by trying to make of it something other than what it was but by attempting to interest listeners in the music as music. Back in the early 50s, we thought we could appeal to what might have been described as our fellow intellectuals with our words and this would bring them around to the sound of our music. But we discovered that what was taken even more resentfully than taking music seriously was *talking* about music seriously. The resentment that this induced made me very, very wary to talk about music again to a general audience. . . . I care very *much* if you listen and *where* you listen and *how* you listen.[13]

György Ligeti (1923-2006)

Hungarian composer György Ligeti made some brief experiments with electronic music, but many of his most famous compositions dealt with exploring the possibilities of more traditional instrumental and vocal performance while trying to incorporate elements more commonly associated with electronic sounds. From the late 1950s through most of the 1960s, Ligeti experimented with dense orchestrations that created a wash of sound perhaps best described as subtle undulations of sound transformation. His two most famous works are *Atmosphéres* (for orchestra) and *Lux aeterna* (Light Eternal, for chorus), both of which were used in the soundtrack for Stanley Kubrick's movie *2001: A Space Odyssey*. In both of these works, Ligeti wrote numerous independent lines of music that contain small, seemingly random changes in only one or two parts at a time. In point of fact, these compositions were strictly controlled, making use of canonic devices throughout. He used both micro-tonal inflections and thick clusters of notes that lend a certain "shimmer" to his music though there is rarely any discernable beat in these compositions. Later works began to explore constantly shifting rhythmic patterns, and in more recent years Ligeti embraced some Minimalistic techniques as well. Two works in this style include *Monument* (for two pianos, the subtitle for this work is "Monument—Self-portrait with Reich and Riley, and Chopin is Also Near") and *Etudes for Piano*.

Philip Glass (b. 1937)

Philip Glass.
Source:
© Shutterstock.com

American composer Philip Glass's early works were built around the 12-tone system of Arnold Schoenberg. Next he embraced the more tonal works of popular mid-century composers such as Aaron Copland, and he also showed an interest in the more experimental compositions of Charles Ives, Harry Partch, and Henry Cowell. In his 20s, Glass studied composition with Vincent Persichetti, Darius Milhaud, and Nadia Boulanger. While working with Boulanger in Paris, Glass took a job transcribing the music of sitar player Ravi Shankar into Western notation. Glass became fascinated with music from places such as India, North Africa, and the Himalayas. This new influence led to an interest in a budding new style called **Minimalism,** which was highly tonal, repetitive music that shared many of the extended meditative qualities found in the music of Eastern cultures. Glass started a bold new performing venture called The Philip Glass Ensemble that made use of new electronic keyboards mixed together with more traditional classical instruments. He also began creating extended theatre projects that culminated with the development of a very unusual opera titled *Einstein on the Beach.* Glass later decided to write an opera trilogy that focused on the lives of three men of ideas. He followed *Einstein* with *Satyagraha,* which dealt with the life of Mahatma Gandhi, and *Akhnaten,* which was based on the life of the first monotheistic pharaoh. In the past 25 years, Philip Glass has been quite prolific as a composer. As explained on his official website, some of his more recent operas include:

Minimalism

> *The making of the Representative for Planet 8* and *Marriages Between Zones Three, Four and Five* with librettos written by Doris Lessing and based on her novels; *Hydrogen Jukebox,* libretto by Allen Ginsberg and based on his poetry; *The Voyage,* based on the exploration of Christopher Columbus, written by David Henry Hwang; *The Fall of the House of Usher,* based on the Edgar Allen Poe short story; and the "pocket opera," *In the Penal Colony,* a musical theater work based on the short story by Franz Kafka. His most recent opera, *Galileo Galilei,* a collaboration with Mary Zimmerman, premiered in 2002.14

Today, Glass has moved away from strict Minimalism, focusing much of his attention toward the creation of a broader spectrum of various new instrumental and vocal works, as well as a great deal of music for film. In 2004 and early 2005, Glass had three world premieres of new compositions, various European premieres and performances, and he also saw three new films released for which he composed new music. In addition, he toured with the Philip Glass Ensemble performing a show titled *Philip on Film,* where the group performed Glass's music in conjunction with screenings of a wide array of films. Some his most recent compositions include Symphony No. 7, which was commissioned by the National Symphony Orchestra to celebrate the 60th birthday of conductor Leonard Slatkin; the *Lewis and Clark Piano Concerto,* a commissioned work whose premiere featured pianist

DIG DEEPER

VIDEO
Glass: A Portrait of Philip in Twelve Parts

Paul Barnes and native American flute player R. Carlos Nakai; and *Orion*, a multi-cultural work that was premiered as part of 2004 Cultural Olympiad in Greece in connection with the 2004 summer Olympic games.15 A few other recent compositions include his Symphony No. 8, a purely instrumental work; *The Passion of Ramakrishna*, a choral work written for the Pacific Symphony and Chorale; *Songs and Poems for Solo Cello*, a work written by cellist Wendy Sutter; and a collaboration with noted singer/songwriter Leonard Cohen titled *Book of Longing*. Glass has also written another new opera, *Appomattox*, which was premiered in late 2007 by the San Francisco Opera.

Finally, it is important to note that while composers associated with Minimalism, such as Philip Glass, have drawn sharp criticism from more traditional members of the classical music community, their compositions have brought an entirely new audience to the world of classical music in general, and opera in particular. Philip Glass and Steve Reich (see below) have also managed to branch out into the broader world of popular music, most commonly being labeled as "new age" artists.

Steve Reich (b. 1936)

Similar to Philip Glass, Steve Reich went through a formal training process, studying composition with Vincent Persichetti, William Bergsma, Darius Milhaud, and Luciano Berio; however, also along the same path as Glass, Steve Reich fell under the influence of music from non-Western cultures. As a percussionist, Reich studied African styles of drumming, Balinese gamelan, and traditional forms of cantillation, or chanting, of Hebrew Scriptures.16 Reich became fascinated with the concept of using subtle rhythmic (and sometimes harmonic) shifts within a vast sea of repetition, which he eventually labeled "pulse music." Some of his compositions made use of electronic tape, but he later broke from that technique. (It is interesting to note, however, that with the development of keyboards and computers capable of "sampling" various sounds, some of his more recent music has again embraced electronic elements.) He formed a group of three like-minded musicians called Steve Reich and Musicians, which has evolved over the years to include as many as 18 musicians depending on the

Steve Reich.
Source: Photo by Wonge Bergmann

work being performed. Reich has toured and recorded extensively with the group, frequently crossing the boundary between "classical" and "popular" music. A number of his recordings have sold very well in the "new age" category, and his concerts have taken place at jazz and popular music venues as well as more traditional concert halls. Some of his most influential explorations of Minimalism include *It's Gonna*

Rain (for tape loops), *Piano Phase* and *Violin Phase* (both of which can be performed with live musicians on stage with pre-recorded tape loops, or by all live musicians), *Drumming, Clapping Music,* and *Music for 18 Musicians.*

By the late 70s, Reich's music had branched out into more melodic territory with works including *Variations for Winds, Strings, and Keyboards, Tehillim* (for voices and orchestra), and *The Desert Music* (for amplified chorus and orchestra). In the 80s, he returned to the use of pre-recorded tape in compositions such as *New York Counterpoint* (which can be played by clarinet or saxophone and tape, or by a variety of other chamber ensemble set-ups) and *Different Trains* (for string quartet and tape). In the 90s, Reich began to experiment with electronic keyboards that could sample various sounds and reproduce them on any pitch. His composition *City Life*, for amplified ensemble, samples sounds such as cabs and buses, street vendors, and the subway, and interjects them at precise moments within a fully-notated live chamber ensemble performance. One of Reich's more recent creations is a video opera titled *Three Tales*, which he wrote in collaboration with video artist Beryl Korot. Each act tells the story of a relatively recent historical event. The individual acts are titled "Hindenburg," "Bikini" (which focuses on the atomic bomb tests in the Bikini atoll during the late 40s/early 50s), and "Dolly" (which deals with issues surrounding the topic of cloning). In performance, images of historic footage, coupled with interviews, photographs, and text are projected in the theatre while instrumentalists and singers perform Reich's music. In April of 2009 Reich was awarded the Pulitzer Prize for Music for his composition *Double Sextet*. Written for two groups of equal instrumentation, the work can be performed by six musicians who play along with a pre-recorded performance of the other sextet parts or by a group of 12 musicians live onstage.

As with many composers who have been lumped into the general category "Minimalist," Steve Reich views the concept of Minimalism as a musical technique, not as a life mantra. In a recent interview he stated:

> The point is, if you went to Paris and dug up Debussy and said, "Excusez-moi Monsieur...are you an impressionist?", he'd probably say "Merde!" and go back to sleep. That is a legitimate concern of musicologists, music historians, and journalists, and it's a convenient way of referring to me, Riley, Glass, La Monte Young, maybe even John Adams, . . . But, anybody who's interested in French Impressionism is interested in how different Debussy and Ravel and Satie are – and ditto for what's called minimalism. So it's hard to get excited about that kind of thing. Basically, those kind[s] of words are taken from painting and sculpture, and applied to musicians who composed at the same period as that painting and sculpture was made. There is some validity to the description; certainly if you listen to *Piano Phase* or *Violin Phase* and you look at Sol LeWitt [a famous Minimalist artist], you're going to note some similarities. That just means people who are alive at a certain period of time and have their antennas up and functioning are going to get similar input messages and they're going to react to . . . those messages. Beyond that, it's all individual, and that's what's interesting.[17]

John Adams (b. 1947)

Of the three "Minimalist" composers in this chapter—Glass, Reich, and John Adams—it was Adams who first broke away from a purely Minimalistic approach to composition. In fact, even his earliest works to achieve large public acclaim contain hints of a more Neo-Romantic language lurking beneath the surface. Perhaps it is this extended musical sensibility that has helped Adams's music reach such a large audience, even winning him praise and acceptance from many in the reserved world of "traditional" classical music. Some of his first works to enjoy critical and commercial success include *Harmonium* (for chorus and orchestra), *Shaker Loops* (for seven solo strings, or string orchestra), *Short Ride in a Fast Machine* (a fanfare for orchestra), and *Fearful Symmetries* (for orchestra). His biggest success to date, however, has come on the opera stage with the works *Nixon in China, The Death of Klinghoffer,* and *Doctor Atomic.* Created in collaboration with poet Alice Goodman and director Peter Sellars, these operas have enjoyed considerable success and have been performed in major opera houses throughout the world. In a recent interview, Adams was asked about his decision to make use of contemporary topics as the basis for his operas. He replied:

John Adams.
Courtesy: Margaretta K. Mitchell

> People always mention that. If I were a novelist like Don DeLillo, Thomas Pynchon or Russell Banks no one would make that connection; if I were a movie maker like Woody Allen or Oliver Stone it would be assumed that my subjects would be contemporary. I think it's more of a comment on the way we approach opera than a comment on me. We somehow feel that opera is this creaky old anachronistic vehicle and that to make it respond to a contemporary subject is rather shocking, but if opera's going to have any meaning for contemporary audiences it has to deal with contemporary subjects.[18]

It is interesting to note that in the past few years, several new operas based on more contemporary subjects have been introduced, including operas based on the *Jerry Springer* talk show, the life of Anna Nicole Smith, and a recent operatic treatment of *Cold Mountain.* Opera in the twenty-first century is clearly evolving, and composers such as John Adams and Philip Glass are leading the charge in helping make opera a more accessible medium for contemporary audiences.

In his more recent compositions, John Adams has moved even farther away from Minimalist techniques. His Chamber Symphony, for example, drew inspiration from such diverse sources as the compositions of Arnold Schoenberg and *Road Runner* cartoon music. Some of his newer works include *My Father Knew Charles Ives* (for orchestra) and *On the Transmigration of Souls* (a work in memory of September 11, 2001, for orchestra, chorus, children's choir, and pre-recorded soundtrack), for which the composer received the 2003 Pulitzer Prize for Music. Adams's latest projects include a new orchestral work commissioned for the Los Angeles Philharmonic to celebrate the opening of the new Disney Hall titled *The Dharma at Big Sur,* and a new opera titled *The Gospel According to the Other many* based on the life of Robert Oppenheimer titled *Doctor Atomic*. In addition to composing, Adams also conducts on a regular basis, frequently championing the works of composers such as Igor Stravinsky, Charles Ives, Steve Reich, Philip Glass, Frank Zappa, and Duke Ellington.

Fearful Symmetries

This composition was written around the time of John Adams's first opera, *Nixon in China*. Not long after the first successful performances of this opera, Adams began to contemplate a new orchestral work. In the liner notes for the CD *Shifting Landscapes*, composer John Adams describes the creation of *Fearful Symmetries*.

Apparently I had more to say in that particular style, although this time it would be purely instrumental music, and the sound would be largely dictated by the Nixon orchestra, a kind of mutated big band, heavy on brass, winds, synthesizer and saxophones. To this ensemble I added for "Fearful Symmetries" a keyboard sampler playing sampled percussion sounds, two horns and a bassoon. Otherwise the ensemble is identical to that called for in the opera. . . . The music is, as its title suggests, almost maddeningly symmetrical. Four- and eight-bar phrases line up end to end, each articulated by blazingly obvious harmonic changes and an insistent chugging pulse. The familiar resemblance to the opening minutes of "The Chairman Dances" is unmistakable, but in "Fearful Symmetries" the gestures are more emphatic, and the music is more closely allied to pop and minimalist rock. It's clearly an example of what I call my "traveling music", music that gives the impression of continuous movement over a shifting landscape. In this piece, however, a cityscape is doubtless the more appropriate analogy as the sound has a distinctly urban feel.[19]

Listening Guide

Fearful Symmetries (excerpt)
John Adams (b. 1947)

Format: One-movement tone poem
Performance: Symphony Orchestra of Norrlands Opera, Kristjan Järvi, conductor
Recording: *Shifting Landscapes* (CCn'C 01912)

Performance Notes: Recorded in May 2001 at Norrlands Opera, Umeå, Sweden. As orchestras go, the Symphony Orchestra of Norrlands Opera has a particularly unusual history.

Originally the orchestra was founded as a military band, established in Umeå (North Sweden) in 1841. In 1974, when the Norrland Opera Company came into being, the band had become a regional woodwind and percussion ensemble, supplemented by a string section borrowed from Stockholm when necessary. In 1976 the orchestra began hiring its own string players and in 1978 the orchestra made its debut performance. . . . Together with [conductor] Kristjan Järvi, Norrlands Opera aims to break down the barriers between different musical genres, revitalize the concert form, and reach young audiences.

Liner notes from CCn'C 01912

:00 This particular excerpt begins just over seven minutes from the end of the composition. The entire work is over 20 minutes in length. The tone poem has a sort of emotional ebb and flow throughout the work, but this is definitely the climax and resolution of the entire piece. Notice how constantly repeated patterns merge into one another. Two diverse textures come together to form an entirely new pattern. Although this piece has a strong rhythmic component, notice that there is also a clear lyrical sense at play in this composition as well.

Ellen Taaffe Zwilich (b. 1939)

Composer Ellen Taaffe Zwilich has broken a great deal of new ground over the course of her career. Among other things, she was the first woman to receive a doctorate in composition from the prestigious Juilliard School of Music, the first woman to win a Pulitzer Prize for music (for her Symphony No. 1), and she continues to be one of the most successful composers in the world of classical music today—gender aside. As we move closer to the present day, it becomes more difficult to determine what documents will truly be of value to history over the long term. If the number of quotes, excerpts, and citations are any suggestion, the following *New York Times Sunday Magazine* article from 1985 should stand the test of time quite well. In it, music critic Tim Page offers a decidedly personal glimpse into Zwilich's life and her compositional process.

DIG DEEPER

RECORDING
Zwilich: Symphony No. 1, Indianapolis Symphony Orchestra

*E*llen Taaffe Zwilich by Tim Page

Author, radio personality and music critic Tim Page.
© Courtesy of Peter Schatte

"Do you remember those time-lapse photography films they used to show in high school biology classes?" Ellen Taaffe Zwilich asks. "Years of growth were compressed into a couple of minutes. First you saw a root, then a sprout, then suddenly the tree began to grow branches, reaching out in every direction. It's as if the tree were dancing. Composers grow the same way. We twist upward, while trying to keep our roots and balance."

It is lunchtime, and Mrs. Zwilich, who became the first woman to win the Pulitzer Prize for music in 1982, has shelved her pencils and music paper for a few hours. "I do most of my composing in the morning," she says. "Music's been running through my subconscious all night. So I get up, turn off the phone and become unavailable."

Zwilich is open, friendly, unpretentious and almost disconcertingly without neurosis. She is also articulate: "I think every musician understands the Pied Piper story. Music is this vast seductive force that draws you on, and you follow wherever it may lead. Don't misunderstand me; I'm no wide-eyed Romantic and I don't underestimate technique. I believe in being as conscious a composer as I can be and I do a lot of thinking before I begin a new work. But then, once I am writing, something mysterious happens. Something beyond explanation; not so much an escape as a confrontation with a deeper reality. You must be prepared, once a new work is under way, to let it take you somewhere that you've never been before."

Wide-eyed or not, Zwilich is, despite her disclaimer, something of a Romantic, at least in comparison with many twentieth-century composers. Igor Stravinsky believed that art was synonymous with technique—pure and simple. Paul Hindemith, when asked where he found inspiration, held up his pencil. In the 1950s and 1960s, it was fashionable to give compositions literalist titles like "Notebooks," "Structures" and so on. There was little talk of mystery, instinct or the subconscious.

Still, it would be simplistic to label Zwilich a neo-Romantic, for her work has a notable degree of classical poise. Yet it is more impulsive than most neo-Classicism and none of the other "isms" that make up our inadequate glossary of musical terminology quite apply. She writes in an idiosyncratic style that, without ostentation or gimmickry, is always recognizably hers. In her early works, one hears the influence of many composers—the String Quartet (1974) blends the knotty intensity of Bartok with the languorous emotionalism of Berg. In her later music, one finds a clear, logical and seemingly inevitable sense of structure—arching, charged melodic lines, aggressive rhythms and a prismatic combination of instrumental colors. Her works reflect a concision and craft that appeals to both professional musicians and the general audience. Her music is directly emotive, yet devoid of vulgarity and characterized by a taut chromaticism that stretches the limits of tonality while rarely venturing outside of them.

Mrs. Zwilich has what might be described as healthy, all-American good looks: big-boned, blue-eyed and blonde, she is the Hollywood "girl next door" grown to womanhood. She speaks softly with a husky, hybrid Florida accent.

For the past 20 years, she has lived in a modern, highrise one-bedroom apartment in the Bronx. "It's been described as one part serene sanctuary, one part cluttered workspace, which seems fair to me. But it's a fifteen-minute drive to Lincoln Center, my desk overlooks the Hudson River and, on a clear day, I can see all the way to the Tappan Zee bridge." She laughs. "It's *inspirational.*"

Like many composers, Zwilich, the daughter of an airline pilot, was writing music before she formally knew how. "I used to simply make things up on the piano and play them again and again; I didn't write anything down until I was about 10. By that point I had begun studying with the neighborhood piano teacher in Miami, where I was born and brought up. It was an unhappy relationship; she made me play all these silly children's pieces and I thought my own compositions were better."

By the time she was in her teens, Zwilich was proficient on three instruments—piano, violin and trumpet. She wrote a high-school fight song, was the concertmaster of the orchestra, first trumpet in the band and a student conductor as well. She continued to compose and, by the age of 18, she was turning out full-scale orchestral works.

Zwilich attended Florida State University in Tallahassee, where she majored in composition. While there, she played in an orchestra for conducting classes given by the late Ernst von Dohnanyi, a highly respected Hungarian pianist and composer. "Dohnanyi was essentially a nineteenth-century European artist—very Old World—and I was glad to be exposed to that sensibility. Meanwhile, I was playing jazz trumpet, singing early music with the Collegium Musicum and composing. I had a ball; it was a very open kind of place. Everything I wrote got played immediately."

She received her master's degree from Florida State in 1962. After one dreary year teaching in a small town in South Carolina, she moved to New York to continue her violin studies with the legendary Ivan Galamian. She quickly established herself in the ranks of New York's freelance violinists and also spent a season working as an usher at Carnegie Hall. During this time, Zwilich also played in the violin section of the American Symphony Orchestra under the direction of Leopold Stokowski.

"Stokowski was both a classic nineteenth-century Romantic, and a visionary crusader," Zwilich remembers. "He could be maddeningly inexact—especially in the modern repertory, which he nonetheless championed. And he was something of a martinet—one of those idealists who fight selflessly for any cause that comes along, but are still capable of unthinking, autocratic cruelty to individuals. Still, you have to credit Stokowski for his belief that the conductor had a mission in life, and that part of that mission was to perform works by contemporary composers.

"I was already aware that I wanted to compose more than I wanted to play. So I kept my ears open—I was always listening to the different sounds the orchestra made, the details of the ensemble sonorities, the range of the various instruments.

"Composers need some kind of hands-on musical experience—either as conductors or performers. If you know the orchestral repertory only from studying scores and listening to finished performances and recordings, you can't really know all that's going on in the music. A score is, at best, an indication, not a final product. Playing in the orchestra allows you a first-hand experience of the subtleties that fall between score and performance." While with the American Symphony, she met and married Joseph Zwilich, a fellow violinist and a member of the Metropolitan Opera orchestra.

In 1970, Zwilich entered the Juilliard School of Music, to study with Roger Sessions and Elliott Carter. "They were immensely helpful in my development. They allowed me my independence, which is the best thing you can say about a teacher. I don't think my music sounds at all like either of them, but they influenced my thinking irrevocably."

In 1975, Zwilich became the first woman to receive a doctorate in composition from Juilliard. Pierre Boulez programmed her "Symposium for Orchestra" (1973) with the New York Philharmonic, and she began to receive critical praise and commissions. She produced a string quartet (1974), a sonata for violin and piano (1974) and the splendid Chamber Symphony in 1979.

That same year, at the age of forty, Zwilich was suddenly widowed. While attending a performance of the Stuttgart Ballet at the Metropolitan Opera House, Joseph Zwilich had a massive heart attack and died in the auditorium where he had served for many years.

"It's still very difficult for me to listen to the Chamber Symphony," Zwilich says today. "I had begun writing it before Joe died, and when I came back to complete it, everything had changed. It was a crucible of sorts. I loved Joe very dearly, and miss him to this day, yet his death taught me nothing so much as the joy of being alive—the joy of breathing, walking, feeling well, swimming, the joy of being human. Suddenly all talk of method and style seemed trivial. I became interested in meaning. I wanted to *say* something, musically, about life and living.

"We've had to come to grips with an incredible amount of evil and pain in this century," she continues, "and you can see, hear and feel it in a lot of 20th-century art. But this agony is only one reality; we shouldn't forget beauty, joy, nobility and love—greater realities which artists must learn to express once again.

"Artists have become hung up on a faulty maxim—'Progress is our most important product.' It's a dangerous way of thinking because with continual progress can come a continual built-in obsolescence. For this reason, I think we've become righ(t)ly disillusioned with progress for its own sake. Besides, if you're a sensitive listener and you listen to Bach, you don't feel that it is somehow less advanced than Mozart, who is in turn less advanced than Beethoven. That's all a hangover from 19th-century musicology: add to the language, extend the boundaries, push back the frontier. Meanwhile, there is another frontier which 20th-century composition has sometimes neglected—an internal frontier. After all, no matter what musical language you choose, every composition is totally a new creation, yet also, in one way or another, bound to the past.

"Since the 1950s, America has had an extremely diverse musical culture, yet nobody's paid much attention to it. You must remember that during the time a lot of press was being given to what was called 'academic serialism'—an inadequate name, by the way—there were other people hard at work following other visions. William Schuman and David Diamond were writing symphonies. Alan Hovhaness was writing what could be considered an early brand of minimalism. A lot of different musics have been flourishing, simultaneously."

Unlike many composers, for whom professional gossip is an integral part of the business, Zwilich refuses to discuss her colleagues—either personally or aesthetically. "I hate the bickering between different groups of composers. I'm not at all threatened by artists who make different choices than I do, and I feel supportive of many kinds of activity.

Ellen Taaffe Zwilich.
Photo courtesy of Cori Wells Braun.
Source: Courtesy of George Sturm/Music Associates of America.

"Instead of living with the combination of pleasure and anxiety that makes up a diverse culture, some people opt for an exact set of formulas to govern their actions—politically, religiously, musically. Instead of weighing different possibilities and then making moral and aesthetic decisions, they chase absolute authority, with all choices ready made.

"Technology has given us a very precious gift—we can examine many different possibilities. A lot of composers of the past only knew their own music, and the music of their community, their era. But we can listen to Michael Jackson one day, spend the next enjoying Balinese gamelan music or follow a recording of 18th-century music played on original instruments with some new sounds for computer. This amazing range of visions—too bad there's no musical equivalent of that term—is unique and unparalleled.

"The whole idea of an avant-garde implies one single, forward-moving stream, and that's a nineteenth-century conceit. It's not only morally wrong to fight for supremacy but also a complete misunderstanding of the imperatives of our own age. Composition is about expression; it has absolutely nothing to do with who's going to end up on top in the 90s.

"Mr. Sessions once said that music was beyond emotion. That's why Mozart was able (to) write his clarinet concerto while he was dying. Throughout musical history, you have that dichotomy—serene pieces created during miserable times, and the other way around. I think this is because composers separate, to some degree, their creativity from their day-to-day lives. Everything that happens to me adds to my understanding, but I go to another level—beyond understanding, in a way—when I write. And what I find is unpredictable.

"I'm lucky. Music comes fast and furiously to me. But even at that speed, I'm still writing much slower than my perceptions. I direct my energies entirely on one composition at a time. It's possible to copy out another work, or edit, or revise, or what have you, but I can only actually *compose* one work. In the course of a year, with any luck, I finish three or four new pieces.

"Although I only spend a few hours a day actively engaged in writing music, I think being a composer is like being a writer of any sort. There's really never a moment when you're not working. I attend concerts as a composer, think about life as a composer, listen to records as a composer, and everything adds to the music, one way or another."

The question is an obvious one, and Zwilich has answered it many times. "Why have there been so few women composers? It's simple: We were, for the most part, denied access. Still, we're finding out that there were some women who continued to compose, knowing full well they'd never hear their music. It's an incredible testimony to the creative spirit that women, despite all odds, wrote music through all those quiet centuries.

"Compare writing a poem to creating a piece of music. Once you've got those words down on paper, they're there forever, and don't need any realization. But a staggering amount of people were involved in the creation of my Symphony No. 1 (Three Movements for Orchestra), for which I won the Pulitzer. There was the Guggenheim Foundation, which helped sponsor it; the MacDowell Colony, where I wrote the beginning; and, of course, the American Composers Orchestra, all of whom put their collective faith into my symphony and allowed me the time to complete it. Now go back a hundred years and compare the situation: Nothing of the sort could possibly have happened, because society simply didn't recognize female achievements."

Zwilich compares the beginning of a new composition to the armature of a sculptor—a general sort of skeletal mold, with a few details in order. She begins with a substantial amount of musical material, sketched over a period

of time—motives, themes, harmonic, structural and dramatic ideas, and a vague conception of form. Then she fleshes the music out, improvising on piano and violin and working with the notes on paper.

Inspiration provides raw ingredients and then, as Zwilich works with what is already written, the music evolves. For all composers, there is an interplay between inspiration and craft.

"Inspiration engenders product, which, in turn, engenders more inspiration," Zwilich says. "All the written arts work this way; you can't imagine an Immanuel Kant in a preliterate age. While still a child, Mozart already possessed an unparalleled musical imagination but his technique evolved over the course of his lifetime, so that his later works have not only the spark and impulse of the early music, but a complexity and depth that can only come from years of experience.

"But it is not enough to manipulate abstract forms and ideas. A composer must also provide color, thrust and purpose, allowing a work to unfold gradually over a given length of time. As such, composition is both a written and a performing art—it must *sound*.

"I become as fully acquainted with a new composition as possible before I begin writing," Zwilich says. "For example, when I began my Double Quartet, I went to Alice Tully Hall to find out exactly where the players would be sitting, and how their sound would reach the audience. By the time I actually started composing, I didn't have to just jot down a disembodied, arbitrary B-flat. I knew that it was a specific B-flat for viola, in this register or that, this context or that. In the case of the Double Quartet, I even knew whether it would sound from the right or the left side of the stage.

"This simply isn't an octet. I wanted the audience to realize that this was not just a piece for two cellos, two violas and four violins, but two separate string quartets, simultaneously competitive and cooperative. Chamber music demands a continual trade-off in musical hierarchy. Now the first violin has the melody, now it's taken by the cello; now the one quartet leads the way, now the other."

Each of Zwilich's compositions has a unique genesis. "I heard the first 15 bars of my symphony immediately," she says. "I never have to work for themes; they can hit me at any time and usually do. When I started the symphony, however, I knew that I wanted to create something that would exploit the rich sonorities of the American Composers Orchestra, and felt free, for example, to write a virtuosic tuba solo, because a modern symphony orchestra is really a stage full of virtuosos. I also wanted to follow an obsession with the minor third—to take this simple interval and use it to generate an entire piece, to create a rich, harmonic palate and a wide variety of melodic gestures, all emanating from a simple source. All the complex harmonies in the symphony are created by piling third upon third upon third."

Still, Zwilich's work is only partly systemic. There are many ways of composing music—from relying on a system so complete that one can explain, technically, exactly why every note is where it is, to a purely intuitive manner of stringing melodies together. Zwilich charts a careful middle course: "I believe in a lot of analysis early in the game, which I then consciously abandon and run wild.

"Once I'm well into a piece, it starts to feed back into me. It's like being a playwright. You create the character, of course, but after a while, the character has a life of his own. By the time Act I is over, you pretty much know what George would or would not say to Martha, and you proceed accordingly, with some sensitivity to dramatic context. After a certain point, a composer's

job is to be a good listener—you listen to what's gone before, and then decide how to continue.

"Some things never get easier. The challenge in composition—in all of the arts—is to be a whole person, not merely part of a school or a reaction to the previous generation or century. And, no matter what your track record, when you try to do something you've never done before, you risk falling on your face. So you have to work up courage. But I have this drive—it's sometimes an uncomfortable feeling, almost like an itch, but it's been my best friend, keeping me going.

"There's a funny story behind my string trio. Somebody I hadn't seen in quite a while called me, asked if I would be interested in doing a work for an upcoming concert. I said that I didn't have the time, but we kept talking for a while and during the conversation I started to hear music. The trio was beginning to take shape in my head. So I said I'd think it over, and I did, throughout the rest of the day and, I guess, through the night as well. In any event, I woke up the next morning, and the whole opening section was waiting to be written down."

The tree, unfettered, begins to dance.

From *The New York Times Sunday Magazine,* 1985. Copyright © 1985 by Tim Page. Reprinted by permission of the author.

In the intervening years since the previous article was published, Ellen Zwilich has continued to create one successful composition after another. A few of her more recent compositions include *Fantasy* (for orchestra), *Peanuts® Gallery* (for piano and orchestra, based on the famous cartoon strip by Charles Schultz), Symphony No. 4 (*The Gardens,* for mixed chorus, children's chorus, and orchestra), and Symphony No. 5 (*Concerto for Orchestra,* premiered by the Julliard School of Music Orchestra in 2008). In addition to being successful compositions in the concert hall, both *Peanuts Gallery* and the Symphony No. 4 have also been featured in special broadcasts on PBS.

Musicians around the world are particularly grateful to Zwilich for her willingness to compose new solo works for their instruments. She has written a number of concertos, some of which feature instruments that are not often featured as a soloist with a symphony orchestra. Some of these concertos include works for trumpet, clarinet, bassoon, horn, trombone, bass trombone, flute, and oboe, as well as works for more traditional solo instruments such as piano and violin. She has also composed a piece titled *Rituals* for percussion ensemble and orchestra and a *Triple Concerto* for piano, violin, cello, and orchestra.

Concerto for Trombone and Orchestra

This concerto was commissioned by the Chicago Symphony Orchestra and was premiered in 1989, featuring Jay Friedman as the trombone soloist. Regarding this work, the composer wrote:

Although it has been neglected as such, I think the trombone is a wonderful solo instrument. In addition to sharing the same range, the tenor trombone possesses all the color and drama of the entire spectrum of male voices, from counter-tenor to bass-baritone. Continuing the vocal analogy, the trombone can be both lyric and dramatic. Add to these noble singing qualities the great instrumental flexibility and agility of our modern artist-performers and you have an instrument which commands the stage as a soloist. . . . Besides its solo capabilities, the

trombone is a most interesting instrument in relation to the orchestra. Its nature allows it to be a significant partner, not only to other brasses, but to woodwinds, strings and percussion as well. . . . Throughout the Concerto for Trombone and Orchestra, the relationship of the solo trombone to the orchestra is one of equal partnership and mutual exploration.[20]

The first movement of this concerto features the trombone soloist along with various members of the brass section. It is a dramatic opening movement, full of bold musical gestures, coupled with more lyrical secondary themes. Throughout the movement other brass instruments enjoy brief solo lines and ensemble passages, sometimes in conjunction with the soloist and at other times alone. Toward the end of the movement there is an excellent solo cadenza that offers the trombonist a real chance to shine. Unlike some of the previous music presented in this chapter, this work is composed with a musical language that is quite modern but still accessible to the general audience.

Listening Guide

Concerto for Trombone and Orchestra
Movement I—*Allegro*
Ellen Taaffe Zwilich (b. 1939)

Format: Concerto
Performance: Christian Lindberg, trombone with the Malmö Symphony Orchestra, James DePreist, conductor
Recording: *American Trombone Concertos* (BIS 628)

Performance Notes: Recorded August 30-31, 1993 at the Malmö Concert Hall, Sweden. Aside from simply being a great recording, this CD is a clear demonstration of the growing diversity in classical music today. Here is a concerto for an instrument rarely heard as a soloist with orchestra, playing a concerto written by a female composer, and played by a symphony conducted by an African-American conductor. In truth, these facts should not be a big deal in the twenty-first century, but like all other segments of our society, classical music has a way to go before it is truly color and gender blind. Nonetheless, as with the rest of society, clearly progress is being made.

:00	Brief introduction, followed by first solo trombone entrance. Entire movement is built around this dramatic opening gesture and the more lyrical line that follows.
1:12	Horn section is featured.
1:43	Soloist re-enters.
2:21	Brief solo line for tuba, followed by trombone section with soloist.
2:50	Soloist continues.
3:19	Entire brass section featured.
3:29	Soloist re-enters.
3:57	Cadenza begins.
6:21	Orchestra joins soloist for dramatic final passage.

Frank Zappa (1940~1993)

As we come to the end of this textbook, it is time to step back a bit and begin to look at the bigger picture. One of the dominant questions in the world of classical music today is "What does the future hold?" Much of classical music today suffers from a serious perception problem. General music education is at an all-time low in America, the arts are marginalized at best by both the government and most media outlets, and many in the world of classical music seem to have no idea how to "re-connect" with their potential audience. One possible future for classical music is to broaden its horizons a bit and embrace more of contemporary society. Popular musician, composer, and cultural iconoclast Frank Zappa seemed to understand that potential future. Zappa's music had always displayed a flair for the unconventional. As a "rock and roll" musician, Zappa was never really in the mainstream, preferring to mix heavy doses of jazz and twentieth-century classical music into many of his performances and recordings. As Zappa's career progressed, he began to delve further into the world of classical music, eventually recording some of his works with the London Symphony Orchestra and creating complex instrumental compositions on the latest electronic equipment. In 1984, Frank Zappa was invited to give the keynote address at a conference hosted by the American Society of University Composers. The following excerpt, taken from a book Zappa wrote titled *The Real Frank Zappa Book*, contains an enhanced excerpt from that speech.

WARNING: The following article contains strong language.

Frank Zappa.
Source: © Corbis Premium Historical / Getty Images

*B*ingo! There Goes Your Tenure! by Frank Zappa

The following section is excerpted from the keynote address I delivered at the 1984 convention of the *American Society of University Composers* (ASUC).

I do not belong to your organization. I know nothing about it. I'm not even interested in it—and yet, a request has been made for me to give what purports to be a *keynote speech*.

Before I go on, let me warn you that I *talk dirty*, and that I will say things you will neither enjoy nor agree with.

You shouldn't feel threatened, though, because I am a mere buffoon, and you are all *Serious American Composers*.

For those of you who don't know, I am also a composer. I taught myself how to do it by going to the library and listening to records. I started when I was fourteen and I've been doing it for thirty years. I don't like schools. I don't like teachers. I don't like most of the things that you believe in—and if that weren't bad enough, I earn a living by playing the electric guitar.

For convenience, without wishing to offend your membership, I will use the word **"WE"** when discussing matters pertaining to composers. Some of the **"WE"** references will apply generally, some will not. And now: *The Speech. . . .*

The most baffling aspect of the *industrial-American-relevance* question is: *"Why do people continue to compose music, and even pretend to teach others how to do it, when they already know the answer? Nobody gives a fuck."*

Is it really worth the trouble to write a new piece of music for an audience that doesn't care?

The general consensus seems to be that music by living composers is not only irrelevant but also genuinely obnoxious to a society which concerns itself primarily with the consumption of disposable merchandise.

Surely **"WE"** must be punished for wasting everyone's precious time with an art form so *unrequired* and *trivial* in the general scheme of things. Ask your banker—ask your loan officer at the bank, he'll tell you: **"WE"** are *scum.* **"WE"** are the *scum of the earth.* **"WE"** are *bad people.* **"WE"** are *useless bums.* No matter how much tenure **"WE"** manage to weasel out of the universities where **"WE"** manufacture our baffling, insipid packages of inconsequential *poot,* **"WE"** know deep down that **"WE"** are *worthless.*

Some of us smoke a pipe. Others have tweed sports coats with leather patches on the elbows. Some of us have mad scientists' eyebrows. Some of us engage in the shameless display of incredibly dramatic *mufflers,* dangling in the vicinity of a turtleneck sweater. These are only a few of the reasons why **"WE"** must be *punished.*

Today, just as in the glorious past, the composer has to accommodate the specific taste (*no matter how* **bad**) of THE KING—reincarnated as a movie or TV producer, the head of the opera company, the lady with the frightening hair on the 'special committee' or her niece, *Debbie.*

Some of you don't know about Debbie, since you don't have to deal with radio stations and record companies the way the people from *The Real World* do, but you ought to find out about her, just in case you decide to *visit* later.

Debbie is thirteen years old. Her parents like to think of themselves as *Average, God-Fearing American White Folk.* Her Dad belongs to a corrupt union of some sort and is, as we might suspect, a lazy, incompetent, over-paid, ignorant son-of-a-bitch.

Her mother is a sexually maladjusted mercenary shrew who **lives** to spend her husband's paycheck on ridiculous clothes—to make her look *'younger.'*

Debbie is *incredibly stupid.* She has been raised to respect the values and traditions which her parents hold sacred. Sometimes she dreams about being kissed by a lifeguard.

When the people in the *Secret Office Where They Run Everything From* found out about Debbie, they were thrilled. She was **perfect.** She was **hopeless.** She was *their kind of girl.*

She was immediately chosen to become the *Archetypical Imaginary Pop Music Consumer & Ultimate Arbiter of Musical Taste for the Entire Nation*—from that moment on, everything musical in this country would have to be modified to conform to what *they* computed to be *her needs and desires.*

Debbie's 'taste' determined the size, shape and color of *all music broadcast and sold in the United States during the latter part of the twentieth century.* Eventually she grew up to be just like her mother, and married a guy just like her Dad. She has somehow managed to reproduce herself. The people in *The Secret Office* have their eye on her daughter at this very moment.

Now, as a serious American composer, should Debbie **really** concern you? I think so.

Since Debbie prefers only short songs with lyrics about boy-girl relationships, sung by persons of indeterminate sex, wearing S&M clothing, and because there is *Large Money* involved, the major record companies (which a few years ago occasionally risked investment in recordings of new works) have all but shut down their classical divisions, seldom recording *new music*.

The small labels that *do*, have wretched distribution. (Some have wretched *accounting procedures*—they might release your recording, but you won't get paid.)

This underscores a *major problem* with living composers: *they like to eat*. (Mostly what they eat is brown and lumpy—and there is no question that this diet has had an effect on their collective output.)

A composer's job involves *the decoration of fragments of time*. Without music to decorate it, time is just a bunch of boring *production deadlines* or dates by which *bills must be paid*. Living composers are entitled to proper compensation for the use of their works. (Dead guys don't collect—one reason *their* music is chosen for performance.)

There is another reason for the popularity of *Dead Person Music*. Conductors prefer it because they need *more than anything else to look good*.

By performing pieces that the orchestra members have hacked their way through since conservatory days, the rehearsal costs are minimized—players go into jukebox mode, and spew off *'the classics'* with ease—and the expensive guest conductor, unencumbered by a score with *'problems'* in it, gets to thrash around in mock ecstasy for the benefit of the committee ladies (who wish he didn't have any pants on).

"*Hey, buddy, when was the last time you* **thwarted a norm?** *Can't risk it, eh? Too much at stake over at the old Alma Mater? Nowhere else to go? Unqualified for 'janitorial deployment'? Look out! Here they come again! It's that bunch of guys who live in the old joke: it's YOU and two billion of your closest friends standing in shit up to your chins, chanting,* '**DON'T MAKE A WAVE!**' "

It's the terror of a *bad review* from one of those tone-deaf elitists who use the premiere performance of every new work as an excuse to sharpen their word skills.

It's settling for rotten performances by musicians and conductors who prefer the sound of *Death Warmed Over* to anything scribbled in recent memory (making them *'assistant music critics,'* but somehow *more glamorous*).

It's clutching the ol' *Serial Pedigree*, secure in the knowledge that *no one checks anymore*.

Beat them to the punch, ladies and gentlemen! *Punish yourselves* before *they* do it for you. (If you do it *as a group*, the TV rights might be worth something.) Start planning now, so that everything will be ready in time for the next convention. Change the name of your organization from *ASUC* to **"WE"**-SUCK, get some cyanide and swizzle it into the punch bowl with some of that *white wine* 'artistic' people really go for, and *Bite The Big One*!

If the current level of ignorance and illiteracy persists, in about two or three hundred years a *merchandising nostalgia* for *this era* will occur—and guess what music they'll play! (They'll still play it wrong, of course, and you won't get any money for having written it, but *what the hey*? At least you didn't die of syphilis in a whorehouse opium stupor with a white curly wig on.)

It's all over, folks. Get smart—take out a real estate license. The least you can do is tell your students: "*DON'T DO IT! STOP THIS MADNESS! DON'T WRITE ANY MORE* **MODERN MUSIC!**" (If you don't, the little stinker might grow up to kiss more ass than you, have a longer, more dramatic neck-scarf, write music more baffling and insipid than your own, and Bingo! *there goes your tenure*.)

DIG DEEPER

BOOK
The Real Frank Zappa Book by Frank Zappa

WEBSITE
www.zappa.com

Black Page #2

Black Page #2 was a piece Frank Zappa performed on the road with his band. The piece originally started its life as a drum solo, to which Zappa later added chords and a melody. Drummer Terry Bozzio remembers: "[Zappa] wrote it because we had done this 40-piece orchestra gig together and he was always hearing the studio musicians in LA that he was using . . . talking about the fear of going into sessions some morning and being faced with 'the black page' [musician's term for a challenging composition with lots of fast notes]. So he decided to write his 'Black Page.'[21] At a live 1978 concert in New York City, Frank Zappa introduced the tune as follows:

> All right now, watch this . . . Let me tell you 'bout this song. This song was originally constructed as a drum solo. That's right. Now, after Terry learned how to play "The Black Page" on the drum set, I figured, well, maybe it would be good for other instruments. So I wrote a melody that went along with the drum solo, and that turned into "The Black Page, Part 1, The Hard Version." Then I said, well, what about the other people in the world who might enjoy the melody of "The Black Page" but couldn't really approach its statistical density in its basic form? So, I went to work and constructed a little ditty which is now being set up for you with this little disco type vamp. This is "The Black Page, Part 2, The Easy Teen-age New York Version." Get down with your bad selves so to speak to "The Black Page, Part 2."[22]

Listening Guide

Black Page #2
Frank Zappa (1940-1993), arr. Olli Virtaperko

Format: Art rock as played by a baroque chamber ensemble
Performance: Ensemble Ambrosius
Recording: *Ensemble Ambrosius: The Zappa Album (BIS NL 5013)*

Performance Notes: Recorded August 9-13, 1999 at TAVI Studios, Helsinki, Finland. This group (and this recording) represents one of the new frontiers open to classical musicians. Here is an "authentic" performance practice group, similar to many of the other groups you heard on some of the Baroque and Classical selections, playing arrangements of compositions by the iconoclast American musician/composer Frank Zappa. For classical music to survive in the twenty-first-century marketplace, musicians must become more open-minded to new ideas and interesting collaborations. This group is a great example of what can happen when you come to the music with little pre-conceived notion of what it "should" be. Frank Zappa would have been very pleased indeed.

:00	Clear rhythmic groove established by the cello (functioning as bass) and harpsichord as melody begins above played on oboe and melodica (a sort of keyboard harmonica).
:50	Cello and harpsichord join melody instruments in dramatic build-up to glockenspiel entrance.
:59	Glockenspiel enters with descending scale pattern. This is a classic Zappa connecting musical gesture. This brief line is followed by more rhythmic complexity in all voices.
1:27	Rhythmic groove returns in cello and harpsichord parts and melody continues above.
2:04	Mood shifts, but complex rhythmic structure continues.
2:59	As work comes to a close, it might feel a bit "incomplete." Zappa sometimes connected this tune together with another piece to form a sort of "mini-suite."

Other Composers and Works of Note

Luciano Berio (1925-2003). Italian. Avant-garde composer, electronic compositions. *Circles* (song cycle based on poems by e.e. cummings), numerous electronic works, various works for voice(s) and orchestra, and an extended series of works for various solo instruments, small ensembles, and/or orchestra titled *Sequenza*.

Samuel Barber (1910-1981) – American. Post-Romanticism. *Overture to School for Scandal, Adagio for Strings, Knoxville: Summer of 1915* (for soprano and orchestra). Also concertos for violin, cello, and piano.

Leonard Bernstein (1918-1990) – American. Composer who bridged the gap between classical music, the Broadway stage, and Hollywood film music. Major compositions include *Jeremiah Symphony,* Symphony No. 3 (Kaddish), *Chichester Psalms, On the Town, Candide,* and *West Side Story.* Also an important conductor.

Benjamin Britten (1913-1976) – English. Best remembered for a work titled *The Young Person's Guide to the Orchestra.* Other important works include the *War Requiem* and the operas *Peter Grimes, Albert Herring,* and *Billy Budd.*

Elliott Carter (1908-2012) – American. Highly individualistic serial composer, complex rhythmic structures. *Variations for Orchestra, A Symphony for Three Orchestras, Concerto for Orchestra,* three string quartets, and various other chamber music.

John Corigliano (b. 1938) – American. Eclecticism. Major works include *Naked Carmen* (an electric rock opera based on Bizet's *Carmen*) and *The Ghosts of Versailles* (a more conventional two-act opera). His Symphony No. 2 won the 2001 Pulitzer Prize for Music.

Peter Maxwell Davies (1934-2016) – English. Uses a wide array of compositional techniques from aleatoric elements to Serialism. *Eight Songs for a Mad King.*

David Del Tredici (b. 1937) – American. Neo-Romanticism. *Alice's Adventures in Wonderland, Through the Looking Glass,* and *Final Alice.*

David Diamond (1915-2005) – American. Post-Romanticism, Serialism. Works include eight symphonies, *Psalm for Orchestra,* incidental music for *Romeo and Juliet* as well as a suite of new music by the same title.

Lukas Foss (1922-2009) – American. Aleatoric music, various other avant-garde techniques. *Time Cycle* (for soprano and orchestra), *Baroque Variations,* and two piano concertos. Also an important conductor and champion of twentieth-century music.

Roy Harris (1898-1979) – American. Twentieth-century nationalism. Important twentieth-century symphonic composer. Works include 16 symphonies, various symphonic tone poems, and three string quartets.

Alan Hovhaness (1911-2000) – American. Prolific composer who embraced a wide variety of compositional styles. Over 20 symphonies and various other symphonic works including *And God Created Great Whales* (for taped whale songs and orchestra).

Witold Lutoslawski (1913-1994) – Polish. Serialism, electronic compositions, Aleatoric music. Three symphonies, *Concerto for Orchestra, Jeux vénitiens* (Venetian Games).

Gian Carlo Menotti (1911-2007) – Born in Italy but lived mostly in America. Important twentieth-century opera composer. Works include *The Medium, The Telephone,* and *Amahl and the Night Visitors.*

Thea Musgrave (b. 1928) – Scottish. Mix of serial techniques and more conventional styles of composition. *Mary, Queen of Scots.*

Pauline Oliveros (b. 1932) – American. Electronic music, avant-garde. *To Valerie Solonas and Marilyn Monroe in recognition of their desperation* (1970), *Sonic Meditations* (1971-1974), and *The Roots of the Moment* (1988).

Harry Partch (1901-1974) – American. Self-taught composer, inventor of unusual modern musical instruments, mostly percussion, extremely avant-garde. His music had a major impact on both other modern classical composers and avant-garde jazz musicians. Works include *Windsong, 2 Settings from Finnegans Wake, The Delusion of Fury,* and *And on the 7th Day Petals Fell in Petaluma.*

Arvo Pärt (b. 1935) – Estonian. Early works are mostly serial while later compositions have embraced extreme Minimalistic techniques. Many of his more recent works are based on religious themes. Three symphonies, *Johannes Passion, Stabat Mater, Magnificat, Salve Regina,* and *Passio Domini nostri Jesu Christi secundum Joannem.*

Krzysztof Penderecki (b. 1933) – Polish. Avoids association with any single modern style, though most works use a more-or-less conventional system of organization. *Threnody for the Victims of Hiroshima, The Passion According to St. Luke,* and *A Polish Requiem.*

Shulamit Ran (b. 1949) – Israeli, though she has spent a great deal of time in the United States. *Concerto for Orchestra,* Symphony No. 1 (1990), *Vessels of Courage and Hope,* and a wide variety of chamber music.

Terry Riley (b. 1935) – American. Minimalism, electronic music. *In C, Keyboard Studies, Rainbow in Curved Air.*

William Schumann (1910-1992) – American. Tonal composer with elements of twentieth-century nationalism. Major works include nine symphonies (two of which were later withdrawn), *American Festival Overture, William Billings Overture, Circus Overture, New England Triptych,* and several excellent string quartets. Also an important music educator, serving as President of the Julliard School of Music from 1945-1961.

Roger Sessions (1896-1985) – American. Early music used Post-Romantic techniques while later music embraced extreme dissonance and elements of atonality and Expressionism. Composed eight symphonies, two string quartets, various choral works and other chamber music. Pupils included Milton Babbitt and David Diamond.

Toru Takemitsu (1930-1996) – Japanese. Avant-garde, electronic music, and some elements of Neo-Romanticism. Has composed various orchestral works and chamber music, as well as a number of important film scores.

Joan Tower (b. 1938) – American. Eclecticism. Major works include *Silver Ladders*, a series of works titled *Fanfare for the Uncommon Woman*, *Concerto for Orchestra*, and various chamber works including *Petroushskates*.

Iannis Xenakis (1922-2001) – Greek, but spent a great deal of his life living in both Paris and the United States. *Avant-garde* composer, electronic music, also makes use of complex structures inspired by his interest in mathematics and architecture. *Pithoprakta* (for 50 instruments), *Metastasis* (for orchestra), various works for percussion.

Endnotes

1. George Sturm, "Encounters: Ellen Taaffe Zwilich," article posted on composer's official website, http://www.musicassociatesofamerica.com/madamina/encounters/zwilich.html (accessed June 30, 2004).

2. John Cage, quoted in *American Piano Music of the 20th Century,* William Grant Naboré, compact disc liner notes, Doron DRC 3002.

3. Ibid.

4. Fred Bugbee (Professional musician and educator, specialist in the music of John Cage), in discussion with the author, Las Cruces, NM, July 16 and 17, 2004.

5. Ibid.

6. Joseph Kerman, *Listen,* 3rd ed. (New York: Worth Publishers, Inc., 1980), 471.

7. George Crumb, *Ancient Voices of Children*, introduction (New York: C. F. Peters, 1970), inside front cover.

8. Ibid.

9. K. Marie Stolba, *The Development of Western Music: A History,* 3rd ed. (Boston: McGraw-Hill, 1998), 641.

10. Ibid.

11. Ibid., 640.

12. Ibid.

13. Tim Page, " A Conversation with Milton Babbitt," *Music from the Road* (New York: Oxford University Press, 1992), 12-13.

14. "Biography," article posted on composer's official website, http://www.philipglass.com/biography.html (accessed June 29, 2004).

15. "News," article posted on composer's official website, http://www.philipglass.com/biography.html (accessed June 29, 2004).

16. "Biography," article posted on composer's official website, http://www.stevereich.com/bio/html (accessed June, 29,2004).

17. Rebecca Y. Kim, "From New York to Vermont: Conversation with Steve Reich," article posted on composer's official website, http://www.stevereich.com/articles/NY-VT.html (accessed June 30, 2004).

18. Alan Olshan, "Compsers in Conversation: John Adams," http://www.meetthecomposer.org/conversations.htm#adams (accessed June 30, 2004).

19. John Adams, quoted in Ulrich Hartmann, translated by Christian Salvesen and Ieva Gaidulis, *Shifting Landscapes,* The Symphony Orchestra of Norrlands Opera, compact disc liner notes, CCn'C 01912.

20. Ellen Taaffe Zwilich, quoted in Phillip Huscher, "Comments," *Chicago Symphony Orchestra Program*, copy of pages from Ellen Taaffe Zwilich official press kit, date unknown, 31-32.

21. Andrew Greenaway, "Interview with Terry Bozzio, September 17, 1992, http://www.globalia.net/donlope/fz/songs/Black_Page.html (accessed July 15, 2004).

22. Frank Zappa, transcript of song introduction from Zappa in New York, compact disc, http://www.globalia.net/donlope/fz/lyrics/Zappa_In_New_York.html#Page (accessed July 15, 2004).

Study Guide

Chapter 9 Review Questions

True or False

___ 1. Perhaps more than any other composer in the 20th century, Milton Babbitt fully embraced the concept of total serialism.

___ 2. Philip Glass's early works were built around the 12-tone system of Arnold Schoenberg.

___ 3. John Adams developed a new rhythmic technique called "pulse music."

___ 4. Steve Reich developed a new rhythmic technique called "pulse music."

___ 5. Composer Ellen Taaffe Zwilich was the first woman to win the Pulitzer Prize for Music.

___ 6. Recently, a new opera appeared on the classical music scene based on the Jerry Springer talk show.

___ 7. Composer Olivier Messiaen was captured by the Nazis during World War II.

___ 8. Composer John Cage drew inspiration from Henry Cowell.

___ 9. Composer John Cage drew inspiration from Zen philosophy.

___10. Composer Leonard Bernstein bridged the gap between classical music, the Broadway stage, and Hollywood film music.

Multiple Choice

11. John Cage's groundbreaking composition that is made up entirely of rests.
 a. *The Perilous Night*
 b. *Fontana Mix*
 c. *4'33"*
 d. *Construction 1 in Metal*

12. Singer whose extreme vocal techniques inspired composer George Crumb.
 a. Marilyn Horne
 b. Florence Foster Jenkins
 c. Martha Rowe
 d. Jan DeGaetani

13. New term beginning to take hold in the world of classical music that is used to refer to composers who are no longer using one clearly definable musical style.
 a. Eclecticism
 b. Expressionism
 c. Neo-Classicism
 d. Minimalism
 e. none of the above

14. First pioneer of *musique concrète*.
 a. Igor Stravinsky
 b. John Cage
 c. Pierre Schaeffer
 d. Luciano Berio

15. American, Post-Romantic composer of *Adagio for Strings*.
 a. Luciano Berio
 b. Samuel Barber
 c. Leonard Bernstein
 d. Benjamin Britten

16. Famous Minimalist opera by John Adams.
 a. *Einstein on the Beach*
 b. *Nixon in China*
 c. *Three Tales*
 d. *Akhnaten*

Fill in the Blank

17. Building on the works of Anton Webern, Boulez was one of the early pioneers of a system called _____.

18. Originally, the term _____ referred to the recording of sounds made in nature or created by man, and then subsequently arranging their recorded elements into a sort of musical collage.

19. Conductor/composer _____ was the founder of the *Institut de Recherche et de Coordination Acoustique/Musique* (IRCAM).

20. Composer _____ was one of the first to write compositions for "prepared" piano.

21. Composer George Crumb based his composition *Ancient Voices of Children* on the poetry of _____.

22. Unconventional rock musician _____ made use of classical elements in his stage performances and also composed original classical compositions.

Short Answer

23. List two works by György Ligeti used in the film *2001: A Space Odyssey.*

24. Other than her *Concerto for Trombone and Orchestra,* list three works by Ellen Taaffe Zwilich.

25. List six important American composers found in Chapter 9.

Essay Questions

1. Reread the article in Chapter 1 written by Aaron Copland. Have your opinions about classical music changed, and if so, how?

2. What do you think the future holds for classical music? Can it continue to be a viable art form in the twenty-first century?

Interlude: Some Thoughts about the Future of Classical Music

"The music teacher came twice each week to bridge the awful gap between Dorothy and Chopin."

George Ade

The following article is taken from Michael Walsh's excellent book *Who's Afraid of Classical Music?*. Mr. Walsh offers a painfully honest appraisal of classical music as it stands today. In particular, he presents a thorough discussion of the problem faced by many performing ensembles, which is that they have become "living museums," forced to perform the same popular works over and over again. As a music critic himself, Walsh also gives us some very good insight into the modern world of music criticism. In the end, he does offer some hope for the future (and even the potential growth) of classical music.

Modern Composers by Michael Walsh

So far, we've been discussing what's right with classical music. Now let's talk about what's wrong with it. Hang on to your hats.

It's time to admit that classical music—or, rather, the *business* of classical music—is in some serious trouble, especially in the United States. No longer solely an art, it has with each passing season become more and more of a commodity, to be packaged, sold, and marketed as if Beethoven were soap—or, better yet, a political candidate. ("I'm not a conductor—I just play one on *Live from Lincoln Center*." That sort of thing.)

Programming, once the exclusive province of the music director, has become a cooperative activity, accomplished in collusion with marketing directors and, sometimes, public relations representatives. Economics has always been a part of musical life in the United States, but today horse-trading is a way of life: of course you can play Schoenberg's cast-of-thousands choral piece, *Gurrelieder*, says the marketing director to the

DIG DEEPER

BOOK
Who's Afraid of Classical Music?
by Michael Walsh

music director, as long as you also program Beethoven's *Fifth Symphony*. On second thought, make that maybe. On third thought, forget about it.

Not that the music director is blameless. The airplane has made the resident conductor a thing of the past. Today's prominent maestros routinely have two or even three major posts, at around half a million dollars per position, and they gad about from North America to Europe and back again in a never-ending search for a favorable exchange rate. These latter-day Flying Dutchmen—and Germans and Italians and English—are really flying carpetbaggers, contributing to the one-major-orchestra-pretty-much-sounds-like-another syndrome that makes the current orchestral scene so drab, dreary, and faceless. Gone are the days when there was a striking aural distinction between the Philadelphia Orchestra under Leopold Stokowski and the New York Philharmonic under Arturo Toscanini, or between Serge Koussevitzky's Boston Symphony and Fritz Reiner's Chicago Symphony. Today, too often, orchestras simply sound like one great big broken Deutsche Grammophon record.

Consider, for example, the 1989 flap over Daniel Barenboim and the Paris Opera. While it's true that nearly everyone eventually comes to grief at the Paris Opera (and at the Vienna State Opera, too), *L'affaire Barenboim* set a new record for greed. Barenboim, you may recall, was summarily fired as music director of the Opera Bastille, ostensibly over his round-up-the-usual-suspects programming plans for the new opera house, but in reality, two things rankled the French: 1. The outlandish size of his salary (nearly a million dollars a year) and 2. The fact that he had also signed to succeed Sir Georg Solti as the conductor of the Chicago Symphony. That job, needless to say, is not *pro bono publico*.

Now if Barenboim were the Herbert von Karajan of thirty years ago, he might have pulled it off; Riccardo Muti, after all, leads the Philadelphia Orchestra and the La Scala Opera in Milan. But by even the most charitable reckoning, Barenboim is nowhere near the first rank of modern conductors. A splendid pianist, he has been learning his podium trade at the top, as it were. And getting top dollar for it, too. As that great music lover, Gordon Gekko, said in *Wall Street:* Greed is good.

Increasingly, soloists have become caught up in keeping up. Fees, as we've already noted, can be very steep. Luciano Pavarotti has sung in some stadium concerts for which he and the company that produced the event got one hundred percent of the gross. That's right, all of it. The sponsoring organization got the prestige of having presented Pavarotti, as well as an opportunity to sell season tickets using the concert as bait. Is it any wonder orchestras and opera companies always seem to have their hands out, like high-class beggars?

The problem is, institutional classical music today is an art so divorced from its time and place that for many (not for you and me, of course) it has become a cult. Just as Catholics believe that the consecrated host is the living body of Christ, so those in the music cult believe that the standard repertoire from Mozart to Mahler is an eternal body of living art—immutable, unchangeable, a never-ending source of verity.

Notice that they never speak of a revival of *Rigoletto*, or of a Mozart retrospective, the way one does in the theater or the cinema. In their ahistorical arbitrariness, the classical-cultists are like the futuristic post-civilization society of John Boorman's film *Zardoz*, whose bible turned out to be an incomplete copy of *The Wizard of Oz* (hence the title: zardOz). Or, in their obsessiveness, like Gabriel Betteredge, one of the narrators of Wilkie Collins's detective masterpiece, *The Moonstone*, who lived his life according to precepts found in Daniel Defoe's *Robinson Crusoe:*

You are not to take it, if you please, as the saying of an ignorant man, when I express my opinion that such a book as Robinson Crusoe *never was written, and never will be written again.... When my spirits are bad—*Robinson Crusoe. *When I want advice—*Robinson Crusoe. *In past times, when my wife plagued me; in present times, when I have had a drop too much—*Robinson Crusoe.

Substitute Beethoven's *Fifth* for *Robinson Crusoe* and you have a pretty fair summation of the problem.

What have they done, and why? They have made a limited group of compositions into a classical canon that, arrogantly, they intend should stand for all ages. They have subjected this body of music to unremitting performance, naively assuming that it can withstand such finetoothed, Jesuitical scrutiny, when the vast majority of its creators would never have dared to make such extravagant claims for its eternal worth. Innocent of any foreknowledge of recordings, most composers expected their works to be heard only once or twice: that's why they wrote so many of them. (Compare the output of, say, Schubert, who wrote hundreds of pieces in his short life, with that of a modern composer. Big difference.) Beethoven had no idea that some day his symphonies would inspire thousands of graduate degrees in analysis, or be used to bring millions of season ticket subscribers to heel with the promise of Guaranteed Culture at No Pain. A miracle has happened: some of the most complex, innovative, and adventurous music of the nineteenth century has become nearly content-free by dint of incessant repetition. Presto: Beethoven Lite–*da-da-da-dum*.

How did this remarkable state of affairs come about? Better yet, how did we allow it to happen? The other performing arts—dance, theater, film—while far from perfect, do not exhibit the advanced atherosclerosis of classical music. There are various reasons for this. Dance, having a repertory that extends back less than a century, and having never developed a fully satisfactory means of notation, is still heavily dependent on new works and new creators. (As the use of videotape in preserving dance patterns becomes ever more expert and widespread, enabling the works of great and late choreographers like Balanchine to be accurately reproduced even without the master present, this could change.) Film too is a relative newcomer, and while it has built up a substantial body of classic work, until the advent of the home videocassette recorder, movies were not readily accessible to the general public; there was, in other words, no home film repertoire the way there is a home music repertoire. Even with VCRs, however, film audiences more eagerly rent the latest movies than old films; the market still craves novelty.

Theater, with a history and repertory even more ancient than classical music's, ought to have suffered a similar fate. But even here, revivals (clearly labeled as such) are the exception, and new plays and musicals the norm. Granted, Broadway will occasionally cast up a freak hit such as *On Your Toes* or *Me and My Gal*, but it is noteworthy that smash revivals are almost invariably musical comedies. In theater, the classic plays, from the Greeks through Shakespeare and the Restoration, coexist without animosity with the works of Samuel Beckett and Sam Shepherd. There, the Old Masters do not seek to strangle their children.

Music, on the other hand, is viewed even within the profession as a practically closed circle. Although the fringes of the repertory have been gingerly pushed back beyond Bach and extended on the other end to early Stravinsky, its core has remained relatively stable; with only minor changes, the very first program performed by the New York Philharmonic in the mid-nineteenth century could be played at Avery Fisher Hall next week and

no one would think the choice of music odd, old-fashioned or in any way unusual. (Do you know what one of the pieces was that the Philharmonic played back in 1842? How did you guess? Beethoven's *Fifth*.) No wonder Virgil Thomson, in his first review as a music critic for the New York *Herald Tribune*, could quote approvingly a friend's remark that the Philharmonic was not part of the intellectual life of New York. It still isn't.

Let's point some fingers and hand out some blame:

The Artist as Hero. Performers ought to serve music, instead of vice versa. Yet today the repertoire has become a kind of international track meet, with conductors and soloists competing for medals in a relative handful of events. It is possible these days to make a whole career specializing in just a few works—Klaus Tennstedt and Carlos Kleiber do—instead of displaying one's musicianship across the spectrum of musical culture. Below the professional level, things look no better: major conservatories seek to emulate past glories instead of preparing young musicians for the modern world.

The Stockholm Syndrome: the Audience as Willing Captive. The motto of today's subscribers to symphony programs can best be summed up in the famously misquoted line from *Casablanca:* "Play it again, Sam." (Just as Sherlock Holmes never says, "Elementary, my dear Watson," so the Bogart character, Rick, never actually says this.) Listeners seek art as religious experience; art as entertainment; art as anything but art. Maybe Beethoven should be banned for a while—fifty years would do nicely—so that future audiences would pick up their ears and really listen, for a change.

The Critic as Coward. From its early healthy pugnacity ("Music that stinks to the ear," wrote one prominent Viennese music critic of the Tchaikovsky *Violin Concerto*), criticism today has been reduced to meek and mild appreciation of the status quo. From foe to friend: from the bite and bile recorded in Nicolas Slonimsky's devastating *Lexicon of Musical Invective* to the bland, bored tone of newspaper criticism today, critics have abandoned their historic role as independent watchdogs of taste and become housebroken lap dogs instead. Woof!

Recordings: A Window on the Past, or The Big Lie? One of the most pernicious movements in modern music criticism is the advocacy of the use of recordings as interpretative guidelines for contemporary performers. Because the widespread acceptance of a new technology guarantees its influence, this was inevitable. Yet arbitrary and often unrepresentative, records are only guides to the way an artist performs, not actual primary source documents. Their baleful influence has resulted in the decline of score-reading—learning the music from the notes—as some performers at least in part acquire their scores by ear. What is the difference between amateur Gilbert Kaplan's performance of *Mahler's Resurrection* Symphony, and Herbert von Karajan's? (Hint: there's a big difference.) Should composers write directly for recordings (as Morton Subotnik did with *Silver Apples of the Moon*), thus bypassing the performer's interpretive choices completely? (On the whole, probably not.) And is a composer's recorded interpretation the most authentic guide to performance, anyway? (In the cases of Stravinsky and Rachmaninoff, definitely not.)

Of these groups, may I single out my own profession for special abuse? Music criticism, as it is currently practiced in the United States, is a fraud. Indeed, it is not music criticism at all. It is *performance* criticism. When critics go to a piano recital, an opera, or a symphonic concert, they are not there

to write about Liszt, Wagner, or Beethoven, except in the vaguest music-appreciation sort of way. Tacitly, they assume that every worthwhile observation about the content of Liszt, Wagner, et al., has already been made by their predecessors and betters. Instead, the modern critics' function has become to describe and comment upon the performance under examination, applying, like some journalistic Supreme Court, prevailing community standards. Their job, as it has evolved in the latter part of the twentieth century, is to discourage bizarre and willful interpretations, to ferret out artfully disguised technical inadequacies, to hold the artist to the impossibly holy standards of art. Music critics are the Brain Police of music, and very proud of it they are, too. Clearly, they have forgotten that it was—or should have been—the emotional power of *music* that first brought them into the fold, not the incunabula of performances. Musical journalism today, by and large, is not criticism, it is hagiography. No wonder much of the critics' mail comes from press agents.

One result of this foolishness has been the choking off of music's traditional lifeline—new works and new ways of playing them—by an infantile fascination with performers who must play Beethoven *just so* or their hand will get slapped. My daughter used to fly into a rage whenever I altered the words of a nursery rhyme even a little bit; this ferocious, protective orthodoxy would have qualified her for a post on any major U.S. daily, even though she was only two years old at the time. By the same token, critics and musical journalists have helped throttle music's economic health by representing it as a cabal to outsiders through both snobbishness and outright—let us use the word—nerdism. There is a reason you always thought classical music was clannish, forbidding, and arcane. They wanted you to think it was.

This is not meant to endorse ignorance. Of course we should honor our great works; of course we should honor our great artists; of course we ought to know as much as possible about the historical circumstances that gave them rise. Not to distinguish between masterpieces and lesser works is not only willful but foolhardy. And not to learn insight from the way great artists perform is the same. However, . . .

To insist that only the canon is worth playing is cultism. To insist on stylistic performance conformity is cultism. And to extrapolate performance practice from a handful of ancient recordings—by definition arbitrarily made and arbitrarily preserved—is a particularly virulent form of Zardozian cultism. Recordings, in fact, are at the heart of the problem, so all-pervasive that it is almost inconceivable that any performer now first encounters a well-known Beethoven sonata by means of the score. Or that any listener first hears the *Fifth Symphony* in the concert hall, one of the cherished bromides of conductors and administrators who need an excuse to serve up the same repertory season after season.

For the first time since concert life took recognizable shape in the nineteenth century, today's generation of performers is the only one which has had effectively zero input in the choice of repertoire and the latitudes of its interpretation. If I were starting out a career as a young pianist, I would find this attitude so appalling that I would seriously consider another, more honest, line of work. Yet remarkably, most young performers now shouldering their way out of the Juilliard School, the Curtis Institute, and the Indiana School of Music cheerfully accept this. Having grown up with tales of derring-do—what performer today wouldn't like to stick it in the eye of some cocky conductor the way Horowitz did to Sir Thomas Beecham at his American debut?—young artists want to ape their

elders in every respect, and appear content to have inherited a pre-chewed and predigested repertory. The older generations were at least playing music with which they had some historical relationship—Toscanini, after all, was born in the middle of the nineteenth century and Brahms was still alive when Rubinstein was born. (The great Arthur was ten in 1897, when Brahms died.) But, at the highest level of performance today, aside from Maurizio Pollini, there is hardly a pianist of note who makes new music a regular part of his art.

I once visited Claudio Arrau at his home in Douglaston, Queens. My respect for Arrau's playing of Liszt (Arrau is Liszt's pedagogical grandson) and Brahms is great. But there, on his piano, alongside the *B-minor Sonata* and the *Handel Variations*, was a work by Pierre Boulez (I think it was the *Second Sonata*). When I expressed my surprise, Arrau told me he was very interested in Boulez. But when I asked him why he did not play such music in recital, he told me his public would never stand for it.

(Gary Graffman's delightful memoir, *I Really Should Be Practicing*, begins like this: "The first time I played at the Hollywood Bowl, it was Tchaikovsky. The second time, two years later, it was the same Tchaikovsky. The third time, two years after that, I was once again told, 'Tchaikovsky . . .'")

The point is that performers of Arrau's generation (see: Rudolf Serkin, Vladimir Horowitz, et al.) have become prisoners of their audience's expectations; prisoners of 57th Street, the Manhattan thoroughfare that is home to the major concert managers of America. For younger performers and conductors, the situation is even worse. Shorn of their historical imperative to seek out and perform contemporary music—indeed, to make their reputations performing contemporary music (see: Liszt, Chopin, et al.)—they have become musical eunuchs trapped in a Santayanesque nightmare that has them not only remembering history, but happily repeating it over and over again.

To deny the primacy of creativity is to condemn concert life to a continuation of its current unsatisfactory status, a ceremonial chanting of a limited liturgy, conducted by the same handful of priests for the same small congregation. We may congratulate ourselves for our exquisite taste in joining this particular sect, especially since it hides behind the facade of art or culture, but at what cost? And to what end?

What we have today is a standoff in which everyone is at fault, but no one wants—or doesn't feel he has the power—to be the one to make the first move to make things better. Conductors are not about to give up their multiple jobs for reasons both financial and emotional. Besides, in each conductor's mind lurks the certainty that he alone has cornered the market on musical truth and that therefore he deserves to bring his message to as wide an audience as possible. Nor are conductors likely to change their programming ways any time soon, no matter how much they protest against the influence of the media marketeers. How many of them, for example, are willing to end a concert with Brahm's *Third Symphony*, and forego the big noise and gratification of, say, Tchaikovsky's *Fourth*? Very few; you could look it up.

Major performers are hardly likely voluntarily to relinquish their fat fees, and they jealously guard their reserved seats at the pinnacle of their profession. Like aging athletes, they warily eye the rookies, helping the talented, blocking the brilliant. But unlike athletes, whose careers are over by age forty if not long before, musicians go on practically forever, into their seventies, eighties, and even nineties. There is not a lot of turnover at the top, nor

is there a very big pool. How many certified great pianists can American concert halls accommodate at any one time? Five? Ten? Not many more. The same goes for violinists. And cellists? Two or three. Flutists? One or two. Horn players, trumpeters, violists, solo double bassists? One, maybe none. That's about it. A ghetto kid has a better chance of becoming the next Michael Jordan than a young pianist does of becoming the next Vladimir Horowitz. If there even is going to *be* a next Horowitz.

Don't expect leadership to come from the major musical organizations, either. Audiences demand to hear the same works performed in much the same way each time they enter the concert hall. Orchestras and opera companies are literally not in the business of challenging their patrons, either intellectually or emotionally. Instead, they offer the solace of the familiar. They are not selling art (once, they would have been ashamed to do even that), they are selling entertainment disguised as art.

And, God knows, don't expect the critics to lead the charge.

So: Beyond Hope or a Brave New World? Should classical music be abolished? (The conventional notion of it, that is, not the music itself.) Or should orchestras and opera companies frankly admit that they are now mostly museums, and drop all pretense otherwise? Should opera companies and symphony orchestras try to be all things to all people, or should there be some diversification in function, especially in metropolitan areas with more than one of each? There are two ways out of the programming cul-de-sac: performing unfamiliar works by dead composers and new works by living ones. Will either path be chosen? And what of the future? Will there be a continuing downward spiral as music sinks ever deeper into irrelevancy? Or is a healthy synthesis of the old and new on the horizon?

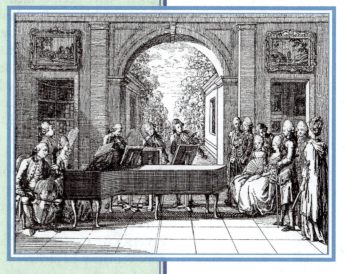

The answer, I believe, is yes. Yes to the healthy synthesis, yes to the programming alternatives, yes to specialization of ensembles. As Molly Bloom says, yes, yes, oh yes. Twenty years ago, who could have foreseen the remarkable rise of the minimalists, the acceptance of art rock in intellectual circles, the triumph of New York City's avant-garde SoHo scene, all of which restored much life and innovation to music. In many ways, serious music today is healthier than it has been in forty years.

There is a hardy band of performers—Pollini, Pierre Boulez, David Burge—who are adamant in their belief that new music is as worthy as old. The popular and critical success of the minimalists has brought the exciting collusion of the classical and rock avant-gardes out into the open. A new generation of music critics interested in the whole range of musical experience, including rock, jazz, Third World, and folk music, is battling the cult and its myths, rediscovering the joy of classical music. Time—and history—is on our side. But we have to stay on the case.

Let's root for the good guys. This means you.

Classical music has changed a great deal in the past three centuries, but more changes are needed to meet the demands of twenty-first-century audiences.
Source: Jupiterimages, Corp.

I must say that, in general, I am personally in agreement with everything you just read in Walsh's article. Of course, the other big element in any consideration of the future of classical music is a discussion about education. Fifty years ago, most students in America attended some sort of general music class during their elementary school years. Today, most of those programs have been cut from public education. We are now three or four generations into a world where many people don't know the folk music of their country, let alone the works of Haydn, Mozart, and Beethoven. The fact that you are taking a college-level class about the history of classical music is good, but, quite frankly, it is coming too late in your educational career. Right now, most of you are much more worried about passing your algebra final than you are about rushing out to buy a new Beethoven CD. And there's nothing wrong with that attitude at this point in your life: there are things more important than classical music. The point is, this is something that can enhance life and enrich your spirit. Music can speak to you on the deepest emotional levels if you allow it to do so. Unfortunately, we've reached a point in the educational system where not only are younger students being robbed of the gift of music, but students have been denied music for so many generations now that many of them don't even know what they are missing. Art and culture have taken several steps back in America, and today, no one seems to even notice anymore.

Some hope for the future of the arts in America comes from an excellent governmental organization called the National Endowment for the Arts. Regardless of what you may have read or heard in the past, it is one of the finest run (and corruption free) government agencies active today. Sadly, their budget as of this writing is around 146 million dollars, which is *lower* than it was ten years ago. Now that sounds like a great deal of money to you and me, but it actually breaks down to a bit less than one-tenth of one percent of the entire federal budget. Per person in America, it works out to somewhere between 35 and 40 cents *per year*. The federal government spends less on the arts in all fifty states then it does on a couple of Air Force jets. Of course we need a strong national defense, but one less plane and a few less spare parts and we could almost DOUBLE the budget for the arts in America. To give you another rough equivalent, it has been suggested that if you cut approximately 12 inches off one Trident nuclear submarine during construction, you could save one *year's* budget for the NEA. For a quick comparison, most European countries' endowment programs are, per capita, 10 to 20 times bigger than what we have in America. In all fairness to the United States system of government, however, it must be said that the American tax code does offer some significant tax incentives for donations to non-profit organizations such as symphonies, opera companies, and most other arts organizations. This sort of indirect support is not as common in most European forms of government. Finally, music education is still in place in most European and Japanese public school systems from kindergarten up. Meanwhile, in America, we are facing ever-shrinking public education arts budgets. Put it all together and you can start to see why people in America don't know much about classical music anymore.

Classical music is not for snobs, and it's not for "artists only." At the risk of sounding pathetically cheesy, the arts in general, and classical music in particular, are a beautiful gift you can give to yourself. It won't cure all your ills; it won't fix your car; but it can fill a space in your soul as nothing else on this planet. Turn on your public radio station. Go hear a symphony concert. Check out the next chamber music festival when it comes around. Buy a classical CD or two. Go on, try it! It's really not painful at all.

Chapter 10
Jazz: America's Classical Music

"Jazz is played from the heart.
You can even live by it. Always love it."

Louis Armstrong

We begin our exploration of jazz by revisiting some of the same material you studied in Chapter One. The same concepts of tonic/dominant axis harmony used by most composers from 1600 forward are also used in jazz. Here, again, are two simple definitions for you: **consonance** - tones at rest; **dissonance** - tones that need to be resolved. Almost all music is based on the contrast of movement between dissonance and consonance—just like the basic concept of how drama and literature function: you create tension (dissonance) and then resolve it (consonance). The only real difference with jazz harmonies is that we tend to relax our definition of what is considered "dissonant."

Dealing with consonance and dissonance means dealing with the movement of harmony or chords. **Chords** are groups of notes that sound consonant or dissonant when played together. They can be played by one instrument such as a piano or guitar or by a group of instruments including trumpets, saxophones, and trombones. A consonant chord is pretty stable. It either is or it isn't. Dissonant chords are a bit more complex as there is a whole sound spectrum from mildly dissonant all the way up to sounding like you put screws, nuts, and rubber bands in a high-speed blender. The same **tonic, dominant,** and **sub-dominant** chords you learned earlier all still apply in the world of jazz; however, in jazz we frequently add extra notes and more harmonic "color" to the chords we use, but these alterations do not change the basic function of the chords.

consonance

dissonance

chords

tonic

dominant

sub-dominant

basic beat

measure (or bar)

We'll get back to chords in just a second, but first you need to learn about finding the **basic beat** in a piece of music. Finding the basic pulse of the music and counting along is the best way to figure out the structure of a piece. In music, we group sets of the basic beat together in something called a **measure (or bar)**. To keep track of the measure groupings as they pass by, count like this: **1**,2,3,4; **2**,2,3,4; **3**,2,3,4; **4**,2,3,4; etc. In jazz, groupings of four beats-per-measure are most common, but we can also have groups of three: **1**,2,3; **2**,2,3; **3**,2,3 like a waltz; and groups of two: **1**,2; **2**,2; **3**,2; **4**,2 like a march or ragtime piece.

12-bar blues

Again, when you group these building block chords together with a certain basic-beat pattern, you've got the formula for literally thousands of songs. This format is called the **12-bar blues.** For convenience, below is the same chart from Chapter 1 that features the beat numbers and the different bars marked for you in groups of four beats per measure. Also included are the chord symbols to show you where the consonance and dissonance fall in the structure. The lyrics are from the *St. Louis Blues* by W. C. Handy.

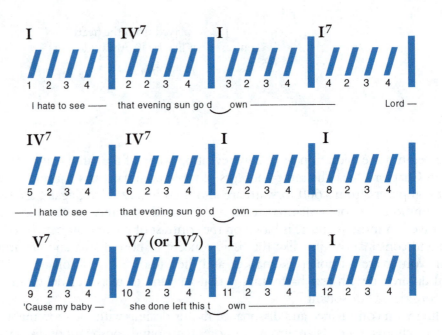

Within the basic 12-bar blues pattern there are lots of minor variations to the chord structure, but they all really work the same way. Here again is a list of well-known tunes that use the blues for their basic structure.

Jazz

West End Blues–Louis Armstrong
C Jam Blues–Duke Ellington
Billie's Bounce–Charlie Parker
Blue Monk–Thelonious Monk
All Blues–Miles Davis
Blue Train–John Coltrane
West Coast Blues–Wes Montgomery
Broadway Blues–Ornette Coleman
Stormy Monday–Eva Cassidy

Rock

Rock Around the Clock–Bill Haley
Maybellene–Chuck Berry
Hound Dog–Elvis Presley
Yer Blues (White Album)–Beatles
Little Wing–Jimmy Hendrix
Ball and Chain–Janis Joplin
Cocaine–Eric Clapton
Cold Shot–Stevie Ray Vaughn
Bad to the Bone–George Thorogood

Another popular formal structure used in jazz is the 32-bar (A-A-B-A) song form. This form is divided into four symmetrical groups of eight measures each. (How about that cool math stuff?) The first eight bars are simply called letter A. Then we repeat that group of eight bars for a total of 16. Next, we have a new melody with a different set of chord changes for the third group of eight, which we call the bridge, the release, or simply letter B. Finally, we have yet another statement of the first eight-bar melody and chords, usually with some minor alterations to make the dissonance and consonance work out just right. This all looks kind of complicated when you read about it, but after you hear a few songs in this format you'll start to pick out the different parts of the song with ease. The thing to remember is to count the measures when they go by as you learned on the previous page. Here are some songs that make use of the 32-bar song-form.

I've Got Rhythm–Every jazz player in the world

Ain't Misbehavin'–Fats Waller/Louis Armstrong

Take the "A" Train–Duke Ellington

Somewhere Over the Rainbow–Judy Garland

Koko–Charlie Parker and Dizzy Gillespie

Boplicity–Miles Davis

Perhaps the most popular format for music today is the verse/chorus format. For example, a song might have a 16-measure verse followed by a 16-measure chorus. You already know how this one works. When you're singing along with a song on the radio as you drive down the road, the chorus is the part that has the same words every time as opposed to those other stupid words that you can never remember. Many jazz tunes actually have this format as well, but in jazz we tend to focus on the structure of the chorus, which is the part we like to improvise over.

In addition to these three forms, jazz makes use of many other formal structures. They all have different formats, but they all function basically the same as the three you just learned about. Count the measures, follow the melody, listen for symmetry in the phrases, and you'll quickly pick up what's going on in just about any song you listen to. As an added bonus, this also works with just about any style of popular music. Try counting along with your current favorite. There really is a repetitive structure there. Music isn't just voodoo magic. We really do have a plan.

Here are a few more basic music terms you will run across in the course of learning about jazz. First up is *rhythm*. **Rhythm** includes the basic beat and everything the musicians play in a given *tempo*. **Tempo** is simply how fast or slow a piece of music is. For jazz in particular, you really must get behind the rhythmic concept of syncopation. Technically, syncopation just means a polyrhythm, or two or more different rhythms grinding against one another. In jazz, however, **syncopation** is an essential rhythmic component that gives jazz its unique rhythmic feel. It functions at its most simple level by "placing an accent on a normally weak beat or on a normally unaccented part of a beat."[1]

rhythm

tempo

syncopation

How a Jazz Band Works

The real key to understanding how jazz works is to understand the concept of *improvisation*. Perhaps the simplest definition of **improvisation** is spontaneous composition. As you will see in the next section, there is a long tradition of "embellishment" in both the African and African-American musical communities. **Embellishment** is simply adding extra rhythms and/or notes to an existing musical texture. Put even more simply, everyone sings and/or plays the same basic

improvisation

embellishment

melodic shape at the same time, but no one performs the song exactly the same as his or her neighbor. Eventually, this leads us right to jazz, where we take the pre-arranged structure of a given tune and we improvise (make up) a new melody on top of the rhythm and harmony of the original song.

Most jazz groups use the basic format of front-line instruments and some type of rhythm section. As we trace the history of jazz, you will see that the basic set-up of the bands will change, but usually the main solo players will be supported by some type of rhythm section. The typical **rhythm section** includes a piano for filling in the harmony, a string bass for playing the bass notes of the harmony and for driving home the basic beat, and a drum set for helping keep time and adding rhythmic color. The **front line** instruments include any of the solo-type instruments such as saxophone, trumpet, and trombone. The front line players tend to do more of the solo (improvised) playing. They usually start and end the tune by playing (or sometimes playing around) the melody.

Both the front line and the rhythm section can take part in two types of improvisation. The early jazz bands all played something called **collective improvisation,** where all the members of the band improvised their musical or rhythmic lines at the same time. Later, jazz groups started to make more use of **solo improvisation** in which one player breaks away from the entire group improvisation but continues to be supported by some or all of the rhythm section. Solo improvisations tend to allow the lead improviser more freedom, and this has become the preferred method for most jazz players. Listening to jazz performances will make very clear to your ear how these two types of improvisation function.

Active Listening and Jazz

As with classical music, in order to really get into jazz as an art form you will need to become an active listener. First, you have to get to know the song being played, and then you have to focus on how each musician improvises on the original tune. This is the thing that can make jazz so great—it never happens the same way twice. Unfortunately, these constant variations on a theme are sometimes the very thing that can turn people away from jazz. The continuous evolution of a song becomes overwhelming for people who aren't really connected with what the musicians are trying to say through their music. Here are some things to keep in mind as you begin (or continue) your journey in the world of jazz. You will notice many similarities between the information below and the *Active Listening* section found in Chapter 1.

- One time through the tune is not enough. The better you know the original tune and understand the basic structure, the more you will get out of the improvisations. If the tune has lyrics, it also doesn't hurt to sing along every once in a while. As you are singing along with the words and melody, listen to how the jazz musician improvises over the top of that structure.

- Listen "down" into the band. Don't just follow what the melody or improvised solo is doing. Jazz is really a musical conversation between the musicians on stage. What one player does on stage can have a great impact on what musical direction the other players take.

- Try to keep the original melody in your head as you listen to the improvisation. Over time, this will become almost second nature. You will begin to "feel" the internal structure of the tune as it passes by. I know you don't really believe that statement as you read this, but trust me: it will come to you as if in a dream. Really.

rhythm section

front line

collective improvisation

solo improvisation

Well, that's about it for the basics of how this music functions. You're ready to become the world's biggest jazz fan, and, believe me; the world needs more jazz fans. In many ways, this music is America's greatest contribution to the artistic world. If nothing else, jazz is certainly one of the most unique artistic forms ever created. Before you dive off into the history of jazz, here is an article written by Dr. Billy Taylor, who is one of the finest jazz pianists alive today and a great supporter of jazz education as well. In this article, he makes a very strong case for jazz as America's classical music. Read this article, and see if you agree with him.

> ## Jazz: America's Classical Music by Dr. Billy Taylor
>
> Jazz is America's Classical Music. It is both a way of spontaneously composing music and a repertoire, which has resulted from the musical language developed by improvising artists. Though it is often fun to play, jazz is *very serious* music. As an important musical language, it has developed steadily from a single expression of the consciousness of *black* people into a *national* music that expresses American ideals and attitudes to Americans and to people from other cultures all around the world.
>
> As a classical music, jazz has served as a model for other kinds of music; its influence is international in scope. It is studied, analyzed, documented, and imitated in India, Thailand, Finland, Sweden, Denmark, Holland, France, Belgium, Great Britain, Cuba and Japan. It is even studied and performed in Russia, Poland, Hungary, and other Iron Curtain countries. This last fact is most important because it is an indication of how jazz is used as a political statement—in a typical jazz performance each individual performer contributes his or her personal musical perspective and thereby graphically demonstrates the democratic process at work. There is no conductor directing the musical flow, but rather, the interaction of individuals combining their talents to make a unique musical statement.
>
> Jazz is simple, complex, relaxed, and intense. It embodies a bold tradition of constantly emerging musical forms and directions. Jazz has developed its own standards of form, complexity, literacy, and excellence. It has also developed a repertoire, which codifies and defines its many varied styles—and its styles are really varied. There is a style of jazz which sounds like European classical music (i.e., the Modern Jazz Quartet); there is a style of jazz that sounds like Latin American Music (i.e., Eddie Palmieri, Machito, and Mongo Santamaria); there is a style of jazz which sounds like East Indian classical music (i.e., Mahavishnu, John Mayer/Joe Harriott). There are styles of jazz which sound like various other kinds of music heard in this country and elsewhere in the world.
>
> Americans of African descent, in producing music which expressed themselves, not only developed a new musical vocabulary, they created a *classical* music—an authentic *American* music which articulated uniquely American feelings and thoughts, which eventually came to transcend ethnic boundaries.
>
> This classical music defines the national character and the national culture. In one sense it serves as a musical mirror, reflecting who and what Americans were in their own view at different points in their development. Thoughts of the 1920s, for example, evoke memories of people dancing to the tune "Charleston," composed by jazz pianist James P. Johnson, *and* of folks from downtown going uptown to the Cotton Club in Harlem to hear Duke

DIG DEEPER

VIDEO
Jazz, a nine-part documentary by Ken Burns (PBS DVD Video)

Ellington play "It Don't Mean a Thing if It Ain't Got That Swing." And thoughts of the 1930's remind us of the way Americans and others danced to the music of the great swing bands. You can pick your favorites—mine were Chick Webb, Benny Goodman, Artie Shaw, Jimmy Lunceford, and of course Count Basie. No matter when or where it is composed or performed, from the "good old days" to the present, jazz, our ubiquitous American music, speaks to and for each generation—especially the generation that creates it.

The jazz of today certainly underscores this point—it speaks to and for the contemporary generation. The work of Wynton Marsalis, Stanley Jordan, Paquito D'Rivera, Emily Remler, Jane Ira Bloom, Tiger Okoshi, Chico Freeman, Branford Marsalis, and Kenny Kirkland provide excellent examples of what I am speaking of in this regard. Their music and the music of many older musicians like Chick Corea, Herbie Hancock, Freddie Hubbard, Toshiko Akiyoshi, Bobby Hutcherson, and Kenny Barron are relevant to the moods and tempo of today's life. Their music expresses—in its melodies, rhythms and harmonies—feelings and emotions which people, regardless of their cultural and ethnic backgrounds, can understand and appreciate. Jazz, America's classical music, has indeed become multi-ethnic and multi-national in usage.

Let's examine this unique American phenomenon a little more closely. Black-American music, from the very beginning of its development in this country, incorporated elements from other musical traditions, yet it has retained its own identity throughout its history. Though jazz has utilized and restructured materials from many other musical traditions, its basic elements were derived from traditions and aesthetics which were non-European in origin and concept. It is an indigenous *American* music whose roots and value systems are *African*. Its basic rhythmic traditions are found throughout the African continent.

In the African tradition there were *no onlookers,* everyone was a participant in creating rhythm and responding to it. This adherence to African rhythmic practices made it easier for people to participate on their own level. They could play an instrument, dance, sing, clap their hands, stomp their feet, or combine these with other rhythmic methods of self-expression such as shaking or rattling makeshift instruments. Rhythm was fundamental in the African musical tradition and has remained so in jazz. It is interesting to note that when the use of African drums was banned by the slaveholders, all of those drums-inspired rhythms were incorporated into melodies which projected similar feelings and other rhythmic devices were substituted (i.e., Hambone, pattin' juba, etc.).

The basic elements of jazz can be found in the work songs, spirituals and other early forms of music created by slaves. When the blacks were brought to this country, they were forced to quickly adapt to new languages, strange new customs, new religious practices, and the cultural preferences of the slave owners. They were only allowed to retain those cultural traditions which in the opinion of the slave masters made them *better* slaves. Since African culture was considered inferior to European culture, it was systematically and deliberately destroyed by Americans engaged in the slave trade. Tribes and families were broken up on the auction block, and many slaves found themselves living and working with people whose language and customs they did not understand.

Since music had always played such an important part in the daily life of so many Africans, despite the fact that they belonged to different nations and had different backgrounds, it was quickly seized upon as a tool by the

slaves to be used for communication and as relief from both physical and spiritual burdens. In the African societies they had come from, there was music for working, playing, hunting, and most daily activities. There was also music for important events, such as births, initiation rites, marriages, and much, much more. For those Africans, music had many uses; its rhythms and melodies were an integral part of whatever they did.

People who came to this country as free people brought with them the songs, customs, and attitudes of the various places of their origin. They also brought musical instruments and other artifacts with them. They were transplanted people, free to express themselves in ways which were traditional to them, so they were able to sustain and maintain their musical heritage without external need to change.

The transplanted Africans who were enslaved did not have the same freedom to maintain their cultural identity, so their musical traditions had to change. As they endured slavery, they were obliged to reshape and redefine work songs, religious music, leisure songs, dance music and other traditional African music to make that music useful in new situations. They also created new forms of musical expression when some of the old forms no longer satisfied their needs. In Africa, music had been used to accompany and define all the activities of life, so the slaves used well-established techniques to restructure the music they needed for survival tools in the hostile atmosphere of the "land of the free."

African-Americans endured indescribable hardships while they were surviving slavery and other forms of racism in America, but by retaining the cultural supports that worked and by restructuring or discarding those that did not, black Americans created something of beauty from the ugliest of situations—human bondage. They created a new idiom—Afro-American music. This new music was the trunk of the tree from which another truly American music would grow—a classical music in every sense of the word—jazz.

Classical music must be time tested, it must serve as a standard or model, it must have established value, and it must be indigenous to the culture for which it speaks. Jazz meets the criteria by which classical music is judged.

The syntax, semantics, and kinesthetics of jazz are American, and its attitudes reflect prevalent American viewpoints. The gradual changes which that syntax has undergone show a consistent process of developing a unique musical expression. This can be examined and analyzed in the same manner that one can examine and analyze the syntax and forms of other classical styles of music. One can study both the written scores and phonograph recordings of the jazz repertoire and the work of the artists who epitomize the chronological and historically-important styles of the music.

The semantics of jazz convey thoughts, impressions, and feelings which are relevant to generations of Americans through implicit and connotative musical symbols. Americans share an understanding of the emotional connotations of jazz which is based on an Afro-American value system, but the *interpretation* of the musical symbols varies a great deal because the music has transcended ethnic boundaries and reflects and defines the national character as well as the national culture. Pianists Chick Corea and Herbie Hancock have different priorities when they write and play jazz, yet their playing is very compatible when they improvise together in a twin-piano setting.

The kinesthetics or physical movements of jazz are important, but often underestimated, factors in the production of the music. Since jazz is a way of playing music as well as a repertoire, these factors must be considered in

any discussion of its characteristics. The physiological aspects of jazz rhythms and tone production supply the music with many of its unique qualities. Because American cultural practices have determined where jazz could be played, those cultural practices have had an influence on how jazz would be played. In many cases the kinesthetics of jazz have been directly related to the place where the performance occurred and to the response of the audience. A night club, a park, or a riverboat might encourage dancing, handclapping, whistling, or stomping, while a church, a concert hall, a school auditorium, or a small classroom might produce a more subdued interaction between the jazz musicians and the audience.

From *The Black Perspective in Music 14:1,* Winter 1986 by Dr. Billy Taylor. Reprinted by permission of the representative for Dr. Billy Taylor.

Precursors of Jazz

When black slaves were brought from Africa to both America and the Caribbean, they arrived with nothing but their personal and cultural memories. For our discussion, the most important of these memories are the musical traditions that eventually led to the development of jazz. Before we take a look at some of the components that came together to create jazz, here are two definitions to keep in mind. Both terms apply roughly to the period 1890 to 1929. **Ragtime** - An early mixture of African, African-American, and European musical elements—no improvisation. **Traditional Jazz (dixieland)** - A later mixture of African, African-American, and European musical elements—lots of improvisation.

Ragtime

Traditional Jazz (dixieland)

In his book *Writings in Jazz,* noted jazz scholar and performer Nathan Davis raises some interesting general questions about the unique situation that led to the development of jazz. Perhaps there are really no satisfactory answers to these questions, but they should certainly give you cause for thought. With the above definitions in mind, consider this:

What kind of music might we have had if African slaves had been taken to China or Japan or any other part of Asia instead of to the Americas? On the other hand, what would have been the results if the Africans had been the captors and supplied various African territories with European slaves? Would we have a form of music similar to the music we now call jazz? These and similar questions arise when we try to solve the mystery of jazz.[2]

Much of the music the slaves carried in their memory was what we call functional music—music created for work, religion, and ceremony. World music scholar David Locke describes it this way: "African music often happens in social situations where people's primary goals are not artistic. Instead, music is for ceremonies (life cycle rituals, festivals), work (subsistence, child care, domestic chores, wage labor), or play (games, parties, love-making). Music-making contributes to an event's success by focusing attention, communicating information, encouraging social solidarity, and transforming consciousness."[3]

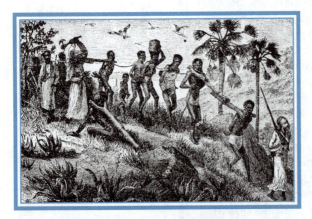

Historic woodcut offering a graphic illustration of slaves being captured in Africa.
Source: © Shutterstock.com

As generations of slaves grew in a new land, their music underwent a series of transformations and transliterations that all play a role in the creation of jazz as a musical style. The key element to keep in mind is the concept of embellishment. Almost all musical formats from traditional African cultures, as well as most music created by African-American culture, contain some type of musical embellishment that gives the music an unending set of variations. These variations run the gamut from slight alterations to an almost total reworking of a given song. Said another way, the performers can sing the same song over and over again, but no two performances will be exactly alike.

The Development of Ragtime

Ragtime music brought together many of the previously discussed elements and mixed them with the European march format. This style fused African syncopation with African-American and European harmonic styles. Around the turn of the last century, almost every piano in the front parlor of an American home had a pile of sheet music on top of it. At this time, there was no radio or television. If you wanted entertainment at home, you had to make it yourself. The concept of rhythmic syncopation was brought into these homes first by music from the minstrel shows and, later, by ragtime, which was the hottest musical rage of the late 1890s and early 1900s. One of the major creators of this new musical style was Scott Joplin.

Scott Joplin was born in Texarkana, Arkansas, the son of freed slaves. He displayed an early talent for music and became a classically-trained pianist. His compositions brought together European formal structures with African syncopated rhythms and African-American harmonies. After the publication of the *Maple Leaf Rag* (see the following listening guide), Joplin quickly became known around the world as the undisputed "King of Ragtime." In Joplin's view, this new style should be considered classical music. In its original form, it was all written out, the same as any other composition for solo piano. In the hands of some of the piano "professors" at work throughout the American South, and particularly in New Orleans, however, embellishments and improvisation began to creep into the performance of ragtime. Nonetheless, Joplin continued to consider his version of ragtime as "classical." In all, he composed almost 100 piano rags, some of which he subsequently arranged for band. In addition, he composed a ballet titled *A Ragtime Dance* and two operas, *A Guest of Honor* and *Treemonisha*. Sadly, the scores to both the ballet and the first opera have been lost, and *Treemonisha* was never performed during Joplin's lifetime. Working from a reconstructed orchestral score, the Houston Grand Opera finally gave the world premiere of *Treemonisha* in 1976. Since then, it has been performed in opera houses around the world.

Making music at home around 1900, when ragtime became the rage across America.
Source: © 2002 www.arttoday.com

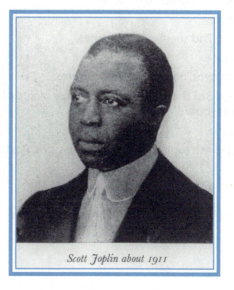

Scott Joplin about 1911

Rare photo of Scott Joplin, the "father" of ragtime music.
Source: © Shutterstock.com

Listening Guide

Maple Leaf Rag
Scott Joplin

Example of ragtime and a typical march form
Recording made from a piano roll created by
Scott Joplin in 1916

The *Maple Leaf Rag* is a masterpiece of the ragtime style. This piece was named in honor of the Maple Leaf Club in Sedalia, Missouri, where Joplin often performed. It was his first published piano rag. This piece follows a typical march format of the day, with four different sections or strains. In music, we typically use letters to represent the different sections of a piece such as this one. Like most rags, this piece is in 2/4 time, meaning there are two basic beats per measure. As you are listening, if you find yourself counting up to 32 instead of 16 at the end of every section, you are going twice as fast as the basic beat. You should also be aware of the fact that this tune has a pick-up note, meaning that the rag actually starts one note earlier than you want to start counting. All of this music was written out by Scott Joplin.

Total time: 3:18

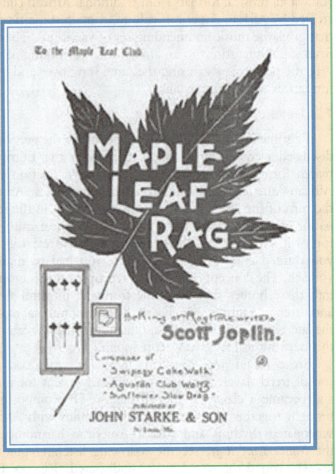

:00	Letter A, also called 1st theme. 16 measures.
:22	Repeat of 1st theme.
:45	Letter B, also called 2nd theme. 16 measures.
1:07	Repeat of 2nd theme.
1:28	Letter A (last statement, no repeat). 16 measures.
1:50	Letter C, also called 3rd theme. 16 measures. This melody is in a new key center and is played much higher up on the piano keyboard.
2:12	Repeat of 3rd theme.
2:34	Letter D, also called 4th (or last) theme. 16 measures. Rhythm in this section is the most syncopated of the entire work.
2:56	Repeat of 4th theme.

The Piano Professors

Out of the ragtime tradition came the piano "professors." These men were highly skilled piano players (mostly black) who performed ragtime and early jazz at social functions, at dances, and in bars and houses of ill repute. When several of these players came together, they would often take part in **cutting contests**. These competitions were usually in a festive party atmosphere where different **cutting contests** "professors" would try to outplay one another. They frequently sped up known tunes to outrageous tempos and added radical embellishments. These embellishments were improvised on the spot, reflecting the spontaneous quality that makes jazz such a unique art form. Even today, the idea of a solo piano player taking a given song and adding his or her own musical ideas and embellishments is a mainstay in jazz culture. The difference today is that cutting contests take place on the various commercial recordings released rather than face-to-face in front of an audience.

Ferdinand "Jelly Roll" Morton, one of the first true innovators of jazz as a musical style, describes a typical scene for a group of piano professors in New Orleans, as well as offering a great description of after-hours life in New Orleans.

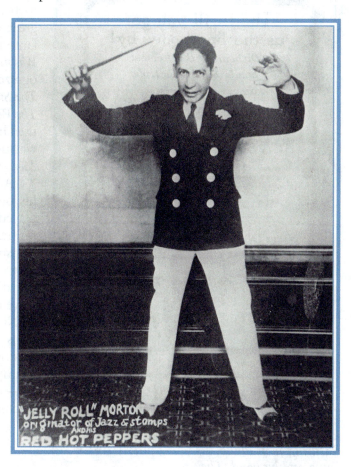

> So in the year of 1902 when I was about seventeen years I happened to invade one of the sections where the birth of jazz originated from [Jelly is referring to an after hours club called The Frenchman's]. . . . It was only a back room, but it was where all the greatest pianists frequented after they got off from work in the sporting-houses. About four A.M., unless plenty of money was involved on their jobs, they would go to The Frenchman's and there would be everything in the line of hilarity there.
>
> All the girls that could get out of their houses was there. The millionaires would come to listen to their favorite pianists. There weren't any discrimination of any kind. . . .
>
> New Orleans was the stomping grounds for all the greatest pianists in the country. We had Spanish, we had colored, we had white, we had Frenchmens, we had Americans, we had them from all parts of the world because there were more jobs for pianists than any other ten places in the world. The sporting-houses needed professors, and we had so many different styles that whenever you came to New Orleans, it wouldn't make any difference that you just came from Paris, or any part of England, Europe, or any place—whatever your tunes were over there, we played them in New Orleans.[4]

Famous photo of Jelly Roll Morton striking a dramatic conducting pose. Courtesy of the Institute of Jazz Studies, Rutgers University

Band Traditions in America

John Philip Sousa

The final element we need to bring into this mix is the tradition of band music in America. A man named **John Philip Sousa** ran a band in the Marine Corps called The President's Own. This band provided music for social occasions around Washington, D.C., as well as the traditional marches used by the military in both Europe and America. In addition to being a world-renowned bandleader, Sousa was also a great march composer. He wrote some of America's most famous marches, including *The Stars and Stripes Forever, The Washington Post,* and *The Liberty Bell March.* You should recognize these march tunes even if you don't know their titles. *The Stars and Stripes Forever* is played every Fourth of July, *The Washington Post* is still one of the most popular marches used by American military bands, and *The Liberty Bell March* was used as the theme song for the comic television show *Monty Python's Flying Circus.*

After Sousa retired from military service, he started his own civilian band and began touring the country. He played his own marches, band transcriptions of classical music, and band arrangements of American popular music. Minstrel show tunes and ragtime pieces were also a popular part of the band's standard shows. More importantly for our discussion, the popularity of the Sousa band created a wave of imitators in almost every city and town in America. In New Orleans, bands made up of black and Creole musicians began to embellish the written music. As with the cutting contests held by piano professors, with the addition of improvisation, jazz was born. It's such a simple thing to say—jazz was born—but it changed the history of American popular music forever.

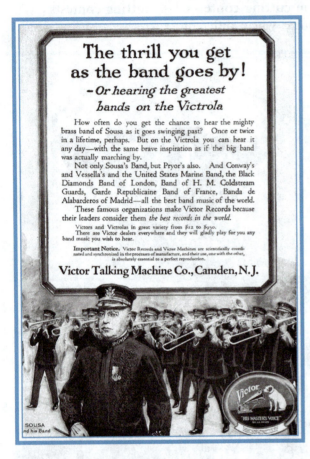

Early Victrola ad featuring John Philip Sousa and his band. The Sousa band was one of the first commercially recorded groups, and the popularity of the Sousa band's style helped lead to the creation of jazz.
Source: © 2002
www.arttoday.com

Traditional Jazz

In order to bring together everything you've learned so far, we need to take a look at the city of New Orleans, Louisiana. The ultimate party town, New Orleans was, and is, unique among American cities. It has existed under Spanish, French, and American rule, and the town's European flair is still quite evident in its food, architecture, and general lifestyle. While Louisiana was a slave state before the Civil War, New Orleans had both a free black and a slave population. In addition, there was a white population of both European and American citizens. Many of the Spanish and French men married or had affairs with black women. The children of these unions were called "Creoles of Color" and were generally treated as members of the aristocratic class until the late 1800s. Most of these Creoles were educated in Europe or at least in the European tradition. For many years, Creoles were a powerful political and social force in New Orleans. In the years after the Civil War, many Southern whites feared they were losing their dominance and, eventually, the Creoles were reduced in social status to the level of blacks after Reconstruction. Both groups were forced to live under severe Jim Crow law restrictions. From all of this injustice, two musical traditions were forced together, and the birth of jazz as we know it was just a few small steps away.

New Orleans had a number of "sporting houses" where prostitution and gambling were the major sources of income. Of course, all these establishments wanted to offer the finest in musical entertainment. First they employed piano professors, and soon many were offering bands modeled on the popular tradition of the day. Eventually, crime and vice in the city grew out of control. At the same time, however, it was a major source of revenue for the city. A city councilman named Sidney Story came up with the idea of isolating the bars, sporting houses, and

Prostitutes from around 1900. Many worked in the "sporting houses" that could be found all over Storyville in New Orleans.
Source: © 2002
www.arttoday.com

Storyville

other dens of iniquity into one small area on the edge of the modern day French Quarter. This area, **Storyville**, was named in the councilman's honor. The development of Storyville helped accelerate the evolution of jazz by placing all these musicians in close proximity to one another. There was a wonderful and continuous exchange of musical ideas and techniques. At the same time, there was also a certain amount of showmanship as the different bands and piano players were constantly trying to outplay one another. In 1917, the U.S. Navy effectively shut down Storyville, fearing the spread of disease and a loss of control over its sailors. Around that time, blacks from all over the South were traveling to northern cities including Chicago and New York in search of a better way of life. As there was less work to be found in New Orleans, many of the city's best musicians followed.

From the book *Mister Jelly Roll*, here is Jelly Roll Morton's account of life in turn-of-the-century New Orleans. Take note of some of the musical terms, which you will see again in the next section. Jelly Roll very modestly takes credit for creating the jazz style almost single-handedly. One particular point of interest is Morton's discussion of what he called the "Spanish tinge." Many think that Latin influences in jazz are fairly recent additions, but Morton and others have pointed out that to some extent Spanish influences were in jazz from its very beginnings. He also presents a very strong opinion about the use of solo "breaks" during the course of a typical jazz performance.

> Jazz music came from New Orleans and New Orleans was inhabited with maybe every race on the face of the globe and, of course, plenty of French people. Many of the earliest tunes in New Orleans was from French origin. Then we had Spanish people there. I heard a lot of Spanish tunes and I tried to play them in correct tempo. . . .

> Now in one of my earliest tunes, *New Orleans Blues,* you can notice the Spanish tinge. In fact, if you can't manage to put tinges of Spanish in your tunes, you will never be able to get the right seasoning, I call it, for jazz. . . .

> A break, itself, is like a musical surprise which didn't come in until I originated the idea of jazz, as I told you. We New Orleans musicians were always looking for novelty effects to attract the public, and many of the most important things in jazz originated in some guy's crazy idea that we tried out for a laugh or just to surprise the folks. . . .

> A lot of people have a wrong conception of jazz. . . . Jazz music is to be played sweet, soft, plenty rhythm. When you have your plenty rhythm with your plenty swing, it becomes beautiful.[5]

Modern-day sign for New Orleans' most famous street. Today, Bourbon Street is the location of many of the city's most successful clubs.
Source: © Shutterstock.com

typical set-up for a traditional jazz band

front line

rhythm section

head

ensemble choruses

solo choruses

out chorus

Traditional Jazz Band Techniques

One of the most important things to remember as we discuss jazz in New Orleans is that no early recorded performances of traditional jazz in New Orleans exist. The first jazz recordings were made in New York and Chicago. Most of the traditional jazz recordings you will study were made in Chicago from 1923 to 1929 and made use of both solo and collective improvisation; however, almost all of the jazz played by bands in New Orleans was done in a collective improvisation style.

Most of the bands in New Orleans took their cues from the American band traditions we discussed in the previous section. The big difference is that jazz musicians agree on a basic melody, chord structure, and rhythmic format; then they just improvise the rest. Each instrument has a role to play in the band, and the musicians learn how to improvise within the constraints of their individual jobs in the band. The **typical set-up for a traditional jazz band** consists of both front line instruments and rhythm section instruments. The **front line** is usually made up of one clarinet, one trumpet, and one trombone. The **rhythm section** consists of a drummer, tuba or string bass, and chord instruments such as banjo and/or piano. All of these instruments can function in the role of soloist.

These are the main jobs for the instruments of a traditional jazz band:

- Clarinet—"noodles," or plays fast embellishments heard at the top of the musical texture
- Trumpet (or cornet)—plays the melody
- Trombone—plays the countermelody
- Drums—keep the basic beat going, add rhythmic color
- Tuba/string bass—plays the bass notes of the harmony, helps define the basic beat
- Banjo/piano—fills in the notes of the harmony, supports the basic rhythm

Some of the tunes these bands performed had multiple sections, much like a typical march or ragtime piece. Other tunes, including those based on the blues, could have a simple 12-bar format that was repeated over and over. Here are some structural terms with which to be familiar. We call the main melody of a typical jazz tune the **head**. The head is almost always played at the beginning of a jazz tune's performance. Each player will embellish the written melody following the jobs described above. As the improvisation continues, you can have **ensemble choruses** where everyone extends their embellishments as above. Remember that this was the common format for performances in New Orleans. Later, musicians such as Louis Armstrong began to break away from the ensemble texture, which allowed them more freedom as soloists. These **solo choruses**, as they are called, continue to be supported by some or all of the rhythm section players. (Keep in mind that these new solo improvisation techniques didn't start to happen until the mid-1920s in Chicago.) Eventually, when the musicians are ready to end a tune, they perform the **out chorus**. The out chorus is a return to the melody of a jazz tune similar to the head, but the last chorus tends to be played more aggressively, with larger deviations from the original melody.

In addition to the basic format information above, here are a few general things to listen for during a typical dixieland tune. A **solo break** is where the band stops playing and one musician improvises (usually two measures). These breaks can occur in the head, the out chorus, and both ensemble and solo choruses. A **stop-time chorus** is a technique of accompaniment where the band plays just the first beat of every measure (or two) while one soloist improvises. You can hear Louis Armstrong playing a great stop-time chorus on one of his finest early recordings, *Potato Head Blues*. And finally, we come to the technique of **trading fours**, where two or more musicians alternate four-measure improvisations. This often becomes a sort of musical conversation that runs through one or more solo choruses. These are just a few of the improvisation techniques you will run into as you learn more about jazz, but this is plenty to get you started.

solo break

stop-time chorus

trading fours

Louis Armstrong

Louis Armstrong is the most important figure in the history of jazz. He established many of the traditions that continue to this day and broke down racial barriers throughout his career. After pioneering solo improvisation in the 1920s, he laid the groundwork for the swing style of the 1930s. In the 30s and 40s, he was one of the first African-Americans featured in films and on network radio, and he continued to be a major jazz performer until his death in 1971. One example of his continued dominance in the world of music was that in 1964 Armstrong knocked the Beatles out of the number one spot on the *Billboard* charts with his recording of *Hello Dolly*. Even today, his voice can be heard on television commercials and in the soundtracks of major Hollywood films. If you've got a happy ending in a movie, it must be time for Louis Armstrong to sing.

For many years, Armstrong's birthday has been officially listed as July 4, 1900. He liked to call himself "a child of the American century."[6] In fact, he was actually born on August 4, 1901, but as a young man he kept changing his birth date to make himself seem older to the musicians with whom he was working. He was born in New Orleans to an extremely poor family and grew up in a very rough part of town called The Battlefield. At the age of 11, Louis was placed in a boy's home in New Orleans after firing a pistol into the air to celebrate New Year's Eve. At the boys home, he joined the band and made very rapid progress as a young trumpet player. Later, Louis spent time with New Orleans trumpet legend Joe "King" Oliver. Much of Armstrong's early knowledge came from the great jazz musicians living in New Orleans. Of these, Armstrong always said that it was King Oliver who was most willing to help out younger musicians. Louis started to play jazz in and around New Orleans every chance he got. In his late teens, he began to play in bands that traveled up and down the Mississippi River. He would sometimes be gone from New Orleans for months at a time, traveling as far north as Minneapolis, Minnesota, playing jazz all the way. When King Oliver left New Orleans, many of his best jobs were passed on to Louis Armstrong. A few years later, it was Oliver who sent back to New Orleans and brought Armstrong north to Chicago.

Louis Armstrong in a press photo from the 1930s.
Source: Courtesy of the Institute of Jazz Studies, Rutgers University

DIG DEEPER

BOOK/VIDEO
Satchmo
by Gary Giddins

When Armstrong joined King Oliver's Creole Jazz Band in 1922, it made for an interesting band set-up. With two trumpet players instead of one, Armstrong spent a great deal of his time improvising lines that accompanied what Oliver was playing as the lead trumpet. Now remember that Oliver himself was improvising most of his material. Musicians were fascinated with Armstrong's ability to improvise the perfect harmony part no matter what Oliver played. As Armstrong's style of playing became more popular, Oliver occasionally let him stretch out musically, breaking away from the standard collective improvisation format. Armstrong's amazing skill at creating a coherent, dramatic improvised musical line could not be contained for long. He married King Oliver's piano player, Lil Hardin, and it was Lil who pushed Armstrong to go out on his own.

In 1924, New York bandleader Fletcher Henderson asked Armstrong to join his band. Henderson was playing society dance music with a larger orchestra, but he wanted to play more of what people were starting to call "hot" jazz. He needed a skilled improviser, and Armstrong fit the bill. Within months, all the best jazz players were imitating Louis Armstrong's dramatic and innovative styles of improvisation.

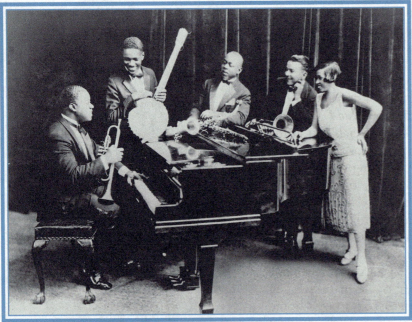

Louis Armstrong and his Hot Five in 1926. Left to right: Louis Armstrong, Johnny St. Cyr, Johnny Dodds, Kid Ory, and Lil Hardin.
Source: Courtesy of the Institute of Jazz Studies, Rutgers University

Just as in Chicago, when Armstrong hit town, the music started to change. Most accounts tell us that Armstrong enjoyed playing in this prototype of a swing era big band, but he was often frustrated with the unprofessional behavior of some of the musicians. While all of Henderson's musicians were very talented, they often drank too much, showed up late to gigs, and sometimes skipped entire jobs. Armstrong eventually returned to his wife in Chicago and started his own band.

In the years 1925 to 1928, Armstrong made a series of recordings with various collections of musicians he called Louis Armstrong and his Hot Five and, later, Louis Armstrong and his Hot Seven. These Hot Five and Hot Seven recordings, as they are usually referred to, codified the art of solo improvisation. Many people view them as the true start of traditional jazz, but in reality, they are the culmination of almost thirty years of musical evolution. In many ways, these recordings laid the groundwork for the swing era. In these recordings, Armstrong produced one incredible improvised instrumental solo after another, and he also raised the level of jazz vocals to a high art. He had been singing off and on for several years, but these recordings represent the first time he was really allowed to demonstrate his innovative vocal style. In addition to singing the regular song lyrics with his rough,

sandpaper-like voice, Armstrong was the first singer to record **scat singing**. This technique of using nonsense syllables to imitate the sound of a horn with the human voice was not uncommon among New Orleans musicians, but Armstrong was the first one to put it on record. Some of these early scat vocals included *Heebie Jeebies* and *Hotter Than That*. For years, instrumentalists and singers would study, imitate, and try to interpret the music of Louis Armstrong. Of the 65 masterpiece recordings made by these bands, incredibly, Armstrong received only fifty dollars per side with no future royalty agreement.[7] The records sold many copies in their day, and they continue to be re-released in new packaging. They truly are the basis for much of what we do in the jazz idiom to this day, but Armstrong never saw another dime from them. One of Armstrong's most famous recordings from the 1920s was a King Oliver tune titled *West End Blues*. The listening guide below is based on the first Hot Five recording of this song, but it was a tune Armstrong would continue to perform and record all of his life.

scat singing

Listening Guide

West End Blues
J. Oliver and C. Williams

Example of the blues, solo improvisation, early scat singing and call and response
Recorded June 28, 1928
Performed by Louis Armstrong and his Hot Five. Louis Armstrong, cornet and vocals; Jimmy Strong, clarinet; Fred Robinson, trombone; Earl "Fatha" Hines, piano; Mancy Carr, banjo; and Zutty Singleton, drums

The *West End Blues* has one of the most frequently copied introductions in all of jazz. The introduction was actually created by King Oliver, but over the years it has become very closely associated with Armstrong. Note the subtle interplay and gentle nuance between Armstrong's voice and the clarinet during the 3rd chorus. You should also be aware of the wide variety of volumes and the extreme range Armstrong is able to command on his cornet.

Total time: 3:16

:00	Introduction. Solo cornet.
:16	Head. Melody played on cornet. Collective improvisation.
:50	Trombone solo chorus.
1:24	Call-and-response improvisation between clarinet and Armstrong's voice.
2:00	Piano solo chorus.
2:32	Out chorus. Collective improvisation.
2:56	Piano interlude as part of ending.
3:05	Band joins in to create ending chords.

As the swing and big band styles became more popular in the 1930s, Armstrong fronted a series of larger groups. He continued to make great recordings, but more and more he focused on popular tunes; however, no matter how commercial the piece of music, he still managed to add his unique jazz touch to the music. He enjoyed great commercial success for a time, both on radio and in film. In fact, he was the first African-American featured on a network radio show. As successful as he was, his bands were eclipsed by more popular groups of the day, including the bands led by Duke Ellington, Count Basie, and Benny Goodman. In the 1940s, Armstrong returned to the small band format. For the rest of his life, he would perform around the world with some of the finest and highest paid musicians in the business. He called all of his bands after 1946 Louis Armstrong and his All-Stars. Eventually, Armstrong and the All-Stars were sent around the world as musical ambassadors for the U.S. government's Department of State. Perhaps one of the most overlooked aspects of Armstrong's career is his early work in the civil

This rare photo of Louis Armstrong was made by musician, radio personality, and concert promoter Bob Burns at the El Paso County Coliseum in West Texas in the 1950s. As a teenager, Mr. Burns arrived early to a concert, met Armstrong backstage and captured this snapshot.
Source: Courtesy of Bob Burns

Page taken from Louis Armstrong's 1947 press and promotional packet as distributed by Joe Glaser's Associated Booking Corp. The booklet ran over 25 pages and included concert reviews, press clips, biographical information and press photos. This packet covers the first full year that Armstrong was on the road with his All-Stars.
Source: Originally appeared as an advertisement in Down Beat Magazine.

rights movement. Long before the serious racial conflicts of the 1960s, Armstrong was using his wit, charm, and talent to knock down many of the racial barriers he faced.

The Swing Era

From 1920 to 1933 there was a federal law banning the manufacture, sale, and transportation of alcohol. Prohibition, as this period was called, was brought on by an

In the 1930s and early 40s, Louis Armstrong fronted a series of big bands like the one pictured here from 1935. Courtesy of the Institute of Jazz Studies, Rutgers University

active temperance movement that wanted to stop the consumption of alcohol in this country. As usual, when you tell people they can't have something, it only makes them want it even more. Illegal nightclubs that served alcohol, called **speakeasies**, sprang up in every city. In a recent interview, jazz historian and critic Gary Giddins makes the point that Prohibition was one of the best things that could have happened to jazz. It created a great deal of work for musicians, as all of these clubs needed entertainment.[8] Later, when Prohibition was repealed and legal nightclubs reappeared, owners wanted to hire the hottest musical acts as they competed for business. Today, most historians discuss swing in terms of its deep musical context. In truth, this was music for dancing. People were impressed with great skills in improvisation, and they enjoyed listening to a good singer. What audiences wanted most, however, was music with a solid, danceable beat. The best bands of the swing era created a smooth, steady groove that almost anyone could dance to. The swing era represents jazz at its most popular. From about 1930 to 1945, jazz was America's major form of popular music. Even during the Depression, jazz was a 100 million dollar industry, employing between thirty and forty thousand musicians across America.[9] For many older people today, the big band sound brings back memories of World War II. This music, and the dancing associated with it, functioned as an escape from the harsh realities with which they were forced to cope. The end of the swing era coincided with the end of the war and the rise in popularity of solo vocalists such as Frank Sinatra.

speakeasies

Poster supporting Prohibition. **Source:** © 2002 www.arttoday.com

swing

orchestration

Swing and Big Band Techniques

Jazz itself was in transition during the late 1920s as the traditional jazz styles expanded and gave way to the more modern **swing** style. Swing rhythms tend to sound more relaxed when compared to dixieland rhythms; therefore, swing music tends to focus on a smoother, four-beat rhythm with the syncopated rhythms falling more on the backside of the beat. In addition to a change in style, many of the bands were growing larger. With all of these extra musicians, the art of **orchestration**, or arranging, became an integral part of the jazz scene for some bands. Composers and arrangers would create musical road maps, or charts, for the musicians to follow. In these larger bands, collective improvisation was replaced by these written

arrangements, but the best bands and their arrangers would create music that left a great deal of room for solo improvisation. To back up these improvised solos, and sometimes to create an entire tune, arrangers would often use *riffs*. A **riff** is a short, repeated, rhythmic and/or melodic phrase.

riff

sweet bands

While improvised traditional jazz was reaching its high point toward the end of the 1920s, a new style of jazz was beginning to take shape in New York City. Large dance bands, often called **sweet bands**, were playing syncopated dance music based on ragtime and traditional jazz styles; however, the music was much more commercial, with little or no improvisation. While sweet music is most closely associated with white bands, both black and white bands were playing this style. Even bands led by Fletcher Henderson and Duke Ellington got their start playing this type of society music. Perhaps the best example of a sweet band is the group led by **Paul Whiteman**, a classically-trained musician who fell under the spell of jazz. His goal, however, was not to imitate the great black musicians he heard but rather to adapt the jazz style to his strictly organized, "classical" view of how music should be performed. His larger orchestra format was typical of the society dance bands of the day.

Paul Whiteman

Victrola record player ad featuring dancers enjoying the "sweet band" music of the day.
Source: © 2002 www.arttoday.com

Saxes, trumpets, and trombones, along with a rhythm section, set the stage for the layout most big bands would use for years to come.

typical set-up for a big band

Although it took a little while to reach a standard size, the **typical set-up for a big band** is as follows: five saxes (two altos, two tenors, one baritone), four trumpets, four trombones, and a rhythm section (piano, string bass, rhythm guitar, and drums). Some of the sweeter sounding bands also used a small string section to lend more of a classical style to their sound. In addition to playing the instruments listed above, some of the players in the band were expected to **double**, or play more than one instrument. For example, all the sax players were expected to sometimes play other woodwind instruments, including clarinet and flute.

double

As we begin to explore the swing era, you should also be familiar with the **stride style** of piano playing. Stride-style piano players copied the written rhythmic styles of ragtime, but they increased the technical demands and, of course, improvised almost everything they played. A simple definition to remember is that the left hand plays the bass notes and the chords while the right hand plays the melody. This style was used by solo piano players including James P. Johnson, Fats Waller, Willie "The Lion" Smith, and Art Tatum, and it was also the main style of playing used in a typical swing rhythm section.

stride style

Fletcher Henderson

In the early 1920s, pianist Fletcher Henderson was leading a band that was performing society dance music, but Henderson and the members of his band wanted to branch out into playing some of the hotter styles of jazz they were hearing on recordings coming out of Chicago. In 1924, Louis Armstrong came to New York, joined Henderson's band, and basically taught everyone how to play jazz in his style. Gary Giddins refers to the big band styles of the swing era as "orchestrated Louis."[10] At the time, most of Henderson's charts were published dance band arrangements that were

reworked by saxophone player Don Redman. In addition, Redman also wrote new charts for the band to play. As improvisation became an important part of their style, the tunes had to be expanded to make room for more and more improvised solos. This is where the concept of the riff really came into play. After Don Redman left the band, Henderson went on to compose and arrange his own tunes, establishing a basic format that was copied by virtually every big band that followed.

Fletcher Henderson was a good musician and became a great arranger, but by all accounts he was never a very successful businessman. His band featured some of the most talented jazz players in New York, but they were undisciplined and often undependable. During the Depression of the early 30s, Henderson's band fell on hard times. He sold his "book," or collection of arrangements, to Benny Goodman, and he eventually created new charts for the Goodman orchestra and even joined Goodman's band as pianist for a brief time.

Fletcher Henderson's first "hot" orchestra pictured in 1924. Left to right: Howard Scott, trumpet; Coleman Hawkins, tenor sax; Louis Armstrong, trumpet; Charlie Dixon, banjo; Fletcher Henderson, piano and leader; Kaiser Marshall, drums; Buster Bailey, clarinet and saxes; Elmer Chambers, trumpet; Charlie Green, trombone; Bob Escudero, tuba; and Don Redman, alto sax and arranger. **Source:** Courtesy of Duncan Schiedt

DIG DEEPER

BOOKS
Music Is My Mistress by Duke Ellington; *Lush Life: A Biography of Billy Strayhorn* by David Hajdu (also a video from PBS – Independent Lens)

sidemen

Duke Ellington

Like Fletcher Henderson, pianist Edward Kennedy "Duke" Ellington got his start in jazz by leading a society band. He was born in Washington, D.C. and had his first success as a musician there. In the mid-1920s Ellington and his band moved to New York City, where they fell under the spell of Louis Armstrong. Soon they too had abandoned sweet music in favor of playing more hot jazz, with lots of solo improvisation and riff-driven ensembles. As the band grew in both size and popularity, Duke moved into a regular performing spot at the Cotton Club. This club was the premiere nightspot in Harlem, and all of the best black performers played there. Ellington quickly established a creative style built around his own compositions. As swing music grew in popularity, the best musicians were in great demand by all the different bandleaders. These players, known as **sidemen**, changed bands frequently, looking for a better working situation. In this regard, Duke's band was very unique. Many of Ellington's men stayed in the band through the entire swing era and beyond. A few, such as Johnny Hodges and Harry Carney, were with him for more than forty years. One reason for this loyalty was that Ellington treated his band members with great respect. For example, during this time period, touring with an African-American band was a very difficult proposition due to strict segregation laws. Especially in the South, there were few hotels and restaurants that would serve blacks. Unlike other bands that toured in buses or cars, Ellington rented Pullman cars and did his touring by train. No matter where they were, his men always had a place to eat and sleep. Ellington made it a point to hire musicians with individual sounds and styles that matched the musical ideas he wanted to get across to an audience. Because the members of his band were so loyal, he was able to write charts requesting very specific sounds and techniques, knowing that the same man would be there every night to play his part. While Ellington is always listed as a piano player, his real instrument was The Duke Ellington Orchestra. A list of the great players who passed through the Ellington band reads like a "Who's Who" of jazz. The following listening guide is for a tune called *Main Stem*, and it features many of Ellington's best players in improvised solos.

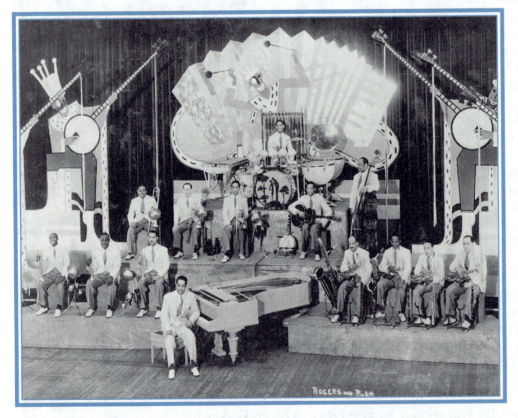

Duke Ellington and his Famous Orchestra, London 1933. Duke Ellington is seated at the piano. Front row, left to right: Freddie Jenkins, Cootie Williams and Arthur Whetsol, trumpet; Otto Hardwicke, Harry Carney, Johnny Hodges and Barney Bigard, woodwinds. Back row, left to right: "Tricky Sam" Nanton, Juan Tizol and Lawrence Brown, trombone; Sonny Greer, drums; Fred Guy, guitar; and Wellman Brauo, bass.
Source: Courtesy of the Institute of Jazz Studies, Rutgers University

Listening Guide

Main Stem
Edward Kennedy Ellington

Example of some of Ellington's great soloists and a good basic swing style with riffs

Recorded June 26, 1942

Performed by Duke Ellington and his Orchestra. Duke Ellington, piano; Johnny Hodges and Otto Hardwick, alto sax; Ben Webster, tenor sax; Barney Bigard, clarinet; Harry Carney, baritone sax; Wallace Jones, Cootie Williams, Rex Stewart and Ray Nance, trumpet; "Tricky Sam" Nanton, Juan Tizol and Lawrence Brown, trombone; Fred Guy, guitar; Alvin Raglin, bass; and Sonny Greer, drums

Duke Ellington's band always featured many gifted improvisers, and this tune gives some of those fine players a chance to shine. The structure for most of the tune is a standard 12-bar blues, but toward the end of the chart Ellington begins to play around with that structure. Don't worry if you don't get all of the counting figured out right away. Just focus on the solos.

Total time: 2:46

Duke Ellington.
Source: Courtesy of the Institute of Jazz Studies, Rutgers University

:00	Head. Played by the full band.
:14	2nd chorus. Improvised trumpet solo by Rex Stewart. Saxes play riffs.
:28	3rd chorus. Improvised sax solo by Johnny Hodges.
:41	4th chorus. Improvised trumpet solo by Rex Stewart.
:55	5th chorus. Improvised trumpet solo by Ray Nance. He is using a mute to change the sound of the instrument.
1:08	6th chorus. Improvised clarinet solo by Barney Bigard.
1:22	7th chorus. Improvised trombone solo by Tricky Sam Nanton. Note his use of the plunger mute and how he growls into the horn for effect.
1:36	6-measure shout played by the entire band.
1:43	18-measure section (4 bars of long-tones from the band, followed by 14 bars of improvisation by tenor sax player Ben Webster).
2:03	18-measure section (4 bars of long-tones from the band, followed by 14 bars of improvisation by trombonist Lawrence Brown).
2:23	Out chorus. Return to 12-bar blues format used for much of the tune.
2:37	Additional 8-bar tag for conclusion of the tune.

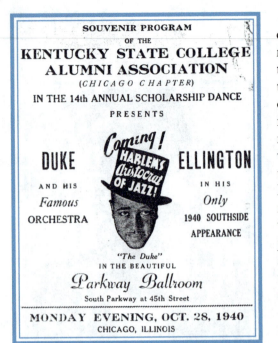

SOUVENIR PROGRAM
OF THE
**KENTUCKY STATE COLLEGE
ALUMNI ASSOCIATION**
(CHICAGO CHAPTER)
IN THE 14th ANNUAL SCHOLARSHIP DANCE
PRESENTS

Coming!
HARLEM'S
Aristocrat
OF JAZZ!

DUKE **ELLINGTON**

AND HIS IN HIS
Famous *Only*
ORCHESTRA 1940 SOUTHSIDE
APPEARANCE

"The Duke"
IN THE BEAUTIFUL
Parkway Ballroom
South Parkway at 45th Street

MONDAY EVENING, OCT. 28, 1940
CHICAGO, ILLINOIS

Program for a 1940 dance concert that featured Duke Ellington and his band. Even at the height of his popularity, Ellington continued to play "one-nighters" and did so well into the 1970s.
Source: Courtesy of the Institute of Jazz Studies, Rutgers University

Billy Strayhorn

Over his long and successful career, Duke Ellington constantly expanded the boundaries of what jazz music could be. Most dance numbers were designed to last three or four minutes each. This time frame coincided nicely with the 78-rpm recordings that were the dominant recording format of the day. In jam sessions, tunes often lasted longer, but, for the public, the general rule was to keep it short and swinging. Ellington created many of these typical swing numbers for his book, but he also began delving deeper into the world of classical music. He began to write musical "tone poems" that painted vivid musical pictures such as the tune *Harlem Airshaft*. He also wrote more extended compositions and even multi-movement suites such as *Black, Brown, and Beige*. Later, Ellington ventured into orchestral composition, fusing together classical and jazz styles. He wrote works including *New World A'comin'*, which is basically a one-movement piano concerto; *Harlem*, which is a tone poem that Ellington scored for both his big band and the full symphony orchestra; and a score for the film *Anatomy of a Murder*.

Perhaps the most unique feature of Duke Ellington's compositional style was his working relationship with pianist/composer **Billy Strayhorn**. Though very different in personality, these two men formed a working relationship that pushed both their creative abilities to new levels. They worked so well together that many times after a work was finished neither man could remember just who wrote what. Their styles were so complimentary that one man could stop at any given measure of a new work, tell the other what he had done, and the work would be completed the next day. Strayhorn also played piano with the orchestra when Ellington wanted to conduct from the front of the band. In fact, Ellington's theme song *Take The "A" Train* was actually composed by Billy Strayhorn.

At the end of World War II, many of the big bands were in decline and began to break up. People weren't going out as much, the popular solo singer was taking over, and it was just too expensive to keep a big band with 15 to 20 musicians working. Ellington's band was one of the few groups to survive. Ellington paid his men a regular salary, and they got paid whether the band worked or not. During the 1950s and 60s the Ellington band continued to enjoy success as both a recording unit and a touring band. By this time, 33⅓-rpm long-play records had taken over as the standard recording format. Now a band could record almost thirty minutes of music per side of an album. Unlike any band before him, Ellington was able to put on vinyl just about every note he ever put on paper. He created major successes, such as the album *Ellington Indigos*, and he was also able to record much of his more obscure music, some of which tested the limits of what jazz could be.

Benny Goodman

Benny Goodman was born into a very poor Jewish family in Chicago, Illinois. Goodman began to study the clarinet, and he became a talented classical player by the time he was a teenager. After hearing the outstanding New Orleans jazz musicians who had relocated to Chicago, he became consumed with an interest in the new art form. Goodman began playing in white dance bands and eventually was able to support his entire family from his earnings as a musician. He settled in New York City, where he attempted to form a band based on the models of Fletcher Henderson and Duke Ellington. In continuing his pursuit of the hot-jazz style, he bought arrangements from Fletcher Henderson, giving his band the exciting material it needed. Goodman's big break came in 1934 when his band got a regular spot on the *Let's Dance* radio program. When the show ended in 1935, the band under-

took a disastrous cross-country tour. Outside of New York City, people were behind the curve when it came to contemporary music: most folks in the Midwest were still dancing to sweet band music. They just weren't ready for hot jazz, and many of the band's engagements were limited or canceled altogether. The big change came when the band finally reached the Palomar Ballroom in Los Angeles. Young people on the West Coast had been listening to the *Let's Dance* broadcasts, and they were more than ready for the new music that Goodman was playing. From this success Goodman was labeled the "King of Swing," and his band was in great demand on the radio, in films, and in live performances.

In addition to performing with his big band, Goodman began recording with African-American pianist Teddy Wilson and drummer Gene Krupa. For a time, the **Benny Goodman Trio** was only a recording ensemble. There was some demand for public performances, but Goodman was a bit reluctant to jeopardize his career by performing in public with a mixed race band. According to most accounts of his life, Goodman was not a racist in any way, but he was conscious of the general mood of the country. When the trio did perform in public to great acclaim, Goodman realized that it was possible to be successful with a mixed band.[11]

He went on to hire other black musicians and continued to have one of the most successful bands in America. With the addition of Lionel Hampton on the vibraphone, the trio was expanded to a quartet. The **Benny Goodman Quartet** was one of the most creative groups of improvising musicians ever assembled. They played "head charts" with lots of collective improvisation. The format was similar to that of a traditional jazz band, but the rhythmic style was pure swing. While the quartet did play ballads and medium-tempo tunes, they specialized in fast numbers that built in intensity all the way to the end of the tune.

Benny Goodman Trio

Benny Goodman Quartet

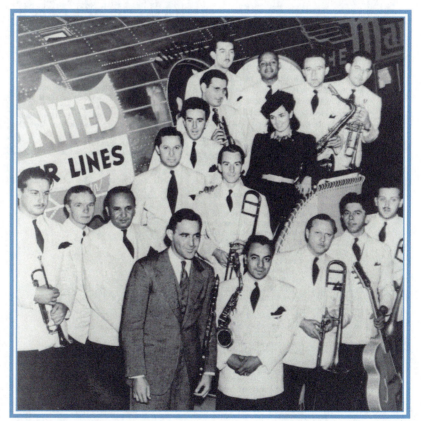

On January 16, 1938, the Benny Goodman Orchestra and Quartet played the first jazz concert in New York's Carnegie Hall. In addition to his regular groups, Goodman featured guest artists from Duke Ellington's band, and he was also joined by Count Basie and members of his band. This concert is considered one of the monumental and pivotal moments in jazz history. It was this event that really proved to the world jazz was a legitimate art form that deserved to be taken as seriously as classical music. As important as we now know this concert was, at the

The Benny Goodman Orchestra in a 1939 press photo. Goodman is standing in the dark suit at the front of the group. Fletcher Henderson can be seen third from the left just behind Goodman's right shoulder.
Source: Courtesy of the Institute of Jazz Studies, Rutgers University

time it was looked at by many outside the jazz world as something of an oddity and perhaps even an annoyance. For example, here is the concert review that appeared in the *New York Times* the day after the show. The concert was recorded, but an album was not released until the 1950s. The following notes by Irving Kolodin are from that historic album.

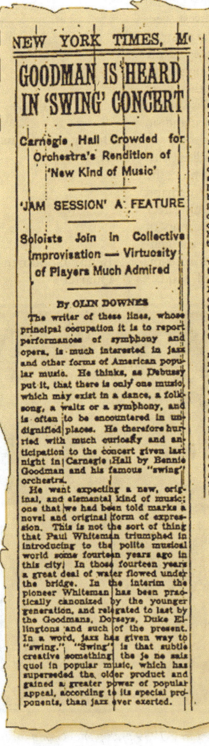

NEW YORK TIMES, M

GOODMAN IS HEARD IN 'SWING' CONCERT

Carnegie Hall Crowded for Orchestra's Rendition of 'New Kind of Music'

'JAM SESSION' A FEATURE

Soloists Join in Collective Improvisation — Virtuosity of Players Much Admired

By OLIN DOWNES

The writer of these lines, whose principal occupation it is to report performances of symphony and opera, is much interested in jazz and other forms of American popular music. He thinks, as Debussy put it, that there is only one music, which may exist in a dance, a folk-song, a waltz or a symphony, and is often to be encountered in undignified places. He therefore hurried with much curiosity and anticipation to the concert given last night in Carnegie Hall by Bennie Goodman and his famous "swing" orchestra.

He went expecting a new, original, and elemental kind of music; one that we had been told marks a novel and original form of expression. This is not the sort of thing that Paul Whiteman triumphed in introducing to the polite musical world some fourteen years ago in this city. In those fourteen years a great deal of water flowed under the bridge. In the interim the pioneer Whiteman has been practically canonized by the younger generation, and relegated to last by the Goodmans, Dorseys, Duke Ellingtons and such of the present. In a word, jazz has given way to "swing." "Swing" is that subtle creative something the je ne sais quoi in popular music, which has superseded the older product and gained a greater power of popular appeal, according to its special proponents, than jazz ever exerted.

Leader Warmly Welcomed.

It may therefore be imagined with what a thumping of the heart the present scribe got into his seat, in good time before the concert began, to hear the very first notes of Goodman's orchestra. It may be said immediately that he was enormously impressed, though not in the precise way he expected. When Mr. Goodman entered he received a real Toscanini send-off from the excited throng. It took some minutes to establish quiet. There was quivering excitement in the air; an almost electrical effect, and much laughter. The audience broke out before the music stopped, in crashing applause and special salvos as one or another of the heroes of the orchestra rose in his place to give his special and ornate contribution to the occasion.

That is almost the sum of it. We went to discover a new, original thrilling music. We stayed to watch a social and physical phenomenon. For the great gathering was almost off its head with joy. The "hotter" the pace, the louder the blasts, the better it went. Sometimes shouts threatened to vanquish the orchestra.

This form of sound is a curious reduction, almost disintegration of music into its component elements. There is hardly an attempt at beauty of tone, and certainly none at construction of melody. A few fragments of well-known popular tunes suffice for a sort of rough material, subject to variation by the players. They do such feats of rhythm and dexterity as occur to them on the tune's basis. The tone of the brass instruments, almost continually overblown, is hard, shrill and noisy. The other instruments add what they can to swell the racket.

What Rhythm Can Do

But why claim that this is new? These are effects and devices as old as the hills to any one who has listened in the last fifteen years to jazz music. They are merely carried to extremes. It is very interesting to see what rhythm can do. It can get an audience wild, and it did. But it did not seem to be able to generate music.

Attend a Negro camp meeting. The people shout and become possessed by rhythm. This invariably produces music. Song is thrown off as a sort of grand ferment of the tumult. The playing last night, if noise, speed and syncopation, all very old devices, are heat, was "hot" as it could be, but nothing came of it all, and in the long run it was decidedly monotonous.

Nor is Mr. Goodman, when he plays his clarinet, anything like as original as other players of the same instrument and the same sort of thing that we have heard. Nor did we hear a single player, in the course of a solid hour of music, invent one original or interesting musical phrase, over the persistent basic rhythm. Not that they lacked technical accomplishment and amazing mastery of their medium. Musically, they let us down. . . .

Much was expected of the "jam session." A "jam session" is improvisation, free for all members of the band, over a basic rhythm, and the devil take the hindmost. Such a form is a special test of the players' invention. No doubt a "jam session" can be dull as ditch-water one night and inspired at the very next meeting. Last night's "jam session" seemed to last a good ten minutes, and though soloist after soloist of the band tried in turn to contribute something original to the ensemble, little or nothing of the sort materialized.

If this is the ideal presentment of "swing" we must own to a cruel disillusion. We may be a hopeless old-timer, sunk in the joys of Whiteman jazz, unable to appreciate the starker, modern product. But we greatly fear we are right, and venture the prediction that "swing" of this kind will quickly be a thing of the past. Some say that it doesn't pretend to be music, but to be "something else." That is perhaps true. If so, rhythms that carry music with them will supplant it.

It is to be recorded that last night's audience remained applauding and cheering till a late hour. It is to be added, so far as one observer's reaction is concerned, that "swing" is a bore, long before an evening has ended.

Source: From *The New York Times*, January 18, 1938. Reprinted by permission of The New York Times.

Benny Goodman Live at Carnegie Hall
by Irving Kolodin

The first intimation I had that there might be such a thing as a concert by Benny Goodman's band in Carnegie Hall came one December afternoon in 1937. I was on a journalistic mission to Gerald Goode, press chief for S. Hurok, when he excused himself to answer the phone. After absorbing the information from the other end, he closed off the mouthpiece and said: "What would you think of a concert by Benny Goodman's band in Carnegie?" "A terrific idea," I responded, "Why?" "It's somebody from Goodman's radio program," Goode stated. "He wants Hurok to run it."

'Somebody from Goodman's radio program' turned out to be Wynn Nathanson, of the Tom Fizdale agency, then promoting the *Camel Caravan* on which Goodman was appearing. The thinking was reasonable enough: the "King of Jazz" in the previous decade (Paul Whiteman) had done it; why not the "King of Swing" in the present (1930) one? Ellington and Armstrong had both given jazz concerts abroad, and in the early days of his national prominence, Goodman had in the Congress Hotel (in Chicago) one Sunday afternoon. Nightly at the Pennsylvania Hotel (now the Statler), the number of those who stood around the band stand, or sat at tables listening, far outnumbered those on the dance floor. It didn't seem any question to me that there would be thousands to pay Carnegie Hall prices.

My brash enthusiasm, aroused by Goodman's records, was passed along to the interested parties. For this, as well as much better reasons, a contract was signed for Sunday night, January 16, 1938, announcements were printed, advertisements placed, and a program book commissioned. The professional misgivings were stronger than my amateur confidence. Hurok was somewhat reassured when he came to the Madhattan Room of the Pennsylvania one night, and was quite taken aback by the uproar of the band, and the artistry of the Goodman-Krupa-Wilson-Hampton quartet. So many well-dressed people spending money on an attraction was obviously a good omen. The deluge of money orders and cash when the tickets went on sale was an even better one.

Goodman's problem was a special one. Naturally he wanted to fill the house, if for no other reason than pride. The probability of making money was remote, if even contemplated, for the program required special rehearsing, a few new arrangements, the disbursement of some free tickets to those in the profession. For that matter, Goodman was so confident that tickets could be purchased whenever he might want them that he had to patronize a speculator during the last week, when his family decided to come on from Chicago. Needless to say, the publicity could not have been purchased for any price.

I knew then that Goodman was concerned about the musical content of the program (Carnegie Hall, after all, was not the Congress Hotel). I didn't know that he asked Beatrice Lillie to go on for comedy relief, for fear that the evening might wear thin. Miss Lillie wisely declined—wisely, I say, because she had a fortunate premonition what the program might be like, and reckoned rightly that her talents might be a little on the quiet side.

One fact was firmly settled at the outset. The concert would consist of the Goodman band and allied talent only. There would be no special "compositions" for the occasion. The musicians, in this kind of music, were the thing, and so it would remain. The regular book built by Fletcher Henderson, Jim Mundy, Edgar Sampson, etc., which had built Goodman's reputation—or vice versa—would suffice. For a little freshness, Henderson was asked to do a

couple of standard tunes (Dick Rodgers' *Blue Room* came in time to be used) and Edgar Sampson—whose *Stompin' At The Savoy* was a by-word with Goodman fans—was asked to bring around a few things.

Here was a singular stroke of luck. Among the arrangements that were passed out at the first rehearsal on the stage of Carnegie Hall was a new version of a piece Sampson had done previously for the band led by the great drummer Chick Webb. The title was *Don't Be That Way*. Benny decided immediately that this was his ice breaker, a decision fully justified by its reception, its subsequent popularity and its history on discs.

The idea for the historical "Twenty Years Of Jazz" was, I am afraid, mine. I apologize for it because it probably caused more trouble in listening to old records and copying off arrangements than it was worth. However, it brought out that family feeling that all good jazz musicians have for their celebrated predecessors, permitting a backward look at such landmarks of the popular music field as the Original Dixieland Band, Bix Beiderbecke, Ted Lewis, Louis Armstrong, and the perennial Duke Ellington. Only a few New Yorkers then knew of Bobby Hackett, an ex-guitar player from New England, who had been impressing the night-club trade with his feeling for the Beiderbecke tradition on cornet. A lean trumpet player named Harry James, who then occupied the Goodman first chair, vowed sure, he could do the Armstrong Shine chorus. For the Ellington episode, only Ellington musicians would suffice, and the calendar was gracious in permitting Johnny Hodges, Harry Carney, and Cootie Williams to participate. The Duke himself was invited, but reasonably demurred, looking ahead to the time when he would make a bow of his own in Carnegie, as, needless to say, he has since.

The jam session was frankly a risk, as the program stated: "The audience is asked to accept the jam session in a spirit of experimentation, with the hope that the proper atmosphere will be established." At the suggestion of John Hammond, Jr., some key members of the then-rising band of Count Basie were invited to sit in, along with Hodges and Carney, and Goodman, James, Krupa and Vernon Brown of the host ensemble. The calculated risk was only too plain in the performance; what remains in this presentation is the kind of edited reconstruction possible in this day of magnetic tape.

With these elements of the program defined, the rest was easy. The trio would have a spot, and then the quartet with Hampton. Nothing could follow this but intermission, and it did. (Goodman was asked the day before, "How long an intermission do you want?" "I dunno," he replied, "how much does Toscanini have?") In the second half, there would be arrangements of tunes by Berlin and Rodgers, some of the recorded specialties of the band— *Swingtime In The Rockies, Loch Lomond,* and a current hit, *Bei Mir Bist Du Schoen,* leading to an inescapable conclusion with *Sing Sing Sing* which had become, by this time, a tradition, a ritual, even an act. I don't suppose that Louis Prima, who wrote the tune, was around Carnegie Hall that night. It is not often that Bach or Beethoven are rewarded, in Carnegie Hall, with the hush that settled on the crowded auditorium as Jess Stacy plowed a furrow—wide, deep and distinctive—through five choruses of it.

Well, that was all yesterday. A chilly, January yesterday, which somehow seems warm and inviting because twelve years have passed, along with a war and some shattering upheavals in the world. But it wasn't warm outside Carnegie Hall that night, as a picture in a contemporary paper, showing an overcoated, begloved line of prospective standees, attests.

Inside, the hall vibrated. Seats had been gone for days, of course, but one of those last minute rushes had set in, when all New York had decided that this was the place it wanted to be on the night of that particular January 16. The boxes were full of important squatters, and a jury-box had been erected on stage to care for the overflow. Tension tightened as the orchestra filed in, and it snapped with applause as Goodman, in tails, strode in, clarinet in hand, bowed, and counted off *Don't Be That Way*.

From then on, one climax piled on another. I remember the critic of the *Times* (who next day wrote, "When Mr. Goodman entered, he received a real Toscanini send-off from the audience") fretting because his teen-aged daughter beside him was bouncing in her seat and he felt nothing . . . a spontaneous outburst for James when he took his first chorus . . . ditto for Krupa . . . a ripple of laughter when Krupa smashed a cymbal from place in a quartet number, and Hampton caught it deftly in the air, stroking it precisely in rhythm . . . the corruscating sound-showers from Hampton's vibes that culminated the first half of the concert, and the reasonable doubt that anything afterwards could come close to matching it . . . until the matchless Stacy resolved all that had preceded with his *Sing Sing Sing* episode . . . the crowd howling its pleasure, the band taking its bows, and the boys dispersing to "cool out" race-horse fashion, all over town (the favored spot was the Savoy Ballroom, in Harlem, where Martin Block presided over a battle of music between the orchestras of Chick Webb and Count Basie). Next day, contemplating the diverse reviews, the interested editorial opinions in the *Times* and *Herald-Tribune*, someone said to Goodman, "It's too damned bad somebody didn't make a record of this whole thing." He smiled and said: "Somebody did."

El Paso musician Bob Foskett made this photo of Benny Goodman during a concert with the El Paso Symphony during the 1970s.
Source: Courtesy of Bob Foskett

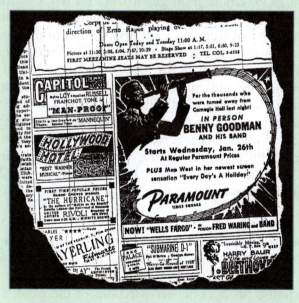

Incredulously, I heard those "takes" (relayed to the CBS studios from a single overhead mike from Carnegie Hall) and relived the experience detailed above. There-after, one set was destined for the Library of Congress, the other— who knows? Twelve years passed, and the whole thing was but a memory, when the other set turned up in a closet of the Goodman home a few months ago. Daughter Rachel came upon it and asked: "Daddy, what's this?" Daddy took a look, and wisely decided to have it transferred to tape before listening again. So has been preserved, in a representative way, one of the authenti documents in American musical history, a verbatim report, in the accents of those who were present, on "The Night of January 16, 1938."

This ad ran next to the New York Times review of the famous Carnegie Hall concert on January 17, 1938. Notice how the ad is directed at the many Goodman fans who were turned away from the concert.

From CD Recording Liner Notes from Columbia Records G2K 40244 *by Irving Kolodin.*
Source: *Courtesy of Columbia Records with permission.*

Press photo of the Benny Goodman Sextet. Left to right: Lionel Hampton, Artie Bernstein, Benny Goodman, Nick Fatool, Charlie Christian, and Dudley Brooks.
Source: Courtesy of the Institute of Jazz Studies, Rutgers University

Charlie Christian

DIG DEEPER

MOVIES
The Benny Goodman Story; A Song Is Born

RECORDING
Benny Goodman: The Complete Carnegie Hall Concert

head charts

Many of the musicians who achieved fame with the Benny Goodman Orchestra went on to form their own successful big bands: Teddy Wilson, Gene Krupa, Harry James, Cootie Williams, and Lionel Hampton all went on to front their own groups. The Lionel Hampton band in particular is interesting as some of the rhythmic styles it began to explore in the 1940s are considered to have laid the groundwork for the birth of rock and roll. One other important musician who passed through the Goodman ranks was guitarist **Charlie Christian**, who joined a sextet Goodman was fronting in 1939. Unlike most guitarists of the day, Christian improvised in flowing, single melodic lines rather then just strumming chords in a straight, four-beat pattern. To make his instrument heard over the rest of the band, Christian played an amplified acoustic guitar. You can listen to Charlie Christian play with the Benny Goodman Sextet on the tune *Air Mail Special (*also known as *Good Enough to Keep)*, found in the listening guide on the following page. While Christian wasn't the first person to play an amplified guitar, his playing and his electric guitar are both viewed as precursors to some rock-and-roll styles. Interestingly enough, Christian is also considered to have been a real inspiration to the creators of bebop. Christian used to jam with players including Dizzy Gillespie, Charlie Parker, and Thelonious Monk, but sadly he passed away in 1942 at the age of 26, several years before the bebop style really broke on the New York scene.

Count Basie

In Kansas City, a more open, relaxed style of swing music was taking shape. Unlike the more commercial bands in New York City, Kansas City bands used few written arrangements. Instead, their performances, called **head charts,** were based on a series of riffs, call and response passages between sections of the band, and great improvised solos. In general, the rhythmic style of swing music in Kansas City was lighter. Fast or slow, there was always a very smooth and steady four-beat pattern. Perhaps the biggest thing the Kansas City bands had in common was a strong

Listening Guide

Air Mail Special

J. Munday, B. Goodman and C. Christian

Example of small-group swing and early use of electric guitar
Recorded June 20, 1940
Performed by the Benny Goodman Sextet. Benny Goodman, clarinet; Lionel Hampton, vibes; Charlie Christian, electric guitar; Dudley Brooks, piano; Artie Bernstein, bass; and Harry Jaeger, drums

With all of his small groups, Benny Goodman returned to the "head chart" style used by many traditional jazz bands. The big difference here is the use of the modern swing style and an increased focus on solo improvisation. This tune uses a standard 32-bar format (A-A-B-A), but the chord changes and the rhythm of the melody have an unusual pattern. This is especially true in the out chorus, so don't worry too much about the formal structure. Just listen to the outstanding improvisations, and pay particular attention to the improvisational style and sound of Charlie Christian on electric guitar.

Total time: 2:53

:00	Head.
:35	Vibe solo.
1:10	Guitar solo.
1:44	Clarinet solo.
2:18	Riff played by the entire band as out chorus.

focus on the blues. Both playing and singing styles from Kansas City were deeply rooted in the language of the blues. Musicians from many different parts of the country congregated in Kansas City in the 1930s and contributed to this common language. Although he was born in New Jersey, learned to play jazz piano in New York, and traveled the country in vaudeville shows, William "Count" Basie was considered a master of the Kansas City style.

One of the things that made the Basie sound so special was the cohesive, relaxed swinging sound of his rhythm section. Walter Page on bass, Jo Jones on drums, Freddie Green on rhythm guitar, and Count Basie on piano are considered by many to be the finest swing rhythm section that ever played this style of music. Walter Page played a note on every beat in a very smooth, even pattern. The technique came to be known as **walking bass.** On drums, Jo Jones shifted the emphasis of the main beat from the bass drum up to the cymbals. This change gave the music a lighter, more buoyant feel. Freddie Green followed the walking-bass rhythm and strummed chords in a very straight, four-beat pattern. He was considered to be a solid time machine by those who worked with him. Basie himself started by playing in the stride style of James P. Johnson and Fats Waller. As his style progressed, however, he began to play fewer and fewer notes. He would let the other players in the rhythm section take care of creating a nice, steady rhythm while he would sporadically interject little groups of chords or

walking bass

comping

even just single notes. This sparse, new style would eventually be called **comping**. Short for *complementing*, comping meant that Basie listened carefully to what was going on around him and improvised accordingly. This new comping style would become the standard technique for pianists in the bebop era and well beyond.

As with Duke Ellington's band, the list of musicians who passed through Count Basie's band over the years reads like a roll call of some of the finest jazz musicians who ever practiced the art. Men such as Lester Young, Harry "Sweets" Edison, Clark Terry, Louis Bellson, Don Byas, Illinois Jacquet, Curtis Fuller, and Snooky Young all went on to have major careers in the world of jazz. Of all the fine players just listed, perhaps the most influential was Lester Young. Unlike other saxophone players of his day, Young played with a lighter, smoother tone with less vibrato than was common at the time. He also put together longer strings of unbroken notes, a technique that looks forward to bebop. You can hear a great example of Lester Young's playing in a small-group recording made by Count Basie and his Kansas City Seven, *Lester Leaps In*. In his recent book on jazz, Alan Axelrod points out that similar to Louis Armstrong, Cab Calloway, and many other jazz musicians over the years, Lester Young developed a unique pattern of speech that many other jazz musicians and fans would try to copy.

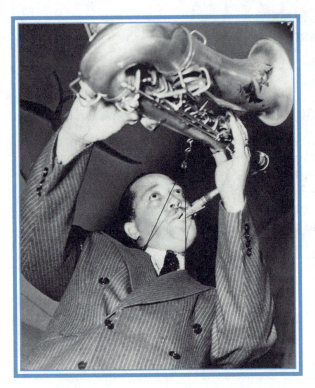

Tenor saxophone titan Lester Young.
Source: Courtesy of the Institute of Jazz Studies, Rutgers University

It was Lester Young who gave Billie Holiday the nickname "Lady Day" (she called Young "Prez," declaring him president of saxophonists). But then, Young called a lot of people "Lady," male or female. In fact, he invented his own language, pinning idiosyncratic labels on a great many things. A white person he might call a "gray," and a black would be an "Oxford gray." When his saxophone keys got bent, he took the instrument to fellow tenor saxophonist and amateur repairman Flip Phillips: "Lady Flip, my people won't play!" Young called policemen "Bob Crosbys," marijuana was "ettuce," and the bridge section of a tune became a "George Washington." If something was a bore or a pain, he'd call it a "von Hangman." If someone slighted him (or he encountered racial discrimination), he'd declare that he was "feeling a draft." And when the Basie band would hit a town that was home to an old girlfriend, he'd excuse himself, saying that he was "going to see a wayback."[12]

Count Basie was one of the few bandleaders to survive the end of the big band era. Except for a brief period in the late 1940s, Basie continued fronting a big band for most of his career. Over the years, his band became a training ground for young jazz musicians and arrangers. In later years, Count Basie was in great demand at jazz festivals and in regular concert tour appearances around the world. He also recorded and toured with great singers including Ella Fitzgerald, Joe Williams, and Frank Sinatra. To get a sense of the Basie style, here is a listening guide for *Lester Leaps In*, which features the famous Basie rhythm section and tenor saxophonist Lester Young.

Listening Guide

Lester Leaps In
Lester Young

Example of small-group swing, Young's more modern approach to improvisation, and Basie's rhythm section style, including his piano comping

Recorded September 5, 1939

Performed by Count Basie and his Kansas City Seven. Count Basie, piano; Lester Young, tenor sax; Buck Clayton, trumpet; Dickie Wells, trombone; Freddie Green, guitar; Walter Page, bass; and Jo Jones, drums

Late 1950s ad from the Village Voice *for a Count Basie show at Birdland, famous New York City jazz club*

Like the Goodman Sextet tune, this performance is a head chart that focuses mostly on solo improvisation. As you listen to Lester Young, notice the lighter tone on the tenor saxophone as well as the longer strings of improvised notes. These techniques will have a big impact on some of the bebop players featured in the next section. In addition, pay close attention to the smooth, swinging style of Count Basie and his famous rhythm section. This tune uses the standard 32-bar song form (A-A-B-A).

Total time: 3:13

:00	4-measure introduction played by rhythm section.
:03	1st chorus. Letter A material played by entire band. Bridge material played by Count Basie on piano, accompanied by the rhythm section.
:35	2nd chorus. Features improvisation by Lester Young throughout.
1:06	3rd chorus. Features Basie and Young improvising as the rhythm section varies their accompaniment between stop-time and regular time-keeping on the bridge.
1:37	4th chorus. Features Basie and Young improvising by trading fours.
2:09	5th chorus. Features call and response between front-line instruments playing a 4-measure riff and Basie and Young improvising answers.
2:40	6th chorus. Continues format of 5th chorus until the last 8 measures when everyone plays the riff one more time, then breaks into collective improvisation for the conclusion of the tune.

Bebop

Between 1945 and 1955 American popular music began to move in several different directions. At first, pop singers such as Frank Sinatra, Doris Day, and Rosemary Clooney were at the top of the charts. As a younger generation of listeners began to control the pop charts, however, early rock-and-roll music began to take over. By the mid 1950s, the big stars of the day included Chuck Berry, Little Richard,

Minton's

Monroe's

bebop

and Elvis Presley. Meanwhile, a more advanced jazz style was taking shape in some of the after-hours clubs in New York City. In search of a more challenging musical experience, younger swing players including Charlie Parker, Dizzy Gillespie, and Thelonious Monk started to make some radical changes to jazz. Inspired by advanced swing players succh as Art Tatum, Lester Young, and Charlie Christian, the "beboppers," as they came to be called, began to speed up tempos, dramatically alter supporting chord structures, and frequently abandon the original melodies to songs altogether. In late-night jam sessions at clubs such as **Minton's** and **Monroe's**, musicians pushed the envelope of what jazz could be throughout the early 1940s.

By 1945 **bebop** had arrived in New York City, but for most music fans in America this new style was largely unknown. Even in New York there was a great deal of resistance to the new musical style. Some older swing musicians had very negative things to say about these young musical upstarts and their strange new ideas.

One of the major difficulties in discussing the evolution of bebop is the fact that in 1942 the American Federation of Musicians issued a recording ban. The union was fighting radio and record companies over royalty payments for recording musicians. No recordings were made for several years at the exact time bebop was taking shape. Historically, the result is that bebop seems to arrive fully formed in 1945 after the recording ban was lifted. While we have excellent written accounts of how bebop evolved and great recordings from the periods before and after the AFM ban, we can only guess at what these historical jam sessions might have sounded like. Even the earliest bebop recordings are not quite true representations of what was going on in the clubs. In the mid-40s, music was still being recorded on 78-rpm discs that could only contain about four minutes of music per side. In live performances, bebop tunes usually lasted much longer.

Bebop Techniques

newly created lines

With just a few exceptions, bebop used a small band format. Most bands consisted of one to three horn players in the front line backed up by the traditional rhythm section of piano, bass, and drums. Most bebop tunes were complex **newly created lines** over a set of standard chord changes. The 32-bar format for the tune *I've Got Rhythm* and the basic 12-bar blues were two of the most popular sets of chord changes used. Other dixieland and swing tunes that players such as Charlie Parker and Dizzy Gillespie created new melodies over included *Indiana, Cherokee, How High the Moon,* and *Honeysuckle Rose.* The bebop style tended to increase the tempo and expand both the rhythmic and harmonic complexity of jazz, but the main goal for most bebop players was extended improvisation. Some of the younger players felt constrained by the big band texture,

where improvised solos were fitted around the written sections of most charts. At these late-night jam sessions, players were allowed much more freedom to break away from the written melody. They took four, five, or even more solo choruses, allowing their improvisations much more time to evolve and expand. A tune's melody would be played once at the beginning of a performance and then again at the end. Often, there would be more than ten minutes of improvisation between statements of the written melody.

In the book *Hear Me Talkin' To Ya,* both Charlie Parker and Dizzy Gillespie make comments on the beginnings of the bebop style. Notice that in both cases they discuss extending the harmonic language of the music as a major component of bebop. For most new listeners, this new harmonic complexity is perceived as more dissonance in the music.

Dizzy Gillespie playing his signature up-bent trumpet with his unique puffed cheeks.
Courtesy of the Institute of Jazz Studies, Rutgers University

Charlie Parker

I remember one night before Monroe's I was jamming in a chili house on Seventh Avenue between 139th and 140th. It was December, 1939. Now I'd been getting bored with the stereotyped changes that were being used all the time at the time, and I kept thinking there's bound to be something else. I could hear it sometimes but I couldn't play it.

Well that night I was working over *Cherokee,* and, as I did, I found that by using the higher intervals of a chord as a melody line and backing them with appropriately related changes, I could play the thing I'd been hearing. I came alive.[13]

Dizzy Gillespie

No one man or group of men started modern jazz, but one of the ways it happened was this: Some of us began to jam at Minton's in Harlem in the early 'forties. But there were always some cats showing up there who couldn't blow at all but would take six or seven choruses to prove it. So on afternoons before a session, Thelonious Monk and I began to work out some complex variations on chords and the like, and we used them at night to scare away the no-talent guys. After a while, we got more and more interested in what we were doing as music, and, as we began to explore more and more, our music evolved.[14]

The other major change in this new bebop style was faster tempos. Influenced by players including Lester Young, Charlie Christian, and especially pianist Art Tatum, the beboppers began to double, triple, and even quadruple the basic tempo of many jazz tunes. As with the transition from traditional jazz to swing, the rhythmic change from swing to bebop was also an evolutionary process. While the expanded technical facility of Parker and Gillespie was truly amazing, much of the new rhythmic style of bebop was focused on the function of the rhythm section. Bebop pianists, inspired by Art Tatum and Count Basie, broke away from stride-style playing in favor of the new **comping** style. Pianists would leave the basic time keeping duties to the bass player and the drummer while they concentrated

comping

on playing musical fills that "complemented" what the main soloist was doing. This comping style could take the form of sporadic interjections of a full chord or simple melodic lines that either filled a silent space left by a soloist or provided a counterpoint line that fit what the soloist was playing. Pianists also used the comping style to accompany their own solos, playing occasional chords with their left hand while their right hand handled most of the improvisation. Bass players continued to play in the straight-four walking style popular in the swing era; however, both piano and bass players were faced with handling the more complex harmonic language of bebop. Led by drummers Kenny Clarke and Max Roach, the drum set became an active weapon in this new musical style. In the manner of Jo Jones in the Count Basie rhythm section, basic time-keeping was taken away from the bass drum in favor of the lighter, crisper sound of the cymbals. In this new syle, however, drummers played with more rhythmic complexity, often using loud outbursts to spur the improvising soloist on to new heights of creativity. One of their favorite tricks was **dropping bombs,** playing unexpected accents randomly within a piece of music.

dropping bombs

modern jazz

Many of the jazz styles that are still played today can trace at least some of their roots back to the development of bebop, and today most historians refer to the creation of bebop as the birth of **modern jazz**. During the 1940s, however, there were two radically different views of this new musical style. At the same time that bebop was evolving, there was also a resurgence in the popularity of traditional jazz. Louis Armstrong had gone back to a small, dixieland band format in 1946. In addition, swing music (though waning in popularity) and pop singers such as Frank Sinatra still maintained the lion's share of popular music fans. The modern jazz players were called "beboppers," "reboppers," or just plain "boppers," whereas the older-style musicians and fans were referred to as "moldy figs." No one really knows who first coined the term "bebop," but most historians gave credit to drummer Kenny Clarke. Apparently he was scat singing in an attempt to describe the sound of this new music and kept using the nonsense syllables "bebop" as he sang. Eventually, the term was picked up by the media and fell into common use.

Charlie Parker

Like Louis Armstrong in the era before him, alto saxophone player Charlie Parker revolutionized solo improvisation and changed the face of jazz forever. Born in Kansas City, Parker got his start playing in the wide-open clubs and dance halls that spawned the relaxed, swinging style of bands such as those led by Count Basie. While traveling to a gig in the mid-1930s, Parker got the nickname "Yardbird" when the car he was riding in hit a chicken that had run into the middle of the road. Parker made the driver go back to pick up the dead chicken. When the band arrived at the home they were staying in, Parker had the lady of the house cook up the chicken for a personal feast. After that episode, he was often referred to as "Yardbird," "Yard," or "Bird." On another fateful car trip, Parker injured his back in an accident, and, as a result, he apparently became addicted to the pain medication morphine. When he could no longer get the drug legally, he switched to

Press photo of Charlie Parker from the 1940s.
Source: Courtesy of the Institute of Jazz Studies, Rutgers University.

heroin. There are other legends of how Parker's addiction began, but regardless of how it started, both heroin and alcohol would play a major role in his short and troubled life.

Inspired first by Kansas City sax players Lester Young and Buster Smith and later by very diverse influences including Art Tatum, Jimmy Dorsey, and twentieth-century classical composers Igor Stravinsky and Paul Hindemith, Charlie Parker almost single-handedly created many of the most important elements of the new bebop style. He was an active listener who took in everything he heard and synthesized it into his own unique style. From players such as Lester Young he took the long, flowing improvised lines and pure, light tone that made Young so successful. From Art Tatum and Jimmy Dorsey he copied the rapid, almost frantic passages that displayed amazing technical facility. Drawing from Art Tatum and also from modern classical music, Parker helped create the complex extended harmonies that would become a trademark of the bebop style.

Parker's greatest successes came in New York City in the after-hours jazz clubs frequented by many of the city's best musicians. Along with Thelonious Monk and Dizzy Gillespie, Parker became a major figure in this evolving new style. In addition, with Dizzy Gillespie, Charlie Parker created many of the most important tunes in the bebop style. In his book *Jazz Styles*, Mark Gridley describes Parker's compositions and their impact on jazz.

> Parker wrote a sizable body of tunes, and their character set the flavor for bop as much as his improvisations did. Though not melody-like in the pop tune sense, they were catchy lines in a jazz vein. Most were accompanied by chord progressions borrowed from popular songs. Many used accompaniments of the twelve-bar blues chord progression. Their phrases were memorized and analyzed by hundreds of jazz soloists. His "Now's the Time," "Billie's Bounce," and "Confirmation" were played at jam sessions for decades after he introduced them. This was the musical language of bop.[15]

Many of bebop's early hits (such as they were) were recorded by bands that featured Parker and Gillespie in the front line. A listening guide for one of their best tunes, *Bloomdido*, can be found on the next page. Over the years, Gillespie and Parker would continue to work together off and on, but Parker's unpredictability strained his professional relationship with Gillespie. They were always close personal friends, but Gillespie began looking in other directions musically.

Several other famous trumpet players got early breaks playing with Charlie Parker. Miles Davis, Chet Baker, and Red Rodney all gained valuable experience playing in groups with the Bird. Sadly, all three used illegal drugs at some point in their lives. For most of his career, Parker fronted a series of quintets playing in the bebop style. He frequently worked with pianist Bud Powell and enjoyed playing with drummer Kenny Clarke as well. Parker's genius was recognized by avid bebop fans, who began following him with primitive tape recorders, taking down every note he played. Unfortunately, to conserve tape they frequently only recorded Parker's solos. The modern listener is forced to guess at what the other players' improvisations might have been like. Toward the end of his career, Parker had the opportunity to make a series of recordings backed by a small chamber orchestra. These recordings, now known collectively as *Charlie Parker with Strings,* opened the door for many musicians in later years who would blend classical music with jazz.

In trying to imitate everything that Charlie Parker did, many musicians followed him into a lifestyle of drug abuse. They wanted to play like Bird, and many seemed to think the drugs were what made it all happen. Players seemed to disregard the fact that, first of all, Parker was truly gifted, with a natural ear for

DIG DEEPER

MOVIE
Bird
(A Film by Clint Eastwood)
BOOK/VIDEO
Celebrating Bird: The Triumph of Charlie Parker
by Garry Giddins

music, and second, he practiced relentlessly. Parker himself admitted that drugs and alcohol actually hindered his performances. He was known to encourage other players and fans to avoid the mistakes he made in his life, but this advice often fell on deaf ears. Charlie Parker died of lobar pneumonia in 1955 at the age of 34, his health condition exacerbated by years of drug and alcohol abuse. It has been said that the New York medical examiner estimated Parker's age to be between 55 and 60 at the time of his death.

Listening Guide

Bloomdido
Charlie Parker

Example of the bebop style
Recorded June 6, 1950
Performed by Charlie Parker, alto sax; Dizzy Gillespie, trumpet; Thelonious Monk, piano; Curly Russell, bass; and Buddy Rich, drums

This new melody, composed by Charlie Parker, is based on the 12-bar blues pattern. In the hands of bebop musicians, however, the tempo was often two or three times as fast as was typical for jazz performances. For bebop players, most of their focus in performance was on improvisation. As you listen, notice how much farther away from the written melody these players go when compared to most swing music.

Total time: 3:24

:00	9-measure introduction featuring drums and piano.
:09	Head. Melody played by Gillespie on muted trumpet and Parker on sax.
:21	Full repeat of melody.
:34	Parker begins improvised sax solo. Plays four choruses total.

 :34 1st solo chorus.
 :47 2nd solo chorus.
 :59 3rd solo chorus. More use of blues here.
 1:12 4th solo chorus. Parker opens this chorus with a quote from the old "shave and a haircut" jingle.

1:25	Gillespie begins improvised trumpet solo. Plays three choruses total. Note that he continues to use a mute to alter the basic sound of his trumpet.

 1:25 1st solo chorus.
 1:38 2nd solo chorus.
 1:51 3rd solo chorus.

2:03	Monk begins improvised piano solo. Plays two choruses, placing more emphasis on dissonance and percussive sounds on the piano. Unlike both Parker and Gillespie, Monk makes less use of fast strings of running notes.

 2:03 1st solo chorus.
 2:16 2nd solo chorus.

2:30	Rich begins improvised drum solo. Plays two choruses. Unlike some bebop drummers, Buddy Rich tends to keep a very steady beat even in his extended solos. Listen to the steady rhythm of the bass drum to count the measures as they go by.

 2:30 1st solo chorus.
 2:42 2nd solo chorus.

2:55	1st out chorus. Return to the original melody heard at the beginning.
3:08	2nd out chorus. Tune ends with both Parker and Gillespie falling off the final note of the song.

Cool School

The cool school movement in jazz is really a collection of closely related styles, drawing inspiration from musical genres as diverse as bebop, swing, classical, and even Latin music. To make things easier for you, **cool school** music can simply be defined as a somewhat relaxed, more listenable offshoot of bebop. There were practitioners of this new "cool" style on both the East and West Coasts. In fact, earlier jazz historians often separated West Coast and cool school as two different styles. While there can be some minor differences in the two perceived styles, the basic goals of the various musicians were similar. Many "West Coast" musicians took part in the most famous cool school recording, *Birth of the Cool* on Capitol Records. This album, which featured a group led by trumpet player Miles Davis, placed more emphasis on written charts and mellower sounds than were common in the bebop style. The recording still carries many of the marks of modern jazz, with a bebop-style rhythm section and a focus on improvisation along with the written material. Historically, this album is very important as it represents the first time in jazz history that an artist (or group of artists) created a new style of music and named it. The cool school attitude was sometimes associated with lifestyle as well as musical performance. In his book *Writings in Jazz*, Nathan Davis (no relation) considers Miles Davis' cool approach to life.

cool school

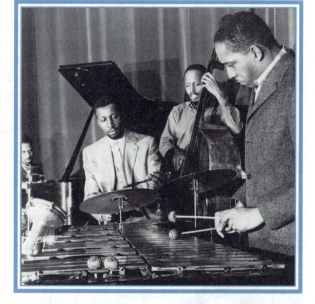

> More than any other musician, Miles Davis typified the cool school. The way he walked, his cool, relaxed manner, and self-assurance made him the symbol of what cool was all about. Bebop was "cool" because it projected an intellectualism, but cool gave the impression that nothing mattered. If you didn't like the music, that was okay. Davis became a folk hero. Among jazz musicians and fans he was high priest, with a following equaled only by that of certain spiritual leaders of the 1970s. Every note that he played was revered.[16]

To some extent, the cool recordings and performances of artists such as Miles Davis, the Modern Jazz Quartet, and Dave Brubeck found more acceptance with the general public when compared to bebop. In the 1950s and 60s, however, jazz was no longer America's most popular music. Older people were listening to pop singers, and younger people were into rock-and-roll. Jazz still had its fans, but the dominance it had enjoyed as America's popular music in the 1930s and 40s was over.

Press photo of the Modern Jazz Quartet. Left to right: John Lewis, Connie Kay, Percy Heath, and Milt Jackson.
Source: Courtesty of the Institute of Jazz Studies, Rutgers University.

Miles Davis

Born in St. Louis, Miles Davis moved to New York City to study trumpet at the Juilliard School of Music. One of the reasons he chose that particular music school was so he could be near the new bebop movement and its main players, including Charlie Parker and Dizzy Gillespie. Before long, he had dropped out of school and started playing in a quintet with Charlie Parker. Miles followed Parker to the West Coast, but when Bird was put away in the Camarillo State Hospital (due to his drug abuse) for several months, Miles was forced to find other work. He played in big bands led by Billy Eckstine and Dizzy Gillespie. When Parker reappeared on the New York music scene in 1947, Davis rejoined the quintet.

After playing with Parker for a while, Miles Davis became somewhat disenchanted with bebop. He liked the concepts but found the frantic pace of bebop and

the constant focus on one style of improvisation a bit limiting. Working with pianist and composer Gil Evans, Davis joined a group of like-minded musicians in a collaboration that would eventually be called the Miles Davis Nonet or the Miles Davis Tuba Band. The "nonet," or group of nine players, featured a rather interesting collection of instruments: Davis on trumpet, Lee Konitz on alto saxophone, Gerry Mulligan on baritone saxophone, and J.J. Johnson or Kai Winding on trombone. In addition to those standard front line instruments, the band also used studio musicians Junior Collins, Sandy Siegelstein, or Gunther Schuller on horn, and Bill Barber on tuba. These six instruments were scored in tightly woven harmony with intricate moving lines. The use of lower-pitched instruments such as trombone and baritone sax, coupled with the warm, rich sounds of the French horn and tuba, gave the group a unique and "cool" sound. The group was rounded out by a bebop-style rhythm section that on various tracks featured John Lewis or Al Haig on piano and Max Roach or Kenny Clarke on drums. Three different bass players were used in the *Birth of the Cool* sessions including Al McKibbon, Nelson Boyd, and Joe Shulman.[17]

The nonet only played a few gigs in public, but in 1949 and 1950 they made a series of 78-rpm records that were soon collected onto one 33⅓-rpm long-play album. By the time Capitol Records released the album, Miles Davis had become the group's leader and selected the album title *Birth of the Cool*. Occasionally, you will also see versions of this album with the title *The Complete Birth of the Cool*. This record demonstrated to many jazz musicians and fans that there were modern jazz outlets that didn't necessarily require complete devotion to the bebop style. It also formed a long-lasting bond between Miles Davis and Gil Evans. Together, they created a series of albums using various large collections of instruments that showcased Miles as a gifted soloist. His playing was intelligent and slightly reserved, but it always had a deep undercurrent of emotional content. The Davis/Evans collaborations produced a number of successful recordings for Capitol Records including *Sketches of Spain, Porgy and Bess*, and *Miles Ahead*.

In addition to working with Gil Evans, Miles Davis often ran a quintet or sextet that played bebop-formatted tunes performed in a cooler jazz style. For the most part, the band used no written arrangements but rather played in the "head-solos-out chorus" format made so common in the bebop style. Because these groups were able to record in the 33⅓-rpm format, they were not constrained by the short time limits in the studio that had been imposed on earlier musicians. Miles and his associates could allow their improvisations to unfold more slowly; they had more freedom to experiment and explore each nuance in the music. Albums including *Relaxin' with the Miles Davis Quintet* and *Milestones* are great examples of the cool school style.

Toward the end of the 1950s, Miles began to conceive a new approach to improvisation. Rather than craft each passage of music to coincide exactly with the chords that would accompany it, Davis and the other players in his group began to experiment with selecting one set of notes or a scale pattern that would, at least to a certain extent, work with all the chords in a given piece of music. This technique is called **modal** improvisation. Don't worry if you don't understand all the technical musical information here; just know that this new approach to improvisation freed the soloists musically, giving them the potential for even more creativity in their improvisations. Recorded in 1959, the album *Kind of Blue* became the first public exploration of this new improvisational style. Jazz historian and author Gary Giddins made these comments about the album *Kind of Blue*:

modal

This opened up the world for improvisers, because they could get away from the . . . gymnastics of popping through all of these complicated harmonic labyrinths, and just concentrate on inventing melody, because the harmony didn't change. The guys who had been beboping through all those chords for all those years were naturally falling into certain clichés, certain easy kinds of phrases. Miles forced them out of it.[18]

The music continued to be cool-sounding for the most part, but like *Birth of the Cool* before it, this new recording had a huge impact on many jazz musicians and fans alike. In fact, although jazz critics, historians, and fans can agree on almost nothing, *Kind of Blue* is universally accepted as one of the greatest artistic expressions the world of jazz has ever created. The following listening guide is for the jazz classic *So What*, which was first recorded on the album *Kind of Blue*.

Listening Guide

So What
Miles Davis

Example of modal jazz
Recorded February 3, 1959. From the album *Kind of Blue*
Performed by Miles Davis, trumpet; "Cannonball" Adderley, alto sax; John Coltrane, tenor sax; Bill Evans, piano; Paul Chambers, bass; and Jimmy Cobb, drums

The tune *So What,* from the groundbreaking album *Kind of Blue*, has become a modern jazz standard. In terms of counting measures, it actually follows the standard 32-bar song form (A-A-B-A). The similarities, however, end there. The entire tune consists of two chords, one used for all of the letter A material and a similar chord one half-step higher for the bridge. This limited and relaxed harmonic structure allowed the musicians much more room to explore different melodic and harmonic ideas without the constraints of the constantly shifting chord structures of standard bebop. Notice that this tune begins with three counts of pick-up notes before the first full measure starts.

Total time: 9:22

:00	Free-form introduction played by Bill Evans and Paul Chambers.
:33	Head. Melody is played on the bass with answers from the front-line instruments.

	:33	1st 8 bars, letter A.
	:49	2nd 8 bars, repeat of letter A.
	1:02	Bridge.
	1:16	Last 8 bars, return to letter A.

1:31	1st chorus of trumpet solo.

	1:31	1st 8 bars, letter A.
	1:46	2nd 8 bars, repeat of letter A.
	2:00	Bridge.
	2:14	Last 8 bars, return to letter A.

2:28	2nd chorus. Trumpet solo continues.
3:25	1st chorus of tenor sax solo.
4:20	2nd chorus. Tenor sax solo continues.
5:16	1st chorus of alto sax solo.
6:11	2nd chorus. Alto sax solo continues.
7:05	Bill Evans piano solo. One chorus only. Horns play riff behind his improvisation.
8:15	Out chorus. Return to original melody. Tune ends by fading out.

Dave Brubeck

Perhaps more than any other musician, pianist and composer Dave Brubeck is very closely associated with music from the West Coast. He grew up in California, where he attended the University of the Pacific and Mills College. He studied composition with noted French classical composer Darius Milhaud. Brubeck had already been playing jazz, but, as he related in the book *Hear Me Talkin' To Ya*: "It was Milhaud who encouraged me in my playing jazz. He felt that playing jazz was an expression of American culture. He felt a musician born in America should be influenced by jazz."[19] In the late 1940s, Brubeck led a series of small- to medium-sized jazz groups in California. Like the Miles Davis Nonet, Brubeck's groups experimented with mixing complex written arrangements and cool improvisations. He frequently worked with noted alto saxophonist Paul Desmond. Between 1951 and 1967, the two of them fronted one of the most successful quartets in the world of jazz. Dave Brubeck frequently mixed classical music ideas with his approach to jazz. His compositions reflect a harmonic sensibility that was clearly influenced by European classical music. In his book *Jazz Styles*, historian Mark Gridley makes the point that part of Brubeck's public appeal was due to his more "classical" approach to jazz.

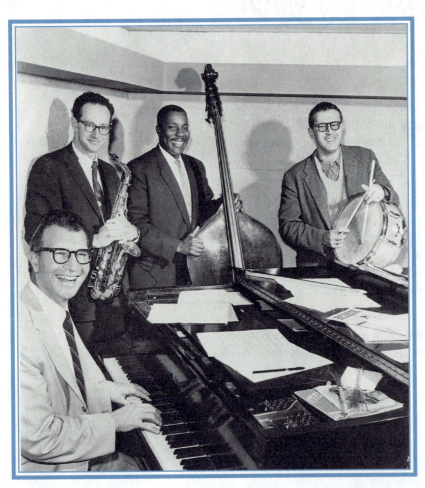

> That Brubeck's work sounds classical may explain part of his popularity. By comparison with the jumpy, erratic character of bop style, his compositions and improvisations are much easier to follow. They possess a simple and tuneful quality. His creations are orderly, and they project a freshness and clarity that make the listener's job easy. In addition, most of Brubeck's pieces are pretty, and they convey a light and pleasant mood.[20]

Dave Brubeck also enjoyed exploring complex rhythms drawn from various world music sources. In using these complex polyrhythms, Brubeck and his quartet pushed jazz beyond its simple, basic beat of 4/4 time. Even the most complex music of Thelonious Monk used rhythms that intentionally contradicted the basic four-beat pattern of popular music. Brubeck used unsquare rhythmic patterns including 5/4 time (an extra beat in every measure of the music), 7/4 time (which usually sounds like alternating measures of 3/4 and 4/4 time), and even more complex rhythms based on African and Indian rhythmic patterns. On Brubeck's most popular album, *Time Out*, every tune made use of odd meters. The big hit off the album was a tune called *Take Five*. Recorded in 1959, the tune became a hit song at a time when jazz in general was not very popular. Its popularity is even more amazing when you consider that it has no vocal, has a long drum solo in the middle, and perhaps most amazingly, is entirely in 5/4 time. Nonetheless, fueled by sales to college students

The Dave Brubeck Quartet in a press photo from the 1950s. Left to right: Dave Brubeck, Paul Desmond, Eugene Wright, and Joe Morello. Courtesy of the Institute of Jazz Studies, Rutgers University

and other "hip" young Americans, *Take Five* climbed to the top of the charts. Like the Modern Jazz Quartet, Brubeck found a great deal of success by taking jazz out of the nightclub and placing it on the concert stage. The Dave Brubeck Quartet was in great demand on college campuses around the country. In fact, several of Brubeck's most successful albums were made from live college shows.

In his later life, Dave Brubeck has continued to tour and record on a regular basis. His four sons all play music, and Brubeck frequently performed with them on tours and in the recording studio. Over the years, he explored fusion (even using electronic instruments) and other forms of music that mixed classical music with jazz. Without fail, however, Brubeck always seemed to return to the cool jazz styles that made him so successful.

Hard Bop

As with the term cool jazz, **hard bop** serves both historians and music fans as a simple, catchall term for easily identifying a number of closely related musical styles. At its core, hard bop expanded on the bebop ideas of the 1940s and early 1950s, but musicians who performed in the hard bop style tended to play with even more aggressive tones, extreme tempos, and extended harmonies. Melodies were made more complex, and improvised solos tended to get longer and longer. Some hard bop tunes could last up to fifteen or twenty minutes.

In addition to the "pure" hard bop style, some musicians began to bring more blues and gospel music elements into their performances. This side of the hard bop style was sometimes referred to as **funky jazz** or **soul jazz** and was able to find greater audience appeal, particularly in the 1960s and early 1970s; however, some musicians and jazz critics alike thought this new, soul-oriented approach was something of a commercial sellout. While there is nothing wrong with making money, in some cases the critics were actually right for a change. Some artists did go too far in attempting to pander their music to the lowest common denominator. The downside for us as modern jazz fans is that we must exercise extra caution when buying recordings that feature some of these artists. Some of their recordings can easily be considered masterpieces, but some were purely commercial ventures attempting to cash in on a quick, catchy pop tune with little or no real creativity.

hard bop

funky jazz

soul jazz

Clifford Brown

The life of trumpet player Clifford Brown is perhaps one of the most frustrating and tragic stories in the history of jazz. Considered a master of the jazz trumpet by the time he was twenty-two years old, Brown was killed in a car accident less than five years later. Unlike many of his contemporaries, he neither drank nor took drugs. He had a strong work ethic and was apparently just an all-around good guy. Brown brought a more aggressive improvisational style to jazz, with even faster tempos and extremely complex, original tunes such as *Joy Spring*. At the same time, however, his tone was warm and rich, and even at the blazing tempos he often played, his musical lines were always lyrical, flowing expressions. His most important recordings were made with a group he co-led with noted bebop drummer Max Roach. Like Charlie Parker and Dizzy Gillespie before him, musicians looked up to Clifford Brown and followed his groundbreaking improvisational style. His impact on many jazz musicians is still felt to this day. The following listening guide is for a very special version of the Cole Porter tune *What Is This Thing Called Love*, as recorded by the Clifford Brown-Max Roach Quintet with tenor saxophonist Sonny Rollins.

Listening Guide

What Is This Thing Called Love
Cole Porter

Example of Clifford Brown's approach to hard bop
Recorded February 16, 1956. From the album *At Basin Street*
Performed by the Clifford Brown-Max Roach Quintet. Clifford Brown, trumpet; Max Roach, drums; Sonny Rollins, tenor sax; Richie Powell, piano; and George Morrow, bass

When Cole Porter wrote the ballad *What Is This Thing Called Love,* this performance was definitely not what he had in mind. Both bebop and hard bop players often increased the tempo of classic ballads, sometimes adding radical rhythmic variations as well. Note the use of a prearranged unison line that was created by this band for added effect. Pay close attention to drummer Max Roach's lyrical drum solo. The concept of gentle lyricism and the word *drummer* rarely go together, but Max Roach has always been one of the few exceptions. Roach does tend to rush (or push the beat ahead) during his solo, making the counting very difficult for a while. This tune follows the standard 32-bar song form (A-A-B-A).

Total time: 7:33

:00	Long introduction. Piano and bass play pedal point while Brown and Rollins improvise little riffs and other melodies.
:59	Head, played by trumpet only. Sax (only) takes over on the bridge.

	:59	1st 8 bars, letter A.
	1:05	2nd 8 bars, repeat of letter A.
	1:13	Bridge, sax takes over.
	1:19	Last 8 bars, return to letter A. Brown starts his improvised solo on the last 2 bars of this section.

1:27	1st chorus of trumpet solo.

	1:27	1st 8 bars, letter A.
	1:33	2nd 8 bars, repeat of letter A.
	1:40	Bridge.
	1:47	Last 8 bars, return to letter A.

1:54	2nd chorus of trumpet solo.
2:21	1st chorus of sax solo.
2:49	2nd chorus of sax solo.
3:16	1st chorus of piano solo. Count with care in these next two choruses, as pianist Richie Powell goes way outside the standard chord changes and really plays with the time as well. You might focus on improvisation the first couple of times you listen and later go back and focus on the rhythm section to help you keep up with the form.
3:43	2nd chorus of piano solo.
4:10	Bass plays one full solo chorus.
4:37	Full band plays one shout chorus. Only the rhythm section plays the bridge.
5:04	Drum solo begins. Roach plays two full choruses. Counting along is very difficult here as Roach rushes quite a bit. When you hear Clifford Brown come back in on trumpet, you will be back at the top of the 32-bar form.
5:52	Brown and Rollins improvise over a full chorus by trading 8-bar solos.
6:17	Brown and Rollins improvise over a full chorus by trading 4-bar solos.
6:43	New shout chorus melody is used as out chorus with a drum solo on the bridge beginning at 6:56.
7:02	Brown returns to the original melody for the last 8 bars of the form. The tune ends with a tag using material similar to that found in the introduction.

John Coltrane

From 1955 until his death in 1967, tenor and soprano saxophone player John Coltrane explored many different jazz styles including traditional ballad playing, modal jazz, hard bop, and free jazz. Coltrane came to national prominence playing in groups led by Miles Davis. In 1959, the same year that he recorded *Kind of Blue* with Davis, Coltrane was featured in a solo recording titled *Giant Steps*. His solos from recordings such as this one were dubbed "sheets of sound" by one jazz critic. The term refers to the relentless flurry of notes that Coltrane played as he explored each complex chord structure from every possible direction.

Following the *Giant Steps* album, Coltrane ventured deeper into modal jazz with recordings including *My Favorite Things* and *A Love Supreme*, among many others. These recordings featured one of the greatest and most cohesive recording ensembles of all time, which included McCoy Tyner, piano; Jimmy Garrison, bass; and Elvin Jones, drums. Unlike Coltrane's work with the Miles Davis quintet/sextet, however, there is nothing "cool" about this quartet's performances. Coltrane's tone is edgy and aggressive, and his solos can almost be overwhelming at times. Oddly enough, *My Favorite Things* went on to become one of John Coltrane's most commercially successful albums. Performances from this time period in Coltrane's life have been endlessly studied and imitated by music students and professional jazz players alike. Perhaps even more than Charlie Parker, the current style of jazz saxophone playing is most directly related to the work of John Coltrane. This next listening guide is for a tune called *The Promise*. As recorded by Coltrane and his famous quartet, this recording is a perfect example of the hard bop style, as well as a good introduction to the concept of Coltrane's "sheets of sound."

Listening Guide

The Promise
John Coltrane

Example of hard bop leaning toward aggressive modal improvisation and free jazz

Recorded October 8, 1963. From the album *Live at Birdland*

Performed by John Coltrane, soprano sax; McCoy Tyner, piano; Jimmy Garrison, bass; and Elvin Jones, drums

Here is the classic John Coltrane Quartet playing an excellent example of the straight-ahead hard bop style. The band members are comfortable with each other's playing styles, and that familiarity is evident in the spontaneous interplay between Coltrane and the other musicians. As Coltrane goes more "outside" of the planned chord structure, the other musicians have no problem going with him. Coltrane is playing the soprano sax, an instrument he helped bring back to the forefront of jazz. This recording was made during a live show at a famous New York City nightclub called Birdland. The head and out chorus of this tune follow the format A-B-A-B-C, played in alternating 8-bar phrases. The improvised solos are all played over the standard 32-bar song form (A-A-B-A), and the chord changes are similar to the Miles Davis tune *So What* (but there are more of them).

Total time: 8:03

:00	Head.	
	:00	A.
	:12	B.
	:23	A.
	:34	B.
	:46	C.

:57 McCoy Tyner begins piano solo. Plays five full choruses. Listen to how he comps for himself and particularly how he and the other rhythm section players change their accompaniment styles as his improvisation shifts moods.

	:57	1st solo chorus.
	1:47	2nd solo chorus.
	2:37	3rd solo chorus.
	3:27	4th solo chorus.
	4:17	5th solo chorus.

5:07 John Coltrane begins soprano sax solo. Plays two full choruses. Pay careful attention to the interplay between the soloist and all the members of the rhythm section, especially drummer Elvin Jones.

	5:07	1st solo chorus.
	5:57	2nd solo chorus.

6:48 Out chorus. Follows same form as opening head. Tune ends with a long piano chord, along with brief improvisations on cymbals and bass.

Charles Mingus

Over the course of his career, bass player and composer Charles Mingus covered a great deal of musical ground. He started out as a swing musician, played bebop with all of the major innovators of that style, and went on to lead some of the most adventurous musical ensembles of the twentieth century. Along the way he performed with musicians as diverse as Louis Armstrong, Duke Ellington, Charlie Parker, Thelonious Monk, and most of the major hard bop players of the day, ending his career by creating a collaborative project with folk-rock singer Joni Mitchell. Mingus was one of the most fiercely original composer/performers of all time. As with his performing career, his musical creations brought together many different influences including swing, bebop, hard bop, free jazz, the blues, and gospel music. From the late 1950s on, Mingus often used the recording studio as a kind of "workshop" to create densely textured performances that pushed all of his musicians to and beyond their preconceived limits. Some of his major recordings include *Pithecanthropus Erectus* (which represents the rise and fall of humankind), *Mingus at Antibes* (perhaps one of the finest live jazz recordings ever made), and *Let My Children Hear Music* (Mingus's personal response to the Beatles' late studio work and one of his favorite albums). The listening guide on the following page is for a 1959 Mingus band performance of the tune *Better Git It In Your Soul*, a piece Mingus would revisit often over the rest of his career.

DIG DEEPER

VIDEO/BOOK
Triumph of The Underdog

RECORDING
Let My Children Hear Music; Mingus
(by Joni Mitchell)

Free Jazz and the Avant-Garde

The entire avant-garde movement in jazz, and free jazz in particular, were direct outgrowths of the continued experimentation with both bebop and hard bop. Players in the **free jazz** style abandoned much of the pre-planned structure that had been present in jazz. Preset chord progressions in particular were often completely abandoned. Some groups, especially those led by Ornette Coleman, rarely used instruments such as piano or guitar because of their potential for playing chords and

free jazz

Listening Guide

Better Git It In Your Soul (Charles Mingus)

Example of Mingus recording in the loose, "workshop" style that became a trademark of his later work
Recorded May 5, 1959
Performed by Charles Mingus, bass; John Handy III, Booker T. Ervin and Shafi Hadi, saxophones; Willie Dennis and Jimmy Knepper, trombone; Horace Parlan, piano; and Dannie Richmond, drums

This is a work that Mingus revisited many times during his career. This particular recording comes from the album *Mingus Ah Um*. If you need a category to put this performance in, call it "soul jazz" or "gospel bop." The truth is it's just Mingus at his very best. This piece uses an A-A-B-A structure (not a 32-bar song form) for both the head and out chorus, but the improvised solos and the middle ensemble sections are played over 6/8 versions of the blues. (With 6/8 you can count 6 really fast beats in each measure, or you can count large beats **1**, 2; **2**, 2; kind of like a two-sided waltz, which would be **1**, 2, 3; **2**, 2, 3; etc . . .) Counting out the full form is very difficult, so don't worry too much about it. Throughout, pay attention to how Mingus keeps yelling and creating a general ruckus, spurring his musicians on to ever greater feats of improvisation.

Total time: 7:20

:00	Introduction.
:16	Head.
1:09	Alto sax solo begins.
1:58	Loose section of collective improvisation begins.
1:58	Piano plays basic riff groove with rhythm section.
2:15	Rest of band enters.
2:32	Alto sax "floats" over rest of band.
3:03	Band clearly joins with piano riff.
3:35	Tenor sax solo begins. All rhythm drops out except hand claps and high-hat cymbals.
4:08	Rhythm section re-enters as tenor sax solo continues.
4:39	Drum solo begins.
4:53	Band re-enters for more loose collective improvisation.
5:27	Return to drum solo.
5:41	Return to loose collective improvisation.
5:59	Return to drum solo.
6:12	Out chorus. Return to main original melody. Tune ends with long "Amen" chords played by the entire band.

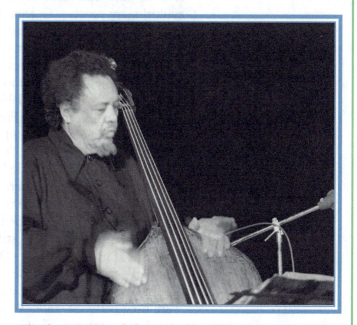

Charles Mingus, photographed by El Paso musician Bob Foskett during a concert at the McKelligon Canyon Amphitheater.

implying tonal progression. Horn players in the free jazz style frequently played with very harsh tones, often exploring the extreme limits of their instruments. Some horn players also made use of many nontraditional sounds by screaming into their instruments, making screeching noises, and just generally causing a big ruckus. Drummers focused on playing random patterns meant to inspire, contradict, and sometimes even compliment what the other musicians were doing. Bass players often listened carefully to the soloist and then decided whether to go with what they were hearing or just go off in their own musical direction.

avant-garde

Musicians in the general **avant-garde** movement tended to use all of the various techniques listed above, but they also made use of more conventional musical styles when they felt it would suit their artistic purposes. Collective improvisation became a very important part of the free jazz and avant-garde styles. For many free and avant-garde players, a growing social consciousness played a big role in the music they were creating. In an attempt to have more control over their material, musicians and composers formed various cooperative groups including the Jazz Composers Guild, the Black Artists Group, and the Association for the Advancement of Creative Musicians.[21]

Ornette Coleman

By far the most important voice in the free jazz movement, saxophonist Ornette Coleman is often credited with almost single-handedly creating this controversial style of jazz. The creation of what we now know as free jazz was very much an evolutionary process. Coleman began his musical career playing rhythm and blues in and around his native Fort Worth, Texas. He later relocated to the West Coast, where he started taking part in jam sessions, playing mostly in the bebop and hard bop styles. His first record features a standard rhythm section, but Coleman quickly abandoned the use of a piano in order to break away from the constraints of formal chord structures.[22] In 1959 he moved to New York City and opened with his quartet at a club called the Five Spot. His quartet consisted of Don Cherry, trumpet; Charlie Haden, bass; and Billy Higgins, drums. Higgins was replaced in 1960 by drummer Ed Blackwell. The group signed with the noted jazz and soul label Atlantic Records and recorded *The Shape of Jazz to Come* and *Change of the Century*.

In the fall of 1960 Coleman released *Free Jazz: A Collective Improvisation,* one of the most controversial jazz recordings ever put on the market. For this particular recording, Coleman added another quartet to his own and called the group a double quartet. There was still no piano player, but the other group did include noted jazz musicians Eric Dolphy, bass clarinet; Scott LaFaro, bass; Freddie Hubbard, trumpet; and the aforementioned Billy Higgins on drums. The entire album was one long free jazz improvisation with a few pre-selected themes that were used between solos. While one player is the lead soloist, the other musicians were free to improvise behind him, often creating riffs, but these were nothing like what you heard from Count Basie's band. The actual term *free jazz* really didn't come into wide use until after the release of this album. Furthermore, this album was so divisive in the jazz community that *Down Beat* magazine felt compelled to publish its first double review. The two wildly divergent opinions accurately reflect the divided feelings of jazz fans and artists toward this new approach.

record reviews

Records are received by Don DeMicheal, Gilbert M. Erskine, Ira Gitler, Barbara Gardner, Richard B. Hadlock, Don Henahan, Frank Kofsky, Bill Mathieu, John A. Tynan, Pete Welding, Martin Williams, and John S. Wilson. Reviews are initialed by the writers.

Ratings are: ★ ★ ★ ★ ★ excellent, ★ ★ ★ ★ very good, ★ ★ ★ good, ★ ★ fair, ★ poor.

DOUBLE VIEW of a DOUBLE QUARTET

Many readers have asked that a record be reviewed by more than one reviewer, their contention being that this would give a more rounded view of the record in question. We agree that two reviews of the same record can be enlightening in some cases; when such albums are brought forth we will publish side-by-side reviews. The first double review is of Ornette Coleman's *Free Jazz.*

Ornette Coleman
FREE JAZZ—Atl...
One: *Free Je...*

completely fluid: rhythm usually follows the soloist's lead (though he may occasionally take his cue from it), and the remaining three horns contribute as they see fit—from complex contrapuntal patterns arrived at spontaneously and independently to accidental "harmonic" riffs of a sort.

A very exciting—but equally dangerous —proposition, to be sure, and one that requires executants of an extraordinary sensitivity and ability. On these grounds this work is not always su... The piece is a... phonic...

made his point with this disc, and this cannot be denied him. I, for one, have been completely won over. I look forward to more pieces of this nature—but of a less ambitious scheme.
(P.W.)

Ornette Coleman
FREE JAZZ—Atlantic 1364: *Free Jazz, Part One; Free Jazz, Part T...*
Personnel: *Free Jazz, Part T...*
Dolphy, ... C...
H... saxophone; Eric Cherry, ... Freddie ..., Charlie Haden, ...ell, drums.

... subtitled "a ... the Ornette ... One might ...sation" by ... to be a ... the moon. ...lt in an ... Rules?

...sychosis ...ewhere

Double View of a Double Quartet
Review by Pete Welding
Rating: ★★★★★

In this most recent Atlantic recording, iconoclast alto saxist Coleman carries to their logical (though some listeners will dispute this term) conclusion the esthetic principles present to a lesser degree—quantitatively at least—in his previous recordings.

The entire LP—both sides—is given over to a collective improvisation by a double quartet (Dolphy, Hubbard, LaFaro, and Higgins make up the second quartet) that lasts 36 1/2 minutes. Using only the sketchiest of outlines to guide them, the players have fashioned a forceful, impassioned work that might stand as the ultimate manifesto of the new wave of young jazz expressionists. The results are never dull.

In first hearing, *Free Jazz* strikes one as a sprawling, discursive, chaotic jumble of jagged rhythms and pointless cacophonies, among which however are interlarded a number of striking solo segments (particularly those of the two bassists). The force, intensity, and biting passion that motivate it also come across.

On repeated listening, however, the form of the work gradually reveals itself, and it is seen that the piece is far less unconventional than it might at first appear. It does not break with jazz tradition; rather it restores to currency an element that has been absent in most jazz since the onset of the swing orchestra—spontaneous group improvisation. Yet Coleman has restored it with a vengeance; here we have better than half an hour's worth, with only a minimal amount of it predetermined to any degree.

In *Free Jazz* the soloist is free to explore any area in his improvisation that his musical esthetic takes him to; he is not bound by a harmonic, tonal, or rhythmic framework to which he must adhere rigidly. The performance (and his role in it) is completely fluid: rhythm usually follows the soloist's lead (though he may occasionally take his cue from it), and the remaining three horns contribute as they see fit—from complex contrapuntal patterns arrived at spontaneously and independently to accidental "harmonic" riffs of a sort.

A very exciting—but equally dangerous—proposition, to be sure, and one that requires executants of an extraordinary sensitivity and ability. On these grounds, this work is not always successful.

The piece is begun by a brief polyphonic ensemble in which the horn men seek to establish the emotional climate of the piece. This determined, a short "arranged" passage leads to a gripping five minute exploration by Dolphy in his most waspish, acerbic manner; Hubbard's graceful solo follows and is of equal length; Coleman's searing solo is next in line and consumes a full 10 minutes. It is by all odds the most successful improvisation of the lot, despite its length, and provokes the other three horns to some of their most complex and interesting contrapuntal interplay on the disc. After a terse unison figure, Cherry's flatulent, meandering solo sputters on for five minutes. It is succeeded by powerful bass statements by both Haden and LaFaro, and finally the drummers have the field before all come together for the close.

All things considered, the disc is largely successful—it certainly lives up to Coleman's dicta, at least. It is a powerful and challenging work of real conviction and honest emotion: it poses questions and provides its own answers to them; it is restless in its re-examination of the role of collective improvisation, and this is, in many respects, where the work is most successful.

Needless to say, there is nothing of smugness or complacency about it. And it is almost a total improvisation, a sort of seamless whole in which the over-all organic structure takes precedence over its constituent elements (selection of notes, etc.). As a result, Cherry's faltering solo makes little real difference in terms of the larger work—enough momentum has been established by this time to carry it right through.

Some salient points:

It seems to me that experiments ought to be presented as such—and not as finished works. This piece does have more than its share of inevitable rough spots; but how much of this results from this group having been brought together in the studio just for the purposes of recording this piece? A much fuller rapport would appear to be necessary before the maximum results could be achieved from this method and approach. Still, Coleman has made his point with this disc, and this cannot be denied him. I, for one, have been completely won over. I look forward to more pieces of this nature—but of a less ambitious scheme.

Review by John A. Tynan
Rating: No Stars

This friendly get-together is subtitled "a collective improvisation by the Ornette Coleman Double Quartet." One might expect a "collective improvisation" by Coleman's usual crew of four to be a merry event. But here we shoot the moon. It's every man-jack for himself in an eight-man emotional regurgitation. Rules? Forget 'em.

Where does neurosis and psychosis begin? The answer must lie somewhere within this maelstrom.

If nothing else, this witch's brew is the logical end product of a bankrupt philosophy of ultraindividualism in music. "Collective improvisation"? Nonsense. The only semblance of collectivity lies in the fact that these eight nihilists were collected together in one studio at one time and with one common cause: to destroy the music that gave them birth. Give them top marks for the attempt.

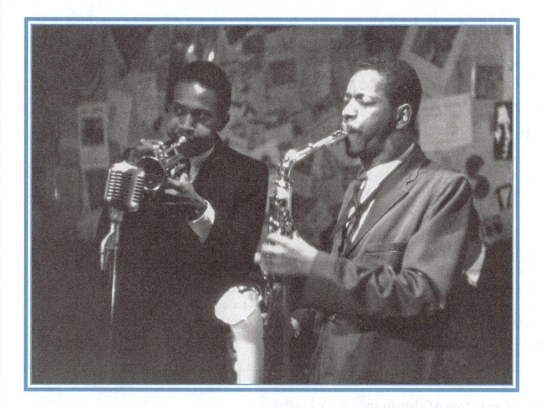

Don Cherry, trumpet, and Ornette Coleman, alto sax, in a 1959 photograph.
Source: Courtesy Bob Parent Archive

Ornette Coleman's radical new approach to jazz had a big impact on the world of music. All of the players mentioned in the rest of this chapter were following in Coleman's musical footsteps as they branched out into the more avant-garde side of jazz. You can hear a reunited version of the original Ornette Coleman band on a 1971 recording titled *Civilization Day* in the listening guide that follows on page 382. In later years, Coleman again sparked controversy when he began to play trumpet and violin in his live performances and on record. Unlike the saxophone, on which he was a trained and gifted performer, Coleman had no formal training on these other instruments. He seemed to feel that his lack of training actually allowed him to play even more freely, but trained instrumentalists begged to differ. They branded Coleman as self-indulgent and a musical fraud.

Over the past few decades, Ornette Coleman embraced a broader array of musical styles, including adding electronic sounds and synthesizer loops to his music. One of the terms sometimes used to describe his newer style is "free funk." He played with a wide variety of musicians including guitarist Pat Metheny and groups as diverse as the London Symphony Orchestra and the Grateful Dead. The Dead's guitarist, Jerry Garcia, also joined Coleman on the album *Virgin Beauty*. Beginning in the 1970s Coleman began fronting a new, electric double quartet, which would eventually include his son Denardo on drums and synthesizers. Some of his best recent recordings include *Colors: Live from Leipzig, Tone Dialing, Virgin Beauty,* and *Soapsuds, Soapsuds*.

After many years of controversy, toward the end of his career Ornette Coleman received numerous honors and accolades for his contributions to the world of jazz. In 2006 he was awarded a Pulitzer Prize for his album *Sound Grammar*; in 2007 he was given a Lifetime Achievement Award from the National Academy of Recording Arts and Sciences (The Grammy Awards); in 2008 he was inducted into the Nesuhi Ertegun Jazz Hall of Fame; and in 2009 he received the Miles Davis Award at the Montreal Jazz Festival.

Listening Guide

Civilization Day
Ornette Coleman

Example of free jazz as performed by the style's founding fathers
Recorded September 9, 1971. From the album *Science Fiction*
Performed by Ornette Coleman, alto sax; Don Cherry, trumpet; Charlie Haden, bass; and Billy Higgins, drums

Nothing in the entire history of jazz has polarized the community as much as the creation of free jazz. This recording represents an early 70s reunion of the original 1958-59 Ornette Coleman Quartet. This recording shows all of these fine musicians at their absolute best. Some feel this music is fraudulent and lacks focus. Others believe it is the logical continuation of the bebop and hard bop styles, with some avant-garde twentieth-century classical techniques thrown in as well. There are no prearranged chord changes here and very little pre-composed material of any kind for the musicians to work with. This is truly jazz without a net. Give the recording your honest attention and reflection, and then decide for yourself.

Total time: 6:02

:00	Head.
:14	Collective improvisation between Coleman and Cherry (rhythm out).
:27	Trumpet solo (begins with a brief collective flourish).
2:53	Sax solo (drums drop out until 3:08).
5:18	Drum solo.
5:48	Out chorus. Full restatement of the opening material.

John Coltrane, Again

In recordings such as *My Favorite Things* and *A Love Supreme,* John Coltrane and his quartet were already becoming more and more musically aggressive. Long solos and wide melodic and harmonic diversions were the order of the day. In the last few years of his life, Coltrane moved more and more toward a totally free jazz style. Unlike Ornette Coleman and others, however, Coltrane frequently continued to use a piano in his groups. Like many jazz players of his time, Coltrane had battled both drug and alcohol addiction. After he overcame his problems he became a very spiritual man, and he viewed this freer style of playing as a pure expression of his spirituality. Some of his last albums are solid explorations of the free jazz style. Recordings such as *Ascension, Meditations,* and *Stellar Regions* can be very difficult listening for beginning jazz fans, but they are masterpieces in their own right.

Fusion: The 70s and 80s

When Miles Davis recorded the albums *In A Silent Way* and *Bitches Brew,* he used the term "jazz-rock" fusion. His recordings set off a firestorm in the music industry, the effects of which we are experiencing to this day. In the late 1960s, jazz was at its lowest point. It had become almost completely eclipsed by other popular music styles. The large multi-day festivals such as Monterey Pop Festival and Woodstock,

which were followed up by ever-growing rock tours, helped expand the world of popular music at an unprecedented rate. With all the money that was coming in from non-jazz artists, large-scale commercial success became much more important to jazz record producers as well. The *Billboard* chart recorded the top 100 albums in terms of sales each week, and it was rare for jazz albums to appear anywhere on it. Jazz-rock fusion, which was later shortened to just **fusion,** was viewed by many jazz musicians—and by producers and promoters alike—as a way to bring a new audience into the world of jazz. In time, the term fusion became a rather generic way of saying that an artist mixed jazz with any other musical style. Today it is one of the most dominant formats in the jazz industry. Also, as with many of the previously discussed styles, fusion is simply one more musical dialect the best jazz musicians today are capable of speaking.

fusion

Miles Davis, Again

In the late 1960s, Miles Davis' second famous quintet (Herbie Hancock, piano; Ron Carter, bass; Tony Williams, drums; and Wayne Shorter, sax) was in transition. For the most part, the group had embraced elements of the hard bop style, but slowly, other musical ideas began to creep into their music. The first thing to happen was that on albums such as *E.S.P.* and *Miles Smiles* the group began to take more of a free approach to improvisation—nothing as far out as Ornette Coleman or the late recordings of John Coltrane—but they were clearly moving in that direction. Then Miles started to incorporate more electric instruments on his recordings. On the record *Miles in the Sky* Herbie Hancock played electric piano along with the traditional acoustic piano, and on one track electric guitarist George Benson joined in as well. By the next album, *Filles de Kilimanjaro,* the group's lean toward fusion was unmistakable. The *All Music Guide to Jazz* describes the album this way:

> The sixth and final studio album by Miles Davis' second classic quintet finds the group looking towards early fusion. . . . The music is less esoteric than his music of a year or two earlier, with funky rhythms and hints at pop and rock music becoming more prevalent although not dominant yet. To many of the jazz purists, this was Miles Davis' final jazz album, but to those with open ears towards electronics and danceable rhythms, this set was the predecessor of his next great innovation.[23]

The next two albums that Miles Davis made, *In A Silent Way* and *Bitches Brew,* changed the face of jazz forever. Miles had become a big fan of both Sly and the Family Stone and guitarist Jimi Hendrix. Davis particularly liked the open improvisations on Hendrix's studio jams such as *Electric Ladyland* and *Voodoo Chile.* It was this open, free-form rock-style jam that led Miles to the creation of *In a Silent Way* and *Bitches Brew.* In his book *Miles: The Autobiography,* Miles Davis discusses meeting Hendrix and, later, goes on to discuss the development of the material that became the seminal double album *Bitches Brew.*

> He was a real nice guy, quiet but intense, and was nothing like people thought he was. . . . Jimi was just a great, natural musician—self taught. He would pick up things from whoever he was around, and he picked up things quick. Once he heard it he really had it down. . . . But Jimi Hendrix came from the blues, like me. We understood each other right away because of that. He was a great blues guitarist. . . .
>
> [At the recording sessions] I brought in these musical sketches that nobody had seen, . . .I told [the record producer], . . . to just let the tapes run and get everything we played. . . . So I would direct, like a conductor, once we started to play, and I would either write down some music for somebody or I would tell

him to play different things I was hearing as the music was growing, coming together. It was loose and tight at the same time. It was casual but alert, everybody was alert to different possibilities that were coming up in the music. . . . That was a great recording session, man, . . . It was like one of them old-time jam sessions we used to have up at Minton's back in the old bebop days.[24]

The album *Bitches Brew* eventually reached number 35 on the *Billboard* pop chart and sold over 400,000 copies in 1970 alone. The album would go on to sell well over a million copies and remains in print on CD today. Miles began performing as the opening act for large rock shows including Blood, Sweat & Tears, Santana, and the Grateful Dead. "Deadheads" in particular seemed very open to the extended jams Davis was exploring at that time. Around this time, Miles and Hendrix had jammed together in private on several occasions. In fact, they had planned to record together, but due to Jimi Hendrix's untimely death the recording never materialized. Miles Davis continued to explore different approaches to fusion until his own death in 1991. Some of his most important late recordings include the albums *Tutu* and *Amandla*. Similar to several of his earlier bands, the various groups Miles Davis fronted in the 1970s and 80s became training camps for an entire generation of fusion musicians.

Magazine advertisement announcing the groundbreaking new recording by Miles Davis titled Bitches Brew.
Source: Courtesy of Tad Hershorn at the Institute of Jazz Studies, Rutgers University

Weather Report

Made up of several musicians who worked on both *In A Silent Way* and *Bitches Brew,* the band Weather Report went through several personnel changes before it arrived at its most successful lineup of musicians. The most popular version of Weather Report featured Joe Zawinul, keyboards; Wayne Shorter, saxes; Peter Erskine, drums; and Jaco Pastorius, bass. In 1977, largely on the strength of their hit song *Birdland,* the album *Heavy Weather* climbed to number 30 on the *Billboard* chart and sold over 500,000 copies.[25] The song *Birdland* became an instant jazz classic. It was later recorded in a big band version by Maynard Ferguson, in a vocalese version by Manhattan Transfer, and even with elements of rap by Quincy Jones and friends. With the exception of Jaco Pastorius (who died tragically in 1987), the members of Weather Report have all continued to record both individually and in various collaborations. Joe Zawinul in particular displayed a great deal of interest in bringing together elements of world music and jazz until his death in 2007.

Listening Guide

Birdland

Josef Zawinul

Example of fusion in the 1970s as recorded by alumni of the Miles Davis band

Recorded in 1977. From the album *Heavy Weather*

Performed by Weather Report. Josef Zawinul, synthesizers, acoustic piano, melodica and vocal; Wayne Shorter, soprano and tenor saxes; Jaco Pastorious, electric bass, mandocello and vocal; Alex Acuna, drums; and Manolo Badrena, tambourine

Weather Report was one of the hottest fusion bands of the 70s and early 80s, and this tune was their biggest hit. Compared to material released by Miles Davis, this is a much more pop-oriented style of fusion. It still contains an excellent improvised solo by Wayne Shorter and some very creative playing by everyone in the band, but the overall performance is definitely more accessible to a larger (even non-jazz fan) audience. The format here is a series of brief melodic statements connected by a relentless, driving rhythmic groove.

Total time: 5:56

:00	Opening bass groove is established.
:18	1st melody.
:43	2nd melody.
:55	Brief interlude with little melodic action.
1:02	3rd melody.
1:31	4th melody.
1:45	Brief collective improvisation between bass and acoustic piano.
1:59	5th melody. (Simple 4-bar riff which is used to build up to full-band shout sound not unlike that in a swing era big band.)
2:36	Longer interlude designed to release some of the tension created by the previous section.
2:48	Brief improvisation on synthesizer.
3:07	Brief improvisation on tenor sax.
3:36	Return of 1st melody, heavily modified and accompanied by a return to the original bass groove.
3:59	Return of 2nd melody.
4:12	Return of 3rd melody.
4:23	Return of 5th melody. Builds up again until the final fadeout at 5:56.

Recent Trends

Beginning in the late 1980s and picking up steam in the 1990s, jazz has made something of a comeback in the world of music. During that time, musicians such as Wynton Marsalis, Harry Connick, Jr., and Diana Krall became fairly well-known names in the music industry. Perhaps beginning with the soundtrack for the film *When Harry Met Sally . . .*, swing music was clearly becoming more mainstream. In the following years, swing dancing would become a fad in many larger American cities. Cigars, martinis, and cosmopolitans became popular as some members of Generation X explored a more "sophisticated" lifestyle. When singer Tony Bennett made an appearance on *MTV Unplugged*—a live performance show—a younger generation of music fans were amazed

Wednesday 10/3

Art Blakey & the Jazz Messengers, Sweet Basil, 88 Seventh Ave So, 242-1785, thru Oct 7, also Oct 9-14.

Kenny Barron Quintet, w/ Eddie Henderson, John Stubblefield, Cecil McBee, Victor Lewis, Village Vanguard, 178 Seventh Ave So, 255-4037, thru Oct 7.

Benny Powell Quintet, Condon's, 117 E 15th St, 254-0960, thru Oct 7.

Bill Evans, w/ Richie Morales, Victor Bailey, Mitch Foreman, Fat Tuesday's, 190 Third Ave, 533-7902, thru Oct 7.

Joanne Brackeen, Fortune Garden Pavilion, 209 E 49th St, 753-0101, thru Oct 7.

Ray Drummond, Hank Jones, Billy Higgins, Bradley's, 70 University Pl, 228-6440, thru Oct 6.

Thursday 10/4

Joe Beck Quartet, w/ Randy Brecker, Mark Egan, Zanzibar & Grill, 550 Third Ave, 779-0606, thru Oct 6.

Joan & Billy Drewes, Visiones, 125 McDougal St, 673-5576, thru Oct 7.

Friday 10/5

Drori Mondlak Jazz Quartet, Sheila's, 271 Adelphi St, at DeKalb Ave, Bklyn, 718-935-0292.

Michel Camilo, Michael Franks, Beacon Thtr, 74th St & Bway, 496-7070.

Al Grey Quintet, Birdland, 2745 Bway, at 105th St, 749-2228, also Oct 6.

Noel Pointer, Trumpets, 6 Depot Sq, Montclair, NJ, 201-746-6100, thru Oct 7.

Saturday 10/6

Kit Holiday, Lum Chin, 113 E 18th St, 982-4485.

Michael Carvin Quintet, w/ Claudio Roditi, Sonny Fortune, Cyrus Chestnut, David Williams, American Jazz Radio Festival, WBGO, FM 88.3, 8 p.m.

Jesse Davis Quintet, w/ Valery Ponomarev, M.K., 204 Fifth Ave, 779-1340.

Sunday 10/7

Howard Johnson & Gravity, Zanzibar & Grill, also Oct 14.

Tania Maria, World Financial Ctr, Winter Garden, 200 Liberty St, 945-2600, 3 p.m.

Warren Chiasson, Ronnie Matthews, Zinno, 126 W 13th St, 924-5182.

Monday 10/8

Bruce Arnold Trio, w/ Kirk Driscoll, Stomu Takeshi, Bar Room 432, 432 W 14th St, 366-5680.

Jane Jarvis, Milt Hinton, Zinno, to Oct 13.

Ronald Shannon Jackson's Decoding Society, Knitting Factory, 47 E Houston St, 219-3006, also Oct 15.

Paquito D'Rivera Band, Mongo Santamaria Band, guest soloist: Arturo Sandoval, Salsa Meets Jazz, Village Gate, Bleecker & Thompson sts, 475-5120.

Joe Metzer Quartet, Blue Note, 131 W

Village Vanguard, thru Oct 14.

Gretchen Langeld & House a Fire, Zanzibar & Grill.

Hiram Bullock Band, Fat Tuesday's, thru Oct 14.

Wednesday 10/10

Captain T-bone Band, w/ Ove Larsson, Fabio Morgera, John Rainey, Torben Westergaard, Larry Banks, Angry Squire; also Oct 11, Caliban's, 360 Third Ave, 689-5155; Oct 12, Willie's 413 10th Ave, 268-1620.

Jon Faddis Quartet, Zanzibar & Grill, thru Oct 13.

Peter Hollinger, Tom Cora, Knitting Factory.

Thursday 10/11

Wynton Marsalis, Marian McPartland radio show, WBGO, FM 88.3, 8 p.m.

Flip Phillips, Dakota Staton, Howard Alden, John Bunch, Jack Lesberg, Oliver Jackson, Pace Downtown Thtr, 3 Spruce St, bet Park Row & Gold St, 346-1715.

Muhal Richard Abrams, w/ American Jazz Orchestra, Cooper Union's Great Hall, 7 E 7th St, 353-4196.

Tim Berne Sextet, w/ Bobby Previte, Mark Dresser, Herb Robertson, Steve Swell, Marc Ducset, Knitting Factory.

Dan Brubeck & the Dolphins, Indigo Blues, 221 W 46th St, 221-0033.

Friday 10/12

Djavan, Ricardo Silveira, Beacon Thtr.

Michael Brecker Band, Andy Summers Band, Town Hall, 123 W 43rd St, 840-2824.

Harper Brothers, Trumpets, also Oct 13.

Saturday 10/13

Kory Grossman, Jerome Korman, Torben Westergaard, Suspenders.

Jean-Paul Bourelly, Knitting Factory.

Anthony Coleman, Roy Nathanson, Brecht Forum, 79 Leonard St, 941-0332.

Pete Malinverni Quartet, w/ Ralph Lalama, Dennis Irwin, Le Roy Williams, M.K.'s.

Sunday 10/14

Michael Marcus Quintet, w/ Joe Bowie, Ted Daniel, Jessie Crawford, Dennis Charles, Knitting Factory.

Jazz Vespers: Dick Smolens—Bill Wurtzel Duo, Yolande Bavan w/ Steve Browman Trio, St. Peter's Jazz Ministry, 619 Lexington Ave, 935-2200.

Gene Bertoncini, Steve LaSpina, Zinno.

Monday 10/15

Jody Espina Band, Bar Room 432.

Stephanie Nakasian, Hod O'Brien, Blue Note.

Tuesday 10/16

Billy Taylor, World Financial Ctr, Winter Garden, 6:30 p.m.

Early 1990s ads and show listings for jazz performances in New York City. Notice that many of the people discussed throughout this chapter were still working on a regular basis.

that he performed without big amps, explosions, or a megawatt light show. With a basic rhythm section of piano, bass, and drums, Bennett simply sang great songs with tremendous emotion. Swing music and the classic jazz standards were the hot new thing. Of course, what this new audience didn't realize was that jazz musicians had been performing like this for nearly 100 years. Regardless, new musical doors were opened. As we move into the twenty-first century, enthusiasm for jazz has cooled a bit as other pop music fads continue to come and go. If you listen to singers such as Alicia Keys, Erykah Badu, Norah Jones, Jamiroquai, and Lady Gaga, as well as groups such as Barenaked Ladies and the Dave Matthews Band, however, you can hear that elements of jazz are still alive in the world of pop music.

Jazz in all of its various styles is still a viable art form in the new century. There are still traditional jazz bands, swing musicians, bebop players, cool school devotees, hard boppers, and practitioners of free jazz working in the music industry. In addition, there are many current jazz artists who bring together one or more of these styles, creating their own unique fusion of musical styles. Listed below are a few of the most recent musical trends and some of the artists that are making these styles happen.

A Return to Older Traditions

In the 1980s and 90s a number of very serious younger musicians appeared on the jazz scene who were skilled in the bebop and hard bop styles of Charlie Parker, Dizzy Gillespie, Clifford Brown, and John Coltrane. Collectively called the "young lions," musicians including Wynton and Branford Marsalis, Joshua Redman, Marcus Roberts, and Jeff Watts all revisited older musical traditions with some success. In the jazz world, the often outspoken Wynton Marsalis in particular created some controversy as he tried to develop a rather narrow definition of what was and, perhaps more importantly, what was not jazz.

Compared to Wynton Marsalis, many other mainstream artists are more willing to explore different kinds of music. For example, his brother, Branford, and many other young jazz musicians, toured with rock musician Sting (himself a jazz player at one point) and later went on to be members of the Tonight Show Band when comedian Jay Leno took over the show. Both Wynton and Branford Marsalis have performed classical music, and Branford has also done some acting in films, including *Throw Mamma from the Train*. In recent years, Wynton Marsalis has become Director of Jazz at Lincoln Center in New York City. He has taken part in yearlong tributes to both Duke Ellington and Louis Armstrong and continues to be in great demand as one of the major spokesmen for the world of jazz. Among other firsts, Wynton Marsalis won the first Pulitzer Prize in music awarded to a jazz performance for his composition and recording of an extended work titled *Blood on the Fields*. The following listening guide is for an excellent tune composed by Marsalis titled *Double Rondo On The River.*

DIG DEEPER

WEBSITE
www.jalc.org
(Jazz at Lincoln Center)

Listening Guide

Double Rondo on the River
Wynton Marsalis

Example of young players' return to older styles of jazz
Recorded in 1990. From the album *Tune In Tomorrow: Soundtrack*
Tune also on Wynton's greatest hits CD
Performed by Wynton Marsalis, trumpet; Dr. Michael White, clarinet; Wes Anderson, alto sax; Todd Williams, soprano and tenor sax, clarinet; Herb Harris, tenor sax; Joe Temperley, baritone sax; Wycliffe Gordon, trombone; Marcus Roberts, piano; Reginald Veal, bass; and Herlin Riley, drums

In many ways, this recording represents jazz having come almost full circle. The musical language of this tune falls somewhere between traditional jazz and the swing style of Duke Ellington. The big difference here is that as you listen carefully to the playing of these fine musicians, little nuances from bebop, hard bop, free jazz, and even fusion begin to make themselves evident. These younger musicians have personal experiences with all of the newer jazz styles—as well as funk, soul, rock, hip-hop, and so on—and all of these styles are part of their musical language. As you learned in Chapter 5, the *rondo* is a classical music form with standard layouts of A-B-A-C-A (five-part) and A-B-A-C-A-B-A (seven-part). This loose treatment of the rondo concept doesn't fit neatly into the classical mold, but it does make use of the alternating A and B melodies, with the improvised solos taking on the function of the letter C material.

Total time: 9:23

:00	Work begins with a long improvised piano solo, which introduces both rhythmic structures and chord progressions that will be used throughout the work.
1:28	Band enters playing letter A material. This Mingus-like passage always occurs in groups of three full statements. The first four bars of the melody are grouped in beat patterns of 3+3+2, followed by two measures of regular 4/4 time. The third statement of the theme is presented in exactly the same way except that it has an extra two measures of 4/4 time at the end of the phrase.
1:54	Letter B-1 material is presented in an 8-bar phrase. The 1st 4 bars are played by sax and trombone, followed by 4 bars of clarinet. The entire 8-bar structure is then repeated.
2:13	Letter B-2 material is played one time. It follows the same structure as the B-1 material except that the melody line has been inverted.
2:23	Letter A material returns with the addition of more solo trumpet licks.
2:49	Soprano sax solo begins. Soloist plays six 8-bar choruses total. In the typical rondo structure, this section of the piece would function as letter C.
3:48	Letter A returns.
4:13	B-1, played twice.
4:33	B-2, played once.
4:43	Trumpet solo begins. Soloist plays nine 8-bar choruses total.
6:10	Letter A.
6:35	B-1.
6:45	B-2.
6:54	B-1.
7:04	Letter A.
7:29	Soprano sax solo begins. Soloist plays six 8-bar choruses total.
8:27	Letter A.
8:52	Letter B material returns, this time presented as a piano solo. The tune ends with a slow fadeout on this piano solo.

In the late 1990s, swing music's recent return to popularity has helped bring a number of singers to prominence. Harry Connick, Jr. has fronted both a big band and a small jazz ensemble. A gifted composer and pianist as well as singer, Connick is often viewed as America's modern version of Frank Sinatra. In truth, Connick is considerably more talented. He writes many of his own tunes, arranges the charts for his big band, and displays a real gift for improvisation as well. Guitarist and singer John Pizzarelli has followed in his father Bucky's footsteps as a very skilled mainstream jazz guitarist. In addition, John Pizzarelli has also added singing to his act, performing many tunes from the great American songbook by composers such as George Gershwin, Cole Porter, and Irving Berlin. Pianist and singer Diana Krall has made inroads to the pop music market with a dark, sultry voice and a true gift for conveying deep emotional content in a song. Like Connick, she is a talented improviser on piano as well. Singers including Cassandra Wilson, Dee Dee Bridgewater, Dianne Reeves, Nancy Wilson, Harvey Thompson, and Kevin Mahogany are keeping a wide variety of vocal jazz styles alive. Most recently, Norah Jones has brought mainstream jazz back to the forefront of popular music, winning five Grammy awards and recording two mega-hit CDs. Similar to Norah Jones, though more energetic at times, is a young British singer named Jamie Cullum. His two major CD releases are *Twentysomething* and *Catching Tales*. Cullum's live shows and his recordings blend creative improvisation with covers of diverse material and original tunes. His eclectic tastes run from the music of Jimi Hendrix through Broadway show tunes and all the way to angst-ridden Generation X melancholia. At the starts his career he performed performed a brilliant set on the acclaimed PBS live music show *Austin City Limits*. Watch for it in reruns or look for it on DVD. These singers perform everything from the blues to jazz standards to vocalese and scat singing. Look for them all at a jazz festival near you.

Smooth Jazz

In his highly opinionated book *Jazz Rock: A History,* author Stuart Nicholson makes a case for keeping the term *jazz rock* alive for describing what he considers to be "credible" jazz-oriented performances that make use of rock elements while reserving the term *fusion* for musical styles he deems less worthy. While the use of these terms in the way described below is very much a minority view, the underlying attitude expressed is quite common.

> Jazz-rock has been with us for a period roughly equivalent to that between Louis Armstrong's solo on "Weather Bird Rag" to Ornette Coleman's album *The Shape of Jazz to Come.* Thirty years is a long time in the history of jazz, yet jazz-rock still remains an enormously controversial subject, not least because it has become increasingly perceived in terms of the commercial excesses of fusion. Indeed, the specter of fusion has grown so large, primarily through commercial FM radio, that today it fills the viewfinder, blotting out jazz-rock and distorting its achievements. In responding to commercial logic, fusion all but turned an art form back into a commodity by allowing itself to be shaped by the requirements of the marketplace. And as we all know, commercial radio gravitates to where the money is and the money is generated by whatever sells advertising. Fusion happened to click with the right money demographic, the 25 to 52-year-olds, and now there are almost two hundred New Adult Contemporary radio stations across the country specializing in formatting fusion with high rotation playlists often put together by market research firms specializing in "audience testing" to ensure recordings are "selected on the basis of the broadest possible appeal" (i.e., the lowest common denominator).[26]

Many jazz critics seem to think it is a cardinal sin to make money, and Heaven forbid if you play a style of music that someone who is not considered a *worthy* jazz fan might enjoy (i.e., John Coltrane never played a solo that went on a bit too long in his entire life). In recent years, mixing jazz styles together with pop music has opened up a large commercial market, which many jazz performers—some very talented, some not so much—have embraced. Critics have used labels such as *smooth jazz, quiet storm, lite-jazz, hot-tub jazz, yuppie jazz,* and *fuzak* (a combination of fusion and Muzak) to describe these more commercial forms of jazz.[27] The industry has particularly embraced the term *smooth jazz,* but for the musicians, radio stations, and record companies that support it, being called a smooth jazz artist is not an insult.

Kenny G

One of the most popular smooth jazz performers today is saxophonist Kenny G. Given the rather opinionated quote at the beginning of this section, Stuart Nicholson actually paints an accurate portrait of the pop saxophone player. Instead of focusing on the artist, Nicholson seems to blame the "Kenny G problem," as it is sometimes known in the jazz world, on music fans.

> Perhaps the biggest-selling crossover artist was the saxophonist Kenny Gorelick, who debuted on the Arista label in 1982 with *Kenny G,* followed by *G Force,* which sold over 200,000 album copies. An uncomplicated R&B-based fusion aimed at FM airplay, both albums and the subsequent *Gravity* were not served well by the inclusion of vocal tracks. With *Duotones,* the vocals were dropped and, with the success of the single taken from the album, "Songbird," Kenny G hit the big time. Subsequent best-selling albums and sellout tours seemed to suggest that an awful lot of people enjoyed his middle-of-the-road, no-surprises, easy-listening style, which had become omnipresent on FM radio.[28]

In truth, there is a bit of a problem with Kenny G, but it's not his music. If you like it, go ahead—it's okay to enjoy it. Think of it as one of life's little guilty pleasures. Keep in mind, however, that this is a performer who has made a very good living billing himself as a jazz musician, but he rarely lends his support to the larger community of jazz. Regardless of how pop-oriented their music became, successful performers including Chuck Mangione and Herbie Hancock, as well as players in bands such as Spyro Grya and Tower of Power, have always been quick to direct their fans toward the past masters of jazz. For Kenny G, there seems to be no other music in the world besides his own. He recently released an album of jazz standards that clearly supports the long-standing opinions about his limited ability as an improviser. He plays a lot of notes, but he just doesn't really say much.

Some Other Smooth Jazz Artists

It is hard to place a finger on exactly when the smooth jazz movement began. In theory, you could go all the way back to some cool school artists, but most of them would not appreciate being included in that theory! In the 1980s, fusion musicians such as Grover Washington, Jr., George Benson, and Al Jarreau brought more of a relaxed, soul-music sensibility to their music. The style grew in popularity as radio stations began programming this music to a much larger audience. In the years that followed, the smooth jazz format was extended to include more

"new age" artists such as John Tesh and Yanni. As with many other forms of jazz, the category of smooth jazz is really a collection of closely related styles. Some artists feature lots of improvisation in more of a pop format, while others bypass true improvisation in favor of a really nice groove and a very accessible melody. Many hardcore jazz fans and musicians alike speak in very negative tones about smooth jazz, but these crossover artists are crying all the way to the bank.

Hip-Hop Influences on Jazz

Some rap artists have explored elements of jazz in their music. The groups A Tribe Called Quest, Arrested Development, and Digable Planets have all used jazz samples or live jazz as a part of their music. Solo artists Erykah Badu and Jamiroquai have both incorporated jazz styles in their performances. In fact, some critics have called Badu the next Billie Holiday. In an attempt to blend jazz and hip-hop culture, artists such as Quincy Jones have brought hardcore old school rappers including Ice T, Big Daddy Kane, and Melle Mel into their projects. Whether they know it or not, some of the best freestyle rappers are continuing the tradition of improvisation that has always been an integral part of jazz.

Steve Coleman
Source: © Mephisto

M-base

One interesting recent development is saxophonist Steve Coleman's creation of a style he calls **M-base.** Short for "Macro-Basic Array of Structured Extemporiza-tion," M-base is a mixture of rap, funk, rock, and jazz styles. Other musicians skilled in the more traditional styles of jazz have also explored M-base as a style. Former Miles Davis keyboard player Geri Allen, for example, and singer Cassandra Wilson have both experimented with this new fusion of jazz styles.[29] Both women are skilled jazz performers with a wide array of musical styles at their disposal. These are gifted artists who may be seeking a more accessible form of communication without having to compromise their art. Only time will tell.

Another catchall category that has grown in popularity recently is **acid jazz.** Ask ten different people and you will get ten different definitions of what acid jazz is. Well, it is really just another approach to musical fusion. A recent series of albums titled *The Roots of Acid Jazz* features hard bop artists including Jimmy Smith and Wes Montgomery along with more modern players such as Herbie Hancock. Modern groups who fall into the acid jazz category include Buckshot LeFonque and US3. The latter group is particularly interesting as they have developed a relationship with a flagship jazz record label, Blue Note. The band was using samples taken from the Blue Note catalog, at first without permission and later with the label's blessing. A song called *Cantaloop* from the album *Hand on the Torch* went on to break into the top 20 on the pop charts. Other than Norah Jones's two recent CDs, the album became the biggest seller ever for a label that has recorded just about every jazz artist mentioned in this book.

acid jazz

The Country Connection

Although most people miss it completely, there has always been a strong connection between country music and jazz. Many of the best "pickers" in country music are masters of improvisation. Older artists such as Bill Monroe, Bob Wills,

and Chet Atkins made heavy use of jazz styles in their music. Modern groups such as New Grass Revival, and the subsequent groups its members have taken part in, have all had a strong leaning toward very creative improvisation. Nashville artists including Sam Bush, Edgar Myers, Jerry Douglas, Matt Rollings, Howard Levy, and Bela Fleck have all gone on to create music that often bounces back and forth between many different musical styles, including jazz. Bela Fleck in particular has broken a lot of new ground with his group Bela Fleck and the Flecktones. Many noted studio musicians, including the late Vasser Clements and John Jorgenson, would quickly tell you that one of their biggest heroes was Gypsy jazz guitarist Django Reinhardt.

Some Final Thoughts on the Future of Jazz

In the final summary of their book *Jazz Issues,* authors David Megill and Paul Tanner point out that jazz today is at something of a crossroads. They note that jazz has the potential to go the way of classical music, becoming something of a "living museum." The cultural mixing that brought us jazz in the first place, however, also offers the potential for continued growth in this art form.

> There are many scenarios that can play themselves out as jazz matures as an art form. It may find, like classical music today, that it spends most of its time looking back as it searches for continued authentication. The fact that jazz is still a performer and improvisationally centered art form may prevent that from happening. We should remember that classical music also once had an exciting improvisational component but lost it to compositional intent. Jazz, as it looks for its own repertory, may suffer a similar loss. Also by looking back, jazz may respond more slowly to current cultural issues. For now, jazz still offers us a relatively quick response to social and cultural change. It still works as a mirror of the struggle for diversity prevalent in American culture and best reflects the dialectic posed when cultures merge. Most of all, jazz has offered us an example of how things we value gain status in our society. The uniqueness of the jazz art form reflects the unique balance of influences at work in our culture as they are played out by the individual artists who have defined the jazz tradition.[30]

The above assessment is a thoughtful consideration of the future of jazz. The only thing missing is the audience. Many classical musicians are notorious for almost daring their potential audience to like their music, and I'm afraid that in some instances jazz musicians aren't far behind. I would encourage jazz musicians to do everything in their power to make themselves more accessible to their audience. In no way do I mean that they should compromise the music they choose to play, but they should strive to develop a better rapport with their listeners. Conversely, I would encourage all jazz fans, and especially those new to the art form, to be a little patient with jazz musicians. Sometimes musicians aren't comfortable trying to put into words what they are doing. In fact, some musicians firmly believe that the music should always speak for itself. Given the lack of general music education over the last 30 or 40 years, my personal feeling is that many people no longer have the basic skills to even begin a journey in the world of jazz. This is an indictment of the general education system in America, not potential jazz fans as individuals. These problems are further compounded by a mainstream music industry that consistently panders to the lowest common denominator and turns its back on any artist who can't sell a million units right out of the starting gate.

DIG DEEPER

WEBSITE
www.allmusic.com
(reviews,
new releases,
artist's biographies)

Exploring the world of jazz is a fascinating, complex, sometimes frustrating, but always rewarding experience. It is one of the purest forms of communication humans have ever created. Sometimes it takes a little work to really understand the language, but at its best, jazz can be a window into a person's soul. Perhaps the most amazing thing is that unlike other forms of art, you don't just examine the finished product. Read a book and you are experiencing the final edit. A painter may struggle for years to capture just the right shades of light before he or she allows the public to experience the work. Even most classical music is at least in part a re-creation. When you hear a Beethoven piano sonata, you are experiencing one performer's interpretation of another artist's creation. Most drama functions exactly the same way. Of all of these art forms, jazz is one of the few that involves an element of spontaneous creation offered before the general public on a regular basis. It never happens the same way twice, and is—at its best—a direct reflection of the moment in which it was created. In the end, perhaps that is jazz's greatest reward to its listeners and performers alike. We are all part of that unique moment of creation. It never happened exactly that way before, and it will never be exactly that way again. Is that cool or what?

Endnotes

1. David Sharp et al., *An Outline History of American Jazz* (Dubuque: Kendall/Hunt Publishing Co., 1998), 128.

2. Nathan T. Davis, *Writings in Music,* 5th ed. (Dubuque: Kendall/Hunt Publishing Co., 1996), 15.

3. David Locke, "Africa," In *Worlds of Music,* 3rd ed., ed. Jeff Titon, (New York: Schirmer Books, 1996), 74.

4. Alan Lomax, *Mister Jelly Roll: The Fortunes of Jelly Roll Morton*, (Berkeley: University of California Press, 1950, 1973), 14.

5. Ibid., 18-20

6. *Satchmo*, videocassette, directed by Gary Giddins (New York: CBS Music Video Enterprises, 1989).

7. *Jazz: A Film by Ken Burns*, Episode 3, videocassette, directed by Ken Burns (Washington D.C.: PBS, 2001).

8. Ibid.

9. Ibid., Episode 5.

10. Ibid.

11. Ibid.

12. Alan Axelrod, *The Complete Idiot's Guide to Jazz* (Indianapolis: Alpha Books, 1999), 147.

13. Nat Shapiro and Nat Hentoff, *Hear Me Talkin' To Ya* (New York: Dover Publications, 1955), 354.

14. Ibid., 337.

15. Mark Gridley, *Jazz Styles*, 7th ed. (Upper Saddle River, N.J.: Prentice Hall, 2000), 152.

16. Nathan T. Davis, *Writings in Jazz* (Dubuque: Kendall/Hunt Publishing Co., 1998), 179.

17. *Birth of the Cool,* compact disc liner notes, Capitol Jazz CDP 7 92862 2.

18. *Jazz: A Film by Ken Burns,* Episode 9.

19. Shapiro and Hentoff, *Hear Me Talkin' To Ya*, 392.

20. Gridley, *Jazz Styles,* 200.

21. *Jazz: A Film by Ken Burns,* Episode 9.

22. Henry Martin and Keith Waters, *Jazz: The First 100 Years* (Belmont, CA: Wadsworth/Thomson Learning, 2002), 245-47.

23. Michael Erlewine et al., eds., *All Music Guide to Jazz,* 3rd ed. (San Francisco: Miller Freeman Books, 1998), 281-82.

24. Miles Davis and Quincy Troupe, *Miles: The Autobiography,* (New York: Simon & Schuster Inc., 1989), 369-373.

25. Erlewine et al., eds., *All Music Guide to Jazz,* 316.

26. Stuart Nicholson, *Jazz Rock: A History* (New York: Schirmer Books, 1998), xiv.

27. Ibid., p. xiii. also Martin and Waters, *Jazz, The First 100 Years,* 296.

28. Nicholson, *Jazz Rock,* 219.

29. Martin and Waters, *Jazz,* 348.

<p>Name _____</p>
<p>Class _____</p>

Study Guide

Chapter 10 Review Questions

True or False

___ 1. Only the front line instruments get solos in traditional jazz.

___ 2. Benny Goodman's Carnegie Hall concert was the first major jazz show ever performed in this historically classical hall.

___ 3. Cool school jazz was performed exclusively on the West Coast while the East Coast heard only bebop.

___ 4. Free jazz is usually very well organized and is often prearranged.

___ 5. Swing music became popular again during the 1980s and 90s.

___ 6. Today, fusion refers to a mixture of jazz and any other musical style.

___ 7. Bebop evolved in after-hours night clubs including Minton's and Monroe's in New York City.

___ 8. Bebop tends to use faster tempos than swing.

___ 9. African slaves brought their musical instruments with them to America.

___10. The rhythm section tends to start and end each piece by playing the melody.

Multiple Choice

11. When everyone in a group embellishes a written melody at the same time it is called:
 a. the head.
 b. an out chorus.
 c. a solo chorus.
 d. a solo break.
 e. an ensemble chorus.

12. Which swing saxophonist influenced bebop musicians by moving further away from the original melody with longer strings of notes?
 a. Cootie Williams
 b. Harry Carney
 c. Billy Strayhorn
 d. Lester Young

13. What is the title of the first jazz album to use modal improvisation?
 a. *The Birth of the Cool*
 b. *Milestones*
 c. *Kind of Blue*
 d. *Miles Ahead*

14. "Sheets of Sound" describes the improvisation style of which musician?
 a. Sonny Rollins
 b. John Coltrane
 c. Horace Silver
 d. Clifford Brown

15. Saxophone player Charlie Parker influenced bebop musicians by:
 a. his drug use.
 b. his amazing technical abilities.
 c. adding new chord changes in the middle of an improvisation.
 d. all of the above.
 e. none of the above.

16. What device gives jazz its unique rhythmic feel?
 a. tonic
 b. front line
 c. solo improvisation
 d. syncopation
 e. rhythm section

Fill in the Blank

17. Louis Armstrong had a *Billboard* chart-topper in 1964 with the tune _____.

18. A _____ is a short, repeated, rhythmic and/or melodic phrase.

19. _____ by _____ is the album viewed by most jazz historians, critics, and fans as the greatest jazz recording ever made.

20. For many musicians, the current jazz saxophone model is based on the playing style of _____.

21. Comping is short for _____.

Short Answer

22. List the instruments that make up a typical rhythm section.

23. List three differences between traditional jazz and swing.

24. List three differences between swing and bebop.

25. List two Miles Davis albums that introduced jazz-rock fusion to the public.

Essay Questions

1. Discuss the life of Louis Armstrong. Using the Internet and other current media sources, consider Armstrong's place in music history.

2. Make your own predictions about the future of jazz. What do you think jazz musicians could do to make their music more accessible to a wider audience?

Chapter 11
Around the World in 58 Pages or Less

Maybe it's naive, but I would love to think that once you grow to love some aspect of a culture—its music, for instance—you can never think of the people of that culture as less than yourself.

David Byrne

Source: © 2009 Shutterstock, Inc.

This chapter will explore music outside the Western art tradition, and I will act as your tour guide along the way. We will race around the world in the flash of an eye, getting a glimpse of how and why music is created in vastly different cultures. As with most tours, this one serves to whet your appetite. Many of the truly unique and amazing aspects of the trip will be left up to YOU, the traveler, to discover. This chapter should in no way be considered an exhaustive study. It is simply a small introduction to inspire you on a quest for further exploration.

At this point you might be asking yourself, "why should I bother taking this tour?" As your guide, it is in my best interest to sell this package to you, but my mom taught me to always tell the truth; therefore, here are the real reasons you should care about this chapter. First, music is globally among our most intimate and prized cultural possessions. It represents who we were, who we are, and who we hope to become. As the two Voyager spacecraft continue their respective journeys outside our solar system, gaining insight into the order of the universe and poised for the

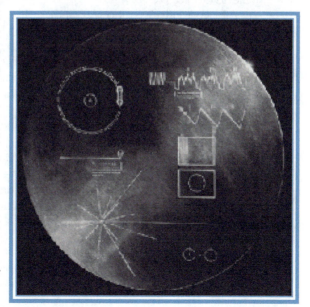

Image of The Golden Record contained in the two voyager spacecraft.
Source:
http://voyager.jpl.nasa/gov

possible discovery of unknown life forms, they contain within them, as means of representing our global heritage, ninety minutes worth of music from around the world.

Music on the Voyager Golden Record

- Bach, Brandenburg Concerto No. 2 in F. First Movement, Munich Bach Orchestra, Karl Richter, conductor. 4:40
- Java, court gamelan, "Kinds of Flowers," recorded by Robert Brown. 4:43
- Senegal, percussion, recorded by Charles Duvelle. 2:08
- Zaire, Pygmy girls' initiation song, recorded by Colin Turnbull. 0:56
- Australia, Aborigine songs, "Morning Star" and "Devil Bird," recorded by Sandra LeBrun Holmes. 1:26
- Mexico, "El Cascabel," performed by Lorenzo Barcelata and the Mariachi México. 3:14
- "Johnny B. Goode," written and performed by Chuck Berry. 2:38
- New Guinea, men's house song, recorded by Robert MacLennan. 1:20
- Japan, shakuhachi, "Tsuru No Sugomori" ("Crane's Nest,") performed by Goro Yamaguchi. 4:51
- Bach, "Gavotte en rondeaux" from the Partita No. 3 in E major for Violin, performed by Arthur Grumiaux. 2:55
- Mozart, The Magic Flute, Queen of the Night aria, no. 14. Edda Moser, soprano. Bavarian State Opera, Munich, Wolfgang Sawallisch, conductor. 2:55
- Georgian S.S.R., chorus, "Tchakrulo," collected by Radio Moscow. 2:18
- Peru, panpipes and drum, collected by Casa de la Cultura, Lima. 0:52
- "Melancholy Blues," performed by Louis Armstrong and his Hot Seven. 3:05
- Azerbaijan S.S.R., bagpipes, recorded by Radio Moscow. 2:30
- Stravinsky, Rite of Spring, Sacrificial Dance, Columbia Symphony Orchestra, Igor Stravinsky, conductor. 4:35
- Bach, The Well-Tempered Clavier, Book 2, Prelude and Fugue in C, No.1. Glenn Gould, piano. 4:48
- Beethoven, Fifth Symphony, First Movement, the Philharmonia Orchestra, Otto Klemperer, conductor. 7:20
- Bulgaria, "Izlel je Delyo Hagdutin," sung by Valya Balkanska. 4:59
- Navajo Indians, Night Chant, recorded by Willard Rhodes. 0:57
- Holborne, Paueans, Galliards, Almains and Other Short Aeirs, "The Fairie Round," performed by David Munrow and the Early Music Consort of London. 1:17
- Solomon Islands, panpipes, collected by the Solomon Islands Broadcasting Service. 1:12
- Peru, wedding song, recorded by John Cohen. 0:38
- China, ch'in, "Flowing Streams," performed by Kuan P'ing-hu. 7:37
- India, raga, "Jaat Kahan Ho," sung by Surshri Kesar Bai Kerkar. 3:30
- "Dark Was the Night," written and performed by Blind Willie Johnson. 3:15
- Beethoven, String Quartet No. 13 in B flat, Opus 130, Cavatina, performed by Budapest String Quartet. 6:37 [1]

To listen to the recording or to see images go to the N.A.S.A. maintained website: goldenrecord.org

Second, as the world becomes more interconnected, it is essential that we attempt to gain insight into cultures outside our own. Global outsourcing has made it possible, and economically worthwhile, for a dinner reservation to be made at a Mexican food restaurant in New York City by speaking with someone in India who, via the Internet, books your reservation back in New York. (This doesn't even begin to take into account the global chain that got the food to the restaurant, printed the menus, made the furniture. . . . I think you get the point). Like it or not, we are interconnected and need to begin learning how our neighbors think and how they view the world. As stated previously, music is among our most intimate and prized cultural possessions, so what better way to get to know our neighbors than by studying their music. Music does not exist in a vacuum. To understand a different culture's music, we have to understand a little about the culture itself. And, if you find they have a penchant for 80s metal, or, worse yet, really bad disco, well at least you know to be very afraid.

Third, by looking outside of ourselves, we can begin to appreciate aspects of our own culture with new insight and often a renewed vigor. How many times have you taken a vacation and thought, "wow this is amazing . . . I can't wait to get home." It's part of who we are as a species. We love to explore and see new things, but we also love to return home. Often, it is only upon our return that we reflect on our trip; we compare and contrast where we have been with where we are. We notice details of our home environment we hadn't noticed before because our vacation exposed us to these new sights and sounds. Lastly, and probably most importantly, it is just really cool! The fact that music exists globally is amazing unto itself and really needs no further discussion.

Before we depart, let's set up some rules for the expedition and take a look at our itinerary. Actually, there is only one rule, and here it is: since it is impossible to fully understand or appreciate any style of music outside of its cultural context, we will not attempt to do so. Music is often referred to as a universal language. It is not! Yes, music exists universally (all people have their own music), but as with any language, you have to make sense of the vocabulary, grammar, and syntax to fully understand what is being said. Put another way, computers are not always compatible. It takes a little bit of time to learn how to work a MAC if all you have been trained on is a PC. Music is a form of communication that operates within its own set of rules and guidelines. It can be listened to on many different levels, but the more familiar you are with the rules of the genre the more you will take away from the listening experience. Think of it as a jigsaw puzzle. Learning about historical expectations and events in the Baroque era gave us one piece of the puzzle, where as studying forms and the musical language of the period gave us another piece. As we put these pieces together and listened to the music, we began to gain a different understanding of what the music was intended to be.

As we look outside our culture and begin studying music of the world, the learning curve becomes steeper. We no longer share a common heritage, and things that we have previously taken for granted need to be examined in more detail. This not only applies to cultural elements but to the very fabrics of the music itself. All our basic concepts of melody, rhythm, harmony, texture, and form must be reexamined for our new trip. Major and minor scales are nowhere to be found in the music of Bali; functional harmony is not going to be used in the classical Indian tradition; and the rhythmic structure of a Navajo Nightway ceremony cannot be felt in even-measured groups of four. As we look at the music from cultures around the world, we will constantly be aware of this. We will examine the music with respect to these basic elements, as well as from a cultural standpoint.

World Atlas showing our
planned itinerary.
Source: © Shutterstock, Inc.

If you are an over-achiever and want to do some "pre-trip" exploring on your own, the Annenberg media website has a wonderful video series titled *Exploring the World of Music* (produced by Pacific Street Films and The Educational Film Center). The series contains twelve separate half-hour videos that explore the basic elements of music from a global perspective. It is free to view if you join the site and can be accessed at www.learner.org. Then do a search for *Exploring the World of Music*. We will examine the basic elements mentioned above throughout the course of this chapter, but trust me; these videos are worth your time and will help you put our trip into perspective.

Our itinerary will be as follows:

1. Oceana (Aboriginal music of Australia)
2. Indonesia
3. India
4. Africa (sub-Saharan)
5. Middle East
6. The Silk Road
7. Japan
8. North America (native culture)
9. African Diaspora (Cuba)

As we prepare for final departure, we need to mention how we are going to get to our destinations and start listening to all of this music. Our means of travel will be through a global system of interconnected computer networks that use the

standardized Protocol Suite, also known as the Internet. You may have noticed that the streaming music included with your text does not include any listening associated with this chapter. Because of this fact, we will use a variety of online sources to help you hear the music of the world. I have chosen sites and material that are very stable and should be there for you. As we are all painfully aware, however, the Internet can change drastically overnight. If you can't find material, please check this book's website for regular updates.

DIG DEEPER

In 1948, a man named Moses Asch founded a record company in New York City called **Folkways Records.** His principal goal in creating the company was to document "people's music," spoken word, instruction, and sounds from around the world.[2] Under his direction, the company recorded and released nearly 2,200 albums.

In 1987, following the death of Moses Asch, the Smithsonian Institution acquired the holdings from the Asch estate, and Smithsonian Folkways Recordings was founded as the nonprofit record label of the Smithsonian Institution, the national museum of the United States. The mission statement of the organization reads as follows:

> We are dedicated to supporting cultural diversity and increased understanding among peoples through the documentation, preservation, and dissemination of sound. We believe that musical and cultural diversity contributes to the vitality and quality of life throughout the world. Through the dissemination of audio recordings and educational materials we seek to strengthen people's engagement with their own cultural heritage and to enhance their awareness and appreciation of the cultural heritage of others.[3]

Used with permission

What better site to use as a home base for our adventure? You can access the holdings through their website at www.folkways.si.edu. Once there, you can access all of the recordings mentioned in the remainder of this chapter. You will be able to listen to a 30-second sample of each recording and download liner notes from all of the recordings for free. If you want to listen to all of the tracks, or the entire album, you can purchase digital downloads and CDs directly from the website. The site also has great streaming radio stations that play random selections from the collection, and over 80 hours worth of free podcasts. Most of the recordings are also available on emusic (emusic.com). This site requires a monthly subscription rate, but if you plan on purchasing a large number of the recordings, this will be a cheaper way to do it. You can also purchase the recordings through Napster (napster.com) or itunes (itunes.com). Lastly, if available through your library, the online music database provided by Alexander Street Press offers free streaming of the entire collection. Ask your local librarian if you have free access. Keep in mind, however, the only place you can get the liner notes is through the Smithsonian. I will mention a few websites with each region that we explore, but here is a good list of general sites.

GENERAL

Smithsonian Folkways—www.folkways.si.edu

emusic—www.emusic.com

Napster—www.napster.com

C. I. A., The World Factbook—www.cia.gov and follow links to World Factbook

NASA—www.goldenrecord.org

Annenberg Media—www.learner.org

Alan Lomax—research.culturalequity.org

National Music Museum—nmmusd.org

Live Radio Links—www.live-radio.net/info.shtml

Music Instrument Museum—mim.org

In addition, almost all of the artists and art forms we will discuss have their own websites that are always at your disposal.

ethnomusicology In academic terms, the purpose of our trip is to investigate **ethnomusicology,** a field that Jeff Todd Titon defines as, "the study of music in the context of human life."[4] It is distinct from musicology, which in general focuses on the music of Western culture (the rest of this book). Ethnomusicology does include the study of Western folk music when examined from a cultural standpoint. In fact, among the first people to become interested in this new academic discipline were composers Béla Bartók and Zoltán Kodály, who, at the beginning of the twentieth century began studying folk traditions of their homeland, Hungary (see page 246, Chapter 8). Other notable pioneers in the field were the father and son team John and Alan Lomax. John Lomax is remembered for his research and recordings of American folk music, while his son, Alan, is remembered for his work with the Library of Congress as Assistant in Charge of the Archive of Folk Songs. Among

Cantometrics other achievements, Alan Lomax is remembered for the development of an analytical system known as **Cantometrics.** The system attempts to gain cultural insights of a given people through a statistical analysis of their music. The New Groves Encyclopedia of Music defines the somewhat controversial method as "A system of analysis for studying various facets of folksong performance. . . . musical factors relating to song style are submitted to statistical analysis and correlated with social and cultural data, with a view to delineating the role of the folksong in its cultural setting."[5]

Also important in the development of the field were Erich von Hornbostel and Curt Sachs, who developed a means of classifying instrumental groupings based on the nature of the initial vibrating body. This system has four principal categories that are then divided into subcategories (300 in all). The system gets a little tricky in places because there are some instruments such as the banjo and the kazoo, which seemingly cross categories. The key, however, is to remember that the system is based on the nature of the *initial* vibrating body.

The four major groupings are:

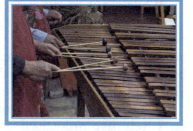

Musicians play on a Marimba in Chiapas, Mexico.
Source:
© Shutterstock, Inc.

- **Idiophones**, which produce sound primarily by the vibrations through the body of the instrument. The criterion for subclasses is based upon the playing method of the instrument. Cymbals, gongs, and xylophones are examples of idiophones.[6]

Finger cymbals.
Source: © Shutterstock, Inc.

- **Membranophones,** which produce sound primarily by a stretched membrane. Drums are the primary example, but instruments such as the kazoo, which has a membrane that is activated by blowing air across it, are also considered membranophones. The criteria for subclasses are based upon the playing method and the shape of the instrument.[7]

A pair of tabla from India.
Source:
© Shutterstock, Inc.

A djembe from Africa.
Source: © Shutterstock, Inc.

- **Chordophones**, which produce sound by vibrating strings. The violin, guitar, harp, and the piano are examples of chordophones. The criteria for subclasses are based upon the relation of the string to the resonator. (Resonators help to amplify the initial vibrations.)[8]

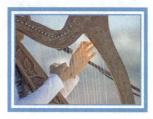

A woman playing the harp.
Source:
© Shutterstock, Inc.

A Chinese woman playing guzheng.
Source: © Shutterstock, Inc.

- **Aerophones**, which produce sound by blown air. The trumpet, flute, clarinet, whistles, bull-roarers, and the didgeridoo are all examples of aerophones. Criteria for subclasses are based upon the method used to vibrate the air.[9]

An Aboriginal man playing didgerdoo.
Source:
© Shutterstock, Inc.

A trumpet.
Source:
© Shutterstock, Inc.

Electrophones

While not included in the original Hornbostel-Sachs system, **Electrophones** are now often added as a fifth group. In this group, sound is produced and amplified through electric means. A synthesizer would be considered an electrophone because sound is produced and amplified through electric triggers. On the other hand, an electric guitar would be considered a chordophone because the initial vibrations are caused by the strings, not the electric amplification.

A translation and revision of the original Hornbostel-Sachs system can be viewed on a web page maintained by the Musical Instrument Museum online at www. mimo.international.com/documents/Hornbostel%suchs.pdf. All instruments are given a number that corresponds with their primary group listing as well as their subclass. An instrument number that begins with a one is an idiophone, two a membranophone, three a chordophone, and four an aerophone.

With ticket and passport finally in hand, it is at last time to start our adventure.

Oceana (*Aboriginal Music of Australia*)

World Atlas with Australia highlighted.
Source: © Shutterstock, Inc.

Australia's indigenous people can boast the oldest intact culture on earth, so examining the music and culture of these people seems a good point of departure. Australia is a continent/nation in the South Pacific that is 2,969,907 square miles (an area slightly smaller than the continental United States) and has a population of over 23 million people, of which over 500,000 are aboriginal.[10]

A migration into Australia occurred over 40,000 years ago, and as the vast continent was populated, regional differences occurred. When contact with Europeans began in the early 1700s, it is estimated that over 250 distinct aboriginal languages were spoken.[11] Contact with Europeans became continuous in 1788 with the founding of Port Jackson (now Sydney) as a British penal colony.[12]

Traditionally, most Aborigines held (and still hold) similar religious beliefs that focus on *The Dreaming,* the story of the actions and path of ancestral beings who created the natural world. These beliefs connect the people intimately to the land around them and have allowed for forty thousand years of continuous habitation in an extremely hostile environment. In *The Rough Guide to World Music,* Marcus Breen states:

> Aboriginal creation myths tell of legendary totemic beings who wandered over the continent in the dreamtime, singing out the name of everything that crossed their path—birds, animals, plants, rocks, waterholes—and so singing the world into existence. The songlines are paths, which can be tracked across the continent linking these totemic emblems: sacred objects that have returned to the land—perhaps a lizard, a kangaroo or an outcrop of rocks. Each Aboriginal tribe takes one of these totemic beings as ancestor and thus will have maybe a lizard-Dreaming or a kangaroo-Dreaming or a rain-Dreaming. . . . the totemic ancestors are thought to have scattered a trail of words and musical notes along the lines of their dreaming-tracks. An ances-

tral song is both a map and a direction finder: . . . Regardless of the words, it seems the melodic contour of the song describes the nature of the land over which the song passes. One phrase would say, Salt Pan, another Creek-bed. . . . An expert song-man, by listening to the order of succession, would count how many times his hero crossed a river, or scaled a ridge—and be able to calculate where and how far along, a Songline he was.[13]

Music, dance, and visual art represent the essence of creation and are thus at the heart of all Aboriginal ceremonies. Stories reenacted within the ceremonies are specific to clans and their respected environment, and they create a series of culture norms about how to live within specific regions. The ceremonies provide a direct link with the past and ensure that essential elements of the belief system remain intact. With this in mind, it is not an overstatement to say that the arts are essential to the survival of the people.[14]

We will center our attention in the northern portion of the continent in an area known as Arnhem Land. Located in the sparsely populated Northern Territory of Australia, Arnhem Land was established in 1931 as the largest Aboriginal reserve in the country. Because of the remote location, it has retained a distinct cultural identity.

In this area, most of the music performed is sacred and relates directly to *The Dreaming*. Performances are often restricted to the initiated. The music is primarily vocal with rhythmic accompaniment supplied by the didgeridoo (*yidaki*), clap sticks (*bilma*), and various body percussion insertions (hands, chest, feet, etc . . .). Depending on the region the songs are sung by a soloist (the *songman*), or in groups. The **songman** can be thought of as a Master of Ceremonies; he is the owner of the songs and dances that he performs, and these pieces are not performed without his permission.

Recommended listening comes from *Tribal Music of Australia* (fwo4439) on the Folkway Records label. Of particular interest in the solo style are tracks one and two, which are both examples of a *dgedbang-ari* dance. The dance form mimics the approach of waves from the ocean to the beach. Listen for the stops and starts in the music, and know that the dancers halt their movements to coincide with these stops and starts. Track seven is a wonderful introduction to the didgeridoo. Listen for the variety of sounds and rhythms played on the instrument, many directly imitating sounds heard in nature. Tracks six and fourteen are excellent examples from the sacred Marian festival, which is an important all-souls festival. The fact that these two tracks were recorded is amazing, for they are sacred material that would normally be reserved for initiated members of the clan.[15]

In addition to the human voice, the principal instruments used by the Australian Aborigines are the previously mentioned didgeridoo, clap sticks and the bull roarer. The **didgeridoo** (an aerophone) is now strongly associated with aboriginal music across the continent; however, it was traditionally associated with only a small number of clans in the Arnhem Land region. Only recently has the use of the instrument spread to the rest of the continent. In keeping with the deep Aboriginal connection to the natural world, the instrument was by tradition more found than made. A eucalyptus branch hollowed out by termites was used as the body of the instrument, to which a beeswax mouthpiece was inserted. The instrument was decorated, and that was it.

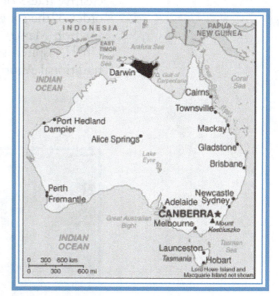

Map of Australia with Arnhem Land highlighted.
Source: map.cia.gov

songman

didgeridoo

clapsticks

bull roarer

The **clapsticks** (idiophone) are two pieces of wood that are struck together and used prominently by the songman to accompany himself. Two boomerangs, one held in each hand, are also often used as clapsticks. The **bull roarer** (aerophone) is a small piece of wood, usually carved into an oval shape and decorated with intricate designs. It is attached to a string or rope and swung over the head to make its sound. A sacred instrument used in male incitation rights, this instrument is found in ancient cultures throughout the world.

Many regions feature group vocals as opposed to the vocals of the solo songman just discussed. In these areas, short songs are arranged into long series (often hundreds of songs in a series), each based on similar melodic contours. The sacred song cycles deal with the creation of a clan's ancestral spirit (specific rock formations, lakes, trees, etc . . .). The ancestral spirits, or totemic spirits, are natural elements or animals that represent the clan.

The song cycle is known by the name of the ancestor (kangaroo, termite etc . . .), and, when linked together with clans of the same region, form a distinctive spiritual landscape. The language used in the music is often a poetic form that does not exist in spoken language but is reserved specifically for music. The songs often have a haiku-like ability of subtly altering one's perception of a subject with very little actually being said. Translations are sometimes difficult because of the complexity of the Aboriginal languages. As the songs are literally following the creative tracks of ancestors, almost no variation is allowed for the song or even the order of the song cycle.[16]

Bob Marley toured Australia in 1979, and his message of "Get Up, Stand Up"[17] inspired some Aboriginal artists to begin using a synthesis of reggae and traditional Aboriginal music as a vehicle for social protest.[18] Currently, numerous

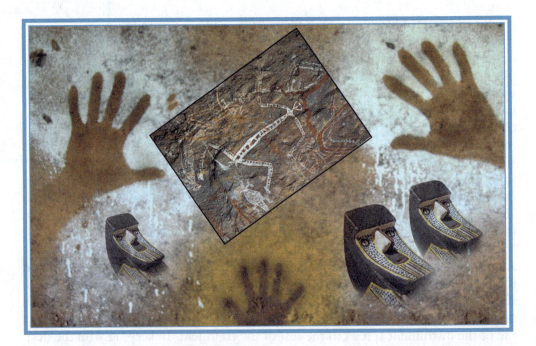

Collage of Aboriginal sculpture with rock art and hand paintings.
Source: © 2009 Shutterstock, Inc.,

artists use various genres of popular music with traditional Aboriginal music to form hybrids that continue to push this music in new directions. In fact, many of the groups themselves are often hybrids, featuring Aboriginal and non-Aboriginal group members, as well as instruments and languages from different cultures. Among the most popular of these groups and solo artists are Yothu Yindi, BlekBala Mujik, The Warumpi Band, Coloured Stone, Ash Dargan (a former member of Coloured Stone), Stephen Kent (and his band Trance Mission), Steve Roach, and Kev Carmody. All of these artists can be heard and seen on YouTube. In addition, most have their own websites. For a somber portrait of the initial interaction between Aboriginal and European cultures listen to Kev Carmody's "Thou Shall Not Steal."[19]

DIG DEEPER

www.indigenousaustralia.info —Introduction to Indigenous Australia

www.manikay.com —The tribal sounds of Australia

www.didjshop.com —a look at Aboriginal instruments

www.aboriginalartonline.com —Aboriginal Art Online

Indonesia

Traveling north from Australia we arrive in Indonesia, an archipelago nation consisting of over 300 ethnic groups spread out among nearly 18,000 islands. It is the largest island nation in the world, in terms of area, covering 735,358 square miles (roughly the combined size of Alaska and Washington). With almost 250 million inhabitants, it is the fourth most populated nation on the planet, and the third largest democracy. The country is predominantly Islamic (85%), but, there are substantial numbers of Buddhists, Hindus, and Christians as well.[20]

With the vast array of ethnicities and religious customs in mind, it should come as no surprise that there are huge cultural differences scattered across the nation. In our Indonesian trek, we will look at the legendary **gamelan orchestras** of Java and Bali, but we also examine some of the lesser-known forms of music from around the nation. As a point of departure, let's start with the shimmering, metallic sounds of the gamelan. The

gamelan orchestras

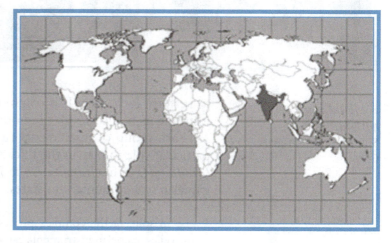

World Atlas with Indonesia highlighted.
Source: © 2009 Shutterstock, Inc.

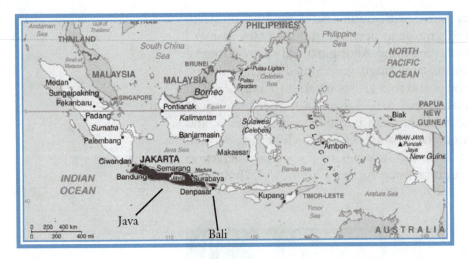

Map of Indonesia with Java and Bali highlighted.
Source: map.cia.gov

gamelan orchestras of Java and Bali have caught the attention of the West for nearly five hundred years.

They have had a large impact on the Western classical tradition through the compositions of composers such as Claude Debussy (see p. 223, Chapter 7), Lou Harrison, John Cage (see p. 285, Chapter 9) and many others. Most gamelan orchestras consist of a set of tuned gongs, various metallophones (instruments similar to Western vibraphones but smaller and tuned differently), and wooden xylophone-like instruments. The ensembles can also include flutes, rebabs (a two-stringed fiddle), and vocalists. The instruments are treated with the utmost respect, and periodically an offering, which can include food, drink, and the burning of incense, is made to the gongs.[21]

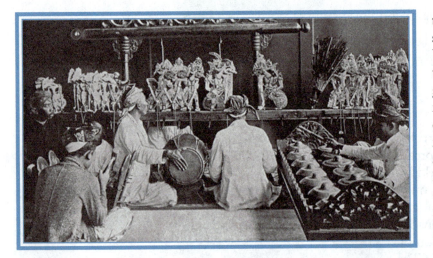

A typical Javanese gamelan.
Source: Jupiterimages, Corp.

The instruments are tuned to one of two scale systems: *pélog* (a seven note scale), and *sléndro* (a five note scale). Unlike most Western ensembles, the tuning of these two scales varies between groups and regions (individual instruments are not interchangeable between different gamelan sets). Some of the intervals within the pélog and sléndro scales are nonexistent in the Western major/minor system, meaning the scales cannot be reproduced on a Western instrument of fixed pitch, such as the piano. Furthermore, the interval relations of these scales do not overlap, so a separate set of instruments is required to perform each scale. It is common for a full gamelan orchestra to consist of the instruments needed to play in both tonalities.

Each group of instruments (gongs, metallophones, etc . . .) has their own particular role to play in the thickly intertwined texture of a gamelan composition (*gendhing*). In his *Introduction to Javanese Gamelan,* noted Javanese musician and gamelan scholar Sumarsam states:

pélog

sléndro

gendhing

> In spite of the complex process in which musicians conceive and express their melodies, gamelan instruments can generally be classified according to their functions, into three major groupings. . . .
>
> I. The instruments and vocalist which carry melody in both elaborate and more simple forms. . . .
> II. The instruments which regulate musical time: to set up the appropriate timing for a composition, control transition, and signal the end of the piece.
> III. The instruments which underline musical structure.[22]

In discussing the elusive melodic structure found in gamelan, Professor Sumarsam says:

> The gamelan ensemble can be characterized as music based on communal expression. The melody of a single instrument cannot be conceived as separable from the whole sound of the ensemble. In identifying what they find to be the main melody of a composition, many theorists have been puzzled by the different limitations of the melodic ranges of the instruments. Actually, the feeling of unity, communality, or totality is based on the interactions or interrelationships among the instruments in the ensemble. This is the most important concept of the gamelan ensemble. The interrelationships among the instruments provide our understanding of how musicians intuitively conceive of the melody of gendhing as the result of their own inner creativity at work. This melody as conceived by the musicians is never explicitly stated on their instruments, yet this implicit melody is in the minds of musicians. I call this melody the "inner melody" of gendhing. Each musician has to coordinate his conception of the inner melody with the range of his or her instrument and its performance technique when creating melodic patterns for a gendhing.[23]

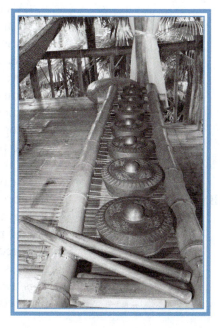

A typical Kulitang.
Source: © 2009 Shutterstock, Inc.

Time is usually kept by a double-headed drum called a *kendhang*. In gamelan compositions, the articulation of time is a concept known as **iråmå**, which encompasses the relations of tempo with the density of melodic instrument notes.[24] Different groups of melodic instruments move at different fixed ratios in relation to the pulse. The overall structure of the work is defined by cyclic return and sounding of the largest gong in the ensemble. This section known as the *gongan*, then receives various symmetrical subdivisions, all of which are emphasized through the reiteration of attacks by specific instruments.[25]

There are a number of different existing gamelan traditions spread across the nation of Indonesia. Several of these styles can be found on Java, an island roughly the size of New York, with a population of over 141 million people. While the island's inhabitants are now primarily Muslim, the Hindu past can be seen and heard as the foundation of the ancient gamelan traditions. The cyclic dogma of Hinduism is mirrored by the cyclic nature of the music.[26]

In Java, gamelan music is rarely performed independently. Instead, it is used as accompaniment for dance (*Srimpi* or *Bedhaya*), as well as the shadow puppet plays called **Wayang Kulit.** The shadow puppet theater, which dates back at least a thousand years, is revered throughout the island. It typically consists of one puppeteer operating numerous puppets, with a giant white screen stretched in front of him, and a powerful overhead lamp to project the images. The puppeteer is accompanied by the gamelan orchestra in an event that typically lasts all evening—six to eight hours is common—with no intermission. While the stories told are not scripted, they are typically depictions of the well-known Hindu epics *The Mahabharata* and *The Ramayana*. Both sagas are central to Hindu beliefs and could be considered equivalent to the Bible in Christianity. Examples of shadow puppet plays can be seen on YouTube, as well as in the film *The Year of Living Dangerously.*

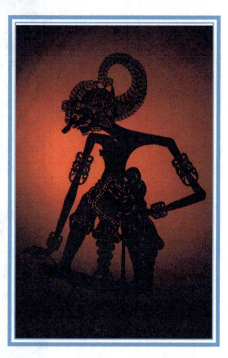

Image of a shadow theater puppet as projected on to a screen.
Source: © 2009 Shutterstock, Inc.

Wayang Kulit

A slightly different type of gamelan tradition exists on the island of Bali. While there are many similarities between the musical traditions of Java and Bali, the Balinese tend to favor faster and more virtuosic musical styles. Another distinct difference between the ensembles of the two islands is the intonation of the respective groups. On Bali, gamelan instruments are tuned in pairs, or perhaps I should say "mistuned"; the instruments are *slightly* mistuned with each other to create a shimmering quality that is caused by the natural harmonic series of the instruments rippling off one another.[27] Performances are similar to the Javanese traditions discussed previous. Numerous audio and video recordings are available of the Balinese style. It is truly spectacular music, so go to YouTube to listen and watch.

Balinese Kecak dance

Leaving the gamelan tradition behind, we discover another amazing tradition on the island of Bali, the famous **Balinese Kecak dance.** Also known as the Ramayana Monkey Chant, the piece depicts a battle sequence from the *Ramayana,* one of the great Hindu epics. It features a large number of male performers (one hundred or more), bare-chested, chanting in a percussive manner. The dance is famous worldwide, and if you have not seen it, it presents a wonderful spectacle. It is available for your listening and viewing pleasure on YouTube, and it is also featured prominently in the Ron Fricke movie *Baraka*.

Performance of the Balinese Kecak dance.
Source: © Shutterstock.com

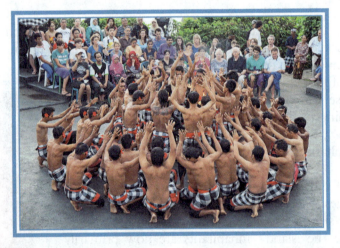

Dig Deeper

Abundant resources are available on the web for more in depth examinations on various aspects of gamelan orchestras. Excellent resource material can be found at the following links:

- java.eyelid.co.uk/film/gamelan1.html—This site contains video performances of Javanese Gamelan, as well as shadow puppet plays.
- www.marsudiraras.org/gamelan—This site is an excellent introduction to Javanese Gamelan. It contains links to pictures and sound clips for many of the various instruments found in the ensemble.
- sumarsam.web.wesleyan.edu/Intro.gamelan.pdf—This is a PDF download of Professor Samarsan's, *Introduction to Javanese Gamelan.*

In addition, there are countless recordings available, on numerous labels. Recordings of various gamelan traditions on the Smithsonian-Folkways label include:

- *Discover Indonesia* (SFW40484)—a compilation of Philip Yampolsky's twenty-volume series, this disc gives us highlights from the entire series that brilliantly explores various Indonesian music-cultures not readily known in the West.

- *Music of Indonesia* (FW04406)—a recording that features traditional Javanese and Balinese Gamelan.

- *Music of the World's Peoples: Volume 1* (FW04504)—a good example of Balinese Gamelan.

Leaving Bali, we come to the largest island lying solely within Indonesia, Sumatra. Home to many different ethnic groups, more than fifty native languages are spoken by the island's forty-five million inhabitants. Let's briefly examine and listen to some of the music-cultures found on this island, which are not commonly heard in the West.

Petalangan musicians from Riau, Central Sumatra, frequently perform on an instrument known as a *gambang*. The gambang is a xylophone-like instrument with five bars. It is played by two people sitting across from one another and is often used, along with drums and gongs, to accompany *silat* dancing. *Silat* is a type of martial art practiced throughout Indonesia and Malaysia. The instrument is also frequently played unaccompanied.[28] The instrument is heard on track one (*Tetigo*) of the Yampolsky compilation disk mentioned on p. 3, *Discover Indonesia* (SFW40484).

gambang

Silat

gondang sabangunan

Also featured on this compilation recording is the music of the Toba people of Northern Sumatra. Track three (*Gondang Si Monang-Monang*) features Toban musicians performing in a *gondang sabangunan* ensemble. The ensemble consists of tuned drums, double-reed instruments, and gongs. The exciting, up-tempo music is used for various ceremonial purposes, including spirit possession ceremonies.[29] Around the world, many religions use music to induce trances. In these religions, the trance-like state is often thought to be a benevolent spirit possession and is con-

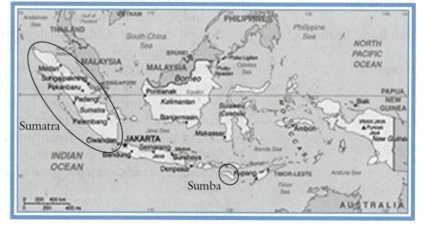

Map of Indonesia with Sumatra and Sumba highlighted.
Source: cia.gov

sidered essential in communicating with the spirit world. These types of ceremonies are common throughout the world and will be discussed in greater detail as we discuss the music of Africa.

In the southeastern portion of Indonesia, we find the relatively small island of Sumba. The island is 6930 square miles and has a population of just over 600,000.

Being heavily influenced by Dutch colonization, the principal religion practiced on the island is now Christianity. If you turn the clock back, however, you would find that prior to the Dutch arrival, the island's inhabitants practiced an animist religion known as Maripu. A basic tenet of animist religions includes the idea that all things on the planet (rocks, plants, mountains, rivers, etc . . .) have a soul or spirit. Track 11 (*Tebung*) on the *Discover Indonesia* compilation features music that comes from an ancient Maripu funeral tradition. The genre features non-melodic gongs and drums. Traditionally, this piece is only performed at funerals, and it would be played continually from the time of death until the burial several days later.[30]

Turning our attention toward more recent additions to the Indonesian musical landscape, we encounter cross-cultural, East-West genres such as *kroncong, gambang kromang,* and *dangdut*. **Kroncong** is the grandfather of these fusion blends of Eastern and Western music and can trace its origins back several centuries to the development of the Portuguese trade routes.[31] Essentially, kroncong takes European instruments such as the cello, violin, guitar, and flute, and combines them with Indonesian instruments and vocal forms. The music is played in an interlocking, gamelan-like style and is favored by the lower classes.[32]

Both, **gambang kromang** and **dangdut** grew out of the earlier style, kroncong, but the focus of the East/West fusion is different with both of the later styles. **Gambang kromang** consists of an eclectic, blend of jazz and gamelan—not to mention the addition of Hawaiian guitars and Chinese flutes thrown in for good measure. **Dangdut** fuses Indonesian styles with Western rock and Indian film music and features the prominent use of electric guitars and synthesizer.[33]

Several examples of Indonesian popular fusion styles are present on the *Discover Indonesia* compilation recording. Track 8 (*Stambul Bila*) is an example of gambang kromang. Track 5 (*Curahan Hati*) is a brass band version of Dangdut. To listen to the more popular guitar and synthesizer driven form of this genre, check out Indonesian superstar Rhoma Irma online. Also, volume two of Yampolsky's twenty-volume Smithsonian-Folkways recording set is devoted to Indonesian pop music and features Rhoma Irma prominently. If you like dangdut and gambang kromang, listen to some of the other pop genres of Indonesia on YouTube including *jaipongan, qasidah modern, gambus,* or *pop-sunda*.

Dangdut star, Rhoma Irma as seen on the cover of Smithsonian-Folkways Recording Music of Indonesia, Vol. 2: Indonesian Popular Music.

Kroncong

gambang kromang

dangdut

India

Lying northwest of Indonesia is the subcontinent of India. With an area of 1,269,219 square miles, roughly a third of the size of the United States, India is the seventh largest nation in the world. The estimated population of India as of July, 2009 is 1.25 billion, making it the second most populated nation in the world. Compare this with the estimated 320 million people currently living in the United States, and you get an idea of the immense degree of humanity pulsating within the borders of this far-off land.

The region has had permanent settlements dating back for thousands of years, including powerful dynasties that ruled vast parts of South Asia. In the sixteenth century, European nations began the process of colonial expansion throughout the region. By the nineteenth century the entire subcontinent was under British control. Through a massive, nonviolent revolution, India gained indepen-dence from Great Britain in 1947 and is now the largest democracy (by population) in the world. The areas that are now Pakistan and Bangladesh were, at that time, part of the British Indian Empire and were also given independence in 1947. The empire was divided into two separate countries, with the partitions based largely upon religious divisions. The Muslim north became Pakistan (the creation of Bangladesh is discussed below), and the Hindu South became India. Unfortunately, a disagreement about ownership of a small border region called Kashmir developed almost immediately, and this has led to continued hostilities (four wars and a lot of nuclear weapons pointed at each other) between the two countries since the achieving of their independence.

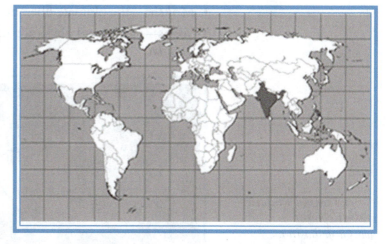

World Atlas with India highlighted
Source: © 2009 Shutterstock, Inc.

Pakistan is roughly twice the size of California with a population of over 182 million (6th most populous nation in the world). Bangladesh, which gained independence from Pakistan in 1971, is slightly smaller than Iowa and has a population of 156 million (8th most populous nation in the world). The two countries together are smaller than the region made up of California, Arizona and Nevada, but have a combined population of 338 million. That's almost 30 million more people than live in the entire United States.[34]

As the census count below indicates, the dominant religion in India today remains Hinduism.[35]

Religious Composition	Population*	(%)
Hindus	827,578,868	80.5
Muslims	138,188,240	13.4
Christians	24,080,016	2.3
Sikhs	19,215,730	1.9
Buddhists	7,955,207	0.8
Other Religions & Persuasions	11,592,67	1.1
Total *	1,028,610,328	100.0

Figures from The Census of India, Office of the Registrar

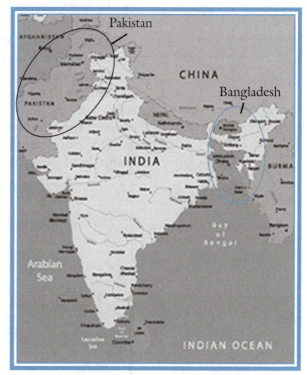

Regional picture of India, Pakistan and Bangladesh.
Source: © 2009 Shutterstock, Inc.

Because **Hinduism** encompasses so many vastly differing traditions and beliefs, it is difficult to give a brief definition. The best we can do is look at a few of the prominent themes central to Hindu beliefs, which include the items listed below.[36]

- **Dharma**—an adherence to ethics, and one's duties.

- **Karma**—understanding cause and effect, with an emphasis on morality.

- **Samsāra**—the continuing cycle of birth, life, death, and rebirth (reincarnation).

Hinduism

- **Moksha**—the ultimate liberation from *Samsāra* and union with Brahman.
- **Yogas**—mental and physical paths or practices that can aid in attaining *Moksha.*

A stone carved sculpture of the elephant god Ganesha in a Khajuraho temple, Madhya Pradesh, India.
Source:
© Shutterstock, Inc.

Present-day India is divided into twenty-eight states and seven union territories. Culturally, there is a North/South divide between these states that is often defined by linguistic families. The four Southern states have language groups based upon the **Dravidian** language family, while the Northern states use Indo-Aryan based languages, also referred to as **Hindustani.** It is believed that the Dravidian-speaking people represent the original inhabitants of the entire region and that they were driven south by the Indo-Aryan invaders.[37] Cultural elements from the South are generally referred to as **Carnatic,** while those from the North are referred to as Hindustani. *Sangeet* is a *Sanskrit* (one of India's many official languages) word associated with music; and so by extension, **Carnatic Sangeet** refers to music from the Dravidian Southern Culture, whereas **Hindustani Sangeet** refers to the Northern Indo-Aryan Culture.

Our examination of the music of India will explore the classical traditions of South India (Carnatic Sangeet) before briefly moving on to the eclectic popular music of Northern India's massive film industry known as Bollywood. India's classical music, both Carnatic and Hindustani, is governed by three principal musical elements: *raga,* which governs the melodic elements; *tala,* which governs the rhythmic elements; and *sruti,* which marks the tonal center as a drone.

So what is a *raga*? The principals behind Hindustani and Carnatic ragas are similar, but between the two traditions there is very little overlap of the actual ragas themselves. A *raga* dictates rules with which melodies can be composed, and, in this way, is similar to modes in Western culture; but a raga is much more

raga

tala

sruti

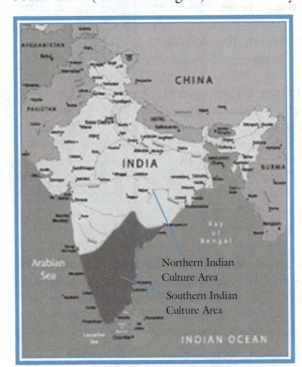

Map of India, showing Hindustani and Carnatic divisions.
Source: © 2009 Shutterstock, Inc.

Northern Indian Culture Area

Southern Indian Culture Area

than a mode or scale. Raga is defined by Indian music scholar David B. Reck as follows:

> The ancient texts define a raga as being "that which colors the mind." In fact, in Sanskrit the primary meaning of the word raga is "coloring, dyeing, tinge-ing." This connection with generating feelings and emotions in human beings, "coloring the mind," is important . . . A raga is in some ways a kind of mystical expressive force with a musical personality all its own. This "musical personality" is, in part, technical—a collection of notes, scale, intonations, ornaments, charac-teristic melodic phrases, and so on. Each raga has its rules and moves, something like the game of chess. While some of the facts about ragas can be verbalized and written down, a musician does not memorize a raga from a book. (Ragas are too elusive for that!) Rather, one gets to know a raga gradually—by contact with it, hearing it performed by others, performing it oneself—almost as one gets to know a friend by his or her face, clothes style, voice and personality.
>
> Traditionally, ragas are said to have "musical-psychological resemblances." A particular raga may be associated with certain human emotions, (actual) colors, various Hindu deities, a season of the year, a time of day, or with certain magical properties.[38]

Focus on Form
Raga, Tala, and Sruti

Without getting too technical, here are a few more theoretical concepts that will help you understand Carnatic ragas. A generation of scales known as the **melekarta system** creates a group of 72 possible scales. Each of the *melekarta scales* are comprised of seven notes that are the same ascending and descending. Each of the seven notes, or **swaras** (*svaras*), are labeled in a manner similar to Western solfege (do, re, mi, fa, sol, la, ti, do = sa, ri, ga, ma, pa, da, ni, sa). While the relationship of notes to one another is fixed, the actual pitch is not. Unlike Western classical compositions, Indian works (and ragas) will be centered on a pitch determined by the performer.

The 72 melekarta scales are the parent scales used to form melekarta ragas, but, again, ragas are more than a collection of notes. To form a raga, we must add **gamakas** (ornamentations, which can be slides, bends, oscillations, etc . . .). Then, there is special intonation that is unique to each particular raga. (The *Carnatic* tradition has 22 divisions within the octave; as you learned at the beginning of the book, in Western culture we divide the octave into twelve equal parts). Depending on the raga, certain swaras will be emphasized, whereas others will be almost ignored. Each raga will con-tain characteristic turns and phrases that will be repeated over and over, and in this way a raga is given its personality.

As there are 72 melekarta scales, there are also a total of 72 melekarta ragas, each having a unique individuality beyond the notes used to make it up. Each part of the musical personality of a raga is made up of a collec-tion of characteristic phrases, as recognizable as the face or speaking habits of a person. Some ragas are complicated and deep (with many phrase possibilities), while others are simple and straightforward (with fewer phrase possibilities).[39]

melekarta systm

swaras

gamakas

Without getting much more technical, let's look at one other type of raga, the **janya ragas.** These derived ragas use the melekarta system but have such variants as:

- Using different notes ascending and descending
- Omitting notes (seven up and five down, etc. . . .)
- Zigzagging melodic movement (ascending, descending or both)
- The addition of visiting notes (a note that does not belong to the parent scale from which it is derived)

There are around thirty thousand *janya ragas,* so to those of you who are musicians, try not to complain about practicing your twelve major scales.

The word **tala** is used in Indian music primarily to discuss rhythmic cycles. *Tala* is similar to meter in Western culture, but it alternates stressed pulses between uneven groupings of beats, much more frequently than done in the West. Once the tala has been established, it will stay the same for the remainder of the composition. (This does not mean that tempos won't change, or that a casual listener will not be completely befuddled by the mathematical, rhythmic virtuosity of a skilled musician; however, rest assured the tala is the same). While there are different theoretical systems in the Carnatic tradition that list numerous *tals,* (one system lists 120 different groupings, while another lists 35, etc. . . .), only a handful are actually used. Below is a list of commonly used tals along with their common subdivisions:

Ata tala: 5+5+2+2 = 14 beats

Rupaka tala: 1+2 = 3 beats

Chapu Tala: 2+3= 5 beats

Triputa Tala: 3+2+2= 7 beats

Adi Tala: 4+2+2= 8 beats[40]

In the Carnatic tradition, it is common to keep track of the tala by using a clap (strong beat), wave (hand is turned palm up), or touching specific fingers for weaker beats. Adi tala for instance would be:

clap, finger, finger, finger, **clap,** wave, **clap,** wave.
 1, 2, 3, 4, 1, 2, 1, 2

In fact, if you go to a concert of South Indian music it is common to see much of the audience keeping track of the tala in this manner.

The other musical element central to this tradition is the **sruti,** or drone. The drone is of central importance to the classical Indian tradition and is always present. In Carnatic music the drone is generally the tonal center (sa) and the fifth (ga). While the ever present drone has an instrument devoted solely to its presentation, it is also supported through the tuning of the rhythm instruments (mridangam—discussed on p. 417), as well as additional drone strings upon some principal melody instruments (i.e., veena—discussed on p. 417). The importance of the drone is eloquently described by David B. Reck as he states, "Unobtrusive, calm, quiet, static, the drone is like the earth from which the melodies of the musicians fly, from which they start and to which they return. It is like a blank movie screen on which images, actions and colors are projected; the screen in essence does nothing, but without it the movie would be lost, projecting into nothingness."[41]

Before we listen to an actual composition and talk about how it is structured, let's talk about a few of the instruments commonly used within this tradition. In the classical tradition, some of the most commonly used Hindustani instruments are the *sitar, sarod,* and *tambura* (chordophones), *tabla* (membranophone), and *bansuri* (aerophone). While in the Carnatic classical tradition, commonly used instruments include the *veena* and *tambura* (chordophones), *mridangam* and *kanjira* (membranophones), and the *venu* (aerophone).

A sitar.
Source:
© Shutterstock, Inc.

The veena and the sitar look similar. Both have strings that are played upon, as well as drone strings (strings that pick up sympathetic vibrations but are not physically played). The body of a sitar is made from a gourd, while the body of a veena is made from ribbed wood.

In Western culture, the sitar is probably the best known Indian musical instrument due in large part to the efforts of the world renowned Ravi Shankar, and his student, George Harrison. Both the sitar and veena are used primarily as melodic instruments.

A veena.
Source:
Jupiterimages,
Corp.

The bansuri and venu are both side-blown (transverse) flutes, made of bamboo. Traditionally the venu has more finger holes than the bansuri, but this distinction is not a given.

The mridangam is the principal rhythmic instrument of the South, while tabla are used in the North. Tabla consist of a pair of single-headed, tuned drums of different sizes, while a mridangam is a single drum that is double headed (both heads are different sizes), and is also tuned. Tabla and mridangam are both capable of a wide range of musical inflections. Mnemonic devices known as *bols* are used to aid in the teaching and performance of these instruments. For a more detailed examination of bols, tabla and Hindustani tala, listen to the Folkways Records recording, *42 Lessons for Tabla,* (FW08369), and be sure to download the liner notes.

A bansuri.
Source: © 2009
Shutterstock, Inc.

The tambura is a string instrument that comes in different shapes and sizes. It typically has four strings, but may have more, and is used as a drone instrument. Sruti boxes and harmoniums are bellows-driven instruments that are also used frequently to produce a drone. There are also electronic boxes that create a drone synthetically.

A pair of tabla from India.
Source: © 2009
Shutterstock, Inc.

To get to know this music, you must listen to it. There are numerous recordings of Carnatic Sangeet, as well as thousands of YouTube clips available for your listening and viewing pleasure. In keeping with our established format of using the Smithsonian Folkways collection, I recommend listening to *Ragas from South India* (FW08854). It is an excellent example of the style we have been discussing and features compositions that are both sung as well as performed instrumentally. The liner notes give information about each of the compositions along with English translations for the texts of the kritis.

Sketch of a Mridangham.
Source: Jupiterimages,
Corp.

Focus on Form
Carnatic Sangeet

Indian classical compositions, both Carnatic and Hindustani, are based upon improvised structures set against pre-composed pieces. In the South, the pre-composed portion of a composition is a song. The song may be sung or performed instrumentally. It would be expected that the audience would recognize and know the words to the piece if played by an instrument. There are several different song forms used in this tradition, with the most common being the **kriti.** This form of song is almost always religious in nature and has three central parts:[42]

1. **Pallavi**—the opening section, which functions like a refrain. The name of the kriti is derived from the first few words of the pallavi. The words and melody are both important throughout the composition. The section typically lasts for one cycle of the tala.

2. **Anupallavi**—a contrasting section that typically builds into a return of the pallavi. This section may be omitted.

3. **Charanum**—The third section, which is typically more relaxed in nature. This section can be repeated or alternated with returns of the pallavi. It almost always concludes with a final return to the pallavi.

Unlike many other improvised forms around the world, which sandwich improvisational form(s) between pre-composed material, the Indian traditions do the opposite. In India, the pre-composed material is sandwiched between improvised material. Improvisational structures occurring at the front-end of a performance include:

Alapana—a section that introduces the *raga* to be used for the piece in a free flowing manner. No sense of pulse exists in the alapana, and the tala will not be established until later in the composition. The alapana is typically divided into three parts that build in virtuosic representations of the raga.

Tanam—This section is frequently omitted, but, when present, it begins to explore the raga through an added sense of pulse. The tala cycle is not established here, but a basic beat can be felt. The *mridangam* often enters during this section to aid in the establishment of pulse.

Improvisational structures after the **kriti** include:

Niraval—a series of virtuosic variations on a single phrase from the *kriti.* This is often a highlight of the performance and is played over the continual recurrence of the *tala* cycle.

Swara Kalpana—an improvisational form that focuses on the individual swaras. If sung, this section would use the swara syllables (sa, ri, etc. . .) as opposed to text. This section can become extremely complex and unfold asymmetrically over the *tala* cycle. Mathematical calculations always allow the asymmetrical phrase to eventually coincide with the beginning of the tala (e.g., if the tala is sixteen beats, and the melodic phrase is five beats, the melodic phrase would have to be repeated sixteen times before lining up with the downbeat of the tala—and this is an easy one!).

> *Tani Avatanam*—a rhythmic, technical, mathematical, virtuosic drum solo (throw out your association of long drum solos with Iron Butterfly's, *Innagaddadivida*; these solos are actually cool and interesting).
>
> A Carnatic Sangeet performance can last from twenty minutes to several hours and follows a structure similar to the one below:
>
> *Alapana* (improvised no *tala*)
>
> *Tanam* (improvised, pulse but no *tala*)
>
> *Kriti* (composed, *tala begins*)
>
> *Niraval* (improvisation over *tala*)
>
> *Swara Kalpana* (improvisation over *tala*)
>
> *Tani Avatanam* (improvisation over *tala*)
>
> Possible brief restatement of a portion of the *Kriti*

Before leaving India, let's take a quick look at a completely different genre, *filmi music.* As can be deduced from the genre's title, *filmi* music is related to the massive Hindustani film industry. Originated in the city of Bombay (now Mumbai), the upstart industry was christened **Bollywood,** a blending of the names Hollywood and Bombay. The eclectic mix of music composed for these movies is incredibly popular throughout the entire subcontinent. *The Rough Guide to World Music* refers to it as the "soundtrack to a billion lives."[43] The best way to describe filmi music is, well . . . indescribable. It is an eclectic mix of Indian genres and styles that have mingled with Western jazz, rock, hip-hop, among others, and has ended up with something original and ever-changing. You are on your own for the rest of this part of the tour, but I would suggest checking out *The Bollywood Box set: Beginners Guide To Bollywood* (B000YHO3FM) on the Saragama label. There are also thousands of clips on YouTube. Have fun.

DIG DEEPER

- www.carnaticindia.com is a site dedicated to Carnatic music and is an excellent beginning point for your research.
- www.ravishankar.org is an excellent website maintained by the Ravi Shankar foundation. It contains a solid introduction to Hindustani music, as well as numerous interviews with master musician Ravi Shankar.
- musicinfoguide.blogspot.com contains an in-depth look at the Carnatic music tradition. It also contains an interesting look at various ragas.
- chandrakantha.com contains a nice introduction to Carnatic and Hindustani musical styles, as well as a chronological listing of Bollywood videos from the 1930s on. It includes some great YouTube links as well.

World Atlas with sub-Saharan Africa highlighted.
Source: © 2009 Shutterstock, Inc.

Africa (Sub-Saharan)

With an area of about 11.7 million square miles, Africa is the second largest continent on the planet. Its population of over a billion people also makes it the second most inhabited continent. Africa currently contains 53 nations, many of whose borders were created during the era of European colonialism. Within these artificial boarders lie thousands of distinct ethnic groups, each with unique languages and customs. Unfortunately, often these diverse groups of people have been traditional adversaries and are forced to share resources as they become fellow countrymen. This has led to great political instability and violence on the continent. Tragically, the region where most anthropologists trace the origins of the human species has often struggled to treat its inhabitants in a humane manner. For much of the continent, the twentieth century was marked with war, famine, oppression, and disease. Despite these and numerous other problems, the resilience of the African people has continued to shine through, and one can only hope that this resilience of spirit will spawn a new era of peace and prosperity for the twenty-first century.

There are numerous ways we could begin our exploration of Africa's music-cultures, but let's start by dividing the continent into two large areas. The vast Saharan Desert creates a natural, North-South division; the area north of the desert is referred to as the *Maghrib,* while the area south of the desert is referred to as sub-Saharan Africa. The photo to the left, taken by NASA, gives you a pretty clear idea of where this line runs.

North and South division of Africa as seen from space.
Source: http://earthobservatory.nasa.gov

Because of the massive natural land barrier, the two regions have developed in distinct ways. For now, our examination will focus on **sub-Saharan Africa.** We will return to North Africa as we observe music-cultures from the Middle East, in the following section of this chapter.

In an attempt to find shared music-culture characteristics throughout sub-Saharan Africa, let's examine the work of esteemed ethnomusicologist, David Locke. Professor Locke, who has traveled and studied extensively in Africa, asserts that there are several key elements that unite the entire region. He begins with the *when, where* and *why* of African music.

Often, Africans conceive of music as a necessary and normal part of life. Neither exalted nor denigrated as Art, music fuses with other life processes . . .

African music often happens in social situations where people's primary goals are not artistic. Instead, music is for ceremonies (life cycle rituals, festivals), work, (subsistence, child care, domestic chores, wage labor), or play (games, parties, lovemaking). Music-making contributes to an event's success by focusing attention, communicating information, encouraging social solidarity, and transforming consciousness . . .

Just as Africans set music in a social context, they associate it with other expressive media (drama, dance, poetry, costuming, sculpture) . . . Although music-making usually is not the exclusive purpose of an event, people do value its aesthetic qualities.[44]

There are also a number of specific stylistic traits common to the music. These common elements are discussed in depth in the following *Focus on Form.*

Focus on Form
Common Stylistic Elements[45]

- Intensive use of polyrhythm—**polyrhythm** consists of playing two different metrical groupings together over the same period of time. A prominent polyrhythm in sub-Saharan music is three over two—an even duple sub-division played over an even triple sub-division. To experience a polyrhythm repeat the following statement over and over; "I'm Bud-dy Rich, I'm Bud-dy Rich . . ." As you say this clap on the syllables "I'm" and "dy," this is the duple sub-division. Now clap on "I'm," "Bud," "Rich;" this is the triple sub-division. Now, get with a partner and while reciting the phrase together, one of you clap the first pattern while the other claps the second. You are a clapping a three-over-two polyrhythm.
- Improvisation—while not always appropriate, the insertion of individual elements of improvisation is frequent. The music is not improvised but often contains room for embellishment upon fixed patterns.
- Repetition—can be of small rhythmic/melodic units or of large phrase structures.
- **Resultant Patterns**—rhythmic and/or melodic patterns that emerge in a piece of music and are a synthesis of two or more separate musical lines. Resultant Patterns are usually dependent upon a high degree of repetition.
- **Call and Response**—a form that consists of a leader, singing or playing a musical phrase that is answered by a group response. This form can be used as a rhythmic or melodic device (or a combination of the two) and can be vocal or instrumental.
- A reliance on pentatonic or diatonic scales.
- Participation—In most cases, those who are present will contribute to the music-making event in some way; whether it be rhythmically clapping, singing, stomping, dancing, etc. . . . These actions would be frowned upon or even forbidden at a classical music concert in Western culture but are expected and valued in African music.

Throughout sub-Saharan Africa, there are numerous examples of instruments from all four of the Sachs-Hornbostel categories for the classification of instruments. While African music is often deservedly associated with drums (membranophones) and drumming, it is important to realize that this does not diminish the use of other types of instruments.

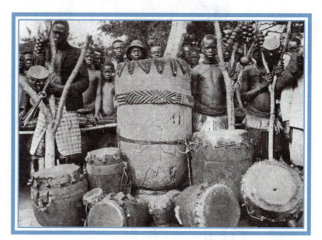

Various drums of West Africa.
Source: Jupiterimages, Corp.

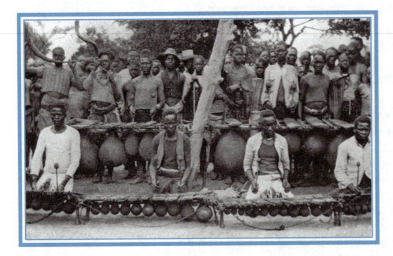

Baliphones from West Africa.
Source: Jupiterimages, Corp.

Idiophones frequently used include bells, double bells, rattles, gongs, xylophones, log drums, and the mbira (often mistakenly referred to as thumb piano).

Commonly used aerophones include various types of flutes, trumpets, reed instruments, panpipes, and bullroarers.

Chordophones of all types are found (lutes, harps, zithers, and lyres).

The human voice, used in many different ways, is also ubiquitous to music of the entire region.

Going from the macro to the micro, we begin our sub-Saharan explorations in

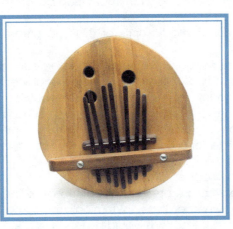

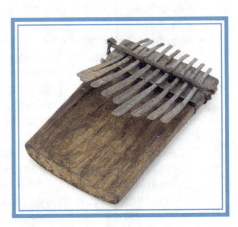

Differing types of mbiras.
Source: © Shutterstock, Inc. **Source:** © Shutterstock.com

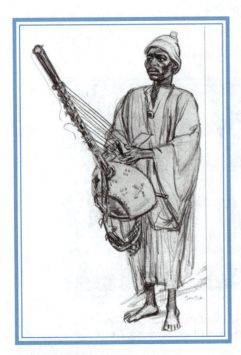

Sketch of man playing a kora.
Source: Jupiterimages, Corp.

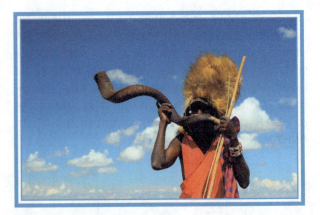

Masai warrior of Kenya playing traditional horn.
Source: © Shutterstock, Inc.

Zimbabwe, a nation that lies in the southern part of the continent.

Zimbabwe is a relatively small country, with an area of 158,000 square miles (an area slightly larger than the state of Georgia), and an estimated population of 14.5 million people. Our examination will focus on the *mbira* traditions of the Shona people. The **mbira,** often condescendingly referred to as a thumb-piano (a term imposed by simplistic European views), is truly a pan-African instrument. It goes by many names throughout the continent such as *likembe, sanza,* and *kalimba,* to name but a few. The instrument is classified as a plucked idiophone. While it comes in many different shapes and sizes across the continent, certain elements remain consistent. In general, the instrument will consist of a piece of wood (hollow or solid), to which are attached different sized keys, or tongues. The tongues are usually made of metal, but wood is sometimes used. If the soundboard is solid, the instrument will be placed in a large gourd, which acts as a resonator.[46]

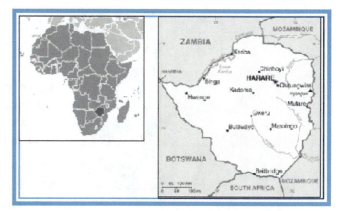

Location of Zimbawe in Africa—map of Zimbabwe. **Source:** cia.gov

While the Shona people have several distinct types of mbiras, we will focus on the *mbira dzavadzimu.*

The instrument contains between twenty-two and twenty-eight keys, which are tuned to a seven-note scale. Within Zimbabwe, the tuning of the instruments varies radically from region to region, as well as from instrument maker to instrument maker. Traditionally, the instrument was played at a ceremony known as a ***bira,*** which is a trance-inducing, spirit possession ceremony. Shona religious dogma centers on a belief that death is a passage to a higher world of living spirits. Ancestral spirits look over and protect the living and can be contacted, through a spirit medium, for guidance and protection. The contact is achieved through the all-night bira ceremony, and of primary importance to the ceremony is the mbira. During the ceremony, the performers will choose from a vast repertoire of music that is designed to call and attract the ancestral spirit of choice.[47]

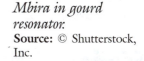

Mbira in gourd resonator. **Source:** © Shutterstock, Inc.

Mbira music generally consists of two separate parts; a *kushaura* (lead part), and the ***kutsinhira*** (the accompanying part). The music will also usually include singing, which occurs in a wide variety of styles; as well as the ***hosho,*** a very loud gourd shaker (think of a maraca on steroids). The music is commonly built upon a forty-eight beat melodic pattern that emphasizes the three-over-two polyrhythm so prevalent on the continent. The two separate parts, kushaura and kutsinhira, frequently play very closely related patterns separated by beat placement. By starting similar melodic patterns on different beats, resultant patterns occur. The music is highly repetitive, with patterns

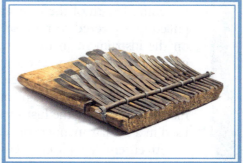

Mbira Dzavadzimu. **Source:** © Shutterstock, Inc.

gradually changing over a long expanse of time. Those present at the bira ceremony participate through a variety of clapping and stomping patterns, various vocal insertions, as well as dancing. Glancing back at the sub-Saharan stylistic characteristics discussed previously, you can see that a majority of the elements are present in this music.

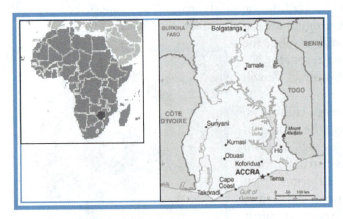

Location of Zimbawe in Africa—map of Zimbabwe.
Source: cia.gov

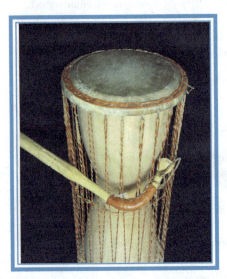

Medium sized lunga drum.
Source: Provided by co-Author

Next we will explore the music-culture of Ghana's *Dagomba* people. With an area of roughly 93 thousand square miles, **Ghana** is slightly smaller than the state of Oregon. Ghana was the first republic in sub-Saharan Africa to achieve its independence from colonial Europe, and it has been one of the most stable countries in the region. This stability comes despite the fact that *Ethnologue,* the encyclopedia for languages of the world, lists Ghana as having 79 living languages among its 28 million residents.[48]

The Dagomba people live in the northern portion of Ghana, and they speak a language that is described as tonal. Many languages around the world are considered tonal, which indicates that word meanings are changed by inflection and pitch level. A set of syllables said together with a rising inflection could mean one thing, while the same syllables strung together with a falling inflection could mean something entirely different. This is an important fact as we look at, and listen to, the music of the Dagomba.

One of the principal instruments used by the Dagomba is called a *lunga drum.* The hourglass-shaped drum is double-headed and has a long string woven through the drum heads. The string runs up and down the entire length of the instrument (see picture to the left). The string is pulled or squeezed to raise or lower the pitch of the drum. Performing on the instrument in this way, Dagomba musicians have the ability to mimic their language. The Dagomba drummers are not only musicians, they are the historians of their people. Through a series of recognizable patterns, which are "spoken" on the drums, the musicians string together metaphors that tell the history of the Dagomba. The instruments are also used in a similar manner for religious celebrations.[49]

An ensemble typically consists of several lunga drums accompanied by a *gun-gon* and a vocalist. The gun-gon is a large, double-headed, cylindrical drum, of fixed pitch; with snares that vibrate on both heads. The music is often organized in a call and response manner; with the vocalist and lead lunga drummer giving calls, which are answered with musical responses by the gun-gon (discussion following), and the accompanying lunga drums.[50]

DIG DEEPER

- An example of Dagomba drumming can be heard on the Folkways recording *Traditional Dances and Drumming of Ghana* (fw 8858).

- sites.tufts.edu/dagomba This site contains detailed breakdowns of the music complete with audio tracks and transcriptions of the music.

Though the music of the Dagomba sounds radically different than the music of the Shona, once again we find that the common characteristics of polyrhythm, repetition, resultant patterns, improvisation, and group participation, as well as call and response patterns, all find their way into this music. As time permits no further examination into traditional sub-Saharan music, I will recommend the Folkways recording *Africa, South of the Sahara* (FW04503) be used for further exploration. The recording is outstanding in its scope, containing 38 tracks from throughout the region. The 14 pages of liner notes offer both a general introduction to sub-Saharan music as well as detailed information on each track. In addition, there are numerous sites on the web that can aid you in further exploration.

Before heading north, however, we are going to briefly look at contemporary culture. Contemporary popular music in Africa is often referred to as *Afropop*. There are a dizzying number of genres that fall under this heading. Because of continual cross-fertilization within genres, labels sometimes become difficult and really go beyond the scope of this book. For more information on the subject, the radio program *Afropop Worldwide* and its website www.afropop.org make an excellent point of departure.

Afropop Worldwide was launched as a weekly radio series in 1988 by National Public Radio. The program was (and is) dedicated to popular music on the African continent, as well as the African Diaspora (a term that refers to the movement of Africans and their culture away from the African continent). The term is particularly applied to the descendents of Africans who were enslaved and shipped to the Americas. The weekly radio program features a mosaic of ever-changing genres. If your local N.P.R. station doesn't carry the program, the website offers podcasts as well as a number of streamed programs. The website is excellent in design and allows anyone to begin their own exploration of the field. You can do a search by country, region, artist, or style. Here are a few topics to help you get started.

- E. T. Mensah and his impact on Ghanaian *Highlife*.

- King Sunny Ade and the development of Nigerian *JuJu*.

- Fela and Femi Kuti and their development of the big band genre known as *Afrobeat*.

- Thomas Mapfumo and his mbira-derived *Chimurenga* music from Zimbabwe. Having listened to mbira music earlier in this section, listen for how the guitar mimics the sound of the traditional *dzavadzimu*.

- Dance music from the Congo—*Rumba, Soukous, Kwassa Kwassa*—call it what you want, but do some research on this and you will see what I mean about cross-fertilization.

- Ali Farka Touré, who reminds us that the Western genre known as the blues came from Africa.

- Ladysmith Black Mambazo and their harmonized vocal music known as *isicathamiya*.

- Balla Tounkara and his amazing use of the *kora*.

- Cesária Évora and her *morna* songs from the Cape Verdi islands.

These are just a few artists and genres to get you started. Find out what you like on the Afropop site, and then do some exploring on YouTube, emusic, or iTunes.

The Middle East

The Middle East is an area that has no clear boundaries. Lying at the juncture of Africa and Asia, the region is considered the birthplace of three major world religions; Islam, Christianity, and Judaism. This vast area contains a number of distinct cultural groups. As a representative of the region's music, we will examine the traditions of classical Arabic music. While taking on many regional idiosyncrasies, the fundamentals underlying this music are prevalent across a vast region that stretches across North Africa and through the Arabian Peninsula.

The predominant religion of the area is **Islam,** the basic tenets of which are taught through a central text known as the *Qur'ân* (*The Recitation*).[51] Islamic tradition holds that the Prophet Muhammad was given the information (the *Qur'ân*) by the angel Gabriel and that the revelations were transmitted to his followers orally. It was only after Muhammad's death that this oral tradition was written down.

The Middle East musical influence also covers portions of North and East Africa.
Source: © 2009 Shutterstock, Inc.

While the *Qur'ân* now exists as a book, the importance of the recitation is still as vital today as it was at the founding of the religion. In the dissemination of the religion, care was taken to preserve the characteristic sounds and cadences of the *Qur'ân*.[52] Regarding current Muslim practices of the recitation of portions of this work, Kristina Nelson Davies states:

The recited *Qur'ân* is one of the most characteristic sounds of everyday life in the Muslim world. It plays a central role in such expressly religious contexts as collective prayer, the ceremonies accompanying the signing of a marriage contract, funerals, wakes and memorial services. On many such occasions, the sound is projected by a loudspeaker into the surrounding streets. Most radio and television stations open and close their daily broadcasts with recitations from the *Qur'ân,* and many feature, as part of their regular programming, memorial services and highlights of recitations from their archives. A recitation may also be heard at the start of almost any enterprise for which God's blessing is sought, be it the opening of a shop or an office, a political summit conference, an academic conference, or even a concert of secular music. The sound of the recited *Qur'ân* may also be heard in a number of informal contexts, as on a bus, in a taxi, in a market, or at a house where friends have gathered to listen to recordings of their favorite reciters.[53]

While there is fierce debate among Islamic scholars, many maintain that correct recitation of the *Qur'ân* involves musically elaborate formulas.[54]

With the religious importance placed upon recitation of the *Qur'ân,* it is not surprising that poetry, spoken or sung, is considered to be the highest of all art forms in the Arab world.[55] While there is a strong vocal tradition, it is not practiced to the exclusion of instrumental works. Throughout the Middle East, there are numerous examples of instruments from all four of the Sachs-Hornbostel categories for the classification of instruments. Common instruments include the following:

- Chordophones—**oud** (a prototype of the European lute) and *rababah,* a spike fiddle

- Aerophones—*nây* (an end-blown flute), *mizmar,* and *mijwiz* (both double reed instruments).

- Membranophones—**duffs, darbukkahs, and riqqs.**

- Idiophones—**zil** (finger cymbals, see picture on p. 403)

An oud.
Source: © Shutterstock, Inc.

An Egyptian mizmar.
Source: © 2009
Shutterstock, Inc.

A riq.
Source: © Shutterstock, Inc.

A Dumbek.
Source: © Shutterstock, Inc.

Maqam

Traditionally, Arabic music has put an emphasis on the elements of melody and rhythm. Melodic modes are determined by a system called **maqam,** which in many ways is reminiscent of the Indian raga. **Maqamat** (plural of maqam) typically divide the octave into eight parts. This division, however, is not built on even divisions of the octave. Like ragas, some maquamat contain notes that would not exist on a Western instrument of fixed pitch. In other words, some of the notes of a particular maqamat would lie in between the half-step divisions available on an equal-tempered piano. Moreover, some maqamat actually skip the note lying an octave higher than the beginning pitch altogether, thus ending on a different note. These particular maqamat typically contain more than eight notes. Here are a few other general defining elements of maquamat.[56]

- Specific moods and emotions are expressed by each various maqam.

- Because of regional variations, a definitive list of maqamat is difficult to generate. There are about 40 generally recognized maqam.

- Maqamat usually start on a fixed pitch, but they can usually be transposed to one or two other starting pitches (e.g., a given maqam might start on a C; it could be transposed to begin on D or E, but would not be transposed to start on any other pitch).

- Maqamat are constructed by putting together three-note (trichord), four-note (tetrachord), or five-note (pentachord) sets called *jins*. Most maqamat are made up of two jins, an upper and a lower. The jins are connected to form a maqam in several ways; they can share a common note, they can by overlapping, or they can be adjacent.

- Each maqam has rules that help define melodic development, use of notes, characteristic phrases, ornamentation and intonation.

- Each maqam includes rules that define the starting note, the ending note, and the *ghammaz* note, which is the starting note of the second jins. The *ghammaz* serves as an important gateway for modulations to various maqam.

îqâ'

The rhythmic structure of traditional Arabic music is regulated by a series of rhythmic modes called *îqâ'* (plural, *îqâ' ât*).[57] Similar to tala in Indian music, îqâ' ât rely on recurring percussion patterns to maintain their cyclic structure. While Middle Eastern membranophones (drums) are capable of creating many timbres, îqâ' ât patterns focus on two distinct sounds as a central structural device. The deepest, fully resonant tone produced on the drum is called *dumm,* while a high pitch sound created by striking the drum-head at the extreme edge of the instrument is called *takk.*[58]

Scott Marcus gives the following example of Arabic patterns in *The Garland Encyclopedia of World Music:*

The following eight-beat pattern of *dumm* strokes (D), *takk* strokes, and rests (*iss* in Arabic, noted here by a hyphen: -) is undoubtedly the most common rhythm used in Arab and Turkish music:

D T—T D—T—

In the Eastern Arab world, the rhythm above is called *maqsûm,* or *düyek* in Turkish. It is completely distinct from the following mode, called *maṣmûdî* or *baladî* in Arabic:

D D—T D—T—

Although the only difference between these modes is the placement of a dumm stroke on the second beat of the rhythm, that itself is considered a major difference in Arab or Turkish music. The presence of two initial dumm strokes creates a feel entirely different from that produced by the maqsûm rhythm (and has a different set of cultural associations).[59]

The numerous Arabic rhythmic modes are determined by the following elements:[60]

- The number of existing beats, which is typically somewhere between 2 and 88.
- The timbre of each beat that is sounded (dumm or takk).
- The interplay of sounded beats verses rests.

Ultimately, the îqâ‘ât can be thought of as rhythmic skeletons, which, while heavily ornamented, always retain their principal shape.

DIG DEEPER

The îqâ‘ ât and maqmat are the building blocks of traditional Arabic music. Whether the music is sacred or secular, instrumental or vocal, these two musical elements combine to shape a vast array of musical forms. An outstanding website that explores îqâ‘ ât, maqmat, as well as various forms found in Arabic music is *Maqam World*—www.maqamworld.com. In addition to providing written information about all of the elements discussed above, the site also offers links to sound files.

Another good Internet resource for the exploration of Arabic music is *The Oud*—www.oud.eclipse.co.uk. Once there, click on the music theory link and explore.

A nice general introduction to Arabic music and culture can be found at www.al-bab.com. This is a general web site dealing with a broad range of cultural elements, so once there start exploring.

There are numerous recordings available through the Smithsonian-Folkways label that explore various elements of the music discussed above. A few recommended recordings include:

- *A Recital of Classsic Arab Music* (fw08818)
- *Arabic songs of Lebanon and Egypt* (fwo6925)
- *When the Soul is Settled: Music of Iraq* (sfw40533)

The "Silk Road"

Heading east, our travels take us on the northern route of the legendary "Silk Road," one of a group of trade routes that crisscrossed Eurasia beginning around 200 B.C.E. and continued into the sixteenth century. This part of our journey will take us through the ancient Persian lands of Iran, across the various "Stans" of Central Asia—Stan is a Persian term that means "place of" (Afghanistan means the place of the Afghans)—and conclude in China. Because of time restrictions, this part of our trip will be taken on an express train. Sights and sounds will pass by in a flash, with no excursions or real cultural exploration. As you board the train for

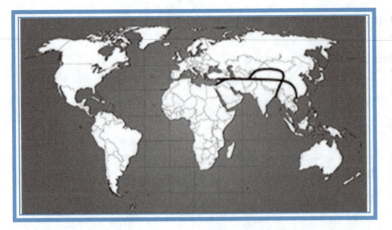

Prominent overland trade routes of the "Silk Road"
Source: © 2009 Shutterstock, Inc.

this day trip, keep in mind you are covering thousands of miles containing radically different cultures and close to a quarter of the world's population. Take what you like and dig further.

In 1998, World renowned cellist Yo-Yo Ma founded The Silk Road Project as a not-for-profit artistic, cultural, and educational organization. The homepage for the Silk Road Project, www.silkroadproject.org, is an excellent source. Once there, you can find recordings, videos, maps, history of the individual areas, and much more. As our principal means of exploration, we will use a 2002 Smithsonian-Folkways recording titled *The Silk Road: a Musical Caravan* (SFW40438), which is an offshoot of Yo-Yo-Ma's project. The recording contains 47 tracks and is accompanied by 22 pages of liner notes. We will begin our journey by looking at several pages of these liner notes.

The Silk Road

It may well have been along the Silk Road that some of the first "world music" jam sessions took place. For both Europeans and Asians, the mesmerizing sound of exotic instruments must have had an appeal not unlike the visual allure of exotic textiles, ceramics, and glass. Innovative musicians and luthiers adapted unfamiliar instruments to perform local music while simultaneously introducing non-native rhythmic patterns, scales, and performance techniques. Before the Crusades, numerous instruments from the Middle East and Central Asia had already reached Europe: lutes, viols, oboes, zithers, drums, and other percussion. Following trade routes in both directions, many of these instruments also turned up in China, Japan, India and Indonesia. For example, the Central Asian short-necked lute called *barbat* is the ancestor of the Middle Eastern *Oud* and European lute as well as the Japanese *Biwa* and Chinese *pipa*—an instrument that Chinese documents record as belonging to the "northern barbarians," which is to say, nomads. Turkic and Mongolian horsemen from Inner Asia were not only lutenists, but were probably the world's earliest fiddlers. Upright fiddles strung with horsehair strings, played with horsehair bows, and often featuring a carved horse's head at the end of the neck have an archaic history among the nomadic peoples of Inner Asia and are closely linked to shamanism and spirit worship. Such instruments may have inspired the round-bodied spike fiddles played in West Asia (*kamanche, ghijak*) and Indonesia (*rebab*) and the carved fiddles of the Subcontinent (*sorud, sarida, sarangi*). Loud oboes called *surani* in Central Asia became the *shahnai* in India, *suona* in China, and *zurna* in Anatolia.

A shanh-qobzy.
Source: © 2009 Shutterstock, Inc.

A doira.
Source:
© Shutterstock, Inc.

Central Asia in turn imported musical instruments from both East and West. For example, at the end of the 14th century, the great Islamic music theorist 'Abd al-Qadir Marâghi described the Mongolian *jatghân* (plucked zither) and European hurdy-gurdy in a work on musical instruments.

Pastoralists And Sedentary Dwellers

From this web of human connectedness two great axes emerge linking musical instruments, styles, performance practices, and repertoires with fundamentally different patterns of culture and visions of the world. The first of these axes represents the culture of nomads, and the second that of sedentary peoples.

Nomadic and sedentary peoples have coexisted in Central Asia for millennia, and their relationship has not always been an easy one. In the 13th century, for example, Ghinggis Khan's nomadic armies laid waste to Central Asia's cities, while in the 20th century, the Soviet Union, an empire built on the power of industry and agriculture, tried forcibly to sedentarize some of inner Asia's last nomads. Yet despite periods of hostility, pastoralists and sedentary dwellers have both relied on an intricate commercial and cultural symbiosis that is one of the hallmarks of Inner Asian civilization.

A dombra.
Source: Jupiterimages, Corp.

In Nomadic cultures, the preeminent musical figure is a bard: a solo performer of oral poetry who typically accompanies himself or herself . . . on a strummed lute with silk or gut strings (certain epics, most notably the Krgyz *Manas*, are traditionally chanted *a capella*). Nomadic cultures have also produced virtuosic instrumental repertories performed by soloists on strummed lutes, Jew's harps, flutes, fiddles, and zithers. The distinguishing features of these repertories is their narrative quality: pieces typically tell stories by using a kind of onomatopoeia, for example, the pounding of horse's hooves or the singing of birds, all represented through musical sound. Individual innovation is highly valued, and bards are performance artists who combine music with gesture, humor, and spontaneous improvisation to entertain their audience. One of the most intriguing aspects of nomadic music is rhythm, which tends toward asymmetry and is never expressed on percussion instruments (with the exception of the ritual drum used by shamens). Such rhythmic asymmetry may be an abstract representation of the natural rhythms of wind and flowing water, the shifting gait of a horse as it adjusts its pace to changes in terrain, or the loping of a camel—all central to the nomadic sound world.

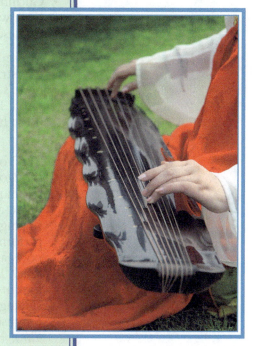

A woman playing guchin.
Source: © 2009 Shutterstock, Inc.

In sedentary cultures, by contrast, the metrical drumming is a highly developed art. Reflecting perhaps the deep impact of Islam as a spiritual and cultural force among Central Asia's sedentary populations (in contrast to its relatively limited impact among nomads), the central artifact of musical performance is the elaboration and embellishment of mixed words and texts by a beautiful voice. Singers are typically accompanied by small ensembles of mixed instruments that almost always include percussion. The beauty of the voice may also be represented symbolically by a solo instrument such as a plucked lute, violin, or flute, which reproduces the filigree embellishments and ornamentation characteristic of a great singer. [61]

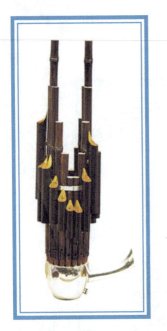

A Chineese sheng.
Source: © 2009
Shutterstock, Inc.

Among the instruments heard on our trip are those listed below. Tracks from *The Silk Road: a Musical Caravan* featuring each of these instruments are listed in parentheses.

- Balaban or Duduk—a double reed wind instrument of the Turkik speaking people (CD 1—Track 4, CD 2 Track—14).

- Rubab—a fretless lute used in Afghanistan and Tajikistan (CD 2—Track 18).

- Chatkhan—a plucked zither from Mogolia (CD 1—Track 14, CD 2—Track 2).

- Daf—a small frame drum with jingles from Azerbaijan (CD 1—Track 7).

- Dambura—a two-stringed lute use in Afghanistan and Tajikistan (CD 2—Track 13).

- Kamanche—a spike fiddle, with 3 or 4 metal strings, used in Iranian popular and classical music. Spike fiddles are found in various designs from North Africa throughout Asia. They are typically bowed instruments and have a spike coming out of the body, so they can be rested on the ground. Other spike fiddles of the area include the Ghijak of the Uzbeks, Tajiks, Turkmans, and Qaraqalpaks, as well as the Rebab of the Afghans (CD 1—Track 5).

- Guchin (Guqin)—a long, shallow wooden zither of the Chinese (CD 1—Track 13).

- Morin Khuur—a Mongolian two-stringed fiddle with a horse's head carved into the scroll. It is often referred to as a horse head fiddle (CD 1—Track 16).

- The Vocal traditions from Mongolia and Tuva include a technique known around the world as multiphonic "throat singing." It involves one performer singing multiple notes at the same time (CD 1—Track 18). For a more detailed look at the Tuvan "throat singing" tradition, listen to the Smithsonian-Folkways recording *Tuva: Voices from the Center of Asia* (SFW40017).

- Nay—An end blown reed flute found throughout Asia. There are variations of this instrument that are side blown as well (CD 1—Track 9).

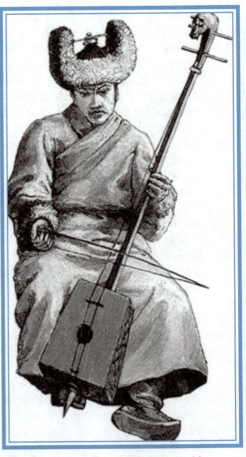

A Tuvan man playing the morin khuur.
Source: Jupiterimages, Inc.

- Pipa—a Chinese lute. (CD 1—Track 12).

- Santur—a struck zither from Iran, typically containing 18 strings (CD 1—Track 20).

- Shakuhachi—Japanese endblown flute (CD 1—Track 10).

- Shanh-qobzy—a metal jew's harp. Found primarily among the nomadic people of Central Asia (CD 2—Track 1).

- Sheng—A free blown Chinese mouth organ (CD 1—Track 24).

The liner notes for *The Silk Road: a Musical Caravan* will take you through diverse cultures steeped in the traditions of antiquity, and the recordings bring these traditions to life. Should you wish to examine specific cultures in more detail, there are numerous other recordings, videos, and websites available.

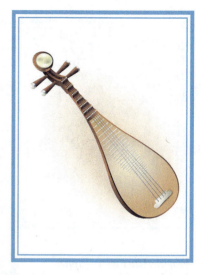

A Pipa.
Source: © Shutterstock.com

DIG DEEPER

As mentioned above, an excellent point of departure is *The Silk Road Project* website, www.silkroadproject.org. Other great websites for the exploration of this music include:

- www.face-music.ch—a bit difficult to navigate, but this site contains great information regarding a number of the areas discussed along the "silk road".

- www.dejkam.com—focuses on the music of Iran and includes pictures and sound clips for a number of the instruments discussed on page 432

- www.fotuva.org—links to a number of sites focusing on the music of Tuva and related areas.

- www.paulnoll.com/China/Music—contains an overview of traditional Chinese music.

Japan

At the eastern extreme of Asia is the island nation of Japan. Consisting of over 3,000 islands, the nation covers an area of roughly 146,000 square miles (slightly smaller than the state of California), with a population of over 127 million people. While sharing many elements with the music-culture of the Asian mainland, the Japanese music-culture also has many basic principles that are unique. Religious predominance is a mixture of **Shintoism,** which is similar to the other animist religions previously discussed, and **Buddhism.**[62]

While encompassing a variety of traditions, the primary tenets of Buddhism are typically centered on the notion that enlightenment is achieved through insight into the ultimate nature of reality.[63] As you explore the traditional music of Japan, it will become apparent that both of these religions have played a large role in the overall music-culture development.

World Atlas with Japan highlighted.
Source: © 2009 Shutterstock, Inc.

The current state of music in Japan is summed up by the *Rough Guide to World Music* in the following way:

Bubblegum pop, some new age sounds, the odd novelty hit and some traditional music—these are the stereotypes of music in Japan. Yet nowhere in Asia can you find such a wide range of music: from ancient Buddhist chanting and court music to folk and old urban styles, from localized popular styles like *kayokyoku* and *enka* to Western classical, jazz and every form of pop you would find in the west.[64]

We will examine traditional Japanese music and also look briefly at some trends in Japanese pop music.

The Japanese octave is divided into 12 notes, but, unlike the Western 12-note division of the octave, the Japanese do not temper their scale (i.e., the half notes are not always equal in distance from one another). While there are several different theories that have been developed to explain the Japanese scale system, we will simply say that the predominant scale in Japanese music is **pentatonic** (a five-note scale) and leave it at that. Well, actually there are two types of pentatonic scales used; those that use semitones (e.g., D, E-flat, G, A, B-flat), and those that don't (e.g., D, E, G, A, B). The scales containing semitones are referred to as **hemitonic,** and those that do not contain semitones are labeled **anhemitonic.**[65] And now, we *will* leave it at that.

Kiyomizu Temple in Kyoto, Japan.
Source: © Shutterstock, Inc.

Traditional Japanese melodies frequently contain short motifs that are repeated throughout a piece. This technique is amplified in Japanese theater, where returning motifs are commonly used to tell the audience of a character's feelings or to foreshadow an upcoming event. Because of the importance given to timbre, dynamics, and rhythm (all discussed later), the change of actual pitch can seem maddeningly slow to Western ears. From a Japanese perspective, however, many elements combine to give a melody its life.[66]

With regard to timbre, or tone color, traditional Japanese music often gives equal importance to sounds of both definite and indefinite pitch. The same is not true in traditional Western music, where exclusive priority is given to sounds of definite pitch (this excludes some modern music, where sounds of indefinite pitch have become focal points). The focus on sounds of indefinite pitch in Japanese music is a cultural element that is also expressed in Japanese poetry, where great importance is placed on sounds occurring in nature (e.g., leaves rustling in the wind, water flowing over rocks, waves crashing, etc . . .). These sounds are also mimicked and treated reverentially in traditional Japanese music, and as a direct result, dynamics are often given an added structural importance as well.

pentatonic

hemitonic

anhemitonic

Space (*ma*) is a crucial and defining element in all forms of Japanese artistic expression. In music, the concept of ma is expressed primarily through rhythm. A distinctive characteristic of traditional Japanese music lies in the flexibility of pulse. While in Western music rhythm is traditionally based upon the regular recurrence of pulses (which are commonly put in groups of two, three, four, or six to form meter), in Japanese music the intervals between pulses are often irregular. The space, or ma, between intervals is left to the discretion of the performer. From a Western perspective this "free" rhythm can be difficult to grasp, while to Japanese ears, it is a powerful expression of feeling. In Japanese music that has a regular, recurring pulse, the division is almost always duple (two, four, or eight). Traditionally, triple meter is a rarity in this culture.[67]

A Japanese Zen garden.
Source: © Shutterstock, Inc.

Texturally, the music is based upon monophony or heterophony with no sense of functional harmony, as discussed earlier in the book, heterophony can basically be described as two or more instruments playing the same melody at the same time, but in a slightly different way, because of the current prevalence of Western music, functional harmony can now easily be found in the Japanese music-culture, but this is not a Japanese tradition.

The most common form found in Japanese music is called ***jo-ha-kyû.*** The form is defined in terms of tempo, which can often be applied to an entire piece, sections of a given work, or to specific musical sections.

jo-ha-kyû

- *Jo* is a slow introduction
- *ha* is a breaking apart, where the tempo builds
- *kyû* is where the tempo reaches its peak, only to subside again

This form, while certainly not exclusive, is common in almost all genres of traditional Japanese music.[68] It is also a central structural element of three distinctly different forms of Japanese theater; ***noh, kabuki,*** and ***baranku.*** All three of these styles, however, revolve around musical elements. Examples of these three types of musical drama can be found on YouTube, and a succinct description of the three genres is given in *The Rough Guide to World Music.*

Japan's most famous theatrical form, noh, was synthesized in the fourteenth century from religious pantomimes, folk theatre and court music. Noh, which combines oratory, dance and singing in a highly stylized manner, is still performed and continues to influence both Japanese and foreign theater and music. There are solo singers, small choruses singing in unison and an instrumental ensemble of *fue* (bamboo flute, the only melodic instrument other than the voice, two hourglass drums and a barrel drum. The profundity of expression through an economy of means is an important part of the aesthetic. The melodramatic puppet style, bunraku, came after noh, and was one of the sources of the colorful and sensual kabuki theater. Kabuki emerged in the early seventeenth century, and the combination of noh narratives, chanting and music based on the shamisen (three-stringed lute), flute and drums led to a more lively and popular musical style.[69]

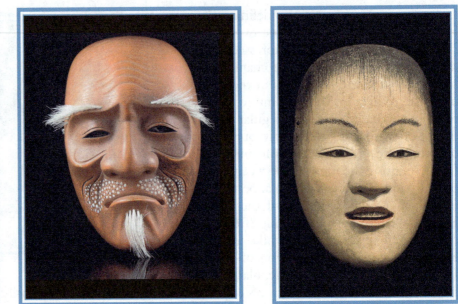

Typical masks used for Noh Theater.
Source: © Shutterstock, Inc.

While many different types of instruments are found throughout Japan, we will briefly turn our attention to four distinct and culturally important instruments: the *koto* (chordophone), the *shamisen* (chordophone), the *shakuhachi* (aerophone), and the *taiko* (membranophone).

- The koto is a large (71 inches), plucked zither (chordophone). It typically has 13 strings with a movable bridge for each. Excellent examples of the koto can be heard on the Smithsonian-Folkways recording *The Japanese Koto* (cook1132).

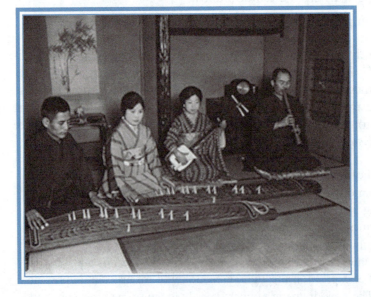

Japanese musicians and their instruments. Instruments from left to right are koto, koto, shamisen, and shakuhachi.
Source: © Getty Images.

- The shamisen is a three-stringed, fretless chordophone, similar to a banjo in that its resonating body is covered with an animal skin. An outstanding website, www.itchu.com, lets you play a virtual shamisen, as well as giving you great information about the instrument and a limited discography with some mp3 samples.

- The shakuhachi is an end-blown bamboo flute (aerophone) with four holes in the front of the instrument and one hole in the back. The principles of ma are expressed nowhere better than through the music of this soulful instrument. The instrument is often used as a form of *Zen Buddhist* meditation. An excellent example of shakuhachi music can be heard on the Folkways Recording *Shakuhachi Honkyoku Japanese Flute Played by Riley Kelly Lee* (FW04229).

Traditional Japanese taiko drummer during a music festival.
Source: © Shutterstock, Inc.

- Taiko is a generic term for drum (membranophone) in Japanese, and Taiko drumming has become something of a worldwide phenomenon in the past few decades. In its current state, the Taiko ensemble is a purely twentieth-century invention, but the instruments themselves have been prominent in the *gagaku* court music of Japan for over a millennium. Great examples of taiko ensemble and gagaku ensembles are abundant on the Internet.

As discussed earlier, pop music exists throughout the islands of Japan in a vast array of forms. A term that was coined in the '90s to describe Japanese-based popular music is J-pop. This is a very loosely defined genre that includes a huge variety of music. In addition to J-pop, there are now genres such as J-rock and J-hip-hop. While there is a large amount of information on the Internet relating to Japanese popular music, Ian Condry's site, web.mit.edu/condry/www, is a great place to begin your further exploration.

DIG DEEPER

- web.mit.edu/condry/www/—as previously mentioned, a great introduction to Japanese popular music.
- www.mustrad.org.uk/articles/japan—a good general introduction to traditional Japanese music.
- www.komuso.com—website for The International Shakuhachi Society.
- www.taiko.com—a nice introduction to taiko

World Atlas with United States highlighted.
Source: © 2009 Shutterstock, Inc.

North America (native culture)

Arriving in North America, we head for the United States, where we will hear and see the music-cultures of the country's indigenous people. With over 500 different tribes, containing some 2.9 million members, there are vast cultural differences between regions.[70] We will begin our journey, however, by searching for some common elements in the music-cultures of these diverse groups of people.

Driving on most Native American reservations today, you are as likely to hear country, rock, metal, or hip-hop as any form of traditional native music. But, there is also a strong movement that attempts to retain the traditional belief systems of these varied groups of people, and it is the traditional music-culture elements on which we will focus our attention.

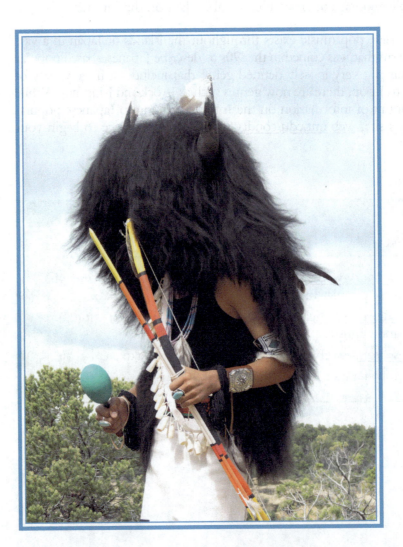

Buffalo Dancer with various rattles.
Source: © Shutterstock, Inc.

Vocalization is the most common thread throughout the various indigenous tribes. While there are no Native American languages that have a word equivalent to the Euro-American definition of music, there are words in every native language that can be translated as "song." Vocalization takes many forms (solo, group, call and response among others) and frequently makes use of vocables, or nonsense syllables. (If you have ever sung *Deck the Halls*, the "fal-la-las" are vocables).[71]

Another common thread throughout the music of this region is the use of percussion instruments. Traditionally, membranophones and idiophones are both central to the music culture of Native Americans. Idiophones (rattles, shakers, rasps, sticks) are the most prevalent group of instruments found. Rattles and jingles suspended from the body, a piece of clothing, or a stick are all common, and they are made from a wide range of materials, including animal hooves, claws, beaks, bones, and tin jingles. Also common are container rattles, which are also made from a wide range of materials, including spider egg sacks, gourds, turtles, pottery, and cow hide.[72]

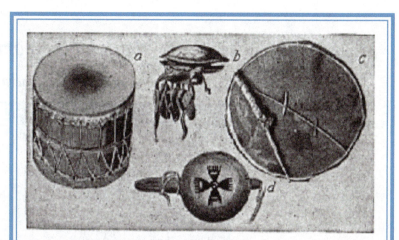

DRUMS AND RATTLES

(*a*) Box drum. (*b*) Pueblo turtle shell, with hoofs of goats or sheep; fastened to the knee when dancing. (*c*) Tambourine drum of the Menominee Indians. (*d*) Pueblo painted gourd with wooden handle. [Illustrations from specimens preserved in the United States Bureau of Ethnology.]

Source: Jupiterimages, Corp.

Membranophones take on a variety of shapes and sizes. The following are just a few of the different types found among the nation's indigenous people.

- Single- or double-headed frame drums—an instrument that typically has a circular frame, often a bent piece of wood, with an animal skin stretched over it.

- Log drums—hollowed out logs with an animal skin stretched over it (see cover).

- Water drums—pottery containing water with an animal skin stretched over it.

The most common aerophones are the end blown flute, whistles and ocarinas, as well as bull roarers.[73]

Chordophones are somewhat rare, but examples can be found, including the Apache fiddle.[74]

Native American tribes can be divided into the following regional subdivisions based on cultural patterns: Eastern Woodlands, Plains, Great Basin, Southwest, Northwest Coast, and Arctic. Excellent examples of regional styles can be found on the Smithsonian-Folkways Recording *Creation's Journey: Native American Music* (SFW 40410). Specific tracks are given in parenthesis for recordings from each region, accompanied by general regional characteristics as noted by the distinguished ethnomusicologist Bruno Nettl.[75]

Native American flute.
Source: © Shutterstock, Inc.

Focus on Form
Musical Tendencies for Native American Culture Regions

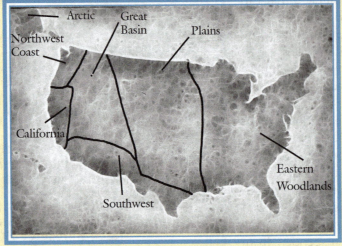

Traditional cultural regions of Native Americans.[76]
Source: © 2009 Shutterstock, Inc.

Eastern Woodlands

- Short reiterative phrases
- Call and response patterns
- Irregular rhythmic patterns
- The use of pentatonic scales
- A tendency for melodic lines to descend
- Vocal quality has a moderate amount of tension and pulsation

Southwest—The Pueblo and the Athabaskan cultures both inhabit the Southwest region.

Pueblo (track 5)

- Vocals tend to be in a relaxed low range
- Slow tempo
- Complex and meticulously detailed
- Hexatonic (six note) and heptatonic (seven note) are common

Athabaskan (tracks 3 and 4)

- Tense vocals with pulsation
- The use of falsetto
- Monophonic
- Use of drums and rattles
- fast tempos

Plains (tracks 1 and 2)

- Extreme vocal tension with nasal quality and high pulsation
- Frequent use of falsetto
- Monophonic texture
- Tetratonic (four note) scales
- Large range
- Rhythmic complexity
- Descending melodies
- Repetitive formal structure

Great Basin

- Short melodies
- Small range (commonly a fifth)
- Monophonic texture
- Relaxed and open vocals
- Tetratonic scales
- Phrase of song usually repeated AABBCC, etc.

Californian-Yuman

- Simple Rhythms
- Pentatonic scales
- Relaxed vocal technique

Northwest Coast (track 14)

- Vocals are extremely tense with the use of pulsation
- The use of ornamentation
- The use of a heterophonic texture
- Large leaps in the melodic lines are common
- Large diversity of instrumentation

Arctic

- Throat singing (as described in our journey along the Silk Road)
- Narrow melodic ranges, rarely over the interval of a sixth
- Ends of phrases are typically marked by repeated notes

The Smithsonian-Folkways collection contains numerous recordings from different indigenous groups across the U.S. Each recording is complete with liner notes that take a more in depth look at the particular cultures. To give you an idea of what's available, here are a few recommendations just focusing on the Southwest, but all of the regions mentioned previously are well represented in the collection.

- *Music of New Mexico: Native American Traditions* (SFW40408)—A look at the music-cultures of the Pueblo, Navajo, and Mescalero Apache.
- *Navajo Songs* (SFW40403)—An excellent recording that contains a look at the healing ceremonies of the Navajo.
- *Indian Music of the Southwest* (FW08850).
- *Music of the American Indians of the Southwest* (FW04420).
- *Music of the Sioux and the Navajo* (FW04401).

DIG DEEPER

- visionmakermedia.org—Native American Public Telecommunications, includes streaming feeds and podcasts.
- www.hanksville.org/voyage/navajo/ceremonials.php3—an excellent description of Navajo ceremonials.
- www.powwows.com—in addition to videos and discussions, this site contains a calendar of scheduled pow wows.

African Diaspora

As we begin the last section of the tour, you will notice that there is no map included. This is because to give an accurate chart of the dispersion of the peoples and cultures of Africa, one would basically have to include a map of the entire world. While we could focus on any number of locations to examine the impact of the African diaspora, the music-culture of Cuba will serve as our barometer.

Diaspora, viewed as a concept, is extremely important in any discussion involving ethnomusicology. The term is used to define the dispersion—forced or voluntary—of any group of people holding common ethnicities. Included in the definition is the implication that there will be an attempt to retain cultural identity. While we will focus on the African diaspora, there are many groups of people to whom this term could be extended. We could examine the Jewish diaspora, the Romani (Gypsy) diaspora, the Turkish diaspora, or countless other ethnic redistributions across the planet, each creating its own unique path and contributing to the ever-changing global culture.

Diaspora

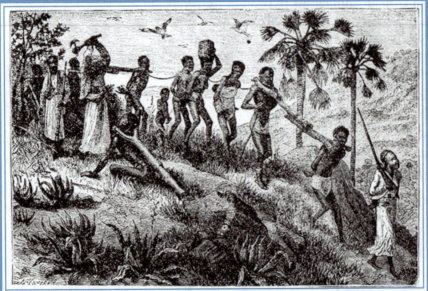

Historic woodcut offering a graphic illustration of slaves being captured in Arica
Source: © Shutterstock.com

A primary force behind the African diaspora was the Atlantic slave trade. It is estimated that somewhere between nine to twelve million Africans were enslaved and brought to the New World from the sixteenth through the nineteenth centuries. The western and central portions of sub-Saharan Africa were the regions of the continent primarily exploited for this endeavor.[77]

As African, European, and, to some extent, Indigenous American cultures collided, colossal musical hybrids were created. Among the new forms shaped were the samba from Brazil, the calypso from Trinidad and Tobago, the blues and jazz from the United States, as well as the *son* and *rumba* from Cuba. As these and other forms mutated and cross-fertilized, we got things such as rock, reggae, salsa, latin-jazz, hip-hop, and soukous to name but a few. The reverberation and mutation of all of these genres continues throughout the world today.

With a population of 11.5 million and an area of over 42 thousand square miles (roughly the size of Tennessee), the archipelago of Cuba is the largest nation in the Caribbean.[78] A concise history of the island can be found at the CIA website.

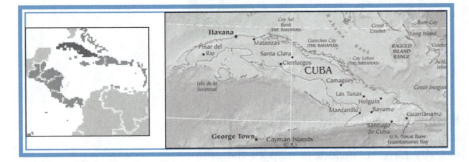

Location and map of Cuba.
Source: cia.gov

The native Amerindian population of Cuba began to decline after the European discovery of the island by Christopher Columbus in 1492 and following its development as a Spanish colony during the next several centuries. Large numbers of African slaves were imported to work the coffee and sugar plantations, and Havana became the launching point for the annual treasure fleets bound for Spain from Mexico and Peru. Spanish rule eventually provoked an independence movement and occasional rebellions that were harshly suppressed. US intervention during the Spanish-American War in 1898 assisted the Cubans in overthrowing Spanish rule. The Treaty of Paris established Cuban independence from the US in 1902 after which the island experienced a string of governments mostly dominated by the military and corrupt politicians. Fidel Castro led a rebel army to victory in 1959; his iron rule held the subsequent regime together for nearly five decades. He stepped down as president in February 2008 in favor of his younger brother Raul Castro.[79]

The slave trade in Cuba came primarily from the Yoruba and Fon speaking people of West Africa, as well as the Bantu speaking people of Central Africa. The ethnic groups retained a strong sense of cultural identity and were allowed to form

associations called *cabildos*. These organizations were supported by Spanish legislation and the Roman-Catholic church as a means of diversion for the slave population. In addition to many social elements, the calbidos held a religious purpose. As such, they were a primary source for the retention of African culture in the New World.

Among the religions brought from Africa to Cuba were the practices now known as *Santeria* and *Palo*. As with most African religions, music was a central element in these traditions.[80] Several great recordings featuring music from these traditions are available on the Smithsonian-Folkways label. Among these recordings are *Cult Music of Cuba* (FW04410), *Music of Cuba* (FW04064), and *Havana, Cuba, ca. 1957: Rhythms and Songs for the Orishas* (SFW40489). Listening to these recordings, it is easy to imagine that you are in Africa rather than Cuba. In addition to the chanted and sung texts, which are primarily in African dialects, all of the principle style elements discussed with regard to sub-Saharan African music are present. Listening to this music, you can hear intensive use of polyrhythm, improvisation, repetition, resultant patterns, and call and response forms. (For a more detailed look at the structure of Santeria music and customs, download the 28 pages of liner notes accompanying *Havana, Cuba, ca. 1957: Rhythms and Songs for the Orishas*). In addition, several of the percussion instruments from these traditions became mainstays of the Afro-Cuban tradition, including:

Set of tumbadoras (conga drums).
Source: © Shutterstock, Inc.

- The *batá,* a double-headed, hour-glass shaped drum of the Yoruba.

- The *tumbadoras* (congas), a set of three drums that are long, thin, single-headed instruments of the Bantu speaking people. The three different drums are referred to as the quinto (highest), conga (middle), and tumba (lowest).

- **Claves,** wooden sticks that are struck together.

- Double bells.

- Shakers.

As we have seen before, one of the difficulties in understanding particular concepts in music can come from confusing terminology (i.e., the multiple definitions given for the term sonata). *Rumba* is an excellent example of a term with multiple definitions, and understanding that the word actually refers to several different types of music can alleviate hours of frustration. **Rumba** was initially a dance form that first emerged in the port city of Matanzas (one hour east of Havana) and developed in the docks and slums of Havana. While incorporating small elements of Spanish culture, the rumba was primarily African. As the form developed, three distinct sub-categories were formed; the **Yambu,** the **Columbia,** and the **Guaguanco.** Distinctions among the sub-categories were based upon, among other things, tempo and variances in dance movements. Yambu, the oldest of the forms, was built around instrumental ostinato patterns played on *cajóns* (wooden boxes), claves, and a *maruga* (a metal shaker). The wooden cajóns were eventually replaced by the conga drums, which were modeled after the Congolese *yuka* drums.[81] An excellent example of rumba yambu can be heard on track one of the *Music of Cuba*.

Son

Easy enough to understand so far, but here is where it gets tricky. The *son,* another Afro-Cuban form, began developing in the rural parts of Cuba, and by the early twentieth-century the form migrated to the urban centers of the island, where it took on a distinct blend of African and Spanish cultures. While the early son relied upon many African musical elements, such as call-and-response patterns and polyrhythms, it also used European instruments including the guitar, the *Cuban tres* (a guitar-like instrument), and, later, the contrabass. As the son spread to urban centers, it went through three distinct phases, each typified by the addition of instruments musical groups.[82]

- Phase one—The ***Sexteto* format** consisted of six musicians performing on guitar, tres, bongos (a set of two single-headed drums played with the hands), double bass and two vocalists (who typically played maracas and claves).[83]

- Phase two—The ***Septeto* format** (seven musicians) included the addition of the trumpet to the sexteto format.[84]

- Phase three—The ***Conjunto* format** included the addition of the piano, a second (and later a third) trumpet, and congas to the septeto format.[85]

In the 1930s Don Azpiazu, a famous Cuban band leader, recorded a piece entitled *The Peanut Vendor* for Victor records. While the piece was in the son conjunto format, it was erroneously referred to as rhumba (with the added "h").[86] The song became a number one hit in the States, and the rumba craze was born. Confusion has existed ever since. To add to this confusion the son, being labeled a rumba, was imported back to Africa and generated yet another hybrid known as African Rumba, or *soukous.* Hearing the difference between all of these forms is easy, but the labeling can be very confusing.

Having looked at music that originated predominantly from African traditions, let's look at music that was based initially on European customs. The Folkways

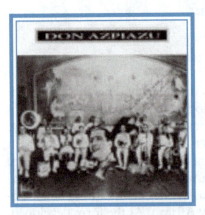

Cover of the recording, Don Azpiazu & His Havana Casino Orchestra.
Source: Harlequin records

Recording, *The Cuban Danzón: Its Ancestors and Descendents* (FWO4066) is an amazing collection that traces the European *contradanza* as it evolves into the Cuban *danzón* and *mambo.* The collections begins with the earliest known contradanza known to be written in Cuba, *San Pascual Bailon.* The piece consists of two eight-bar sections, each of which were repeated (A A B B). It was danced in an extremely formalized manner, with each of the four sections having its own dance pattern.

The collection traces the contradanza as it gives way to the slightly more exotic danza, eventually arriving at the danzón. While still based on alternating 16-bar sections, the danzón featured the addition of a third section, giving it a formal structure of A B A C.[87] Early danzóns were performed by groups known as ***orquesta típicas,*** which consisted of a combination of woodwinds, brass, violins, a contrabass, and a pair of small timpani. As the form became more popular, the instrumentation shifted to the lighter texture of what is known as a ***charanga.*** This group typically

Charanga

consisted of a piano, bass, timbales (two small drums that are direct descendents

of the orchestral timpani), a guiro (a scraped idiophone), two violins, and a small wooden flute.

By 1910, as the form continued to develop, it began to incorporate rhythmic and dance elements from the newly popularized son. It also borrowed from the son a final section known as a **montuno,** which included an improvised instrumental solo. Finally, by the late 1930s, the charanga began using congas, claves, and an expanded string section to perform interlocking African ostinatos, which would eventually transform the danzón into the mambo.[88] In the 1940s and 50s musicians such as Perez Prado helped catapult the son/danzón-inspired genre of mambo to the height of global popularity. While the Prado-led big band mambo dance craze was underway, there was also a separate melding of Jazz and Afro-Cuban music going in the New York City. The new form, which came to be known as Latin Jazz, was spearheaded by Cuban-born immigrants Mario Bauzá and his brother-in-law Machito, and it had a profound impact on the world of Jazz. That's a different, story however, so we will leave it at that. Turning our eyes away from Cuba, we set sail for home knowing that we have only uncovered the surface of the monumental creative legacy caused by the African diaspora.

DIG DEEPER

- www.pbs.org/buenavista—A Public Broadcasting System website that look at the music of Cuba and the Buena Vista Social Club.
- www.pbs.org/theblues—A Public Broadcasting System website that site that traces the history of the blues.
- www.brazzil.com/musaug98.htm—website briefly looks at the history of Brazilian music.

Focus on Form
The Commercial World of World Music

When Xavier Cugat, Machito, Chano Pozo, and Tito Puente settled in New York City, none of them had immediate plans to bring a new awareness of "world music" to America. They were simply mixing jazz elements with the music from their respective homelands. 50 to 70 years later, however, we are still enjoying the fruits of their labor. Each of these artists laid part of the foundation for opening American ears to a wide spectrum of styles we now refer to as world music. A few years later, saxophonist Stan Getz visited Brazil, met Antonio Carlos Jobim, and together they created a new bossa nova craze that swept across America and the jazz world in general. As you've already seen in this chapter, historians including Alan Lomax, among many others, played an important role in introducing the music of other cultures to intrepid listeners. As the recording industry geared up to ever-higher levels of

commercial excess, independent labels began promoting "niche" music, locating and recording artists from many different cultures and musical styles. Between 20 and 30 years ago, the commercial world of "world music" hit something of a critical mass, and artists lumped into this collective category have been enjoying great success ever since. To at least some extent, every artist discussed in this *Focus On Form* can be considered something of a "fusion" artist, blending the musical styles of multiple cultures and traditions.

Among other milestones, in the 1950s America was introduced to the calypso sounds of Harry Belafonte. In the 1970s it was the reggae sounds of Bob Marley and the Wailers. Both of these artists, along with many others, demonstrated to Americans that there were musical horizons beyond Elvis, The Beatles, the artists featured at Woodstock and, somewhat tragically, disco. Then, in 1986, American musician Paul Simon traveled to South Africa, where he recorded with a number of very talented local musicians and groups, including Ladysmith Black Mambazo. The resulting album, *Graceland,* won Grammy awards that year for both song and album of the year. Suddenly, world music was big business in America. The success of *Graceland* opened the door for a number of African artists including Cesaria Evora, Samite, Sam Mangwana, Habib Koité, the previously mentioned Ladysmith Black Mambazo, and many of the artists already mentioned in this chapter's section on African music.

To further fan the world music flame, American musician and producer Ry Cooder traveled to Cuba in search of some older musicians he had been listening to on a series of bootlegged cassette recordings. A documentary was made about his search, and the resulting film and subsequent series of recordings launched *The Buena Vista Social Club* into world music megastardom (see picture of Papi Oviedo on p. 444). CD sales were huge for such an esoteric project, and the artists, who had been living in total obscurity in Cuba, began touring the world and playing to sold out houses every night. Similar bands followed, and many of them continue very successful touring schedules today.

As the "new age" genre became a commercial driving force in the music industry, many artists began blending various forms of world music with new age musical styles. Celtic music in particular lent itself nicely to this new blend, and artists including Enya, the band Clannad, and, most recently, Celtic Woman, have enjoyed great success on film and TV soundtracks, as well as in live performances. Native American musicians including R. Carlos Nakai have also found themselves lumped into this "new age" categories though, in truth, his music crosses many different musical boundaries.

Film scores, TV Soundtracks, and even commercials have also played a major role in broadening musical horizons. One recent example is the use of Hawaiian musician Israel "IZ" Kamakawiwo'ole's recording of *Somewhere Over the Rainbow* in various soundtracks including *50 First Dates, Inside the NFL, The Miss America Pageant, Cold Case* and ER, along with a number of prominent commercials including spots for Eddie Bauer, Microsoft, and Celebrity Cruises, among many others. Sadly, the artist passed away before he could enjoy great commercial success, but his music's repeated use in film and TV has boosted his CD sales and downloads to the top of the world music charts. The previously mentioned band Clannad has also enjoyed great success in the movie soundtrack business with music featured in such films as *Patriot Games, Braveheart,* and *The Last Of The Mohicans.*

Today, there are a number of record labels, radio stations, and live performance series that promote world music (or at least some commercial fusion version of world music) on a regular basis. Many public radio stations devote some of their programming each week to the world music genre, including the previously mentioned (and wildly popular) *Afropop Worldwide* with Georges Collinet. Online, there are a number of streaming radio stations and podcasts to be found around the globe that focus on various world music traditions and fusions. Beyond the traditional world music labels already mentioned in this chapter, prominent record labels including Putumayo, Shanachie, Nonesuch, and Luaka Bop all devote a great deal of their respective energies to the promotion of world music. Putumayo in particular took an interesting marketing approach a few years back when they began putting listening/sales kiosks in non-traditional retail markets. Their music can be found in hip clothing stores, museum gift shops, airports, and Starbucks around the world. Throughout America, there are a number of concert series and music festivals that devote some, if not all, of their programming to artists who fall into the world music category. This music is actually all around you. Stop. Look. Listen. Thus will you discover that this music has been a part of your world for quite some time.

DIG DEEPER

WEBSITE
www.putumayo.com
www.shanachie.com
www.nonesuch.com
www.luakabop.com

Home

The conclusion of any trip is often bittersweet; while it's always great to sleep in your own bed, the excitement of exploration is missed. Luckily, as our trip was "virtual," you can hit the road anytime you have a few free minutes and an Internet connection. Your opportunity for continued exploration in this realm is truly endless. Our trip was governed by a desire to explore music from a cultural standpoint. While we focused on music-cultures outside of European-based traditions, a separate and equally incredible discovery awaits those wanting to delve into the vast array of music-cultures of Europe, or South America, or Russia, or any of the countless genres skipped in North America, or . . . you get the point. The world is a vast place, and we actually skipped far more than we talked about!

While we took glances at current trends, our primary focus was on traditional genres. You might be more interested in a different approach. You might wish to delve into the roots of reggae, or the bossa nova, or any of the other countless global fusions that have altered the way hundreds of millions of people listen to music. Using the resources presented in this chapter, you now have the tools to carry on in whatever direction you choose.

As you continue your exploration, personalize it to the areas we studied that interest and excite you. Explore new cultures that we didn't mention, or that you have never heard of. Listen and discover as the music from one culture blends with the music of a different culture to form a new synthesis. Watch as these newly synthesized forms cross-fertilize with other forms to create fusions that are impossible to define as belonging to any one, single tradition. Go to the Smithsonian-Folkways website and do a search for Celtic music, Gypsy music, Flamenco, Samba, or just listen to the site's stream for an hour and see what you like. If you find something that interests you—DIG DEEPER.

Finally, before going to bed tonight, look and listen to some of the music currently in your iPod from the perspective presented in this chapter. Ask yourself, "What is it that I like about this particular piece of music? What does it say about

me? What does it say about my culture?" Distinguish the difference between preference and comparison (i.e., you might like apples better than oranges, but this is a preference that does not tarnish the qualities of the orange as a fruit. Someone else could just as easily prefer oranges). As you attempt to answer these questions, realize that the study of music is not an exact science. Music is intensely subjective and often expresses ideas or emotions that transcend the barriers of written or spoken language. Because of this fact, objective studies of music are difficult at best, and you might find these questions impossible to answer. If this happens, relax, listen, and renew your attempt at another time. That really is ok because music is a part of who we are as a species. It defines us in ways that nothing else can, and at times one needs to listen without agenda or academic reference.

Endnotes

1. Voyager the Interstellar Mission, "Music from Earth," *NASA,* http://voyager.jpl.nasa.gov/spacecraft/music.html (accessed June 20, 2009).

2. Our Mission and History, "Folkways Records founder Moses Asch in his office," Smithsonian Folkways, http://www.folkways.si.edu/about_us/mission_history.aspx (accessed June 24, 2009).

3. Our Mission and History, "Mission," Smithsonian Folkways, http://www.folkways.si.edu/about_us/mission_history.aspx (accessed June 24, 2009).

4. Jeff Todd Titon, "Preface," in *Worlds of Music,* 3rd ed., ed. Jeff Titon, (New York: Schirmer Books, 1996), xxii.

5. Darius L. Thieme, "Cantometrics," in *The New Grove Dicionary of Music and Musicians,* ed. Stanley Sadie, ex. Ed. John Tyrrell (London: Macmillan Publishers Limited, 2001), v.5, 64–65.

6. Klaus Wachsmann and Margret J. Kartomi, "Instruments, classification of," in *The New Grove Dictionary of Music and Musicians,* ed. Stanley Sadie, ex. ed. John Tyrrell (London: Macmillan Publishers Limited, 2001), v.12, 418–419.

7. Ibid.

8. Ibid.

9. Ibid.

10. The World Factbook, "Australia," CIA, https://www.cia.gov/library/publications/the-world-factbook/geos/as.html (accessed July 2, 2009).

11. About Australia, "Indigenous Languages," Australian Government, http://www.dfat.gov.au/facts/Indigenous_languages.html (accessed July 2, 2009).

12. About Australia, "A Snapshot," Australian Government, http://www.dfat.gov.au/facts/snapshot.html (accessed July 2, 2009).

13. Marcus Breen, "Australia—Aboriginal music," in *The Rough Guide to World Music,* ed. Simon Broughton and Mark Ellingham (London: Rough Guide Ltd, 2000), v.2, 10–14.

14. Stephen A. Wild and Adrienne L. Kaeppler, "The Music and Dance of Australia," in *The Garland Encyclopedia of World Music,* ed. Adrienne L. Kaeppler and J. W. Love (New York and London: Garland Publishing, Inc., 1998), 408–417.

15. Recording liner notes, "Tribal Music of Australia," Smithsonian Folkways Recordings FWO4439, http://media.smithsonianfolkways.org/ liner_notes/ folkways/FW04439.pdf (accessed July 2, 2009).

16. Wild, "The Music and Dance of Australia," in *The Garland Encyclopedia of World Music,* 410–412.

17. Bob Marley and The Wailers, *Burin'*. Tuff Gong/Island.

18. Breen, "Australia—Aboriginal music," in *The Rough Guide to World Music,* 12.

19. Kev Carmody, "Thou Shall Not Steal."

20. The World Factbook, "Australia," CIA, https://www.cia.gov/library/ publications/the-world-factbook/geos/id.html (accessed July 2, 2009).

21. Sumarsam, "Introduction to Javanese Gamelan," *Wesleyan.edu,* http:// sumarsam.web.wesleyan.edu/Intro.gamelan.pdf (accessed July 8, 2009).

22. Ibid., 6.

23. Ibid., 6.

24. Ibid., 18.

25. Ibid., 18–21.

26. R. Anderson Sutton, "Asia/Indonesia," in *Worlds of Music,* 3rd ed., ed. Jeff Titon, (New York: Schirmer Books, 1996), 319–352.

27. Ibid., 352–356.

28. Recording liner notes, "Discover Indonesia: Selections from the 20 CD Series," Smithsonian Folkways Recordings SFW40484, http://media. smithsonianfolkways.org/liner_notes/smithsonian_folkways/SFW40484.pdf (accessed July 8, 2009).

29. Ibid.

30. Ibid.

31. Colin Bass, "Indonesia—Pop and folk," in *The Rough Guide to World Music,* ed. Simon Broughton and Mark Ellingham (London: Rough Guide Ltd, 2000), v.2, 131.

32. Ibid., 132.

33. Ibid., 132–133.

34. The World Factbook, "India, Pakistan, Bangladesh, United States," CIA, https://www.cia.gov/library/publications/the-world-factbook/index.html (accessed July 18, 2009).

35. India at a Glance, "Religious Composition," Census of India, http:// censusindia.gov.in/Census_Data_2001/India_at_glance/religion.aspx (accessed July 18, 2009).

36. Maya Warrier, "Hinduism," in *Introduction to World Religions,* ed. Christopher Partridge (Minneapolis: First Fortress Press, 2005), 134–164.

37. David B. Reck, "India/South India," in *Worlds of Music,* 3rd ed., ed. Jeff Titon, (New York: Schirmer Books, 1996), 252–256.

38. Ibid., 275.

39. Ibid., 308.

40. Ibid., 278–279.

41. Ibid., 274.

42. Ibid., 281–282.

43. Ken Hunt, "India—Film Music," in *The Rough Guide to World Music,* ed. Simon Broughton and Mark Ellingham (London: Rough Guide Ltd, 2000), v.2, 102.

44. David Locke, "Africa/Ewe, Mande, Dagbamba, Shona, BaAka," in *Worlds of Music,* 3rd ed., ed. Jeff Titon, (New York: Schirmer Books, 1996), 74.

45. Ibid., 74.

46. Paul Berliner, *The Soul of Mbira: Music and Traditions of the Shona People of Zimbabwe* (Chicago, University of Chicago Press, 1981), 8–53.

47. Ibid., 59–65, 186–206.

48. Languages of the World, "Languages of Ghana," Ethnologue, http://www.ethnologue.com/show_country.asp?name=GH (Accessed July 28, 2009).

49. David Locke, *Drum Damba: Talking Drum Lessons* (Crown Point, Indiana: White Cliffs Media, 1990), 1–42.

50. Ibid.

51. "Qur'ân," Britannica Online Encyclopedia, http://www.britannica.com/EBchecked/topic/487666/Quran (accessed August 4, 2009).

52. Kristina Nelson Davies, "The Qur'ân Recited," in *The Garland Encyclopedia of World Music,* ed. Virginia Danielson, Scott Marcus, and Dwight Reynolds (New York and London: Garland Publishing, Inc., 1998), v. 6, 157.

53. Ibid.

54. David Lodge and Bill Bradley "Arab World/Egypt: Classical," in *The Rough Guide to World Music,* ed. Simon Broughton, Mark Ellingham, and Trillo (London: Rough Guide Ltd, 2000), v.1, 324.

55. Ibid., 323.

56. Maqamat, "The Arabic Maqam," Maqam World, http://maqamworld.com/maqamat.html (accessed August 4, 2009).

57. Scott Marcus, "Rhythmic Modes in Middle Eastern Music," in *The Garland Encyclopedia of World Music,* ed. Virginia Danielson, Scott Marcus, and Dwight Reynolds (New York and London: Garland Publishing, Inc., 1998), v. 6, 89.

58. Ibid., 89.

59. Ibid.

60. Lodge, "Arab World/Egypt: Classical," in *The Rough Guide to World Music,* v1, 325.

61. Recording liner notes, "The Silk Road: A Musical Caravan," Smithsonian Folkways Recordings SFW40438, http://media.smithsonianfolkways.org/liner_notes/smithsonian_folkways/SFW40438.pdf (accessed July 8, 2009).

62. The World Factbook, "Japan," CIA, *https://www.cia.gov/library/publications/the-world-factbook/* (accessed August 24, 2009).

63. Edward Conze, *Buddhism: Its Essence and Development* (New York: Harper & Row Publishers, 1959), 11–18.

64. John Clewley, "Japan—The Culture Blender," in *The Rough Guide to World Music,* ed. Simon Broughton and Mark Ellingham (London: Rough Guide Ltd, 2000), v.2, 144.

65. Linda Fujie, "East Asia/Japan," in *Worlds of Music,* 3rd ed., ed. Jeff Titon, (New York: Schirmer Books, 1996), 372–373.

66. Ibid., 374

67. Ibid., 374–375.

68. Ibid., 375–376.

69. John Clewley, "Japan—The Culture Blender," in *The Rough Guide to World Music,* v.2, 144.

70. Census, "The American Indian and Alaska Native Population: 2000," U.S. Census Bureau, http://www.census.gov/prod/2002pubs/c2kbr01-15.pdf (accessed July 15, 2009).

71. David P. McAllester, "North America/Native America," in *Worlds of Music,* 3rd ed., ed. Jeff Titon, (New York: Schirmer Books, 1996), 17–19.

72. J. Richard Haefer, "Music Instruments" in *The Garland Encyclopedia of World Music,* ed. Ellen Koskoff (New York and London: Garland Publishing, Inc., 1998), v. 3, 472–479.

73. Ibid.

74. Ibid.

75. Bruno Nettl, *Music in Primitive Culture* (Cambridge: Harvard University Press, 1956), 105–119.

76. Ibid.

77. Black History, "Slavery," Britannica Online Encyclopedia, http://www.britannica.com/blackhistory/article-24156 (accessed August 20, 2009).

78. The World Factbook, "Cuba," CIA, https://www.cia.gov/library/publications/the-world-factbook/geos/cu.html (accessed August 20, 2009).

79. Ibid.

80. Martha Ellen Davis "The Music of the Caribbean," in *The Garland Encyclopedia of World Music,* ed. Dale A. Olsen and Daniel E. Sheehy (New York and London: Garland Publishing, Inc., 1998), v. 2, 791–793.

81. Nat Geo Music, "Rumba Music," National Geographic Music, http:// worldmusic.nationalgeographic.com/view/page.basic/genre/ content.genre/rumba_779/en (accessed August 20, 2009).

82. Olavo Alen Rodriguez, "Cuba," in *The Garland Encyclopedia of World Music,* ed. Dale A. Olsen and Daniel E. Sheehy (New York and London: Garland Publishing, Inc., 1998), v. 2, 822–839.

83. Buena Vista Social Club, "Cuban Music History," PBS, http://www.pbs.org/ buenavista/music/timeline.html (accessed August 20, 2009).

84. Ibid.

85. Ibid.

86. Gene Santoro, "Latin Jazz," in *The Oxford Companion to Jazz,* ed. Bill Kirchner (New York: Oxford University Press, Inc., 2000), 526–528.

87. Recording liner notes, "The Cuban Danzón: Its Ancestors and Descendents," Folkway Records FWO4066, http://media.smithsonianfolkways.org/ liner_ notes/folkways/FW04066.pdf (accessed August 20, 2009).

88. Ibid.

Name _____

Class _____

Study Guide

Chapter 11 Review Questions

True or False

___ 1. Ethnomusicology is described as the study of social and cultural aspects of music and dance in local and global contexts.

___ 2. *Songmen* are associated with the music of the Middle East.

___ 3. *Pélog* scales are found in Indonesian *gamelan* music.

___ 4. *A raga* deals with the rhythmic aspect of *Carnatic* and Hindustani music.

___ 5. Polyrhythms almost never occur in sub-Saharan African music.

___ 6. Maqmat are melodic modes used in music of the Middle East.

___ 7. Yo-Yo Ma founded *The Silk Road Project*.

___ 8. The most common form found in Japanese music is called *jo-ha-kyū*.

___ 9. Native American music revolves primarily around chordophones.

___10. The *Son* is an important form found in Afro-Cuban music.

Multiple Choice

11. An instrument(s) associated with Aboriginal music of Australia is:
 a. the didgeridoo.
 b. clap sticks.
 c. the bull roarer.
 d. the boomerang.
 e. all of the above.

12. An instrument(s) associated with traditional South Indian music is:
 a. the *sitar*.
 b. the *veena*.
 c. the *tabla*.
 d. the *mbira*.
 e. none of the above.

13. An instrument associated with Japanese music is:
 a. the *shaukhachi*.
 b. the *sheng*.
 c. the *pipa*.
 d. the trombone.
 e. none of the above.

14. An instrument associated with Naïve American music is:
 a. the *pipa*.
 b. the *mbira*.
 c. the *vena*.
 d. The *sheng*.
 e. none of the above.

15. An instrument associated with Afro-Cuban music is:
 a. the *bata*.
 b. the *sheng*.
 c. the *sitar*.
 d. the *mridangam*.
 e. none of the above.

16. An instruments associated with Indonesian music is:
 a. the *sitar*.
 b. the *veena*.
 c. the *tabla*.
 d the *mbira*.
 e. none of the above.

Fill in the Blank

17. The shadow puppet theater of Indonesia is known as _____.

18. Classical music of India is governed by three principal musical elements: _____, which governs the melodic elements; _____, which governs the rhythmic elements; and _____, which marks the tonal center as a drone.

19. The rhythmic structure of traditional Arabic music is regulated by a series of rhythmic modes called _____.

20. _____, _____ and _____ are all forms of Japanese theater which revolve around musical elements.

21. In Native American music, vocalization takes many forms and frequently makes use of _____, or nonsense syllables.

22. _____ is a dance form that first emerged in the port city of Matanzas and developed in the docks and slums of Havana. While incorporating small elements of Spanish culture, it was primarily African.

453

Short Answer

23. Name the four original categories used in the Hornbostel-Sachs system of instrument classification and briefly describe the parameters of each category.

24. Name five common stylistic elements associated with sub-Saharan African music.

25. Name five popular music genres from around the world that incorporate fusion blends of the music of various cultures.

Essay

1. Discuss the elements of melody and rhythm from a global perspective.

2. Discuss the objectives of studying world music.

Appendix A
Websites for Classical Music, Jazz, and World Music

Classical Music Websites

As you might imagine, there is an incredible amount of information about the world of classical music on the World Wide Web. Beyond the selected websites listed here, Google just about any performing ensemble or modern composer and you will find that they all have some sort of web presence. In addition to the National Public Radio link included below, many public radio stations now stream their broadcasts over the web in real time for free. We have created three separate categories for the different major genres covered in this textbook, but be aware that there is some overlap among the different genres on some of these websites. In particular, The National Pubic Radio and Kennedy Center Millennium Stage websites offer a great deal of content that cover all three genres. For the most part, we have avoided duplicating website information that can be found in the *Dig Deeper* sections located throughout the textbook. The following websites were all active as of November 1, 2016.

http://www.classicalarchives.com

This site claims to be the largest classical music site on the entire web, with over 600,000 full-length classical music files by 7,800+ composers. To access all of the MP3 files and some other documents you must pay a membership fee. There is also a limited free membership that still offers access to a great deal of material including excellent composer biographies complete with photographs. If you want to try a new piece of music before you purchase a recording or study a composition before attending a live concert, this website is a great place to start. Highly recommended.

www.classical.net

This extensive site offers thousands of record reviews, composer information, a brief history of classical music, and numerous active links to other websites of interest.

www.npr.org

Here is the parent website for all of National Public Radio. This enormous website includes news, classical music, jazz, and a wealth of other information. There are archives of live performances, radio interviews, and links to other streaming audio. Highly recommended. Make this site your new homepage.

classicalusa.com

This website is something of an active link clearing house for general classical music websites, reviews, and web radio broadcasts. It also offers some very good links to a number of different jazz websites.

www.naxos.com

The Naxos record label has made a commitment to offer one good recording of as many different works as possible instead of creating 20 different versions of Beethoven's Fifth Symphony, as many classical record labels do. In addition to simply having a good website to sell their products, this massive website offers detailed biographies of composers, podcasts, opera libretti, and an extensive music education area, which is, by the way, a very good place to study for the work you're doing with this textbook. (Now don't you wish you'd read this part sooner?)

www.arkivmusic.com

This is an outstanding general website for classical music that covers composers, conductors, performers, ensembles, record labels, and many other detailed areas in the world of classical music. The site also offers old school CD sales with extensive sound samples, and it often has great "website only" deals.

www.classicstoday.com

This website bills itself as "your guide to classical music online." This is yet another detailed site that offers numerous music reviews, as well as book, score, and concert reviews. Also of particular interest here are the editorials posted on this site that include such provocative titles as "The Truth About Composers Who Died of Syphilis" and "Let's Just Say Bach Wrote It." The site contains free content, but to read the really good stuff, you have to pay a yearly fee; the money is well worth it.

www. classicalwebcast.com

This site is a clearing house for links to a great deal of streaming classical audio on the Internet. You will find links to individual websites with various classical music content, as well as direct streaming links that will open players.

Jazz Websites

There is an amazing amount of jazz material on the Internet, including a wealth of biographical information; club, concert and festival information; as well as live video of jazz concerts and tons of downloadable recordings of great music. In addition to the general sites listed in this appendix, just about every artist and club out there today has some presence on the web. The following list offers a few of the most stable and accessible websites as of November 1, 2016.

www.allaboutjazz.com

In my opinion, this is the best jazz site on the web right now. It is very well organized with a lot of very enjoyable content. The site includes news, reviews, artist interviews and profiles, regular columns, jazz directories, an interesting gallery, and a comprehensive calender listing of jazz festivals and related events. There are also good suggestions about building a jazz library and discovering more information elsewhere on the web. This is a great place to start.

www.jazzpolice.com

This site bills itself as "the jazz and travel website." It offers good club listings in most major American cities, festival listings, current jazz news, and streaming audio previews. Similar to www.allaboutjazz.com mentioned above, this is a great place to start your Internet jazz odyssey.

www.smithsonianjazz.org

The Smithsonian labels this site "A Jazz portal intended to preserve and promote one of America's greatest art forms—Jazz." What more do you need to know? Tons of great stuff and the site updates frequently.

newarkwww.rutgers.edu/IJS

This is the website for the Institute for Jazz Studies at Rutgers University. Many of the photos and historical images found in Chapter 10 came from this outstanding research facility. Recently, they have undertaken a project to post some of their material on innovative web pages that include both sound recordings and wonderful photos.

www.downbeat.com

Here is the website for *Down Beat* magazine. This is now the oldest jazz magazine in existence, but with this website, they arc clearly alive and well in the 21st century. There is a great deal of good content here, and it changes frequently. One of my favorite things about the site is that they offer access to archived *Down Beat* articles that go all the way back to the swing era.

www.jazztimes.com

Jazz Times is another very good monthly magazine about jazz.

www.pbs.org/jazz

Noted historian and documentary film-maker Ken Burns recently did a ten-part series for Public Television titled *Jazz*. This is the website that accompanies the project, which also includes CDs and a companion book. There is a wealth of great information here.

www.kennedy-center.org/programs/millennium/archive.html#search

This is, without a doubt, one of the finest performance sites on the web. The Millennium Stage project hosted by the Kennedy Center in Washington, D.C., offers daily live performances on the web. In addition, all of these performances are archived and available for viewing at any time. The rather extensive address above takes you right to the archive search page, where you can look for different styles of music or search for a specific artist. Be careful, as this site can be very addictive.

World Music Websites

www.flyglobalmusic.com

This efficient, well-organized website offers current world music news, reviews, videos, and timely audio and video podcast that are updated on a regular basis. The site is separated by regions were possible, offering sub-category pages for Africa and the Middle East, Asia and the Pacific, The Caribbean, Europe, Latin America,

and the US and Canada. The site also has a useful link to an Amazon store front where you can buy most of the music you encounter on the website.

worldmusiccentral.org

This densely packed site can be difficult to navigate, but the content is worth the trouble. There is a ton of useful information, forums, sounds, reviews, videos, and artist links. You just have to dig around a bit to find it all.

www.linktv.org/worldmusic

This is the website built to support music programming found on Link TV. The website offers streaming music video blocks, full documentaries, artist interviews, and programming information for the cable/satellite TV channel.

www.rootsworld.com/rw/

This is an online world music magazine with great record reviews and a number of links to online radio stations.

www.putumayo.com

This is the website for the world music label listed in the final Chapter 11 *Focus on Form*. The site is included in this listing because it goes well beyond the typical record label site, offering a great deal of general world music information and some really nice audio samples and streaming radio. In addition, if you are a parent, the Putumayo Kids web area is also a lot of fun for the entire family.

www.worldmusic.net

This website is built around several record labels and offers a nice selection of streaming radio and video. The site also has a very useful links page.

10 Music Festivals You Should Attend Before You Die

The New Orleans Jazz & Heritage Festival

For my money, this is the best music festival held in America today. There are a number of individual stages that cover a wide variety of music, great food, and after-hours shows in many of New Orleans' best nightclubs. You should plan on spending a lot of money and several days at one, or both, of the festival's two weekends of activity. Check out their website at www.nojazzfest.com.

The Tanglewood Music Festival

Tanglewood is the summer home of the Boston Symphony Orchestra, and it is also a summer music institute for younger gifted musicians. In addition, there are regular guest artist concerts in a number of different musical genres and a yearly jazz festival. Situated in the beautiful Berkshires a few hours west of Boston, this is one of the nation's oldest continuous classical (and now jazz and world music) festivals. Their website is www.tanglewood.org, but it will re-direct you to an extensive website that is part of the main Boston Symphony Orchestra website.

The Montreux Jazz Festival

This is the granddaddy of them all. Held in and around Montreux, Switzerland, this multi-week festival features great jazz, blues, and contemporary acts from around the world. Recent festivals have included artists such as Michael Brecker, Herbie Hancock, The Lincoln Center Jazz Orchestra with Wynton Marsalis, US3, Buddy Guy, B. B. King, Paul Simon, Youssou N'Dour, Chucho Valdés, and Jamie Cullum. www.montreuxjazz.com.

Telluride Festivals

The little mountain town of Telluride, Colorado offers a series of festivals each summer that bring world-class musical talent from a number of different musical genres to Rockies. The Telluride Bluegrass Festival is the most famous, but the city also offers a great jazz festival and a classical chamber music festival as well. The websites are: www.bluegrass.com/telluride, telluridejazz.org, and www.telluridechambermusic.org.

Bayreuth Festival

An annual festival held in Bayreuth, Germany that offers performances of Wagner's epic *Ring Cycle* in the opera house the composer built. Order your tickets early, and bring lots and lots of money! The website is offered in both German and English: www.bayreuther-festspiele.de.

Mostly Mozart Festival

A summer tradition in New York City, the Mostly Mozart Festival offers innovative live performances by some of the best classical music artists alive today. While the focus is, obviously, on music from the Classical period, music from all periods is represented. The festival is run by New York's Lincoln Center, and their extensive website houses the event's Internet information. The current address is for the recently completed festival, so you may need to surf around a bit in coming years to find the current Mostly Mozart Festival information. www.mostlymozart.org.

Santa Fe Opera

One of the longest running summer opera festivals in America, the Santa Fe Opera is legendary for high programming standards, inventive staging, and a beautiful outdoor setting. For those of us who live in New Mexico, we tend to take this tremendous resource for granted, but people come from around the world to see opera performed live in the Southwest. www.santafeopera.org.

The Edinburgh Festival Fringe

Universally referred to as "The Fringe Festival," Edinburgh's annual artistic free-for-all has spawned numerous imitators around the world. This festival features a wide array of performance art, music, theatre, and various other artistic endeavors that you would not usually find presented under the auspices of one presenting organization. It is over the top, outrageous, and incredibly fun. Don't ask why, just go and prepare to be amazed. Their website offers a good overview to the event, along with some nice introductory video: www.edfringe.com.

The Proms

This London summer festival of classical music lasts for two months and offers daily concerts, along with a number of other special events. Most of the shows take place in the famous Royal Albert Hall, and there are also chamber music concerts and outdoor park concerts offered on a regular basis. The last night of the Proms festival each year has become a British musical tradition and is considered the high point of the musical year. The BBC bills the festival as the largest classical music festival in the world and houses the festival's website at: www.bbc.co.uk/proms.

Bonnaroo

This is a relatively new festival that has quickly introduced a generation of new music fans to the incredible diversity available in the world of music today. Cross-collaborations and genre-mixing performances are a standard feature at Bonnaroo. The multi-day festival is held outside of Manchester, Tennessee. Attendance at the show almost requires camping out, and it is always ridiculously hot. No one seems to mind. The music is always first rate, and the programming is incredibly inventive. Take lots of water and power bars! www.bonnaroo.com.

Appendix C

Some Thoughts on Shopping for Classical, Jazz, and World Music CDs

New CDs aren't cheap. In fact, as of this writing, some new releases are going for as much as $18.95. There is a common line that goes something like "Boy, are the record companies ripping me off, 'cause I know it costs less than a buck to make this thing." While it is true that it doesn't cost much to physically produce a CD or download, the things that lead up to that final production can be VERY expensive. For all music recorded, royalties must be paid to both the composers and/or arrangers (for works composed after 1922) and all of the contracted musicians. Typical studio time can run anywhere from $75 to $250 per hour depending on where you are and how state-of-the-art the recording facility is. The big name studios in New York, Nashville, and L.A. can be even more expensive. In addition, you must pay a photographer to shoot photos and hire a graphic artist (or a full art studio) to create the packaging. Next, there has to be a marketing strategy complete with print ads, complimentary copies to media outlets, and product placement. In particular, you may not realize that the product placement in a record or department store *COSTS* the record label money. When you go walking through some major store such as Barnes & Noble, WalMart, Target, or Best Buy, it costs money to have your recording placed at the end of a store aisle or included at one of those cool listening stations. Finally, you should also realize that the wholesale cost of a record is somewhere between $3.00 and $7.00. Then a distribution company takes its cut and, of course, the retail store makes a profit as well. Now don't get me wrong, the record industry does make money, but they don't make $17.95 on a CD for which you paid $18.95.

Building a Classical, Jazz, and World Music Jazz Record Collection

Here are some general thoughts on building a good, basic CD collection that goes beyond the latest top 40 hits. First, stay with recordings on the major labels unless you know exactly what you are buying. (Having said that, there will be major exceptions to that statement in the next section on buying used and cutout CDs.) If you just want to own a few representative titles, stick with the classics such as a good recording of Beethoven's Fifth Symphony and some of the major works of composers including J. S. Bach, Haydn, Mozart, and Brahms. Next, you can start to branch out into deeper classical waters by attending some live concerts, listening to the radio, and searching the web for some new classical composers you might enjoy. The same basic concepts also apply to the world of jazz. Start your record collection with a few "masterpiece" recordings such as *Kind of Blue* (Miles Davis), *Time Out* (Dave Brubeck), *Ellington Indigos* (Duke Ellington), and *Heavy Weather* (Weather Report).

For classical music, jazz, and world music, several good books to help you get started including *The Rough Guide,* the *All Music Guide,* and the *Penguin Guide.* Each of these titles offers extensive listings with reviews in separate books for both classical and jazz recordings. The following list includes information for some of the major labels with which you will rarely go wrong.

Classical Record Labels

Naxos

For my money, this is the best (and by far the most affordable) classical music record label going today. Founded in 1987, this record label has started a minor revolution in the recording industry. The various labels under the parent company of Naxos currently offer over 5,000 different titles of mostly classical music, with just a bit of jazz and other music thrown in for good measure. Most Naxos recordings sell for much less than $10.00, and some major record stores are now devoting an entire bin exclusively to Naxos CD releases. Currently, Amazon.com offers most of their single Naxos CD products for $8.99 per disc. One other interesting policy on the Naxos label is that there is little duplication of repertory. Once they have recorded a work it is usually the only recording of that composition Naxos will feature in their catalog. Their roster of artists may not contain the biggest and hottest names in the classical music industry, but Naxos's recordings are always of the highest quality. This is a great place to start building your classical music CD library. http://www.naxos.com.

Sony Classical

This label is part of the mega-giant Sony Music Entertainment Inc. Most of their new releases are very mainstream, and many are marketed with the concept of "crossover" sales in mind. Having said that, most of their recordings are of the highest quality, and all of their artists are quite talented. Sony Classical also owns the rights to a number of older recording catalogs that they have purchased over the years, and you can find a number of very good re-release recordings on the Sony Classical label. Beyond the recordings themselves, Sony's website is extremely well organized, with recording samples and even a good many video clips. The site offers you a great opportunity to hear (and in some cases see) what you are interested in before you purchase it. http://www.sonymasterworks.com.

Deutsche Grammophon

Here is one of the oldest classical music recording companies in existence. DG has a very large back catalog of historic recordings that it continues to re-release on a regular basis, and they continue to produce many high quality new recordings as well. Most of their recordings are quite expensive and are usually well worth it. Just about any standard repertory you are looking for can be found on this label, which is now part of the Universal Music Group. http://www.deutschegrammophon.com.

EMI Classics/Angel

This is the current American label name for most classical recordings released by the EMI Music Group, which also includes Virgin Records, Virgin Classics, and Capitol Records to name but a few. Compared to the other large conglomerate labels, EMI tends to be more willing to produce and release recordings of challenging modern music. They still have a wealth of mainstream releases in their catalog to be sure, but you can also find more Stravinsky, more Bartok, and even some really freaky avant-garde music as well. Their main website page is http://www.emiclassics.com.

Telarc

This is a mainstream record label that focuses on releasing classical music with a wide audience appeal, "crossover" symphonic pops recordings, and accessible chamber music. This label also offers a number of mainstream jazz recordings as well (see below). Telarc is actively involved in the release of classical music and jazz recorded or reformatted for the SACD (Super Audio Compact Disc) surround-sound format. http://Telarc.com.

Delos

This large independent classical record label offers an interesting catalog of music that includes numerous recordings of the works of more modern composers such as David Diamond, Howard Hanson, Alan Hovhaness, and Dimitri Shostakovich. They also offer a large selection of more mainstream classical recordings from all the major style periods, though they don't focus much attention on early music. http://www.delosmus.com.

Decca Records and Philips Records

These two major labels offer over 2,200 titles in their catalog, including many famous re-releases of older recordings as well as many mainstream new releases. As with Deutsche Grammophon, both of these labels are now part of the Universal Music Group. http://www.deccaclassics.com.

Qualiton Imports LTD

This is not a single record label, but rather a clearinghouse for a wide array of small European record labels that Qualiton imports into the United States. All of the selections on your listening CDs were taken from recordings currently being offered by Qualiton. A few of the most important labels Qualiton represents include BIS, Col Legno, Doron, Glossa, Hungaroton, Musicaphon, Novalis, Orfeo, and Supraphon. https://qualiton.com.

Jazz Record Labels

Blue Note

The Blue Note record label is one of the best labels for bebop, hard bop, and more "straight ahead" modern jazz styles. They also have an active stable of current artists including Norah Jones. Over the decades, they have recorded just about

every major name mentioned in Chapter 10. Musicians including Herbie Hancock, Chick Corea, Horace Silver, John Coltrane, Clifford Brown, J.J. Johnson, Wayne Shorter, and Art Blakey can all be found on Blue Note. This label is now owned by Capitol Records, which is owned by EMI Music Group. http://www.bluenote.com.

Telarc

The Telarc record label offers a tried and true collection of jazz artists, mostly recording in the mainstream jazz styles. The quality is always very good, and their boxed-set prices are usually quite reasonable. http://Telarc.com.

Verve

Here is a label that has several different functions. They continue to record new jazz artists, they have retained the rights to older projects they recorded, and they have also purchased the catalogs of some other jazz record labels, which they then re-release, usually at a reduced price. There are lots of great recordings available here. Currently, Verve also holds the catalogs of GRP and Impulse! Records. They also offer a very good website with numerous active links at http://www.vervemusicgroup.com.

Sony/Columbia

This big conglomerate records a wide range of jazz styles, and they also own an enormous back-catalog of older jazz recordings. Of particular note is the *Columbia Jazz Masterpiece* series. You can't go wrong with any of the recordings in this series, which include many of the masterpieces mentioned in this book, as well as many of the major releases from artists including Billie Holiday, Louis Armstrong, Thelonious Monk, and Miles Davis. Under the Legacy label, this is the company issuing all of the *Ken Burns' Jazz* series CDs. http://www.sonymusic.com.

Fantasy, Riverside, and Original Jazz Classics

These three labels (now known as "back catalogs") offer a great deal of straight-ahead jazz and blues from the mid-50s through today. Many of the best re-release projects currently available can be found among these three labels. All of these labels, along with several other more contemporary jazz labels, are now part of the Concord Music Group. http://www.concordmusicgroup.com.

Pacific

The Pacific jazz label was formed in the 1950s to record the Gerry Mulligan-Chet Baker "Pianoless" Quartet, and the label went on to record many of the finest West Coast jazz artists, as well as many of the popular New York acts that made visits to the "other" coast. The label is now part of Blue Note Records, and the Pacific label recordings are posted along with all other Blue Note releases. http://www.bluenote.com.

World Music Record Labels

Smithsonian Folkways Records

For Americans, this is the proverbial mother lode for world music, old time blues, folk music, and other non-mainstream recordings. As you saw in Chapter 11, Folkways Records' productions are extensive and always first-rate. http://www.folkways.si.edu.

Putumayo

Putumayo has become something of a flagship label for world music in the past few years. This website offers easy access to their entire catalog and a nice children's music area as well. http://www.putumayo.com.

Shanachie

This eclectic record label offers world music, down-home blues, jazz, and a mixed variety of older re-releases. This website is a bit bare bones, but all of their music and videos are available in one place. http://www.shanachie.com.

Nonesuch

Nonesuch is another eclectic record label that offers a wide variety of musical styles and also seems more willing to release adventurous recording projects. They offer classical music, jazz, world music, and selected artists in various popular music genres. http://www.nonesuch.com.

Luaka Bop

This is the world music label started by former Talking Heads front man David Byrne. Although something of an independent record label, Byrne has established major label distribution deals that help put Luaka Bop artists and the label's compilation recording projects firmly in the mainstream media's eyesight. This website is very cutting edge, with embedded videos, podcasts, and links to myspace, facebook, and twitter pages. http://www.luakabop.com.

Shopping for Used and Cut-Out Compact Discs

The used CD market is a great place to start building a CD collection, and it can also be a wonderful way to discover composers and artists you have never heard before. I personally own well over 4,000 CDs, and most of them cost less than $5.00. Some of my favorite recordings only cost 25¢. My best day was getting almost 40 CDs (many from wonderful artists I had never heard before) and walking out of the store for less than $10.00. It can be done—if you know how to shop and are willing to spend the time digging through gigantic piles of mostly bad recordings. Here are some basic rules of thumb when digging through the used bins at your local record store.

You should rarely have to pay more than $7.99 for a used CD, and most should fall in the $4.00 to $6.00 range. At these prices, look for artists whose names you know, or for any of the labels listed above in the new records section. When things get below a buck or two, however, it's time to get bold and try some new stuff. And, of course, when the CDs are less than a buck, the sky is the limit. If the recording is bad, you can always toss out the disc and use the jewel case to replace a broken one in your collection. With bad recordings, you can also try to sell them back to another record store that buys used CDs. There have been times when I've actually made a nice profit doing this, but don't tell the record stores because I'll deny everything! Keep in mind that classical music, jazz, and world music, tend to be a relatively low priority at most record stores. The bins tend to be poorly organized, and some really good recordings often end up filed under used rock, punk, soul, new age, or contemporary Christian music. The more you dig through everything, the better your chances are at finding a real deal. The good news about this lack of focus at most record stores is that used classical, jazz, and world music, CDs often get marked incorrectly. If you find a recording you want for $5.99, make sure to look at other copies of the same used CD. You will often find the same CD marked at a lower price in another bin. Don't be afraid to haggle about prices. Often, store clerks will know little or nothing about classical music, jazz, or world music, and if you are polite and act like you know what you are talking about you can get them to give you a lower price (especially on a box-set).

Cut-out recordings are new recordings that have usually gone out-of-print and the label or distributor is clearing out their backlog of old material. You have to be in the right place at the right time, but as with used CDs, you can find some great deals in the cut-out bin if you shop long enough. Beyond the typical record stores, keep your eyes open for cut-out recordings at discount stores such as Big Lots and Ross.

Shopping and Listening on the Internet

Shopping for used CDs on the Internet is something of a mixed bag. Sometimes you can find real deals on sites such as www.overstock.com and www.amazon.com, but by the time you pay the shipping charges you will not have saved much money. Having said that, if you find something you know you really want, these can be good places to go hunting for that long lost treasure. Used online bookstores also offer good deals sometimes on used CDs, but it often involves a serious Internet search party to find anything worthwhile.

There are also a few independent music resources that offer new CDs at very reasonable prices. One of the best is www.cdbaby.com. This innovative, and often downright funny, website serves mostly independent artists who want to maintain control over their product without the interference of a major record label. Best of all, to entice new listeners, cdbaby offers a $5 CD bin that artists can elect to place selected recordings in with the hope of finding a broader audience for their music. It's a fun place to waste an afternoon. Each CD offered has selected mp3 samples and, in some cases, you can stream the entire recording before you decide to buy. Once again, be careful because this website is quite addictive!

There are also a number of legal mp3 download sites, and now many more traditional websites, such as Wal-Mart, Target, Amazon, and Barnes and Noble to name but a few, offer mp3 downloads side-by-side with standard CD offerings. The most famous mp3 site today is iTunes, but for my money they are overpriced. Personally, I really enjoy www.emusic.com. Though they have recently changed their pricing structure, it's still the best legal deal on the Internet. The downloads are mostly high quality, and the site is easy to navigate and quick to load.

Finally, the last few years have seen an explosion of streaming radio websites. One of the first, and in my opinion still the best for jazz and classical music, is www.pandora.com. The site is intuitive, easy to customize, and totally free. Similar sites that also work well include www.last.fm and www.slacker.com. In addition, you will also find more and more record label websites and other music websites offering their own streaming radio offerings. Through most computer media player programs today i.e., iTunes, Real Player, Widows Media Player, etc., you will also find a wealth of free online streaming media. Go forth and listen.

Glossary

Aerophones	A classification of instruments within the Hornbostel-Sachs system that produce sound initially by blown air.
Aleatory music	In this system, elements of pieces, or even the preparation of entire compositions and performances, are left up to chance operations and/or the discretion of the performer(s).
Aria	Popular solo vocal style of which there are several different types including da capo (ABA) and strophic (same melody over and over). Common in operas, oratorios, and cantatas among many other forms.
Basso continuo	New style of accompaniment developed around the beginning of the Baroque era. This is the performing ensemble or solo instrument that realizes a figured bass. Originally, the continuo might have been one instrument such as a harpsichord or a lute, but it quickly evolved into a two-instrument ensemble that most frequently featured a harpsichord and some sort of bass instrument.
Bridge	Similar to the term transition, this term indicates the connecting material used between two main themes. Some scholars use the term *transition* to indicate changes in key center while reserving the term *bridge* to indicate times when the music does not change keys between two given themes.
Cadenza	Most common during a concerto. This is a portion of music where the orchestral accompaniment drops out and the soloist continues alone. During the Classical period many cadenzas were improvised, but after 1825 most cadenzas were written out by the composer.
Call and Response	A form that consists of a leader, singing or playing a musical phrase that is answered by a group response. This form can be used as a rhythmic or melodic device (or a combination of the two) and can be vocal or instrumental.
Cantata	Early works were sacred or secular solo vocal works accompanied by a lute or basso continuo. During the second half of the Baroque era, J. S. Bach raised the level of composition and overall scope of his sacred cantatas to the point where they have actually been referred to as short oratorios. Bach made use of impressive contrapuntal writing for both voices and orchestra, and he also incorporated operatic-style arias, duets, and recitatives. All of his sacred cantatas are written for

solo voices, chorus, and orchestral accompaniment with basso continuo, and many of them are based on pre-existing hymn tunes that usually show up written as a four-part chorale in the last movement.

Cantus Firmus Fixed song. Indicates the use of a Gregorian chant or other older melody to provide the basis for new compositions with one or more extra melodic lines written over the top of a pre-existing melody. Common during the later Middle Ages and throughout the Renaissance in both mass and motet compositions.

Character Pieces Small, single-movement pieces most popular during the Romantic era. Works for the solo piano were most common, but small character pieces were composed for a number of solo instruments with piano accompaniment as well. Many of these works were absolute, but some did carry programmatic titles.

Chordophones A classification of instruments within the Hornbostel-Sachs system that produce sound initially by vibrating strings.

Chords Groups of notes that sound consonant or dissonant when played together or when sounded close together in two or more polyphonic lines. They can be played by one instrument such as a piano or guitar or by a group of instruments including strings, woodwinds, and/or brass.

Church modes Prior to 1600 there were seven different patterns of half-steps and whole-steps, each consisting of an eight-note pattern within a given octave. Each different mode was said to convey a specific set of emotions though in practice composers did not always adhere to that theory.

Claves Wooden sticks that are struck together in Afro-Cuban music.

Comping Short for complimenting, comping became a common style of jazz piano playing around 1945. Sparse harmonic and/or melodic interjections over a steady rhythm.

Compound form Formal structures that function on more than one level. For example, the overall structure of a typical minuet and trio is ABA, but within each individual section there will be smaller two- or three-part forms.

Concert overtures Also overture-fantasias. These programmatic overtures are single-movement symphonic works that frequently draw their inspiration from earlier literary works such as the plays of Shakespeare.

Concerto Usually a three-movement work (fast-slow-fast) for one solo instrument, such as piano, violin, flute, or oboe, with an orchestral accompaniment.

Concerto grosso Similar to a solo concerto, but it features a small group of instruments (the *concertino*) against the full orchestra (the *tutti* or *ripieno*). Popular format throughout the Baroque era.

Consonance Tones at rest. A consonant chord is pretty stable: it either is or it isn't.

Cyclic	Melodic and/or rhythmic idea(s) presented in the first movement that return in subsequent movements of a multi-movement composition.
Development	Middle section of all sonata forms. This section allows the composer a chance to experiment with the themes from the exposition. Here the composer frequently changes key centers and alters the thematic material by changing the basic shape of theme.
Diaspora	The dispersion—forced or voluntary—of any group of people holding common ethnicities.
Didgeridoos	Aerophones associated with aboriginal music of Australia.
Dissonance	Tones that need to be resolved. There is a whole sound spectrum of dissonance from mildly dissonant to extremely harsh, clashing sounds.
Double exposition	Common only during Classical era solo concertos. The first time through the exposition all of the themes are presented by the orchestra only, and the second theme (and third theme if there is one) does not move to a new key center. The second time through the exposition the soloist enters and dominates the texture. This time the first theme will be played by the soloist with orchestral accompaniment, and the second theme will change key centers as the soloist continues to dominate the texture.
Dynamics	Musical marks that indicate how loud or soft a certain musical event should be. (See dynamic chart in Chapter 1 for specific dynamic marking terms.)
Eclecticism	New term beginning to take hold in the world of classical music. This term is sometimes being used to refer to contemporary composers who are no longer using one clearly definable musical style, but rather, are freely mixing elements from a wide array of styles and techniques to create their compositions.
Embellishment	Adding extra rhythms and/or notes to an existing musical texture. In classical music, embellishment was a common feature in music from the late Middle Ages through the Classical period. In jazz, embellishment is a basic building block for creating more extended improvisations.
Empfindsamkeit	Sentimentality or sensibility. Popular style for Pre-Classical and Classical composers. This technique, found most commonly in slow movements, featured composers making sudden harmonic and/or rhythmic shifts while writing free-flowing, highly expressive melodies.
Ethnomusicology	The study of music as it pertains to human culture.
Exposition	First large section found in every sonata form. The first theme will be presented in the tonic key, followed by a transition where the composer will change from one key center to another. This transition is followed by a second and sometimes a third theme presented in a closely related key center.

For contrast between the two themes, the first one tends to be dramatic and rhythmically active, whereas the second theme is usually more lyrical.

Expressionism

An artistic movement that flourished in the early years of the twentieth century. Composer Arnold Schoenberg altered his compositional style from lush Post-Romanticism to embrace these new artistic concepts. Along with this new stylistic approach, Schoenberg attempted to develop a new musical language with which he could better convey his musical message. At first, he began writing compositions in a harsh, freely atonal format. Later, he developed a new system of musical organization called *serialism*.

Figured bass

With the adoption of the major/minor tonal system a style of musical short hand quickly developed called figured bass. In this system, the bass line would be written out along with numbers and musical symbols to indicate what notes the harpsichord was to play above the bass. The actual accompaniment would be improvised, or *realized*, during the performance according to the standard musical styles of the day.

Filmi music

The music related to the massive Hindustani film industry that originated in the city of Bombay (now Mumbai). The upstart industry was christened *Bollywood,* a blending of the names Hollywood and Bombay.

French Overture

Instrumental format that was something of a mirror to the Italian Overture in that the section tempos are slow, fast, slow.

French Suite

Instrumental format using an overture for the first movement followed by a number of individual dance movements.

Fugue

Multiple-voiced texture used in both instrumental and vocal compositions. Main components are the exposition, which includes the subject, answer, and countersubject(s), followed by contrasting episodes and subsequent statements of the full subject.

Galant style

Popular style for Pre-Classical and Classical composers. Music is graceful, gentle, sometimes playful, and always pleasant to the ear.

Gamelan Orchestras

Indonesian ensembles that usually consist of a set of tuned gongs, various metallophones and wooden xylophone-like instruments. The ensembles can also include flutes, rebabs, and vocalists.

Gregorian Chant

Pope Gregory I (ca. 540 – 604) set down an edict saying that the monasteries should preserve melodies used in the church by writing them all down using a system of musical notation. For that reason, the early monophonic music of the church is most frequently referred to as Gregorian Chant, but you will also see the term *plainchant* or *plainsong* used in reference to the same music. Most Gregorian chants fall into three basic categories: syllabic, neumatic, and melismatic.

Harmonic rhythm

The frequency with which chords change in a given composition.

Harmony	A grouping of two or more different pitches.
Homophonic	Combined sounds. Playing groups of different notes with the same basic rhythm.
Idée fixe	Fixed idea. Berlioz was the first to use this concept in his *Symphonie fantastique*. He used this theme in all five movements to represent his love interest and modified the theme to match the story as the work progressed.
Idiophones	A classification of instruments within the Hornbostel-Sachs system that produce sound primarily by vibrations through the body of the instrument.
Improvisation	Also referred to as spontaneous composition. A major component of improvisation is embellishment. In classical music, cadenzas were frequently improvised during the Classical era. In addition, some modern classical works require extensive improvisation as well. In jazz, improvisation is a major component of the art form.
Intervals	Pitches of different frequencies are called intervals, with the smallest interval being 1/2 step away from its neighbor. Next comes a whole step, a step and 1/2, and so forth, all the way up to an interval 12 half-steps (or 8 whole steps) wide, called an octave.
Īqā'āt	A series of rhythmic modes that govern the rhythmic structure of traditional Arabic music.
Iråmå	A system that governs the articulation of time in Indonesian music.
Italian Overture	These Baroque overtures follow a three-section pattern of fast-slow-fast, which laid the groundwork for the development of the multi-movement sonata cycle popular in almost all instrumental forms of the Classical era.
Jo-ha-kyū	The most common form found in Japanese music. It is defined in terms of tempo, which can often be applied to an entire piece, sections of a given work, or to specific musical sections. *Jo* is a slow introduction. *Ha* is a breaking apart, where the tempo builds. *Kyū* is where the tempo reaches its peak, only to subside again.
Klangfarbenmelodie	The technique of assigning certain tone colors to certain notes in an effort to create identifiable melodic patterns through timbre changes.
Kriti	Indian religious songs that are pre-composed. They are often central to the classical tradition of South Indian music.
Leitmotiv	Leading motive. The term is said to have been originated by the biographer of early romantic composer Carl Maria von Weber to describe the composer's practice of the systematic use of recurring thematic material. Wagner extended the practice to embrace Berlioz's concept of the *idée fixe* and Liszt's idea of thematic transformation. Wagner used recurring themes to identify characters, places, and things in his operas, as well as to keep a sort of musical commentary running throughout his works.

Lied	A romantic poem set to music for a solo voice with piano accompaniment.
Lunga drum	Hourglass-shaped drums that are double-headed and have a long string woven through both heads. The string is pulled or squeezed to raise or lower the pitch of the drum. They are one of the principal instruments used by the Dagomba people of Ghana.
Madrigal	Polyphonic secular vocal format popular during the late Renaissance and early Baroque periods. The style is marked by richly polyphonic music set with poetry that speaks of love and other popular courtly topics.
Maqamat	A series of melodic modes that govern the melodic elements of Arabic music.
Mbira	African instruments that are classified as plucked idiophones. In general, the instrument will consist of a piece of wood (hollow or solid), to which are attached different sized keys, or tongues. The tongues are usually made of metal, but wood is sometimes used. If the soundboard is solid, the instrument will be placed in a large gourd, which acts as a resonator.
Measure or **Bar**	System of organization for the basic beat in a given piece of music. Groupings of two, three, and four are most common, but there can also be more complex groupings of 6, 9, and 12 basic beats, which then sub-divide into larger patterns of two, three, or four. During the twentieth century, more complex asymmetrical beat patterns also became popular with some composers.
Melody	An organized series of pitches. Melodies can be simple or complex, harsh or beautiful, full of wide intervallic leaps or conjunct passages of one note flowing up or down to the next.
Minimalism	Highly tonal, repetitive modern music that shares many of the extended meditative qualities found in the music of Eastern cultures.
Membranophones	A classification of instruments within the Hornbostel-Sachs system that produce sound initially through a stretched membrane.
Minuet and trio	Format derived from music for the dance. Most common during the Classical era and used as the third movement of a four-movement sonata cycle.
Monody	A single melody over a simple accompaniment. The development of monody at the beginning of the Baroque era made the creation of opera possible.
Monophonic	Literally one sound. A single line of melody with no accompaniment. All of the earliest Gregorian chants were monophonic.
Motet	Three-, four-, or five-voice compositions popular during the late Middle Ages and throughout the Renaissance. Most early motets were sacred, whereas later compositions could be either sacred or secular.
Mridangam	Double-headed drums that are tuned to specific pitches, used primarily in the music of Southern India.

Musique concrète	Refers to the recording of sounds made in nature or created by man, and then subsequently arranging these recorded elements into a sort of musical collage. Over the years, the term has evolved to include significant electronic alterations of a variety of recorded sounds, both natural and man-made, which can then be put on tape as a completed work or used in conjunction with other methods of musical production.
Music drama	Term developed by Wagner to describe his operas, in which he attempted to unify all the elements of the artistic world into one fully synthesized work of art.
Nationalism	Nineteenth- and twentieth-century compositional style. Nationalistic elements in music can include: (1) the use of local folk tunes, dance rhythms, and/or the creation of new melodies that resemble the music of a composer's homeland; (2) programmatic music (especially tone poems) that paint musical portraits of local folk tales or scenes from the countryside; and (3) the creation of nationalist operas, written in the local language and telling stories of folk life or local mythology.
Neo-Classicism	A general term that could refer to the reduced size and/or instrumental make-up of a chosen ensemble, a return to the use of simpler formal structures, consciously altered melodic and/or harmonic concepts, or any combination of the above elements.
Neo-Romanticism	As with Neo-Classicism above, this style marks a return by modern composers to a more "audience friendly" Romantic sensibility.
Opus	Literally "work." Most composers tend to number their first composition Opus 1 (or Op. 1) and, subsequent works follow in sequential order.
Oratorio	The strict definition for oratorio is a vocal work with many of the same characteristics as an opera but based on a sacred topic and containing little or no dramatic action on the stage (no sets, costumes, or drama). In practice, most oratorios during the Baroque era adhered to this principle though there were exceptions.
Ordinary	The five sections of the mass that make up the Ordinary are the same text week after week: Kyrie, Gloria, Credo, Sanctus, Agnus Dei.
Organum	Two-voice sacred vocal compositions from the Middle Ages.
Parallelism	Compositional technique developed by Debussy in which he would move large, extended-harmony chords up and down in direct parallel motion.
Pedal Point	Use of an extended note, usually in lower voices of a given ensemble, over which harmonies continue to unfold. Very common to establish a dominant functioning pedal point when building up to a return to tonic.
Pélog	A seven note scale used in Indonesian gamelan music.

Pentatonic scale	Five-note scales that are used in many areas around the world.
Pitch	Any sound that has an identifiable, sustained harmonic frequency can be considered a musical sound or be said to have a definite "pitch."
Polyphonic	Many sounds. The term polyphonic applies when two or more simultaneous melodies weave together with different rhythms and notes. Harmony is created, but so is a certain amount of rhythmic complexity.
Polyrhythm	A rhythmic device that consists of playing two different metrical groupings together over the same period of time.
Proper	Portions of the mass text that change every week, thus following the liturgical calendar.
Raga	"Super-modes" that governs the melodic elements within the music of India.
Ragtime	An early mixture of African, African-American, and European musical elements—no improvisation.
Recapitulation	Last major portion of a typical sonata form. The recapitulation is a restatement of the material just as it was heard in the exposition except that this time the composer won't change keys as he moves from the first to the second theme. The entire recapitulation will be presented in the tonic key.
Recitative	A singing pattern developed during the Baroque era that is closer to normal speech patterns that allows the story in an opera or oratorio to unfold at a much faster pace. Eventually, two types of recitative were created: *secco* (dry), with a very basic accompaniment usually played on the harpsichord, and *accompangnato* (accompanied), in which the singer still had a lot of words but the composer wrote out a more elaborate accompaniment for the orchestra.
Resultant Patterns	Rhythmic and/or melodic patterns that emerge in a piece of music and are a synthesis of two or more separate musical lines. Resultant Patterns are usually dependent upon a high degree of repetition.
Rhythm	Includes the basic beat and everything the musicians play in a given tempo.
Riff	A short, repeated, rhythmic and/or melodic phrase.
Rondo	This single-movement form is typically used in the second and fourth movements of the sonata cycle. There are two basic types of rondo structures, the five-part rondo and the seven-part rondo, and the real trick to both of them is the back-and-forth contrasting of the first theme with all of the subsequent themes. The typical seven-part rondo layout is A-B-A-C-A-B-A.
Rumba	A dance form that first emerged in the port city of Matanzas (one hour east of Havana) and developed in the docks and slums of Havana. While incorporating small elements of Spanish culture, the rumba was primarily African.

Scales	A pattern of eight half-steps and whole steps that form a basic building block for most classical music and jazz. Prior to 1600 there were seven different patterns of half-steps and whole-steps, each consisting of an eight-note pattern within a given octave. After 1600, composers began to focus their attention on the major and minor scale patterns almost exclusively.
Scherzo and trio	Beethoven created the scherzo and trio in an attempt to give the third movement of a four-movement sonata cycle more drama and to help it stand on a more equal footing with the other three movements. The literal translation of *scherzo* is joke. A scherzo can also appear as an independent character piece.
Serialism	A new, mathematical system of musical organization created by Arnold Schoenberg that guaranteed him absolute atonality in his compositions. The octave was divided into 12 equal half-steps, then Schoenberg used a formula to organize each of the 12 individual notes into a pattern called a tone row.
Sitar	A Plucked chordophone used primarily in the music of Northern India.
Sléndro	A five note scale used in Indonesian gamelan music.
Son	An Afro-Cuban form, that contains a distinct blend of African and Spanish cultures. While the early son relied upon many African musical elements, such as call-and-response patterns and polyrhythms, it also used European instruments including the guitar, *Cuban tres* (a guitar-like instrument), contrabass, piano, trumpet and congas.
Sonata (Classical era)	A multi-movement work for solo piano, or a work for one solo instrument with piano accompaniment.
Sonata da Camera	Chamber sonata. "Chamber" sonatas most commonly had some sort of generic introductory movement followed by a series of dance movements. Be clear on the fact that while rhythms and formal structures were borrowed from older styles of dance music, this was music for listening, not for dancing. A few common dance movement styles included *allemande, courante, sarabande, gigue, minuet, gavotte, bourrée,* and *passepied*.
Sonata da Chiesa	Church sonata. Most of the "church" sonatas featured alternating slow and fast movements, several of which usually had some contrapuntal writing.
Sonata cycle	A multi-movement instrumental format. The sonata cycle is used in almost every type of Classical instrumental music you care to name. The symphony, the string quartet, the piano trio, the concerto, and the sonata all make use of some kind of multiple-movement layout. The typical sonata cycle format is made up of three or four contrasting movements with tempos that are usually (1) fast, (2) slow, (3) medium, and (4) really fast.

Sonata form	A one-movement structure that must have an exposition, a development, and a recapitulation. In addition, it can also have an introduction and a coda, but these two sections are optional. Commonly used in the first movement of a sonata cycle but it can also be found in the second and fourth movements as well.
Sonata-rondo form	A hybrid single-movement formal structure. In its most common presentation the first A-B-A represents the exposition, letter C represents the development, and the last A-B-A will function as the recapitulation.
Sprechstimme	A dramatic form of vocal delivery that is half-spoken, half-sung on specific, notated musical pitches. Popular technique for Expressionist composers.
Stride-style Piano	Stride-style piano players copied the written rhythmic styles of ragtime, but they increased the technical demands and improvised almost everything they played. A simple definition to remember is that the left hand plays the bass notes and the chords while the right hand plays the melody.
Strophic	Song style that literally sings the same tune over and over with new text. Also common is the use of a modified strophic technique, which is basically the same tune but with significant alterations where the text requires.
Sturm und drang	Literally "storm and stress." A popular literary style around the beginning of the Classical era whose concepts spilled over into both music and the fine arts.
Symphonic Poem or **Tone Poem**	Developed during the Romantic era, these works were programmatic, single-movement orchestral works. Tone poems tended to carry programs about new topics or to in some way concern themselves with nature.
Syncopation	An essential rhythmic component that gives jazz its unique rhythmic feel. It functions at its most simple level by placing an accent on a normally weak beat or on a normally unaccented part of a beat. Also a common element in some classical music.
Tabla	A pair of single-headed drums that are tuned to specific pitches, used primarily in the music of Northern India.
Tala	Rhythmic modes that govern the elements of time within the music of India.
Tempo	How fast or slow a piece of music is performed. (See tempo chart in Chapter 1 for specific tempo marking terms.)
Tempo rubato	Using subtle tempo fluctuations to heighten the emotional content of music. Popular during the Romantic era, particularly with composers such as Chopin and Liszt.
Ternary form	Follows an A-B-A format, or literally, play a theme, play a different melody (often in a different key center) and then go back to the first melody.

Text painting	Also known as word painting, this technique became quite popular during the Renaissance and Baroque periods as a means of heightening the dramatic impression of the words through musical "tricks." For example, the words "pain" or "death" would be coupled with harsh, clashing dissonances, and the words "love" or "sigh" would feature music that gently rocked back and forth between two pleasant sounding intervals. Text passages such as "up and down" would be set with rapid musical lines that quickly ran up and down the melodic scale.
Thematic transformation	Romantic compositional technique developed by Franz Liszt. Similar to Berlioz's *idée fixe*, Liszt wrote music that focused on one major thematic idea, which he would constantly develop throughout the course of a given piece.
Theme and Variations	Single-movement formal structure. Literally, play a theme and then create some variations on that theme. Variation techniques include changing the accompaniment, changing the rhythm, varying the melodic shape, and changing the melody and harmony from a major key to a minor key. Most of the early theme and variation movements were *sectional* where one variation clearly followed another. Later, composers began to write *continuous* variations where the individual variation techniques can be harder to pick up on.
Through-composed	The concept of through-composition makes it sound as though the composer starts writing at the beginning and never returns to the opening material. Usually that is not true, as a recognizable theme often keeps returning, but through-composed works have no clear, discernable structure.
Tone Row	System developed by Schoenberg to help guarantee absolute atonality. Each octave is divided into twelve individual notes and organized into a sequential row. Schoenberg established a basic set of principles for the application of these tone rows so that they could be used to develop all the melodic and harmonic material to be used in a given composition.
Total serialism	Modern system of composition where not only the notes of a given composition were treated in a serial manner but also rhythm, dynamics, and even orchestration could be organized through mathematical formulas.
Traditional Jazz (dixieland)	A later mixture of African, African-American, and European musical elements—lots of improvisation.
Tumbadoras (congas)	A set of three drums that are long, thin, single-headed instruments derived from instruments of the Bantu speaking people. The three different drums are referred to as the quinto (highest), conga (middle), and tumba (lowest).
Veena	A Plucked chordophone used primarily in the music of Southern India.

Verismo Literally "realism." Toward the end of the nineteenth century some composers began to create works with a more realistic tone. Unlike the historical settings used by Verdi or the mythical ones favored by Wagner, these new operas were set in modern times and avoided focusing on "known" characters. Important composers include Puccini, Bizet, Mascagni, and Leoncavallo.

Selected Bibliography

Amis, John, and Michael Rose, eds. *Words about Music: A Treasury of Writings.* New York: Marlowe & Company, 1995.

Berliner, Paul. *The Soul of Mbira: Music and Traditions of the Shona People of Zimbabwe.* Chicago, University of Chicago Press, 1981.

Blume, Friedrich. "Requiem but No Peace." *The Musical Quarterly*, vol. XLVII, No. 2, (April, 1961): 147–169.

Borge, Victor, and Robert Sherman. *My Favorite Intermissions.* Garden City, NY: Doubleday and Company, Inc., 1971.

Broughton, Simon, Mark Ellingham, ed. *The Rough Guide to World Music,* ed. London: Rough Guide Ltd, 2000.

Buena Vista Social Club, "Cuban Music History," PBS, http://www.pbs.org/buenavista/music/timeline.html (accessed August 20, 2009).

Conze, Edward. *Buddhism: Its Essence and Development.* New York: Harper & Row Publishers, 1959.

Copland, Aaron. *Copland on Music.* Garden City, NY: Doubleday & Company, Inc., 1960.

Dallin, Leon. *Techniques of Twentieth Century Composition: A Guide to the Materials of Modern Music.* Dubuque: Wm. C. Brown Company Publishers, 1974.

David, Hans T., and Arthur Mendel, eds. *The Bach Reader: A Life of Johann Sebastian Bach in Letters and Documents*, revised ed. New York: W. W. Norton & Company, Inc., 1972.

Deutsch, Otto Erich. *Mozart: A Documentary Biography.* Stanford, CA, Stanford University Press, 1965.

Duckworth, William. *20/20: 20 New Sounds of the 20th Century.* New York: Schirmer Books, 1999.

Forte, Allen. *The Atonal Music of Anton Webern.* New Haven: Yale University Press, 1998.

Grout, Donald Jay, and Claude V. Palisca. *A History of Western Music*, 6th ed. New York: W. W. Norton & Company, Inc., 2001.

Harnoncourt, Nikolaus. *The Musical Dialogue: Thoughts on Monteverdi, Bach and Mozart.* Translated by Mary O'Neill. Portland, OR: Amadeus Press, 1984.

Kaeppler, Adrienne and J. W. Love, eds. *The Garland Encyclopedia of World Music,* New York and London: Garland Publishing, Inc., 1998.

Kennedy, Michael, ed. *The Concise Oxford Dictionary of Music*, 4th ed. Oxford: Oxford University Press, 1985.

Kerman, Joseph. *Listen*, 3rd ed. New York: Worth Publishers, Inc., 1980.

Kirchner, Bill, ed. *The Oxford Companion to Jazz,* New York: Oxford University Press, Inc., 2000.

Kolodin, Irving, ed. *The Composer as Listener: A Guide to Music.* New York: Collier Books, 1962.

Lessem, Alan Philip. *Music and Text in the Works of Arnold Schoenberg.* Ann Arbor: UMI Research Press, 1979.

Levarie, Siegmund. *Mozart's Le Nozze di Figaro.* Chicago: The University of Chicago Press, 1952.

Locke, David. *Drum Damba: Talking Drum Lessons.* Crown Point, Indiana: White Cliffs Media, 1990.

Machlis, Joseph, and Kristine Forney. *The Enjoyment of Music*, 7th ed. New York: W. W. Norton & Company, Inc., 1995.

Moldenhauer, Hans. *The Death of Anton Webern*. New York: Philosophical Library, 1961.

Morgenstern, Sam, ed. *Composers on Music: An Anthology of Composers' Writings from Palestrina to Copland*. New York: Pantheon Books, 1956.

Nettl, Bruno. *Music in Primitive Culture*. Cambridge: Harvard University Press, 1956.

Page, Tim. *Music From the Road*. New York: Oxford University Press, 1992.

Partridge, Christopher, ed. *Introduction to World Religions,* Minneapolis: First Fortress Press, 2005.

Pogue, David, and Scott Speck. *Classical Music for Dummies*. Forest City, CA: IDG Books Worldwide, Inc., 1997.

Politoske, Daniel T. *Music*, 5th ed. Englewood Cliffs, NJ: Prentice Hall, 1992.

Recording liner notes, "Discover Indonesia: Selections from the 20 CD Series," Smithsonian Folkways Recordings SFW40484, http://media.smithsonianfolkways.org/liner_notes/ smithsonian_folkways/SFW40484.pdf (accessed July 8, 2009).

Recording liner notes, "The Cuban Danzón: Its Ancestors and Descendents," Folkway Records FWO4066, http://media.smithsonianfolkways.org/liner_notes/folkways/FW04066.pdf (accessed August 20, 2009).

Reid, Charles. *The Music Monster: A Biography of James William Davison, Music Critic of The Times of London, 1846-78, With Excerpts from His Critical Writings*. London: Quartet Books, 1984.

Rosen, Charles. *The Classical Style: Haydn, Mozart, Beethoven*. New York: W. W. Norton & Company, Inc., 1972.

Rowen, Ruth Halle, ed. *Music Through Sources & Documents*. Englewood Cliffs, NJ: Prentice-Hall, Inc., 1979.

Sadie, Stanley and Ed. John Tyrrell ed. *The New Grove Dicionary of Music and Musicians,* London: Macmillan Publishers Limited, 2001.

Shearer, James E. *Jazz Basics: A Brief Overview with Historical Documents and Recordings*. Dubuque: Kendall/Hunt Publishing Co., 2002.

Sherman, Robert, and Philip Seldon. *The Complete Idiot's Guide to Classical Music*. New York: Alpha Books, 1997.

Stolba, K. Marie. *The Development of Western Music: A History,* 3rd ed. Boston: McGraw-Hill, 1998.

Strunk, Oliver, ed. *Source Readings in Music History: From Classical Antiquity through the Romantic Era*. New York: W. W. Norton & Company, Inc., 1950.

Sullivan, Jack, ed. *Words on Music*. Athens, OH: Ohio University Press, 1990.

Sumarsam, "Introduction to Javanese Gamelan," *Wesleyan.edu,* http://sumarsam.web.wesleyan.edu/Intro.gamelan.pdf (accessed July 8, 2009).

Titon, Jeff Todd, ed. *Worlds of Music,* 3rd ed. New York: Schirmer Books, 1996.

Walsh, Michael. *Who's Afraid of Classical Music?*. New York: Simon & Schuster, Inc., 1989.

Webern, Anton. *The Path to the New Music*. Edited by Willi Reich. Translated by LeoBlack. Bryn Mawr, PA: Theodore Presser Company, 1963.

Weiss, Piero, and Richard Taruskin, eds. *Music in the Western World: A History in Documents*. New York: Schirmer Books, 1984.

Wold, Milo, Gary Martin, James Miller, and Edmund Cykler. *An Outline History of Western Music*, 9th ed. Boston: McGraw-Hill, 1998.

Wolff, Christoph. "The Composition and Completion of Mozart's Requiem, 1791 – 1792." In *Mozart Studies*, edited by Cliff Eisen, 1–82. Oxford: Elarendon Press, 1991.

Yudkin, Jeremy. *Music in Medieval Europe*. Englewood Cliffs, NJ: Prentice Hall, 1989.

———. *Understanding Music*. Upper Saddle River, NJ: Prentice Hall, 1996.

Zorn, Jay, and June August. *Listening to Music,* 3rd ed. Upper Saddle River, NJ: Prentice Hall, 2000.

Index